The Humanities
Culture, Continuity & Change

SECOND EDITION

Henry M. Sayre
OREGON STATE UNIVERSITY

BOOK 6
MODERNISM AND THE GLOBALIZATION OF CULTURES: 1900 TO THE PRESENT

Prentice Hall

Boston Columbus Indianapolis New York San Francisco Upper Saddle River
Amsterdam Cape Town Dubai London Madrid Milan Munich Paris Montréal Toronto
Delhi Mexico City São Paulo Sydney Hong Kong Seoul Singapore Taipei Tokyo

For Bud Therien, art publisher and editor par excellence, and a good friend.

Editorial Director: Craig Campanella
Editor in Chief: Sarah Touborg
Acquisitions Editor: Billy Grieco
Assistant Editor: David Nitti
Editor-in-Chief, Development: Rochelle Diogenes
Development Editor: Margaret Manos
Media Director: Brian Hyland
Senior Media Editor: David Alick
Media Project Manager: Rich Barnes
Vice President of Marketing: Brandy Dawson
Executive Marketing Manager: Kate Stewart Mitchell
Senior Managing Editor: Ann Marie McCarthy
Associate Managing Editor: Melissa Feimer
Senior Project Manager: Barbara Marttine Cappuccio
Project Manager: Marlene Gassler
Senior Manufacturing Manager: Mary Fisher
Senior Operations Specialist: Brian Mackey

Senior Art Director: Pat Smythe
Interior Design: PreMediaGlobal
Cover Designer: Pat Smythe
Manager, Visual Research: Beth Brenzel
Photo Research: Francelle Carapetyan / Image Research Editorial Services
Pearson Imaging Center: Corin Skidds, Robert Uibelhoer
Full-Service Project Management: PreMediaGlobal
Composition: PreMediaGlobal
Printer/Binder: Courier / Kendallville
Cover Printer: Phoenix Color, Corp.
Cover Image: Chuck Close, *Stanley* 1980–1981. Oil on canvas, 274.3 × 213.4 cm (108 × 84 in.) ©The Solomon R. Guggenheim Foundation, New York. Purchased with funds contributed by Mr. and Mrs. Barrie M. Damson, 1981.81.2839. Photograph by David Heald. (FN 2839). Courtesy The Pace Gallery.

Credits and acknowledgments borrowed from other sources and reproduced, with permission, in this textbook appear on appropriate page within text and beginning on page Credits-1.

Library of Congress Cataloging-in-Publication Data
Sayre, Henry M.
 The humanities: culture, continuity & change / Henry M. Sayre.—2nd ed.
 p. cm.
 Includes bibliographical references and index.
 ISBN-13: 978-0-205-78215-4 (alk. paper)
 ISBN-10: 0-205-78215-9 (alk. paper)
 1. Civilization—History—Textbooks. 2. Humanities—History—Textbooks. I. Title.
CB69.S29 2010
909—dc22

 2010043097

10 9 8 7 6 5 4 3 2

Prentice Hall
is an imprint of

www.pearsonhighered.com

ISBN-10: 0-205-01332-5
ISBN-13: 978-0-205-01332-6

SERIES CONTENTS

BOOK ONE

THE ANCIENT WORLD AND THE CLASSICAL PAST:
PREHISTORY TO 200 CE

1 The Rise of Culture: From Forest to Farm
2 Mesopotamia: Power and Social Order in the Early Middle East
3 The Stability of Ancient Egypt: Flood and Sun
4 The Aegean World and the Rise of Greece: Trade, War, and Victory
5 Golden Age Athens and the Hellenic World: The School of Hellas
6 Rome: Urban Life and Imperial Majesty
7 Other Empires: Urban Life and Imperial Majesty in China and India

BOOK TWO

THE MEDIEVAL WORLD AND THE SHAPING OF CULTURE:
200 CE TO 1400

8 The Flowering of Christianity: Faith and the Power of Belief in the Early First Millennium
9 The Rise and Spread of Islam: A New Religion
10 The Fiefdom and Monastery, Pilgrimage and Crusade: The Early Medieval World in Europe
11 Centers of Culture: Court and City in the Larger World
12 The Gothic Style: Faith and Knowledge in an Age of Inquiry
13 Siena and Florence in the Fourteenth Century: Toward a New Humanism

BOOK THREE

THE RENAISSANCE AND THE AGE OF ENCOUNTER:
1400 TO 1600

14 Florence and the Early Renaissance: Humanism in Italy
15 The High Renaissance in Rome and Venice: Papal Patronage
16 The Renaissance in the North: Between Wealth and Want
17 The Reformation: A New Church and the Arts
18 Encounter and Confrontation: The Impact of Increasing Global Interaction
19 England in the Tudor Age: "This Other Eden"
20 The Early Counter-Reformation and Mannerism:Restraint and Invention

BOOK FOUR

EXCESS, INQUIRY, AND RESTRAINT:
1600 TO 1800

21 The Baroque in Italy: The Church and Its Appeal
22 The Secular Baroque in the North: The Art of Observation
23 The Baroque Court: Absolute Power and Royal Patronage
24 The Rise of the Enlightenment in England: The Claims of Reason
25 The Rococo and the Enlightenment on the Continent: Privilege and Reason
26 The Rights of Man: Revolution and the Neoclassical Style

BOOK FIVE

ROMANTICISM, REALISM, AND EMPIRE:
1800 TO 1900

27 The Romantic World View: The Self in Nature and the Nature of Self
28 Industry and the Working Class: A New Realism
29 Global Confrontation and Civil War: Challenges to Cultural Identity
30 In Pursuit of Modernity Paris in the 1850s and 1860s
31 The Promise of Renewal: Hope and Possibility in Late Nineteenth-Century Europe
32 The Course of Empire: Expansion and Conflict in America
33 The Fin de Siècle: Toward the Modern

BOOK SIX

MODERNISM AND THE GLOBALIZATION OF CULTURES:
1900 TO THE PRESENT

34 The Era of Invention: Paris and the Modern World
35 The Great War and Its Impact: A Lost Generation and a New Imagination
36 New York, Skyscraper Culture, and the Jazz Age: Making It New
37 The Age of Anxiety: Fascism and Depression, Holocaust and Bomb
38 After the War: Existential Doubt, Artistic Triumph, and the Culture of Consumption
39 Multiplicity and Diversity: Cultures of Liberation and Identity in the 1960s and 1970s
40 Without Boundaries: Multiple Meanings in a Postmodern World

CONTENTS

Preface vi

MODERNISM AND THE GLOBALIZATION OF CULTURES: 1900 TO THE PRESENT 1114

34 The Era of Invention
PARIS AND THE MODERN WORLD 1117

Pablo Picasso's Paris: At the Heart of the Modern 1119
 The Aggressive New Modern Art: *Les Demoiselles d'Avignon* 1120
 Matisse and the Fauves: A New Color 1122
 The Invention of Cubism: Braque's Partnership with Picasso 1124
 Futurism: The Cult of Speed 1128
 Modernist Music and Dance: Stravinsky and the Ballets Russes 1129
The Expressionist Movement: Modernism in Germany and Austria 1130
 Die Brücke: The Art of Deliberate Crudeness 1130
 Der Blaue Reiter: The Spirituality of Color 1131
 A Diversity of Sound: Schoenberg's New Atonal Music versus Puccini's Lyricism 1133
Early-Twentieth-Century Literature 1134
 Guillaume Apollinaire and Cubist Poetics 1134
 Ezra Pound and the Imagists 1134
The Origins of Cinema 1136
 The Lumière Brothers' Celluloid Film Movie Projector 1136
 The Nickelodeon: Movies for the Masses 1137
 D. W. Griffith and Cinematic Space 1137

READINGS
 34.1 from Gertrude Stein, *The Autobiography of Alice B. Toklas* (1932) 1119
 34.2 from Filippo Marinetti, *Founding and Manifesto of Futurism* (1909) 1141
 34.3 from Guillaume Apollinaire, "Lundi, rue Christine" (1913) 1134
 34.4 Guillaume Apollinaire, "Il Pleut" (1914) 1134
 34.5 Ezra Pound, "In a Station of the Metro" (1913) 1135
 34.6 Ezra Pound, "A Pact" (1913) 1135

FEATURES
 CLOSER LOOK Picasso's Collages 1126
 CONTINUITY & CHANGE The Prospect of War 1139

35 The Great War and Its Impact
A LOST GENERATION AND A NEW IMAGINATION 1143

Trench Warfare and the Literary Imagination 1145
 Wilfred Owen: "The Pity of War" 1146
 In the Trenches: Remarque's *All Quiet on the Western Front* 1146
 William Butler Yeats and the Specter of Collapse 1147
 T. S. Eliot: The Landscape of Desolation 1147
Escape from Despair: Dada in the Capitals 1148
Russia: Art and Revolution 1152
 Vladimir Lenin and the Soviet State 1152
 The Arts of the Revolution 1152
Freud, Jung, and the Art of the Unconscious 1155
 Freud's *Civilization and Its Discontents* 1155
 The Jungian Archetype 1158
 The Dreamwork of Surrealism 1158
Experimentation and the Literary Life: The Stream-of-Consciousness Novel 1164
 Joyce, *Ulysses*, and Sylvia Beach 1164
 Virginia Woolf: In the Mind of Mrs. Dalloway 1165
 Marcel Proust and the Novel of Memory 1166

READINGS
 35.1 from Alfred, Lord Tennyson, "Charge of the Light Brigade" (1854) 1145
 35.2 Wilfred Owen, "Dulce et Decorum Est" (1918) 1146
 35.3 from Erich Maria Remarque, *All Quiet on the Western Front* (1928) 1146
 35.4 William Butler Yeats, "The Lake Isle of Innisfree" (1893) 1147

 35.5 William Butler Yeats, "The Second Coming" (1919) 1147
 35.6 from T. S. Eliot, *The Waste Land, Part III*, "The Fire Sermon" (1921) 1169
 35.6a from T. S. Eliot, *The Waste Land* (1921) 1148
 35.7 Tristan Tzara, "Dada Manifesto 1918" (1918) 1148
 35.8 Tristan Tzara, "Monsieur Antipyrine's Manifesto" (1916) 1148
 35.9 from Hugo Ball, "Gadji beri bimba" (1916) 1149
 35.10 from Kasimir Malevich *The Non-Objective World* (1921) 1153
 35.11 from Sigmund Freud, *Civilization and Its Discontents* (1930) 1170
 35.12 from André Breton, *Surrealist Manifesto* (1924) 1158
 35.14 from Virginia Woolf, "A Room of One's Own" (1929) 1171
 35.15 from Virginia Woolf, *Mrs. Dalloway* (1925) 1165
 35.16 from Marcel Proust, *Swann's Way* (1913) 1166

FEATURES
 CLOSER LOOK Eisenstein's *The Battleship Potemkin*, "Odessa Steps Sequence" 1156
 CONTINUITY & CHANGE Harlem and the Great Migration 1167

36 New York, Skyscraper Culture, and the Jazz Age
MAKING IT NEW 1173

The Harlem Renaissance 1174
 "The New Negro" 1175
 Langston Hughes and the Poetry of Jazz 1176
 Zora Neale Hurston and the Voices of Folklore 1176
 The Quilts of Gee's Bend 1177
 All That Jazz 1177
 The Visual Arts in Harlem 1179
Skyscraper and Machine: Architecture in New York 1181
 The Machine Aesthetic 1182
 The International Style 1184
Making It New: The Art of Place 1187
 The New American Novel and Its Tragic Sense of Place 1187
 The New American Poetry and the Machine Aesthetic 1190
 The New American Painting: "That, Madam . . . is paint." 1194
 The American Stage: Eugene O'Neill 1199
The Golden Age of Silent Film 1199
 The Americanization of a Medium 1200
 The Studios and the Star System 1201
 Audience and Expectation: Hollywood's Genres 1202
 Cinema in Europe 1202

READINGS
 36.1 from W. E. B. Du Bois, *The Souls of Black Folk* (1903) 1174
 36.2 Claude McKay, "If We Must Die" (1919) 1174
 36.3 Alain Locke, *The New Negro* (1925) 1175
 36.4 Countee Cullen, "Heritage" (1925) 1207
 36.5 Langston Hughes, Selected Poems 1208
 36.5a from Langston Hughes, "Jazz Band in a Parisian Cabaret" (1925) 1176
 36.6 from James Weldon Johnson, "The Prodigal Son" (1927) 1179
 36.7a-b from F. Scott Fitzgerald, *The Great Gatsby* (1925) 1187
 36.8 from Ernest Hemingway, "Big Two-Hearted River" (1925) 1188
 36.9 from William Faulkner, *The Sound and the Fury* (1929) 1189
 36.10 William Carlos Williams, "The Red Wheelbarrow," from *Spring and All* (1923) 1190
 36.11 E. E. Cummings, "she being Brand" (1926) 1191
 36.12 from Hart Crane, "To Brooklyn Bridge," *The Bridge* (1930) 1191
 36.13 from William Carlos Williams, *The Autobiography of William Carlos Williams* (1948) 1195

FEATURES
 CLOSER LOOK Williams's "The Great Figure" and Demuth's *The Figure 5 in Gold* 1192
 CONTINUITY & CHANGE The Rise of Fascism 1205

37 The Age of Anxiety
FASCISM AND DEPRESSION, HOLOCAUST AND BOMB 1211

The Glitter and Angst of Berlin 1212
 Kafka's Nightmare Worlds 1212
 Brecht and the Berlin Stage 1213
 Kollwitz and the Expressionist Print 1214

The Rise of Fascism 1215
 Hitler in Germany 1216
 Stalin in Russia 1221
 Mussolini in Italy 1223
 Franco in Spain 1224
Revolution in Mexico 1224
 The Mexican Mural Movement 1224
 The Private World of Frida Kahlo 1228
The Great Depression in America 1228
 The Road to Recovery: The New Deal 1228
Cinema: The Talkies and Color 1233
 Sound and Language 1234
 Disney's Color Animation 1235
 1939: The Great Year 1235
 Orson Welles and *Citizen Kane* 1237
World War II 1237
 The Holocaust 1238
 The War in the Pacific 1240
 The Allied Victory 1240
 Decolonization and Liberation 1240
 Bearing Witness: Reactions to the War 1242

READINGS
 37.1 from Franz Kafka, *The Trial* (1925) 1213
 37.2 from Franz Kafka, *The Metamorphosis* (1915) 1246
 37.3 from Bertolt Brecht, "Theater for Pleasure or Theater for Imagination"
 (ca. 1935) 1214
 37.4 from Adolf Hitler, *Mein Kampf* (1925) 1216
 37.5 from Elie Wiesel, *Night* (1958) 1242

FEATURES
 CLOSER LOOK Picasso's *Guernica* 1226
 CONTINUITY & CHANGE The Bauhaus in America 1244

38 After the War
EXISTENTIAL DOUBT, ARTISTIC TRIUMPH,
AND THE CULTURE OF CONSUMPTION 1249

Europe after the War: The Existential Quest 1250
 Christian Existentialism: Kierkegaard, Niebuhr, and Tillich 1250
 The Philosophy of Sartre: Atheistic Existentialism 1250
 De Beauvoir and Existential Feminism 1251
 The Literature of Existentialism 1252
 The Art of Existentialism 1253
America after the War: Triumph and Doubt 1254
 The Triumph of American Art: Abstract Expressionism 1255
The Beat Generation 1265
 Robert Frank and Jack Kerouac 1265
 Ginsberg and "Howl" 1266
 Cage and the Aesthetics of Chance 1267
 Architecture in the 1950s 1269
Pop Art 1270
Minimalism in Art 1274

READINGS
 38.1 from Jean-Paul Sartre, *No Exit* (1944) 1251
 38.2 from Simone de Beauvoir, *The Second Sex* (1949) 1251
 38.3 from Albert Camus, Preface to *The Stranger* (1955) 1252
 38.4 from Samuel Beckett, *Waiting for Godot* (1953) 1278
 38.4a-b from Samuel Beckett, *Waiting for Godot*, Act I, II (1953) 1253
 38.5 from Allen Ginsberg, "Howl" (1956) 1266
 38.6 from Allan Kaprow, "The Legacy of Jackson Pollock" (1958) 1269

FEATURES
 CLOSER LOOK Hamilton's *Just What Is It That Makes Today's
 Homes So Different, So Appealing?* 1256
 CONTINUITY & CHANGE The Civil Rights Movement 1276

39 Multiplicity and Diversity
CULTURES OF LIBERATION AND IDENTITY
IN THE 1960s AND 1970s 1281

Black Identity 1283
The Vietnam War: Rebellion and the Arts 1288

 Kurt Vonnegut's *Slaughterhouse-Five* 1288
 Artists Against the War 1288
 Conceptual Art 1292
 Land Art 1292
 The Music of Youth and Rebellion 1296
High and Low: The Example of Music 1298
 György Ligeti and Minimalist Music 1298
 The Theatrical and the New *Gesamtkunstwerk* 1299
The Birth of the Feminist Era 1301
 The Theoretical Framework: Betty Friedan and NOW 1301
 Feminist Poetry 1302
 Feminist Art 1303
Questions of Male Identity 1307

READINGS
 39.1 from Martin Luther King, "Letter from Birmingham Jail" (1963) 1282
 39.2a-b from Ralph Ellison, *Invisible Man* (1952) 1284
 39.3 Amiri Baraka, "Ka'Ba" (1969) 1287
 39.4 from Gil Scott-Heron, "The Revolution Will Not Be Televised"
 (1970) 1287
 39.5 from Kurt Vonnegut, *Slaughterhouse-Five* (1969) 1288
 39.6 from Joni Mitchell, "Woodstock" (1970) 1297
 39.7 from Betty Friedan, *The Feminine Mystique* (1963) 1302
 39.8 Sylvia Plath, "Lady Lazarus" (1962) 1311
 39.9 Anne Sexton, "Her Kind" (1960) 1302
 39.10 from Adrienne Rich, "Diving into the Wreck" (1973) 1303

FEATURES
 CLOSER LOOK Rosenquist's *F-111* 1290
 CONTINUITY & CHANGE The Global Village 1309

40 Without Boundaries
MULTIPLE MEANINGS IN A POSTMODERN
WORLD 1313

Postmodern Architecture: Complexity, Contradiction,
and Globalization 1315
Pluralism and Postmodern Theory 1320
 Structuralism 1321
 Deconstruction and Poststructuralism 1322
 Chaos Theory 1322
 The Human Genome 1323
Pluralism and Diversity in the Arts 1323
 A Plurality of Styles in Painting 1324
 Multiplicity in Postmodern Literature 1328
 Postmodern Poetry 1330
 A Diversity of Cultures: The Cross-Fertilization of the Present 1331
 A Multiplicity of Media: New Technologies 1338

READINGS
 40.1 from Michel Foucault, *The Order of Things* (1966) 1328
 40.2 from Jorge Luis Borges, "Borges and I" (1967) 1345
 40.3a-b from Paul Auster, *City of Glass* (1985) 1329
 40.4a David Antin, "If We Get It" (1987–1988) 1330
 40.4b David Antin, "If We Make It" (1987–1988) 1330
 40.5 from John Ashbery, "On the Towpath" (1977) 1330
 40.6 Aurora Levins Morales, "Child of the Americas" (1986) 1333
 40.7 from Luis Valdez, *Zoot Suit* (1978) 1335

FEATURES
 CLOSER LOOK Basquiat's *Charles the First* 1326
 CONTINUITY & CHANGE The Environment and the Humanist
 Tradition 1343

Index Index-1

Photo and Text Credits Credits-1

DEAR READER,

You might be asking yourself, why should I be interested in the Humanities? Why do I care about ancient Egypt, medieval France, or the Qing Dynasty of China?

I asked myself the same question when I was a sophomore in college. I was required to take a year long survey of the Humanities, and I soon realized that I was beginning an extraordinary journey. That course taught me where it was that I stood in the world, and why and how I had come to find myself there. My goal in this book is to help you take the same journey of discovery. Exploring the humanities will help you develop your abilities to look, listen, and read closely; and to analyze, connect, and question. In the end, this will help you navigate your world and come to a better understanding of your place in it.

What we see reflected in different cultures is something of ourselves, the objects of beauty and delight, the weapons and wars, the melodies and harmonies, the sometimes troubling but always penetrating thought from which we spring. To explore the humanities is to explore ourselves, to understand how and why we have changed over time, even as we have, in so many ways, remained the same.

I've come to think of this second edition in something of the same terms. What I've tried to do is explore new paths of inquiry even as I've tried to keep the book recognizably the same. My model, I think, has been Bob Dylan. Over the years, I've heard the man perform more times than I can really recall, and I just saw him again in concert this past summer. He has been performing "Highway 61" and "Just Like a Woman" for nearly fifty years, but here they were again, in new arrangements that were totally fresh—recognizably the same, but reenergized and new. That should be the goal of any new edition of a book, I think, and I hope I've succeeded in that here.

ABOUT THE AUTHOR

Henry M. Sayre is Distinguished Professor of Art History at Oregon State University–Cascades Campus in Bend, Oregon. He earned his Ph.D. in American Literature from the University of Washington. He is producer and creator of the 10-part television series, *A World of Art: Works in Progress,* aired on PBS in the Fall of 1997; and author of seven books, including *A World of Art, The Visual Text of William Carlos Williams, The Object of Performance: The American Avant-Garde since 1970;* and an art history book for children, *Cave Paintings to Picasso.*

The Humanities: Culture, Continuity & Change helps students see context and make connections across the humanities by tying together the entire cultural experience through a narrative story-telling approach. Written around Henry Sayre's belief that students learn best by remembering stories rather than memorizing facts, it captures the voices that have shaped and influenced human thinking and creativity throughout our history.

With a stronger focus on engaging students in the critical thinking process, this new edition encourages students to deepen their understanding of how cultures influence one another, how ideas are exchanged and evolve over time, and how this collective process has led us to where we stand today. With several new features, this second edition helps students to understand context and make connections across time, place, and culture.

To prepare the second edition, we partnered with our current users to hear what was successful and what needed to be improved. The feedback we received through focus groups, online surveys, and reviews helped shape and inform this new edition. For instance, to help students make stronger global connections, the organization of the text and the Table of Contents have been modified. As an example, reflections of this key goal can be seen in Chapters 6 and 7, which are now aligned to show parallels more easily in the developments of urban culture and imperial authority between Rome, China, and India.

Through this dialogue, we also learned how humanities courses are constantly evolving. We learned that more courses are being taught online and that instructors are exploring new ways to help their students engage with course material. We developed MyArtsLab with these needs in mind. With powerful online learning tools integrated into the book, the online and textbook experience is more seamless than ever before. In addition, there are wonderful interactive resources that you, as the instructor, can bring directly into your classroom.

All of these changes can be seen through the new, expanded, or improved features shown here.

SEE CONTEXT AND MAKE CONNECTIONS . . .

NEW
THINKING AHEAD

These questions open each chapter and represent its major sections, leading students to think critically and focus on important issues.

NEW
THINKING BACK

These end-of-chapter reviews follow up on the **Thinking Ahead** questions, helping students further engage with the material they've just read and stimulate thought and discussion.

NEW
CLOSER LOOK

Previously called "Focus" in the first edition, these highly visual features offer an in-depth look at a particular work from one of the disciplines of the humanities. The annotated discussions give students a personal tour of the work—with informative captions and labels—to help students understand its meaning. A new critical thinking question, *Something to Think About*, prompts students to make connections and further apply this detailed knowledge of the work.

1 The Rise of Culture
From Forest to Farm

THINKING AHEAD

What features characterize the beginnings of human culture?

What characteristics distinguish the Neolithic from the Paleolithic?

What is a megalith?

How can we understand the role of myth in prehistoric culture?

THINKING BACK

What features characterize the beginnings of human culture?

The widespread use of stone tools and weapons by Homo sapiens, the hominid species that evolved around 120,000 to 100,000 years ago, gives rise to the name of the earliest era of human development, the Paleolithic era. Carvers fashioned stone figures, both in the round and in relief. In cave paintings, such as those discovered at Chauvet Cave, the artists' great skill in rendering animals helps us to understand that the ability to represent the world with naturalistic fidelity is an inherent human skill, unrelated to cultural sophistication. Culture can be defined as a way of living—religious, social, and/or political—formed by a group of people and passed on from one generation to the next. What can the earliest art tell us about these first human cultures? What questions remain a mystery?

What characteristics distinguish the Neolithic from the Paleolithic?

As the ice that covered the Northern Hemisphere slowly melted, people began cultivating edible grasses and domesticating animals. Gradually, farming supplanted hunting as the primary means of sustaining life, especially in the great river valleys where water was abundant. The rise of agriculture is the chief characteristic of the Neolithic age. Along with agriculture, permanent villages such as Skara Brae begin to appear. What does the appearance of fire-baked pottery tell us about life in Neolithic culture?

What is a megalith?

During the fifth millennium BCE, Neolithic peoples began constructing monumental stone architecture, or megaliths, in France and England. Upright, single stone posts called menhirs were placed in the ground, either individually or in groups, as at Carnac in Brittany. Elementary post-and-lintel construction was employed to create dolmens, two posts roofed with a capstone. The most famous of the third type of monumental construction, the circular cromlech, is Stonehenge, in England. What does the enormous amount of human labor required for the construction of these megaliths suggest about the societies that built them?

How can we understand the role of myth in prehistoric culture?

Neolithic culture in the Americas lasted well into the second millennium CE. Much of our understanding of the role of myth in prehistoric cultures derives from the traditions of contemporary Native American tribes that still survive in tribes such as the Hopi and Zuni, who are the direct descendents of the Anasazi. Their legends, such as the Zuni emergence tale, encapsulate the fundamental religious principles of the culture. Such stories, and the ritual practices that accompany them, reflect the general beliefs of most Neolithic peoples. Can you describe some of these beliefs? What role do sacred sites, such as those at Ise in Japan, or Cahokia in the Mississippi Valley, play?

PRACTICE MORE Get flashcards for images and terms and review chapter material with quizzes at **www.myartslab.com**

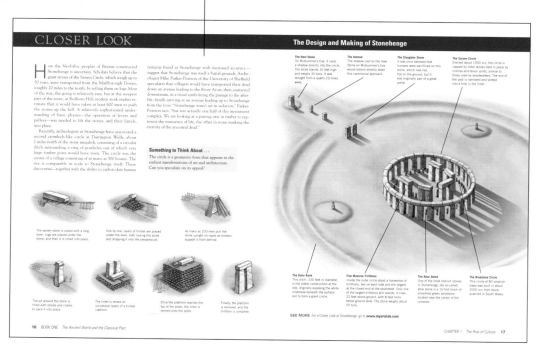

CLOSER LOOK

The Design and Making of Stonehenge

How the Neolithic peoples of Britain constructed Stonehenge is uncertain. Scholars believe that the giant stones of the Sarsen Circle, which weigh up to 50 tons, were transported from the Marlborough Downs, roughly 20 miles to the north, by rolling them on logs. Most of the way, the going is relatively easy, but at the steepest part of the route, at Redhorn Hill, modern work studies estimate that it would have taken at least 600 men to push the stones up the hill. A relatively sophisticated understanding of basic physics—the operation of levers and pulleys—was needed to lift the stones, and their lintels, into place.

Recently, archeologists at Stonehenge have uncovered a second cromlech-like circle at Durrington Wells, about 2 miles north of the stone megalith, consisting of a circular ditch surrounding a ring of postholes out of which very large timber posts would have risen. The circle was the center of a village consisting of as many as 300 houses. The site is comparable in scale to Stonehenge itself. These discoveries—together with the ability to carbon-date human remains found at Stonehenge with increased accuracy—suggest that Stonehenge was itself a burial grounds. Archeologist Mike Parker-Pearson of the University of Sheffield speculates that villagers would have transported their dead down an avenue leading to the River Avon, then journeyed downstream, in a ritual symbolizing the passage to the afterlife, finally arriving at an avenue leading up to Stonehenge from the river. "Stonehenge wasn't set in isolation," Parker-Pearson says, "but was actually one half of this monument complex. We are looking at a pairing-one in timber to represent the transience of life, the other in stone marking the eternity of the ancestral dead."

Something to Think About . . .
The circle is a geometric form that appears in the earliest manifestations of art and architecture. Can you speculate on its appeal?

The Heel Stone
On Midsummer's Eve, it casts a shadow directly into the circle. The stone stands 16 feet high and weighs 35 tons. It was brought from a quarry 23 miles away.

The Avenue
The shadow cast by the Heel Stone on Midsummer's Eve would extend directly down this ceremonial approach.

The Slaughter Stone
It was once believed that humans were sacrificed on this stone, which now lies flat on the ground, but it was originally part of a great portal.

The Sarsen Circle
Erected about 1500 BCE, the circle is capped by lintel stones held in place by mortise-and-tenon joints, similar to those used by woodworkers. The end of the post is narrowed and slotted into a hole in the lintel.

The sarsen stone is raised with a long lever. Logs are placed under the stone, and then it is rolled into place.

One by one, layers of timber are placed under the lever, both raising the stone and dropping it into the prepared pit.

As many as 200 men pull the stone upright on ropes as timbers support it from behind.

The pit around the stone is filled with stones and chalks to pack it into place.

The lintel is raised on successive layers of a timber platform.

Once the platform reaches the top of the posts, the lintel is levered into the posts.

Finally, the platform is removed, and the trilithon is complete.

The Outer Bank
This ditch, 330 feet in diameter, is the oldest construction at the site, originally exposing the white limestone beneath the surface soil to form a giant circle.

Five Massive Trilithons
Inside the outer circle stood a horseshoe of trilithons, two on each side and the largest at the closed end at the southwest. Only one of the largest trilithons still stands. It rises 22 feet above ground, with 8 feet more below ground level. The stone weighs about 50 tons.

The Altar Stone
One of the most distinct stones at Stonehenge, the so-called Altar stone is a 15-foot block of smoothed green sandstone located near the center of the complex.

The Bluestone Circle
This circle of 80 smaller slabs was built in about 2000 BCE from stone quarried in South Wales.

SEE MORE For a Closer Look at Stonehenge, go to **www.myartslab.com**

CONTINUITY & CHANGE ESSAYS

These full-page essays at the end of each chapter illustrate the influence of one cultural period upon another and show cultural changes over time.

CONTINUITY & CHANGE ICONS

These in-text references provide a window into the past. The eye-catching icons enable students to refer to material in other chapters that is relevant to the topic at hand.

CONTINUITY & CHANGE

The Pyramids of Menkaure, p. 74

CONTEXT

These boxes summarize important background information in an easy-to-read format.

MATERIALS AND TECHNIQUES

These features explain and illustrate the methods artists and architects use to produce their work.

CONTINUITY & CHANGE
Representing the Power of the Animal World

The two images shown here in some sense bracket the six volumes of *The Humanities*. The first (Fig. 1.24), from the Chauvet Cave, is one of the earliest known drawings of a horse. The second (Fig. 1.25), a drawing by contemporary American painter Susan Rothenberg (b. 1945), also represents a horse, though in many ways less realistically than the cave drawing. The body of Rothenberg's horse seems to have disappeared and, eyeless, as if blinded, it leans forward, its mouth open, choking or gagging or gasping for air.

In his catalog essay for a 1993 retrospective exhibition of Rothenberg's painting, Michael Auping, chief curator at

the Albright-Knox Museum in Buffalo, New York, described Rothenberg's kind of drawing: "Relatively spontaneous, the drawings are Rothenberg's psychic energy made imminent [They] uncover realms of the psyche that are perhaps not yet fully explicable." The same could be said of the cave drawing executed by a nameless hunter-gatherer more than 20,000 years ago. That artist's work must have seemed just as strange as Rothenberg's, lit by flickering firelight in the dark recesses of the cave, its body disappearing, too, into the darkness that surrounded it.

It seems certain that in some measure both drawings were the expression of a psychic need on the part of the artist—whether derived from the energy of the hunt or of nature itself—to fix upon a surface an image of the power and vulnerability of the animal world. That drive, which we will see in the art of the Bronze Age of the Middle East in the next chapter—for instance, in the haunting image of a dying lion in the palace complex of an Assyrian king at Nineveh—remains constant from the beginning of art to the present day. It is the compulsion to express the inexpressible, to visualize the mind as well as the world. ■

Fig. 1.24 Horse. Detail from Chauvet Cave, Vallon-Pont-d'Arc, Ardèche gorge, France (Fig. 1.1). ca. 30,000 BCE. Note the realistic shading that emphasizes the volume of the horse's head. It is a realism that artists throughout history have sometimes sought to achieve, and sometimes ignored, in their efforts to express for the forces that drive them.

Fig. 1.25 Susan Rothenberg, Untitled. 1978. Acrylic, flashe, and pencil on paper. 20″ × 20″. Collection Walker Art Center, Minneapolis: Art Center Acquisition Fund, 1979. © 2008 Susan Rothenberg/Artist's Rights Society (ARS), NY. Part of the eeriness of this image comes from Rothenberg's use of flashe, a French vinyl-based color that is clear and to creates a misty, ghostlike surface.

CHAPTER 1 *The Rise of Culture* **27**

PRIMARY SOURCES

Each chapter of *The Humanities* includes Primary Source Readings in two formats. Brief readings from important works are included within the body of the text. Longer readings located at the end of each chapter allow for a more in-depth study of particular works. The organization offers great flexibility in teaching the course.

Materials & Techniques
Methods of Carving

Carving is the act of cutting or incising stone, bone, wood, or another material into a desired form. Surviving artifacts of the Paleolithic era were carved from stone or bone. The artist probably held a sharp instrument, such as a stone knife or a chisel, in one hand and drove it into the stone or bone with another stone held in the other hand to remove excess material and realize the figure. Finer details could be scratched into the material with a pointed stone instrument. Artists can carve into any material softer than the instrument they are using. Harder varieties of stone can cut into softer stone as well as bone. The work was probably painstakingly slow.

There are basically two types of sculpture: sculpture in the round and relief sculpture. **Sculpture in the round** is fully three-dimensional; it occupies 360 degrees of space. The Willendorf statuette (see Fig. 1.3) was carved from stone and is an example of sculpture in the round. **Relief sculpture** is carved out of a flat background surface; it has a distinct front and no back. Not all relief sculptures are

alike. In *high relief* sculpture, the figure extends more than 180 degrees from the background surface. *Woman Holding an Animal Horn*, found at Laussel, in the Dordogne region of France, is carved in high relief and is one of the earliest relief sculptures known. This sculpture was originally part of a great stone block that stood in front of a Paleolithic rock shelter. In *low* or *bas relief*, the figure extends less than 180 degrees from the surface. In *sunken relief*, the image is carved, or incised, into the surface, so that the image recedes below it. When a light falls on relief sculptures at an angle, the relief casts a shadow. The higher the relief, the larger the shadows and the greater the sense of the figure's three-dimensionality.

Woman Holding an Animal Horn, Laussel (Dordogne), France. ca. 30,000–15,000 BCE. Limestone, height 17 ⁵⁄₈″. Musée des Antiquites Nationales, St. Germain-en-Laye, France.

EXPLORE MORE To see a studio video about carving, go to **www.myartslab.com**

READINGS

READING 2.3

from the *Epic of Gilgamesh*, Tablet I (ca. 1200 BCE) (translated by Maureen Gallery Kovacs)

The Epic of Gilgamesh describes the exploits of the Sumerian ruler Gilgamesh and his friend Enkidu. The following passage, from the first of the epic's 12 tablets, recounts how Enkidu, the primal man raised beyond the reach of civilization and fully at home with wild animals, loses his animal powers, and with them his innocence, when a trapper, tired of Enkidu freeing animals from his traps, arranges for a harlot from Uruk to seduce him. The story resonates in interesting ways with the biblical tale of Adam and Eve and their loss of innocence in the Garden of Eden.

TABLET I

THE HARLOT

The trapper went, bringing the harlot, Shamhat, with him,
they set off on the journey, making direct way.
On the third day they arrived at the appointed place,
and the trapper and the harlot sat down at their posts(?).
A first day and a second they sat opposite the watering hole.
The animals arrived and drank at the watering hole,
the wild beasts arrived and slaked their thirst with water.
Then he, Enkidu, offspring of the mountains,
who eats grasses with the gazelles,
came to drink at the watering hole with the animals,
with the wild beasts he slaked his thirst with water.
Then Shamhat saw him—a primitive,
a savage fellow from the depths of the wilderness!
"That is he, Shamhat! Release your clenched arms,
expose your sex so he can take in your voluptuousness.

Shamhat unclutched her bosom, exposed her sex, and he
took in her voluptuousness.
She was not restrained, but took his energy.
She spread out her robe and he lay upon her,
she performed for the primitive the task of womankind.
His lust groaned over her;
for six days and seven nights Enkidu stayed aroused,
and had intercourse with the harlot
until he was sated with her charms.
But when he turned his attention to his animals,
the gazelles saw Enkidu and darted off,
the wild animals distanced themselves from his body.
Enkidu . . . his utterly depleted (?) body,
his knees that wanted to go off with his animals went right;
Enkidu was diminished, his running was not as before.
But then he drew himself up, for his understanding had
broadened.

(for example, "the land shattered like a pot").

Perhaps most important, the epic illuminates the development of a nation or race. It is a national poem, describing a people's common heritage and celebrating its cultural identity. It is hardly surprising, then, that Ashurbanipal preserved the *Epic of Gilgamesh*. Just as Sargon II depicted himself at the gates of Khorsabad in the traditional horned crown of Akkad and the beard of Sumer, containing within himself all Mesopotamian history, the *Epic of Gilgamesh* preserves the historical lineage of all Mesopotamian kings—Sumerian, Akkadian, Assyrian, and Babylonian. The tale embodies their own heroic grandeur, and thus the grandeur of their peoples.

The poem opens with a narrator guiding a visitor (the reader) around Uruk. The narrator explains that the epic was written by Gilgamesh himself and was deposited in the city's walls, where visitors can read it for themselves. Then the narrator introduces Gilgamesh as an epic hero, two parts god and one part human. The style of the following list of his deeds is the same as in hymns to the gods (**Reading 2.3a**):

READING 2.3a

from the *Epic of Gilgamesh*, Tablet I (ca. 1200 BCE)

Supreme over other kings, lordly in appearance,
he is the hero, born of Uruk, the goring wild bull.
He walks out in front, the leader,
and walks at the rear, trusted by his companions.
Mighty net, protector of his people,
raging flood-wave who destroys even walls of stone! . . .
It was he who opened the mountain passes,
who dug wells on the flank of the mountain.

MORE CONNECTIONS TO MyArtsLab

The text is keyed to the dynamic resources on MyArtsLab, allowing instructors and students online access to additional information, music, videos, and interactive features.

The **'SEE MORE'** icon correlates to the Closer Look features in the text, directing students to MyArtsLab to view interactive **Closer Look** tours online. These features enable students to zoom in to see detail they could not otherwise see on the printed page or even in person. **'SEE MORE'** icons also indicate when students can view works of architecture in full 360-degree panoramas.

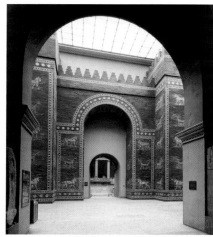

No trace of the city's famous Hanging Gardens survives, once considered among the Seven Wonders of the World, and only the base and parts of the lower stairs of the Marduk ziggurat still remain. But in the fifth century BCE, the Greek historian Herodotus [he-ROD-uh-tus] (ca. 484–430/420 BCE) described the ziggurat as follows:

There was a tower of solid masonry, a furlong in length and breadth, on which was raised a second tower, and on that a third, and so on up to eight. The ascent to the top is on the outside, by a path which winds round all the towers. . . . On the topmost tower, there is a spacious temple, and inside the temple stands a couch of unusual size, richly adorned with a golden table by its side. . . . They also declare that the god comes down in person into this chamber, and sleeps on the couch, but I do not believe it.

Although the ziggurat has disappeared, we can glean some sense of the city's magnificence from the Ishtar Gate (Fig. 2.18), named after the Babylonian goddess of fertility.

Fig. 2.18 Ishtar Gate (restored), from Babylon. ca. 575 BCE. Glazed brick. Staatliche Museen, Berlin. The dark blue bricks are glazed—that is, covered with a film of glass—and they would have shown brilliantly in the sun

SEE MORE To view a Closer Look feature about the Ishtar Gate, go to **www.myartslab.com**

CHAPTER 2 *Mesopotamia* 55

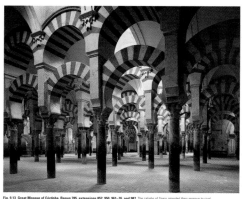

Fig. 9.13 Great Mosque of Córdoba. Begun 785, extensions 852, 950, 961–76, and 987. The caliphs of Spain intended their mosque to rival those in Jerusalem, Damascus, and Iraq. The forestlike expanse of the interior is a result of these aspirations. Even though only 80 of the original 1,200 columns survive, the space appears infinite, like some giant hall of mirrors.

LEARN MORE View an architectural simulation of Islamic arches at **www.myartslab.com**

by the Umayyads in Toledo [toh-LEH-doh] soon was responsible for spreading the nearly forgotten texts throughout the West. Muslim mathematicians in Spain invented algebra and introduced the concept of zero to the West, and soon their Arabic numerals replaced the unwieldy Roman system. By the time of Abd ar-Rahman III (r. 912–61), Córdoba was renowned for its medicine, science, literature, and commercial wealth, and it became the most important center of learning in Europe. The elegance of Abd ar-Rahman III's court was unmatched, and his tolerance and benevolence extended to all, as Muslim students from across the Mediterranean soon found their way to the mosque-affiliated madrasa that he founded—the

earliest example of an institution of higher learning in the Western world.

Outside of Córdoba, Abd ar-Rahman III built a huge palace complex, Madinat al-Zahra, to honor his wife. (Its extensive remains are still being excavated.) Its staff included 13,750 male servants along with another 3,500 pages, slaves, and eunuchs. Its roof required the support of 4,300 columns, and elaborate gardens surrounded the site. As many as 1,200 loaves of bread were required daily just to feed the fish in the garden ponds.

The decorative arts of the era are equally impressive. A famous example is a **pyxis**, a small, cylindrical box with a lid, made for Prince al-Mughira, Abd ar-Rahman III's

CHAPTER 9 *The Rise and Spread of Islam* 301

The **'HEAR MORE'** icons indicate where musical performances can be listened to in streaming audio on www.myartslab.com. Online audio also includes **'Voices'**– vivid first-person accounts of the experiences of ordinary people during the period covered in the chapter.

The **'LEARN MORE'** icons lead students online for additional primary source readings or to watch architectural simulations.

The **'EXPLORE MORE'** icons direct students to videos of artists at work in their studios, allowing them to see and understand a wide variety of materials and techniques used by artists throughout time.

Designed to save instructors time and to improve students' results, MyArtsLab, is keyed specifically to the chapters of Sayre's *The Humanities*, second edition. In addition, MyArtsLab's many features will encourage students to experience and interact with works of art. Here are some of those key features:

• A complete **Pearson eText** of the book, enriched with multimedia, including: a unique human-scale figure by all works of fine art, an audio version of the text, primary source documents, video demonstrations, and much more. Students can highlight, make notes, and bookmark pages.

• 360-degree **Architectural Panoramas** for major monuments in the book help students understand buildings from the inside and out.

• **Closer Look Tours** These interactive walk-throughs offer an in-depth look at key works of art, enabling students to zoom in to see detail they could not otherwise see on the printed page or even in person. Enhanced with expert audio, they help students understand the meaning and message behind the work of art.

• Robust **Quizzing** and **Grading Functionality** is included in MyArtsLab. Students receive immediate feedback from the assessment questions that populate the instructor's gradebook. The gradebook reports give an in-depth look at the progress of individual students or the class as a whole.

• MyArtsLab is your one stop for instructor material. Instructors can access the Instructor's Manual, Test Item File, PowerPoint images, and the Pearson MyTest assessment-generation program.

MyArtsLab with eText is available for no additional cost when packaged with *The Humanities*, second edition. The program may also be used as a stand-alone item, which costs less than a used text.

To register for your MyArtsLab account, contact your local Pearson representative or visit the instructor registration page located on the homepage of www.myartslab.com.

FLEXIBLE FORMATS

CourseSmart eTextbooks offer the same content as the printed text in a convenient online format—with highlighting, online search, and printing capabilities. With a CourseSmart eText, student can search the text, make notes online, print out reading assignments that incorporate lecture notes, and bookmark important passages for later review. *Students save 60% over the list price of the traditional book. www.coursesmart.com.*

Books à la Carte editions feature the exact same text in a convenient, three-hole-punched, loose-leaf version at a discounted price—allowing students to take only what they need to class. Books à la Carte editions are available both with and without access to MyArtsLab. *Students save 35% over the net price of the traditional book.*

Custom Publishing Opportunities

The Humanities is available in a custom version specifically tailored to meet your needs. You may select the content that you would like to include or add your own original material. See you local publisher's representative for further information. **www.pearsoncustom.com**

INSTRUCTOR RESOURCES

Classroom Response System (CRS) In-Class Questions

Get instant, class-wide responses to beautifully illustrated chapter-specific questions during a lecture to gauge students' comprehension—and keep them engaged. Available for download under the "For Instructors" tab within your MyArtsLab account–**www.myartslab.com.**

Instructor's Manual and Test Item File

This is an invaluable professional resource and reference for new and experienced faculty. Each chapter contains the following sections: Chapter Overview, Chapter Objectives, Key Terms, Lecture and Discussion Topics, Resources, and Writing Assignments and Projects. The test bank includes multiple-choice, true/false, short-answer, and essay questions. Available for download from the instructor support section at **www.myartslab.com.**

ClassPrep

Instructors who adopt Sayre's *The Humanities* will receive access to ClassPrep, an online site designed to make lecture preparation simpler and less time-consuming. The site includes the images from the text in both high-resolution JPGs, and ready-made PowerPoint slides for your lectures. ClassPrep can be accessed through your MyArtsLab instructor account.

MyTest

This flexible, online test-generating software includes all questions found in the printed Test Item File. Instructors can quickly and easily create customized tests with MyTest. **www.pearsonmytest.com**

ADDITIONAL PACKAGING OPTIONS

Penguin Custom Editions: The Western World lets you choose from an archive of more than 1,800 readings excerpted from the Penguin Classics™, the most comprehensive paperback library of Western history, literature, culture, and philosophy available. You'll have the freedom to craft a reader for your humanities course that matches your teaching approach exactly! Using our online book-building system, you get to select the readings you need, in the sequence you want, at the price you want your students to pay. **www.pearsoncustom.com** keyword: penguin

 Titles from the renowned Penguin Classics series can be bundles with *The Humanities* for a nominal charge. Please contact your Pearson Arts and Sciences sales representative for details.

 The Prentice Hall Atlas of World History, second edition includes over 100 full-color maps in world history, drawn by Dorling Kindersley, one of the world's most respected cartographic publishers. Copies of the Atlas can be bundled with *The Humanities* for a nominal charge. Please contact your Pearson Arts and Sciences sales representative for details.

 Connections: Key Themes in World History. Series Editor Alfred J. Andrea. Concise and tightly focused, the titles in the popular Connections Series are designed to place the latest research on selected topics of global significance, such as disease, trade, slavery, exploration, and modernization, into an accessible format for students. Available for a 50% discount when bundled with *The Humanities*. For more information, please visit **www.pearsonhighered.com.**

THE HUMANITIES: *CULTURE, CONTINUITY & CHANGE*

is the result of an extensive development process involving the contributions of over one hundred instructors and their students. We are grateful to all who participated in shaping the content, clarity, and design of this text. Manuscript reviewers and focus group participants include:

ALABAMA
Cynthia Kristan-Graham, Auburn University

CALIFORNIA
Collette Chattopadhyay, Saddleback College
Laurel Corona, San Diego City College
Cynthia D. Gobatie, Riverside Community College
John Hoskins, San Diego Mesa College
Gwenyth Mapes, Grossmont College
Bradley Nystrom, California State University-
 Sacramento
Joseph Pak, Saddleback College
John Provost, Monterey Peninsula College
Chad Redwing, Modesto Junior College
Stephanie Robinson, San Diego City College
Alice Taylor, West Los Angeles College
Denise Waszkowski, San Diego Mesa College

COLORADO
Renee Bragg, Arapahoe Community College
Marilyn Smith, Red Rocks Community College

CONNECTICUT
Abdellatif Hissouf, Central Connecticut State
 University

FLORIDA
Wesley Borucki, Palm Beach Atlantic University
Amber Brock, Tallahassee Community College
Connie Dearmin, Brevard Community College
Kimberly Felos, St. Petersburg College
Katherine Harrell, South Florida Community
 College
Ira Holmes, College of Central Florida
Dale Hoover, Edison State College
Theresa James, South Florida Community College
Jane Jones, State College of Florida, Manatee-
 Sarasota
Jennifer Keefe, Valencia Community College
Mansoor Khan, Brevard Community College
Connie LaMarca-Frankel, Pasco-Hernando
 Community College
Sandi Landis, St. Johns River Community College-
 Orange Park
Joe Loccisano, State College of Florida
David Luther, Edison College
James Meier, Central Florida Community College
Brandon Montgomery, State College of Florida
Pamela Wood Payne, Palm Beach Atlantic
 University
Gary Poe, Palm Beach Atlantic University
Frederick Smith, Florida Gateway College
Kate Myers de Vega, Palm Beach Atlantic
 University
Bill Waters, Pensacola State College

GEORGIA
Leslie Harrelson, Dalton State College
Lawrence Hetrick, Georgia Perimeter College
Priscilla Hollingsworth, Augusta State University
Kelley Mahoney, Dalton State College
Andrea Scott Morgan, Georgia Perimeter
 College

IDAHO
Jennifer Black, Boise State University
Rick Davis, Brigham Young University-Idaho
Derek Jensen, Brigham Young University-Idaho

ILLINOIS
Thomas Christensen, University of Chicago
Timothy J. Clifford, College of DuPage
Leslie Huntress Hopkins, College of Lake County
Judy Kaplow, Harper College
Terry McIntyre, Harper College
Victoria Neubeck O'Connor, Moraine Valley
 Community College
Sharon Quarcini, Moraine Valley Community
 College
Paul Van Heuklom, Lincoln Land Community College

INDIANA
Josephina Kiteou, University of Southern Indiana

KENTUCKY
Jonathan Austad, Eastern Kentucky University
Beth Cahaney, Elizabethtown Community
 and Technical College
Jeremy Killian, University of Louisville
Lynda Mercer, University of Louisville
Sara Northerner, University of Louisville
Elijah Pritchett, University of Louisville

MASSACHUSETTS
Peter R. Kalb, Brandeis University

MICHIGAN
Martha Petry, Jackson Community College
Robert Quist, Ferris State University

MINNESOTA
Mary Johnston, Minnesota State University

NEBRASKA
Michael Hoff, University of Nebraska

NEVADA
Chris Bauer, Sierra College

NEW JERSEY
Jay Braverman, Montclair State University
Sara E. Gil-Ramos, New Jersey City University

NEW MEXICO
Sarah Egelman, Central New Mexico Community
 College

NEW YORK
Eva Diaz, Pratt Institute
Mary Guzzy, Corning Community College
Thelma Ithier Sterling, Hostos Community College
Elizabeth C. Mansfield, New York University
Clemente Marconi, New York University

NORTH CAROLINA
Melodie Galloway, University of North Carolina
 at Asheville
Jeanne McGlinn, University of North Carolina
 at Asheville

Sophie Mills, University of North Carolina
 at Asheville
Constance Schrader, University of North Carolina
 at Asheville
Ronald Sousa, University of North Carolina
 at Asheville
Samer Traboulsi, University of North Carolina
 at Asheville

NORTH DAKOTA
Robert Kibler, Minot State University

OHIO
Darlene Alberts, Columbus State Community
 College
Tim Davis, Columbus State Community College
Michael Mangus, The Ohio State University
 at Newark
Keith Pepperell, Columbus State Community
 College
Patrice Ross, Columbus State Community College

OKLAHOMA
Amanda H. Blackman, Tulsa Community College-
 Northeast Campus
Diane Boze, Northeastern State University
Jacklan J. Renee Cox, Rogers State University
Jim Ford, Rogers State University
Diana Lurz, Rogers State University
James W. Mock, University of Central Oklahoma
Gregory Thompson, Rogers State University

PENNSYLVANIA
Elizabeth Pilliod, Rutgers University-Camden
Douglas B. Rosentrater, Bucks County Community
 College
Debra Thomas, Harrisburg Area Community
 College

RHODE ISLAND
Mallica Kumbera Landrus, Rhode Island School
 of Design

TENNESSEE
Richard Kortum, East Tennessee State University

TEXAS
Mindi Bailey, Collin County Community College
Peggy Brown, Collin County Community College
Marsha Lindsay, Lone Star College-North Harris
Aditi Samarth, Richland College
Lee Ann Westman, University of Texas at El Paso

UTAH
Matthew Ancell, Brigham Young University
Terre Burton, Dixie College
Nate Kramer, Brigham Young University
Joseph D. Parry, Brigham Young University

VIRGINIA
Margaret Browning, Hampton University
Carey Freeman, Hampton University
John Long, Roanoke College
Anne Pierce, Hampton University

No project of this scope could ever come into being without the hard work and perseverance of many more people than its author. In fact, this author has been humbled by a team at Pearson Prentice Hall that never wavered in their confidence in my ability to finish this enormous undertaking (or if they did, they had the good sense not to let me know); never hesitated to cajole, prod, and massage me to complete the project in something close to on time; and always gave me the freedom to explore new approaches to the materials at hand. At the down-and-dirty level, I am especially grateful to fact-checker, Julia Moore; to Mary Ellen Wilson for the pronunciation guides; for the more specialized pronunciations offered by David Atwill (Chinese and Japanese), Jonathan Reynolds (African), Nayla Muntasser (Greek and Latin), and Mark Watson (Native American); to Margaret Gorenstein for tracking down the readings; to Laurel Corona for her extraordinary help with Africa; to Arnold Bradford for help with critical thinking questions; and to Francelle Carapetyan for her remarkable photo research. The maps and some of the line art are the work of cartographer and artist, Peter Bull, with Precision Graphic drafting a large portion of the line art for the book. I find both in every way extraordinary.

In fact, I couldn't be more pleased with the look of the book, which is the work of Pat Smythe, senior art director. Cory Skidds, senior imaging specialist, worked on image compositing and color accuracy of the artwork. The production of the book was coordinated by Melissa Feimer, associate managing editor, Barbara Cappuccio, senior production project manager, and Marlene Gassler, production project manager, who oversaw with good humor and patience the day-to-day, hour-to-hour crises that arose. Brian Mackey, production-planning and operations specialist, ensured that this project progressed smoothly through its production route. And I want to thank Lindsay Bethoney and the staff at PreMedia Global for working so hard to make the book turn out the way I envisioned it.

The marketing and editorial teams at Prentice Hall are beyond compare. On the marketing side, Brandy Dawson, vice president of marketing, and Kate Mitchell, executive marketing manager, helped us all to understand just what students want and need. On the editorial side, my thanks to Yolanda de Rooy, president of the Social Sciences and the Arts division; to Sarah Touborg, editor-in-chief; Billy Grieco, editor; Bud Therien, special projects manager; David Nitti, assistant editor; and Theresa Graziano, editorial assistant. The combined human hours that this group has put into this project are staggering. This book was Bud's idea in the first place; Billy and Sarah have supported me every step of the way in making it as good, or even better, than I envisioned; and Yolanda's over-arching vision is responsible for helping to make Pearson such an extraordinarily good publisher to write for.

Deserving of special mention is my development team, Rochelle Diogenes, editor-in-chief of development; and Margaret Manos, development editor. Margaret has been an especially valuable partner, helping me literally to "re-vision" this revision and bringing clarity and common sense to those moments where they were lost.

Finally, I want to thank, with all my love, my beautiful wife, Sandy Brooke, who has supported this project in every way. She has continued to teach, paint, and write, while urging me on, listening to my struggles, humoring me when I didn't deserve it, and being a far better wife than I was a husband. In some ways, enduring what she did in the first edition must have been tougher in the second, since she knew what was coming from the outset. She was, is, and will continue to be, I trust, the source of my strength.

Modernism and the Globalization of Cultures

1900 TO THE PRESENT

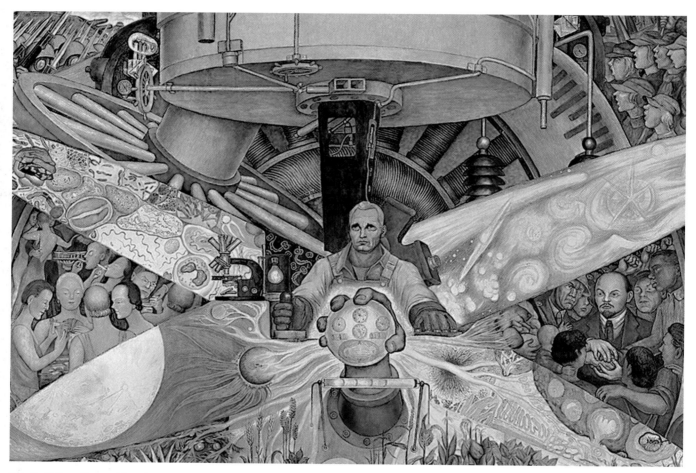

Detail of Diego Rivera, *Man, Controller of the Universe*. 1934. Fresco, main panel 15′11″ × 37′6″. Palacio de Bellas Artes, Mexico City, D. F. Mexico. © 2003 Banco de Mexico Diego Rivera & Frida Kahlo Museums Trust. Av. Cinco de Mayo No. 2, Col. Centro, Del. Cuauhtemoc 06059, Mexico, D. F. Reproduction authorized by the Instituto Nacional de Bellas Artes y Literatura. Photo credit: Schalkwijk/Art Resource, New York. (See Fig. 37.15.)

The twentieth century began in a frenzy of creativity and invention. If we think of the 1890s as a sort of prologue—during which the motion picture, the rubber bicycle tire, the diesel engine, the typewriter, the tape recorder, the carburetor, and even the zipper were all invented—then the first 14 years of the new century amount to a revolution in human life. Flight was, perhaps, the first emblem of this revolution. July 2, 1900, marked the first successful flight of a steerable airship, Ferdinand Zeppelin's dirigible, at Lake Constance in the south of Germany, and on December 17, 1903, Orville and Wilbur Wright flew a powered aircraft on four separate flights at Kitty Hawk, North Carolina—the longest of the day lasting 59 seconds and covering 852 feet of ground. On July 25, 1909, Louis Blériot [blay-ree-OH] crossed the 22 miles of the English Channel between Calais and Dover in a plane of his own design in 37 minutes.

But those first years of the new century were more than just a technological revolution. Science itself was transformed, and the knowable universe with it. It seemed possible, suddenly, to conceive of space in four, not three, dimensions, and to think of physics not as a system of coherence and truth, but rather as a condition of contradiction and uncertainty. And the traditions of science were by no means the only thing transformed. Rhymed verse gave way to "free verse," representational painting to abstraction. Music based on a tonal system was abandoned for atonal composition. Narrative became internalized into what was called stream of consciousness.

But this period of unbridled creativity was soon followed by what resembled nothing more than a long, sustained tragedy. The faith in human progress that had shaped the nineteenth century was thrown into doubt first by World War I, in which civilized Europe committed a kind of self-genocide, and then by the rise of totalitarian states, themselves intent on committing genocide on their own. The fruits of "progress" seemed to be guns, tanks, poison gas, and, ultimately, the atomic bomb. Disillusion and doubt were the inevitable result. The Cold War followed World War II, the Vietnam War added fuel to the Cold War, and the specter of war seemed unending. Sigmund Freud, who had begun his investigation of dreams at the end of the nineteenth century, posited a strong death wish in humankind's psychic makeup. The French existentialists, led by Jean-Paul Sartre, argued that the universe lacked both divine guidance and moral absolutes. Humans are thus "condemned to be free," he wrote, their condition one of perpetual anxiety, their only truth the inevitability of death.

But if humanity is condemned to freedom, many soon realized that freedom was theirs to gain. Anything seemed possible. Youth led the way—in the civil rights movement in the United States, the antiwar movement protesting U.S. involvement in Vietnam, the drug and music cultures of the 1960s and 1970s, and the growing feminist movement. Between 1944 and 1960, nation after nation—in Africa, Asia, and Southeast Asia—won their liberty from Britain, France, the Netherlands, Belgium, and Italy. The grip of the United States and Spain over the Western Hemisphere was loosened, most notably through the example of the Cuban Revolution.

By the beginning of the twenty-first century, many argued that, despite the continued existence of authoritarian rule in many parts of the world, a new form of power had substituted itself for the political control exercised in earlier times. A culture defined by an explosion in creative and technological ingenuity that seemed determined to break down borders and barriers between peoples began to emerge, based on the rise of the personal computer, the Internet, and digital media. This new culture seemed to close the brackets on the era from the outbreak of World War I in 1914 to the fall of the Soviet Union in 1989. Its promise—realizable or not—was a global culture of extraordinary diversity and plurality in which people throughout the world struggled to find their unique cultural and personal identities—and to express their identities through their art.

1903
W.E.B. Du Bois, *The Souls of Black Folk*

1905
Albert Einstein proposes theory of relativity

1907
Pablo Picasso, *Les Demoiselles d'Avignon*

1910
Stravinsky's *Firebird* performed in Paris

1917
Marcel Duchamp, *Fountain*

1917
Russian Revolution

1922
James Joyce, *Ulysses*

1924–29
The Harlem Renaissance

1924
Andre Breton, *Surrealist Manifesto*

1929
Stock market crash leads to Great Depression

1933–45
Adolf Hitler and Nazi Party rule Germany

1945
Lee Miller, *Buchenwald, Germany*

1950
Jackson Pollack, *Number 27*

1953
Karl Stockhausen composes first synthesized music

1954
Godzilla destroys Tokyo

1954
Samuel Beckett, *Waiting for Godot*

1963
Martin Luther King, Jr., "Letter from Birmingham Jail", Betty Friedan, *The Feminine Mystique*

1969
Woodstock music festival

1972
Robert Venturi, Denise Scott Brown, Steve Izenour write, *Learning from Las Vegas* advocating architectural postmodernism

1989–90
Collapse of U.S.S.R.

1994
Shirin Neshat, *Rebellious Silence*
2001
Terrorist attacks on United States; United States attacks Afghanistan

2003
United States attacks Iraq

LEARN MORE Explore an interactive timeline on **www.myartslab.com**

1115

34

The Era of Invention
Paris and the Modern World

THINKING AHEAD

What are Cubism, Fauvism, and Futurism?

What is German Expressionism?

What innovations distinguish the literary world in the first years of the twentieth century?

What are the origins of cinema?

If the rhythm of life had been regulated by the physiology of a man or a horse walking, or, on a sailing voyage, by the vagaries of weather (calm, storm, and wind direction), after 1850 it was regulated by the machine—first by the steam engine and the train, then, in 1897, by the automobile, and then, finally, by the airplane. At the dawn of the twentieth century, the world was in motion. As early as 1880, one French advertising company boasted that it could post a billboard ad in 35,937 municipalities in five days' time—a billboard of the kind advertising Astra Construction in *The Cardiff Team* (Fig. **34.1**), a painting by Robert Delaunay [duh-lawn-AY] (1885–1941). The painting depicts the men of the Cardiff (Wales) rugby team leaping up at a rugby ball in the center of the painting. They represent the internationalization of sport; the first modern Olympic Games had taken place in 1896 in Athens, followed by the 1900 Games in Paris, staged in conjunction with the Exposition Universelle, and rugby was a medal sport in each. The rugby ball is framed by the famous Grande Roue de Paris. Built for the 1900 Exposition Universelle, at 100 meters (328 feet) in height, it was the tallest Ferris wheel in the world, surpassing by 64 feet the original Ferris wheel, built for Chicago's Columbian Exposition in 1893 (see Chapter 32), and although it would be demolished in 1920, the Grande Roue remained the world's tallest Ferris wheel until it was surpassed by three Japanese Ferris wheels in the 1990s. On July 1, 1913, the year that Delaunay painted *The Cardiff Team*, a signal was broadcast from the top of the Eiffel Tower, seen towering over Delaunay's work, establishing worldwide Standard Time. By 1903, Orville Wright had been airborne 59 seconds, and by 1908, he would fly for 91 minutes. A year later, Blériot crossed the English Channel by plane (though it would be another 18 years until Charles Lindbergh would cross the Atlantic by air). The aeroplane in Delaunay's painting is a "box kite" design built in a Paris suburb beginning in 1907 by the Voisin brothers, Gabriel and Charles, the first commercial airplane manufacturers in Europe. Finally, the signboard "MAGIC" refers to Magic City, an enormous dance-hall near the Eiffel Tower. Delaunay's *Cardiff Team* captures the pulse of Paris in the first decades of the twentieth century, and the heartbeat of modern life.

◀ **Fig. 34.1 Robert Delaunay, *L'Equipe de Cardiff (The Cardiff Team).* 1913.** Oil on canvas, 10′ 8³⁄₈″ × 6′10″. Collection Van Abbemuseum © L & M Service B.V. The Hague 20100903. Everything in the painting seems to rise into the sky as if, for Delaunay, the century is "taking off" much like the aeroplane. Even the construction company's name, "Astra," refers to the stars.

HEAR MORE Listen to an audio file of your chapter at **www.myartslab.com**

Delaunay called his work Simultanism, a term derived from Michel Eugène Chevreul's 1839 book on color *The Principle of Harmony and Contrast of Colors* (see Chapter 33)—in the original French title the word translated as "harmony" is *simultanée*—but the term signifies more than just an approach to color theory. The name referred to the immediacy of vision, and suggested that in any given instant, an infinite number of states of being existed in the speed and motion of modern life. Everything was in motion, including the picture itself.

The still photograph suddenly found itself animated in the moving picture, first in 1895 by the Brothers Lumière, in Paris, and then after 1905, when the Nickelodeon, the first motion-picture theater in the world, opened its doors in Pittsburgh, Pennsylvania. By 1925, Russian filmmaker Sergei Eisenstein would cram 155 separate shots into a four-minute sequence of his film *The Battleship Potemkin*—a shot every 1.6 seconds. In 1900, France had produced 3,000 automobiles; by 1907, it was producing 30,000 a year. The technological advances represented by the automobile were closely connected to the development of the internal combustion engine, pneumatic tires, and, above all, the rise of the assembly line. After all, building 30,000 automobiles a year required an efficiency and speed of production unlike any ever before conceived. Henry Ford (1863–1947), the American automobile maker, attacked the problem. Ford asked Frederick Taylor (1856–1915), the inventor of

"scientific management," to determine the exact speed at which the assembly line should move and the exact motions workers should use to perform their duties; in 1908, assembly-line production as we know it was born.

Amid all this speed and motion, the world also suddenly seemed a less stable and secure place. Discoveries in science and physics confirmed this. In 1900, German physicist Max Planck (1858–1947) proposed the theory of matter and energy known as quantum mechanics. In quantum mechanics, the fundamental particles are unknowable, and are only hypothetical things represented by mathematics. Furthermore, the very technique of measuring these phenomena necessarily alters their behavior. Faced with the fact that light appeared to travel in absolutely contradictory ways, as both particles and waves, depending upon how one measured it, in 1913, Danish physicist Niels Bohr (1885–1962) built on quantum physics to propose a new theory of complementarity: two statements, apparently contradictory, might at any moment be equally true. At the very end of the nineteenth century, in Cambridge, England, J. J. Thompson detected the existence of separate components in the previously indivisible atom. He called them electrons, and by 1911, Ernest Rutherford had introduced a new model of the atom—a small, positively charged nucleus containing most of the atom's mass around which electrons continuously orbit. Suddenly matter itself was understood to be continually in motion. Meanwhile, in 1905, Albert Einstein had published his theory of relativity

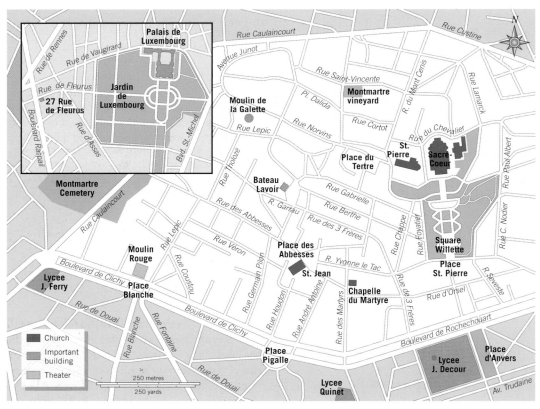

Map 34.1 Picasso's Montmartre.

and by 1915 had produced the *General Principles of Relativity*, with its model of the non-Euclidean, four-dimensional space-time continuum. Between 1895 and 1915, the traditional physical universe had literally been transformed—and it was not a universe of entities available to the human eye.

In the arts, the Spanish-born Pablo Picasso [pee-KAH-soh] (1881–1973) stood at the center of the new spirit of change and innovation that is the subject of this chapter. Picasso's studio in Paris was quickly recognized by artists and intellectuals as the center of artistic innovation in the new century. From around Europe and America, artists flocked to see his work, and they carried his spirit—and the spirit of French painting generally—back with them to Italy, Germany, and America, where it influenced the arts there. New art movements—new "isms," including Delaunay's Simultanism—succeeded one another in rapid fire. Picasso's work also encouraged radical approaches to poetry and to music, where the discordant, sometimes violent distortions of his paintings found their expression in sound.

PABLO PICASSO'S PARIS: AT THE HEART OF THE MODERN

Picasso's Paris was centered at 13 rue Ravignon [rah-veen-YOHN], at the Bateau-Lavoir [bah-TOH lah-VWAHR] ("Laundry Barge"), so nicknamed by the poet Max Jacob. It was Picasso's studio from the spring of 1904 until October 1909, and he continued to store his paintings there until September 1912. Anyone wanting to see his work would have to climb the hill topped by the great white cathedral of Sacre Coeur [sah-KRAY ker] in the Montmartre [mohn-MART] quarter, beginning from the Place Pigalle [plahss pee-GAHL], and finally climb the stairs to the great ramshackle space, where the walls were piled deep with canvases (see Map **34.1**). Or they might see his work at the Saturday evening salons of expatriate American writer and art collector Gertrude Stein [stine] (1874–1946) at 27 rue de Fleurus [fler-OOS] behind the Jardin du Luxembourg [zhar-DEHN due louks-em-BOOR] on the Left Bank of the Seine. If you knew someone who knew someone, you would be welcome enough. Many Picassos hung on her walls, including his portrait of her, painted in 1906 (Fig. **34.2**).

In her book *The Autobiography of Alice B. Toklas* (1932)—actually her own memoir disguised as that of her friend and lifelong companion—Stein described the making of this picture in the winter of 1906 (**Reading 34.1**):

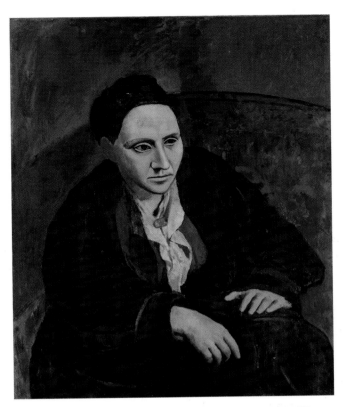

Fig. 34.2 Pablo Picasso, *Gertrude Stein*. Winter–Autumn 1906. Oil on canvas, 39 ³/₈″ × 32″. Bequest of Gertrude Stein, 1946 (47.106). The Metropolitan Museum of Art, New York. Image © The Metropolitan Museum of Art/Art Resource, New York. © Art Rights Society (ARS), New York. According to Stein, in painting her portrait, "Picasso passed [on] . . . to the intensive struggle which was to end in Cubism."

READING 34.1

from Gertrude Stein, *The Autobiography of Alice B. Toklas* (1932)

Picasso had never had anybody pose for him since he was sixteen years old. He was then twenty-four and

Gertrude had never thought of having her portrait painted, and they do not know either of them how it came about. Anyway, it did, and she posed for this portrait ninety times. There was a large broken armchair where Gertrude Stein posed. There was a couch where everybody sat and slept. There was a little kitchen chair where Picasso sat to paint. There was a large easel and there were many canvases. She took her pose, Picasso sat very tight in his chair and very close to his canvas and on a very small palette, which was of a brown gray color, mixed some more brown gray and the painting began. All of a sudden one day Picasso painted out the whole head. I can't see you anymore when I look, he said irritably, and so the picture was left like that.

Picasso actually finished the picture early the following fall, painting her face in large, masklike masses in a style very different from the rest of the picture. No longer relying on the visual presence of the sitter before his eyes, Picasso painted not his view of her, but his idea of her. When Alice B. Toklas later commented that some people thought the painting did not look like Stein, Picasso replied, "It will."

The Aggressive New Modern Art: *Les Demoiselles d'Avignon*

In a way, the story of Gertrude Stein's portrait is a parable for the birth of modern art. It narrates the shift in painting from an optical art—painting what one sees—to an imaginative construct—painting what one thinks about what one sees. The object of painting shifts, in other words, from the literal to the conceptual. The painting that most thoroughly embodied this shift was *Les Demoiselles d'Avignon* [lay dem-wah-ZELL dah-veen-YOHN], which Picasso began soon after finishing his portrait of Stein (Fig. 34.3).

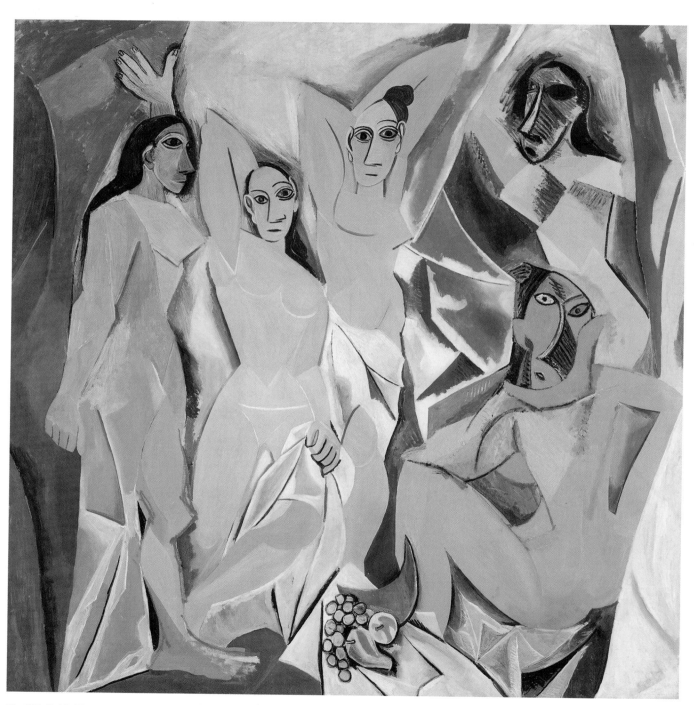

Fig. 34.3 Pablo Picasso, *Les Demoiselles d'Avignon*. May–July 1907. Oil on canvas, 95 1/8″ × 91 1/8″. Acquired through the Lillie P. Bliss Bequest. The Museum of Modern Art/Licensed by SCALA/Art Resource, New York. © 2008 Artists Rights Society (ARS), New York. Central to Picasso's composition is the almond shape, first used for Gertrude Stein's eyes and repeated in the eyes of the figures here and in other forms—thighs and arms particularly. The shape is simultaneously rounded and angular, reinforcing the sense of tension in the painting.

SEE MORE For a Closer Look at Pablo Picasso's *Les Demoiselles d'Avignon*, go to **www.myartslab.com**

Completed in the summer of 1907, *Les Demoiselles d'Avignon* was not exhibited in public until 1916. So if you wanted to see it, you had to climb the hill to the Bateau-Lavoir. And many did because the painting was notorious, understood—correctly—as an assault on the idea of painting as it had always been understood. At the Bateau-Lavoir, a common insult hurled by Picasso and his friends at one another was "Still much too symbolist!" No one said this about *Les Demoiselles*. It seemed entirely new in every way.

The painting represents five prostitutes in a brothel on the carrer d'Avinyo (Avignon Street) in Picasso's native

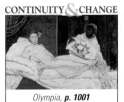

CONTINUITY & CHANGE

Olympia, p. 1001

Barcelona. As the figure on the left draws back a curtain as if to reveal them, the prostitutes address the viewer with the frankness of Manet's *Olympia* (see *Closer Look*, Chapter 30), a painting Picasso greatly admired. In fact, in January 1907, as Picasso was planning *Les Demoiselles*, *Olympia* was hung, for the first time, in the Louvre, to much public comment and controversy. It was placed, not coincidentally, alongside Ingres's

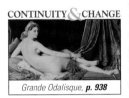

CONTINUITY & CHANGE

Grande Odalisque, p. 938

Grande Odalisque (see Fig. 28.13). Both figures turn to face the viewer, and the distortions both painters work upon their figures— Manet's flat paint, Ingres's elongated spine and disconnected extremities—probably inspired Picasso to push the limits of representation even further.

Also extremely important to Picasso was the example of Cézanne, who, a year after his death in October 1906, was honored with a huge retrospective at the 1907 Salon d'Automne [doh-TUN]. Cézanne, Picasso would say, "is the father of us all." In the way Picasso shows one object or figure

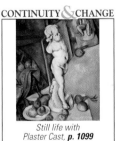

CONTINUITY & CHANGE

Still life with Plaster Cast, p. 1099

from two different points of view, the compressed and concentrated space of *Les Demoiselles* is much like Cézanne's (see *Still Life with Plaster Cast* in *Closer Look*, Chapter 33). Consider the still-life grouping of melon, pear, apple, and grapes in the center foreground. The viewer is clearly looking down at the corner of a table, at an angle completely inconsistent with the frontal view of the nude who is parting the curtain. And note the feet of the nude second from the left. Could she possibly be standing? Or is she, in fact, reclining, so that we see her from the same vantage point as the still life?

Picasso's subject matter and ambiguous space were disturbing to viewers. Even more disturbing were the strange faces of the left-hand figure and the two to the right. X-ray analysis confirms that originally all five of the figures shared the same facial features as the two in the middle left, with their almond eyes and noses drawn in an almost childlike profile. But sometime in May or June 1907, after he visited

the ethnographic museum at the Palais du Trocadéro [pah-LAY due troh-kah-DAY-roh], across the river from the Eiffel Tower, Picasso painted over the faces of the figure at the left and the two on the right, giving them instead what most scholars agree are the characteristics of African masks. But equally important to Picasso's creative process was a retrospective of Gauguin's

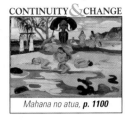

CONTINUITY & CHANGE

Mahana no atua, p. 1100

painting and sculpture at the 1906 Salon d'Automne with their Polynesian imagery (see Fig. 33.17). At any rate, Picasso's intentions were clear. He wanted to connect his prostitutes to the seemingly authentic—and emotionally energizing—forces that Gauguin had discovered in the "primitive." Many years later, he described the meaning of African and Oceanic masks to *Les Demoiselles*:

> The masks weren't just like any other pieces of sculpture. Not at all. They were magic things. . . . They were against everything—against unknown, threatening spirits. I always looked at fetishes. I understood; I too am against everything. I too believe that everything is unknown, that everything is an enemy! . . . All the fetishes were used for the same thing. They were weapons. To help people avoid coming under the influence of spirits again, to help them become independent. They're tools. If we give spirits a form, we become independent. . . . I understood why I was a painter. All alone in that awful museum [the Trocadéro] with masks, with dolls made by the redskins, dusty manikins. *Les Demoiselles d'Avignon* must have come to me that very day, but not because of the forms; because it was my first exorcism painting—yes absolutely!

Les Demoiselles, then, was an act of liberation, an exorcism of past traditions, perhaps even of painting itself. It would allow Picasso to move forward into a kind of painting that was totally new.

Picasso scholar Patricia Leighten has argued convincingly that the African masks in *Les Demoiselles* are designed not only to challenge and mock Western artistic traditions but also to evoke and critique the deplorable exploitation by Europeans of black Africans, particularly in the Congo—a theme, as we have seen, taken up by Joseph Conrad in his *Heart of Darkness* (see Chapter 33). A scandal had erupted in 1905 when the French government's administrators in the Congo, Gaud and Toqué, were accused of a wide variety of atrocities. In addition to their salaries, these administrators received bonuses for rubber collected under them, and they coerced natives to furnish them with rubber by pillaging their villages, executing "lazy" or uncooperative villagers, kidnapping their wives and children, and even more scandalous assaults. Gaud and Toqué were accused specifically of dynamiting an African guide in celebration of Bastille Day and of forcing one of their servants to drink soup they had made

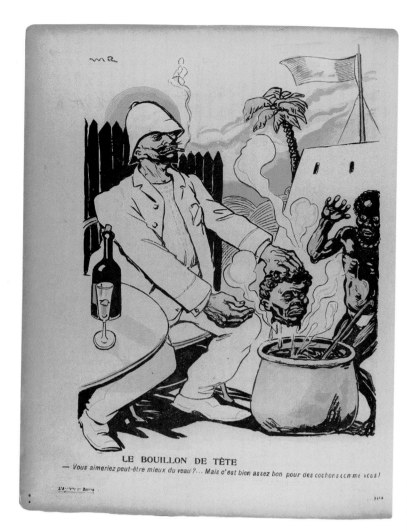

Fig. 34.4 Maurice Radiguez, "Le Bouillon de Tête." *L'Assiette au beurre*, **March 11, 1905.** Photo: Morris Library, University of Delaware. The caption reads: "You'd perhaps like veal better? Well, it's plenty good enough for pigs like you!"

In fact, it verges on becoming an illustration for Mallarmé's *L'Après-midi d'un faune* (see Chapter 33). And not long before he painted *The Joy of Life*, Matisse had titled one of his large canvases *Luxe, calme, et volupté* (*Luxury, Calm, and Pleasure*), taken from Baudelaire's poem "L'invitation au voyage":

Là, tout n'est qu'ordre et beauté,	There, all is only order and beauty,
Luxe, calme, et volupté.	Luxury, calm, and pleasure.

Twelve years older than Picasso, Matisse was the favorite of Gertrude Stein's brother Leo. He had established himself, at the Salon des Indépendants in 1904, as the leader of a radical new group of experimental painters known as the Fauves [fohvz]—or "Wild Beasts." **Fauvism** [FOHV-izm] was known for its radical application of arbitrary, or unnatural, color, anticipated in a few of van Gogh's paintings and in the pool of color in the foreground of Gauguin's *Mahana no atua* (see Fig. 33.17). The fractured angularity of Picasso's *Demoiselles*, its subdued coloration, its shallow space, and its childlike as opposed to sensuous use of line, are diametrically opposed to the circular, undulating, and frankly erotic space of Matisse's field of color in *The Joy of Life*. The tension that dominates Picasso's painting—the way it pulls the viewer into the scene even as it repels entry—is totally absent in the Matisse, where harmony rules. It is as if Picasso consciously rejected Matisse's modernism.

Picasso and Matisse saw each other regularly at the Steins' apartment, but their relationship was competitive. In fact, it is useful to think of Matisse's monumental *Dance II* (Fig. 34.6) as something of a rebuttal to the upstart Picasso's *Demoiselles*. For one thing, Matisse's circle dance consists of six figures that were in the distant yellow field of *Joy of Life*, but when Matisse repeats the motif in *Dance II*, the number is five, like Picasso's five prostitutes. Matisse also replaces Picasso's squared and angular composition with a circular and rounded one. Where Picasso's painting seems static, as if we are asked to hold our breath at the scene before us, Matisse's is active, moving as if to an unheard music. Most astonishing is Matisse's color—vermillion (red-orange), green, and blue-violet, the primary colors of light. In effect, Matisse's modernism takes place in the light of day, Picasso's in the dark of night; Matisse's with joy, Picasso's with fear and trepidation.

from a native's head. These atrocities were illustrated in a March 11, 1905, special issue of the Parisian political journal, *L'Assiette au beurre* (*The Butter Plate*), entitled "The Torturers of Blacks" (Fig. **34.4**). Thus Picasso's painting confronts a variety of idealizations: the idealization of the world as reflected in traditional European art, the idealization of sexuality—and love—and the idealization of the colonizing mission of the European state. It acknowledges, in other words, the artist's obligation to confront the horrific truths that lie behind and support bourgeois complacency.

Matisse and the Fauves: A New Color

When the painter Henri Matisse [mah-TEES] saw *Les Demoiselles*, he is said to have considered it an "audacious hoax," an "outrage [ridiculing] the modern movement." It is little wonder as the two painters' aesthetic visions were diametrically opposed. Gertrude Stein had introduced the two men in April 1906, just after Matisse had exhibited his *The Joy of Life* at the Salon des Indépendants [en-day-pahn-DAHN] (Fig. **34.5**). The painting is a sensual celebration of Symbolist sexuality, conceived under the sway of Baudelaire and Mallarmé.

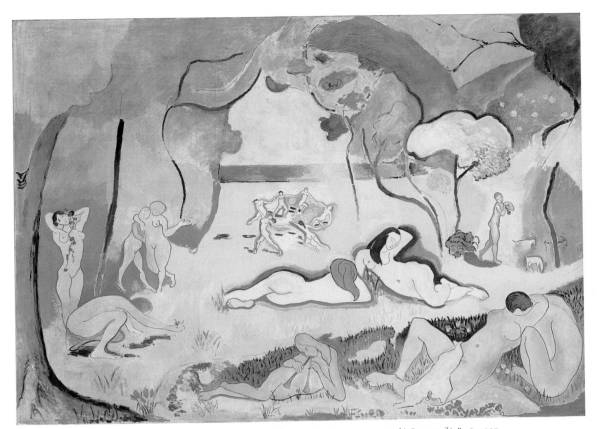

Fig. 34.5 Henri Matisse, *Bonheur de vivre* (*The Joy of Life*). 1905–06. Oil on canvas, 69 ⅛″ × 94 ⅞″. © 1995 The Barnes Foundation. 2008 Succession H. Matisse, Paris/Artists Rights Society (ARS), New York. Note how Matisse balances the scene's eroticism with a relaxed, almost innocent sense of nudity.

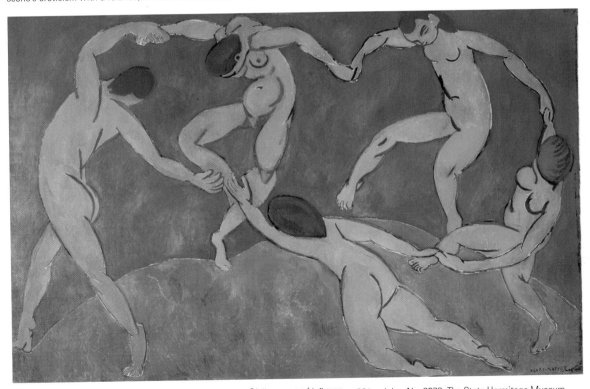

Fig. 34.6 Henri Matisse, *Dance*. 1910. Oil on canvas, 8′ 5 ⅝″ × 12′ 9 ½″ (260 × 391 cm). Inv. No. 9673. The State Hermitage Museum, St. Petersburg, Russia. © 2008 Succession H. Matisse/Artists Rights Society (ARS), New York. This work and another similarly colored painting of musicians called *Music* were commissioned by the Russian collector Sergei Shchukin to decorate the staircase of his home in Moscow.

The Invention of Cubism:
Braque's Partnership with Picasso

When the French painter Georges Braque [brahk] (1882–1963) first saw *Les Demoiselles*, in December 1907, he said that he felt burned, "as if someone were drinking gasoline and spitting fire." He was, at the time, a Fauve, painting in the manner of Matisse, but like Picasso, he was obsessed with Cézanne, so much so that he planned to paint the following summer in Cézanne's l'Estaque (see Fig. 33.15). When he returned to Paris in September, he brought with him a series of landscapes, among them *Houses at l'Estaque* (Fig. **34.7**). Picasso was fascinated with their spatial ambiguity and cube-like shapes. Note in particular the central house, where (illogically) the two walls that join at a right angle are shaded on both sides of the corner, yet are similarly illuminated. And the angle of the roofline does not meet at the corner, thus flattening the roof. Details of windows, doors, and moldings have been eliminated, as have the lines between planes so that one plane seems to merge with the next in a manner reminiscent of Cézanne. The tree that rises on the left seems to merge at its topmost branch into the distant houses. The curve of the bush on the left echoes that of the tree, and its palmlike leaves are identical to the trees rising between the houses behind it. The structure of the foreground mirrors that of the houses. All this serves to flatten the composition even as the lack of a horizon causes the whole composition to appear to roll forward toward the viewer rather than recede in space.

Seeing Braque's landscapes at a gallery in November 1908, the critic Louis Vauxcelles [voh-SELL] wrote: "He [Braque] is contemptuous of form, reduces everything, sites and figures and houses to geometric schemas, to cubes." But the movement known as **Cubism** was born out of collaboration. "Almost every evening," Picasso later recalled, "either I went to Braque's studio or Braque came to mine. Each of us had to see what the other had done during the day." The two men were inventors, brothers—Picasso even took to calling Braque "Wilbur," after the aeronautical brothers Orville and Wilbur Wright. When Picasso returned to Paris from Spain in the fall of 1909, he brought

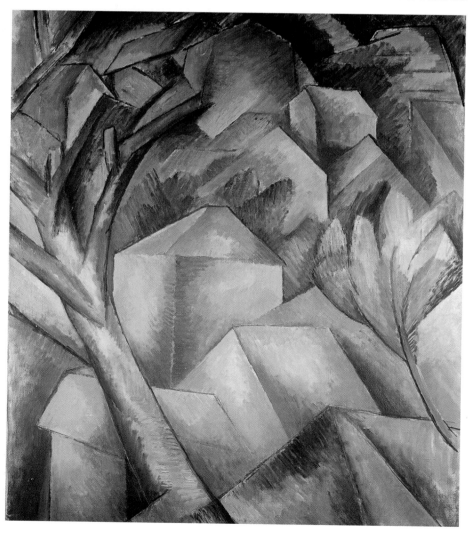

Fig. 34.7 Georges Braque, *Houses at l'Estaque*. 1908. Oil on canvas, 28 ³⁄₄″ × 23 ³⁄₄″. Peter Lauri/Kunstmuseum Bern. Estate of George Braque © 2008 Artists Rights Society (ARS), New York/ADAGP, Paris. Hermann and Margit Rupf Foundation. Braque's trip to l'Estaque in the summer of 1908 was a form of homage to Cézanne, whose style he consciously radicalized in works such as this.

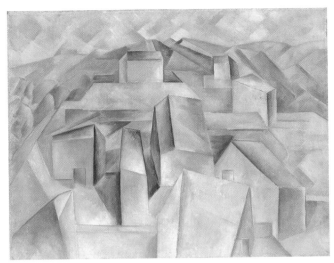

Fig. 34.8 Pablo Picasso, _Houses on the Hill, Horta de Ebro_. 1909. Oil on canvas, 25 ⁵/₈" × 31 ⁷/₈". Jens Ziehe/Nationalgalerie, Museum Berggruen, Staatliche Museen zu Berlin, Berlin, Germany. Bildarchiv Preussischer Kulturbesitz/Art Resource, New York. © Artists Rights Society (ARS), New York. This is one of a series of some 15 paintings executed at Horta de Ebro (known today as Horta de Sant Joan) in the hills above Valencia during the summer of 1909.

with him landscapes that showed just how much he had learned from Braque (Fig. **34.8**).

Picasso and Braque pushed on, working so closely together that their work became indistinguishable to most viewers. They began to decompose their subjects into faceted planes, so that they seem to emerge down the middle of the canvas from some angular maze, as in _Violin and Palette_ (Fig. **34.9**). Gradually they began to understand that they were questioning the very nature of reality, the nature of "truth" itself. This is the function of the trompe-l'oeil nail casting its shadow onto the canvas at the top of Braque's painting. It announces its own artifice, the practice of illusionistically representing things in three-dimensional space. But the nail is no more real than the violin, which is about to dissolve into a cluster of geometric forms. Both are painted illusions, equally real as art.

From 1910 to 1912, Picasso and Braque took an increasingly abstract approach to depicting reality through painting. They were so experimental, in fact, that the subject nearly disappeared. Only a few cues remained to help viewers understand what they were seeing—a moustache, the scroll of a violin, a treble clef.

Increasingly, they added a few words here and there. Picasso used words from a popular song "_Ma Jolie_" ("My pretty one") to identify portraits of his current lover, or "_Jou_," to identify the newspaper _Le Journal_. "_Jou_" was also a pun on the word _jeu_ ("play"), and it symbolized the play between the reality of the painting as an object and the reality of the world outside the frame. This kind of ambiguity led Braque and Picasso to introduce actual two- and three-dimensional elements into the space of the canvas, in what Picasso

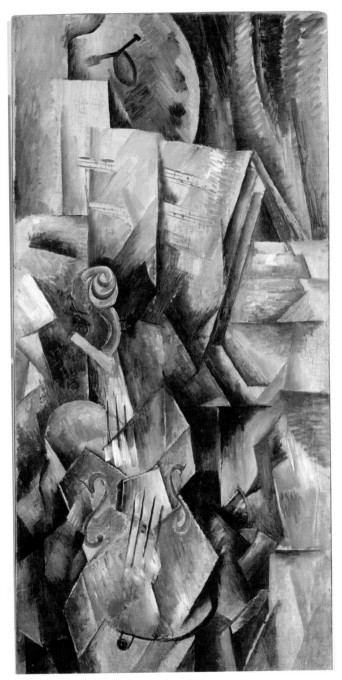

Fig. 34.9 Georges Braque, _Violin and Palette_. Autumn 1909. Oil on canvas, 36 ¹/₈" × 16 ⁷/₈". Solomon Guggenheim Museum. 54.1412. George Braque © 2008 Artists Rights Society (ARS), New York/ADAGP, Paris. As in Picasso's _Les Demoiselles_, the primary tension in the painting is created by the juxtaposition of the rounded and angular forms.

and Braque came to call **collage** [kuh-LAHZH], from the French _coller_ [koll-AY], "to paste or glue" (see _Closer Look_, pages 1126–1127). These elements—paper, fabric, rope, and other material—at least challenged, if they did not completely obliterate, the space between life and art.

ate in the summer of 1912, wandering through Avignon, Braque came upon a decorator's shop selling wallpaper with a simulated wood-grain pattern. He bought it and pasted it onto a drawing called *Fruit Dish and Glass*, where it stood for both the wooden wall in the background and the drawer of a table. It was at once real wallpaper and fake wood. Now, the real and the recognizable had reentered the Cubist vocabulary in the form of ***papiers-collés***, meaning "pasted paper." It was as if modern life had erupted into the space of painting, interrupting what had been the increasing abstraction and subjectivity of the Cubist project. Picasso saw *Fruit Dish and Glass* when he returned to Paris from the south of France in September. "The bastard," Picasso later joked. "He waited until I'd turned my back." Soon Picasso was incorporating paper objects into his works, as in *Violin*.

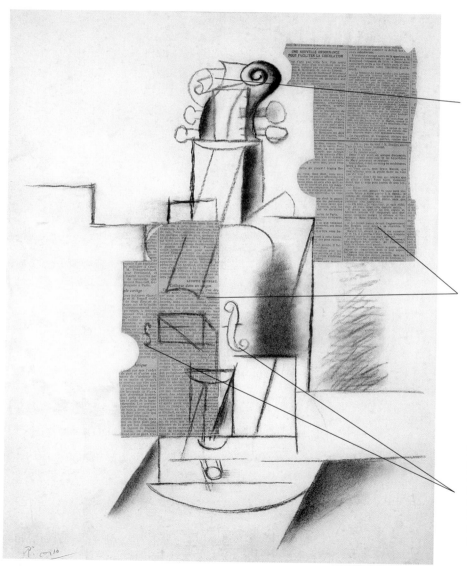

The spiral scroll at the top of the violin is drawn from two points of view, in profile and three-quarter. The spiral has special significance. It occurs throughout Cubist painting and not only on violins. It can be found at the end of armrests on armchairs, as rope, and so on. It signifies the interplay between two and three dimensions, flat design versus the sculptural vortex or coil.

These two pieces of newspaper are cut from the same page. The one on top is the reverse side of the one on the bottom and, like a jigsaw puzzle piece, would fit into the left side of the bottom piece if it were turned over. So the two pieces reveal simultaneously the front and back of the same thing. The bottom piece also represents the body of the violin (note Picasso's drawing at its top left), while the upper piece, cupping the scrollwork, becomes the background or shadow.

Picasso depicts the *f*-holes of the violin in completely different ways. The one on the left is a small, simple line, while the one on the right is a much larger, fully open and fully realized form. It is as if we see the right one from the front, and the left one as if it were swiveled away to a three-quarter view and deeper in space.

Pablo Picasso, *Violin*. Late 1912. Charcoal and *papiers-collés* on canvas, 24 ³⁄₈" × 18 ¹⁄₂". Musée National d'Art Moderne. Centre National d'Art et de Culture. Georges Pompidou Paris, France. CNAC/MNAM/Réunion des Musées Nationaux/Art Resource, New York. © 2008 Artists Rights Society (ARS), New York.

Pablo Picasso, *Guitar, Sheet Music, and Wine Glass.* **1912.** Charcoal, gouache, and *papiers-collés*, 18 $^7/_8$" × 14 $^3/_8$". The McNay Art Museum, San Antonio, Texas. Bequest of Marion Koogler McNay. © 2008 Estate of Pablo Picasso/Artists Rights Society (ARS), New York. The newspaper fragment at the bottom of the painting derives from the front page of *Le Journal*, November 18, 1912, reproduced below.

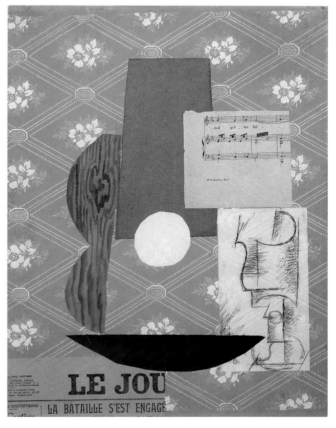

Picasso challenged the subjectivity of the creative act by including newspaper fragments in the painting. Newspaper insists on the inescapable reality of daily life. By admitting this element of pop culture into the space of art, Picasso and Braque defined painting as the setting in which the forces of the high and low, art and the real world, must engage one another.

Thus in Picasso's 1912 *Guitar, Sheet Music, and Wine Glass,* at the bottom of the page, the headline of *Le Journal* reads, "*La bataille s'est engagé,*" "The battle is joined." Literally, it refers to a battle in the Balkans, where Bulgaria attacked the Turks, November 17 through 19. But the "battle" is also metaphorical, the battle between art and reality (and perhaps between Braque and Picasso as they explored the possibilities of collage). Similarly, the background's trellis-and-rose wallpaper is no more or less real than the fragment of the actual musical score, the *faux-bois* ("false wood") guitar, and the Cubist drawing of a goblet, cut out of some preexisting source as the other *papier-collé* elements in the work. Collage is the great equalizer in which all the elements are united on the same plane, both the literal plane of the canvas and the figurative plane of reality.

Something to Think About . . .

How is the drawing of the wine glass in *Guitar, Sheet Music, and Wine Glass* typically Cubist?

SEE MORE For a Closer Look at Pablo Picasso's collages, go to **www.myartslab.com**

Futurism: The Cult of Speed

News of the experimental fervor of Picasso and Braque spread quickly through avant-garde circles across Europe, and other artists sought to match their endeavors in independent but related ways. On February 20, 1909, for instance, the front page of the Paris newspaper *Le Figaro* [fee-gah-ROH] published the *Founding and Manifesto of Futurism*, written by the Italian Filippo Marinetti [mah-ree-NET-tee] (1876–1944). Reflecting the same antitraditional feelings that motivated Picasso's *Les Demoiselles* and the same distaste for a bourgeoisie seemingly secure in its complacency, Futurism rejected the political and artistic traditions of the past and called for a new art. Marinetti quickly attracted a group of painters and sculptors to invent it. These included the Italian artists Giacomo Balla [BAHL-lah] (1871–1958), Umberto Boccioni [boch-ee-OH-nee] (1882–1916), Carlo Carrà [KAH-rah] (1881–1966), Luigi Russolo [roo-SOH-loh] (1885–1947), who was also a musician, and Gino Severini [sev-eh-REE-nee] (1883–1966). The new style was called Futurism. The Futurists repudiated static art and sought to render what they thought of as the defining characteristic of modern urban life—speed. But it was not until Marinetti took Boccioni, Carrà, and Russolo to Paris for two weeks in the fall of 1911, arranging for visits to the studios of Picasso and Braque, that the fledgling Futurists discovered *how* they might represent it—in the fractured idiom of Cubism.

However, the work they created was philosophically remote from Cubism. It reflected Marinetti's *Manifesto* (see **Reading 34.2**, page 1141), which affirmed not only speed, but also technology and violence. In the manifesto, Futurism is born out of a high-speed automobile crash in the "maternal ditch" of modernity's industrial sludge, an intentionally ironic image of rebirth and regeneration. Where the Cubist rejection of tradition had largely been the invention of two men working in relative isolation, the Futurist rejection was public, bombastic, and political. As the Futurists traveled around Europe between 1910 and 1913 promoting their philosophy in public forums and entertainments, their typical evening featured insult-slinging and scuffles with the audience, usually an arrest or two, and considerable attention in the press.

Marinetti's artists turned to a variety of subjects for inspiration but particularly focused on the car, the plane, and the industrial town, all of which represented for the Futurists the triumph of humankind over nature. Balla painted a cycle of between 15 and 20 paintings representing speeding cars. Carrà was particularly sympathetic with Marinetti's poetic endeavors and Russolo's ideas about music, the former desiring to create "words-in-freedom . . . destroying the canals of syntax," and the latter a music of "noise-sounds." His *Interventionist Demonstration*, he said, celebrates "a love for modern life in its essential

Fig. 34.10 Carlo Carrà, *Interventionist Demonstration*. 1914. Tempera and collage on cardboard, 15 1/8″ × 11 7/8″. Collezione Mattioli, Milan, Italy. Scala/Art Resource, New York. © 2008 Artists Rights Society (ARS), New York. Carrà's inspiration for this image was a flurry of leaflets being dropped from an airplane flying over the Piazza del Duomo in Florence. The image is composed of sounds as much as words, suggesting a raucous political demonstration.

dynamism—its sounds, noises and smells" (Fig. **34.10**). It takes the form, essentially, of a spinning phonograph, its "music" represented by collaged elements from the newspaper.

One of the great masterpieces of Futurist art is Boccioni's *Unique Forms of Continuity in Space* (Fig. **34.11**), a work oddly evocative of the very *Nike of Samothrace* (see Fig. 5.24) that Marinetti in his manifesto found less compelling than a speeding car. Boccioni probably intended to represent a nude, her musculature stretched and drawn out as she moves through space. "What we want to do," he explained, "is show the living object in its dynamic growth."

CONTINUITY & CHANGE

Nike of Samothrace, **p. 163**

LEARN MORE Gain insight from a primary source document about Futurism at **www.myartslab.com**

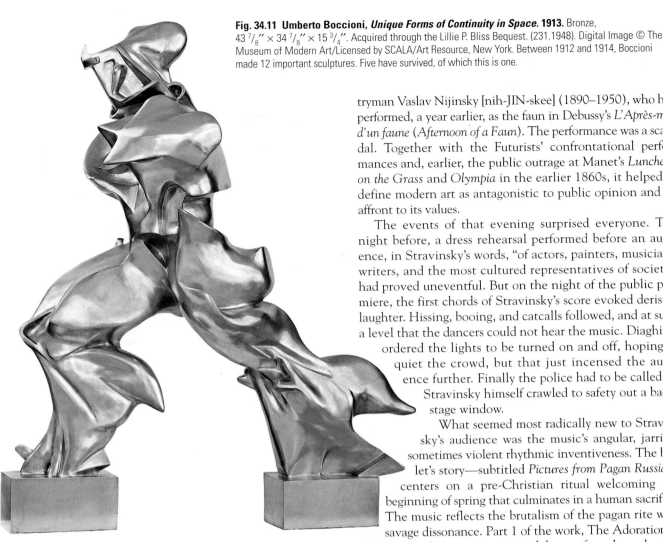

Fig. 34.11 Umberto Boccioni, *Unique Forms of Continuity in Space.* **1913.** Bronze, 43 $\frac{7}{8}$″ × 34 $\frac{7}{8}$″ × 15 $\frac{3}{4}$″. Acquired through the Lillie P. Bliss Bequest. (231.1948). Digital Image © The Museum of Modern Art/Licensed by SCALA/Art Resource, New York. Between 1912 and 1914, Boccioni made 12 important sculptures. Five have survived, of which this is one.

tryman Vaslav Nijinsky [nih-JIN-skee] (1890–1950), who had performed, a year earlier, as the faun in Debussy's *L'Après-midi d'un faune* (*Afternoon of a Faun*). The performance was a scandal. Together with the Futurists' confrontational performances and, earlier, the public outrage at Manet's *Luncheon on the Grass* and *Olympia* in the earlier 1860s, it helped to define modern art as antagonistic to public opinion and an affront to its values.

The events of that evening surprised everyone. The night before, a dress rehearsal performed before an audience, in Stravinsky's words, "of actors, painters, musicians, writers, and the most cultured representatives of society," had proved uneventful. But on the night of the public premiere, the first chords of Stravinsky's score evoked derisive laughter. Hissing, booing, and catcalls followed, and at such a level that the dancers could not hear the music. Diaghilev ordered the lights to be turned on and off, hoping to quiet the crowd, but that just incensed the audience further. Finally the police had to be called, as Stravinsky himself crawled to safety out a backstage window.

What seemed most radically new to Stravinsky's audience was the music's angular, jarring, sometimes violent rhythmic inventiveness. The ballet's story—subtitled *Pictures from Pagan Russia*—centers on a pre-Christian ritual welcoming the beginning of spring that culminates in a human sacrifice. The music reflects the brutalism of the pagan rite with savage dissonance. Part 1 of the work, The Adoration of the Earth, culminates in a spirited dance of youths and maidens in praise of the earth's fertility. In Part 2, The Sacrifice, one of the maidens is chosen to be sacrificed in order to guarantee the fertility celebrated in Part 1. All dance in honor of the Chosen One, invoking the blessings of the village's ancestors, culminating in the frenzied Sacrificial **HEAR MORE at** Dance of the Chosen One herself (track **34.1**). **www.myartslab.com** Just before the dancer collapses and dies, Stravinsky shifts the meter eight times in 12 measures (see the score below); the men then carry the Chosen One's body to the foot of a sacred mound and offer her up to the gods.

Sometimes different elements of the orchestra play different meters simultaneously. Such **polyrhythms** contrast

Modernist Music and Dance: Stravinsky and the Ballets Russes

The dynamism and invention evident in both Cubism and Futurism also appeared in music and dance. On May 29, 1913, the Ballets Russes, a company under the direction of impresario Sergei Diaghilev [dee-AH-ghee-lev] (1872–1929), premiered the ballet *Le Sacre du printemps* (*The Rite of Spring*) at the Théâtre des Champs-Élysées in Paris. The music was by the cosmopolitan Russian composer Igor Stravinsky [strah-VIN-skee] (1882–1971) and the choreography by his coun-

dramatically with other passages where the same rhythmic pulse repeats itself persistently—such as when at the end of the ballet's first part the orchestra plays the same eighth-note chords 32 times in succession. (This technique is known as *ostinato*—Italian for "obstinate.") In addition to its rhythmic variety, Stravinsky's ballet was also **polytonal**: Two or more keys are sounded by different instruments at the same time, and the traditional instruments of the orchestra are used in startlingly unconventional ways, so that they sound raw and strange. Low-pitched instruments, such as bassoons, play at the top of their range, for instance, and clarinets at the gravelly bottom of their capabilities. Integrated across these jarring juxtapositions are passages of recognizable Russian folk songs. Stravinsky's music was enormously influential on subsequent composers, who began to think about rhythmic structure in a totally different way.

If his first Paris audience found Stravinsky's music offensive—more than one critic thought he was a disciple of the Futurists' "noise-sound"—Nijinsky's choreography seemed a downright provocation to riot: "They repeat the same gesture a hundred times over," wrote one critic, "they paw the ground, they stamp, they stamp, they stamp, they stamp and they stamp. . . . Evidently all of this is defensible; it is prehistoric dance." It certainly was not recognizable as ballet. It moved away from the traditional graceful movements of ballerinas dancing *en pointe* (on their toes in boxed shoes) toward a new athleticism. Nijinsky's choreography called for the dancers to assume angular, contorted positions that at once imitated ancient bas-relief sculpture and Cubist painting, hold these positions in frozen stillness, and then burst into wild leaps and whirling circle dances.

THE EXPRESSIONIST MOVEMENT: MODERNISM IN GERMANY AND AUSTRIA

Like Stravinsky, Nijinsky, and Diaghilev, by 1910, almost every European artist had turned to Paris for inspiration. German artists were no exception. We call the modernist style they created Expressionism, though no group of artists actually called itself Expressionist. We can think of German Expressionism as combining the Fauves' exploration of the emotional potential of color with Nijinsky's choreographic representation of raw primitivism and sexual energy. Like the Fauves, the Expressionists' interest in color can be traced to the art of van Gogh and Gauguin, while the sexual expressivity of their work has its roots in the art of the Vienna Secession (see Chapter 33). Their subject matter was often drawn from their own psychological makeup. They laid bare in paint the torment of their lives. There were Expressionist groups throughout Europe that encompassed the visual arts and other media, but the most important in Germany were Die Brücke, originally based in Dresden but moving later to Berlin; Der Blaue Reiter, based in Munich; and the musicians of the Second Viennese School.

Die Brücke: The Art of Deliberate Crudeness

In 1905, four young artists from Dresden calling themselves Die Brücke [dee BROO-kuh] ("The Bridge") exhibited new work in an abandoned chandelier factory. They took the name from a passage in Nietzsche's *Thus Spoke Zarathustra* where Zarathustra calls for humanity to assert its potential to "bridge" the gulf between its current state and the condition of the *Übermensch*, the "higher man," who is the embodiment of the ideal future (see Chapter 33).

The original four artists were Karl Schmidt-Rottluff (1884–1976), Erich Heckel (1883–1970), Fritz Bleyl (1880–1966), and Ernst Ludwig Kirchner (1880–1938). In 1906, Emile Nolde [NOHL-duh] (1867–1956) and Max Pechstein [PEK-shtine] (1881–1955) joined them. They believed that through jarring contrasts of color and jagged, linear compositions—they admired, especially, the gouging, splintered effects that could be achieved in woodblock printing, a deliberately crude but more "direct" and unmediated medium—they could free the imagination from the chains that enslaved it. Kirchner's *Self-Portrait with Model* (Fig. **34.12**) embodies the raw, almost aggressive

Fig. 34.12 Ernst Ludwig Kirchner, *Self-Portrait with Model*. 1910. Oil on canvas, 58 ⅝″ × 39″. Photo: Elke Walford. Hamburger Kunsthalle, Hamburg, Germany. Bildarchiv Preussischer Kulturbeisitz/Art Resource, New York. Die Brücke exhibited as a group in Berlin, Darmstadt, Dresden, Dusseldorf, Hamburg, and Leipzig, as well as in traveling exhibitions to smaller German communities.

Fig. 34.13 Franz Marc, *The Large Blue Horses*. 1911. Oil on canvas, 3′5 ³/₈″ × 5′11 ¹/₄″ (1.05 × 1.81 m). Walker Art Center, Minneapolis. Gift of T. B. Walker Collection, Gilbert M. Walter Fund, 1942. The painting is meant to contrast the beauty of the untainted natural world to the sordidness of modern existence, very much in the spirit of Gauguin.

energy of Die Brücke's style. The artist stands in his striped robe, his masklike face contemplating his painting (unseen but in the space occupied by the viewer). He grips his wide paintbrush (implicitly a symbol for his own sexuality) in a manner that could only result in slashing, almost uncontrolled bands of color, as in fact exist in the painting itself. Behind him, possibly seated on a bed, is his model, dressed in her underwear, present (as in almost all Die Brücke work) solely as the eroticized object of male sexual desire.

Der Blaue Reiter: The Spirituality of Color

Der Blaue Reiter [dair BLAU-uh RY-tur] ("The Blue Rider") did not come into being until 1911. It was headed by the Russian émigré Wassily Kandinsky [kan-DIN-skee] (1866– 1944) and by Franz Marc (1880–1916), an artist especially fond of painting animals, because he believed they possessed elemental energies. They were joined by a number of other artists, including Auguste Macke [MAH-kuh] (1887–1914) and Gabriele Münter [MUN-tur] (1877–1962), who met Kandinsky when she was his student in Munich in 1902.

These artists had no common style, but all were obsessed with color. "Color," Kandinsky wrote in *Concerning the Spiritual in Art*, first published in 1912 in the *Blaue Reiter Almanac*, "directly influences the soul. Color is the keyboard, the eyes are the hammers, the soul is the piano with many strings. The artist is the hand that plays . . . to cause vibrations of the soul." The color blue, Kandinsky wrote, is "the typical heavenly color." Marc saw in blue what he thought of as the masculine principle of spirituality. So his *The Large Blue Horses*, with its seemingly arbitrary color

Fig. 34.14 Gabriele Münter, *The Blue Gable*. 1911. Oil on canvas, 34 ¹⁵/₁₆″ × 39 ⁵/₈″. Krannert Art Museum, University of Illinois, Champaign. Gift of Albert L. Arenberg 1956-13-1. Münter lived in Murnau until her death in 1962. During World War II, she preserved her collection of Blaue Reiter works in the cellar of her house, hiding them first from the Nazis, who thought her work "degenerate," then from the occupying U.S. troops.

and interlocking rhythm of fluid curves and contours, very much influenced by Matisse, is the very image of the spiritual harmony in the natural world (Fig. **34.13**).

Yellow, on the other hand, was the female principle, a fact that deeply informs Gabriel Münter's *The Blue Gable* (Fig. **34.14**). Münter was one of the most original of the Blaue Reiter artists. At a time when, especially in Germany,

Fig. 34.15 Wassily Kandinsky, *Composition VII.* **1913.** Oil on canvas, 6′6 ³/₄″ × 9′11 ¹/₈″. Tretyakov Gallery, Moscow. Among practitiners of nonfigurative abstract art, Kandinsky was perhaps unique in not forcing his point of view on his colleagues. If his was what he called "the Greater Abstraction," theirs was "the Greater Realism," equally leading to "the spiritual in art."

it was widely believed that women were not capable of artistic creation, she created a body of totally original work while involved in a relationship with Kandinsky that was emotionally painful for her. Eleven years her senior, he had seduced her as his student, promising to divorce his wife and marry her. Kandinsky never did marry her, though after he went to Russia in 1914, aspiring to help create a new revolutionary Russian art, he did divorce his wife and marry another woman. Münter remained deeply in love with Kandinsky and bought a summer house for them in the town of Murnau [MUR-now] in the foothills of the Bavarian Alps. At Murnau, she began to collect and emulate the Bavarian folk art of reverse-glass painting. The dark outlines of her forms in *The Blue Gable* function like leading in stained glass. A winter view of Murnau, it seems to suppress all the Blaue Reiter's coloristic tendencies, except for the yellow house and the deep blue gable. Given Kandinsky and Marc's color theory, the blue was probably a symbol of the masculine, even a symbol of Kandinsky himself. The yellow (feminine) house stands crookedly beside it, behind the tilted diagonals of a fence. In the foreground, a giant snow-covered rock and a jagged, leafless tree stand guard,

suggesting the opposite of Marc's natural harmony. On a symbolic level, they seem to reflect tensions that existed between Münter and Kandinsky.

Kandinsky's chief theme was the biblical Apocalypse, the moment when, according to a long tradition in the Byzantine church, Moscow would become the New Jerusalem. "Der Reiter," in fact, was the popular name for Saint George, patron saint of Moscow, and the explosions of contrasting colors across *Composition No. 7* (Fig. **34.15**) suggest that the fateful moment has arrived. Earthly yellow competes with heavenly blue, and red with green. Red, he wrote, "rings inwardly with a determined and powerful intensity," while green "represents the social middle class, self-satisfied, immovable, narrow." Linear elements, Kandinsky felt, were equivalent to dance, and the painting can be interpreted as a rendering of dance set to music. But *Composition No. 7* is the last of a series of "compositions"— the title in fact refers to music—the biblical themes of war and resurrection, deluge and apocalypse, with each painting becoming more and more abstract. Certain passages, however, remain legible, especially when seen in light of the earlier works, such as a boat with three oars at the

LEARN MORE Gain insight from a primary source document about Wassily Kandinsky at **www.myartslab.com**

bottom left which is, for Kandinsky, an emblem for the deluge. But above all, the painting remains a virtually nonobjective orchestration of line and color.

A Diversity of Sound: Schoenberg's New Atonal Music versus Puccini's Lyricism

On January 2, 1911, Kandinsky and Marc heard the music of Arnold Schoenberg [SHERN-berkh] (1874–1951) at a concert in Munich. Schoenberg was from Vienna, where he led a group of composers, including Alban Berg and Anton Webern, who believed that the long reign of tonality, the harmonic basis of Western music, was over. Marc later wrote to a friend, "Can you imagine a music in which tonality is completely suspended? I was constantly reminded of Kandinsky Schoenberg seems, like [ourselves], to be convinced of the irresistible dissolution of the European laws of art and harmony."

Schoenberg did in fact abandon **tonality**, the organization of the composition around a home key (the tonal center). In its place, he created a music of complete **atonality**, a term he hated (since it implied the absence of musical tone altogether), preferring instead "pantonal." His 1912 setting for a cycle of 21 poems by Albert Giraud, *Pierrot lunaire* [pee-yair-OH lune-AIR], is probably the first atonal composition to be widely appreciated, though to many it repre- ((• **HEAR MORE** at www.myartslab.com sented, as one critic put it, "the last word in cacophony and musical anarchy" (track **34.2**). Pierrot is a character from the Italian commedia dell'arte [kom-MAY-dee-ah dell-AR-tay], the improvisational traveling street theater that first developed in the fifteenth century. He is a moonstruck clown whose mask conceals his deep melancholy, brought on by living in a state of perpetually unrequited desire. (Picasso often portrayed himself as Pierrot, especially early in his career.) In *Pierrot lunaire*, five performers play eight instruments in various combinations in accompaniment to a voice that does not sing but instead employs a technique that Schoenberg calls **Sprechstimme** [SHPREK-shtim-muh] or "speech-song." "A singing voice," Schoenberg explained, "maintains the pitch without modification; speech-song does, certainly, announce it [the pitch], only to quit it again immediately, in either a downward or an upward direction." In the *Madonna* section of *Pierrot lunaire*, which addresses Mary at the moment of the pietà, when she mourns over the dead body of her son, the lyrics focus on the blood of Christ's wounds, which "seem like eyes, red and open." The atonality of Schoenberg's music reflects this anguish with explosive force.

Creating long works without the resources of tonality was a very real challenge to Schoenberg—hence the usefulness of 21 short works in the *Pierrot lunaire* series. By 1924, Schoenberg had introduced a system in which none of the 12 tones of the chromatic scale could be repeated by a given instrument until each of the other 11 had been played— they could, however, be repeated in counterpoint by another instrument. This **12-tone system** reflected his belief that every tone was equal to every other. The 12 notes in their given order are called a **tone row**, and audiences soon grew accustomed to not hearing a tonal center in the progression and variation of the tone row as it developed in Schoenberg's increasingly **serial composition**. The principal tone row can be played upside down, backward, or upside down and backward. While the possibilities for writing an extended composition with a single tone row and its variations might at first seem limited, by adding rhythmic and dynamic variations, as well as contrapuntal arrangements, the development of large-scale works became feasible.

The radical nature of Schoenberg's composition can best be understood by comparing it to its opposite, the emotional lyricism of the Italian opera composer Giacomo Puccini (1858–1924). So Romantic is Puccini's music, and so Realist are his librettos, that in many ways, he is closer to Romantic and Realist writers and painters of the nineteenth century than to those of the twentieth. His first two great operas, *Manon Lescaut* and *La Bohème*, both love stories set in France, date from the last decade of the nineteenth century, 1893 and 1896 respectively, but the rest of his output dates from the twentieth century. *Tosca* (1900) is a passionate love story that ends in murder and suicide. *Madama Butterfly* (1904) describes the betrayal of a Japanese geisha by an American sailor, and her eventual suicide. *The Girl of the Golden West* (1910) is set in the American "Wild West" and features saloons, gunfights, and a manhunt. Puccini looked to Beijing, China, for the story of *Turandot*, an opera that is based on a Chinese folk tale. The opera was not quite finished when Puccini died in 1924, and the last two scenes were completed by a colleague for its premiere in 1926. These operas and their continued popularity demonstrate the enduring power of tradition over both composers and listeners throughout the twentieth century and down to the present day.

Two arias, *Un bel dì* ("One Fine Day") from *Madama Butterfly* and *Nessun dorma* ("Let No One Sleep") from *Turandot*, embody Puccini's extraordinary **HEAR MORE** at •)) www.myartslab.com melodic gifts (tracks **34.3** and **34.4**). *Madama Butterfly* tells the story of an American sailor, Lieutelnant Benjamin Franklin Pinkerton, who has rented a house in Japan for 999 years. As part of the deal, he is also given a bride, Cio-Cio-San ("Butterfly"). Pinkerton does not take the marriage seriously and soon returns to America, promising to return. Cio-Cio-San gives birth to a son and fully expects the boy's father to return to them. Pinkerton has no such plan and marries an American woman. When he returns to Japan with his wife three years later, the devastated Cio-Cio-San kills herself. Cio-Cio-San sings *Un bel dì* ("One Fine Day") near the beginning of Act II, after Pinkerton has left for America, as she tries to convince herself that her husband will one day return.

The aria *Nessun dorma* ("Let No One Sleep") occurs in the last act of *Turandot*. Turandot is a beautiful princess whose hatred of men has led her to declare that any suitor who does not correctly answer three riddles that she poses must die. Calàf, a prince from Tartary, is smitten by Turandot's beauty, and surprises her by answering each riddle

correctly. Turandot is horrified, but Calàf offers her an out: If she can discover his name by dawn, he will forfeit his life. She immediately orders that no one shall sleep until Calàf's identity is discovered, and in *Nessun dorma*, Calàf's aria, he expresses his certainty that no one will discover his name.

The music of both Schoenberg and Puccini shares an emotionally charged expressivity, but there could be no greater contrast to Schoenberg's *Sprechstimme* than Puccini's lyricism. "Without melody," Puccini said, "there can be no music." If Schoenberg agreed, he differed in believing that melody could exist exclusive of harmony.

EARLY-TWENTIETH-CENTURY LITERATURE

If one word could express the literature of the early twentieth century, it would be *innovation*. Like visual artists and composers, writers too were drawn to uncharted ground and experimented with creating new forms in an effort to embrace the multiplicity of human experience. Like Picasso in his *Demoiselles d'Avignon*, they sought a way to capture the simultaneous and often contradictory onslaught of information and feelings that characterized the fabric of modern life. And writers understood that these multiple impulses from the real world struck the brain randomly, inharmoniously, in rhythms and sounds as discordant as the music of Stravinsky and Schoenberg.

Guillaume Apollinaire and Cubist Poetics

Picasso's good friend and a champion of his art, Guillaume Apollinaire [ah-pol-ee-NAIR] (1880–1918), was one of the leaders in the "revolution of the word," as this new approach to poetry and prose has been called. Modeling his work on the example of Picasso, Apollinaire quickly latched on to the principle of collage. In his poem "Lundi, rue Christine" [lun-DEE rue kree-STEEN] ("Monday in the rue Christine"), snatches of conversation overheard on a street in Paris, not far from the École des Beaux Arts [ay-KOHL day bohz-AR], follow one another without transition or thematic connection (**Reading 34.3**):

> READING 34.3
>
> **from Guillaume Apollinaire, "Lundi, rue Christine" (1913)**
>
> Those pancakes were divine
> the water's running
> Dress black as her nails
> It's absolutely impossible
> Here sir
> The malachite ring
> The ground is covered with sawdust

> Then it's true
> The red headed waitress eloped with a book seller.
> A journalist whom I really hardly know
> Look Jacques it's extremely important what I'm going
> to tell you
> Shipping company combine

In this short, representative fragment from the poem, Apollinaire has transformed this collage of voices into poetry by the act of arranging each phrase into poetic lines.

He would feel free, as well, to reorganize poetic lines into visual images. In "Il Pleut" [eel pleh] ("It's Raining") (Fig. 34.16), Apollinaire deployed the following lines in loose vertical columns down the page to represent wind-blown sheets of rain (**Reading 34.4**):

> READING 34.4
>
> **Guillaume Apollinaire, "Il Pleut" (1914)**
>
> It is raining women's voices as if they were dead even
> in memory
> you also are raining down marvelous encounters of
> my life o little drops
> and these rearing clouds are beginning to whinny a
> whole world of auricular towns
> listen to it rain while regret and disdain weep an old
> fashioned music
> listen to the fall of all the perpendiculars of your existence

Apollinaire called such visual poems **calligrammes** [kah-lee-GRAHM], a word of his own invention related to *calligraphy* and meaning, literally, "something beautifully written." The poem purposefully combines sound and sight, imaging, for instance, clouds as rearing horses neighing, "auricular towns"—that is, towns addressed to the ear, the noise of the modern urban street. As we listen to "an old fashioned music" verse/poetry, but also tradition as a whole—we also hear the "fall of all the perpendiculars" of our existence, everything generally considered "upright" both physically and morally. In Apollinaire's image of the poem, the voices of the old world literally rain down on us to give way to the new.

Ezra Pound and the Imagists

Apollinaire's strategy of juxtaposing fragments of speech heard simultaneously thereby juxtaposing two (or more) unlike words, objects, or images was, in fact, a fundamental strategy of modern art. It informs, as well, the poetry of the Imagists, a group of English and American poets who sought to create precise images in clear, sharp language. Imagism was the brainchild of American poet Ezra Pound (1885–1972), who in October 1912 submitted a group of

poems under the title *Imagiste* to the new American journal *Poetry*. The poet and critic F.S. Flint would succinctly define the Imagist poem in the March 1913 issue of the magazine. Its simple rules were:

1. Direct treatment of the "thing," whether subjective or objective.
2. To use absolutely no word that does not contribute to the presentation.
3. As regarding rhythm: to compose in sequence of the musical phrase, not in sequence of the metronome.

It's Raining

Fig. 34.16 Guillaume Apollinaire, "Il Pleut" (It's Raining"). 1914. Translated in its original form by Oliver Bernard. From *Selected Poems of Apollinaire*, trans. Oliver Bernard. (Vancouver, British Columbia: Anvil Press, 2003). Apollinaire's book *Les peintres cubistes* (*The Cubist Painters*), published in 1913, helped to define the aims of Picasso and Braque for a broader, more general audience.

Pound's "In a Station of the Metro" (**Reading 34.5**) which first appeared in *Poetry* in 1913, is in many ways the classic Imagist poem:

READING 34.5

Ezra Pound, "In a Station of the Metro" (1913)

The apparition of these faces in the crowd;
Petals on a wet, black bough.

Pound was an avid scholar of Chinese and Japanese poetry, and the poem is influenced both by the Japanese *waka* tradition, with its emphasis on the changing seasons, and formally, in its brevity at least, by the *haiku* tradition (see Chapter 11). (Haiku normally consist of 3 lines in 17 syllables, while Pound's poem is made up of 19 syllables in 2 lines.) The poem's first line seems relatively straightforward—except for the single word "apparition." It introduces Pound's predisposition, his sense that Paris is inhabited by the "living dead." It contrasts dramatically with the poem's second and final line, which is an attractive picture of nature. The first line's six-beat iambic meter—da-duh, da-duh, and so on—is transformed into a five-beat line that ends in three long strophes—that is, single beats—"wet, black bough." The semicolon at the end of the first line acts as a kind of hinge, transforming the bleak vision of the moment into a vision of possibility and hope, the implicitly "white" apparition of the faces of the ghostlike crowd transformed into an image of spring itself, the petals on the wet, black bough. The poem moves from the literal subway underground, from burial, to life, reborn in the act of the poetic vision itself. It captures that moment, as Pound said, when a thing "outward and objective" is transformed into a thing "inward and subjective."

Pound was also self-consciously working in the shadow of Walt Whitman (see Chapter 32), who, Pound believed, had opened poetry to the vast expanse and multiplicity of American culture. The poem "A Pact," also published in 1913 in *Poetry*, addresses Whitman (**Reading 34.6**):

CONTINUITY & CHANGE
"Song of Myself", p. 1079

READING 34.6

Ezra Pound, "A Pact" (1913)

I make truce with you, Walt Whitman—
I have detested you long enough.
I come to you as a grown child
Who has had a pig-headed father;
I am old enough now to make friends.
It was you that broke the new wood,
Now is a time for carving.
We have one sap and one root—
Let there be commerce between us.

Pound clearly recognizes in Whitman the poetic force that liberated poetry to address the world in all its multiplicity. But he feels he must whittle Whitman's voluminous work down to a more manageable size—to the single image, in fact. As it would turn out, over the course of his career, Pound would write a poem even longer than Whitman's *Leaves of Grass*, the massive *Cantos*, which would occupy him until his death (see Chapter 32). In fact, the legacy Whitman left for twentieth-century American poetry was not only the freedom to invent, but the propensity to write the long poem.

THE ORIGINS OF CINEMA

In 1894, a book called *Movement* was published in Paris. It was a treatise on human and animal locomotion written by Étienne-Jules Marey [mah-RAY] (1830–1904), a French physiologist who had long been fascinated by the possibility of breaking down the flow of movement into isolated data that could be analyzed. Marey himself had seen the series of photographs of a horse trotting published by his exact contemporary, the American photographer Eadweard Muybridge [MY-brij] (1830–1904), in the French journal *La Nature* [nah-CHOOR] in 1878 (Fig. **34.17**). Muybridge had used a trip-wire device in an experiment commissioned by California governor Leland Stanford to settle a bet about whether there were moments in the stride of a trotting or galloping horse when all four feet are off the ground. Intrigued by Muybridge's photographs, Marey began to use the camera himself, dressing models in black suits with white points and vertical stripes on the side that allowed him to study, in images created out of a rapid succession of photographs, the flow of their motion. He called them *chronophotographs*, literally "photographs of time."

Not long after Muybridge and Marey published their work, Thomas Edison (1847–1931) and W. K. Laurie Dickson (1860–1935) invented the Kinetoscope [kih-NET-oh-skope], the first continuous-film motion-picture viewing machine. After visiting with Marey in 1889, Edison had become convinced that a motion picture was possible, especially if he used celluloid film, the new invention of George Eastman (1854–1932) that came on a roll. Eastman had introduced his film in 1888 for a new camera called the Kodak. Dickson devised a sprocket wheel that would advance the regularly perforated roll of film, and Edison decided on a 35mm width (eventually the industry standard) for the film strip of their new motion-picture camera, the Kinetograph. But Edison's films were only viewable on the Kinetoscope through a peephole by one person at a time. Although viewing parlors first appeared in 1894, the commercial possibilities of film seemed limited since each of Edison's motion pictures lasted for only about 20 seconds.

The Lumière Brothers' Celluloid Film Movie Projector

The first projected motion pictures available to a large audience had their public premiere on December 28, 1895, in Paris. That night, August and Louis Lumière (1862–1954, 1864–1948) showed 10 films that lasted for about 20 minutes through their Cinématographe [see-nay-may-toh-GRAHF], a hand-cranked camera that, when connected to the equipment used for "magic lantern" shows (early "slide" shows), served as a projector as well. The program began with *Workers Leaving the Lumière Factory*, a film that conveyed, if nothing else, the large size of the Lumière brothers' operation.

Fig. 34.17 Eadweard Muybridge, *Annie G, Cantering Saddled*. December 1887. Collotype print, sheet 19″ × 24″, image 7″ × 16″. Philadelphia Museum of Art: City of Philadelphia, Trade & Convention Center, Dept. of Commerce (Commercial Museum). From photographs such as this, especially others showing the human body in motion, the science of physiology was born.

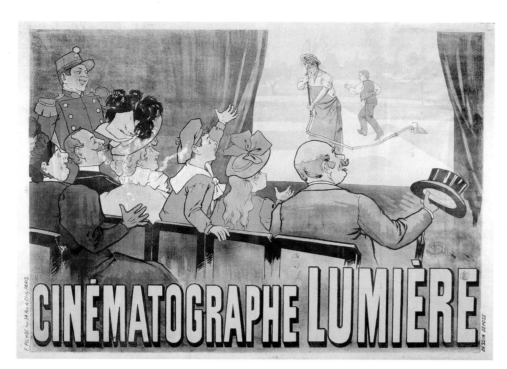

Fig. 34.18 Poster for the Cinématographe, with the Lumière brothers' film *L'Arroseur arrosé* (*Waterer and Watered*) on screen. 1895. British Film Institute. Notable in this poster is the audience. From the beginning, cinema defined itself as family entertainment.

Two of their most famous films were not shown that night, *Arrival of a Train at La Ciotat* [see-oh-TAH] and *Waterer and Watered* (Fig. **34.18**). The first film depicts, in a single shot, a train arriving at a station—and the story goes that original audience members panicked as the train got closer to the camera because it seemed so real to them. The second film introduced comedy to the medium. A boy steps on a gardener's hose, stopping the flow of water; when the gardener looks at the nozzle, the boy steps off the hose, and the gardener douses himself. A brief chase ensues, with both boy and gardener leaving the frame of the stationary camera for a full two seconds.

The Nickelodeon: Movies for the Masses

By the turn of the century, the motion picture had established itself as little more than an interesting novelty. That would change when at first a few and then hundreds of entrepreneurs understood where the real audience for motion pictures was. By the turn of the century, thousands of immigrants to the United States, mostly from southern and central Europe, were living in overcrowded tenements in miserable city slums. They could not afford to pay much for entertainment, but they could afford a nickel (approximately $1 in today's money)—and so by 1905, the nickelodeon theater was born. By 1910, there were more than 10,000 nickelodeons in the United States. With names like the World's Dream Theater, they catered to the aspirations of the working class, and most often to women and children (though even before Prohibition, the movies would pull so many men out of saloons that thousands of bars around the country closed down). The nickelodeons showed a wide variety of films. Vitagraph [VIGH-tah-graf], an early producer, released a military film, a drama, a Western, a comedy, and a special feature each week. Civil War films were popular (though not as popular as Westerns, which European audiences also adored). There were also so-called quality films: adaptations of Shakespeare, biblical epics, and the like.

Although by 1909 motion picture companies were increasingly using **intertitles**—printed text that could announce a scene change, provide lines of dialogue, or even make editorial comment—to aid in the presentation of their narratives, by and large, silent films were particularly accessible to working-class, immigrant audiences whose often rudimentary grasp of the English language was thus not a major obstacle to enjoying what remained primarily a visual medium.

D. W. Griffith and Cinematic Space

The need for a weekly supply of films to satisfy the nickelodeon audience dictated, at first, the length of films. Most were one-reelers—that is, a single film spool holding about 1,000 feet of film—and their running time was 10 to 15 minutes. But by 1914, more than 400 films of four reels or more had been produced in the United States (few survive), and audiences soon demanded longer narrative experiences.

This demand was met by D. W. Griffith (1875–1948), the foremost single-reel director of the day. In January 1915, his 13-reel epic *The Birth of a Nation* premiered, released with its own score, to be played by a 40-piece orchestra, and with an admission price of $2, the same as for legitimate theater. A film about the Civil War and Reconstruction, its unrepentant racism, culminating in a tightly edited sequence in which a white woman tries to fend off the sexual advances of a black man as the Ku Klux Klan rides to her rescue, led the newly formed NAACP (National Association for the Advancement of Colored People) to seek to have it banned. Riots broke out in

Fig. 34.19 D. W. Griffith, battle scene from *The Birth of a Nation*. 1915. The Museum of Modern Art, Film Stills Archive. Griffith was the son of a Confederate colonel, which sheds light on his racism.

Boston and Philadelphia, while Chicago, Denver, Pittsburgh, St. Louis, Minneapolis, and eight states denied its release. Nevertheless, its box office receipts were among the largest in film history (partly due to its large admission fee), grossing nearly $18 million by the late 1920s, when the advent of talking films made it more or less obsolete. If nothing else, *The Birth of a Nation* demonstrated the viability of what came to be called the feature film, a film of multiple reels that ran for at least 40 minutes; they were "featured" with prominent billing and shown after several shorts, including newsreels and animated cartoons.

An even more important aspect of *The Birth of a Nation* was the large repertoire of camera shots that Griffith used to create visual variety in a film of such length. A *shot* is a continuous strip of motion picture film that portrays a subject and runs for an uninterrupted period of time. As the contemporary American film critic Roger Ebert has put it, "Griffith assembled and perfected the early discoveries of film language, and his cinematic techniques have influenced the visual strategies of virtually every film made since; they have become so familiar we are not even aware of them." Griffith's film techniques created a new sense of space, what might be called "cinematic space," as he combined his shots in innovative ways. His repertoire included the *full shot*, showing the actor from head to toe; the *medium shot*, from the waist up; the *close-up* of the head and shoulders; and the *extreme close-up* of a portion of the face. The *pan* is a name given to the panoramic vista in which the camera moves across the scene from one side to the other. Griffith also invented the *traveling shot*, in which the

camera moves from back to front or from front to back. Related to the traveling shot is the *long shot*, a shot that takes in a wide expanse and many characters at once, as in the rather remarkable battle scene (Fig. **34.19**). Figure 34.19 is also an example of an *iris shot*, which involves the frame slowly opening in a widening circle as a scene begins, or slowly blacking out in a shrinking circle to end a scene.

Griffith arranged all of these shots by editing them in innovative ways as well. He incorporated intertitles in ways that interfered minimally with narrative action. The *flashback*, in which the film cuts to narrative episodes that are supposed to have taken place before the start of the film, is now standard in film practice, but it was entirely original when Griffith first used it. And he was a master at *cross-cutting*, in which the film moves back and forth between two separate events in ever shorter sequences, the rhythm of the shots eventually becoming furiously paced. The alternating sequence at the end of *The Birth of a Nation*, of an endangered maiden and the Ku Klux Klan riding to her rescue, is a classic example. The technique would become a staple of cinematic chase scenes.

It is almost impossible to imagine what it must have been like for early audiences to see, for the first time, a film jump from, say, a full shot of a couple embracing to an extreme close-up of their lips kissing. But audiences rapidly learned Griffith's skillful cinematic language. Here, they must have recognized, was a medium for the new age—a dynamic, moving medium, embodying the change and speed of the times.

The Prospect of War

In his collages of 1912 and 1913, Picasso brought not only the "real" world into the space of the canvas, but also an edge of dread and foreboding. The subject of his still life, *Bottle of Suze* (Fig. **34.20**), is a tabletop at some Parisian café on which stand a bottle of aperitif, a glass, and newspaper. But what would appear to be a metaphor for a comfortable autumn morning, the good life in Paris, is not. The war in the Balkans, which everyone feared would erupt into a larger, pan-European conflict (as indeed it did), is the real theme of this collage. Suze is a Balkan aperitif. Injecting a serious note into the pleasantries of café culture, the upside-down newspaper reports a cholera epidemic at the front. It begins:

Before long I saw the first corpse still grimacing with suffering and whose face was nearly black. Then I saw two, four, ten, twenty; then I saw a hundred corpses. They were stretched out there where they had fallen during the march of the left convoy, in the ditches or across the road, and the files of cars loaded with the almost dead everywhere stretched themselves out on the devastated route.

To the left of the bottle is another article, right side up, reporting on a mass socialist/pacifist/anarchist meeting attended by an estimated 50,000 citizens. The third speaker to address the crowd is represented only by his opening words: "In the presence of the menace of a general [Euro]pean war . . ." Here Picasso's scissors have terminated the report.

The prospect of a general war was real enough. Raymond Poincaré (1860–1934), who became France's premier and foreign minister in 1912, quickly began to ready for a war with Germany, which, he predicted, would be "short but glorious." As is so often the case, the war, which would officially begin on August 4, 1914, was far worse than expected. Within a month, the first major fight, the battle of the Marne, was underway, resulting in a half million casualties on each side. By the time the war was over, in November 1918, it had cost Germany 3.5 million men. The Allies—England and America had joined forces with France—had lost over 5 million.

The day after the British entered the war, the novelist Henry James wrote a friend:

The plunge of civilization into this abyss of blood and darkness . . . is a thing that gives away the whole long age during which we have supposed the world to be, with whatever abatement, gradually bettering, that to have to take it all now for what the treacherous years were all the while really making for and meaning is too tragic for words.

The myth of progress had ground to a halt. The technological advances that had driven the era of invention now seemed only preparation for wholesale human slaughter. The airplane, which had seemed so promising a machine, flying heavenward, was now an agent of death. The world had turned upside down. ■

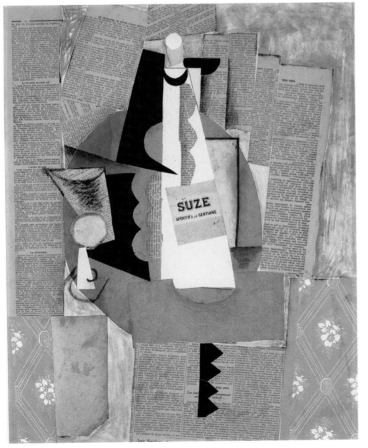

Fig. 34.20 Pablo Picasso, *Glass and Bottle of Suze (Le Bouteille de Suze)*. 1912. Pasted papers, gouache, and charcoal on paper. 25 $^2/_5$" × 19 $^2/_3$" (64.5 × 50 cm). Mildred Lane Kemper Art Museum, Washington University in St. Louis. University purchase, Kende Sale Fund, 1946. © Succession Picasso/DACS 1998. © 2008 Estate of Pablo Picasso/Artists Rights Society (ARS), New York.

What are Cubism, Fauvism, and Futurism?

The new century was marked by technological innovation epitomized by the automobile (and its speed), the motion picture, the airplane, and, perhaps most of all, by new discoveries in physics, to quantum mechanics, the theory of complementarity, and the theory of relativity. The focal point of artistic innovation was Pablo Picasso's studio in Paris. There, in paintings like the large canvas *Les Demoiselles d'Avignon*, he transformed painting. In what ways is *Les Demoiselles* a radical departure from then-contemporary art? Picasso's project was quickly taken up by Georges Braque, and the two worked together to create the style that came to be known as Cubism. What are the primary features of Cubism? How would you describe collage as a technique? Henri Matisse meanwhile helped to create the Fauve movement. What is Fauvism's chief concern? How would you compare the paintings of Matisse and Picasso? The Futurists, led by Filippo Marinetti, would introduce the idea of speed and motion into painting. How is their work an attack on traditional values? In music and dance, composer Igor Stravinsky and the Ballets Russes of impresario Sergei Diaghilev would shock Paris with the performance of *Le Sacre du printemps* in May 1913. How would you describe Stravinsky's music and Diaghilev's dance?

What is German Expressionism?

German Expressionism combined the Fauves' exploration of color with the primitivism of Nijinsky's choreography in an art that centered on the psychological makeup of its creators. The two chief groups in painting were Die Brücke and Der Blaue Reiter. What are the primary characteristics of each? How do Wassily Kandinsky's theories about color inform the paintings of the Blaue Reiter group? In music, the Viennese composer Arnold Schoenberg, who exhibited his own self-portrait paintings with the Der Blaue Reiter, dispensed with traditional tonality, the harmonic basis of Western music, and created new atonal works. What is the 12-tone system that he used? What is *Sprechstimme*, and how did he use it? Nothing could be further from the lyrical compositions of his near-contemporary, Giacomo Puccini, whose operas—and a number of arias in particular—are nearly without parallel for the beauty of their melodies. Despite their differences, what beliefs do both Schoenberg and Puccini share?

What innovations distinguish the literary world in the early years of the twentieth century?

Like the visual arts and music, a spirit of innovation dominated the literary scene as well. The French poet Guillaume Apollinaire experimented with poetic forms. What characterizes his *calligrammes*? What techniques does he share with his friend Picasso? Ezra Pound and the Imagists sought to capture the moment, in the most economic terms, when the "outward and objective" turns "inward and subjective." What was Walt Whitman's influence on Pound?

What are the origins of cinema?

The invention of cinema is anticipated in the photographic work of Étienne-Jules Marey and Eadweard Muybridge. What was the primary focus of their work? The Kinetoscope, the first continuous-film motion-picture viewing machine, was invented by Thomas Edison and W. K. Laurie Dickson. It used celluloid film on a roll introduced by George Eastman in 1888 for the new Kodak camera. The first projected motion pictures available to a large audience had their public premiere on December 28, 1895, in Paris when August and Louis Lumière showed 10 films that lasted for about 20 minutes. When entrepreneurs realized the potential market of the thousands of immigrants who had arrived from southern and central Europe, the nickelodeon was born. In January 1915, D. W. Griffith introduced his 13-reel epic, *The Birth of a Nation*. What possibilities for cinema did this film propose? What visual vocabulary did it introduce?

PRACTICE MORE Get flashcards for images and terms and review chapter material with quizzes at **www.myartslab.com**

GLOSSARY

atonality The absence of a home key (tonal center).

calligrammes Literally, "something beautifully written," this term was invented by the poet Guillaume Apollinaire to describe his visual poems that purposefully conflate sound and vision.

collage The technique of pasting cut-out or found elements into the work of art.

Cubism An art style developed by Pablo Picasso and Georges Braque noted for the geometry of its forms, its fragmentation of the object, and its increasing abstraction.

Fauvism A style in art known for its bold application of arbitrary color.

intertitle Text inserted between scenes in a film to announce a change of location, provide dialogue lines, or make editorial comment.

ostinato The repetition of the same rhythmic pulse with the same or different notes.

papiers-collés Literally "pasted paper," the technique that is the immediate predecessor of collage in Cubism.

polyrhythm A musical technique in which different elements of an ensemble might play different meters simultaneously.

polytonal Occurs when two or more keys are sounded by different instruments at the same time.

serial composition Extending the potential of the prime tone row by inversion (playing it upside down so that a rise of a major third in the prime row becomes the fall of a major third in its inversion); the row may also be played backward (retrograde) or upside down and backward (retrograde inversion).

Sprechstimme Literally "speaking tone," a technique between speech and song, in which a text is enunciated in approximated pitches.

tonality The organization of a composition around a home key (the tonal center).

tone row The 12 chromatic notes in their chosen order in a musical composition.

12-tone system In its most basic form, a system developed by the composer Arnold Schoenberg in which none of the 12 tones of the chromatic scale could be repeated in a composition until each of the other 11 had been played.

READINGS

READING 34.2

from Filippo Marinetti, *Founding and Manifesto of Futurism* (1909)

Filippo Marinetti published the Founding and Manifesto of Futurism *on the front page of the Paris newspaper* Le Figaro *on February 20, 1909. The manifesto is a form of attack particularly suited to bombast and bravura, provocation and propaganda. Marinetti's first Futurist manifesto—many more would follow—is all of these. He thought of himself as "the caffeine of Europe," dedicated to keeping conservative culture awake all night with worry. He was also, as this excerpt from the document makes clear, something of an anarchist, desirous of overthrowing all traditions.*

We had stayed up all night, my friends and I, under hanging mosque lamps with domes of filigreed brass, domes starred like our spirits, shining like them with the prisoned radiance of electric hearts. For hours we had trampled our atavistic ennui into rich oriental rugs, arguing up to the last confines of logic and blackening many reams of paper with our frenzied scribbling Suddenly we jumped, hearing the mighty noise of the huge double-decker trams that rumbled by outside, ablaze with colored lights Under the windows we suddenly heard the famished roar of automobiles. "Let's go!" I said. "Friends, away! Mythology and the Mystic Ideal are defeated at last We went up to the three snorting beasts, to lay amorous hands on their torrid breasts. I stretched out on my car like a corpse on its bier, but revived at once under the steering wheel, a guillotine blade that threatened my stomach. The raging broom of madness swept us out of ourselves and drove us through streets as rough and deep as the beds of torrents. Here and there, sick lamplight through the window glass taught us to distrust the deceitful mathematics of our perishing eyes And on we raced Death, domesticated, met me at every turn, gracefully holding out a paw, or once in a while hunkering down, making velvety caressing eyes at me from every puddle. "Let's give ourselves utterly to the Unknown, not in desperation but only to replenish the deep wells of the Absurd!!" The words were scarcely out of my mouth when I spun my car around with the frenzy of a dog trying to bite its tail, and there, suddenly, were two cyclists coming toward me, shaking their fists I stopped short and to my disgust rolled over into a ditch with my wheels in the air Oh! Maternal ditch, almost full of muddy water! Fair factory drain! I gulped down your nourishing sludge When I came up—torn, filthy, and stinking—from under the capsized car, I felt the white-hot iron of joy deliciously pass through my heart And so, faces smeared with good factory muck—plastered with metallic waste, with senseless sweat, with celestial soot—we, bruised, our arms in slings, but unafraid, declared our high intentions to all the *living* of the earth:

MANIFESTO OF FUTURISM

1. We intend to sing the love of danger, the habit of energy and fearlessness.

2. Courage, audacity, and revolt will be essential elements of our poetry

4. We say that the world's magnificence has been enriched by a new beauty; the beauty of speed. A racing car whose hood is adorned with great pipes, like serpents of explosive breath—a roaring car that seems to ride on grapeshot is more beautiful than the *Victory of Samothrace.*

. . .

8. Time and space died yesterday. We already live in the absolute, omnipresent speed.

9. We will glorify war—the world's only hygiene—militarism, patriotism, the destructive gesture of freedom-bringers, beautiful ideas worth dying for, and scorn for women.

10. We will destroy the museums, libraries, academies of every kind. . . .

11. We will sing of great crowds excited by work, by pleasure, and by riot; we will sing of the multicolored, polyphonic tides of revolution in the modern capitals; we will sing of the vibrant nightly fervor of arsenals and shipyards blazing with violent electric moons; greedy railway stations that devour smoke-plumed serpents; factories hung on clouds by the crooked lines of their smoke; bridges that stride rivers like giant gymnasts, flashing in the sun with a glitter of knives . . . and the sleek flight of planes whose propellers chatter in the wind like banners and seem to cheer like an enthusiastic crowd.

READING CRITICALLY

To many readers, one of the most appalling aspects of Marinetti's manifesto is its worship of war, "the world's only hygiene." Why might that be more a rhetorical strategy than an actual position?

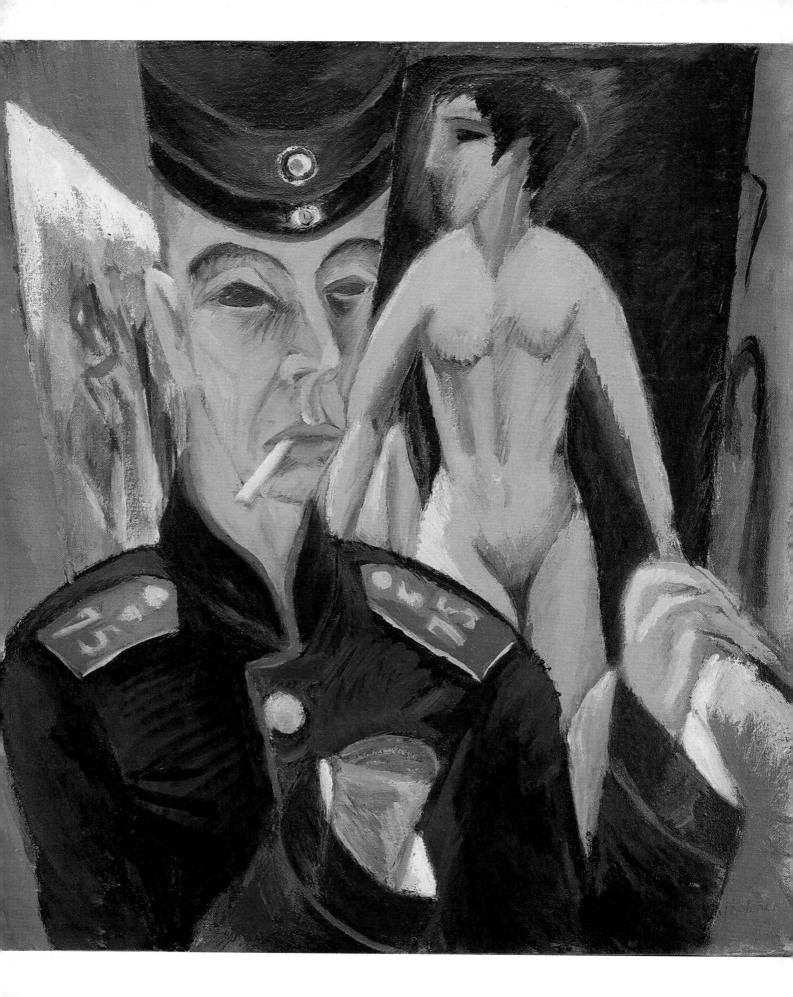

35

The Great War and Its Impact

A Lost Generation and a New Imagination

THINKING AHEAD

What were the effects of trench warfare on the European imagination?

What is Dada?

How did the arts respond to the Russian Revolution?

How does Freudian psychology manifest itself in the Surrealist art movement?

What is the stream-of-consciousness style of writing?

O n June 28, 1914, a young Bosnian nationalist assassinated Archduke Francis Ferdinand, heir to the Austrian throne, in the Bosnian capital of Sarajevo. Europe was outraged, except for Serbia, which had been at war with Bosnia for years. Austria suspected that Serbian officials were involved (as in fact they were). With Germany's support, Austria declared war on Serbia, Russia mobilized in Serbia's defense, and France mobilized to support its ally, Russia. Germany invaded Luxembourg and Belgium, and then pushed into France. Finally, on August 4, Britain declared war on Germany, and Europe was consumed in battle.

Though the Germans advanced perilously close to Paris in the first month of the war, the combined forces of the British and French stopped them. From then on, along the Western Front on the French/Belgian border, both sides dug in behind zigzagging rows of trenches protected by barbed wire that stretched from the English Channel to Switzerland (Map **35.1**), some 25,000 miles of them. In the three years after its establishment, the Western Front moved only a few miles either east or west.

Stagnation accompanied the carnage. Assaults in which thousands of lives were lost would advance the lines only a couple of hundred yards. Poison mustard gas was introduced

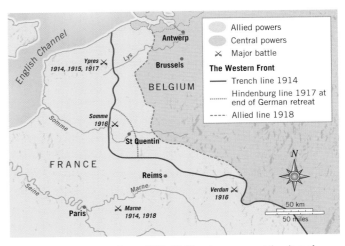

Map 35.1 The Western Front, 1914–18. The stars represent the sites of major battles.

in the hope that it might resolve the stalemate, but it changed nothing, except to permanently maim and kill thousands upon thousands of soldiers. Mustard gas blinded those who encountered it, but it also slowly rotted the body from within and without, causing severe blistering and damaging the

◀ **Fig. 35.1 Ernst Ludwig Kirchner, *Self-Portrait as a Soldier*. 1915.** Oil on canvas, 27 1/4″ × 24″. The Allen Memorial Art Museum, Oberlin College, Oberlin, OH. Charles F. Olney Fund, 1950. 1950.29. This painting contrasts dramatically with his self-confident *Self-Portrait with Model* (Fig. 34.12), painted before the war.

HEAR MORE Listen to an audio file of your chapter at **www.myartslab.com**

bronchial tubes, so that its victims slowly choked to death. Most affected by the gas died within four to five weeks. British troops rotated trench duty. After a week behind the lines, a unit would move up, at night, to the front-line trench, then after a week there, back to a support trench, then after another week back to the reserve trench, and then, finally, back to a week of rest again. Attacks generally came at dawn, so it was at night, under the cover of darkness, that most of the work in the trenches was done—wiring, digging, moving ammunition. It rained often, so the trenches were often filled with water. The troops were plagued by lice, and huge rats, which fed on cadavers and dead horses, roamed through the encampments. The stench was almost as unbearable as the weather, and lingering pockets of gas might blow through at any time. As Germany tried to push both east and west (Map 35.2), the human cost was staggering.

By the war's end, casualties totaled around 10 million dead—it became impossible to count accurately—and somewhere around twice that many wounded. Among the dead and maimed were some of the artists and writers discussed in the last chapter: Auguste Macke, Franz Marc, and Umberto Boccioni died; Braque was severely wounded and Apollinaire suffered a serious head wound in 1916. Ernst Ludwig Kirchner served as a driver in the artillery, and the experience overwhelmed him. In 1915, he was declared unfit for service. While recuperating in eastern Germany, he painted himself in the uniform of the Mansfelder Field Artillery Regiment Nr. 75 (Fig. 35.1), cigarette dangling from his mouth, his eyes flat and empty, his right hand a bloody stump. He was

not literally wounded, but the painting is a metaphorical expression of his fears—his sense of both creative and sexual impotence in the aftermath of war. Three years later, John Singer Sargent painted *Gassed* (Fig. **35.2**) after witnessing soldiers maimed by a mustard gas attack. The nobility and heroism of the Hellenic *Dying Gaul* (see Fig. 5.23) has been replaced by the kind of brutal realism we saw earlier in the foreground of Antoine Jean Gros's celebration of Napoleon's victory in *Napoleon at Eylau* (see Fig. 26.30).

CONTINUITY & CHANGE

Dying Gaul, **p. 162**

This chapter explores the effect of the war on the Western imagination. After 1918, Western art and literature seemed fundamentally different from art before the war. For one thing, the spirit of optimism that marked the era of invention and innovation in the years before 1914 had evaporated. In its place, the art and literature of the period reflect an increasing sense of the absurdity of modern life, the fragmentation of experience, and the futility of even daring to hope. The war created such a sense of alienation that Gertrude Stein would say of those who had gone to war and survived, "You are all a lost generation"—aimless and virtually uncivilized. The term stuck.

Nevertheless, in Russia, the war years brought a sense of possibility, as revolution overturned centuries of imperial domination by the tsars and the Russian nobility. There, experimentation with new means of expression, including film, flourished. And in fact, the spirit of experimentation

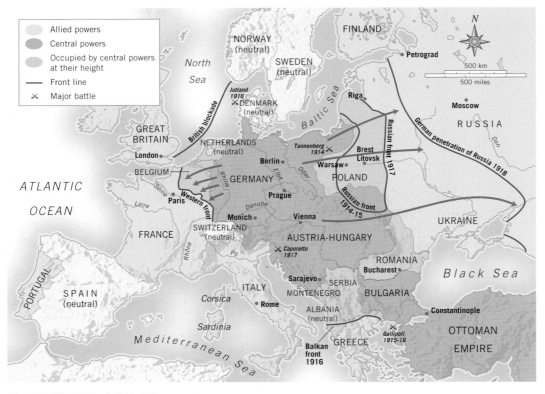

Map 35.2 World War I, 1914–1918.

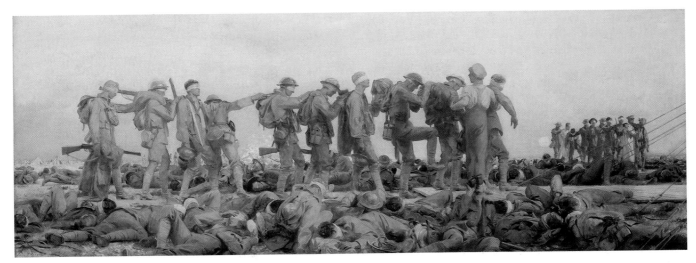

Fig. 35.2 John Singer Sargent (1856–1925), *Gassed,* an Oil Study. 1918–19. Oil on canvas, 7 1/2' × 20'. Private Collection. Imperial War Museum, Negative Number Q1460. In 1918, Sargent (see Fig. 32.20) was commissioned to paint a large canvas commemorating British/American cooperation in the war. He went to France, where he saw this scene of troops blinded by mustard gas being evacuated from the field as others lay waiting to be led away.

that marked the years before the war carried on afterward unabated, but tempered now with a sense of crisis, doubt, and despair. But perhaps it was the war's nightmare aspect that most profoundly affected the arts after 1918. Psychoanalysis and therapy, used to treat shell-shocked troops (what today we call post-traumatic stress syndrome), provided insights into the workings of the human mind, and artists and writers soon explored these insights in their work.

TRENCH WARFARE AND THE LITERARY IMAGINATION

At the outset of the war, writers responded to the conflict with buoyant enthusiasm, along with thousands of others, their patriotic duty calling them to arms. Theirs was, after all, a generation raised on heroic poetry of the likes of Alfred, Lord Tennyson [TEN-ih-sen] (1809–1892), whose "Charge of the Light Brigade" celebrates the suicidal charge of the British cavalry at the Battle of Balaclava (Ukraine) in the Crimean War, fought in the last century (see *Continuity & Change,* Chapter 28) (**Reading 35.1**):

READING 35.1

from Alfred, Lord Tennyson, "Charge of the Light Brigade" (1854)

Cannon to right of them,
Cannon to left of them,
Cannon behind them
Volley'd and thunder'd;
Storm'd at with shot and shell,

While horse & hero fell,
They that had fought so well
Came thro' the jaws of Death,
Back from the mouth of Hell,
All that was left of them,
Left of six hundred.

When can their glory fade?
O the wild charge they made!
All the world wonder'd.
Honour the charge they made!
Honour the Light Brigade,
Noble six hundred!

Life in the trenches soon brought the meaninglessness of such rhetoric crashing down around this new generation of soldiers. Words like *glory* and *honor* suddenly rang hollow. The tradition of viewing warfare as a venue in which heroes exhibit what the Greeks called *areté,* or virtue (see Chapter 4)—that is, an arena in which men might realize their full human potential—no longer seemed applicable to experience, and a new kind of writing about war, an antiwar literature far removed from the heroic battle scenes of poems like Homer's *Iliad,* soon appeared.

The American novelist Ernest Hemingway served as a Red Cross ambulance driver on the Italian Front, and on his first day on duty was required to pick up the remains, mostly those of female workers, who were blown to pieces when the ammunition factory at which they worked was blown up. He was himself later wounded by mortar fragments and machine-gun fire while delivering supplies to the troops. German soldiers like novelist Erich Maria Remarque shared similar stories. The titles alone of the poems that came out of the war speak volumes: "Suicide in Trenches" by Siegfried Sassoon; "Dead Man's Dump" by

Isaac Rosenberg, who was killed on the Western Front in 1918; or "Disabled," a poem about a former athlete, with both legs and one arm gone, by Wilfred Owen.

Wilfred Owen: "The Pity of War"

In fact, the poetry of 25-year-old Wilfred Owen (1893–1918), killed in combat just a week before the armistice was signed in 1918, caused a sensation when it first appeared in 1920. "My subject is War, and the pity of War," he wrote in a manuscript intended to preface his poems, "and the Poetry is in the pity." The poems drew immediate attention for Owen's horrifying descriptions of the war's vic-

CONTINUITY & CHANGE
Ode 13, **p. 211**

tims, as in "Dulce et Decorum Est," its title drawn from Ode 13 of the Roman poet Horace (see Chapter 6), "It is sweet and fitting to die for one's country." But Owen's reference to Horace is bitterly ironic (**Reading 35.2**):

READING 35.2

Wilfred Owen, "Dulce et Decorum Est" (1918)

Bent double, like old beggars under sacks,
Knock-kneed, coughing like hags, we cursed through sludge,
Till on the haunting flares we turned our backs
And towards our distant rest began to trudge.
Men marched asleep. Many had lost their boots
But limped on, blood-shod. All went lame; all blind;
Drunk with fatigue; deaf even to the hoots
Of disappointed shells that dropped behind.

GAS! Gas! Quick, boys!—An ecstasy of fumbling,
Fitting the clumsy helmets just in time;
But someone still was yelling out and stumbling
And floundering like a man in fire or lime.—
Dim, through the misty panes and thick green light
As under a green sea, I saw him drowning.

In all my dreams, before my helpless sight,
He plunges at me, guttering, choking, drowning.

If in some smothering dreams you too could pace
Behind the wagon that we flung him in,
And watch the white eyes writhing in his face,
His hanging face, like a devil's sick of sin;
If you could hear, at every jolt, the blood
Come gargling from the froth-corrupted lungs,
Obscene as cancer, bitter as the cud
Of vile, incurable sores on innocent tongues,—
My friend, you would not tell with such high zest
To children ardent for some desperate glory,
The old Lie: Dulce et decorum est
Pro patria mori.

The quotation from Horace in the last lines is, notably, labeled by Owen a "lie." And the fact is, Owen's intent is that the reader should share his horrific dreams. His rhetorical

strategy is to describe the drowning of this nameless man in a sea of green gas in such vivid terms that we cannot forget it either.

In the Trenches: Remarque's *All Quiet on the Western Front*

The horror of trench warfare is probably nowhere more thoroughly detailed than in *All Quiet on the Western Front*, a novel by Erich Maria Remarque [ruh-MARK], a German soldier who had witnessed it firsthand. Remarque had fought and been wounded by grenade fragments on the front. In the preface to the novel, he writes that his story "is neither an accusation nor a confession, and least of all an adventure, for death is not an adventure to those who stand face to face with it. It will simply try to tell of a generation of men, who, even though they may have escaped its shells, were destroyed by the war." Remarque's narrator, Paul Baumer [BOW-mur], recounts a moment when, in the midst of battle, under bombardment in a cemetery, the British launch poisonous gas in their direction (**Reading 35.3**):

READING 35.3

from Erich Maria Remarque, *All Quiet on the Western Front* (1928)

I reach for my gas-mask. . . . The dull thud of gas-shells mingles with the crashes of the high explosives. A bell sounds between the explosions, gongs, and metal clappers warning everyone—Gas—Gas—Gaas.

Someone plumps down beside me, another. I wipe the goggles of my mask clear of the moist breath. . . . These first minutes with the mask decide between life and death: is it tightly woven? I remember the awful sights in the hospital: the gas patients who in day-long suffocation cough their burnt lungs up in clots.

Cautiously, the mouth applied to the valve, I breathe. The gas creeps over the ground and sinks into all the hollows. Like a big, soft jelly-fish it floats into our shell-hole and lolls there obscenely

Inside the gas-mask my head booms and roars—it is nigh bursting. My lungs are tight. They breathe always the same hot, used-up air, the veins on my temples are swollen, I feel I am suffocating.

A grey light filters through to us. I climb out over the edge of the shell-hole. In the dirty twilight lies a leg torn clean off; the boot is quite whole, I take that all in at a glance. Now someone stands up a few yards distant. I polish the windows, in my excitement they are immediately dimmed again, I peer through them, the man there no longer wears his mask.

I wait some seconds—he has not collapsed—he looks around and makes a few paces—rattling in my throat I tear my mask off too and fall down, the air streams into me like cold water, my eyes are bursting, the wave sweeps over me and extinguishes me.

All Quiet on the Western Front sold more than a million copies in Germany the first year of its publication in 1928, and millions more read the book after it was translated into other languages and distributed outside Germany. In the United States, the film based on the novel won the Academy Award for Best Picture. The Nazi government considered the novel's antimilitarism disloyal and banned it in 1933; five years later, Remarque was stripped of his citizenship.

William Butler Yeats and the Specter of Collapse

The impact of the war unmoored the European poetic imagination from its earlier Symbolist reveries (see Chapter 33). The Symbolists favored *suggesting* the presence of meaning in order to express the inexpressible, and turned away from the physical world to explore the realm of imaginative experience. In his youth, the Irish poet William Butler Yeats [yates] (1865–1939) had longed to escape to an imaginary landscape that he dubbed the Lake Isle of Innisfree (**Reading 35.4**).

READING 35.4

William Butler Yeats, "The Lake Isle of Innisfree" (1893)

I will arise and go now, and go to Innisfree,
And a small cabin build there, of clay and wattles made:
Nine bean-rows will I have there, a hive for the honey-bee,
And live alone in the bee-loud glade.

And I shall have some peace there, for peace comes
 dropping slow,
Dropping from the veils of the morning to where the
 cricket sings;
There midnight's all a glimmer, and noon a purple glow,
And evening full of the linnet's wings.

And I will arise and go now, for always night and day
I hear the lake water lapping with low sounds by the shore;
While I stand on the roadway, or on the pavements gray,
I hear it in the deep heart's core.

Innisfree is the symbolic home of the poet's spirit, the source of his poetic inspiration, and although in the next-to-last line he acknowledges his physical presence in the everyday world, Innisfree remains for Yeats, as the memory of Tintern Abbey remains for Wordsworth a century earlier (see Reading 27.2), an imaginative reality in which he is literally attuned to the music and rhythms of nature.

But now, writing in 1919, Yeats imagines a much darker world. Apocalypse—if not the literal Second Coming of Christ predicted in the Bible's Book of Revelation, then its metaphorical equivalent—seemed at hand (**Reading 35.5**):

READING 35.5

William Butler Yeats, "The Second Coming" (1919)

Turning and turning in the widening gyre
The falcon cannot hear the falconer;
Things fall apart; the centre cannot hold;
Mere anarchy is loosed upon the world,
The blood-dimmed tide is loosed, and everywhere
The ceremony of innocence is drowned;
The best lack all conviction, while the worst
Are full of passionate intensity.

Surely some revelation is at hand;
Surely the Second Coming is at hand.
The Second Coming! Hardly are those words out
When a vast image out of Spiritus Mundi
Troubles my sight; somewhere in sands of the desert
A shape with lion body and the head of a man,
A gaze blank and pitiless as the sun,
Is moving its slow thighs, while all about it
Reel shadows of indignant desert birds.
The darkness drops again; but now I know
That twenty centuries of stony sleep
Were vexed to nightmare by a rocking cradle,
And what rough beast, its hour come round at last,
Slouches towards Bethlehem to be born?

The poem's opening image, of the falcon circling higher and higher in wider and wider circles, is a metaphor for history itself spinning further and further from its origin until it is out of control. In another poem written at about the same time, "A Prayer for My Daughter," Yeats had asked, "How but in custom and ceremony / Are innocence and beauty born?" Now, he despairs, custom and ceremony, those things that connect us to our origins, have been abandoned and "mere anarchy is loosed upon the world." In their place, a beast resembling the Sphinx at Giza (see Fig. 3.7) rises in the desert, possibly an image of the anti-Christ, the embodiment of Satan who in some biblical traditions anticipates the second coming of Christ himself. This beast is the new Spiritus Mundi [SPIR-ih-toos MOON-dee], or collective spirit of mankind, the specter of life in the new postwar era, insentient, pitiless, and nightmarish.

T. S. Eliot: The Landscape of Desolation

The American poet T. S. (Thomas Sternes) Eliot (1888–1965) was studying at Oxford University in England when World War I broke out. Eliot had graduated from Harvard with a degree in philosophy and the classics, and his poetry reflects both the erudition of a scholar and the depression of a classicist who feels that the tradition he so values is in jeopardy of being lost. In Eliot's

poem *The Waste Land*, the opening section, called "The Burial of the Dead," is a direct reference to the Anglican burial service, performed so often during and after the war. "April is the cruelest month," the poem famously begins (**Reading 35.6a**).

READING 35.6a

from T. S. Eliot, *The Waste Land* (1921)

April is the cruelest month, breeding
Lilacs out of the dead land, mixing
Memory and desire, stirring
Dull roots with spring rain.
Winter kept us warm, covering
Earth in forgetful snow, feeding
A little life with dried tubers.

The world, in short, has been turned upside down. Spring is cruel, winter consoling. Eliot sees London as an "Unreal City" populated by the living-dead:

Unreal City,
Under the brown fog of a winter dawn,
A crowd flowed over London Bridge, so many,
I had not thought death had undone so many.
Sighs, short and infrequent, were exhaled,
And each man fixed his eyes before his feet.
Flowed up the hill and down King William Street,
To where Saint Mary Woolnoth kept the hours
With a dead sound on the final stroke of nine.

In the crucial middle section of the poem, Eliot describes modern love as reduced to mechanomorphic tedium (see **Reading 35.6**, page 1169). And in the poem's last section, "What the Thunder Said," the poet describes a landscape of complete emotional and physical aridity, a land where there is "no water but only rock," "sterile thunder without rain," and "red sullen faces sneer and snarl / From doors of mudcracked houses." At first Eliot dreams of the possibility of rain:

If there were rock
And also water
And water
A spring
A pool among the rock
If there were the sound of water only
Not the cicada
And dry grass singing
But sound of water over a rock
Where the hermit-thrush sings in the pine trees
Drip drop drip drop drop drop drop
But there is no water.

Finally, as the poem nears conclusion, there is "a flash of lightning. Then a dry gust / Bringing rain." What this signifies is difficult to say—hope certainly, but hope built on what premise? The poem is richly allusive—the passages excerpted here are among its most accessible—and the answer seems to reside in the weight of poetic and mythic tradition to which it refers, from Shakespeare to the myth of the Holy Grail and Arthurian legend, what Eliot calls at the poem's end, the "fragments I have shored against my ruin." Eliot resolves, apparently, as the critic Edmund Wilson put it, "to claim his tradition and rehabilitate it."

ESCAPE FROM DESPAIR: DADA IN THE CAPITALS

Some writers and artists—Picasso, for instance—simply waited out the war. Many others openly opposed it and vigorously protested the social order that had brought about what seemed to them nothing short of mass genocide, and some of these soon formed the movement that named itself *Dada*. The Romanian poet Tristan Tzara [TSAH-rah] (1896–1963) claimed it was his invention. The German Richard Huelsenbeck [HULL-sen-bek] (1892–1972) claimed that he and poet Hugo Ball (1886–1927) had discovered the name randomly by plunging a knife into a dictionary. Whatever the case, Tzara summed up its meaning best (**Reading 35.7**):

READING 35.7

Tristan Tzara, "Dada Manifesto 1918" (1918)

DADA DOES NOT MEAN ANYTHING . . . We read in the papers that the Negroes of the Kroo race call the tail of a sacred cow: dada. A cube, and a mother, in certain regions of Italy, are called: dada. The word for hobbyhorse, a children's nurse, a double affirmative in Russian and Romanian, is also: DADA.

Dada was an international signifier of negation. It did not mean anything, just as, in the face of war, life itself had come to seem meaningless. In fact, Tzara could be far more strident in the negativity of his claims for the movement. His *Monsieur Antipyrine's Manifesto* is a case in point (**Reading 35.8**):

READING 35.8

Tristan Tzara, "Monsieur Antipyrine's Manifesto" (1916)

dada is life with neither bedroom slippers nor parallels; it is against and for unity and definitely against the future; we are wise enough to know that our brains are going to become flabby cushions, that our antidogmatism is as exclusive as a civil servant, and that we cry liberty but are not free. . . . dada remains within the framework of

European weaknesses, it's still shit, but from now on we want to shit in different colors so as to adorn the zoo of art with all the flags of all the consulates This is Dada's balcony, I assure you. From there you can hear all the military marches, and come down cleaving the air like a seraph landing in a public bath to piss and understand the parable.

Tzara's "parable" is intentionally nonsensical. But its dissatisfaction with modern European life—its outright repugnance for its era—is palpable.

Dada came into being at the Cabaret Voltaire in Zurich, founded in February 1916 by a group of intellectuals and artists escaping the conflict in neutral Switzerland, including Tzara, Huelsenbeck, Ball, Jean Arp (1896–1966), and the poet, dancer, and singer Emmy Hennings (1885–1948). At the end of May, Ball created a "concert bruitiste" [brwee-TEEST] or "noise concert," inspired by the Futurists, for a "Grand Evening of the Voltaire Art Association." Language, Ball believed, was irrevocably debased. After all, the vocabulary of nationalism—the uncritical celebration of one's own national or ethnic identity—had led to the brutality of the War. Ball replaced language with sounds, whose rhythm and volume might convey feelings that would be understood on at least an emotional level. Dressed in an elaborate costume, so stiff that he could not walk and had to be carried onto the stage, he read (**Reading 35.9**):

READING 35.9

from Hugo Ball, "Gadji beri bimba" (1916)

gadji beri bimba
glandridi lauli lonni cadori
gadjama bim beri glassala
glandridi blassala tuffm i zimbrabim
blass galassasatuffm i zimbrabim. . . .

Soon the entire Cabaret Voltaire group was composing such sound poems, which they viewed as a weapon against convention, especially the empty rhetoric of nationalism that had led to the War. Those who believed in the War—notably Apollinaire, in Paris—accused them in turn of nihilism, anarchism, and cowardice.

In March 1917, the group opened the Galerie Dada. Arp's relief wall pieces—they were something between sculpture and painting—were among the most daring works on display (Fig. **35.3**). They were constructed "according to the laws of chance." His procedure was to draw random doodles on paper, allowing his pencil to move without any conscious intervention. He would then send these drawings to a carpenter who would cut them out in wood. The pieces were variously painted, then piled—again quite randomly—one on top of another and secured in place. Arp delighted in giving the resulting relief names, of usually two or more words with no logical connection—*Flower Hammer*, for instance.

Fig. 35.3 Hans Arp, *Fleur Manteau* (*Flower Hammer*). 1916. Painted paper, 24 3/8″ × 19 5/8″. Fondation Arp. Clamart, France. © 2008 Artists Rights Society (ARS), New York. Arp was from the sometimes German, sometimes French region of Alsace, and spoke both French and German, referring to himself sometimes as Jean (French), sometimes as Hans (German).

Such works, in their willful denial of the artist's aesthetic sensibilities, were considered by many used to thinking of art in more serious, high-minded terms as "anti-art." These more serious minds were especially offended by the so-called ready-mades of Marcel Duchamp [doo-SHAHM] (1887–1968). The term itself derived from the recent American invention, ready-made (as opposed to tailor-made) clothes, and Duchamp adopted it soon after arriving in New York in 1915, where he joined a group of other European exiles, including his close colleague Francis Picabia [peh-KAH-bee-ah] (1879–1953), in still-neutral America. He was already notorious for his *Nude Descending a Staircase* (Fig. **35.4**), which had been the focus of critical debate in February 1913 at the International Exhibition of Modern Art at the 69th Infantry Regiment Armory in New York. Known simply as the Armory Show, the exhibit displayed nearly 1,300 pieces, including

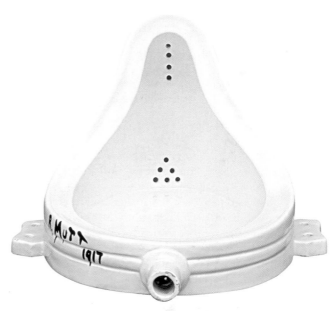

Fig. 35.5 Marcel Duchamp, *Fountain*. 1917; replica 1963. Porcelain, height 14 ″. Purchased with assistance from the Friends of the Tate Gallery 1999. Tate Gallery, London, Great Britain. © 2008 Artists Rights Society (ARS), New York. It is important to recognize that Duchamp has turned the urinal on its back, thus undermining its utility.

Fig. 35.4 Marcel Duchamp, *Nude Descending a Staircase, No. 2*. 1912. Oil on canvas, 58″ × 35″. Philadelphia Museum of Art, Louise and Walter Arenberg Collection. Photo: Graydon Wood, 1994. © 2008 Artists Rights Society (ARS), New York. Interestingly, when Duchamp submitted this painting to the 1912 Salon des Indépendants in Paris, the selection committee objected to its literal title and traditional subject matter.

17 Matisses, 7 Picassos, 15 Cézannes (plus a selection of lithographs), 13 Gauguins (plus, again, a number of lithographs and prints), 18 van Goghs, 4 Manets, 5 Monets, 5 Renoirs, 2 Seurats, a Delacroix, and a Courbet. It was the first time that most Americans were able to view French modernist painting. One newspaper writer called Duchamp's *Nude* "an explosion in a shingle factory." The *American Art News* called it "a collection of saddlebags" and offered a $10 reward to anyone who could locate the nude lady it professed to portray. President Theodore Roosevelt compared it to the Navajo rug in his bathroom. Considering the European artists shown at the exhibition as a whole, he concluded that they represented the "lunatic fringe." But if Duchamp's nude seemed inexplicable to Americans in 1913, today we can easily identify several influences that shaped the work. Duchamp was familiar with Picasso and Braque's Cubist reduction of the object into flat planes (see Figs. 34.7 and 34.8). He also knew of the Futurists' ideas about depicting motion, and, perhaps more important, he was familiar with new developments in photography that captured moving figures on film, especially Étienne-Jules Marey's book *Movement* (see Chapter 34).

Thus, when Duchamp introduced his ready-mades, the New York art world was prepared to be shocked. And *Fountain* (Fig. **35.5**) shocked them indeed. A urinal purchased by Duchamp in a New York plumbing shop, laid on its back and signed with the pseudonym "R. Mutt," it was submitted by Duchamp to the New York Society of Independent Artists exhibition in April 1917. The exhibition committee, on which Duchamp served, had agreed that all work submitted would be shown, and was therefore unable

SEE **MORE** For a Closer Look at Marcel Duchamp's *Nude Descending the Staircase, No. 2*, go to **www.myartslab.com**

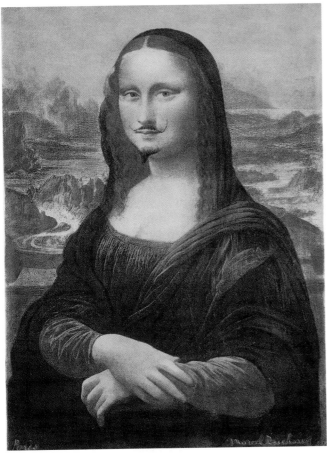

Fig. 35.6 Marcel Duchamp, _Mona Lisa_ (_L.H.O.O.Q._). 1919. Rectified Readymade (reproduction of Leonardo da Vinci's _Mona Lisa_ altered with pencil), 7 3/4″ × 4 1/8″. The Louis and Walter Arensberg Collection. Lynn Rosenthal, 1988/ Philadelphia Museum of Art. © 2007 Artists Rights Society (ARS), New York. The fact that this image is a postcard underscores Duchamp's sense that painting was little more than just another commodity to be bought and sold at will.

to reject the piece. To Duchamp's considerable amusement, they decided instead to hide it behind a curtain. Over the course of the exhibition, Duchamp gradually let it be known that he was "R. Mutt," and in a publication called _The Blind Man_ defended the piece:

> Whether Mr Mutt with his own hands made the fountain or not has no importance. He CHOSE it. He took an ordinary article of life, placed it so that its useful significance disappeared under the new title and point of view—created a new thought for the object.

By the end of the war, it was clear to most observers that Duchamp had given up painting altogether—to play chess, he claimed. He nevertheless continued on throughout his career with a number of projects, ranging from film to installation. But his disregard for painting, which seemed to him the embodiment of bourgeois taste, is particularly manifest in his "rectified-readymade," _L.H.O.O.Q._ (Fig. **35.6**), a poster of Leonardo da Vinci's _Mona Lisa_ to which he has added a mustache and goatee.

The title is a pun—pronounced in French, the letters sound like "_Elle a chaud au cul_," (She's hot in the ass"). The pun was, in fact, one of his favorite things. It was the very embodiment of the simultaneity of opposites. Like Bohr's theory of complementarity (see Chapter 34), the pun meant to refer to mutually exclusive and contradictory things simultaneously.

Duchamp's antiestablishment sensibilities were reflected across the Dada scene. Even before the end of the war in November 1918, Huelsenbeck had attacked Expressionist painting, objecting to its subjective soul-searching. He called, instead, for "artists who every hour snatch the tatters of their bodies out of the frenzied cataract of life." Artists, he believed, could literally "snatch the tatters" of German life out of the everyday press, and they did, by snipping photographs from newspapers and recombining them as collages. His new _Club Dada_ began publishing work that exploited the possibilities offered by this new technique, known as **photomontage.** In _The Art Critic_ (Fig. **35.7**), Hausmann has placed a disproportionately large head, blinded in both eyes, on a brown-suited bourgeois body identified as that of his friend and Dada colleague George Grosz. The figure carries a large Venus pencil projecting phalluslike in front of him and stands before a section of a pink sound poem-poster created by Hausmann to be pasted on the walls of Berlin. Behind him is a German banknote, suggesting that his opinions are for sale. On his forehead a shoe steps on a German postage

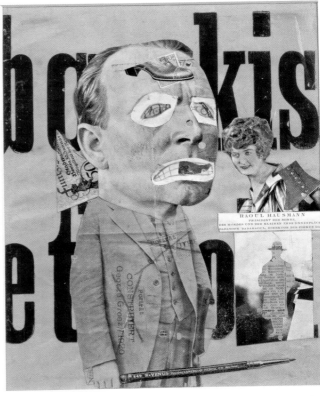

Fig. 35.7 Raoul Hausmann, _The Art Critic_. 1919–20. Photomontage, 12 1/2″ × 10″. Tate Museum, London. T01918. Hausmann's business card is pasted below the woman. It identifies him as a "Dadasoph," as opposed to a "philosophe."

stamp. For all its rejection of the contemporary art world, the work's humor also reflects the survival of a positive energy in the face of devastation and despair. Like all of Dada, it offers up an arena in which the creative impulse might not only survive, but thrive.

RUSSIA: ART AND REVOLUTION

In 1914, Russia entered the war ill-prepared for the task before it; within the year, Tsar Nicholas II (1868–1918) oversaw the devastation of his army. One million men had been killed, and another million soldiers had deserted. Famine and fuel shortages gripped the nation. Strikes broke out in the cities, and in the countryside, peasants seized the land of the Russian aristocrats. The tsar was forced to abdicate in February 1917.

Vladimir Lenin and the Soviet State

Through a series of astute, and sometimes violent, political maneuvers, the Marxist revolutionary Vladimir Ilyich Lenin (1870–1924) assumed power the following November. Lenin headed the most radical of Russian postrevolutionary groups, the Bolsheviks. Like Marx, he dreamed of a "dictatorship of the proletariat," a dictatorship of the working class. Marx and Lenin believed that the oppression of the masses of working people resulted from capitalism's efforts to monopolize the raw materials and markets of the world for the benefit of the privileged few. He believed that all property should be held in common, that every member of society would work for the benefit of the whole and would receive, from the state, goods and products commensurate with their work. "He who does not work," he famously declared, "does not eat."

Lenin was a utopian idealist. He foresaw, as his socialist state developed, the gradual disappearance of the state: "The state," he wrote in *The State and Revolution* (1917), "will be able to wither away completely when society has realized the rule: 'From each according to his ability: to each according to his needs,' *i.e.*, when people have become accustomed to observe the fundamental rules of social life, and their labor is so productive that they voluntarily work *according to their ability.*" But he realized that certain pragmatic changes had to occur as well. He emphasized the need to electrify the nation: "We must show the peasants," he wrote, "that the organization of industry on the basis of modern, advanced technology, on electrification . . . will make it possible to raise the level of culture in the countryside and to overcome, even in the most remote corners of land, backwardness, ignorance, poverty, disease, and barbarism." And he was, furthermore, a political pragmatist. When, in 1918, his Bolshevik party received less than a quarter of 1 percent of the vote in free elections, he dissolved the government, eliminated all other parties, and put the Communist party into the hands of five men, a committee called the Politburo, with himself at its head. He also systematically eliminated his opposition: Between 1918 and 1922, his secret police arrested and executed as many as 280,000 people in what has come to be known as the Red Terror.

The Arts of the Revolution

Before the Revolution in March 1917, avant-garde Russian artists, in direct communication with the art capitals of Europe, particularly Paris, Amsterdam, and Berlin, established their own brand of modern art. Most visited Paris, and saw Picasso and Braque's Cubism in person, but Kasimir Malevich [muh-LAY-vich] (1878–1935), perhaps the most inventive of them all, never did. By 1912, he had created Cubo-Futurism, a style that applied modernist geometric forms to Russian folk themes. But Malevich was soon engaged, he wrote, in a "desperate attempt to free art from the ballast of objectivity." To this end, he says, "I took refuge in the square," creating a completely nonobjective painting, in 1913, consisting of nothing more than a black square on a white ground. He called his new art Suprematism, defining it as "the supremacy of . . . feeling in . . . art."

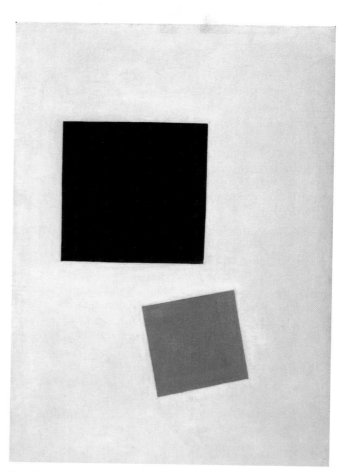

Fig. 35.8 Kasimir Malevich, *Painterly Realism: Boy with Knapsack - Color Masses in the Fourth Dimension.* **1915.** Oil on canvas, 28″ × 17 ½″. Museum of Modern Art, New York. 1935 Acquisition confirmed in 1999 by agreement with the Estate of Kasimir Malevich and made possible with funds from the Mrs. John Hay Whitney Bequest (by exchange). 816.1935. Malevich always insisted that he painted not in three, but in four dimensions—that time, in other words, played a role in creating a work. Later, he claimed to work in five dimensions, the fifth being "economy," or minimal means.

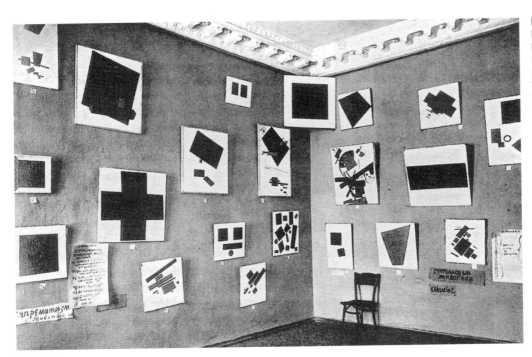

From Suprematism to Constructivism The "feeling" of which Malevich speaks is not the kind of personal or private emotion that we associate with, say, German Expressionism. Rather, it lies in what he believed was the revelation of an absolute truth—a utopian ideal not far removed from Lenin's political idealism—discovered through the most minimal means. Thus, his *Painterly Realism: Boy with Knapsack - Color Masses in the Fourth Dimension* (Fig. **35.8**) is not really a representation of a boy with a knapsack, nor is it an example of realism. The title is deeply ironic, probably intended to jolt any viewer expecting to see work like that of the Travelers (see Fig. 31.17). The painting is, rather, about the two forms—a black square and a smaller red one—that appear to float above a white ground, even, it seems, at different heights. The painting was first exhibited in December 1915 at an exhibition in Petrograd entitled "0,10: The Last Futurist Exhibition of Painting," where it can be seen in the photographic documentation of the event just above and to the left of the chair (Fig. **35.9**). The exhibition's name refers to the idea that each of the ten artists participating in the show were seeking to articulate the "zero degree"—that is, the irreducible core—of painting. What, in other words, most minimally makes a painting? In this particular piece, Malevich reveals that in relation, these apparently static forms—two squares set on a rectangle—are energized in a dynamic tension.

Malevich's installation of his works at the "0,10" exhibition is notable as well for the fact that what is probably the most "zero degree" of all his works, *Black Square*, is placed high in the corner of the room in the place usually reserved in traditional Russian houses for religious icons. The work is, in part, parodic, replacing images designed to invoke deep religious feeling with what Malevich referred to as a "void,"

a space empty of meaning or feeling. But, at the same time, and paradoxically, Malevich felt that it contained all feeling. As he wrote in his treatise, *The Non-Objective World* (**Reading 35.10**):

READING 35.10

from Kasimir Malevich *The Non-Objective World* (1921)

When, in the year 1913, in my desperate attempt to free art from the ballast of objectivity, I took refuge in the square form and exhibited a picture which consisted of nothing more than a black square on a white field, the critics and, along with them, the public sighed, "Everything which we loved is lost. We are in a desert Before us is nothing but a black square on a white background!" . . . But a blissful sense of liberating nonobjectivity drew me forth into the "desert," where nothing is real except feeling . . . and so feeling became the substance of my life. This was no "empty square" which I had exhibited but rather the feeling of nonobjectivity. . . .The black square on the white field was the first form in which nonobjective feeling came to be expressed. The square = feeling, the white field = the void beyond this feeling. Yet the general public saw in the nonobjectivity of the representation the demise of art and failed to grasp the evident fact that feeling had here assumed external form. The Suprematist square and the forms proceeding out of it can be likened to the primitive marks (symbols) of aboriginal man which represented, in their combination, not ornament, but a feeling of rhythm. Suprematism did not bring into being a new world of feeling but, rather, an altogether new and direct form of representation of the world of feeling.

At the end of the Russian Revolution in 1917, Malevich and other artists in his circle were appointed by the Soviet government to important administrative and teaching positions in the country. Malevich went to the Vitebsk [vih-TEPSK] Popular Art School in 1919, soon becoming its director. In 1921, he wrote to one of his pupils that Suprematism should adopt a more "Constructive" approach to reorganizing the world. By this he meant that art should turn to small-scale abstract works in three dimensions. He considered this "laboratory" work, explorations of the elements of form and color, space and construction, that would eventually serve some practical social purpose in the service of the revolution.

Malevich's thinking was inspired in part by Lazar Lissitzsky [lih-SIT-skee] (1890–1941), known as El Lissitzsky, a teacher of architecture and graphics at Vitebsk Popular Art School when Malevich arrived. For his part, El Lissitzsky quickly adopted Malevich's Suprematist designs to revolutionary ends. His poster *Beat the Whites with the Red Wedge* (Fig. 35.10) refers to the conflict between the Bolshevik "Reds" and the "White" Russians who opposed Lenin's party. As in Malevich's *Suprematist Painting*, a triangle crosses over into another form, this time a circle. The wedge is symbolically male, forceful and aggressive as opposed to the passive (and womblike) white circle, which it penetrates both literally and figuratively from the "left." Here design is in the service of social change.

The New Russian Cinema One of the greatest of Russia's revolutionary innovators was the filmmaker Sergei Eisenstein [EYE-zen-shtine] (1898–1948). After the Revolution, he had worked on the Russian agit-trains, special propaganda trains that traveled the Russian countryside bringing "agitational" materials to the peasants. ("Agitational," in this sense, means to present a political point of view.) The agit-trains distributed magazines and pamphlets, presented political speakers and plays, and, given the fact that the Russian peasantry was largely illiterate, perhaps most important of all presented films, known as *agitkas*. These films were characterized by their fast-paced editing style, designed to keep the attention of an audience that, at least at first, had never before seen a motion picture.

Out of his experience making *agitkas*, Lev Kuleshov (1899–1970), one of the founders of the Film School in Moscow in the early twenties, developed a theory of **montage**. He used a close-up of a famous Russian actor and combined it with three different images—a bowl of soup, a dead woman lying in a coffin, and a girl playing with a teddy bear. Although the image of the actor was the same in each instance, audiences believed that he was hungry with the soup, sorrowful with the woman, joyful toward the girl—a phenomenon that came to be known as the *Kuleshov effect*. Shots, Kuleshov reasoned, acquire meaning through their relation to other shots. Montage was the art of building a cinematic composition out of such shots.

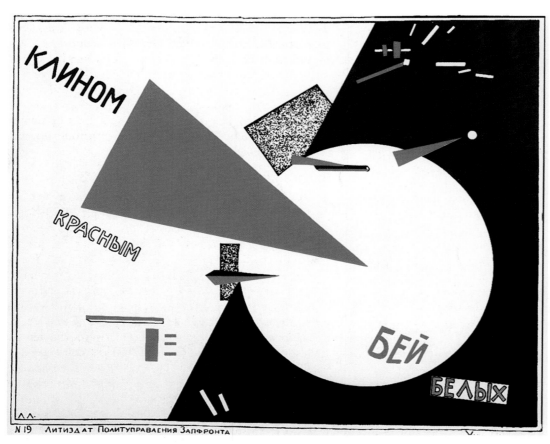

Fig. 35.10 El Lissitzsky, *Beat the Whites with the Red Wedge.* 1919. Lithograph. Collection: Stedelijk Van Abbemuseum, Eindhoven, Holland. © 2007 Artists Rights Society (ARS), New York/VG Bild-Kunst, Bonn. The diagonal design of the composition gives the red wedge a clear "upper hand" in the conflict.

Eisenstein learned much from Kuleshov, though he disagreed about the nature of montage. Rather than using montage to build a unified composition, Eisenstein believed that montage should be used to create tension, even a sense of shock, in the audience, which he believed would lead to a heightened sense of perception and a greater understanding of the film's action. His aim, in a planned series of seven films depicting events leading up to the Bolshevik revolution, was to provoke his audience into psychological identification with the aims of the revolution.

None of his films accomplishes this better than *The Battleship Potemkin* [puh-TEM-kin], the story of a 1905 mutiny aboard a Russian naval vessel and the subsequent massacre of innocent men, women, and children on the steps above Odessa harbor by tsarist troops. The film, especially the famous "Odessa Steps Sequence," which is a virtual manifesto of montage, tore at the hearts of audiences and won respect for the Soviet regime around the world (see *Closer Look*, pages 1156–1157).

FREUD, JUNG, AND THE ART OF THE UNCONSCIOUS

Eisenstein's emphasis on the viewer's psychological identification with his film was inspired in no small part by the theories of Viennese neurologist Sigmund Freud. By the start of World War I, Freud's theories about the nature of the human psyche and its subconscious functions (see *Continuity & Change*, page 1109) were gaining wide acceptance. As doctors and others began to deal with the sometimes severely traumatized survivors of the war, the efficacy of Freud's psychoanalytic techniques—especially dream analysis and "free association"—were increasingly accepted by the medical community.

Freud had opened a medical practice in Vienna in 1886, specializing in emotional disorders. Just a year earlier, he had gone to Paris to study with neurologist Jean-Martin Charcot, and in his new practice, Freud began using Charcot's techniques—the use of hypnosis, massage, and cranial pressure to help patients recognize mental conditions related to their symptoms. This would later develop into a practice he called free association, in which patients were asked to say whatever crossed their minds. In 1895, in collaboration with another Viennese physician, Josef Breuer, he published *Studies in Hysteria*. But even then he was changing his techniques. Free association allowed him to abandon hypnosis. Freud had observed that when patients spoke spontaneously about themselves, they tended to relate their particular neurotic symptoms to earlier, usually childhood, experiences.

But Freud understood that free association required interpretation, and increasingly, he began to focus on the obscure language of the unconscious. By 1897, he had formulated a theory of infantile sexuality based on the proposition that sexual drives and energy already exist in infants. Childhood was no longer "innocent." One of the

keys to understanding the imprint of early sexual feeling upon adult neurotic behavior was the interpretation of dreams. Freud was convinced that their apparently irrational content could be explained rationally and scientifically. He concluded that dreams allow unconscious wishes, desires, and drives censored by the conscious mind to exercise themselves. "The dream," he wrote in his 1900 *The Interpretation of Dreams*, "is the (disguised) fulfillment of a (suppressed, repressed) wish." And the wish, by extension, is generally based in the sexual.

Freud theorized, as a result, that most neurotic behavior was the result of sexual trauma stemming from the subconscious attachment of the child to his or her parent of the opposite sex and the child's jealousy of the parent of the same sex. (Freud called this the Oedipus [ED-ih-pus] complex, after the Greek legend in which Oedipus, king of Thebes, unwittingly kills his father and marries his mother. In girls, the complex is called the Electra complex.) Since, as he argued, human behavior was governed by the libido, or sex drive, the guilt that resulted from the repression of the trauma associated with the child's sexual feelings and jealousy leads to powerful inner tensions that manifest themselves as psychic disorders.

During the war itself, Freud continued work at the University of Vienna, speaking in 1916 on the psychological roots of sadism, homosexuality, fetishism, and voyeurism in a lecture called "The Sexual Life of Human Beings." These subjects were still largely taboo, as Freud acknowledged at the lecture's outset: "First and foremost," he began, "what is sexual is something improper, something one ought not to talk about." He then proceeded to shock his audience by talking in detail about sexual behaviors that he knew his audience found to be, in his words, "crazy, eccentric and horrible." Though his conclusions are disputable—predating later research linking homosexuality to biological rather than psychological causes, for example—Freud opened the subject of human sexuality to public discussion, altering attitudes toward sexuality permanently and irrevocably.

Freud's *Civilization and Its Discontents*

But World War I provided Freud with evidence of another, perhaps even more troubling source of human psychological dysfunction—society itself. In 1920, in *Beyond the Pleasure Principle*, he speculated that human beings had death drives (Thanatos) that were in conflict with sex drives (Eros). Their opposition, he believed, helped to explain the fundamental forces that shape both individuals and societies; their conflict might also explain self-destructive and outwardly aggressive behavior. To this picture he added, in the 1923 work, *The Ego and the Id*, a model for the human mind that would have a lasting impact on all subsequent psychological writings, at least in their terminology. According to Freud, human personality is organized by the competing drives of the id, the ego, and the superego. The **id** is the seat of all instinctive, physical desire—from the need for nourishment to sexual gratification. Its goal is

The most famous sequence in *The Battleship Potemkin* is the massacre on the Odessa Steps. Odessa's citizens have responded to the mutiny on the Potemkin by providing the sailors with food and good company. Without warning, tsarist soldiers carrying rifles appear at the top of the flight of marble steps leading to the harbor. They fire on the crowd, many of whom fall on the steps. Eisenstein's cuts become more and more frenetic in the chaos that ensues.

Eisenstein utilized 155 separate shots in 4 minutes and 20 seconds of film in the sequence, an astonishing rate of 1.6 seconds per shot. He contrasts long shots of the entire scene and close-ups of individual faces, switches back and forth between shots from below and from above (essentially the citizens' view up the steps and the soldiers' looking down), and he changes the pace from frenzied retreat at the start of the sequence to an almost frozen lack of action when the mother approaches the troops carrying her murdered son, to frantic movement again as the baby carriage rolls down the steps. Some shots last longer than others. He alternates between traveling shots and fixed shots.

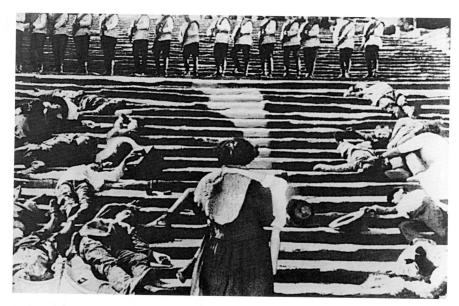

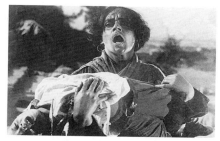

From the "Odessa Steps Sequence," of Sergei Eisenstein's *The Battleship Potemkin*. 1925. Goskino. Courtesy of the Kobal Collection. A mother picks up her murdered child and confronts the troops marching down the steps. At the point where she stands, soldiers in front of her, she is framed by the diagonal lines of the steps and the bodies strewn on each side of her. The soldiers continue to advance.

Eisenstein also understood that sound and image could be treated independently in montage, or used together in support of one another. A phrase of music might heighten the emotional impact of a key shot. Or the rhythm of the music might heighten the tension of a sequence by juxtaposing itself to a different rhythm in his montage of shots, as when the soldiers' feet march to an altogether different rhythm in the editing. Eisenstein called this *rhythmic montage*, as he explains:

> In this the rhythmic drum of the soldiers' feet as they descend the steps violates all metrical demands. Unsynchronized with the beat of the cutting, this drumming comes in off-beat each time, and the shot itself is entirely different in its solution with each of

these appearances. The final pull of tension is supplied by the transfer from the rhythm of the descending feet to another rhythm—a new kind of downward movement—the next intensity level of the same activity—the baby-carriage rolling down the steps.

This attention to the rhythm of his film allows Eisenstein to abandon strict temporality. At the start of the baby carriage scene, for instance, the rhythm of the music slows dramatically and the pace of "real time" is elongated in a series of slow shots. The mother clutches herself. The carriage teeters on the brink. The mother swoons. The carriage inches forward. The mother falls, in agony. This is, as has often been said, "reel time," not "real time."

From the "Odessa Steps Sequence," of Sergei Eisenstein's *The Battleship Potemkin*. 1925.
Goskino. Courtesy of the Kobal Collection. The falling body of another mother, shot by the soldiers, falls across her baby's carriage, causing it to roll out of control down the steps. Note the way the diagonals on the steps in the last image at the right echo those of the mother looking up the steps holding her dead child in the earlier scene.

There was, in fact, no tsarist massacre on the Odessa Steps, though innocent civilians were killed elsewhere in the city. Eisenstein's cinematic re-creation is a metaphor for those murders, a cinematic condensation of events that captures the spirit of events so convincingly that many viewers took it to be actual newsreel footage.

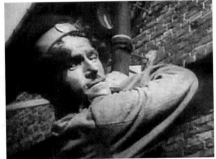

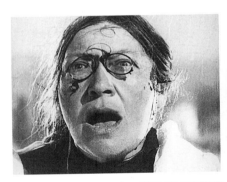

From the "Odessa Steps Sequence," of Sergei Eisenstein's *The Battleship Potemkin*. 1925.
Goskino. Courtesy of the Kobal Collection.
At the end of the sequence, an old woman wearing pince-nez glasses who has looked on horrified as the baby stroller careens down the stairs is attacked and slashed by a saber-bearing Cossack.

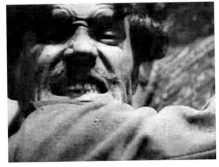 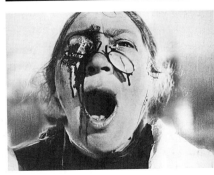

Something to Think About . . .

How would you compare Eisenstein's montage to Picasso's collage?

SEE MORE For a Closer Look at Sergei Eisenstein's *The Battleship Potemkin,* go to **www.myartslab.com**

immediate gratification, and acts in accord with the pleasure principle. The **ego** manages the id. It mediates between the id's potentially destructive impulses and the requirements of social life, seeking to satisfy the needs of the id in socially acceptable ways. Freud used the word *sublimation* to describe the redirection of the id's primal impulses into constructive social behavior. So, for example, an artist or a writer might express unacceptable impulses in work or art rather than acting them out.

For Freud, civilization itself is the product of the ego's endless effort to control and modify the id. But Freud's recognition of yet a third element in the psyche—the **superego**—is crucial. The superego is the seat of what we commonly call conscience, the psyche's moral base. The conscience comes from the psyche's consideration of criticism or disapproval leveled at it by the family, where family can be understood broadly as parents, clan, and culture. The superego is always close to the id and can act as its representative to the ego. But, since it does not distinguish between thinking a deed and doing it, it can also instill in the id enormous subconscious guilt.

Freud's thinking culminated in 1930 in *Civilization and Its Discontents* (see **Reading 35.11**, page 1170). In that book, Freud wrote that the greatest impediment to human happiness was aggression, what he called the "original, self-subsisting instinctual disposition in man." Aggression was the basic instinctual drive that civilization was organized to control, and yet, on every count, civilization had failed miserably at its job. "The fateful question for the human species," Freud argued, in terms that would ring truer and truer as the twentieth century wore on,

> seems to me to be whether and to what extent their cultural development will succeed in mastering the disturbance in their communal life by the human instinct of aggression and self-destruction. It may be that in this respect precisely the present time deserves a special interest. Men have gained control over the forces of nature to such an extent that with their help they would have no difficulty in exterminating one another to the last man.

The Jungian Archetype

Almost as influential as Freud was his colleague, the Swiss physician Carl Jung [yung] (1875–1961). Jung believed that the unconscious life of the individual was founded on a deeper, more universal layer of the psyche, which he called the **collective unconscious**, the innate, inherited contents of the human mind. It manifests itself in the form of **archetypes** [AR-kuh-types], those patterns of thought that recur throughout history and across cultures, in the form of dreams, myths, and fairy tales. The "mother archetype," for instance, recurs throughout ancient myth in symbols associated with fertility, such as the garden, the lotus, the fountain, the

cave, and so on. It manifests itself positively in Christianity as the Virgin Mary, and negatively as the witch in fairy tales and legends. Other archetypes include the father figure, the hero (who is essentially the ego), the child (often the child-hero), the maiden, the wise old man, the trickster, and so on. Such archetypal figures are prominent in popular culture—consider Darth Vader, Luke Skywalker, Princess Leia, and Obi-Wan Kenobi in George Lucas's *Star Wars*.

The Dreamwork of Surrealism

In his 1924 *Surrealist Manifesto*, the French writer, poet, and theorist André Breton [bruh-TOHN] (1896–1966) credited Freud with encouraging his own creative endeavors: "It would appear that it is by sheer chance that an aspect of intellectual life—and by far the most important in my opinion—about which no one was supposed to be concerned any longer has, recently, been brought back to light. Credit for this must go to Freud. On the evidence of his discoveries a current of opinion is at last developing which will enable the explorer of the human mind to extend his investigations, since he will be empowered to deal with more than merely summary realities." Breton continued (**Reading 35.12**):

READING 35.12

from André Breton, *Surrealist Manifesto* (1924)

It was only fitting that Freud should appear with his critique on the dream. In fact, it is incredible that this important part of psychic activity has still attracted so little attention. . . . I have always been astounded by the extreme disproportion in the importance and seriousness assigned to events of the waking moments and to those of sleep by the ordinary observer. Man, when he ceases to sleep, is above all at the mercy of his memory, and the memory normally delights in feebly retracing the circumstance of the dream for him, depriving it of all actual consequence and obliterating the only determinant from the point at which he thinks he abandoned this constant hope, this anxiety, a few hours earlier. He has the illusion of continuing something worthwhile. The dream finds itself relegated to a parenthesis, like the night. And in general it gives no more counsel than the night.

In order to restore the dream to its proper authority, Breton adopted the term *surrealism*, previously used by the poet Guillaume Apollinaire, and defined it as follows:

> SURREALISM, noun, masc., Pure psychic automatism by which it is intended to express, either verbally or in writing, the true function of thought. Thought dictated in the absence of all control exerted by reason, and outside all aesthetic or moral preoccupations.

ENCYCL. Philos. Surrealism is based on the belief in the superior reality of certain forms of association heretofore neglected, in the omnipotence of the dream, and in the disinterested play of thought. It leads to the permanent destruction of all other psychic mechanisms and to its substitution for them in the solution of the principal problems of life.

Breton had trained as a doctor and had used Freud's technique of free association when treating shell-shock victims in World War I. As his definition indicates, he had initially conceived of Surrealism as a literary movement, with Breton himself at its center. All of the Surrealists had been active Dadaists, but as opposed to Dada's "anti-art" spirit, their new "surrealist" movement believed in the possibility of a "new art." Nevertheless, the Surrealists retained much of Dada's spirit of revolt. They were committed to verbal *automatism*, a kind of writing in which the author relinquishes conscious control of the production of the text. In addition, the authors wrote dream accounts, and Breton's colleague Louis Aragon [ah-rah-GOHN] (1897–1982), especially, emphasized the importance of chance operations: "There are relations other than reality that the mind may grasp and that come first, such as chance, illusion, the fantastic, the dream," Aragon wrote. "These various species are reunited and reconciled in a genus, which is surreality."

They found precedent for their point of view not only in Freud, but in the painting of Giorgio de Chirico and the Dadaist Max Ernst (1891–1976). When Breton saw *The Child's Brain* (see Fig. 33.22) in the window of Paul Guillaume's [ghee-YOHMZ] gallery in March 1922, he jumped off a bus in order to look at it. He bought the canvas and immediately published a reproduction in his magazine *Littérature*. Breton would later look back at Ernst's 1921 exhibition of small collage-paintings like the aptly titled *The Master's Bedroom* (Fig. 35.11) as the first Surrealist work in the visual arts. This painting consists of two pages from a small pamphlet of clip art, on the left depicting assorted animals and on the right various pieces of furniture. Ernst painted over most of the spread to create his perspectival view, leaving unpainted the whale, fish, and snake at the bottom left, the bear and sheep at the top, and the bed, table, and bureau at the right. This juxtaposition of diverse elements, which would normally never occupy the same space—except perhaps in the dream work—is one of the fundamental stylistic devices of Surrealist art.

Fig. 35.11 Max Ernst, *The Master's Bedroom, It's Worth Spending a Night There* (Letter from Katherine S. Dreyer to Max Ernst, May 25, 1920). Collage, gouache, and pencil on paper, 6 3/8″ × 8 5/8″. Yale Collection of American Literature, Beinecke Rare Book and Manuscript Library. Translation from German by John W. Gabriel. From "Max Ernst, Life and Work" by Werner Spies, published by Thames & Hudson, page 67. © 2008 Artists Rights Society (ARS), New York. Prior to World War I, Ernst studied philosophy and abnormal psychology at the University of Bonn. He was well acquainted with the writings of Freud.

Fig. 35.12 Joan Miró, *The Birth of the World*. 1925. Oil on canvas, 8′ 2 ¾″ × 6′ 6 ¾″. Museum of Modern Art, New York. Acquired through an Anonymous Fund, the Mr. and Mrs. Joseph Slifka and Armand G. Erpf Funds, and by gift of the Artist. (262.1972). Digital Image © The Museum of Modern Art/Licensed by SCALA/Art Resource, New York. © Artists Rights Society (ARS), New York. André Breton would come to call this painting "the *Demoiselles d'Avignon* of the '*informel*'"—in other words, the founding painting of the European free gesture painting in the 1950s, l'art informel.

Picasso and Miró Breton argued that Picasso led the way to Surrealist art in his *Les Demoiselles d'Avignon* (see Fig. 34.3), which jettisoned art's dependence on external reality. The great founder of Cubism, Breton said, possessed "the facility to give materiality to what had hitherto remained in the domain of pure fantasy." Picasso was attracted to the Surrealist point of view because it offered him new directions and possibilities, particularly in the example of his fellow Spanish artist, Joan Miró [mee-ROH] (1893–1983), whose work Breton was avidly collecting. Miró's first Paris exhibition was mounted expressly as a Surrealist show, highlighted by a private midnight opening for all the Surrealist crowd. It was followed quickly by an astonishing array of paintings, including *The Birth of the World* (Fig. **35.12**). "Rather than setting out to paint something," Miró explained, "I begin painting and as I paint, the picture begins to assert itself. . . . The first stage is free, unconscious." But, he added, "The second stage is carefully calculated." He equated the first stage with Breton's "psychic automatism." Like the universe itself, the painting began with the "void"—the blank canvas. This was followed by "chaos," randomly distributed stains and dots. Then, Miró explained, "One large portion of black in the upper left seemed to need to become bigger. I enlarged it and went over it with opaque black paint. It became a triangle to which I added a tail. It might be a bird." He later identified the red circle with the yellow tail as a shooting star, and, at the bottom left, a "personage," with a white head whose foot almost touches a spiderlike black star.

Picasso's Surrealism would assert itself most fully in the late 1920s and early 1930s, especially in a series of monstrous bonelike figures that alternated with sensuous portraits of his mistress Marie-Thérèse Walter (1909–1977), whom he had met when she was only 17 in January 1927. For eight years, until 1935, he led a double life, married to Olga Koklova [koh-KLOH-vah] (1891–1955) while conducting a secret affair with Marie-Thérèse. Since Marie-Thérèse is so readily

identifiable in her portraits, it is tempting to see the more monstrous figures as portraits of Olga.

Picasso was indeed obsessed in these years with the duality of experience, the same opposition between Thanatos (the death drive) and Eros (the sex drive) that Freud had outlined in *Beyond the Pleasure Principle*. His 1932 double portrait of Marie-Thérèse, *Girl before a Mirror* (Fig. **35.13**), expresses this—she is the moon, or night, at the right, and the sun, or light, on the left, where her own face appears in both profile and three-quarter view. Her protruding belly on the left suggests her fertility (indeed, she gave birth to their child, Maya, in 1935, soon after Picasso finally separated from Olga), though in the mirror, in typical Picasso fashion, we see not her stomach but her buttocks, her raw sexuality. She is the conscious self on the left, her subconscious self revealing itself in the mirror. Picasso's

work addresses Surrealism's most basic theme—the self in all its complexity. And he adds one important theme—the self in relation to the Other, for Picasso is present himself in the picture, not just as its painter, but in his symbol, the harlequin design of the wallpaper. But the painting also suggests that the self, in the dynamic interplay between the conscious and unconscious selves, might actually be the Other to itself.

Salvador Dalí's *Lugubrious Game* This sense of self-alienation is central to the work of Spanish artist Salvador Dalí [dah-LEE] (1904–1989), who in 1928, at age 24, was introduced to the Surrealists by Joan Miró. Already eccentric and flamboyant, Dalí had been expelled from the San Fernando Academy of Fine Arts two years earlier for refusing to take his final examination, claiming

Fig. 35.13 Pablo Picasso, *Girl Before a Mirror*. 1932. Oil on canvas, 64″ × 51 ¼″. Gift of Mrs. Simon Guggenheim. (2.1938). Digital Image © The Museum of Modern Art/Licensed by SCALA/Art Resource, New York. © Artists Rights Society (ARS), New York. The long oval mirror into which Marie-Thérèse gazes, supported on both sides by posts, is known as a *psyche*. Hence Picasso paints her psyche both literally and figuratively.

Fig. 35.14 Salvador Dalí, *The Lugubrious Game*. 1929. Oil and collage on card, 17 ½″ × 12″. Private Collection, Paris, France, © DACS. The Bridgeman Art Library. © 2008 Artists Rights Society (ARS), New York. Grasshoppers terrified Dalí—hence its nightmarish presence beneath his nose.

Dalí, in other words, did not hesitate to confront the "lugubrious"—or mournful and gloomy side—of sexuality. He followed, he said, a "paranoiac critical method," a brand of self-hypnosis that he claimed allowed him to hallucinate freely. "I believe the moment is at hand," he wrote in a description of his method, "when, by a paranoiac and active advance of the mind, it will be possible (simultaneously with automatism . . .) to systematize confusion and thus to help to discredit the world of reality." He called his images "new and menacing," and works such as the famous 1931 *Persistence of Memory* (Fig. **35.15**) are precisely that. Again, this is a self-portrait of the sleeping Dalí, who lies sluglike in the middle of the painting, draped beneath the coverlet of time. Ants, which are a symbol of death, crawl over a watchcase on the left. A fly alights on the watch dripping over the ledge, and another limp watch hangs from a dead tree that gestures toward the sleeping Dalí in a manner reminiscent of the statue in *The Lugubrious Game*.

By the mid-1930s, Breton and the Surrealists parted ways with Dalí over his early admiration for Adolf Hitler and his reluctance to support the Republic in the Spanish Civil War. To this could be added Dalí's love of money, for which he earned the name Avida Dollars (Greedy Dollars), an anagram of his name created by Breton. In 1938, he was formally expelled from the Surrealist movement.

Surrealist Sculpture The work that caused the Surrealists to take serious interest in the possibilities of a Surrealist sculptural project was *Suspended Ball* (Fig. **35.16**), by the Swiss sculptor Alberto Giacometti [jah-koh-MET-tee] (1901–1966) in 1930 to 1931. The work is composed of a crescent-shaped wedge above which hangs a ball with a slotted groove in its underside, the pair contained in an open three-dimensional frame. It invites touch, for the ball is meant to swing in a pendulum fashion across the crescent wedge. Breton and Dalí were both ecstatic with the object. Many years later, in his *History of Surrealism*, Maurice Nadeau recalled the sculpture's impact: "Everyone who saw it experienced a strong but indefinable sexual emotion relating to unconscious desires. The emotion was . . . one of disturbance, like that imparted by the irritating awareness of failure."

that he knew more than the professor who was to examine him. He brought this same daring self-confidence to the Surrealist movement. Among the first paintings executed under the influence of the Surrealists is *The Lugubrious Game* (Fig. **35.14**). At the lower right, a man wears a suit jacket but no pants, only his soiled underwear. He holds up one hand that clutches a bloodstained cloth, signifying his castration. He stares at the vision in front of him: a cluster of men's hats at the top (probably signifying the father), metamorphosing into egglike forms. Below it is Dalí's own profile, his eye closed in sleep or dream, with a grasshopper perched on his mouth. Below his mouth stretches a bowel-like form culminating at the bottom of the stairs in a woman's buttocks seen from the rear. The statue of the male figure on the left reaches out an enlarged hand toward Dalí even as it covers its eyes in disgust.

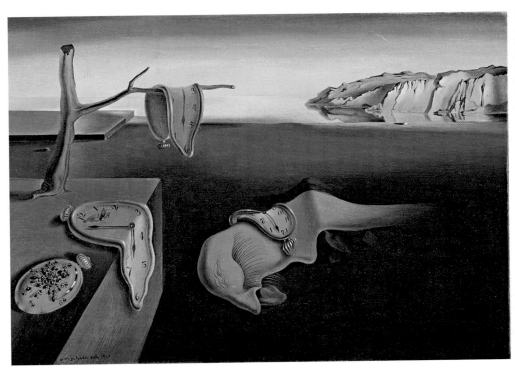

SEE MORE For a Closer Look at Salvador Dalí's *The Persistence of Memory*, go to **www.myartslab.com**

For the most part, women were allowed to participate in the movement only as the object of their male companions' dreams and fantasies, but the German-born Meret Oppenheim [OH-pen-hime] (1901–1985) made a significant contribution in her own right, by creating strikingly original objects that captivated the Surrealists' imagination. Oppenheim's sense of humor, which consists largely in the unexpected transformations that she works upon her objects, is at its most obvious in her *Object (Le Déjeuner en fourrure)* [leh day-zhun-AY ahn foo-RURE] (Fig. **35.17**), literally her "luncheon in fur." One day,

Fig. 35.16 Alberto Giacometti, *Suspended Ball*. 1930–1931. Wood and metal, 24" × 14 $\frac{1}{2}$" × 14". Inv. AM 1996-205. Photo: Georges Meguerditchian. Musée National d'Art Moderne. Centre National d'Art et de Culture. Georges Pompidou. CNAC/MNAM/Dist. Réunion des Musées Nationaux/Art Resource, New York. © 2008 Artists Rights Society (ARS), New York. A plaster version of this sculpture, from which this version was cast, exists in the Kunstmuseum, Basel, Switzerland.

Fig. 35.17 Meret Oppenheim, *Object (Le Déjeuner en fourrure)*. 1931. Fur-covered cup, saucer, and spoon; cup 4 $\frac{3}{4}$" diameter; saucer 9 $\frac{3}{8}$" diameter; spoon 8" long; overall height 2 $\frac{3}{8}$". Purchase. The Museum of Modern Art/Licensed by SCALA/Art Resource, New York. © 2008 Artists Rights Society (ARS), New York. This work was given its title by Breton in 1938, when it was included in the new Museum of Modern Art's exhibition "Fantastic Art, Dada, Surrealism."

SEE MORE For a Closer Look at Meret Oppenheim's *Object (Le Déjeuner en fourrure)*, go to **www.myartslab.com**

while Oppenheim and Picasso were at a café, Picasso noticed a bracelet she was wearing of her own design lined with ocelot [OSS-uh-lot] fur. He remarked that one could cover anything in fur, and Oppenheim agreed. Then, her tea having gotten cold, she asked the waiter for "a little more fur." The Freudian slip suggested the work. Its title is a reference to Manet's *Le Déjeuner sur l'herbe* (see Fig. 30.6), in which a naked model blithely sits between two dressed gentlemen in the Bois de Bologne. The sexual frankness of Manet's painting is transformed here into a suggestion of oral eroticism, the potential user of this tea set becoming a kind of animal licking its own fur or cleaning the fur of its children. But what sets Oppenheim's work apart is the good-natured humor that she brings to Surrealism's "lugubrious" game.

EXPERIMENTATION AND THE LITERARY LIFE: THE STREAM-OF-CONSCIOUSNESS NOVEL

Where Hemingway sought to pare down his writing style to the most basic and direct description, perhaps the most important literary innovation of the era was the **stream-of-consciousness** novel. The idea had arisen in the late nineteenth century, in the writings of both William James (1842–1910), the novelist Henry James's older brother, and the French philosopher Henri Bergson (1859–1941). For Bergson, human consciousness is composed of two somewhat contradictory powers: intellect, which sorts and categorizes experience in logical, even mathematical terms; and intuition, which understands experience as a perpetual stream of sensations, a duration or flow of perpetual becoming. Chapter XI of James's 1892 *Psychology* is actually entitled "The Stream of Consciousness." "Now we are seeing," James writes, "now hearing; now reasoning, now willing; now recollecting, now expecting; now loving, now hating; and in a hundred other ways we know our minds to be alternately engaged Consciousness . . . is nothing jointed; it flows. A 'river' or a 'stream' are the metaphors by which it is most naturally described. *In talking of it hereafter, let us call it the stream of thought, of consciousness, or of subjective life.*"

The rise of the stream-of-consciousness novel in the twentieth century can be attributed to two related factors. On the one hand, it provided authors a means of portraying directly the psychological makeup of their protagonists, as their minds leap from one thing to the next, from memory to self-reflection to observation to fantasy. In this it resembles the free association method of Freudian psychoanalysis. But equally important, it enabled writers to emphasize the subjectivity of their characters' points of view. What a character claims might not necessarily be true. Characters might have motives for lying, even to themselves. And certainly no character in a "fiction" need be a reliable narrator of events. Nothing need prevent characters from creating their own fiction within the author's larger fictional work. Thus, in the stream-of-consciousness novel, the reader is forced to become an active participant in the fiction, sorting out "fact" from "fantasy," distinguishing between the actual events of a story and the characters' "memory" of them.

Joyce, *Ulysses,* and Sylvia Beach

No writer was more influential in introducing the stream-of-consciousness narrative than James Joyce (1882–1941), the Irish writer who left Ireland in 1905 to live, chiefly, in Paris, and no novel better demonstrates its powers than his *Ulysses.*

Early chapters of *Ulysses* had originally been serialized in the American *Little Review*, but postal authorities in both Britain and the United States had banned it for obscenity. Joyce's cause was taken up by Sylvia Beach, owner of an English-language-only bookstore and lending library on the rue l'Odéon [loh-day-OHN] frequented by almost every American writer in Paris. After meeting Joyce at the bookstore, she agreed to publish *Ulysses* in an edition of 1,000, the first two copies of which were delivered on the eve of Joyce's fortieth birthday, February 2, 1922 (Fig. **35.18**).

The novel takes place on one day, June 16, 1904, in 18 episodes spread about an hour apart and ending in the early hours of June 17. It loosely follows the episodes of Ulysses from the *Odyssey* of Homer, with Stephen Dedalus figuring as the new Telemachus, Leopold Bloom as Ulysses, and Molly Bloom as Penelope. Like Penelope in the *Odyssey*, Molly has a suitor, the debonair Blazes Boylan. To win back her affection, Bloom must endure 12 trials—his Odyssey—in the streets, brothels, pubs, and offices of Dublin. Each character is presented through his or her own stream-of-consciousness narration—we read only what is experienced in the character's mind from moment to moment, following his or her thought process through the

CONTINUITY & CHANGE
Odyssey, p. 106

Fig. 35.18 Sylvia Beach and James Joyce reading reviews of Ulysses. 1922. Princeton University Library, Princeton, NJ. Sylvia Beach Collection. Joyce suffered from glaucoma, and endured a number of operations. In order to support Joyce, Beach went into debt herself to advance him money, printing 11 small editions of the novel over the next decade.

interior monologue. Molly Bloom's final soliloquy, the last episode of the book, underscores the experimental vitality of Joyce's prose. It opens with Molly contemplating her husband's request to be served breakfast in bed in the morning. A full-blown stream-of-consciousness monologue in which the half-asleep Molly mulls over her entire sexual life, it concludes with her rapturous remembrance of giving herself to Bloom on Howth Head, the northern enclosure of Dublin Bay, 16 years earlier.

In its near-total lack of punctuation—there are eight sentences in the entire episode, the first of which is 2,500 words long—as well as its uncensored exploration of a woman's sexuality, Joyce's final episode remains revolutionary, as does the novel as a whole.

Virginia Woolf: In the Mind of Mrs. Dalloway

As soon as episodes from *Ulysses* began to appear in the *Little Review*, Joyce's experiments caught the attention of other writers. Although the English novelist Virginia Woolf (1882–1941) disapproved of Joyce's book—it ultimately seemed to her the product of a "working-man," and, she added, "we all know how distressing they are, how egotistic, insistent, raw, striking, & ultimately nauseating"—she was fascinated by Joyce's style. In August 1922, just as she was beginning her novel *Mrs. Dalloway*, a work published in 1925 about a higher social class of people than those of Joyce's *Ulysses*, she wrote that after reading the first 200 pages of Joyce's novel she was "amused, stimulated, charmed[,] interested." So she determined to examine for herself "an ordinary day" of a decidedly different character.

Woolf was at the center of a circle of London intellectuals known as the Bloomsbury Group, named for the London neighborhood in which they lived. Although women in England had gained the right to vote in 1918, Woolf argued that women could realize their full potential only if they achieved both financial and psychological independence from men. In her important 1929 essay "A Room of One's Own," she argues that in order to realize their full creative capacities, women must find the means to possess rooms of their own—spaces freed of male constraints (see **Reading 35.14**, page 1171). By the mid-1920s, Woolf had largely eliminated external action from her prose, concentrating instead on trying to capture the ebb and flow of her characters'—particularly her women characters'—consciousness. It was their psychological makeup, and by extension her own, that most interested her.

Mrs. Dalloway takes place on a single day in post–World War I London as Clarissa Dalloway prepares for a party, and Woolf follows her heroine's stream of consciousness, her memories and feelings, as well as the streams of consciousness of other characters who encounter her as they go through the day. Chief among these other characters is Septimus Warren Smith, a shell-shocked war veteran whose depression in many ways mirrors Woolf's own. These are the novel's opening paragraphs (**Reading 35.15**):

READING 35.15

from Virginia Woolf, *Mrs. Dalloway* (1925)

Mrs. Dalloway said she would buy the flowers herself.

For Lucy had her work cut out for her. The doors would be taken off their hinges; Rumpelmayer's men were coming. And then, thought Clarissa Dalloway, what a morning—fresh as if issued to children on a beach.

What a lark! What a plunge! For so it had always seemed to her, when, with a little squeak of the hinges, which she could hear now, she had burst open the French windows and plunged at Bourton into the open air. How fresh, how calm, stiller than this of course, the air was in the early morning; like the flap of a wave; the kiss of a wave; chill and sharp and yet (for a girl of eighteen as she then was) solemn, feeling as she did, standing there at the open window, that something awful was about to happen; looking at the flowers, at the trees with the smoke winding off them and the rooks rising, falling; standing and looking until Peter Walsh said, "Musing among the vegetables?"—was that it?—"I prefer men to cauliflowers"—was that it? He must have said it at breakfast one morning when she had gone out on to the terrace—Peter Walsh. He would be back from India one of these days, June or July, she forgot which, for his letters were awfully dull; it was his sayings one remembered; his eyes, his pocket-knife, his smile, his grumpiness and, when millions of things had utterly vanished—how strange it was!—a few sayings like this about cabbages.

She stiffened a little on the kerb, waiting for Durtnall's van to pass. A charming woman, Scrope Purvis thought her (knowing her as one does know people who live next door to one in Westminster); a touch of the bird about her, of the jay, blue green, light, vivacious, though she was over fifty, and grown very white since her illness. There she perched, never seeing him, waiting to cross, very upright.

For having lived in Westminster—how many years now? over twenty,—one feels even in the midst of the traffic, or waking at night, Clarissa was positive, a particular hush, or solemnity; an indescribable pause; a suspense (but that might be her heart, affected, they said, by influenza) before Big Ben strikes. There! Out it boomed.

As the 52-year-old Clarissa leaves her house to buy flowers for her party, she recalls standing at the open window of her father's estate when she was 18, chatting with Peter Walsh, and feeling "something awful was about to happen." Clarissa's neighbor, Scrope Purvis, notices her from his window, and we are briefly in his mind. Then we return to Clarissa. As past and present mingle, and points of view shift from character to character, we enter into the private worlds of them all, all ironically frustrated in their attempts to communicate with one another.

Woolf's next novel, the 1927 *To the Lighthouse*, opens with a long stream-of-consciousness account of a day in the life of Mr. and Mrs. Ramsay and their guests vacationing on the Isle of Skye, followed by a shorter poetic description of the passing of 10 years' time, and concluding with another stream-of-consciousness narrative in which the actions of 10 years earlier are finally resolved. The contrast in the passing of time—two days' events narrated at length, 10 years' in a matter of pages—underscores Woolf's sense of the malleability of time. But at the heart of the narrative is the realization that it is the consciousness of Mrs. Ramsay that determines the events of the final day, even though in the intervening years she has died.

Marcel Proust and the Novel of Memory

If Joyce was the first to use stream of consciousness as a narrative device, it was Marcel Proust [proost] (1871–1922) who first imagined the novel as a mental space. Proust grew up in Paris near the Champs-Elysées, spending holidays with relatives in the country towns of Auteuil [oh-TOY] and Illiers [eel-ee-AY]. These two villages inspired Proust's fictional village, Combray [kohm-BRAY], site of the narrator's childhood memories in his monumental seven-volume novel *À la recherche du temps perdu* (literally *In Search of Lost Time*, but known in the English-speaking world for decades as *Remembrance of Things Past*, a title invented by the novel's translator from Shakespeare's Sonnet XXX: "When to the sessions of sweet silent thought/I summon up remembrance of things past"). After a bout of depression that followed the deaths of his father in 1903 and his mother in 1905, Proust gave up his social life almost entirely, retreating to his quiet, cork-lined apartment on the boulevard Haussmann and devoting almost all his waking hours to the composition of his novel.

Calling the novel "psychology in space and time," his plan was to explore the deepest recesses of the unconscious and bring them to conscious life. Thus the famous moment that concludes the "Overture" to *Swann's Way*, the first volume of *À la recherche*, published in 1913, when the narrator, Marcel, tastes a madeleine, "one of those short, plump little cakes . . . which look as though they have been moulded in the fluted scallop of a pilgrim's shell" (**Reading 35.16**):

READING 35.16

from Marcel Proust, *Swann's Way* (1913)

I raised to my lips a spoonful of the tea in which I had soaked a morsel of the cake. No sooner had the warm liquid, and the crumbs with it, touched my palate than a shudder ran through my whole body, and I stopped, intent upon the extraordinary changes that were taking place. An exquisite pleasure had invaded my senses, but individual, detached, with no suggestion of its origin. And at once the vicissitudes of life had become indifferent to me, its disasters innocuous, its brevity illusory—this new sensation having had on me the effect which love has of filling me with a precious essence; or rather this essence was not in me, it was myself. I had ceased now to feel mediocre, accidental, mortal. Whence could it have come to me, this all-powerful joy? I was conscious that it was connected with the taste of tea and cake, but that it infinitely transcended those savours, could not, indeed, be of the same nature as theirs. Whence did it come? What did it signify? How could I seize upon and define it?

What Marcel comes to understand is that, in a process of free association, the taste of the madeleine had evoked his experience of tasting the same little cake, given him by his aunt Léonine [lay-oh-NEEN] on Sunday mornings at Combray, and thus the entire landscape of Combray itself. The past, in other words, comes alive in the present, freeing Marcel from the constraints of time and opening to him the recesses of his subconscious.

The philosopher Henri Bergson, whom Proust considered "the first great metaphysician" of the modern era, had argued that past, present, and future were part of an organic whole, in which the past is a "continuous progress . . . which gnaws into the future and which swells it as it advances." The role of art, he argued, was to capture "certain rhythms of life and breath" which invite us to "join in a dance. Thus," he wrote, "they compel us to set in motion, in the depth of our own being, some secret chord which was only waiting to thrill." Just as the madeleine struck this same secret chord in Marcel, Proust hoped his fiction would strike it in his reader. In the last volume of *À la recherche*, *Time Regained*, not published until 1927, he wrote:

> I thought more modestly of my book and it would be inaccurate even to say that I thought of those who would read it as "my" readers. For, it seemed to me that they would not be "my" readers but the readers of their own selves, my book being merely a sort of magnifying glass like those which the optician at Combray used to offer his customers—it would be my book but with its help I would furnish them with the means of reading what lay inside themselves.

It is the book and the acts of memory that it restores to the present—and hence the future—that time, in all its flux, is finally "regained."

Harlem and the Great Migration

In February 1924, a young African-American student named Langston Hughes (1902–1967), restless, determined to see the world, and equally determined to become a poet, arrived in Paris. He had graduated from Central High School in Cleveland, Ohio, in 1920. After dropping out of Columbia University in 1922, he made three transatlantic voyages working as a seaman on a freighter that took him to Senegal, Nigeria, the Cameroons, the Belgian Congo, Angola, and Guinea in Africa, and later to Italy and France, Russia, and Spain. Paris did not much impress him. In the second week of March, he wrote his friend, Countee Cullen (1903–1946):

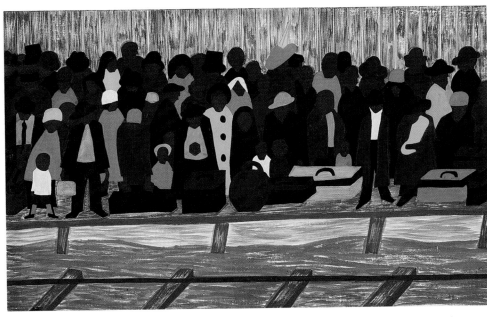

Fig. 35.19 Jacob Lawrence, ***The Migration of the Negro,*** **Panel no. 60:** ***And the migrants kept coming.*** **1940–41.** Casein tempera on hardboard panel, 18″ × 12″. Gift of Ms. David M. Levy. (28.1942.30). Digital Image © The Museum of Modern Art/Licensed by SCALA/Art Resource, New York. © Artists Rights Society (ARS), New York.

> But about France! Kid, stay in Harlem! The French are the most franc-loving, sou-clutching, hard-faced, hard-worked, cold and half-starved set of people I've ever seen in my life. Heat unknown. Hot water, what is it? You even pay for a smile here. Nothing, absolutely nothing is given away. You even pay for water in a restaurant or the use of the toilette. And do they like Americans of any color? They do not!! Paris, old and ugly and dirty. Style? Class? You see more well-dressed people in a New York subway station in five seconds than I've seen all my three weeks in Paris. Little old New York for me! But the colored people here are fine, there are lots of us.

Over the course of the First World War, Hughes's Harlem—and New York City itself—had changed dramatically. In 1914, nearly 90 percent of all African Americans lived in the South, three-quarters of them in the rural South. But as millions of men in the North went to fight in Europe, a huge demand for labor followed. Lured by plentiful jobs, Southern blacks began to move north—between 200,000 and 350,000 in the years 1915 through 1918 alone. This Great Migration, as it was called, was later celebrated in a series of 60 paintings by the African-American artist Jacob Lawrence (1917–2000) (Fig. **35.19**), who moved to

Harlem in 1924 at the age of seven, into a cultural community so robust, and so new, that the era has come to be known as the Harlem Renaissance. Lawrence was trained as a painter at the Harlem Art Workshop, and in his teens he was introduced to Hughes. "Without the black community in Harlem, I wouldn't have become an artist," he later said. Lawrence painted his *Migration* series when he was just 23 years old. It won him immediate fame. In 1942, the Museum of Modern Art in New York and the Phillips Collection in Washington, D.C. each bought 30 panels. That same year, Lawrence became the first black artist represented by a prestigious New York gallery—the Downtown Gallery. In 1949, he would team up with Hughes to illustrate Hughes's own book of poems about the Great Migration, *One Way Ticket*. "I pick up my life," the title poem begins:

> And take it with me,
> And I put it down in
> Chicago, Detroit,
> Buffalo, Scranton,
> Any place that is
> North and East,
> And not Dixie. ■

What were the effects of trench warfare on the European imagination?

The realities of trench warfare along the Western Front in northeast France and northwest Germany had an immense impact on the Western imagination. The almost unbounded optimism that preceded the war was replaced by a sense of the absurdity of modern life, the fragmentation of experience, and the futility of even daring to hope. How does Wilfred Owens's "The Pity of War" reflect these feelings? What about William Butler Yeats's poetry? Among the most powerful realizations of this condition is T. S. Eliot's poem *The Waste Land*. How does it depict modern love?

What is Dada?

Many found the war incomprehensible, and they reacted by creating an art movement based on negation and meaninglessness: Dada. What beliefs did Dada's sound poetry reflect? What role did chance operations play in their work? One of their most influential spokesmen, Marcel Duchamp, turned found objects into works of art, including the urinal *Fountain*, which he called ready-mades. What are ready-mades? How did the Dadaists use the technique of photomontage? Dada, finally, was an art of provocation, but in its very energy, it posited that the forces of creativity might survive.

How did the arts respond to the Russian Revolution?

In Russia, political upheaval offered the promise of a new and better life. Led by Vladimir Lenin, the Bolshevik party envisioned an ideal utopian state in which society does away with government and life is lived upon the principle "From each according to his ability: to each according to his needs." In the arts, Kasimir Malevich pursued an art he called Suprematism. What is Suprematism? How are its principles reflected in his *Black Square*? Soon Malevich sought to apply these principles in more practical ways that might serve a social purpose—Constructivism, he called it. In film, Sergei Eisenstein's new montage techniques were created to attract a largely illiterate audience through fast-paced editing and composition. What is montage?

How does Freudian psychology manifest itself in the Surrealist art movement?

The era after the war was especially influenced by the work of Sigmund Freud, whose psychoanalytic techniques, especially that of free association, were employed to treat victims of shell shock. What is free association and what theories did Freud develop based on it? After the war, in *Beyond the Pleasure Principle*, he added to his theories the idea that humans might be equally driven by a death drive that begins to explain self-destructive and aggressive human behaviors, including war. Almost as influential as Freud was his colleague Carl Jung, who believed that the unconscious life of the individual was founded on a deeper, more universal layer of the psyche, which he called the collective unconscious. How does the collective unconscious manifest itself?

In the arts, the discoveries of Freud and Jung manifested themselves in the Surrealist projects of André Breton and his colleagues. How did Breton define Surrealism? Breton reproduced the work of Max Ernst in the journals that he published. He recruited Picasso to the movement, as well as Picasso's Spanish colleague Joan Miró. Miró in turn introduced Salvador Dalí to the movement. All of these artists, including sculptors like Alberto Giacometti and Meret Oppenheim, openly pursued the undercurrent of Freudian sexual desire that they believed lay at the root of their creative activity.

What is the stream-of-consciousness style of writing?

After the war, writers struggled to find a way to express themselves authentically in a language that the war had seemed to have left impoverished. The life of the unconscious was the subject of the stream-of-consciousness novel that rose to prominence in the same era, including James Joyce's *Ulysses*, Virginia Woolf's *Mrs. Dalloway*, and Marcel Proust's *À la recherche du temps perdu*. What are the attractions of the stream-of-consciousness style?

PRACTICE MORE Get flashcards for images and terms and review chapter material with quizzes at **www.myartslab.com**

GLOSSARY

archetype In Jung's view, a pattern of thought that recurs throughout history, and across cultures, in the form of dreams, myths, and fairy tales.

collective unconscious The innate, inherited contents of the human mind.

ego In Freudian psychology, the part of the human mind that manages the id, mediating between the id's potentially destructive impulses and the requirements of social life.

id In Freudian psychology, the part of the human mind that is the seat of all instinctive, physical desire; the principal mechanism of the subconscious.

montage An image (whether photographic or cinematographic) made by combining several different images.

photomontage A collage work containing photographic clippings.

stream-of-consciousness A type of narration in which the reader reads only what is experienced in the character's mind from moment to moment, following his or her thought process through the interior monologue.

sublimation The act of modifying and redirecting the id's primal impulses into constructive social behavior.

superego In Freudian psychology, the seat of what is commonly called "conscience," the psyche's moral base.

READINGS

READING 35.6

from T. S. Eliot, *The Waste Land, Part III*, "The Fire Sermon" (1921)

The following selection from Eliot's long poem occurs at the very center of the poem. Eliot describes the sexual encounter between a typist and her "young man carbuncular"—that is, covered with boils—as overseen by the figure of Tiresias. In a note, Eliot describes Tiresias as "the most important personage in the poem," despite the fact that he is a "mere spectator." In his Metamorphoses *(see Chapter 6), Ovid describes how Tiresias spent seven years as a woman. Later, he was asked to settle a quarrel between Zeus and Hera over who enjoyed sex more, men or women. When Tiresias agreed with Zeus that women enjoyed it more, Hera blinded him, but Zeus compensated him by giving him the gift of prophesy. Tiresias, here, blind yet able to see with complete clarity, embodies the modern condition, a doomed individual who can neither hope nor act, but only sit and watch.*

At the violet hour, when the eyes and back
Turn upward from the desk, when the human engine waits
Like a taxi throbbing waiting,
I Tiresias, though blind, throbbing between two lives,
Old man with wrinkled female breasts, can see
At the violet hour, the evening hour that strives
Homeward, and brings the sailor home from sea,
The typist home at teatime, clears her breakfast, lights
Her stove, and lays out food in tins.
Out of the window perilously spread 10
Her drying combinations[1] touched by the sun's last rays,
On the divan are piled (at her night bed)
Stockings, slippers, camisoles, and stays.
I Tiresias, old man with wrinkled dugs
Perceived the scene, and foretold the rest—
I too awaited the expected guest.
He, the young man carbuncular, arrives,
A small house agent's clerk, with one bold stare,
One of the low on whom assurance sits
As a silk hat on a Bradford millionaire.[2] 20
The time is now propitious, as he guesses,
The meal is ended, she is bored and tired,
Endeavours to engage her in caresses
Which are still unreproved, if undesired.
Flushed and decided, he assaults at once;

Exploring hands encounter no defense;
His vanity requires no response,
And makes a welcome of indifference.
(And I Tiresias have foresuffered all
Enacted on this same divan or bed; 30
I who have sat by Thebes below the wall
And walked among the lowest of the dead.)[3]
Bestows one final patronising kiss,
And gropes his way, finding the stairs unlit . . .

She turns and looks a moment in the glass,
Hardly aware of her departed lover;
Her brain allows one half-formed thought to pass:
"Well now that's done: and I'm glad it's over."
When lovely woman stoops to folly and
Paces about her room again, alone, 40
She smoothes her hair with automatic hand,
And puts a record on the gramophone.

READING CRITICALLY

In his notes to *The Waste Land,* Eliot writes: "What Tiresias sees, in fact, is the substance of the poem." How would you summarize that "substance"?

[1]**combinations** one-piece underwear.
[2]**Bradford millionaire** The industrial town of Bradford thrived on war contracts during World War I, and thus the gentleman described is, for Eliot, the image of a war profiteer.

[3]**Thebes . . . lowest of the dead** Tiresias was originally from the Greek city of Thebes, but prophesied from Hades.

from Sigmund Freud, *Civilization and Its Discontents* (1930)

Civilization and Its Discontents is among Freud's most philosophical works. In it he traces the effects of archaic instinctual impulses, once necessary for survival, on modern society. In the following passage, he surveys the role that aggression plays in impeding man's ability to live in peace and harmony. Later in this same argument, he will argue that civilization often forces us to turn our aggression inward, to the Self, causing the psychological phenomenon of depression and despair.

Men are not gentle creatures, who want to be loved, who at the most can defend themselves if they are attacked; they are, on the contrary, creatures among whose instinctual endowments is to be reckoned a powerful share of aggressiveness. As a result, their neighbor is for them not only a potential helper or sexual object, but also someone who tempts them to satisfy their aggressiveness on him, to exploit his capacity for work without compensation, to use him sexually without his consent, to seize his possessions, to humiliate him, to cause him pain, to torture and to kill him. *Homo homini lupus* [man is wolf to man]. Who in the face of all his experience of life and of history, will have the courage to dispute this assertion? As a rule this cruel aggressiveness waits for some provocation or puts itself at the service of some other purpose, whose goal might also have been reached by milder measures. In circumstances that are favorable to it, when the mental counter-forces which ordinarily inhibit it are out of action, it also manifests itself spontaneously and reveals man as a savage beast to whom consideration towards his own kind is something alien. Anyone who calls to mind the atrocities committed during the racial migrations or the invasions of the Huns, or by the people known as Mongols under Jenghiz Khan and Tamerlane, or at the capture of Jerusalem by the pious Crusaders, or even, indeed, the horrors of the recent World War—anyone who calls these things to mind will have to bow humbly before the truth of this view.

The existence of this inclination to aggression, which we can detect in ourselves and justly assume to be present in others, is the factor which disturbs our relations with our neighbor and which forces civilization into such a high expenditure [of energy]. In consequence of this primary mutual hostility of human beings, civilized society is perpetually threatened with disintegration. The interest of work in common would not hold it together; instinctual passions are stronger than reasonable interests. Civilization has to use its utmost efforts in order to set limits to man's aggressive instincts and to hold the manifestations of them in check by psychical reaction-formations. . . .

The communists believe they have found the path to deliverance from our evils. According to them, man is wholly good and as well-disposed to his neighbor; but the institution of private property has corrupted his nature. The ownership of private wealth gives the individual power, and waited the temptation to ill-treat his neighbor; while the man who is excluded from possession is bound to rebel in hostility against his oppressor. If private property were abolished, all wealth held in common, and everyone allowed to share in the enjoyment of it, ill-will and hostility would disappear among men. Since everyone's needs would be satisfied, no one would have any reason to regard another as his enemy; all would willingly undertake the work that was necessary. I have no concern with any economic criticisms of the communist system; I cannot inquire into whether the abolition of private property is expedient or advantageous. But I am able to recognize that the psychological premises on which the systems based are an untenable illusion. In abolishing private property we deprive the human love of aggression of one of its instruments, certainly a strong one, though certainly not the strongest; but we have in no way altered the differences in power and influence which are misused by aggressiveness, nor have we altered anything in its nature. Aggressiveness was not created by property. It reigned almost before property had given up its primal, anal form; it forms the basis of every relation of affection and love among people (with the single exception, perhaps, of the mother's relation to her male child). If we do away with personal rights over material wealth, there still remains prerogative in the field of sexual relationships, which is bound to become the source of the strongest dislike in the most violent hostility among men who in other respects are on an equal footing. If we were to remove this factor, too, by allowing complete freedom of sexual life and thus abolishing the family, the germ-cell of civilization, we cannot, it is true, easily foresee what new paths the development of civilization could take; but one thing we can expect, and that is that this indestructible feature of human nature will follow it there.

It is clearly not easy for man to give up the satisfaction of this inclination to aggression. They do not feel comfortable without it. The advantage which a comparatively small cultural group offers of allowing this instinct an outlet in the form of hostility against intruders is not to be despised. It is always possible to bind together a considerable number of people in love, so long as there are other people left over to receive the manifestations of their aggressiveness. . . . In this respect the Jewish people, scattered everywhere, have rendered most useful services to the civilizations of the countries that have been their hosts; but unfortunately all the massacres of the Jews in the Middle Ages did not suffice to make that period more peaceful and secure for their Christian fellows. When once the Apostle Paul had posited universal love between men as the foundation of his Christian community, extreme intolerance, part of Christendom towards those who remained outside it became the inevitable consequence. To the Romans, who had not founded their communal life as a State upon love, religious intolerance was something foreign, although with them religion was a concern of the State and the State was permeated by religion. Neither was it an unaccountable chance that the dream of a Germanic world-dominion called for anti-Semitism as its complement; and it is intelligible that the attempts to establish a new, communist civilization in Russia should find its psychological support in the persecution of the bourgeois. One only wonders, with concern, what the Soviets will do after they have wiped out their bourgeois.

READING CRITICALLY

How and why does Freud disagree with Lenin's basic premise as stated in *The State and Revolution*?

from Virginia Woolf, "A Room of One's Own" (1929)

Woolf's long essay, which originated as a series of lectures given at two women's colleges at Cambridge University in October 1928, is a response to a remark by an English clergyman that no woman could ever have approached the genius of William Shakespeare. In the section excerpted here, Woolf imagines what it might have been like to be Shakespeare's sister—a sibling as gifted as her brother but trapped in her time.

Be that as it may, I could not help thinking, as I looked at the works of Shakespeare on the shelf, that the bishop was right at least in this; it would have been impossible, completely and entirely, for any woman to have written the plays of Shakespeare in the age of Shakespeare. Let me imagine, since facts are so hard to come by, what would have happened had Shakespeare had a wonderfully gifted sister, called Judith, let us say. Shakespeare himself went, very probably,—his mother was an heiress—to the grammar school, where he may have learnt Latin—Ovid, Virgil and Horace—and the elements of grammar and logic. He was, it is well known, a wild boy who poached rabbits, perhaps shot a deer, and had, rather sooner than he should have done, to marry a woman in the neighbourhood, who bore him a child rather quicker than was right. That escapade sent him to seek his fortune in London. He had, it seemed, a taste for the theatre; he began by holding horses at the stage door. Very soon he got work in the theatre, became a successful actor, and lived at the hub of the universe, meeting everybody, knowing everybody, practising his art on the boards, exercising his wits in the streets, and even getting access to the palace of the queen. Meanwhile his extraordinarily gifted sister, let us suppose, remained at home. She was as adventurous, as imaginative, as agog to see the world as he was. But she was not sent to school. She had no chance of learning grammar and logic, let alone of reading Horace and Virgil. She picked up a book now and then, one of her brother's perhaps, and read a few pages. But then her parents came in and told her to mend the stockings or mind the stew and not moon about with books and papers. They would have spoken sharply but kindly, for they were substantial people who knew the conditions of life for a woman and loved their daughter—indeed, more likely than not she was the apple of her father's eye. Perhaps she scribbled some pages up in an apple loft on the sly but was careful to hide them or set fire to them. Soon, however, before she was out of her teens, she was to be betrothed to the son of a neighbouring woolstapler. She cried out that marriage was hateful to her, and for that she was severely beaten by her father. Then he ceased to scold her. He begged her instead not to hurt him, not to shame him in this matter of her marriage. He would give her a chain of beads or a fine petticoat, he said; and there were tears in his eyes. How could she disobey him? How could she break his heart? The force of her own gift alone drove her to it. She made up a small parcel of her belongings, let herself down by a rope one summer's night and took the road to London. She was not seventeen. The birds that sang in the hedge were not more musical than she was. She had the quickest fancy, a gift like her brother's, for the tune of words. Like him, she had a taste for the theatre. She stood at the stage door; she wanted to act, she said. Men laughed in her face. The manager—a fat, looselipped man—guffawed. He bellowed something about poodles dancing and women acting—no woman, he said, could possibly be an actress. He hinted—you can imagine what. She could get no training in her craft. Could she even seek her dinner in a tavern or roam the streets at midnight? Yet her genius was for fiction and lusted to feed abundantly upon the lives of men and women and the study of their ways. At last—for she was very young, oddly like Shakespeare the poet in her face, with the same grey eyes and rounded brows—at last Nick Greene the actor-manager took pity on her; she found herself with child by that gentleman and so—who shall measure the heat and violence of the poet's heart when caught and tangled in a woman's body?—killed herself one winter's night and lies buried at some cross-roads where the omnibuses now stop outside the Elephant and Castle.

That, more or less, is how the story would run, I think, if a woman in Shakespeare's day had had Shakespeare's genius [S]o it seemed to me, reviewing the story of Shakespeare's sister as I had made it, is that any woman born with a great gift in the sixteenth century would certainly have gone crazed, shot herself, or ended her days in some lonely cottage outside the village, half witch, half wizard, feared and mocked at. For it needs little skill in psychology to be sure that a highly gifted girl who had tried to use her gift for poetry would have been so thwarted and hindered by other people, so tortured and pulled asunder by her own contrary instincts, that she must have lost her health and sanity to a certainty To have lived a free life in London in the sixteenth century would have meant for a woman who was poet and playwright a nervous stress and dilemma which might well have killed her. Had she survived, whatever she had written would have been twisted and deformed, issuing from a strained and morbid imagination. And undoubtedly, I thought, looking at the shelf where there are no plays by women, her work would have gone unsigned.

READING CRITICALLY

Although Woolf is imagining what it might have been like to be a talented woman in the sixteenth century, she clearly identifies with her character Judith—her own father had kept her at home while sending her brothers to school. What does this suggest about Woolf's own genius?

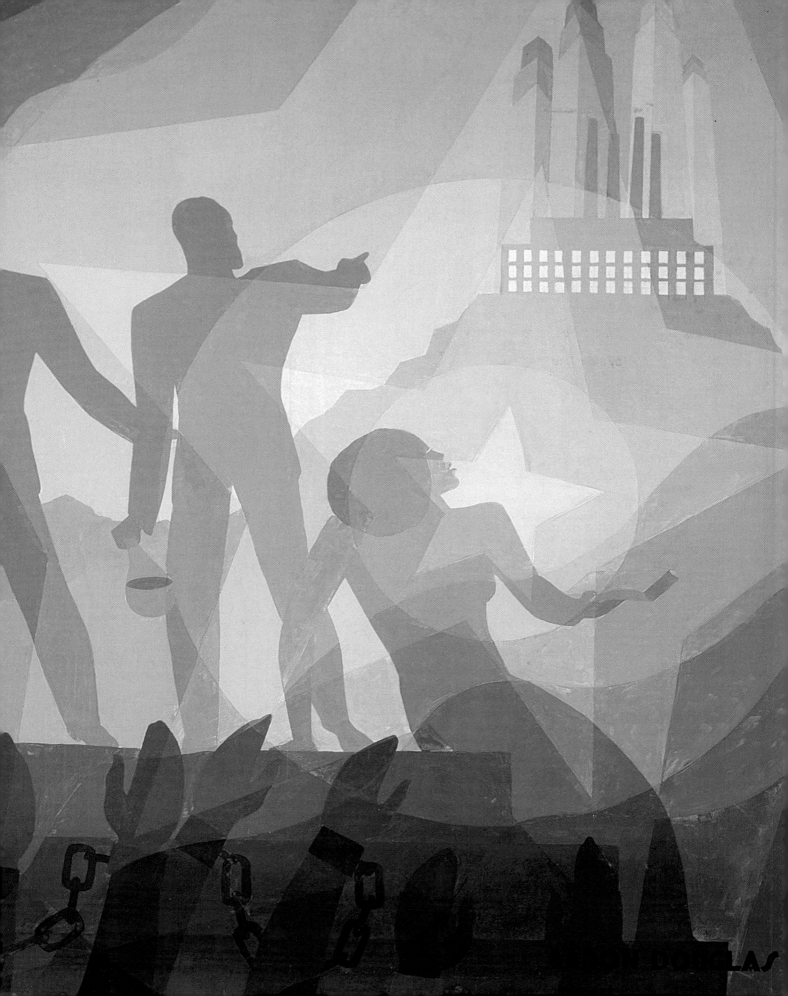

36 | New York, Skyscraper Culture, and the Jazz Age

Making It New

THINKING AHEAD

What was the Harlem Renaissance?

What is the International Style in architecture?

What is suggested by the adage "make it new"?

What characterizes the "golden age" of silent film?

By the mid-1920s, both white and black Americans understood that New York's Harlem neighborhood was alive with a new, vibrant sense of cultural possibility. This new cultural climate, which came to be known as the Harlem Renaissance, had been inaugurated by the mass migration of blacks out of the South into the North after the outbreak of World War I (see Fig. 35.19). In 1914, nearly 90 percent of all African Americans lived in the South, three-quarters of them in the rural South. But lured by a huge demand for labor in the North once the war began, and impoverished after a boll weevil infestation ruined the cotton crop, blacks flooded into the North. In the course of a mere 90 days early in the 1920s, 12,000 African Americans left Mississippi alone. An average of 200 left Memphis every night. Many met with great hardship, but there was wealth to be had as well, and anything seemed better than life under Jim Crow in the South. They hoped to find a new life in the urban North, the promise of which African-American artist Aaron Douglas (1898–1979) captures in his painting *Aspiration* (Fig. 36.1). A native of Topeka, Kansas, with a Bachelor of Fine Arts degree from the University of Nebraska, where he had been the only black student in his class, Douglas arrived in Harlem in 1925.

"My first impression of Harlem," he would later write, "was that of an enormous stage swarming with humanity Here one found a kaleidoscope of rapidly changing colors, sounds, movements—rising, falling, swelling, contracting, now hurrying, now dragging along without end and often without apparent purpose. And yet beneath the surface of this chaotic incoherent activity one sensed an inner harmony, one felt the presence of a mysterious hand fitting all these disparate elements into a whole."

In fact, what was happening in Harlem was happening in New York City as a whole. From Wall Street to Midtown, construction boomed, and the rapid pace of building mirrored the frenetic pace of New York City itself. Like the pre–World War I years, movement and speed defined the era. Until the stock market crash of 1929, New York was the center of world commerce. Uptown, in Harlem, nightlife thrived—in the clubs and cabarets, life seemed to continue 24 hours a day. Despite Prohibition, which had outlawed the production, transportation, and sale of alcoholic beverages in 1920, liquor was plentiful, and white socialites from downtown filled the jazz clubs, dancing the night away to the bands that catered to their sense of freedom—and the "outlaw" status that their willful disregard for Prohibition underscored.

◄ **Fig. 36.1 Detail of Aaron Douglas, *Aspiration*. 1936.** © Estate of Aaron Douglas, Courtesy Fine Arts Museum of San Francisco. Douglas's painting is composed as a series of stars within stars, all pointing toward the future and the promise he believed it held for African Americans.

HEAR MORE Listen to an audio file of your chapter at **www.myartslab.com**

It was, as one prominent writer of the era recognized, a Jazz Age—a world moving to its own beat, improvising as it went along, discovering new and unheard-of chords with which life might resonate. The stock market boomed, money flowed, and American industry thrived. And everywhere one looked, new buildings, new products, new creations, and new works of art competed for the public's attention. Across the country in Hollywood, the film industry advanced the new, machine-created art that seemed to capture the spirit of the day. "Make it new" was the catchphrase of the era.

THE HARLEM RENAISSANCE

If the social roots of the Harlem Renaissance can be traced back to the Great Migration during the First World War, the philosophical roots reach back to the turn of the century and the work of black historian and sociologist W. E. B. Du Bois (1868–1963), whose *The Philadelphia Negro* (1899) was the first sociological text on a black community published in the United States. In 1903, in his book *The Souls of Black Folk*, Du Bois had proposed that the identity of African Americans was fraught with ambiguity (**Reading 36.1**):

READING 36.1

from W. E. B. Du Bois, *The Souls of Black Folk* (1903)

[America] yields him no true self-consciousness It is a peculiar sensation, this double-consciousness, this sense of always looking at one's self through the eyes of others, of measuring one's soul by the tape of a world that looks on in an amused contempt and pity. One ever feels his two-ness,—an American, a Negro; two souls, two thoughts, two unreconciled strivings; two warring ideals in one dark body, whose dogged strength alone keeps it from being torn asunder.

The history of the American Negro is the history of this strife,—this longing to attain self-conscious manhood, to merge his double self into a better and truer self. In this merging he wishes neither of the older selves to be lost. He would not Africanize America, for America has too much to teach the world and Africa. He would not bleach his Negro soul in a flood of white Americanism, for he knows that Negro blood has a message for the world. He simply wishes to make it possible for a man to be both a Negro and an American, without being cursed and spit upon by his fellows, without having the doors of Opportunity closed roughly in his face.

When in 1909 the National Association for the Advancement of Colored People (NAACP) was founded to advance the rights of blacks, Du Bois became editor of its magazine,

The Crisis. His sense of the double-consciousness informing African-American experience (a double-consciousness that informs the very term "African American") was often expressed in the magazine's pages.

This double-consciousness is especially apparent in the work of Claude McKay (1889–1948), a poet who generally published in white avant-garde magazines and only occasionally in magazines like *The Crisis*. His poem "If We Must Die" was inspired by the race riots that exploded in the summer and fall of 1919 in a number of cities in both the North and South. The three most violent episodes of what came to be known as the "Red Summer" occurred in Chicago, Washington, D.C., and Elaine, Arkansas, all started by whites, who were stunned when blacks fought back. A "Southern black woman," as she identified herself, wrote a letter to *The Crisis*, praising blacks for fighting back: "The Washington riot gave me a thrill that comes once in a life time . . . at last our men had stood up like men I stood up alone in my room . . . and exclaimed aloud, 'Oh I thank God, thank God.' The pent up horror, grief and humiliation of a life time—half a century—was being stripped from me." McKay's poem expresses the same militant anger (**Reading 36.2**):

READING 36.2

Claude McKay, "If We Must Die" (1919)

If we must die—let it not be like hogs
Hunted and penned in an inglorious spot,
While round us bark the mad and hungry dogs,
Making their mock at our accursed lot.

If we must die—oh, let us nobly die,
So that our precious blood may not be shed
In vain; then even the monsters we defy
Shall be constrained to honor us though dead!

Oh, Kinsmen! We must meet the common foe;
Though far outnumbered, let us show us brave,
And for their thousand blows deal one deathblow!
What though before us lies the open grave?

Like men we'll face the murderous, cowardly pack,
Pressed to the wall, dying, but fighting back!

Ironically, years later, during World War II, British Prime Minister Winston Churchill would use the poem, without acknowledging its source—probably without even knowing it—to rally British and American troops fighting in Europe. That Churchill could so transform the poem's meaning is indicative of its very doubleness. Written in sonnet form, it harks back to the genteel heroism of Alfred, Lord Tennyson's "Charge of the Light Brigade" (see page 1145), and yet it was, in its original context, a call to arms.

McKay's book of poems, *Harlem Shadows*, is one of the first works by a black writer to be published by a mainstream, national publisher (Harcourt, Brace and

Company). Together with the novel *Cane* (1923) by Jean Toomer (1894–1967), an experimental work that combined poetry and prose in documenting the life of American blacks in the rural South and urban North, it helped to launch the burst of creative energy that was the Harlem Renaissance.

"The New Negro"

Perhaps the first self-conscious expression of the Harlem Renaissance took place at a dinner party, on March 21, 1924, hosted by Charles S. Johnson (1893–1956) of the National Urban League. The League was dedicated to promoting civil rights and helping black Americans address the economic and social problems they encountered as they resettled in the urban North. At Johnson's dinner, young writers from Harlem were introduced to New York's white literary establishment. A year later, the *Survey Graphic*, a national magazine dedicated to sociology, social work, and social analysis, produced an issue dedicated exclusively to Harlem. The issue, subtitled *Harlem: Mecca of the New Negro*, was edited by Alain Leroy Locke (1886–1954), an African-American professor of philosophy at Howard University in Washington, D.C. He was convinced that a new era was dawning for black Americans, and wrote a powerful introduction to a new anthology. In his essay, sometimes referred to as the manifesto of the New Negro Movement, Locke argued that Harlem was the center of this new arena of creative expression (**Reading 36.3**):

READING 36.3

Alain Locke, *The New Negro* (1925)

[There arises a] consciousness of acting as the advance-guard of the African peoples in their contact with Twentieth Century civilization . . . [and] the sense of a mission of rehabilitating the race in world esteem from that loss of prestige for which the fate and conditions of slavery have so largely been responsible. Harlem, as we shall see, is the center of both these movements The pulse of the Negro world has begun to beat in Harlem The New Negro . . . now becomes a conscious contributor and lays aside the status of beneficiary and ward for that of a collaborator and participant in American civilization. The great social gain in this is the releasing of our talented group from the arid fields of controversy and debate to the productive fields of creative expression And certainly, if in our lifetime the Negro should not be able to celebrate his full initiation into American democracy, he can at least, on the warrant of these things, celebrate the attainment of a significant and satisfying new phase of group development, and with it a spiritual Coming of Age.

In Locke's view, each ethnic group in America had its own identity, which it was entitled to protect and promote, and this claim to cultural identity need not conflict with the claim to American citizenship. Locke further emphasized that the spirit of the young writers who were a part of this anthology would drive this new Harlem-based movement by focusing on the African roots of black art and music, but they would, in turn, contribute mightily to a new, more inclusive American culture.

Among the many poems and stories published in the *Survey Graphic* and *The New Negro* is "Heritage" by Countee Cullen (1903–1946) (Fig. **36.2**). Cullen was the adopted son of Frederick Cullen, pastor of the Salem Methodist Episcopal church in Harlem, and his wife, Carolyn, both of whom had strong ties to the NAACP and the National Urban League. Cullen later described his life in their household as a constant attempt at "reconciling a Christian upbringing with a pagan inclination." "Heritage" investigates that tension (see **Reading 36.4**, pages 1207–1208, for the complete poem):

Fig. 36.2 Carl Van Vechten, *Portrait of Countee Cullen in Central Park*. 1941. Gelatin silver photographic print. Library of Congress Prints and Photographs Division, Washington, D.C. The photographer, Carl Van Vechten (1880–1964), was a white journalist and novelist who actively promoted black artists and writers in the 1920s. His popular 1926 novel *Nigger Heaven*, named after the top tier of seats reserved for blacks in a segregated theater, was white America's introduction to Harlem culture, although the black intelligentsia almost unanimously condemned it for its depiction of Harlem as an amoral playground.

Lamb of God, although I speak
With my mouth thus, in my heart
Do I play a double part.
Ever at Thy glowing altar
Must my heart grow sick and falter,
Wishing He I served were black . . .

Although the poem has been criticized for its romantic depiction of Africa, it remains a powerful statement of Du Bois's sense of African-American double-consciousness. As cultural historian Houston Baker, Jr., has described it in *Afro-American Poetics: Revisions of Harlem and the Black Aesthetic*, "The entire poem is placed in a confessional framework as the narrator tries to define his relationship to some white . . . being and finds that a black impulse ceaselessly draws him back."

This theme of "doubleness" was underscored when the poem appeared in *Survey Graphic*. There it was illustrated by photographs of African statues and masks, reproduced from the collection of the Barnes Foundation in Philadelphia. Albert C. Barnes, who had made his fortune from the development of an antiseptic drug, was particularly noted not only for his collection of modern art, including Matisse's *Bonheur de vivre* (see Fig. 34.5), but also for his early and vigorous collecting of African art. In an article for the *Survey Graphic*, entitled "Negro Art and America," Barnes wrote:

> The renascence [sic] of Negro art is one of the events of our age which no seeker for beauty can afford to overlook. It is as characteristically Negro as are the primitive African sculptures. As art forms, each bears comparison with the great art expressions of any race or civilization. In both ancient and modern Negro art we find a faithful expression of a people and of an epoch in the world's evolution.

This kind of support from the white establishment was central to the cultural resurgence of Harlem. Many of New York's whites also supported the uptown neighborhood's thriving nightlife scene. Prohibition, and the speakeasies it spawned, had created in Harlem a culture of alcohol, nightlife, and dancing, and with them, the loose morality of the party life, indulged in particularly by the white clientele to whom the clubs catered.

Langston Hughes and the Poetry of Jazz

As the young poet Langston Hughes (1902–1967) later put it, "Negro was in vogue." Hughes was among the new young poets that Locke published in *The New Negro*, and the establishment publishing house, Knopf, would publish his book of poems, *Weary Blues*, in 1926. Twenty-two years of age in 1924, Hughes had gone to Paris seeking a freedom he could not find at home (see *Continuity & Change*, Chapter 35). He was soon writing poems inspired by the jazz rhythms he was hearing played by the African-American bands in the clubs where he worked as a busboy and dishwasher. The music's syncopated rhythms can be heard in poems such as "Jazz Band in a Parisian Cabaret" (**Reading 36.5a**):

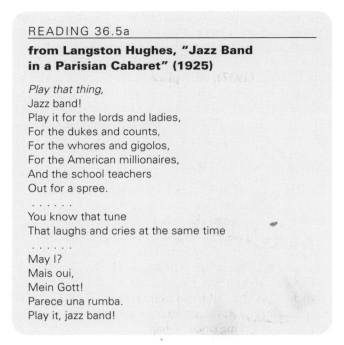

READING 36.5a

from Langston Hughes, "Jazz Band in a Parisian Cabaret" (1925)

Play that thing,
Jazz band!
Play it for the lords and ladies,
For the dukes and counts,
For the whores and gigolos,
For the American millionaires,
And the school teachers
Out for a spree.
.
You know that tune
That laughs and cries at the same time
.
May I?
Mais oui,
Mein Gott!
Parece una rumba.
Play it, jazz band!

African Americans like Hughes had been drawn to Paris by reports of black soldiers who had served in World War I, in the so-called Negro divisions, the 92nd and 93rd Infantries. Something approaching jazz was introduced to the French by Lieutenant James Reese Europe, whose 815th Pioneer Infantry band played in city after city across the country. They played a combination of standard band music, dance music, and tunes subjected to some degree of "ragging." In fact, he was the principal composer for the white society dancers Vernon and Irene Castle, and his music helped propel the foxtrot into great popularity. But most important, the band experienced something they never had in the United States—total acceptance by people with white skin. But Harlem, largely because of the efforts of Du Bois, Johnson, and Locke, soon replaced Paris in the African-American imagination.

In Harlem, Hughes quickly became one of the most powerful voices. His poems (see **Reading 36.5**, pages 1208–1209, for a selection) narrate the lives of his people, capturing the inflections and cadences of their speech. In fact, the poems celebrate, most of all, the inventiveness of African-American culture, especially the openness and ingenuity of its music and language. Hughes had come to understand that his cultural identity rested not in the grammar and philosophy of white culture, but in the vernacular expression of the American black, which he could hear in its music (the blues and jazz especially) and its speech.

Zora Neale Hurston and the Voices of Folklore

The writer and folklorist Zora Neale Hurston (1891–1960) felt the same way. Slightly younger than many of her other Harlem Renaissance colleagues, while still an undergraduate at Howard University she attracted the attention of Hughes when she published a short story, "Spunk," in the black

journal *Opportunity*. She transferred to Columbia, where she finished her degree under the great anthropologist Franz Boas, undertaking field research from 1927 to 1932 to collect folklore in the South. Her novel, *Their Eyes Were Watching God* (1937), takes place in a town very much like her native Eatonville, Florida, where she was raised. Its narrator, Janie Crawford, has returned home after being away for a very long time. The townsfolk, particularly the women, are petty, unwelcoming, and gossipy.

The Quilts of Gee's Bend

From the outset, Hurston's writing concerned itself primarily with the question of African-American identity—an identity she located in the vernacular speech of her native rural South and in the stories of the people who lived there. Hurston's mastery of the dialect and the nuances of African-American speech is unsurpassed. She recognized in this vernacular language something distinctly modern.

In fact, in the isolated community of Gee's Bend, Alabama, an indigenous grassroots approach to textile design had been flourishing since perhaps the late nineteenth century, although it would remain completely unknown until William Arnett, a collector and scholar of African-American art, rediscovered the community and its continuing quilt-making tradition in the late 1990s. Surrounded on three sides by the Alabama River, and open to the world on the other by an often impassable road, Gee's Bend was almost completely isolated, and over the years, its quilters had developed a distinct aesthetic sensibility that they had passed on from one generation to the next. In 2006, the Museum of Fine Arts, Houston, organized an exhibit of quilts made by four generations of Gee's Bend women that rivaled in every way the inventiveness and freedom of modern abstract art. In *Gee's Bend: The Architecture of the Quilt*, Arnett describes the quilts in terms that evoke jazz, that other vernacular form of African-American expression that rose to prominence in the Harlem Renaissance (and which will be discussed in a moment). The quilts are distinguished, he writes, by their preference for "asymmetry, strong contrast, and affective color changes, syncopation and pattern breaks, and an improvisational flair." They take on, especially, the shapes and rhythms of the improvisational rural architecture of Gee's Bend itself, in which, in the case of Jessie T. Pettway's *Bars and String-Pieced Columns* (Fig. **36.3**), random scraps of odd-shaped wooden slats might be nailed across a frame of two-by-fours. As the Houston exhibit has traveled around the United States since 2006, it has become clear that a new and unique vernacular modernism has developed independently of the mainstream art world.

All That Jazz

By the time of the Great Migration, jazz had established itself as the music of African Americans. So much did the music seem to define all things American that the novelist F. Scott Fitzgerald (1896–1940) entitled a collection of

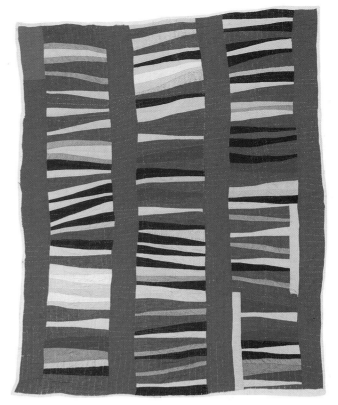

Fig. 36.3 Jessie T. Pettway, *Bars and String-Pieced Columns,* **1950s.** Cotton, 95″ × 76″. Provided by the Tinwood Alliance (http://www.tinwoodmeida.com) Photo: Steve Pitking / Pitking Studios © 2003. Collection, Atlanta. The loose structure of Pettway's quilt creates an almost giddy sense of imbalance.

short stories published in 1922 *Tales of the Jazz Age*, and the name stuck. By the end of the 1920s, jazz was *the* American music, and it was almost as popular in Paris and Berlin as it was in New York, Chicago, and New Orleans. As we saw in Chapter 32, it originated in New Orleans in the 1890s, probably the most racially diverse city in America, particularly in the ragtime piano music of Scott Joplin and others. But it had deep roots as well in the blues.

The Blues and Their "Empress," Bessie Smith If syncopated rhythm is one of the primary characteristics of jazz, another is the **blue note**. Blue notes are slightly lower or flatter than conventional pitches. In jazz, blues instrumentalists or singers commonly "bend" or "scoop" a blue note—usually the third, fifth, or seventh notes of a given scale—to achieve heightened emotional effects. Such effects were first established in the blues proper, a form of song that originated among enslaved black Americans and their descendants.

The **blues** are by definition laments bemoaning loss of love, poverty, or social injustice, and they contributed importantly to the development of jazz. The standard blues form consists of three sections of four bars each. Each of these sections corresponds to the single line of a three-line stanza, the first two lines of which are the same. In his 1925 poem "Weary Blues," Langston Hughes describes listening

to a blues singer in a Harlem club (see Reading 36.5, pages 1208–1209 for the entire poem):

> Droning a drowsy syncopated tune,
> Rocking back and forth to a mellow croon,
> I heard a Negro play.
> Down on Lenox Avenue the other night
> By the pale dull pallor of an old gas light
> He did a lazy sway . . .
> He did a lazy sway . . .
>
> Thump, thump, thump, went his foot on the floor.
> He played a few chords then he sang some more—
> "I got the Weary Blues
> And I can't be satisfied.
> I got the Weary Blues
> And I can't be satisfied.
> I ain't happy no mo'
> And I wish that I had died."

The last lines are the standard blues form (expanded by Hughes to six instead of three lines for the sake of his own poetic meter).

Early blues artists whose performances are preserved on record include Ma Rainey (1886–1939) and Robert Johnson (1911–1938). But perhaps the greatest of the 1920s blues singers was Bessie Smith (1892–1937), who grew up in Tennessee singing on street corners to support her family (Fig. **36.4**). In 1923, when she was 29 years old, she made her first recording, and audiences were stunned by the feeling that she brought to her performances. She was noted particularly for the way she added a chromatic note before

the last note of a line, so that, in her *Florida-Bound Blues* (track **36.1**), for instance,

becomes

The additional note might be delivered quickly, or it might be stretched out, adding an extended sense of dissonance and anguished tension to the blues form. When, by the early 1930s, audiences began to prefer a smoother approach to the blues, Smith's popularity waned. Nor did she fit the more acceptable image of the light-skinned, white-featured black entertainer. Traveling from one-night stand to one-night stand in honky-tonks across the Deep South, she died in an automobile accident in 1937.

Dixieland and Louis Armstrong in Chicago

The bands that played around 1910 to 1920 in the red-light district of New Orleans, the legendary Storeyville, quickly established a standard practice. A "front line," consisting of trumpet (or cornet), clarinet, and trombone, was accompanied by banjo

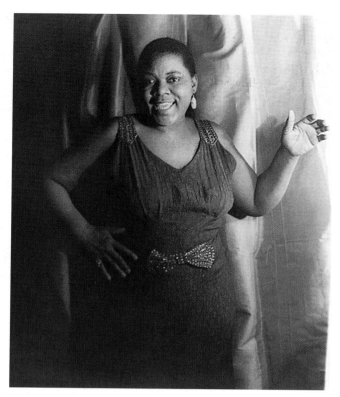

Fig. 36.4 Carl Van Vechten, Bessie Smith. n.d. Black-and-white negative, 4″ × 5″. Yale Collection of American Literature, Beinecke Rare Book and Manuscript Library. Van Vechten's collection of photographs and other documents pertaining to the Harlem Renaissance remains one of the era's most important documentary records.

(later guitar), piano, bass, and drums. In **Dixieland jazz**, as it came to be known, the trumpet carried the main melody and the clarinet played off against it with a higher counter-melody, while the trombone played a simpler, lower tune. The most popular forms of Dixieland were the standard 12-bar blues and a 32-bar AABA form. The latter consists of four 8-measure sections. Generally speaking, the trumpet plays the basic tune for the first 32 measures of the piece, then the band plays variations on the tune in a series of solo or collective improvisations keeping to the 32-bar format. Each 32-bar section is called a "chorus."

When Storeyville was shut down in 1917 (on orders from the U.S. Navy, whose sailors' discipline they believed was threatened by its presence), many of the bands that had played in the district joined the Great Migration and headed north. Among them was trumpeter Louis Armstrong (1901–1971), who arrived in Chicago in 1922 to play for Joe Oliver's Creole Jazz Band. The pianist and composer Lil Hardin (1898–1971) was the pianist and arranger for Oliver's band, and she and Armstrong were married in 1924. Soon, Armstrong left Oliver's band to play on his own. He formed two studio bands composed of former New Orleans colleagues, the Hot Five and the Hot Seven, with whom he made a series of groundbreaking recordings. One, *Hotter Than That* (track **36.2**),

HEAR MORE at www.myartslab.com

HEAR MORE at www.myartslab.com

written by Hardin and recorded in 1927, is based on a 32-bar form over which the performers improvise. In the third chorus, Armstrong sings in nonsense syllables, a method known as **scat**. This is followed by another standard form of jazz band performance, a **call-and-response** chorus between Armstrong and guitarist Lonnie Johnson, the two imitating one another as closely as possible on their two different instruments.

Swing: Duke Ellington at the Cotton Club The same year that Armstrong recorded *Hotter Than That*, Duke Ellington, born Edward Kennedy Ellington in Washington, D.C. (1899–1974), began a five-year engagement at Harlem's Cotton Club (Fig. **36.5**). The Cotton Club itself was owned by a gangster who used it as an outlet for his "Madden's #1 Beer," which, like all alcoholic beverages, was banned after National Prohibition was introduced in 1920. The Club's name was meant to evoke leisurely plantation life for its "white only" audience who came to listen to its predominantly black entertainers.

Ellington had formed his first band in New York in 1923. His 1932 *It Don't Mean a Thing (If It Ain't Got That Swing)* (track **36.3**) introduced the term **swing** to jazz culture. (A particularly clear example of a "blue note" can be heard, incidentally, on the first "ain't" of the first chorus of *It Don't Mean a Thing*.) Swing is characterized by big bands—as many as 15 to 20 musicians, including up to five saxophones (two altos, two tenors, and a baritone)—resulting in a much bigger sound. Its rhythm depends on subtle avoidance of downbeats with the solo instrument attacking the beat either just before or just after it.

By the time Ellington began his engagement at the Cotton Club, commercial radio was seven years old, and many thousands of American homes had a radio. Live radio broadcasts from the Cotton Club brought Ellington national fame, and he was widely imitated throughout the 1930s by bands who toured the country. These included bands led by clarinetist Benny Goodman, soon known as "the King of Swing"; trumpeter Harry James; trombonist Glenn Miller; trombonist Tommy Dorsey; pianist Count Basie; and clarinetist Artie Shaw. These bands also featured vocalists, and they introduced the country to Frank Sinatra, Bing Crosby, Perry Como, Sarah Vaughan, Billie Holiday, Peggy Lee, Doris Day, Rosemary Clooney, and Ella Fitzgerald.

Jazz influenced almost every form of music after 1920. Debussy imitated rag in his 1908 *Golliwog's Cakewalk*. Stravinsky composed a *Ragtime for Eleven Instruments* in 1917. The American composer George Gershwin incorporated jazz rhythms into his 1924 piano and orchestra composition, *Rhapsody in Blue*, and his 1935 opera *Porgy and Bess* incorporated jazz, blues, and spiritual in a way that revived musical theater and paved the way for the great musicals of the 1940s and 1950s. In fact, *Porgy and Bess* has been staged and recorded both by jazz greats—Louis Armstrong and Ella

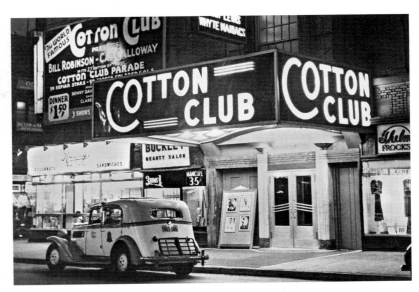

Fig. 36.5 The Cotton Club, Lenox Avenue and 143rd Street. Early 1930s. Corbis-Bettmann Photo Archive. In 1927, Duke Ellington's orchestra was hired to play at the club, and soon Cab Calloway's band alternated with Ellington. It was also at the Cotton Club that Lena Horne began her career in 1933, at age 16.

HEAR MORE at www.myartslab.com

Fitzgerald—and by professional opera companies, bridging the gap between popular art and high culture as few works before it ever had.

The Visual Arts in Harlem

The leading visual artist in Harlem in the 1920s was Aaron Douglas (see Fig. 36.1). When he arrived in Harlem in 1925, his first major work was as illustrator of a book of verse sermons by the Harlem Renaissance poet and executive secretary of the NAACP James Weldon Johnson (1871–1938), *God's Trombones: Seven Sermons in Verse*. Like his friend and colleague Zora Neale Hurston, Johnson was interested in preserving the voices of folklore, specifically folk sermons. "I remember," Johnson writes in the preface to *God's Trombones*, "hearing in my boyhood sermons that . . . passed with only slight modifications from preacher to preacher and from locality to locality." One of these was the story of "The Prodigal Son," updated to reflect life in the streets of 1920s Harlem (**Reading 36.6**):

READING 36.6

from James Weldon Johnson, "The Prodigal Son" (1927)

And the city was bright in the night-time like day,
The streets all crowded with people,
Brass bands and string bands a-playing,
And ev'rywhere the young man turned
There was singing and laughing and dancing.
And he stopped a passer-by and he said:
Tell me what city is this?

And the passer-by laughed and said: Don't you know?
This is Babylon, Babylon,
That great city of Babylon.
Come on, my friend, and go along with me.
And the young man joined the crowd

And the young man went with his new-found friend,
And bought himself some brand new clothes,
And he spent his days in the drinking dens,
Swallowing the fires of hell.
And he spent his nights in the gambling dens,
Throwing dice with the devil for his soul.
And he met up with the women of Babylon.
Oh, the women of Babylon!
Dressed in yellow and purple and scarlet,
Loaded with rings and earrings and bracelets,
Their lips like a honeycomb dripping with honey,
Perfumed and sweet-smelling like a jasmine flower;
And the jasmine smell of the Babylon women
Got in his nostrils and went to his head,
And he wasted his substance in riotous living,
In the evening, in the black and dark of night,
With the sweet-sinning women of Babylon.
And they stripped him of his money,
And they stripped him of his clothes,
And they left him broke and ragged
In the streets of Babylon

Fig. 36.6 Aaron Douglas, Illustration for "The Prodigal Son," in James Weldon Johnson, *God's Trombones: Seven Sermons in Verse.* 1927. University of North Carolina Library. Douglas's inclusion of the fragment of a dollar, the tax stamp from a package of cigarettes (at the bottom right), a playing card, and the fragment of the word "gin" all reflect his awareness of French Cubism.

Douglas's illustration (Fig. **36.6**) makes the timeliness of Johnson's poem abundantly clear. His two-dimensional silhouetted figures would become the signature style of Harlem Renaissance art, in which a sense of rhythmic movement and sound is created by abrupt shifts in the direction of line and mass.

His influence is evident in the later work of Jacob Lawrence (1917–2000) (see Fig. 35.18), who met Douglas soon after arriving in Harlem in the mid-1930s. The angularity and rhythmic repetition of forms that Douglas introduced is evident in many of Lawrence's paintings for the *Great Migration* series of 1939 to 1941, particularly in his illustration of three girls writing on a chalkboard at school (Fig. **36.7**). Here the intellectual growth of the girls, as each reaches higher on the board, is presented as a musical crescendo in a syncopated, four-beat, rhythmic form where the first beat, as it were, is silent and unplayed. But above all, what the art of both Douglas and Lawrence makes clear is the connectedness of literature, music, and visual image in African-American experience. Such connections would continue to inform African-American culture for the rest of the century.

Fig. 36.7 Jacob Lawrence, *In the North the Negro had better educational facilities,* panel 58 from *The Migration of the Negro.* 1940–41. Casein tempera on hardboard, 12″ × 18″. Gift of Mrs. David M. Levy. The Museum of Modern Art/Licensed by SCALA/Art Resource, New York. © 2007 Artists Rights Society (ARS), New York. Note that Lawrence dresses the girls in the primary colors of red, yellow, and blue, thus emphasizing the fundamental nature of primary education.

SKYSCRAPER AND MACHINE: ARCHITECTURE IN NEW YORK

After the First World War, New York experienced a building boom outstripped only by the growth of its population. The skyscraper, a distinctly American invention, was first developed in Chicago, where Louis Sullivan took the lead (see Fig. 32.25), but it found its ultimate expression in New York. There, skyscrapers were usually commissioned by corporations as their national and international headquarters (Map **36.1**). The skyscraper was above all a grand advertisement, a symbol of corporate power and prestige that changed the skyline of New York and became a symbol for the city around the world. The Singer Building of 1902 was followed by the Metropolitan Life Tower (1909), the Woolworth Building (1913), the Shelton Towers (1924), the Chrysler Building (1930) (Fig. **36.8**), the Empire State

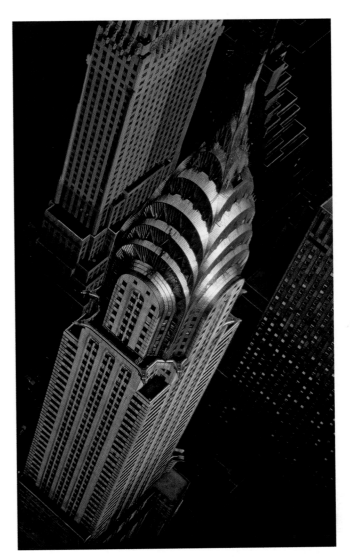

Fig. 36.8 William van Alen, Chrysler Building, New York. 1928–30.
The building's steel crown, shown in this detail, was understood to be an emblem of the new technological ascendancy of not just the Chrysler Corporation, but America itself.

SEE MORE For a Closer Look at William van Alen's Chrysler Building, go to **www.myartslab.com**

Building (1931), and the RCA Building (1933). Each strove to be the world's highest, and briefly was, until it was succeeded, often within a matter of months, by the next.

Walter Chrysler's Chrysler Building was, for instance, pure advertisement. The site was opposite Grand Central Station on 42nd Street and Lexington Avenue, at the very heart of Manhattan. Chrysler informed William van Alen, his architect, that he expected the building to be the tallest building in the world, "higher than the Eiffel Tower." Van Alen's former partner, H. Craig Severance, had already broken ground for the Bank of Manhattan Trust Building at 40 Wall Street (today the Trump Building), and the two entered into a fierce competition. When Severance's building was completed, just months before van Alen's, it was, at

Map. 36.1 New York City skyscrapers.

LEARN MORE Gain insight from an architectural simulation of sckyscrapers at **www.myartslab.com**

71 stories and 927 feet tall, the tallest structure in the world. Then van Alen surprised everyone. He had secretly constructed a 185-foot spire inside his building. At the last minute, he hoisted it up through the roof and bolted it in place. The Chrysler Building was now a staggering 77 stories and 1,046 feet tall.

The first six floors of the crowning spire were reserved for Walter Chrysler's private use. They included an observation deck and a lounge displaying his personal tool box, consisting of forged and tempered steel tools that Chrysler made by hand when he was 17 years of age and that he referred to as the "tools that money couldn't buy." The exterior of the spire was crowned with a stainless steel crest, punctuated by triangular windows in radiating semicircles (designed to evoke Chrysler hubcaps). At night, the windows were lit, adding a new graceful, arcing form to the increasingly rectilinear horizon of the New York cityscape.

Within a year, the Empire State Building became the world's tallest building, at 102 stories and 1,250 feet high. But aside from its sheer size, the Chrysler Building's decoration was what set it apart. It was self-consciously Art Deco, a term coined in the 1960s after the 1925 Arts Décoratifs exhibition in Paris to describe a style that was known at the

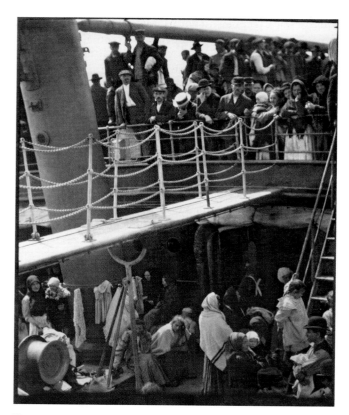

Fig. 36.10 Alfred Stieglitz, *The Steerage.* **1907.** Photogravure, 13 $^3/_{16}$″ × 10 $^3/_8$″. Courtesy George Eastman House. © 2008 Artists Rights Society (ARS), NY. Stieglitz first published this photograph in *Camera Work* in 1911.

time as Art Moderne, noted for its highly stylized forms and exotic materials. And among the most exotic of these materials in the late 1920s was stainless steel, first patented in the United States in 1915. The spire's crown was clad in the material and from the sixty-first floor of the Chrysler Building, giant Art Deco stainless steel eagles, replicas of Chrysler's hood ornaments, pointed their beaks outward like gargoyles (Fig. **36.9**)

The Machine Aesthetic

Perhaps more than anything else, the Chrysler Building is a monument to the technology and the spirit of the new that technology inspired. Around the thirty-first floor, Chrysler hubcaps were placed in brickwork shaped like tires. It was part and parcel of a machine aesthetic that dominated the day, most fully articulated by Alfred H. Barr, Jr. (1902–1981), director of the new Museum of Modern Art in New York, and his young curator of architecture, Philip Johnson (1906–2005), in an exhibition entitled *Machine Art.* The subject of enormous press coverage when it opened in 1934, the exhibit featured springs, propellers, ball bearings, kitchen appliances, laboratory glass and porcelain (including boiling flasks made from Pyrex, a new durable material that would transform modern kitchenware), and machine parts displayed on pedestals. Crowds thronged to the museum to see the 402 items Barr and Johnson had chosen. All of these objects were defined by

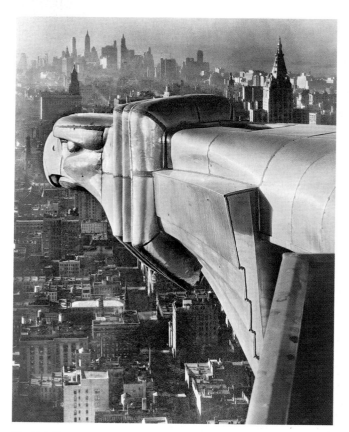

Fig. 36.9 Margaret Bourke-White, *Chrysler Building: Gargoyle outside Margaret Bourke-White's Studio.* **1930.** Gelatin silver print, 12 $^{15}/_{16}$″ × 9 $^1/_4$″. Courtesy George Eastman House, Rochester, NY. One of the most important photographers of the day, Bourke-White would become one of *Life* magazine's most important contributors (the magazine's first cover was shot by her in 1936). This shot was taken from her studio in the Chrysler Building.

their simple geometric forms, symmetry, balance, and proportion—in short a new, machine-inspired classicism.

Earlier in the century, Alfred Stieglitz [STEE-glitz] (1864–1946) had proposed that modern art—and his own photography in particular—should concern itself with revealing the underlying geometries of the world. At a small New York gallery, named simply 291, after its address at 291 Fifth Avenue, Stieglitz had hosted Matisse's first one-person show outside of France. He mounted two more shows of Matisse's work in 1910 and 1912. Stieglitz had also been the first in the United States to exhibit Picasso, showing more than 80 of his works on paper in 1911.

Stieglitz valued both artists for the attention they paid to formal composition over and above any slavish dependence on visual appearance. He valued, in other words, the conceptual qualities of their work as opposed to their imagery. This is perhaps surprising for a photographer, but describing the inspiration of his own 1906 photograph *The Steerage* (Fig. **36.10**), he would later recall:

There were men, women and children on the lower level of the steerage [the lower class deck of a steamship] The scene fascinated me: A round straw hat; the funnel leaning left, the stairway leaning right; the white drawbridge, its railings made of chain; white suspenders crossed on the back of a man below; circular iron machinery; a mast that cut into the sky, completing a triangle. I stood spellbound for a while. I saw shapes related to one another—a picture of shapes, and underlying it, a new vision that held me

The photographers and painters Stieglitz championed—including Georgia O'Keeffe (1887–1986), whom he would later marry—were all dedicated to revealing these same geometries in the world. In *Camera Work*, the photography magazine he published from 1903 to 1916, Stieglitz reproduced modern paintings and similarly modern photographs like *Abstraction, Porch Shadows* by Paul Strand (1890–1976) (Fig. **36.11**). Strand's image is an unmanipulated

Fig. 36.11 Paul Strand, *Abstraction, Porch Shadows*. 1916. Silver-platinum print, 12$\frac{15}{16}$" × 9$\frac{5}{8}$". Inv. Pho1981-35-10. Repro-Photo: Rene-Gabriel Ojeda. Musée d'Orsay, Paris, France. Réunion des Musées Nationaux/Art Resource, New York. When Stieglitz published this photograph in the last issue of *Camera Work*, June 1917, he called it "the direct expression of today."

Fig. 36.12 Alfred Stieglitz, *Looking Northwest from the Shelton, New York*. 1932. Gelatin silver print, 9$\frac{1}{2}$" × 7$\frac{9}{16}$". The Metropolitan Museum of Art, New York. Ford Motor Company Collection, Gift of Ford Motor Company and John C. Waddell, 1987 (1987.1100.11). Image © The Metropolitan Museum of Art/Art Resource, New York. © 2008 Artists Rights Society (ARS), New York. The Shelton Towers, on Lexington Avenue between 48th and 49th Streets, was built in 1924. At 36 stories, it was the tallest building in the world, a record soon surpassed as this photograph, taken from Stieglitz's suite on the thirtieth floor, suggests.

photograph (that is, not altered during the development process) of the shadows of a railing cast across a porch and onto a white patio table turned on its side. Its debt to Picasso and Braque's Cubism was not lost on the magazine's audience.

In 1925, Stieglitz moved into an apartment on the thirtieth floor of the 36-story Shelton Towers (see Map 36.1), and from his window, he began to photograph the city rising around him—the grids of buildings under construction, the rhythmic repetition of window and curtain wall, the blocks of form delineated by the intense contrast of black and white in the photographic print (Fig. **36.12**). In the skyscraper, he believed he had discovered the underlying geometry of modernity itself.

The International Style

Stieglitz lived in the Shelton Towers for 12 years, and from his window, he witnessed a building boom like none other in the history of architecture. In the second half of the 1920s, the city's available office space increased by 92 percent. By the early 1930s, after buildings begun before 1929 were completed, the available space increased by another

56 percent. The building frenzy took place in an atmosphere of intense debate among architects themselves. On one side were the traditionalists whose decorative style was epitomized by the Woolworth Building (Fig. **36.13**).

Fig. 36.13 Cass Gilbert, *Woolworth Building, New York City, sketch elevation*. December 31, 1910. Graphite on paper. Library of Congress, Prints and Photographs Division. Gilbert's sketch captures the building's Gothic spirituality even better than actual photographs of the finished building, which was completed in 1913.

Fig. 36.14 Frank Lloyd Wright, Robie House, South Woodlawn, Chicago, Illinois. 1909. Wright derived from Louis Sullivan the belief that good architecture must be rooted in its relation to the natural world.

Writing about its neo-Gothic facade, architect Cass Gilbert (1859–1934) described it as follows: "A skyscraper, by its height . . . a monument whose masses must become more and more inspired the higher it rises The Gothic style gave us the possibility of expressing the greatest degree of aspiration . . . the ultimate note of the mass gradually gaining in spirituality the higher it mounts." From the modernist point of view, Gilbert's building represented the height of absurdity, and "Woolworth Gothic" became synonymous with bad taste, but building after building continued to emulate the Woolworth's emphasis on decorative styling.

On the other side of the debate were those who advocated an austere, clean modernism that revealed its plain geometries. This new architecture would come to be known as the International Style, after Alfred H. Barr, Jr., and Philip Johnson curated another show, in 1932, two years before the *Machine Art* exhibition, called the *International Exhibition of Modern Architecture* with an accompanying catalogue titled *The International Style: Architecture since 1922*. From the curators' point of view, a new "controlling" architectural style had emerged in Europe after the war without regard to national tastes or individual concerns (its European manifestations are discussed in Chapter 37). The principles of this new International Style were related to the machines they also admired: pure forms ("architecture as volume rather than mass") without "arbitrary applied ornament" (a slap at Louis Sullivan's Chicago School of architecture), and with severe, flat surfaces in its place. The American chosen to represent the style was Frank Lloyd Wright (1867–1959).

It was Barr who insisted that Wright be included in the exhibition. His colleague Philip Johnson regarded Wright as old-fashioned, of no serious worth, and stylistically inconsistent with the International Style. Wright, in turn, despised both the International Style and Johnson. But he was included because he was a former student of Louis Sullivan and because Europeans considered him the leader of modern architecture. What Wright had done, they understood, was open up the interior of the building, to destroy the box-like features that traditionally defined a room.

In his early architecture, like the Robie House (Figs. **36.14** and **36.15**), Wright had employed many of the same principles that guided architects of the

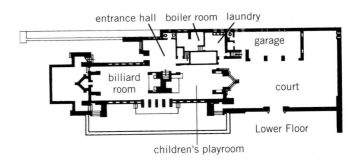

children's playroom

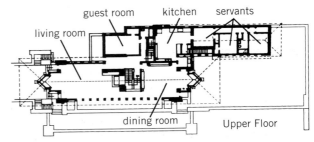

Fig. 36.15 Plan of the Robie House.

International Style—open interior spaces, steel-frame construction, concrete cantilevers that extended over porches to connect exterior and interior space, a raised first floor to provide for privacy, and walls consisting entirely of windows. But his inspiration was nature—his sense of place—not the machine. He called houses such as the Robie House "Prairie Houses," because in their openness and horizontality they reflected the Great Plains. The materials he employed were local—brick from local clays, oak woodwork, and so on.

Furthermore, Wright believed that each house should reflect not just its region but also its owner's individuality.

He abhorred the uniformity that the International Style promoted. This is especially evident at Fallingwater, the house at Bear Run in Pennsylvania which he designed in 1935 for Pittsburgh entrepreneur Edgar Kaufmann, owner of the largest men's clothing store in the country (Fig. **36.16**). Wright thought of Fallingwater as consistent with his earlier Prairie Houses because it was wedded to its site. But this site was distinguished by the cascades of Bear Run, falling down over a series of cliffs. Wright opened a quarry on the site to extract local stone and built a three-level house literally over the stream, its enormous cantilevered decks echoing the surrounding cliffs.

Fallingwater, finally, for Wright had to be in harmony with its site, not some white industrial construction plopped into the landscape. "I came to see a building," Wright wrote in 1936, "primarily . . . as a broad shelter in the open, related to vista; vista without and vista within. You may see in these various feelings, all taking the same direction, that I was born an American, child of the ground and of space." Wright's stunning and original design suggests a distinctly American sensitivity to place.

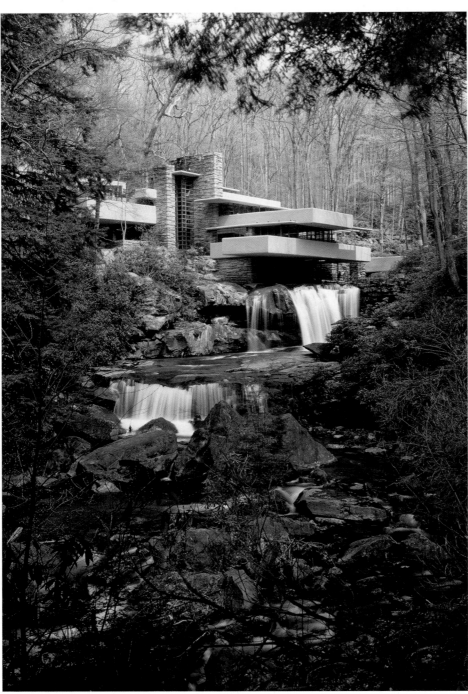

Fig. 36.16 Frank Lloyd Wright, Fallingwater (Kaufmann House), Bear Run, Pennsylvania. 1935–36. The first drawings for Fallingwater were done in a matter of hours after Wright had thought about the project for months.

MAKING IT NEW: THE ART OF PLACE

In the fall of 1929, Stieglitz opened a new gallery called An American Place on the seventeenth floor of a building on Madison Avenue at 53rd Street in New York (see Map 36.1). The name was primarily intended to reflect the gallery's emphasis on American art, but it also defined that art as possessing, as indeed Frank Lloyd Wright's architecture did, a distinct sense of place. The Harlem Renaissance had played an enormous role in creating this sense of an distinct American identity. Its music, especially, was widely understood as one of the first truly "authentic" expressions of American experience, unfettered by European influence or tradition. The blues, jazz, and swing constituted a "new," distinctly American music, to which writer F. Scott Fitzgerald had responded by coining the phrase "Jazz Age."

The New American Novel and Its Tragic Sense of Place

If the music of the era seemed to grow out of the American experience with the ring of certain truth; the Jazz Age itself, as Fitzgerald portrayed it, seemed to rise out of its opposite, the crassly and tragically materialistic culture of the day (the same world of easy money, fast women, and alcohol that swirls around Douglas's illustration of Johnson's "Prodigal Son"), out of the tragedy of war—not only World War I but also the still lingering effects of the American Civil War—which was, in the eyes of many, a direct result of this culture.

Fitzgerald and *The Great Gatsby* "That's the whole burden of this novel," Fitzgerald wrote of his novel *The Great Gatsby* in 1924, the year before it was published, "the loss of those illusions that give such color to the world that you don't care whether things are true or false as long as they partake of the magical glory." Set in New York City and on Long Island in the 1920s, the novel tells the story of Jay Gatsby, born Jimmy Gatz, who, as a boy of 17, "his heart . . . in a constant turbulent riot," had imagined for himself "a universe of ineffable gaudiness," and by the time he was 32, realized it. His neighbor, Nick Carraway, the novel's narrator, relates the weekend scene at Gatsby's West Egg home (**Reading 36.7a**):

READING 36.7a

from F. Scott Fitzgerald, *The Great Gatsby* (1925)

In his blue gardens men and girls came and went like moths among the whisperings and the champagne and the stars. At high tide in the afternoon I watched his guests diving from the tower of his raft, or taking the sun on the hot sand of his beach while his two motor-boats slit the waters of the Sound, drawing aquaplanes over the cataracts of foam And on Mondays eight servants, including an extra gardener, toiled all day with mops and scrubbing-brushes and hammers and garden-shears, repairing the ravages of the night before.

Every Friday, five crates of lemons and oranges arrived from a fruiterer in New York—every Monday these same lemons and oranges left his backdoor in a pyramid of pulpless halves. There was a machine in the kitchen that could extract the juice of two hundred oranges in half an hour if a little button was pressed two hundred times by a butler's thumb.

At least once a fortnight a crop of caterers came down with several hundred feet of canvas and enough colored lights to make a Christmas tree of Gatsby's enormous garden. On buffet tables, garnished with glistening hors-d'oeuvre, spiced baked hams crowded against salads of harlequin designs and pastry pigs and turkeys bewitched to a dark gold. In the main hall, a bar with a real brass rail was set up, and stocked with gins and liquors and with cordials

By seven o'clock the orchestra has arrived, no thin five-piece affair, but a whole pitful of oboes and trombones and saxophones and viols and cornets and piccolos and high and low drums The bar is in full swing, and floating rounds of cocktails permeate the garden outside, until the air is alive with chatter and laughter, and casual innuendo and introductions forgotten on the spot, and enthusiastic meetings between women who never knew each other's names.

It is all a great show, a charade conceived by Gatsby to win the heart of Daisy Buchanan, who lives with her husband Tom across the bay in more fashionable East Egg, the green light on her dock forever in his view. Gatsby is "an unbroken series of successful gestures," a fabric of deceit built on an empty morality of wealth as an end itself that inevitably collapses. Nick Carraway goes so far as to say that listening to Gatsby talk "was like skimming hastily through a dozen magazines," the American Dream in all its shallowness.

And yet, Nick recognizes, there is something about Gatsby that is indeed "great." At the novel's end, Gatsby dead, Nick stretches out on Gatsby's beach and recalls the spirit of discovery and wonder that the original settlers of America must have felt (**Reading 36.7b**):

READING 36.7b

from F. Scott Fitzgerald, *The Great Gatsby* (1925)

I gradually became aware of the old island here that flowered once for Dutch sailors' eyes—a fresh, green breast of the new world. Its vanished trees, the trees that had made way for Gatsby's house, had once pandered in whispers to the last and greatest of all human dreams; for a transitory enchanted moment man must have held his breath in the presence of this continent,

compelled into an aesthetic contemplation he neither understood nor desired, face to face for the last time in history with something commensurate to his capacity for wonder.

And as I sat there brooding on the old, unknown world, I thought of Gatsby's wonder when he first picked out the green light at the end of Daisy's dock. He had come a long way to his blue lawn, and his dream must have seemed so close that he could hardly fail to grasp it. He did not know that it was already behind him, somewhere back in the vast obscurity beyond the city, where the dark fields of the republic rolled on under the night.

Gatsby believed in the green light, the orgiastic future that year by year recedes before us. It eluded us then, but that's no matter—tomorrow we will run faster, stretch out our arms farther and one fine morning—

So we beat on, boats against the current, borne back ceaselessly into the past.

As corrupted by the crass materialism of the day as Gatsby's dream is, it remains the quintessential American dream, the dream of a new world in which the imagination is free to create itself anew as well. From Fitzgerald's point of view, Gatsby had simply been born too late for his dream to have been realized—that is both his tragedy and his greatness.

Hemingway's Michigan In 1925, Fitzgerald introduced Ernest Hemingway (1899–1961) to his editor at Scribner's, and a year later Scribner's published Hemingway's first novel, *The Sun Also Rises*. The novel takes for its epigraph Gertrude Stein's famous phrase, "You are all a lost generation," and its cast of hard-drinking, fast-living, essentially aimless American expatriates seemed to capture the spirit of the age. It was an immediate success. As the American critic Malcolm Cowley put it in his 1934 memoir, *Exile's Return*: "Young men tried to get as imperturbably drunk as the hero, young women of fairly good family cultivated the heroine's nymphomania, and the name 'the lost generation' was fixed. It was a boast at first, like telling what a hangover one had after a party to which someone else wasn't invited." The hero, Jake Barnes, an American journalist, has suffered an injury in World War I, which makes it impossible for him to consummate his relationship with the novel's heroine, Lady Brett Ashley. About halfway through the novel, a character named Jeff Gorton mockingly describes to Jake just who he has become: "You're an expatriate. You've lost touch with the soil. You get precious. Fake European standards have ruined you. You drink yourself to death. You become obsessed by sex. You spend all your time talking, not working. You are an expatriate, see? You hang around cafés." It is safe to say that the only thing separating Hemingway from his character—aside from

his own sexual self-esteem—was that Hemingway worked, and worked hard, on his writing.

Hemingway had first come to Europe when the United States entered the war in 1917. He tried to enlist but was judged unfit for service because of his poor eyesight. "I can't let a show like this go on without getting into it," he wrote to his family, and so he volunteered to serve as an ambulance driver for the American Red Cross. He was stationed on the Italian Front where he was almost immediately wounded in the legs from mortar fire. Recuperating in Milan, he fell in love with Agnes von Kurowsky, who nursed him back to health and won immortality as the inspiration for Catherine in Hemingway's 1929 novel, *A Farewell to Arms*. "Abstract words, such as glory, honor, courage, or hallow," Hemingway wrote in that novel, in what amounts to a manifesto of his rhetorical style, "were obscene beside the concrete names of villages, the numbers of roads, the names of rivers, the numbers of regiments and dates." For Hemingway the use of a stripped-down, concrete language became a means of survival. In the concrete he could not be betrayed, either by his own emotions or by his belief in the sincerity of someone else's.

But if in 1925 Fitzgerald's American place was to be discovered in the Gatsby's "blue gardens"—and if the expatriate world of Jake Barnes reflected many of the same problematic values—Hemingway preferred the wilder settings of untamed nature, particularly the lakes and rivers of upper Michigan. In his story "Big Two-Hearted River," published in London in the collection *In Our Time* in 1925, just before Hemingway's lifelong relationship with Scribner's was established, Hemingway's hero, Nick Adams, back from the war and suffering from what is apparently post-traumatic stress syndrome, goes fishing by himself in northern Michigan: "He felt he had left everything behind, the need for thinking, the need to write, other needs. It was all back of him." The story is only ostensibly about fishing. It is more about healing, about doing concrete things—making camp, cooking, smoking, feeding out a line into a stream—that in their very simplicity convince us that we are alive (**Reading 36.8**):

READING 36.8

from Ernest Hemingway, "Big Two-Hearted River" (1925)

In the morning the sun was up and the tent was starting to get hot. Nick crawled out under the mosquito netting stretched across the mouth of the tent, to look at the morning. The grass was wet on his hands as he came out. The sun was just up over the hill. There was the meadow, the river and the swamp. There were birch trees in the green of the swamp on the other side of the river.

The river was clear and smoothly fast in the early morning. Down about two hundred yards were three logs all the way across the stream. They made the water smooth and deep above them. As Nick watched, a

mink crossed the river on the logs and went into the swamp. Nick was excited. He was excited by the early morning and the river. He was really too hurried to eat breakfast, but he knew he must. He built a little fire and put on the coffee pot.

The meticulous, careful observations and actions of Nick Adams in "Big Two-Hearted River" are, in essence, means to hold at bay and at the same time allude to the emotional depth and complexities embodied by "the swamp" that Nick does not yet feel he is ready to fish even as he knows he someday must. As Hemingway put it, "I was trying to write then, and I found the greatest difficulty . . . was to put down what really happened in action; what the actual things were which produced the emotion that you experienced." He wanted to write, he said, "one true sentence" that would accurately reflect what he "had seen or had heard someone say." Like Flaubert searching out *le mot juste* (see Chapter 28), Hemingway was striving for something as immediately real as the feeling of wet grass on his hands, something to hold onto in the inauthentic world that had led to a Great War that still seemed unresolved.

William Faulkner and the Southern Novel "I discovered," the native Mississippian William Faulkner (1897–1962) wrote, "that my own little postage stamp of native soil was worth writing about and that I would never live long enough to exhaust it I opened up a gold mine of other people, so I created a cosmos of my own." This cosmos is the imaginary Mississippi county of Yoknapatawpha, with Jefferson its county seat. *As I Lay Dying* (1930), which Faulkner wrote while working the night shift in the University of Mississippi boiler room, tells the story of the Bundren family's efforts to fulfill their deceased mother's wishes to bury her in Jefferson. Deeply experimental, the story unfolds through the alternating interior monologues of 15 different characters, whose motives and perspectives are sometimes wildly at odds. Also experimental is its use of the stream-of-consciousness technique (see Chapter 35) pioneered by Irish writer James Joyce and English writer Virginia Woolf, and its use of chapters of widely varying length.

Even more experimental is the 1929 novel *The Sound and the Fury*, which tells the story of the Compson family from four perspectives: those of the three Compson brothers, Benjy, Quentin, and Jason, and their maid, Dilsey. In this novel is probably the most daring use of stream of consciousness in modern fiction: Faulkner's representation of the mental workings of the intellectually and developmentally disabled Benjy Compson. It is Benjy's interior monologue that opens the novel **(Reading 36.9)**:

READING 36.9

from William Faulkner, *The Sound and the Fury* (1929)

Through the fence, between the curling flower spaces, I could see them hitting. They were coming toward where the flag was and I went along the fence. Luster was hunting in the grass by the flower tree. They took the flag out, and they were hitting. Then they put the flag back and they went to the table, and he hit and the other hit. Then they went on, and I went along the fence. Luster came away from the flower tree and we went along the fence and they stopped and we stopped and I looked through the fence while Luster was hunting in the grass.

"Here, caddie." He hit. They went away across the pasture. I held to the fence and watched them going away.

"Listen at you, now." Luster said. "Aint you something, thirty-three years old, going on that way. After I done went all the way to town to buy you that cake. Hush up that moaning. Aint you going to help me find that quarter so I can go to the show tonight."

This scene takes place in the present, on April 7, 1928, as Benjy accompanies the black servant Luster, who is assigned to take care of him, as he hunts for a quarter beside the golf course. Benjy confuses the golfer's call for his "caddie" with the name of his sister Caddy, who has treated him with more respect than any other member of the family. It is when he thinks of her that he begins to moan and holler.

Benjy's mind moves fluidly by free association across time. In the opening pages of the novel, we are carried back to Christmas Day 1900, when he and Caddy deliver a letter to Mrs. Patterson, then back to the present ("What you moanin' about," Luster says), then back to December 23, 1900, back to the present once more ("Can't you shut up that moaning"), then to a trip to the cemetery shortly after Mr. Compson's funeral in 1912, then back to the present ("Cry baby"), then to Christmas Day 1900 when Benjy delivers the letter ("Mrs. Patterson was chopping flowers"), and finally into the present again ("There ain't nothing over yonder but houses"). Faulkner asks his readers to abandon the traditional literary categories of space, time, and causality, but in compensation he teaches them the humility required of compassion and empathy. In all his novels, Faulkner celebrates the many strengths of his fellow Southerners, while exposing with almost pitiless precision the price their history of racism, denial, and guilt has extracted from them. His work would inspire the next generation of Southern fiction writers— Eudora Welty, Flannery O'Connor, William Styron, and Walker Percy.

The New American Poetry and the Machine Aesthetic

In 1928, Ezra Pound (see Chapter 34) had invoked the necessity of newness when he translated from the Chinese the *Ta Hsio*, or *Great Digest*, a Confucian text dating from the fifth to second century BCE:

As the sun makes it new
Day by day make it new
Yet again make it new

The saying "make it new," Pound well knew, had originated in the eighteenth century BCE, when the Emperor Tang, founder of the Shang dynasty (see Chapter 7), had written the phrase on his bathtub. Pound is obviously not invoking the phrase in the interest of leaving tradition behind. In fact, he invokes tradition—centuries of Chinese tradition—in order to underscore the necessity of continual cultural renewal. Like the poets and artists of the Harlem Renaissance, his short poem is driven by the rhythmic repetition not only of the phrase ("make it new") but "day by day," the diurnal cycle. Even more to the point, it underscores the labor of making the repetitive, often tedious rhythm of writing and rewriting, each successive line a revision of what has come before. And it is, perhaps above all, a "translation," an act of renewal as Pound transforms the original Chinese into English. The lesson is, for Pound, a simple one: In each new context, each new place, tradition is itself renewed.

CONTINUITY & CHANGE
Shang Dynasty, **p. 215**

Pound would publish a collection of essays in 1934 titled *Make It New*, and his "make it new" mantra soon became something of a rallying cry for the new American poetry. It especially influenced his friends, the poets William Carlos Williams (1883–1963), E. E. Cummings (1894–1962), and Hart Crane (1899–1932). Williams met Pound when they were both students at the University of Pennsylvania in 1902. Cummings had been a volunteer ambulance driver for the Red Cross in France, and in 1921 returned to Paris, where he met Pound. They were also attracted to the Imagist principle of verbal simplicity: "Use absolutely no word that does not contribute to the presentation," as F. S. Flint put it in the March 1913 issue of *Poetry* magazine (see Chapter 34). Their language should reflect, in Williams's words, "the American idiom," just as the Harlem Renaissance writers sought to capture black American vernacular in their work.

William Carlos Williams and the Poetry of the Everyday

Williams was a physician in Rutherford, New Jersey, across the Hudson River from New York City. He was immediately attracted to Imagism when Pound defined it in the pages of *Poetry* magazine. He praised it for "ridding the field of verbiage." His own work has been labeled "Radical Imagism," for concentrating on the stark presentation of commonplace objects to the exclusion of inner realities. His famous poem, "The Red Wheelbarrow," is an example (**Reading 36.10**):

READING 36.10

William Carlos Williams, "The Red Wheelbarrow," from *Spring and All* (1923)

so much depends
upon

a red wheel
barrow

glazed with rain
water

beside the white
chickens

The first line of each stanza of Williams's poem raises expectations which the second line debunks in two syllables. Thus a mere preposition, "upon," follows the urgency of "so much depends." A "red wheel" conjures images of Futurist speed, only to fall flat with the static "barrow." "Rain/water" approaches redundancy. Our expectations still whetted by the poem's first line, the word "white" suggests purity, only to modify the wholly uninspiring image, "chickens." Williams's aesthetic depends upon elevating the commonplace and the everyday into the realm of poetry, thus transforming them, making them new.

E. E. Cummings and the Pleasures of Typography

In 1920, when Williams wrote a poem describing a fire engine racing down a Manhattan street in the dark of night (see *Closer Look*, pages 1192–1193), the motorized fire engine was not even a decade old. Williams's poem celebrates the same machine culture, a culture of the "new," to which Alfred Barr, Jr., and Philip Johnson would later pay homage in their *Machine Art* exhibition. As Williams would later put it, in the introduction to a book of poems published in 1944 called *The Wedge*:

To make two bald statements: There's nothing sentimental about a machine, and: A poem is a small (or large) machine made of words. When I say there's nothing sentimental about a poem I mean that there can be no part, as in any other machine, that is redundant.

The newness of this same machine aesthetic is celebrated by E. E. Cummings in his poem "she being Brand" (his name is commonly spelled entirely in lowercase letters, a practice initiated by his publishers to which Cummings objected) (**Reading 36.11**):

E. E. Cummings, "she being Brand" (1926)

she being Brand

-new;and you
know consequently a
little stiff i was
careful of her and(having
thoroughly oiled the universal
joint tested my gas felt of
her radiator made sure her springs were O.

K.)i went right to it flooded-the-carburetor cranked her

up,slipped the
clutch(and then somehow got into reverse she
kicked what
the hell)next
minute i was back in neutral tried and

again slo-wly;bare,ly nudg. ing(my

lev-er Right-
oh and her gears being in
A 1 shape passed
from low through
second-in-to-high like
greasedlightning)just as we turned the corner of Divinity

avenue i touched the accelerator and give
her the juice,good

 (it

was the first ride and believe i we was
happy to see how nice she acted right up to
the last minute coming back down by the Public
Gardens i slammed on

the

internalexpanding

&

externalcontracting
brakes Bothatonce and

brought allofher tremB
-ling
to a:dead.

stand-
;Still)

Cummings's poem is laden with sexual innuendo, describing his first ride in his new car as if he were making love to the machine, and linking, in a fashion already long exploited by the automobile industry in the 1920s, his own sexual prowess with freedom and mastery of the road. But one of the most notable aspects of this poem is its dependence on the visual characteristics of capitalization, punctuation, and line endings to surprise the reader—effects evident in the first two lines: "Brand / -new." The poem, like Williams's work, is addressed both to the eye and the ear.

Hart Crane and *The Bridge* Although a poet of very different temperament than either Williams or Cummings, both of whom he knew well, Hart Crane (1899–1932) believed like both of them that the modern poet must, in his words, "absorb the machine." For Crane, the symbol of the machine aesthetic was the Brooklyn Bridge, and from 1926 until 1930, he worked on a long, epic poem that attempted to encapsulate, for modernity, the America that Walt Whitman had celebrated in the last half of the nineteenth century. The first great suspension bridge in the United States, the bridge was built in 1883 and was anything but new, yet it was precisely Crane's intention to "make it new" in the poem, to reinvent it as the gateway to modernity itself (**Reading 36.12**):

from Hart Crane, "To Brooklyn Bridge," *The Bridge* (1930)

How many dawns, chill from his rippling rest
The seagull's wings shall dip and pivot him,
Shedding white rings of tumult, building high
Over the chained bay waters Liberty—

Then, with inviolate curve, forsake our eyes
As apparitional as sails that cross
Some page of figures to be filed away;
—Till elevators drop us from our day . . .

I think of cinemas, panoramic sleights
With multitudes bent toward some flashing scene
Never disclosed, but hastened to again,
Foretold to other eyes on the same screen;

And Thee, across the harbor, silver-paced
As though the sun took step of thee, yet left
Some motion ever unspent in thy stride—
Implicitly thy freedom staying thee! . . .

O harp and altar, of the fury fused,
(How could mere toil align thy choiring strings!)
Terrific threshold of the prophet's pledge,
Prayer of pariah, and the lover's cry,—

Again the traffic lights that skim thy swift
Unfractioned idiom, immaculate sigh of stars,
Beading thy path—condense eternity:
And we have seen night lifted in thine arms

O Sleepless as the river under thee,
Vaulting the sea, the prairies' dreaming sod,
Unto us lowliest sometime sweep, descend
And of the curveship lend a myth to God.

As Crane was preparing *The Bridge* for publication, a friend showed Crane a short essay by painter Joseph Stella (1877–1946), who had painted the Brooklyn Bridge as part of a large five-panel painting, *The Voice of the City of New York*

CLOSER LOOK

William Carlos Williams often wrote poems on the spur of the moment—on prescription pads, for instance—and as a result, his work has a certain sense of immediacy, even urgency. His poem "The Great Figure" is a case in point. In his *Autobiography*, Williams recalls writing the poem one day after leaving his post-graduate clinic in Manhattan on his way to visit the painter Marsden Hartley (1877–1943) for a drink: "As I approached his number I heard a great clatter of bells and the roar of a fire engine passing the end of the street down Ninth Avenue. I turned just in time to see a golden figure 5 on a red background flash by. The impression was so sudden and forceful that I took a piece of paper out of my pocket and wrote a short poem about it."

Their friend, the painter Charles Demuth (1883–1935), later celebrated the poem in what he called a "poster-portrait."

The focus of the poem, and later the painting, is "the figure 5." It serves to organize the chaotic urban landscape that confronts the artist's vision just as the poem itself organizes the passing engine's cacophony of sirens, clangs, and howls into a formal poetic arrangement. The poem's central image embodies tension, speed, and change, a fact that Williams underscores by placing the lines "moving/tense" at the poem's heart. The figure 5 contradicts this tension. The poet sees the number with a clarity that is very different from the blurry refracted light of the night's rain. As Demuth's painting makes clear, the figure 5 is a kind of ordering design, its curvilinear form echoed in the street lights and light posts, its strong horizontal top echoed in the red engine and its horizontal axle all racing down the street into the geometric one-point perspective of the skyscraper canyon.

"The Great Figure"
from *Sour Grapes* (1921)

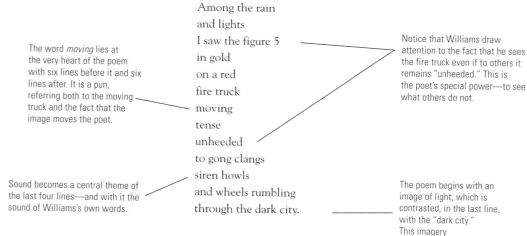

The word *moving* lies at the very heart of the poem with six lines before it and six lines after. It is a pun, referring both to the moving truck and the fact that the image moves the poet.

Among the rain
and lights
I saw the figure 5
in gold
on a red
fire truck
moving
tense
unheeded
to gong clangs
siren howls
and wheels rumbling
through the dark city.

Notice that Williams draw attention to the fact that he sees the fire truck even if to others it remains "unheeded." This is the poet's special power—to see what others do not.

Sound becomes a central theme of the last four lines—and with it the sound of Williams's own words.

The poem begins with an image of light, which is contrasted, in the last line, with the "dark city." This imagery corresponds to the acuity of the poet's vision versus the general population's blindness to the scene.

Something to Think About . . .

Why do you think Williams uses the word "great" to describe the "figure 5" in the title to his poem?

What might be a "billboard" is actually Williams's first name— "Bill."

Williams's middle name, Carlos, lights a marquee on a building down the street.

The curved frame in the corner suggests that it is the inside edge of yet another, even larger "figure 5."

The steep perspective of the street is indicated by the cornices on the buildings, both right and left. As opposed to Duchamp's Nude *Descending a Staircase* (see Fig. 35.4), which Demuth knew well, which indicates movement horizontally from left to right, Demuth indicates movement as a recession into space, one of the most innovative aspects of the painting.

The lamppost is shaped like the base of Demuth's "figure 5," creating yet another rhythmic repetition in the painting.

Although the legible lettering on the window reads "ART Co," there seems to be another letter in front of the "A"— perhaps a "T" or an "F"—in either case a relatively crude joke and perfectly consistent with Demuth's sense of humor.

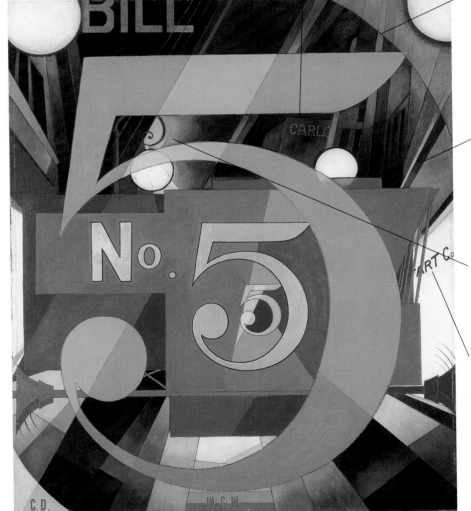

At the bottom of the painting, Demuth has placed both his own and Williams's initials.

Charles Demuth, *The Figure 5 in Gold*. 1928. Oil on cardboard, 35 1/2" × 30". Metropolitan Museum of Art, New York. Alfred Stieglitz Collection, 1949 (49.59.1). Image © The Metropolitan Museum of Art/Art Resource, New York. Demuth's painting was called by his friend William Carlos Williams "the most distinguished American painting that I have seen in years."

Interpreted in 1920–22 (Fig. **36.17**). Stella's essay, "The Brooklyn Bridge (A Page of My Life)," which appeared in the little magazine *Transition* in 1929, captured Crane's attention:

> Many nights I stood on the bridge – and in the middle alone – lost – a defenseless prey to the surrounding swarming darkness – crushed by the mountainous black impenetrability of the skyscrapers – here and there lights resembling suspended falls of astral bodies or fantastic splendors of remote rites – shaken by the underground tumult of the trains in perpetual motion, like the blood in the arteries – at times, ringing as alarm in a tempest, the shrill sulphurous voice of the trolley wires – now and then strange moanings of appeal from tug boats, guessed more than seen, through the infernal recesses below – I felt deeply moved, as if on the threshold of a new religion or in the presence of a new DIVINITY.

Stella's painting is, in fact, a kind of altarpiece to the machine age, and for a while, Stella considered using the painting as the frontispiece to his poem. But he finally settled for three photographs of the bridge by his neighbor, the photographer Walker Evans, whose work is discussed in Chapter 37.

The New American Painting: "That, Madam . . . is paint."

Both Stella's view of the Brooklyn Bridge and Demuth's celebration of Williams's "figure 5" indicated the new direction of American painting. Even its focal point changed. During the early 1900s, Alfred Stieglitz's Gallery 291 had been the place to exhibit. By the late 1920s, his new space in midtown Manhattan, An American Place, and the Daniel Gallery, a few blocks away, at 2 West 47th Street (see Map 36.1), were the places artists and writers gathered routinely to discuss new directions in American art and literature. In his *Autobiography*, Williams recalls a story that, he said, "marks the exact point in the transition that took place, in the world at that time," to the conception of the modern in American art. Alanson Hartpence was employed at the Daniel Gallery (**Reading 36.13**):

Fig. 36.17 Joseph Stella, *The Voice of the City of New York Interpreted: The Brooklyn Bridge (The Bridge)*. 1920–22. Oil and tempera on canvas, 88$\frac{1}{2}$″ × 54″. Collection of the Newark Museum, New Jersey. This is one of five panels, each over 7 feet high, celebrating New York. The others are *The Battery (The Port)*, *The Great White Way Leaving the Subway (White Way I)*, *The Prow (The Skyscrapers)*, and *Broadway (White Way II)*.

from William Carlos Williams, *The Auto-biography of William Carlos Williams* (1948)

One day, the proprietor being out, Hartpence was in charge. In walked one of their most important customers, a woman in her fifties who was much interested in some picture whose identity I may at one time have known. She liked it, and seemed about to make the purchase, walked away from it, approached it and said, finally, "But Mr. Hartpence, what is all that down in this left hand lower corner?"

Hartpence came up close and carefully inspected the area mentioned. Then, after further consideration, "That, Madam," said he, "is paint."

The object lesson was plain and simple. Painting was not about copying reality, not about "merely reflecting something already there, inertly," in Williams's words, but to make it new, in the new twentieth-century American landscape. It did so, he explained, by recognizing that a picture was "a matter of pigments upon a piece of cloth stretched on a frame . . . It is in the taking of that step over from feeling to the imaginative object, on the cloth, on the page, that defined the term, the modern term—a work of art."

Charles Demuth, Charles Sheeler, and the Industrial Scene

Charles Demuth and Williams met as students at the University of Pennsylvania, and they remained close friends. It was Demuth's wit that most attracted Williams to the painter, and his clear-eyed view of what constituted the new American landscape. He would, for instance, paint a picture of two grain elevators and call it *My Egypt*, ironically suggesting their equivalence to the pyramids on the Nile. Or he would paint a chimney rising in the sky beside a silo and name it *Aucassin and Nicolette*, after the medieval fable of the love affair between a French nobleman and a Saracen slave girl. Without its title, *Incense of a New Church* (Fig. **36.18**) is as depressing an image as any painted in America in the 1920s, its factory chimneys belching forth an almost suffocating flume of soot and smoke. But with the title, the painting becomes a deeply ironic—and funny—commentary on the American worship of machine and manufacture.

Fig. 36.18 Charles Demuth (American 1883–1935), *Incense of a New Church*. 1921. Oil on canvas, 26¼" × 20". Columbus Museum of Art, Ohio. Gift of Ferdinand Howald 1931.135; Courtesy Demuth Museum, Lancaster PA. William Carlos Williams owned a painting similar to this—of factories billowing smoke—entitled *End of the Parade—Coatsville, Pa.* He purchased it at the Daniel Gallery in 1920.

Charles Sheeler (1883–1965) was equally gifted as a painter and a photographer, and his painting clearly evidences the impact of photography. In 1927, he was commissioned to photograph the Ford Motor Company's new River Rouge Plant near Detroit, the world's largest industrial complex employing more than 75,000 workers to produce the new Model A, successor to the Model T. The subject, he said, was "incomparably the most thrilling I have had to work with," and he soon translated it into paint. *Classic Landscape* (Fig. **36.19**) depicts an area of the plant where cement was made from by-products of the manufacturing process. The silos in the middle distance stored the cement until it could be shipped for sale. For Sheeler, they evoke the classic architecture of ancient Greece and Rome—which inspired the painting's title, *Classic Landscape*.

Marsden Hartley and the Influence of Cézanne

CONTINUITY&CHANGE

Mont Sainte-Victoire, **p. 1097**

Of all the American modernists, Marsden Hartley was most influenced by the example of Paul Cézanne, especially Cézanne's paintings of Mont Sainte-Victoire (see Fig. 33.16). Stieglitz had exhibited watercolors by Cézanne at 291 in 1913, and by the 1920s, a number of significant Cézannes had entered American collections.

Hartley was particularly drawn to the American Southwest, visiting Santa Fe and Taos in both 1918 and 1919. Like Mont Sainte-Victoire for Cézanne, the mountains there became a motif for Hartley to which he returned again and again. In a June 1918 letter to Stieglitz, he describes them as "Chocolate mountains . . . those great isolated, altarlike forms that stand alone in a great mesa with the immensities of blue around and above them and that strange Indian red earth making such almost unearthly foregrounds."

Although Hartley's painterly and curvilinear forms seem far removed from the machine-age art of Demuth and Sheeler, Hartley's work was as formally balanced and orderly as any classical composition. For example, compare the formal symmetry of Hartley's *New Mexico Landscape* (Fig. **36.20**) to Joseph Stella's *The Bridge* (see Fig. 36.16). Hartley's is a completely natural landscape, rising to a central mountain balanced by two smaller mountains on each side. Stella's is a man-made architectural environment, and yet both are reminiscent of church altarpieces, each placing the viewer before his chosen subject—landscape and bridge—in a

CONTINUITY&CHANGE

Trinity, **p. 470**

composition not far removed from Masaccio's 1425 *Trinity* at Santa Maria Novella in Florence.

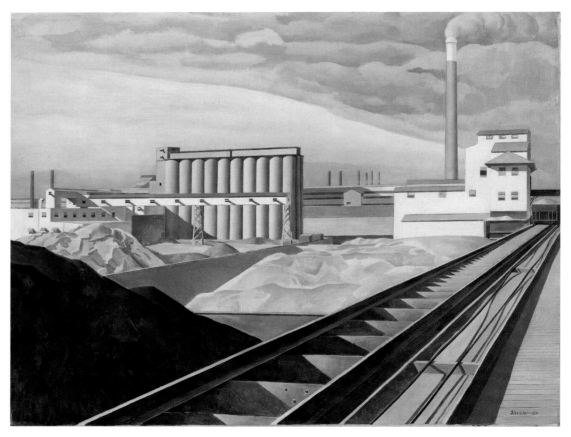

Fig. 36.19 Charles Sheeler, *Classic Landscape*. 1931. Oil on canvas, 25″ × 32¹/₄″. Collection of Barney A. Ebsworth. Image © 2009 Board of Trustees, National Gallery of Art, Washington, D.C. The strong perspectival lines created by the railroad tracks underscore the geometric classicism of the scene.

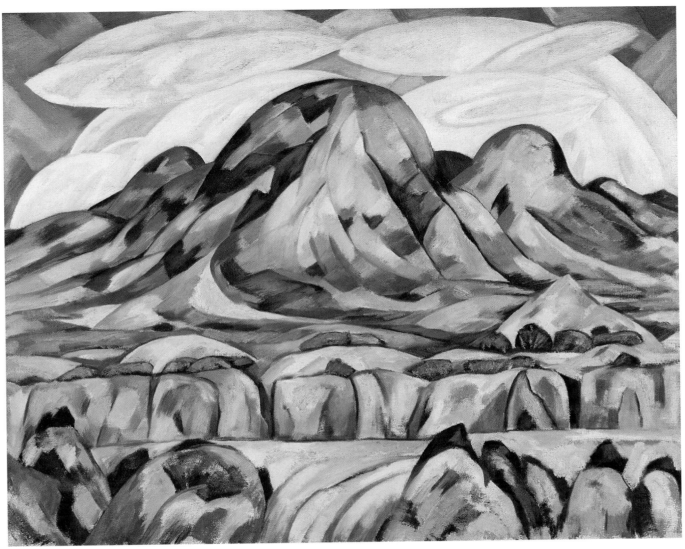

Fig. 36.20 Marsden Hartley, ***New Mexico Landscape.*** **1920–22.** Oil on canvas, 30" × 36". The Alfred Stieglitz Collection, 1949. Philadelphia Museum of Art, Philadelphia Art Resource, New York. Hartley would visit Aix-en-Provence in 1928, where he undertook a series of landscapes with Mont Sainte-Victoire as their theme.

Georgia O'Keeffe and the Question of Gender Of all the American artists who came into their own in the 1920s and 1930s, Georgia O'Keeffe (1887–1986) would become the most famous. But, from her first exhibit on, her work was burdened by its identification with her gender. Alfred Stieglitz showed a group of her abstract charcoal drawings at his Gallery 291 in 1916, calling them an example of "feminine intuition," and for the rest of her career, O'Keeffe's work was described solely in terms of its "female" imagery.

Marsden Hartley wrote an article in 1920 describing her work in Freudian terms as examples of "feminine perceptions and feminine powers of expression." By then she had married Stieglitz, who viewed O'Keeffe's art in the same way, so Hartley's review carried some authority. O'Keeffe's flower paintings—large-scale close-ups of petals, stamens, and pistols—were especially susceptible to Freudian interpretation. Many viewers found them erotically charged; between 1918 and 1932, she made over 200 of them. O'Keeffe complained that no one read flower paintings by male artists in this way—Demuth and Hartley both did many floral still lifes—and she addressed one critic directly: "Well— I made you take time to look at what I saw and when you took time to really notice my flower you hung all your own associations with flowers on my flower and you write about my flower as if I think and see what you think and see of the flower—and I don't."

O'Keeffe's struggle for recognition of her painting on its own terms was intensified by her closeness to Stieglitz. "His

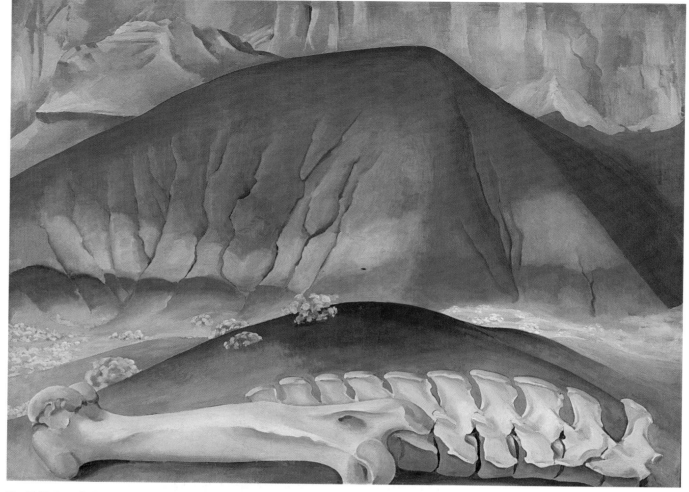

Fig. 36.21 Georgia O'Keeffe, *Red Hills and Bones*. 1941. Oil on canvas, 29 $\frac{3}{4}$" × 40". The Alfred Stieglitz Collection, 1949. Philadelphia Museum of Art, Philadelphia. © 2008 Artists Rights Society (ARS), New York. In 1940, O'Keeffe bought a house, Rancho de los Burros, a few miles from Ghost Ranch, an isolated dude ranch near the small town of Abiquiu.

power to destroy," she later acknowledged, "was as destructive as his power to build—the extremes went together. I have experienced both and survived, but I think I only crossed him when I had to—to survive." After 1929, one of her major modes of survival was to retreat to New Mexico, to which she returned for part of every year until 1949, three years after Stieglitz's death, when she moved there permanently. *Red Hills and Bones* (Fig. **36.21**) is an example of the many paintings of the New Mexican landscape that so moved her. Its surprising juxtaposition of hills and bones animates the hills, lending them a sort of body, like skin stretched over a hidden skeletal structure. Though, in her words, "the red hill is a piece of the badlands where even the grass is gone," it is anything but dead. In the same breath, she would call it "our waste land . . . our most beautiful country," reminding the viewer that the red hill was made "of apparently the same sort of earth that you mix

with oil to make paint." And explaining her attraction to bones, she wrote: "When I found the beautiful white bones on the desert I picked them up and took them home too I have used these things to say what is to me the wideness and wonder of the world as I live in it."

O'Keeffe's career would span almost the entire twentieth century. She would, in 1946, become the first woman to have a one-person retrospective of her work at the Museum of Modern Art. In 1970, when she was 83, the Whitney Museum of American Art staged the largest retrospective of her work to date, introducing it to a new generation of admirers just at the moment that the feminist movement in the United States was taking hold. Finally, in July 1997, 11 years after her death, the Georgia O'Keeffe Museum opened its doors in Santa Fe, New Mexico, with a permanent collection of more than 130 O'Keeffe paintings, drawings, and sculptures.

The American Stage: Eugene O'Neill

If many American artists sought to portray the everyday reality of American life, just as poets of the era sought to reflect everyday speech in their poems, it was on the stage that both the visual texture of American life and the language of modern America were best experienced. Eugene O'Neill (1888–1953) took up the challenge. The son of an Irish actor and raised in a Broadway hotel room in New York's theater district, O'Neill was sensitive both to the subtleties of the American scene and to the rhythms and vocabulary of American speech.

Toward the end of 1912, while hospitalized for tuberculosis in a Connecticut sanitarium, O'Neill read Ibsen (see Chapter 33) and the Greek tragedies. Their effect was so powerful that he decided to become a playwright. By 1920, he had won the Pulitzer Prize, the first of four, for his first full-length play, *Beyond the Horizon*, and he had begun to experiment freely with theatrical conventions in another play, *The Emperor Jones*.

The subject of the play was unheard-of. It narrates the life of one Brutus Jones, an African American who kills a man and goes to prison before escaping to a Caribbean island where he declares himself emperor. His story is told, against an incessant beat of drums, almost entirely in monologue, as a series of flashbacks as he flees through a forest chased by his rebellious former subjects. *The Emperor Jones* was soon followed by *The Hairy Ape* (1922), the story of a powerful, hulking engine stoker on an ocean liner, who is called a "filthy beast" by a socialite onboard ship. Unable to understand what she means, he leaves the ship and wanders through Manhattan, seeking someplace to fit in. Finally, dehumanized by his experiences, he enters the gorilla cage at the New York's City Zoo and dies, himself a "hairy ape," in the animal's embrace.

Both of these plays—and O'Neill's many great later plays, including *Desire Under the Elms* (1924), *Strange Interlude* (1928), *The Iceman Cometh* (1946), and the posthumously produced *Long Day's Journey into Night* (1953)—stress the isolation and alienation of modern life. Even in dialogue, his characters seem to talk past one another, not to one another, as this stage direction, from *Strange Interlude*, suggests: "They stare straight ahead and remain motionless. They speak, ostensibly one to the other, but showing by their tone it is a thinking aloud to oneself, and neither appears to hear what the other has said."

THE GOLDEN AGE OF SILENT FILM

It is a bit of an exaggeration to claim that New York invented Hollywood, but in many ways it did. In 1903, Hollywood (Fig. **36.22**) was a scattered community in the foothills of the Santa Monica mountains boasting about 700 residents. Twenty years later, it was the center of a "colony" of movie people, almost none of them native Californians, and a large majority of them second-generation American Jews newly arrived from points east. Many had gravitated to the movie business—first as exhibitors, then

Fig. 36.22 The "Hollywoodland" sign. 1923. The famous sign, rebuilt in 1978 after years of abuse and wear and shortened then to just "Hollywood," was originally constructed to advertise a real-estate development in the foothills above Hollywood.

Fig. 36.23 William Cameron Menzies, sets for *The Thief of Bagdad*, starring Douglas Fairbanks. 1924. Menzies was one of the greatest set designers and art directors of the day. He would design the sets for David O. Selznick's *Gone with the Wind* (see Fig. 37.25), working for roughly two years on the epic motion picture.

distributors, and then producers—from the garment industry in New York City, where they had learned to appraise popular taste and react to it with swift inventiveness. And, indeed, they were so successful in understanding their audience's desires that by 1939, arguably the greatest year in the history of the medium, between 52 and 55 million Americans went to the movies they made each week. There were 15,115 movie theaters, and box office receipts were $673 million.

The Americanization of a Medium

Why Hollywood came to be the center of the movie industry—and not New York, or Chicago, or, for that matter, just about anyplace else—is a complex question. Weather played a role—350 days a year of temperate sunshine, perfect for the slow film speeds of the day. So did the city's remoteness from the East, where the so-called "Trust"—the Motion Picture Patents Company, run by Thomas Edison, which controlled the rights to virtually all the relevant technology—sought to monopolize the industry. There was an abundance of relatively cheap available property on which to build giant "lots" and construct elaborate sets (Fig. 36.23). It is also true that after the first companies arrived in the early 1900s—producers Jesse Lasky and Sam Goldfish (later Goldwyn) hired Cecil B. DeMille to make the first feature-length American movie, *The Squaw Man*, in a rented barn at Vine and Selma in Hollywood in 1914, and William Fox (born Wilhelm Fuchs in Hungary) set up his studios at the corner of Sunset

and Western in 1916—other Jewish immigrant independent filmmakers followed, sensing the creation of a real community.

But for whatever reason the movie industry was drawn to Hollywood, it is certain that once there, it made Hollywood the center of cinema as a medium. Filmmaking went on all over the city of Los Angeles, not just in Hollywood—in Culver City, in the west, toward the ocean, and Universal City, an incorporated town over the Santa Monica mountains in the San Fernando Valley owned by Universal Pictures. But they were all "Hollywood." Despite the fact that not a single technological innovation in the medium was made anywhere near the city, despite the fact that it depended almost entirely upon New York City institutions for financing, it became the place where dreams came true, where fame and wealth were there for the taking, and where anything seemed possible.

It was the studio system that set Hollywood filmmaking apart from filmmaking anywhere else in the world, an organizational structure of production, distribution, and exhibition within the same company. In this system, studio magnates owned and controlled a "stable" of actors, writers, and directors who contracted to work exclusively for the studio. These companies produced predictable product—westerns, horror pictures, romances, and so forth—featuring stars whom the public adored. By the end of the 1920s, there were five major American studios—Fox, MGM, Paramount, RKO, and Warner—and three smaller ones—Universal, Columbia, and United Artists. These companies all had agents in Europe. Metro-Goldwyn-Mayer and Paramount,

for instance, loaned money to help the German film production company UFA establish itself after the war, and in return, UFA distributed their films in Germany. UFA executives soon recognized that it was more profitable to import American movies than to produce their own. The pattern was repeated across Europe, so that during the 1920s and 1930s, somewhere between 75 percent and 90 percent of the films screened in most countries were made in Hollywood. Europeans, who had long imposed their cultures on the world, now found American culture imposing itself on them.

The Studios and the Star System

As early as 1920, Hollywood was making 750 feature films a year and focusing its promotional efforts on the appeal of its stars. Among the most important of the early stars was Mary Pickford. She had risen to fame starring in D. W. Griffith's early one-reelers, specializing in the role of the adolescent girl. By 1917, when "America's Sweetheart," as Pickford soon became known, starred in feature films such as *The Poor Little Rich Girl* and *Rebecca of Sunnybrook Farm*, she was making $10,000 a week, working for Adolph Zukor's Famous Players-Lasky Corporation. Paramount, the Famous Players distributor, soon began block-booking its entire yearly output of 50 to 100 feature films, so that if theaters wanted to show the enormously popular Pickford films, they were forced to show films featuring less-well-known stars as well. When theaters resisted this arrangement, Zukor borrowed $10 million from the Wall Street investment banking firm of Kuhn Loeb and bought them, thus gaining control of the entire process of moviemaking, from production to distribution to exhibition. Other studios followed suit—Metro-Goldwyn-Mayer, Fox, and Universal all soon mirrored Zukor's operations.

It didn't take the stars long to recognize that the studios' successes depended on them. Some negotiated better contracts, but in 1919, three of the biggest stars—Pickford, Douglas Fairbanks, and Charlie Chaplin—and its most famous director, D. W. Griffith, bucked the studio system and formed their own finance and distribution company, United Artists. Chaplin was film's leading comedian, his trademark Little Tramp known worldwide. At his studio in Hollywood, in 1925, he made what many consider his greatest film, *The Gold Rush*. To open the film, Chaplin brought in thousands of extras, many of them hoboes, to the location in northern California near Truckee for a shot of prospectors making their way up the snow-covered Chilkoot Pass in the Alaskan gold rush of 1897 (Fig. **36.24**). Thematically, the gold rush is a vehicle that allows Chaplin to play the pathos of poverty off against the dream of wealth. In one of its most memorable scenes, at once funny and poignant, the starving tramp eats his own boot with the relish of a New York sophisticate, twisting his shoelaces around his fork like spaghetti and sucking on its nails as if they were the most succulent of morsels.

Fairbanks and Pickford married and formed their own studio. Pickford, now over 30, continued to cast herself as an adolescent girl, but Fairbanks began making a series of

Fig. 36.24 Charlie Chaplin in *The Gold Rush*. 1925. Chaplin modeled this opening scene on photographs he had seen of prospectors headed for the Klondike gold fields in 1897.

humorous adventure films, often drawing on stories written for boys. Increasingly elaborate sets were created for these films on the Santa Monica Boulevard lot, culminating with *The Thief of Bagdad*'s, one of the largest sets ever built in Hollywood. Special effects included flying carpets, winged horses, fearsome beasts, and an invisibility cloak, but neither the sets nor the effects could match the audience's attraction to Fairbanks's winning smile (Fig. **36.25**).

Fig. 36.25 Douglas Fairbanks in *The Thief of Bagdad*. 1924. Museum of Modern Art, Film Stills Archive. Almost 40 years old, Fairbanks appeared bare-chested throughout most of the movie, to the delight of his female fans.

Audience and Expectation: Hollywood's Genres

In addition to the appeal of its stars, Hollywood also depended on its audience's attraction to certain **genres** of film. A genre is a standard type, a sort of conceptual template or form readily recognizable by its audience. By the early 1920s, most of the genres that characterized Hollywood production through the 1950s had come into existence—comedy; fantasy; adventure; the crime or gangster film; the coming-of-age film (a Pickford specialty); the so-called woman's film, combining romance and family life; romantic drama; the horror film; war films; and the western chief among them—all, that is, except the musical, which awaited the advent of sound.

From the earliest days of cinema, producers had been well aware that their stars' sex appeal was fundamental to their popularity, and romantic drama was the main genre in which a star's sex appeal could be exploited. Female audience members worshiped Rudolph Valentino, whose soft sensuality infuriated many American males, even as he seduced on-screen actress after actress through the 1920s. The Swedish actress Greta Garbo, who arrived in the United States in 1925 to work at MGM, was appealing on a different level. From the moment of her first American film, the 1926 *Flesh and the Devil*, she exuded a combination of mature, adult sexuality and melancholy sadness. A sex siren like none before her, she was perfectly cast as the adulteress, playing Tolstoy's Anna Karenina in her next picture, *Love* (1927), and *A Woman of Affairs* (1928) in her next. Nearly all of Garbo's Hollywood films were shot in a rich, romantic lighting style that became synonymous in film with romance itself.

Male fans, who of course adored Garbo, also gravitated to Lon Chaney, whose most famous roles were *The Hunchback of Notre Dame* and *The Phantom of the Opera*, 1923 and 1924 respectively. Traditionally, the monster in horror films stands for that which society rejects or is uncomfortable with. Chaney specialized in characters who were disfigured, mutilated, or otherwise physically grotesque, and he single-handedly defined the horror genre in the 1920s. What appealed to his largely male audience was apparently the very horror of his appearance, the romantic agony of his characters' inability to fit comfortably into society, his audience's sense of their own alienation.

The Western was introduced with Edwin S. Porter's 1903 film *The Great Train Robbery*, with its famous final shot of a sheriff shooting his six-gun straight at the camera (and the audience). William S. Hart was the first big Western star, generally playing the part of an outlaw reformed by the love of a good woman. The most popular of the Western stars in the 1920s was Tom Mix (Fig. **36.26**), who had been a working cowboy. Decked out in his huge white hat, Mix performed his own stunts in movies filled with galloping horses, fistfights, and chases. Many of his films were shot on location in spectacular Western landscapes like the Grand Canyon, adding to their appeal.

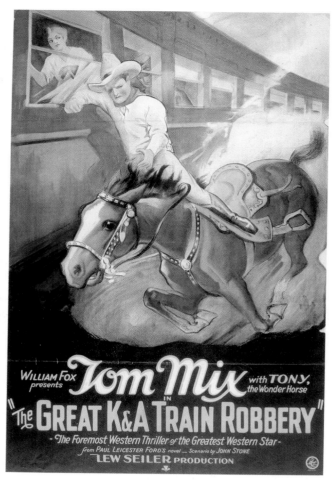

Fig. 36.26 Tom Mix in *The Great K & A Train Robbery*. 1926. Poster, 11″ × 17″. The film is laden with Mix stunts, opening with Mix sliding down a long cable to the bottom of a gorge. He also, as shown here, jumps off his horse onto a train so that he might fight the villains. This would become a staple of the Western genre—riding on the roof of the moving train.

Cinema in Europe

At the same time Hollywood dominated the American film industry, a distinctly European cinema thrived. Many of Europe's greatest filmmakers and stars were hired by American companies and brought to the United States to work. (Remember that before the talkies, language was not a barrier in the film industry.) Moreover, it seems clear that many of the more experimental and avant-garde contributions to the cinema originated in Europe. (See the *Closer Look* on Sergei Eisenstein in Chapter 35.) Europeans tended to regard cinema, at least potentially, as a high art, not necessarily as the crassly commercial product aimed at a low-brow popular audience that characterized most American movies.

German Expressionism Influenced directly by the Expressionist painting of Ernst Kirchner, Wassily Kandinsky, and Franz Marc (see Figs. 34.12, 34.13, and 34.15), soon after the war, some German filmmakers began to search for ways to express themselves similarly in film. Their films were

Fig. 36.27 The City, in Fritz Lang and Thea von Harbou's *Metropolis*. 1926. The cinematographer for *Metropolis*, responsible for creating the film's towering and sweeping visual effects, was Karl Freund, who later became director of photography for Desilu, supervising over 400 episodes of *I Love Lucy*, where he revolutionized television lighting and production.

deeply affected by the violence of the war and the madness they perceived the war to embody.

Chief among these was Robert Wiene, whose *Cabinet of Dr. Caligari* appeared soon after the war. An inmate at an insane asylum narrates the action, the story of a mysterious doctor, Caligari, who makes a living exhibiting a sleepwalker named Cesare at sideshows. At night, Cesare obligingly murders the doctor's enemies. All the action takes place in a deliberately exotic and weirdly distorted landscape of tilting houses, misshapen furniture, and shadowy atmospherics. As it turns out, the doctor is the head of the mental ward where the sleepwalker is his patient, and the entire story is perhaps a figment of the storyteller's insane imagination.

The word *Stimmung*—an emphasis on mood or feeling, particularly melancholy—is often used to describe German cinema throughout the silent era. A film's entire *mise-en-scène*—a French phrase for the totality of a film's visual style, from decor to lighting, camera movement, and costume—was often constructed to convey this sense of melancholy and resignation. Fritz Lang and his wife Thea von Harbou created one of the most oppressive and disquieting *mise-en-scènes* of all for their 1926 vision of a world in which humanity is at the edge of extinction, *Metropolis* (Fig. 36.27). In a city in which workers are virtually cogs in a giant machine, barely human, a scientist by the name of Rotwang has succeeded in constructing a robot, which proves, he says, that "now we have no further use for living workers." But the Master of Metropolis orders Rotwang to recreate the robot in the likeness of Maria, an idealistic young woman who has been preaching to the workers in order to help them free themselves from oppression. Instead, the robot preaches violence and leads them to self-destruction. In retrospect, the film seems ominously prescient, as if Lang and von Harbou have at least subconsciously exposed what influential film historian Siegfried Krakauer (1889–1966) has called "the deep layers of collective mentality" that would soon manifest themselves in the rise of the fascist state. Krakauer's history of German cinema, *From Caligari to Hitler*, revealingly subtitled A *Psychological History of German Film*, was written in the United States after he had fled Germany in 1933. It remains one of the seminal arguments concerning the mass appeal of commercial film and what that appeal reveals about its audience and society as a whole.

Surrealist Film Throughout the late 1910s and 1920s, while moviemakers were striving to make their narratives coherent and understandable to a wide audience, the Surrealists had an entirely different agenda. They saw film's potential to fragment rather than create sense. Through skillful editing of startling images and effects, film became a new tool for exploring the unconscious. Among the first films associated with Surrealism is René Clair's 1924 *Entr'acte*. An entr'acte is the intermission between parts of a stage production. Clair's film, which runs approximately 22 minutes, was conceived to run between the two acts of the ballet *Relâche*, written by Francis Picabia with music by Eric Satie (*relâche* means "closed"). The film is full of visual tricks—views of Paris seen from upside down on a roller coaster, a chase after a coffin filmed alternately at high speed and slow motion, actors disappearing before our eyes, and so on. Marcel Duchamp makes an appearance playing chess on the roof of a Paris building.

The two Spanish Surrealists, Salvador Dalí and Luis Buñuel, collaborated in 1929 on the 17-minute film *Un Chien andalou* (*An Andalusian Dog*) (Fig. **36.28**). Buñuel was a huge fan of Eisenstein and montage, and he used the technique to create a dream logic of fades—from a hairy armpit to a sea urchin, for instance. The film's famous opening sequence, a close-up of a girl's eye being sliced open by a razor (a cow's eye from the local butcher shop was actually used), is probably best understood as a metaphor for giving up dependence on reality and acceptance of Surrealism's inner vision. A year later, this time on his own, Buñuel made *L'Age d'or* (*The Golden Age*), one of the first French sound films. One scene, in which a religious reliquary was placed on the ground in front of an elegant lady getting out of her car, resulted in a riot that led Parisian authorities to destroy all prints of the film (in fact a few copies survived).

But despite the spirit of innovation in Europe, films made in "Hollywood"—which soon simply meant in the general vicinity of Los Angeles—dominated the world market and defined the medium, initiating the exportation of American culture that, for better or worse, would result in the gradual "Americanization" of global culture as a whole.

Fig. 36.28 Scene from Salvador Dalí and Luis Buñuel's *Un Chien andalou* (*An Andalusian Dog*). 1929. Museum of Modern Art, Film Stills Archive. Though it is never easy to say with any conviction just what a Surrealist image might "mean," it seems likely that the two pianos with dead donkeys laid across them, being dragged across the room, suggest the weight of tradition.

The Rise of Fascism

The experimental fervor of the avant-garde did not go forward without meeting resistance. In the Soviet Union, abstract art was banned as the product of "bourgeois decadence," and artists were called upon to create "a true, historically concrete portrayal of reality in its revolutionary development." In other words, artists were expected to create propaganda in support of the Soviet state. In Germany, a similar edict was issued by Hitler, this time motivated by racism. He began a 1934 speech by declaring, "All the artistic and cultural blather of Cubists, Futurists, Dadaists, and the like is neither sound in racial terms nor tolerable in national terms. It . . . freely admits that the dissolution of all existing ideas, all nations and races, their mixing and adulteration, is the loftiest goal."

A year earlier, Nazi Minister for Popular Enlightenment and Propaganda, Joseph Goebbels, had inaugurated a program to "synchronize culture"—that is, align German culture with Nazi ideals. To that end, he enlisted German university students to lead the way, and on April 6, 1933, the German Student Association proclaimed a nationwide "Action against the Un-German Spirit." They demanded, in 12 "theses" (a direct reference to Martin Luther's revolutionary theses), the establishment of a "pure" national culture as opposed to the spread of what they called "Jewish intellectualism."

Then, on the night of May 10, in most university towns, the students staged a national march "Against the Un-German Spirit," culminating in the burning of more than 25,000 volumes of "un-German" books, including works by Thomas Mann, Erich Maria Remarque, Albert Einstein, Jack London, Upton Sinclair, H. G. Wells, Sigmund Freud, Ernest Hemingway, and Helen Keller. The events were broadcast live on radio to the nation. Addressing the crowd in front of the Opera House in Berlin's Opernplatz (Fig. **36.29**), Goebbels proclaimed:

> German students: We have directed our dealings against the un-German spirit; consign everything un-German to the fire, against class conflict and materialism, for people, community, and idealistic living standards
>
> Against decadence and moral decay! For discipline and propriety in family and state! I hand over to the fire the writings of Heinrich Mann
>
> Against literary betrayal of the soldiers of the world war, for education of the people in the spirit of truthfulness! I hand over the writings of Erich Maria Remarque to the fire.

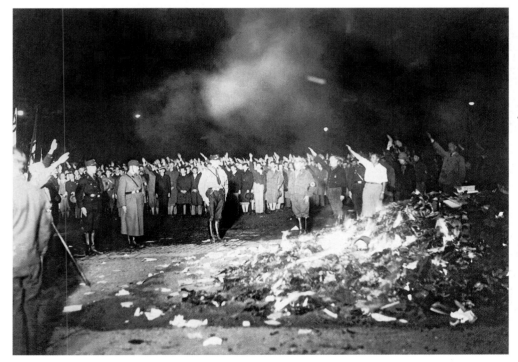

Authors whose works were spared felt insulted. Bertolt Brecht, author of *The Threepenny Opera* and *Mother Courage*, wrote an angry poem, *Die Bücherverbrennung* (*The Book Burning*), demanding that the regime burn him, since it had not burned his writings. Soon art criticism was required to be purely descriptive, German Expressionist painting was described as "Nature as seen by sick minds," and the market in modern art was explained as a conspiracy of Jewish dealers to dupe the German public. Conflict extending far beyond the art world soon seemed inevitable. ■

Fig. 36.29 Burning books on the Opernplatz, Berlin, May 10, 1933.

What was the Harlem Renaissance?

Originating in the writings of W. E. B. Du Bois, the Harlem Renaissance explored the double-consciousness defining African-American identity. Poet Claude McKay, Charles S. Johnson of the National Urban League, and philosopher Alain Locke all saw Harlem as the center of an avant-garde destined to rehabilitate African Americans from a position of spiritual and financial impoverishment for which, in Locke's words, "the fate and conditions of slavery have so largely been responsible." To this end, first in the Harlem issue of the sociology journal the *Survey Graphic*, and then in his anthology *The New Negro*, both published in 1925, Locke emphasized the spirit of the young writers, artists, and musicians of Harlem. What elements of Harlem culture were they especially interested in capturing in their work? Harlem was, after all, the center of the blues and jazz. The greatest of the blues singers in the 1920s was Bessie Smith. What new kind of phrasing did Smith bring to her work? In jazz, Louis Armstrong's Dixieland jazz originated out of New Orleans and made its way north to Chicago. What are the characteristics of Dixieland? In 1927, Duke Ellington began a five-year engagement at Harlem's Cotton Club. What distinguishes his brand of jazz?

What is the International Style in architecture?

The 1920s represent a period of unprecedented growth in New York City, as downtown skyscraper after skyscraper rose to ever greater heights, and the promise of the machine became a driving force in culture. What did artists and photographers see in both the skyscraper and the machine? The New York building boom of the 1920s, dominated by the highly ornamented and decorative architecture epitomized by Cass Gilbert's neo-Gothic Woolworth Building and William van Alen's Art Deco Chrysler Building, was countered by the International Style. How does the International Style differ from Gilbert's and van Alen's work?

What is suggested by the adage "make it new"?

American novelists of the era responded to the sense of the country's new and unique identity—embodied perhaps most of all in its "jazz"—by concentrating on the special characteristics of the American scene. How would you distinguish between F. Scott Fitzgerald's sense of place and Ernest Hemingway's? What distinguishes William Faulkner's Yoknapatawpha County?

The "new" sound of jazz also embodied the modernist imperative, first expressed by Ezra Pound, to "make it new." In poetry, this imperative was realized in the work of William Carlos Williams, E. E. Cummings, and Hart Crane. The work of all three celebrates the new machine culture of the era even as it attempts to capture the vernacular voice of everyday Americans. These interests are reflected as well in the painting of Joseph Stella, Charles Demuth, Marsden Hartley, and Georgia O'Keeffe. How is the idea of a new "machine-inspired classicism" expressed in American verse and painting of the 1920s? Like the poets of the era, the experimental plays of Eugene O'Neill captured, as perhaps never before in the theater, the vernacular voices of the American character even as they stressed the isolation and alienation of modern experience.

What characterizes the "golden age" of silent film?

During the early 1900s, large numbers of immigrants, particularly second-generation American Jews, migrated out of New York, where many had worked in the garment industry, to California, where they founded the motion picture industry in and around Hollywood. The studio system they developed dominated filmmaking worldwide. What are the features of the studio system? By the end of the 1920s, there were five major American studios—Fox, MGM, Paramount, RKO, and Warner—and three smaller ones—Universal, Columbia, and United Artists. They focused their promotional efforts on the appeal of their stars, including Mary Pickford, Charlie Chaplin, and Douglas Fairbanks. They also depended on their audience's attraction to certain genres. What are some of the chief genres that they developed? Experimental film flourished in Europe—in German Expressionist cinema and Surrealist film—but the American studios dominated the industry, producing between 75 percent and 90 percent of all films in the 1920s.

PRACTICE MORE Get flashcards for images and terms and review chapter material with quizzes at **www.myartslab.com**

GLOSSARY

blue note A musical note that is slightly lower or flatter than a conventional pitch.

blues A musical *genre* consisting of laments bemoaning loss of love, poverty, or social injustice; the standard blues form consists of three sections of four bars each.

call-and-response A technique in which two musicians imitate each other as closely as possible on their different instruments.

Dixieland jazz A musical *genre* in which the trumpet carries the main melody, the clarinet plays off it with a higher countermelody, and the trombone plays a simpler, lower tune.

genre A standard type of musical number that is usually readily recognizable by its audience.

scat A technique in which the performer sings an instrumental-like solo in nonsense syllables.

swing A musical *genre* characterized by big bands that produced a powerful sound and whose rhythm depends on subtle avoidance of downbeats.

READINGS

READING 36.4

Countee Cullen, "Heritage" (1925)

The poem Heritage *is both typical and something of an anomaly in Countee Cullen's work. Cullen longed to write poetry that succeeded not by force of his race but by virtue of its place in the tradition of English verse. In its form, the poem is completely traditional: rhymed couplets and iambic tetrameter (the first foot in each line is truncated—that is, the short syllable of the iambic foot has been dropped, leaving only the long syllable). But in its subject matter—Cullen's sense of his own uncivilized Africanness—its concerns are entirely racial.*

What is Africa to me:
Copper sun or scarlet sea,
Jungle star or jungle track,
Strong bronzed men, or regal black
Women from whose loins I sprang
When the birds of Eden sang?
One three centuries removed
From the scenes his fathers loved,
Spicy grove, cinnamon tree,
What is Africa to me? 10

So I lie, who all day long
Want no sound except the song
Sung by wild barbaric birds,
Goading massive jungle herds,
Juggernauts of flesh that pass
Trampling tall defiant grass
Where young forest lovers lie,
Plighting troth beneath the sky.
So I lie, who always hear,
Though I cram against my ear 20
Both my thumbs, and keep them there,
Great drums throbbing through the air.
So I lie, whose fount of pride,
Dear distress, and joy allied,
Is my somber flesh and skin,
With the dark blood dammed within
Like great pulsing tides of wine
That, I fear, must burst the fine
Channels of the chafing net
Where they surge and foam and fret. 30

Africa? A book one thumbs
Listlessly, till slumber comes.
Unremembered are her bats
Circling through the night, her cats
Crouching in the river reeds,
Stalking gentle flesh that feeds
By the river brink; no more
Does the bugle-throated roar
Cry that monarch claws have leapt

From the scabbards where they slept. 40
Silver snakes that once a year
Doff the lovely coats you wear,
Seek no covert in your fear
Lest a mortal eye should see;
What's your nakedness to me?
Here no leprous flowers rear
Fierce corollas in the air;
Here no bodies sleek and wet,
Dripping mingled rain and sweat,
Tread the savage measures of 50
Jungle boys and girls in love.
What is last year's snow to me,
Last year's anything? The tree
Budding yearly must forget
How its past arose or set—
Bough and blossom, flower, fruit,
Even what shy bird with mute
Wonder at her travail there,
Meekly labored in its hair.
One three centuries removed 60
From the scenes his fathers loved,
Spicy grove, cinnamon tree,
What is Africa to me?

So I lie, who find no peace
Night or day, no slight release
From the unremittent beat
Made by cruel padded feet
Walking through my body's street.
Up and down they go, and back,
Treading out a jungle track. 70
So I lie, who never quite
Safely sleep from rain at night—
I can never rest at all
When the rain begins to fall;
Like a soul gone mad with pain
I must match its weird refrain;
Ever must I twist and squirm,
Writhing like a baited worm,

While its primal measures drip
Through my body, crying, "Strip! 80
Doff this new exuberance.
Come and dance the Lover's Dance!"
In an old remembered way
Rain works on me night and day.
Quaint, outlandish heathen gods
Black men fashion out of rods,
Clay, and brittle bits of stone,
In a likeness like their own,
My conversion came high-priced; 90
I belong to Jesus Christ,
Preacher of humility;
Heathen gods are naught to me.

Father, Son, and Holy Ghost,
So I make an idle boast;
Jesus of the twice-turned cheek,
Lamb of God, although I speak
With my mouth thus, in my heart
Do I play a double part.
Ever at Thy glowing altar 100
Must my heart grow sick and falter,
Wishing He I served were black,
Thinking then it would not lack
Precedent of pain to guide it,
Let who would or might deride it;
Surely then this flesh would know

Yours had borne a kindred woe.
Lord, I fashion dark gods, too,
Daring even to give You
Dark despairing features where, 110
Crowned with dark rebellious hair,
Patience wavers just so much as
Mortal grief compels, while touches
Quick and hot, of anger, rise
To smitten cheek and weary eyes.
Lord, forgive me if my need
Sometimes shapes a human creed.
All day long and all night through,
One thing only must I do:
Quench my pride and cool my blood, 120
Lest I perish in the flood.
Lest a hidden ember set
Timber that I thought was wet
Burning like the dryest flax,
Melting like the merest wax,
Lest the grave restore its dead.
Not yet has my heart or head
In the least way realized
They and I are civilized.

READING CRITICALLY

How are the sentiments Cullen expresses in the last three
lines reflected in the rest of the poem?

READING 36.5

Langston Hughes, Selected Poems

Hughes began writing poems almost directly out of high school, and by the mid-1920s, his was considered the strongest voice in the Harlem Renaissance. The Weary Blues, *below, reflects Hughes's lifelong interest in the spoken or sung qualities of African-American vernacular language and its roots in musical idiom. The other two poems, from later in Hughes's career, reflect the challenges faced by African-American society, their simultaneous hope and despair in relation to American culture as a whole.*

THE WEARY BLUES (1923)

Droning a drowsy syncopated tune,
Rocking back and forth to a mellow croon,
 I heard a Negro play.
Down on Lenox Avenue the other night
By the pale dull pallor of an old gas light
 He did a lazy sway . . .
 He did a lazy sway . . .
To the tune o' those Weary Blues.
With his ebony hands on each ivory key
He made that poor piano moan with melody. 10
 O Blues!
Swaying to and fro on his rickety stool
He played that sad raggy tune like a musical fool.
 Sweet Blues!
Coming from a black man's soul.
 O Blues!
In a deep song voice with a melancholy tone
I heard that Negro sing, that old piano moan—

"Ain't got nobody in all this world,
Ain't got nobody but ma self. 20
I's gwine to quit ma frownin'
And put ma troubles on the shelf."

Thump, thump, thump, went his foot on the floor.
He played a few chords then he sang some more—
 "I got the Weary Blues
 And I can't be satisfied.
 Got the Weary Blues
 And can't be satisfied—
 I ain't happy no mo'
 And I wish that I had died." 30
And far into the night he crooned that tune.
The stars went out and so did the moon.
The singer stopped playing and went to bed
While the Weary Blues echoed through his head.
He slept like a rock or a man that's dead.

HARLEM (1951)

What happens to a dream deferred?

Does it dry up
like a raisin in the sun?
Or fester like a sore—
And then run?
Does it stink like rotten meat?
Or crust and sugar over—
like a syrupy sweet?

Maybe it just sags
like a heavy load. 10

Or does it explode?

THEME FOR ENGLISH B (1951)

The instructor said,

Go home and write
a page tonight.
And let that page come out of you—
Then, it will be true.

I wonder if it's that simple?
I am twenty-two, colored, born in Winston-Salem.
I went to school there, then Durham, then here
to this college on the hill above Harlem.
I am the only colored student in my class. 10
The steps from the hill lead down into Harlem,
through a park, then I cross St. Nicholas,
Eighth Avenue, Seventh, and I come to the Y,
the Harlem Branch Y, where I take the elevator
up to my room, sit down, and write this page:

It's not easy to know what is true for you or me
at twenty-two, my age. But I guess I'm what
I feel and see and hear, Harlem, I hear you:
hear you, hear me—we two—you, me, talk on this page.
(I hear New York, too.) Me—who? 20
Well, I like to eat, sleep, drink, and be in love.
I like to work, read, learn, and understand life.
I like a pipe for a Christmas present,
or records—Bessie, bop, or Bach.
I guess being colored doesn't make me *not* like
the same things other folks like who are other races.
So will my page be colored that I write?
Being me, it will not be white.
But it will be
a part of you, instructor. 30
You are white—
yet a part of me, as I am a part of you.
That's American.
Sometimes perhaps you don't want to be a part of me.
Nor do I often want to be a part of you.
But we are, that's true!
As I learn from you,
I guess you learn from me—
although you're older—and white—
and somewhat more free. 40

This is my page for English B.

READING CRITICALLY

Although Hughes's voice is distinctly African-American, his poetry also reflects his clear understanding of modernist principles. What does it share with the writing of poets like Ezra Pound or William Carlos Williams?

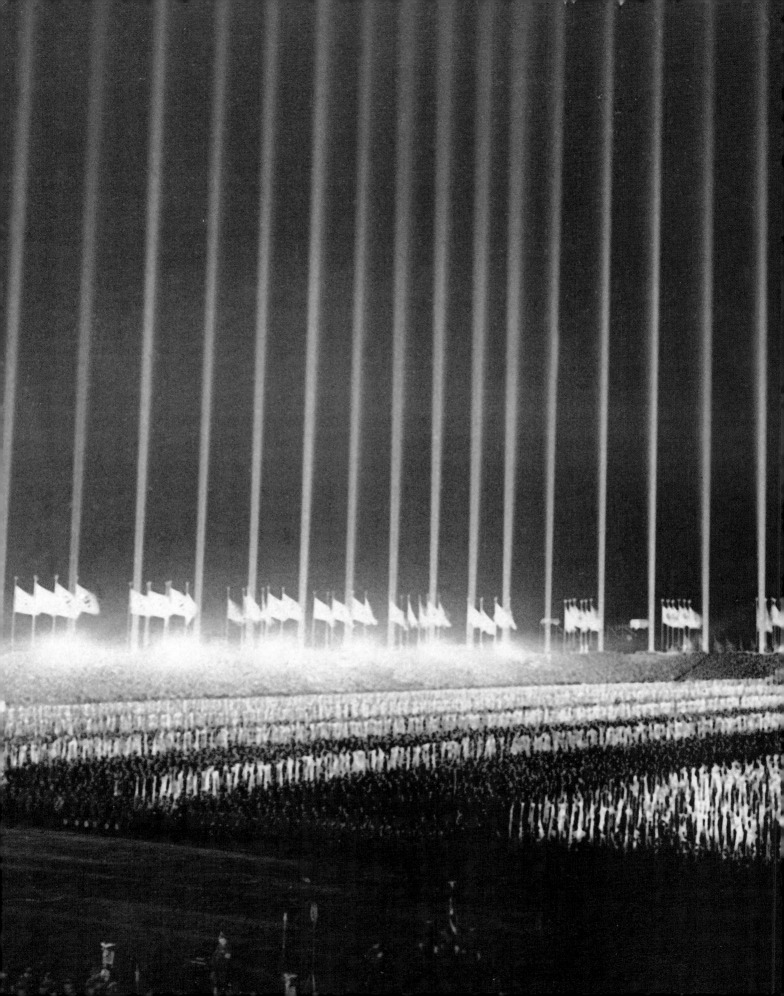

37

The Age of Anxiety
Fascism and Depression, Holocaust and Bomb

THINKING AHEAD

What was Berlin like in the 1920s?

What is fascism?

What is the Mexican mural movement?

What was the WPA?

How did sound and color change the motion-picture industry?

What was the Holocaust?

In the 1920s, Berlin, the capital of Germany, rivaled and may even have surpassed New York and Paris as a center of the arts. Its Philharmonic Orchestra was without equal, its political theater and cabaret were daring and innovative, its architecture was the most advanced and modern in Europe, and its art was challenging, nonconformist, and politically committed. It is no wonder that Dada thrived in Berlin (see Chapter 35).

Not everyone was mesmerized by Berlin's cultural glitter. The Austrian writer Stefan Zweig [tsvike (long "i," as in "eye")] (1881–1942), who arrived in the city in the early 1920s, described the place in disapproving terms:

> I have a pretty thorough knowledge of history, but never, to my recollection, has it produced such madness in such gigantic proportions. All values were changed, and not only material ones, the laws of the State were flouted, no tradition, no moral code, was respected, Berlin was transformed into the Babylon of the world. Bars, amusement parks, honky-tonks sprang up like mushrooms. . . . Along the entire Kurfürstendamm [ker-fer-shten-dahm] powdered and rouged young men sauntered . . . and in the dimly lit bars one might see

government officials and men of the world courting drunken sailors without shame. . . . In the collapse of all values a kind of madness gained hold.

This is the libertine world of homosexuals and prostitutes that the National Socialist (Nazi) party of Adolf Hitler (1889–1945) would condemn in its massive public demonstrations (Fig. 37.1). Hitler blamed intellectuals for his country's moral demise—specifically Jewish intellectuals. And he assumed without question that they were, in one way or another, associated with communism, which he saw as a threat to the economic health of Germany, due to the association of communists with labor unions. Hitler's success at controlling German public opinion brought the Nazi party to power in 1933 and led to the imposition of a fascistic (totalitarian and nationalistic) regime known as the Third Reich on that formerly republican state. Similar regimes arose across Europe as well.

This chapter surveys the rise of fascism and its consequences for art and culture in the two decades after World War I in Germany, Italy, Spain, and the Soviet Union. It also surveys the struggle for freedom in Mexico and the work of the artists who supported the Mexican Revolution

◀ **Fig. 37.1 Nazi Rally, Berlin. 1936.** Faced with the chaos resulting from World War I and the revolution in Russia, much of Europe looked to the uniformity and stability promised by totalitarianism to relieve the anxiety they saw reflected in the arts. In Germany, massive demonstrations, like the one depicted here, were organized in support of Hitler's National Socialist (Nazi) Party.

HEAR MORE Listen to an audio file of your chapter at **www.myartslab.com**

and the effects of the Great Depression in the United States. Over all of these developments, the specter of fascism hung like a dark cloud as, throughout the 1930s, another world war seemed increasingly inevitable.

Ever since the nineteenth century, when Japan, China, India, and Africa experienced social dislocation and upheaval as a result of confrontation with the West (see Chapter 33), and as the West colonized large parts of the globe, the impact of political events and social issues had become increasingly global in impact. World War I had taken place along a fairly compact front in northeastern France and northwestern Germany. By contrast, World War II was a truly worldwide conflict. No other event of the first half of the twentieth century so greatly increased the growing decenteredness of culture. In Germany, in what has come to be called the **Holocaust**, somewhere around 6 million Jews were killed in Hitler's concentration camps along with 5 million others whom the Nazis considered racially inferior or otherwise culturally problematic—particularly Gypsies, Slavs, the handicapped, and homosexuals. In the Pacific, the United States ended the war by dropping atomic bombs on the cities of Hiroshima and Nagasaki. Between them, the concentration camps and the bomb exposed an unprecedented capacity for hatred and genocide at the center of Western culture.

THE GLITTER AND ANGST OF BERLIN

At the end of World War I, the Weimar Republic became successor to the German Empire, with Berlin remaining as its capital (Map **37.1**). Two years later, in 1920, the Greater Berlin Act united numerous suburbs, villages, and estates around Berlin into a greatly expanded city with Berlin as its administrative center. The population of the expanded city was around 4 million. As a result, Berlin was Germany's largest city. It was the center not only of German cultural and intellectual life but also that of Eastern Europe, a city to

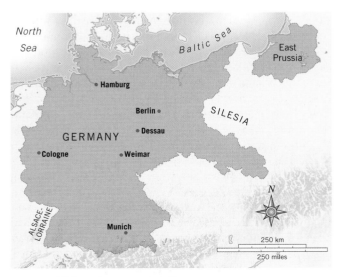

Map 37.1 Weimar Germany, 1919–33.

which artists and writers were drawn by the very liberalism and collapse of traditional values that Stefan Zweig bemoaned. The poet and playwright Carl Zuckmeyer [TSOOK-my-er] (1896–1977) described the decadent glitter of the city's brothels and nightclubs in sexually frank terms:

> People discussed Berlin . . . as if Berlin were a highly desirable woman, whose coldness and capriciousness were widely known; the less chance anyone had to win her, the more they decried her. We called her proud, snobbish, nouveau riche, uncultured, crude. But secretly everyone looked upon her as the goal of their desires. Some saw her as hefty, full-breasted, in lace underwear, others as a mere wisp of a thing, with boyish legs in black silk stockings. The daring saw both aspects, and her very capacity for cruelty made them the more aggressive. All wanted to have her, she enticed all.

Here was a city of pleasures that one could not resist, yet its attractions were informed by a deeply political conscience. German communists shuttled back and forth between Moscow and Berlin, bringing with them Lenin's views on culture (see Chapter 35). They scoffed at the politics of the Weimar Republic, which seemed farcical to them. (In the 15 years of its life, there were 17 different governments as the economy plunged into chaos.) Political street fights were common. In Berlin, artists and intellectuals, workers and businessmen wandered through a maze of competing political possibilities—all of them more or less strident.

The painter Georg Grosz [grohs] (1893–1959) would parody this world in his 1926 *The Pillars of Society* (Fig. **37.2**). The title refers to three major divisions of society: the military, the clergy, and above all, the middle class. All varieties of German politics are Grosz's target. Standing at the bar, sword in one hand, beer in the other, is a middle-class National Socialist (identifiable by the swastika on his tie), a warhorse rising out of his open skull. Behind him, the German flag in his hand, is a Social Democrat, his skull likewise open, displaying his party's slogan—"Socialism is work"—as he stands idly at the bar. Beside him is a journalist, chamberpot on his head, quill and pencil in hand, apparently ready to demonstrate to the National Socialist that the pen is mightier than the sword. A clergyman, his eyes closed, turns as if in praise of the fiery streets visible out the door even as soldiers commit violence behind his back. Grosz's vision is of a society at the edge of chaos and doom, led by brainless politicians, incompetent journalists, an angry middle class, a blind clergy, and a vindictive military. Such a vision, shared by many, created a certain feeling of *angst* in Berlin and elsewhere in Germany, a feeling of nervous anxiety and dread that would manifest itself in fiction, the theater, and the arts.

Kafka's Nightmare Worlds

One of the many Eastern Europeans drawn to Berlin—perhaps for its angst as well as its glitter—was the Jewish Czech-born author Franz Kafka [KAHF-kuh] (1883–1924), who wrote in German. He came to Berlin in 1923 only to

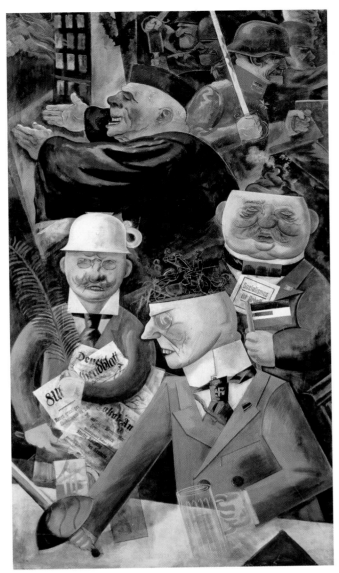

Fig. 37.2 Georg Grosz (1893–1959), *Stuetzen der Gesellschaft* (*The Pillars of Society*). 1926. Oil on canvas, 78 ³/₄″ × 42 ¹/₂″ (200.0 × 108.0 cm). Inv.: NG 4/58. Photo: Joerg P. Anders. Nationalgalerie, Staatliche Museen zu Berlin, Berlin, Germany. Art © Estate George Grosz/Licensed by VAGA, New York, New York. Grosz's biting wit was not tolerated by Hitler's fascist regime, and in the 1930s he fled Germany to the United States.

accused, Josef K. can only address the empty court with a virtually paranoid sense of his own impotence (**Reading 37.1**):

Embodied in this excerpt and in the entire novel is the clash between state politics and individual liberty that fueled Berlin life.

In Kafka's novella *The Metamorphosis*, first published in 1915, Gregor Samsa [SAHM-sah] similarly awakes to a stunning predicament: Overnight he has been transformed into a gigantic insect. (See **Reading 37.2**, pages 1246–1247, for the story's opening paragraphs.) Gregor's predicament is not unlike that of a person suffering from a severe disability, but it also suggests the deep-seated sense of alienation of the modern consciousness. For Gregor's metamorphosis is inexplicable and unexplained. It is simply his condition: dreadful, doomed, and oddly funny—a condition with which many in Berlin identified.

Brecht and the Berlin Stage

In 1924, Bertolt Brecht [brehkt](1898–1954), a young playwright from Munich, arrived in Berlin. He had already achieved a certain level of fame among intellectuals of his own generation for his deeply cynical and nihilistic play *Drums in the Night* (1918). It is the story of a young woman, Anna Balicke, who believes her love, Andreas, has died in the war and who is about to marry a wealthy war materials manufacturer when Andreas returns. It encapsulates the feelings of a generation of soldiers who felt that they had fought for nothing while a greedy older generation profited from their sacrifice.

Drums in the Night is set against the backdrop of the communist-inspired Spartikusbund (Spartacus League) uprising of January 1919 in Germany. (The *bund* took its name from Spartacus, leader of the largest slave rebellion in the Roman Republic.) It was the last act of a postwar revolution that had begun the previous November when sailors in the German navy refused to sacrifice themselves in a pointless final battle with the British Royal Navy. Quickly supported by workers across Germany, the league protested in the streets under the

leave a year later, just before dying from complications of tuberculosis. His fellow Prague native and friend Max Brod (1884–1968) made sure that Kafka's unpublished works found their way to press in Germany.

Kafka was something of a tortured soul, and the characters in his works of fiction typically find themselves caught in inexplicable circumstances that bear all the markings of their own neuroses. Berliners identified with these characters immediately. His novel *The Trial*, left unfinished but published in Berlin in 1925, opens with this sentence: "Someone must have been telling lies about Josef K., he knew he had done nothing wrong but, one morning, he was arrested." The story is at once an indictment of modern bureaucracy and a classic study in paranoia. Never informed of what he has been

slogan, "Frieden" und "Brot" [FREE-den oond brot] ("Peace and Bread"). So massive was the protest that it forced Kaiser Wilhelm II to abdicate in favor of the Social Democratic Party (SPD) under the leadership of Friedrich Ebert [AY-bert] (1871–1925). But when 500,000 people surged into the streets of Berlin on January 7, 1919, occupying buildings, Ebert ordered the anti-Republican paramilitary organization known as the Freikorps [FRY-kor], which had kept its weapons and equipment after the war, to attack the workers. The Freikorps quickly retook the city, killing many workers and innocent civilians even as they tried to surrender.

These events inspired Brecht to turn to Marxism, which he began to study intensely. The first major hit to result from this study was a collaboration with composer Kurt Weill [vile] (1900–1950) on the "scenic cantata" *Mahagonny-Songspiel*, which premiered in Baden Baden in 1927. Consisting of a series of songs, taking earlier Brecht poems for their lyrics, the success of the 40-minute musical paved the way for a much larger production the next year in Berlin of *The Threepenny Opera*, an updating of John Gay's eighteenth-century play *The Beggar's Opera* (see Chapter 25). When it premiered at Berlin's Schiffbauerdamm [SHIF-bau-er-dahm] Theater in 1928, *The Threepenny Opera* was a huge success. It is not, in fact, an opera but a work of musical theater focusing on the working class of Victorian London, who are as organized and well-connected in their shady businesses as any bourgeois banker or corporation president. Its hero, Macheath, or Mackie Messer (Mack the Knife), is a criminal sentenced to hang at the instigation of his lover Polly's father, Mr. Peachum, an entrepreneur of the crassest kind. Mr. Peachum is boss of London's beggars, whom he equips and trains in return for a cut of whatever they can beg. At the last moment Macheath is unexpectedly saved by a royal pardon and is granted a castle and a pension as an unjust reward for his life of crime.

The play is Brecht's socialist critique of capitalism, but aside from its political message, it embodies a revolutionary approach to theater based on alienation. It rejects the traditional relationship between play and audience, in which the viewer is invited to identify with the plight of the main character and imaginatively enter the world of the play's illusion. Brecht wanted his audience to maintain a detached relationship with the characters in the play and to view them critically. He believed they should always be aware that they were watching a play, not real life. Brecht called his new approach to the stage **epic theater**, which he later explained as follows (**Reading 37.3**):

READING 37.3

from Bertolt Brecht, "Theater for Pleasure or Theater for Imagination" (ca. 1935)

The spectator was no longer in any way allowed to submit to an experience uncritically (and without practical consequences) by means of simple empathy with the characters in a play. The production took the subject matter and the incidents shown and put them through a process of alienation: the alienation that is necessary to all understanding. When something seems "the most obvious thing in the world" it means that any attempt to understand the world has been given up.

What is "natural" must have the force of what is startling. This is the only way to expose the laws of cause and effect. People's activity must simultaneously be so and be capable of being different.

It was all a great change.

The dramatic theater's spectator says: Yes, I have felt like that too—Just like me—It's only natural—It'll never change—The sufferings of this man appall me, because they are inescapable—That's great art; it all seems the most obvious thing in the world— I weep when they weep, I laugh when they laugh.

The epic theater's spectator says: I'd never have thought it—That's not the way—That's extraordinary, hardly believable—It's got to stop—The sufferings of this man appall me, because they are unnecessary—That's great art; nothing obvious in it—I laugh when they weep, I weep when they laugh.

Brecht realizes this alienation effect, as he called it, in many ways. First, the scenes do not flow continuously one to the next; rather, the narrative jumps around. Second, actors make it clear that they are, indeed, acting. Third, there is no curtain; stage sets are visible from the moment the audience enters the theater, and stage machinery is entirely visible. Fourth, although the play's opening song, "Mack the Knife" (track **37.1**), immediately follows the overture in a highly traditional manner, the other songs are purposefully designed to interrupt, not further, the action.

HEAR MORE at www.myartslab.com

"Mack the Knife," like the rest of the score, is strongly influenced by what the Germans of the day conceived of as jazz, music largely based on the foxtrot and other popular dance music, with some parodies of "classical" genres. In fact, the original production specified a 15-piece jazz combo. The play opens, then, with a cabaret number, introduced in the original score by a harmonium, that celebrates the dark underworld of murder and mayhem that lies beneath the surface of London life, jarring its audience out of complacency.

Kollwitz and the Expressionist Print

One of the most powerful voices of protest in Berlin during the 1920s was artist Käthe Kollwitz [KOLL-vits] (1867–1945). She trained at art schools in Berlin and Munich but married a doctor whose practice concentrated on tending the poor of the city. As a result, she was in constant contact with workers and their plight. As she explained:

The motifs I was able to select from this milieu (the workers' lives) offered me, in a simple and forthright way, what I discovered to be beautiful. . . . People from

the bourgeois sphere were altogether without appeal or interest. All middle-class life seemed pedantic to me. On the other hand, I felt the proletariat had guts. . . . [W]hen I got to know the women who would come to my husband for help, and incidentally also to me . . . I was powerfully moved by the fate of the proletariat and everything connected with its way of life.

Kollwitz's work before World War I consisted of highly naturalist portrayals of the German poor, including a series of prints depicting the Peasants' War during the Reformation in 1525 (see Chapter 17). They are profoundly moving images of grief, suffering, and doom. The loss of her son Peter in October 1914, just months into World War I, permanently changed Kollwitz's art, politicizing it, as she became increasingly attracted to communism. The death also radicalized

her work stylistically. Before the war, she had concentrated on etching—the rich, densely linear medium of her German forebear Albrecht Dürer (see Chapters 16 and 17). But now she turned to the more dramatic, Expressionist media of woodblock and lithograph favored by members of Die Brücke and Der Blaue Reiter (see Chapter 34). On the block, she could gouge out the areas of white with violent ferocity. In lithographs, which she used particularly to make broadly distributed political posters with messages such as *Never Again War!* (1924) (Fig. 37.3), she was able to achieve a gestural freedom as powerful and strident as her woodblocks.

THE RISE OF FASCISM

In response to the exciting but disturbing freedom so evident in Berlin's urban art world and nightlife, European conservatives longed to return to a premodern, essentially rural past. In Germany, bourgeois youth thronged to the Wandervogel [VAHN-der-foh-gul] (literally, "freebirds" or "hikers") movement, joining together around campfires in the mountains to play the guitar and sing in an effort to reinvent a lost German romantic ideal. They longed for the sense of order and cultural preeminence that had been destroyed by Germany's defeat in World War I. They longed to be "whole" again, a longing that to many was geographical as well as psychological because the country had been stripped of the territories of Alsace-Lorraine [AHL-sahss-lor-REN] to the west and Silesia [sy-LEE-zhuh] to the east.

Modernity itself, which after all had brought them the war, was their enemy. It was in the city of Weimar [VY-mar], where the nineteenth-century Romantics Goethe and Schiller had lived, that the National Assembly convened to draft a new constitution at the end of World War I, lending the new republic its name even as Berlin remained the German capital (see Map 37.1). But the politics of the Weimar Republic were anything but comfortable. As historian Peter Gay has put it, "The hunger for wholeness was awash with hate: the political, and sometimes the private, world of its chief spokesmen was a paranoid world, filled with enemies: the dehumanizing machine, capitalist materialism, godless rationalism, rootless society, cosmopolitan Jews, and that great all-devouring monster, the city." Out of this hate, the authoritarian political ideology known as fascism was born. Fascism arose across Europe after World War I. It was the manifestation of mass

Fig. 37.3 Käthe Kollwitz, *Never Again War.* 1924. Lithograph, 37″ × 27 ½″. Kollwitz shunned the painting medium, choosing to work in prints, which could be circulated to a wide audience that included the working class.

movements that subordinated individual interests to the needs of the state as they sought to forge a sense of national unity based on ethnic, cultural, and, usually, racial identity. The German fascists led the way.

Hitler in Germany

Late in 1923, Adolf Hitler, the son of an Austrian customs official, staged an unsuccessful *putsch* [pooch], or revolt, at a Munich beer hall. In his youth, Hitler had wanted to be an artist and had served in the German army in World War I, where he was awarded the Iron Cross for bravery but rose only to the rank of private. He was strongly affected by the German defeat to join the National Socialist (Nazi) party. He was accompanied in his revolt by fellow "storm troopers," the private soldiers of the Nazi party noted for their brown shirts and vigilante tactics. Local authorities killed 16 Nazis and arrested Hitler. He used his trial to attract national attention, condemning the Versailles Treaty, Jews, and the national economy, which was suffering from astronomical inflation as paper money became essentially worthless. Convicted and sentenced to five years in jail, he spent the few months that he actually served writing the racist tract *Mein Kampf* [mine kahmpf] (*My Struggle*), published in 1925. In it he argued for the superiority of the German race, which he wrongly described as "Aryan" in the belief Western languages and civilizations could be traced back to the same Aryan nomads who invaded India in 1500 BCE (see Chapter 7) and that these nomads were themselves descendents of pure, white Nordic stock. In his mind, the Aryan race was distinct, especially, from Semitic peoples (**Reading 37.4**):

READING 37.4

from Adolf Hitler, *Mein Kampf* (1925)

Every manifestation of human culture, every product of art, science and technical skill, which we see before our eyes today, is almost exclusively the product of Aryan creative power. . . . On this planet of ours human culture and civilization are indissolubly bound up with the presence of the Aryan. If he should be exterminated or subjugated, then the dark shroud of a new barbarian era would enfold the earth.

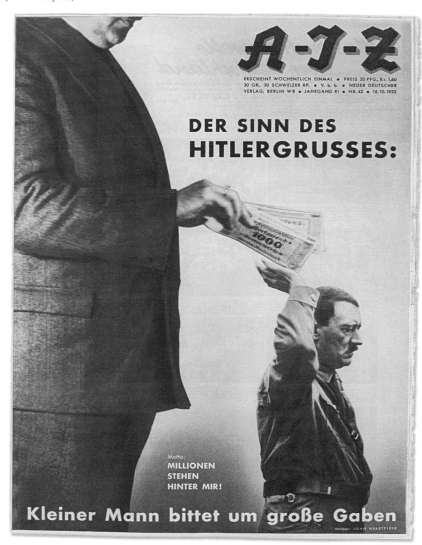

Fig. 37.4 John Heartfield, *Der Sinn des Hitlergrusses: Kleiner Mann bittet um große Gaben.* Motto: *Millonen Stehen Hinter Mir!* (The Meaning of the Hitler Salute: Little Man Asks for Big Gifts. Motto: Millions Stand Behind Me!). **1932.** Photo-mechanical reproduction. The Metropolitan Museum of Art, New York (1987.1125.8). Image © The Metropolitan Museum of Art/Art Resource, New York. After the National Socialists took power in 1933, Heartfield fled to Czechoslovakia, where he continued to create photomontages for *Arbeiter-Illustrierte Zeitung*. He did not return to Germany until after World War II.

the bourgeois sphere were altogether without appeal or interest. All middle-class life seemed pedantic to me. On the other hand, I felt the proletariat had guts. . . . [W]hen I got to know the women who would come to my husband for help, and incidentally also to me . . . I was powerfully moved by the fate of the proletariat and everything connected with its way of life.

Kollwitz's work before World War I consisted of highly naturalist portrayals of the German poor, including a series of prints depicting the Peasants' War during the Reformation in 1525 (see Chapter 17). They are profoundly moving images of grief, suffering, and doom. The loss of her son Peter in October 1914, just months into World War I, permanently changed Kollwitz's art, politicizing it, as she became increasingly attracted to communism. The death also radicalized her work stylistically. Before the war, she had concentrated on etching—the rich, densely linear medium of her German forebear Albrecht Dürer (see Chapters 16 and 17). But now she turned to the more dramatic, Expressionist media of woodblock and lithograph favored by members of Die Brücke and Der Blaue Reiter (see Chapter 34). On the block, she could gouge out the areas of white with violent ferocity. In lithographs, which she used particularly to make broadly distributed political posters with messages such as *Never Again War!* (1924) (Fig. **37.3**), she was able to achieve a gestural freedom as powerful and strident as her woodblocks.

THE RISE OF FASCISM

In response to the exciting but disturbing freedom so evident in Berlin's urban art world and nightlife, European conservatives longed to return to a premodern, essentially rural past. In Germany, bourgeois youth thronged to the Wandervogel [VAHN-der-foh-gul] (literally, "freebirds" or "hikers") movement, joining together around campfires in the mountains to play the guitar and sing in an effort to reinvent a lost German romantic ideal. They longed for the sense of order and cultural preeminence that had been destroyed by Germany's defeat in World War I. They longed to be "whole" again, a longing that to many was geographical as well as psychological because the country had been stripped of the territories of Alsace-Lorraine [AHL-sahss-lor-REN] to the west and Silesia [sy-LEE-zhuh] to the east.

Modernity itself, which after all had brought them the war, was their enemy. It was in the city of Weimar [VY-mar], where the nineteenth-century Romantics Goethe and Schiller had lived, that the National Assembly convened to draft a new constitution at the end of World War I, lending the new republic its name even as Berlin remained the German capital (see Map 37.1). But the politics of the Weimar Republic were anything but comfortable. As historian Peter Gay has put it, "The hunger for wholeness was awash with hate: the political, and sometimes the private, world of its chief spokesmen was a paranoid world, filled with enemies: the dehumanizing machine, capitalist materialism, godless rationalism, rootless society, cosmopolitan Jews, and that great all-devouring monster, the city." Out of this hate, the authoritarian political ideology known as fascism was born. Fascism arose across Europe after World War I. It was the manifestation of mass

Fig. 37.3 Käthe Kollwitz, *Never Again War*. 1924. Lithograph, 37″ × 27 ¹/₂″. Kollwitz shunned the painting medium, choosing to work in prints, which could be circulated to a wide audience that included the working class.

movements that subordinated individual interests to the needs of the state as they sought to forge a sense of national unity based on ethnic, cultural, and, usually, racial identity. The German fascists led the way.

Hitler in Germany

Late in 1923, Adolf Hitler, the son of an Austrian customs official, staged an unsuccessful *putsch* [pooch], or revolt, at a Munich beer hall. In his youth, Hitler had wanted to be an artist and had served in the German army in World War I, where he was awarded the Iron Cross for bravery but rose only to the rank of private. He was strongly affected by the German defeat to join the National Socialist (Nazi) party. He was accompanied in his revolt by fellow "storm troopers," the private soldiers of the Nazi party noted for their brown shirts and vigilante tactics. Local authorities killed 16 Nazis and arrested Hitler. He used his trial to attract national attention, condemning the Versailles Treaty, Jews, and the national economy, which was suffering from astronomical inflation as paper money became essentially worthless. Convicted and sentenced to five years in jail, he spent the few months that he actually served writing the racist tract *Mein Kampf* [mine kahmpf] (*My Struggle*), published in 1925. In it he argued for the superiority of the German race, which he wrongly described as

"Aryan" in the belief Western languages and civilizations could be traced back to the same Aryan nomads who invaded India in 1500 BCE (see Chapter 7) and that these nomads were themselves descendents of pure, white Nordic stock. In his mind, the Aryan race was distinct, especially, from Semitic peoples (**Reading 37.4**):

READING 37.4

from Adolf Hitler, *Mein Kampf* (1925)

Every manifestation of human culture, every product of art, science and technical skill, which we see before our eyes today, is almost exclusively the product of Aryan creative power. . . . On this planet of ours human culture and civilization are indissolubly bound up with the presence of the Aryan. If he should be exterminated or subjugated, then the dark shroud of a new barbarian era would enfold the earth.

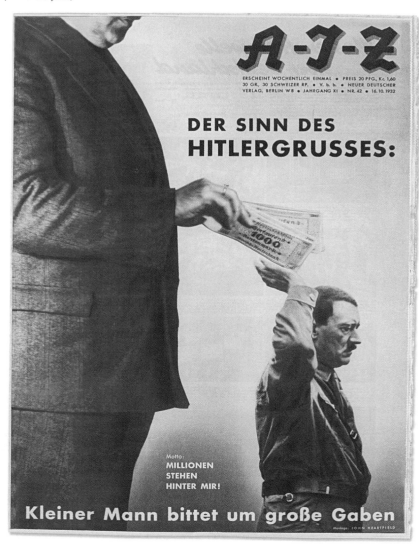

Fig. 37.4 John Heartfield, *Der Sinn des Hitlergrusses: Kleiner Mann bittet um große Gaben*. Motto: *Millonen Stehen Hinter Mir!* (The Meaning of the Hitler Salute: Little Man Asks for Big Gifts. Motto: Millions Stand Behind Me!). 1932. Photo-mechanical reproduction. The Metropolitan Museum of Art, New York (1987.1125.8). Image © The Metropolitan Museum of Art/Art Resource, New York. After the National Socialists took power in 1933, Heartfield fled to Czechoslovakia, where he continued to create photomontages for *Arbeiter-Illustrierte Zeitung*. He did not return to Germany until after World War II.

Anti-Semitism Hitler felt that the forces of modernity, specifically under the leadership of Jewish intellectuals, were determined to exterminate the Aryan race. Fearmongering was the rhetorical bread and butter he used to drive others to his view:

> [A] Jewish youth lies in wait for hours on end satanically glaring at and spying on the unconscious girl whom he plans to seduce, adulterating her blood with the ultimate idea of bastardizing the white race which they hate and thus lowering its cultural and political level so that the Jew might dominate.

The collapse of world economies in the Great Depression, a direct result of the crash of the New York stock market on October 29, 1929, fueled middle-class fears. As far as Hitler was concerned, Jewish economic interests were responsible for the crash. By 1932, more than 6 million Germans were unemployed, and thousands of them joined the Nazi storm troopers. Their ranks rose from 100,000 in 1930 to over 1 million in 1933.

Artists and intellectuals responded to this anti-Semitic challenge. Some of the most extraordinary examples are the posters of John Heartfield (1891–1968). Heartfield had anglicized his name from Helmut Herzfeld to antagonize Germans who, as a result of World War I, almost reveled in Anglophobia. He had satirized the Weimar Republic from the outset, but he savagely attacked Hitler in political photomontages—collages composed of multiple photographs—many published in the *Arbeiter- Illustrierte Zeitung* [AR-by-tuh-ill-oos-TREER-tuh TSY-toong], a widely distributed workers' newspaper that had 500,000 readers in 1931. Heartfield clearly understood the ability of photomontage to bring together images of a vastly different scale in a single work with an immense impact. In *Der Sinn des Hitlergrusses: Kleiner Mann bittet um große Gaben. Motto: Millonen Stehen Hinter Mir!* (The Meaning of the Hitler Salute: Little Man Asks for Big Gifts. Motto: Millions Stand Behind Me!) Heartfield exposes Hitler's reliance on fat, wealthy German industrialists—whom the readers of *Arbeiter-Illustrierte Zeitung* despised— suggesting that the famous Nazi salute is, in reality, a plea for money (Fig. **37.4**).

Many workers were sympathetic to communism. But if they were initially leery of Hitler, enough of them had been won over by the end of January 1933 to elect him chancellor (prime minister) of Germany. This election ended the Weimar Republic and inaugurated the Third Reich [ryek] (1933–1945), Hitler's name for the totalitarian and nationalistic dictatorship he led. When, on February 27, 1933, a mentally ill Dutch communist set fire to the Reichstag, seat of the German government in Berlin, Hitler invoked an act that had been written into the original Weimar Constitution allowing the president to rule by decree in an emergency. (He convinced the president to sign the decree.) By the next day, he had arrested 4,000 members of the Communist Party. Communism was, after all, the creation of yet another German Jew, Karl Marx. So, from Hitler's paranoid point of view, the destruction of the German state was part and parcel of communism's international conspiracy.

The Nazis urged German citizens to boycott Jewish businesses, and they expelled Jews from the civil service. Finally, in September 1935, with the passage of the so-called Nuremberg Laws, anti-Semitism became official German policy. A Jew was defined as anyone with at least one Jewish grandparent, and his or her German citizenship was revoked. Intermarriage and extramarital relationships between Jews and non-Jews were forbidden. Jews were prohibited from writing, publishing, making art, giving concerts, acting on stage or screen, teaching, working in a bank or hospital, and selling books. In this atmosphere of hatred, it is little wonder that, in November 1938, Herschel Grynszpan, a Jewish boy of 17, would take it upon himself to kill the secretary of the German embassy in Paris, driven mad by the persecution of his parents in Germany. And it is even less wonder that mobs throughout Germany and parts of Austria, egged on by the Nazis, responded, on what has become known as the Kristallnacht [kri-SHTAHL-nahkt] (Night of Broken Glass), by burning and looting Jewish shops and synagogues, invading Jews' homes, beating them, and stealing their possessions.

The Bauhaus and the Rise of the International Style The impact on the arts of Hitler's rise to power is nowhere more clearly demonstrated than in the history of the Bauhaus (from the German verb *bauen* [BOW-en (as in "now")], "to build"), the art school created by architect Walter Gropius [GROH-pee-us] (1883–1969) in Weimar in 1919. Its aim, Gropius wrote in the Bauhaus manifesto, was to

> conceive and create the new building of the future, which will combine everything—architecture and sculpture and painting—in a single form which will one day rise towards the heavens from the hand of a million workers as the crystalline symbol of a new and coming faith.

To this end, Gropius recruited the most outstanding faculty he could find. Among them were the Expressionist painters Wassily Kandinsky (see Chapter 34) and Paul Klee [klay] (1879–1940), the designer and architect Marcel Breuer [BROY-ur] (1902–1981), the painter and color theorist Josef Albers [AL-berz] (1888–1976), the graphic designer Herbert Bayer [BY-ur] (1900–1985), and later the architect Ludwig Mies van der Rohe [meez van-der ROH] (1886–1969).

The Bauhaus aesthetic drew on developments from across Europe—the Cubism of Picasso and Braque (see Chapter 34), the geometric simplicity of Kasimir Malevich and the Russian Constructivists (see Chapter 35), and especially the Dutch Modernist movement known as De Stijl, literally "the style." The De Stijl movement was led by the painter Piet Mondrian (1872–1944) and the architect, painter, and theorist Theo van Doesburg (1883–1931), who sought to create a new, "purely plastic work of art" of total abstraction. It completely rejected literal reality as experienced by the senses. Instead it reduced creative terms to the

Fig. 37.5
Piet Mondrian (1872–1944), *Composition with Blue, Yellow, Red and Black*, 1922. Oil on canvas, $16\,^{1}/_{2}{}'' \times 19\,^{1}/_{4}{}''$ (41.9×48.9 cm). Minneapolis Institute of Arts. © 2010 Mondrian/Holtzman Trust c/o HCR International, VA. USA. For Mondrian, "each thing represents the whole on a smaller scale; the structure of the microcosm resembles that of the macrocosm." This painting suggests the structure of what Mondrian called the "Great Whole."

Fig. 37.6 Gerrit Rietveld, Schröder House, Utrecht, The Netherlands. 1924. Artists Rights Society (ARS), New York/Beeldrecht, Amsterdam.

bare minimum: the straight line, the right angle, the three primary colors (red, yellow, and blue), and the three basic noncolors (black, gray, and white). Mondrian believed that the grid, a network of regularly spaced lines that cross one another at right angles, represented a cosmic interaction between the masculine and spiritual (vertical) and the feminine and material (horizontal). By the early 1920s, he had extended this belief to include a color/noncolor interaction. More important, he eliminated the traditional figure/ground relation of representational painting, where the blank white canvas is considered the painting's "ground." In his *Composition with Blue, Red, Yellow, and Black* of 1922, the white square set off-center in the middle of the painting appears to be on exactly the same plane as the colored planes that surround it (Fig. **37.5**).

Like the Bauhaus theorists and despite his own interest in painting, Mondrian claimed that the culmination of art rested in architecture. The principles of De Stijl, he wrote, govern "the interior as well as the exterior of the building." Gerrit Rietveld's Schröder House, built in Utrecht, Holland, in 1924 to 1925, has been called "a cardboard Mondrian" (Fig. **37.6**). To a certain extent this is true, but in other ways it is the exact opposite of his dogmatically flat canvasses, as if Mondrian's surface has been stretched out into three-dimensional space. The house is a cubelike form interrupted by the planar projections of its interior walls. All of the walls of the upper floor could be removed, sliding back into recesses and transforming a series of small rooms into a single space (Fig. **37.7**). In other words, the space is fluid and open,

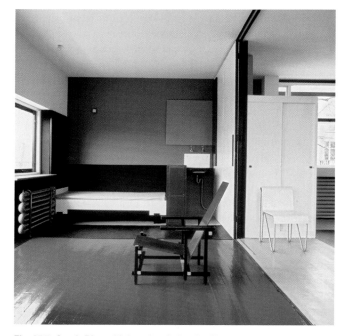

Fig. 37.7 Gerrit Rietveld, Interior, Schröder House, with "Red-Blue" Chair, Utrecht, The Netherlands. 1924. Photo: Jannes Linders Photography. © 2008 Artists Rights Society (ARS), NY. Rietveld explained the openness of the top floor, seen above: "It was of course extremely difficult to achieve all this in spite of the building regulations and that's why the interior of the downstairs part of the house is somewhat traditional, I mean with fixed walls. But upstairs we simply called it an 'attic' and that's where we actually made the house we wanted." Note the famous Red-Blue Chair, designed by Rietveld in 1918, when he was still working as a cabinetmaker.

LEARN MORE Gain insight from a primary source document from Piet Mondrian at **www.myartslab.com**

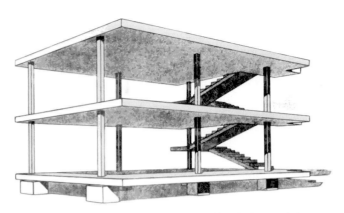

Fig. 37.8 Le Corbusier, Domino House. 1914. The plan's name derives from the six pillars positioned on the floor like the six dots on a domino.

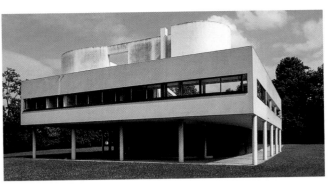

Fig. 37.9 Le Corbusier, Villa Savoye, Poissy-sur-Seine, France. 1928–30. Anthony Scibilia/Art Resource, New York. © 2008 Artists Rights Society (ARS), New York/ADAGP, Paris/FLC. Le Corbusier wrote: "The columns set back from the facades, inside the house. The floor continues cantilevered. The facades are no longer anything but light skins of insulating walls or windows. The facade is free."

waiting to be composed by its inhabitants. Built-in and movable furniture of Rietveld's design is geometric and abstract in concept. The predominant colors are white and gray, highlighted by selective use of primary colors and black lines. According to van Doesburg, it demonstrated that "the work of art is a metaphor of the universe obtained with artistic means."

Equally influential was the architecture of Frenchman Charles-Édouard Jeanneret (1887–1965), known as Le Corbusier [kor-booz-YAY], who founded the magazine and movement known as *L'Esprit Nouveau* (The New Spirit) after World War I. Le Corbusier's importance rested on his belief in the possibility of creating low-cost, easily replicable, but essentially superior housing for everyone. In order to cope with the massive destruction of property in the war, Le Corbusier proposed what he called the "domino" system of architecture, a basic building prototype for mass production (Fig. **37.8**). The structural frame of this building was of reinforced concrete supported by steel pillars. The lack of supporting walls turned the interior into an open, free-flowing, and highly adaptable space that could serve as a dwelling for a single family or be replicated again and again to form apartment units or industrial and office space. In a 1923 article called "Five Points of a New Architecture," Le Corbusier insisted that (1) the house should be raised on columns to provide for privacy, with only an entrance on the ground level; (2) it should have a flat roof, to be used as a roof garden; (3) it should have an open floor plan; (4) the exterior curtain walls should be freely composed; and (5) the windows should be horizontal ribbons of glass.

Calling his homes "machines for living in," Le Corbusier employed those five principles to design the Villa Savoye in Poissy-sur-Seine, France, west of Paris (Fig. **37.9**). The entry is set back, beneath the main living space on the second floor, which is supported by steel columns. Rounded windbreaks shelter a roof garden. The combination of

rectangle, square, and circle creates a sense of geometric simplicity. As Le Corbusier had put it in his 1925 *Towards a New Architecture*: "Primary forms are beautiful forms because they can be clearly appreciated."

This is the new architecture Alfred H. Barr, Jr., and Philip Johnson labeled the International Style in the same 1932 exhibition at the Museum of Modern Art in New York in which they had included the work of Frank Lloyd Wright (see Chapter 36). The show also featured the work of Le Corbusier and two Bauhaus architects, Gropius and Mies van der Rohe.

Nazi pressure had forced the Bauhaus out of Weimar in 1925, when the community withdrew its financial support due to the school's perceived leftist bent. The school moved to Dessau, closer to Berlin, where Gropius designed a new building (Fig. **37.10**). Although its look is familiar enough today—an indication of just how influential it would become—the building was revolutionary at the time. It was

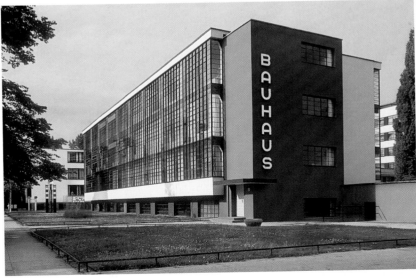

Fig. 37.10 Walter Gropius, Bauhaus Building, Dessau, Germany. 1925–26. Photograph courtesy Bauhaus Dessau Foundation, Dessau, Germany. Gropius described his building as a "clear, organic [form] whose inner logic [is] radiant, naked, unencumbered by lying facades and trickeries."

essentially a skeleton of reinforced concrete with a skin of transparent glass. As Gropius himself explained:

> One of the outstanding achievements of the new constructional technique has been the abolition of the separating function of the wall. Instead of making the walls the element of support, as in a brick-built house, our new space-saving construction transfers the whole load of the structure to a steel or concrete framework. Thus the role of the walls becomes restricted to that of mere screens stretched between the upright columns of this framework to keep out rain, cold, and noise. . . . This, in turn, naturally leads to a progressively bolder (i.e. wider) opening up of the wall surfaces, which allows rooms to be much better lit. It is, therefore, only logical that the old type of window—a hole that had to be hollowed out of the full thickness of a supporting wall—should be giving place more and more to the continuous horizontal casement, subdivided by thin steel mullions, characteristic of the New Architecture.

Gropius stepped down as director in 1928. He was replaced by Hannes Meyer [MY-er], a communist architect who saw nothing wrong with teaching Marxist doctrine in the classroom and who deemphasized fine art in favor of functional goods to benefit the working class. Meyer's communist politics made the Bauhaus an easy target for the Nazis. Even after Mies van der Rohe replaced Meyer in 1930, the Nazis proposed demolishing Gropius's "decadently modern" building. Although the plan was rejected, the school in Dessau was closed in October 1932 and then reopened by Mies in Berlin as a private institution. Finally, on April 11, 1933, Gestapo (secret state police) trucks appeared at the door. They padlocked the school, and it never reopened.

The Degenerate Art Exhibition To the Nazis, the Bauhaus represented everything that was wrong with modernism—its inspiration by foreigners (especially Russians like Kandinsky), its rejection of traditional values, and its willingness to "taint" art with (leftist) politics. Between the Bauhaus's closing and 1937, virtually all avant-garde artists in Germany were removed from teaching positions and their works confiscated by the state. On July 19, 1937, many of these same works were among the over 600 displayed in the exhibition of Degenerate Art in Munich, organized at Hitler's insistence to demonstrate the mental and moral degeneracy of modernist art. Over 2 million people—nearly 20,000 a day—visited the show before it closed in November.

In the first room, religious art was chosen that, according to the catalogue, illustrated the "insolent mockery of the Divine" that had been championed by the Weimar Republic. It featured a nine-painting cycle by Emile Nolde (see Chapter 34), who was, ironically, a member of the Nazi party and so believed himself to be immune from persecution. In the second gallery, Jewish art was pilloried. In the third gallery, Dada and abstract painting were attacked, and Expressionist nudes were labeled "An insult to German womanhood." In another gallery, Expressionist still lifes were introduced as "Nature as seen by sick minds." After the exhibition, the Commission for the Disposal of Products of Degenerate Art arranged for those pieces with the highest value in the international art market to be sold at auction in Lucerne [loo-SERN], Switzerland. However, most of the confiscated works—1,004 oil paintings and 3,825 works on paper—were burned in the yard of the Berlin Fire Brigade on March 20, 1939.

The Art of Propaganda The Degenerate Art show was carefully calculated to create public outrage. It coincided with the first of eight Great German Art exhibitions, which opened the day before, on July 18, 1937. Hitler spoke for an hour and a half on the nature and function of art. A pageant with more than 6,000 participants depicting 2,000 years of German culture followed the speech. It was all part of a concentrated effort by the Nazis to control culture by controlling what people saw and heard.

Radio played an enormous role. The Nazis understood that radio was replacing the newspaper as the primary means of mass communication. Since they controlled all German radio stations, they could make effective use of it. Addressing a group of German broadcasters, Joseph Goebbels [GOHB-uls] (1897–1945), Hitler's Minister for Public Enlightenment and Propaganda, emphasized the medium's importance:

> I consider radio to be the most modern and the most crucial instrument that exists for influencing the masses. I also believe—one should not say that out loud—that radio will in the end replace the press. . . . First principle: At all costs avoid being boring. I put that before everything. . . . The correct attitudes must be conveyed but that does not mean they must be boring. . . . By means of this instrument you are the creators of public opinion. If you carry this out well we shall win over the people and if you do it badly in the end the people will once more desert us.

Hitler's extraordinary oratorical skills were perfectly suited to the radio. Loudspeakers were set up throughout the nation so that everyone might hear his broadcasts. "Without the loudspeaker," Hitler wrote in 1938, "we would never have conquered Germany."

Film was likewise understood to be an important propaganda tool. In 1933, Hitler invited the talented director Leni Riefenstahl [REEF-en-shtahl] (1902–2003) to make a film of the 1934 Nazi rally in Nuremberg, providing her with a staff of more than 100 people, 30 cameras, special elevators, ramps, and tracks. The result was *Triumph of the Will*, a film that does not so much politicize art as aestheticize politics. Riefenstahl portrays Hitler as at once hero and father figure, lending him and his Nazi party a sense of grandeur and magnificence. March music dominates the score. The regularity of its beat mirrors the regularity and order of Hitler's storm troopers and suggests military strength and the order and stability that the Nazi regime promised to bring to the German people.

Stalin in Russia

Nazism was not the only totalitarian ideology to achieve political power in the aftermath of World War I. The consolidation of the Bolshevik revolution in Russia after World War I produced the longest-lasting totalitarian government. In the power vacuum that followed Lenin's death in 1924, two factions emerged in the Communist Party. Leon Trotsky [TROT-skee] (1879–1940) led one of them and Joseph Stalin [STAH-lin] (1878–1953) headed the other. Their rivalry took the form of a debate over the speed of industrialization of the Russian economy. Trotsky's faction favored rapid industrialization through the collectivization of agriculture; Stalin's faction pressed for relatively slow industrialization and the continuation of Lenin's tolerance of a modest degree of free enterprise in which peasant farmers were allowed to sell their produce for profit. Stalin was a master at manipulating the party bureaucracy, and by 1927, he had succeeded in expelling Trotsky from the party and sending him into exile, first to Siberia and then later to Mexico. He was murdered in Mexico in 1940, probably by one of Stalin's agents.

The Collectivization of Agriculture Once Stalin took power, he behaved very much the way Trotsky had advocated. In 1928, he decided to collectivize agriculture, consolidating individual land holdings into cooperative farms under the control of the government. This alleviated food shortages in the cities, produced enough for export, and freed the peasant labor force for work in the factories. At the same time, he inaugurated a series of five-year plans for the rapid industrialization of the economy. Finally, he accepted Trotsky's position that terror was a necessity of revolution. Stalin blamed the few prosperous peasant farmers, or **kulaks** [KOO-lahks], for the economic ills of the country.

The kulaks represented less than 5 percent of the rural population, but they did not want to collectivize and were unhappy that there were so few goods to purchase with their cash. In protest, they withheld grain from the market. "Now," Stalin proclaimed, "we are able to carry on a determined offensive against the kulaks, to break their resistance, to eliminate them as a class." Before long, anyone who opposed Stalin was considered a kulak, and between 1929 and 1933, his regime killed as many as 10 million peasants and sent millions of others to forced labor on collective farms and **gulags** [GOO-lahgs], labor camps. The peasants retaliated by killing over 100 million horses and cattle, causing a severe meat shortage. But Stalin persevered, not least of all because his plan for rapid industrialization was working. Soviet industrial production rose 400 percent between 1928 and 1940, by far the fastest-growing economy in the world at the time.

Fig. 37.11 Leni Riefenstahl, still from *Olympia*. 1936. The Museum of Modern Art, New York. Film Stills Archive. Riefenstahl herself appeared briefly nude in the film among a group of nude dancers on a beach on the Baltic Sea.

With Hitler's approval, Riefenstahl was appointed by the International Olympic Committee to film the 1936 Olympic Games in Berlin. Her two-part film, *Olympia*, was less political than *Triumph of the Will* and emphasized the beauty of the human body—albeit, decidedly white and "Aryan" human bodies. For the Games, Hitler inaugurated the tradition of runners carrying the Olympic torch from Athens to the Olympic venue, suggesting that Hitler's Germany was the modern successor to Classical Greece, and Riefenstahl's film begins with a 20-minute prelude filmed at the Parthenon and featuring Greek sculptures of original Olympic athletes which she then transforms, through montage, into live bodies both male and female—all of them nearly nude (Fig. 37.11). The film was designed to demonstrate that Germans were, first and foremost, a beautiful people, but also fair and friendly competitors capable of cheering even the black American runner, Jesse Owens. Hitler, of course, hoped that German athletes would win many prizes, thus demonstrating Aryan superiority.

The Rise of Social Realism in Art and Music Stalin's five-year economic plans were supported by a series of propaganda posters that appeared across the country, such as *The Development of Transportation, The Five-Year Plan* by Gustav Klucis [kloo-cis] (1895–1944) (Fig. **37.12**). Klucis's poster is an example of social realism, the style of Russian art that followed Constructivism in the early 1920s (see Chapter 35). Klucis was himself a Constructivist, but like his fellow Constructivists, he was drawn to the necessity of communicating clearly with the largely illiterate peasant class. So he, like they, turned to graphic design and photomontage, a technique that seemed at once modern and Realist in the tradition of the great Russian realists of the nineteenth century, especially the revered Travelers (see Chapter 31). In doing so, he sacrificed abstraction in favor of an unwavering political commitment.

As early as 1921, the Soviet government had urged Russian artists to give up their avant-garde experiments on the grounds that abstraction was unintelligible to the masses. Other groups argued that it was necessary to concentrate on themes such as the daily life of the workers and the peasants. By 1934, the First All-Union Congress of Soviet Writers officially proclaimed all expressions of "modernism" decadent and called upon Soviet artists to create "a true, historically concrete portrayal of reality in its revolutionary development." Social realism was from that time on the official state style, and in literature, music, and the visual arts, all other styles were banned.

The Soviet authorities brought all musical activities under their control by a decree in 1932 and attacked Russian avant-garde composers in the same way they had attacked artists. They accused Sergei Prokofiev [pro-KOF-ee-ev] (1891–1953) and Dimitri Shostakovich [shoh-stuh-KOV-ich] (1906–1975) of writing music that was "too formalistic" and "too technically complicated"—and thus "alien to the Soviet people." The party Central Committee pressured both men to apologize publicly for the error of their ways. Prokofiev's very accessible symphonic fairy tale of 1936, *Peter and the Wolf*, is most likely an attempt to appease the Soviet authorities. Two years earlier, in 1934, the Soviet press had hailed Shostakovich's four-act opera *Lady Macbeth of the Mtsensk District* as a model of social realism. The opera was meant to be the first part of a trilogy dealing with Russian womanhood. It featured not only modernist dissonance but also themes of adultery, murder, and suicide. Two years later, in 1936, after Stalin had seen it himself and decided that the themes did not live up to the standards of official Soviet art, the newspaper *Pravda* [PRAHV-dah] condemned it as "Chaos, Not Music," and the opera was dropped from the repertory. Shostakovich repented by composing his 1937 Symphony No. 5, subtitled "A Soviet Artist's Response to Just Criticism."

In its relative lack of dissonance, Symphony No. 5 appeared to conform more closely to the ideals of social realism, but the piece is actually a monument to musical irony. Everything about it is a repudiation of Stalin and the Soviet authorities. The first movement opens with a cry of despair that, after a fairly long development, gives way to a march that is meant to evoke Stalinist authority. The party Central Committee was able to hear this passage as a sign of Shostakovich's capitulation, but Shostakovich hoped that his audience would understand the goose-stepping march as hopelessly shallow. The third movement is a profound work of mourning. If the Central Committee took it as an apology, Shostakovich meant it as a memorial to those lost in the gulags. The final, fourth movement, overtly a celebration of Soviet triumph, is instead a parody of celebration (track **37.2**). In his memoirs, smuggled out of Russia after his death, Shostakovich explained what he had in mind:

> What exultation could there be? I think it is clear to everyone what happens in the Fifth. The rejoicing is forced, created under threat. . . . It's as if someone were beating you with a stick and saying "Your business is rejoicing, your business is rejoicing,'" and you rise, shaky, and go marching off, muttering, "Our business is rejoicing, our business is rejoicing." What kind of apotheosis is that? You have to be a complete oaf not to hear that.

Fig. 37.12 Gustav Klucis, *The Development of Transportation, The Five-Year Plan.* 1929. Gravure, 28 7/8" × 19 7/8". Purchase fund, Jan Tschichold Collection. (146.1968). Digital Image © The Museum of Modern Art/Licensed by SCALA/Art Resource, New York. While incorporating realist imagery through photomontage, Klucis retains the dynamic interplay of geometric forms that mark earlier, more abstract Russian Constructivist design (see Chapter 35).

Some music historians doubt the authenticity of this autobiography, but, in truth, the fourth movement is brassy and bombastic, its chords continually rising into an almost shrill hysteria. About seven minutes into the movement, the percussion beats out the rhythms of a militaristic march, asserting a kind of totalitarian control over the symphony. At the end, the percussion seems almost threatening as it insists on its controlling authority.

Mussolini in Italy

One of the most important differences between Stalin's totalitarian state and the totalitarian regimes in the rest of Europe is that the latter all arose out of a vigorously anti-Marxist point of view and fear of the Soviet state. By 1920, the Communist Party in Russia had made it clear that it intended to spread its doctrines across Europe. "The Communist International has declared," it announced, "a decisive war against the entire bourgeois world." Such pronouncements nourished a climate of fear among middle-class small-business owners, property owners, and small farmers, which opportunistic leaders could easily exploit.

Italy's Benito Mussolini [moo-soh-LEE-nee] (1883–1945) was one of these. After World War I, Italy was in disarray. Peasants seized uncultivated land, workers went on strike and occupied factories, and many felt that a Communist revolution was imminent. In the face of inaction by the government of King Victor Emmanuel III, Mussolini and his followers formed local terrorist squads, called Black Shirts because they always dressed in shirts of that color. These squads beat up and even murdered Socialist and Communist leaders, attacked strikers and farm workers, and systematically intimidated the political left.

By 1921, Mussolini's Fascist Party had hundreds of thousands of supporters, and when in October 1922 they marched on Rome, Victor Emmanuel III appointed Mussolini prime minister in order to appease them. In November, the king and Parliament granted Mussolini dictatorial powers for one year in order to produce order in the country. By 1926, Mussolini had managed to outlaw all opposition political parties, deny all labor unions the right to strike, and organize major industries into 22 corporations that encompassed the entire economy.

Although the king remained nominal ruler, Mussolini had established a single-party totalitarian state, declaring himself Il Duce [DOO-cheh], "the leader."

Of all the Fascist leaders of Europe, Mussolini was the most supportive of modernist architecture. "In five years' time," Mussolini proclaimed in 1925, echoing the popes in the fifteenth century (see Chapter 15), "Rome must astonish the peoples of the world. It must appear vast, orderly and powerful as it was in the days of Augustus." It took another ten years for Mussolini's vision to begin to take shape. In 1936, Mussolini won the right to host the next World Exhibition in Rome, scheduled for 1941, but delayed until 1942 in order to celebrate the twentieth anniversary of Mussolini's rule. The plan was to build a vast fairground outside the city walls above the Tiber on the road to Rome's port at Ostia. The architect Marcello Piacentini [pee-ah-chin-TEEN-ee] (1881–1960) was asked to coordinate the development of the site, which was envisioned as becoming a permanent new quarter of the city. Piacentini's plan emphasized the monumental aspects of the new quarter, which came to be known as EUR, the acronym of Esposizione Universale Roma, the World Exposition in Rome. Among the first buildings finished was the Palazzo degli Uffici, the Building of Offices, the administrative headquarters for the fair (Fig. 37.13)—most of the other buildings proposed by Piacentini would not be completed until after World War II. But Piacentini's sense of what a Fascist architecture might be is readily apparent. The EUR district was laid out according to the urban-planning techniques of the Roman republic (see Fig. 6.2), and that sense of order and geometric regularity is repeated in the facade of the Palazzo degli Uffici. The facade itself is travertine, a white limestone chosen to imitate the marble of ancient Rome. The scale is enormous, suggesting the imperial power of the Fascist state.

Fig. 37.13 Marcello Piacentini, Palazzo degli Uffici, Expositione Universale Europa (EUR). 1937–39. The Art Archive. This building is full of mosaics and reliefs, some of which recall the scenes of Roman soldiers sacking the Temple of Jerusalem on the Arch of Titus (see Fig. 6.21).

Franco in Spain

The Fascist ideologies that dominated Germany and Italy spread to Spain by the mid-1930s. Spain was in political turmoil. A free election in 1931 had resulted in a victory for republican democrats and the declaration of the Second Republic of Spain. Support for the monarchy collapsed, and King Alfonso XIII, who had called for the elections hoping to establish a constitutional monarchy, left the country without abdicating. This gave conservatives the hope that the monarchy might one day be restored. A strong anarchist movement soon developed, however, resulting in major uprisings, strikes, and full jails. In February 1936, the Spanish Popular Front, a coalition of republicans, communists, and anarchists that promised amnesty to all those previously imprisoned, was elected to office. This dismayed the Falange [fah-LAHN-hay] ("Phalanx"), a right-wing fascist organization with a private army much like Hitler's and that had the sympathy of the Spanish army stationed in Morocco. In July, the Falange retaliated, the army in Morocco rebelled, and General Francisco Franco [FRAHN-koh] (1892–1975) led it into Spain from Morocco in a coup d'état against the Popular Front government.

In the civil war that ensued, Germany and Italy supported Franco's right-wing Nationals, while the Soviet Union and Mexico sent equipment and advisors to the leftist Republicans. The United States remained neutral, but liberals from across Europe and America, including Ernest Hemingway, joined the republican side, fighting side by side with the Spanish.

Hitler conceived of the conflict as a dress rehearsal for the larger European conflict he was already preparing. He was especially interested in testing the Luftwaffe [LOOFT-vah-fuh], his air force. Planes were soon sent on forays across the country in what the German military called "total war," a war not just between armies but between whole peoples. This allowed for the bombing of civilians, as in the famous incident of Guernica, in the Basque region of Spain, which inspired Spanish-born artist Pablo Picasso to produce a painterly act of searing rage from his base in Paris (see *Closer Look*, pages 1226–1227).

The Spanish Civil War extended from 1936 to 1939 and tore the country apart (Map **37.2**). With the help of the Falangists, Franco was able to overcome the Republicans, first capturing Madrid in March 1939 and then, a few weeks later, Barcelona. He ruled Spain in a totalitarian manner until 1975.

REVOLUTION IN MEXICO

Armed conflict had begun in Mexico in 1910, when Francisco I. Madero [mah-DHAY-roh] (1873–1913), a respectable upper-class politician, led the overthrow of Mexican dictator Porfirio Díaz [DEE-ahs] (1830–1915). In trying to modernize Mexico, Díaz had turned over large landholdings to foreign investors for the United States and Britain to the dismay of many, including Madero. But Madero quickly lost control of events, and Díaz's supporters soon deposed and executed him. This inaugurated a period of intense bloodshed during which some 900,000 Mexicans (of a population of about 15 million) lost their lives.

Guerrilla groups led in southern Mexico by Emiliano Zapata [zah-PAH-tah] (1879–1919) and in northern Mexico by Doroteo Arango Arámbula [ah-RAHM-boo-lah] (1878–1923), better known as Pancho Villa [VEE-yah], demanded "land, liberty, and justice" for Mexico's peasant population. Their primary purpose was to give back to the people land that the Díaz government had deeded to foreign investors. Technically, the Mexican Revolution ended in 1921 with the formation of the reformist government of Álvaro Obregón [oh-rbay-GOHN] (1880–1928), but bloodshed continued through the 1920s. Zapata and Villa were assassinated, as was Obregón himself. Peace was not finally restored until the administration of Lázaro Cárdenas [KAR-day-nahs] (1895–1970) in 1934, when the reforms of the 1917 Constitution of Mexico were finally implemented.

The Mexican Mural Movement

The Mexican Revolution fueled a wave of intense nationalism to which artists responded by creating art that, from their point of view, was true to the aspirations of the people of Mexico. When the government initiated a massive building campaign, a new school of muralists arose to decorate these buildings. It was led by Diego Rivera [ree-VAIR-ah] (1886–1957), David Siqueiros [see-KAIR-ohs] (1896–1974), and José Clemente Orozco [oh-ROH-skoh] (1883–1949).

Rivera had lived in Europe from 1907 to 1921, mostly in Paris, where he had developed a Picasso-inspired Cubist technique. But responding to the revolution—and the need to address the Mexican people in clear and concise terms—he transformed his style by using a much more realist and accessible imagery focused on Mexican political and social life. He shared the style with the other muralists as well. The large fresco *Sugar Cane* depicts the plight of the Mexican worker before the revolution (Fig. **37.14**). Armed

Map 37.2 The Spanish Civil War on March 30, 1937.

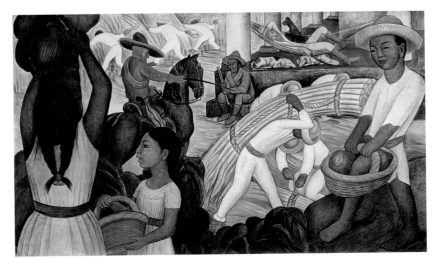

overseers hired by foreign landowners, including one lounging on a hammock in the shade with his dogs, force the peasants to work. But in the foreground, Rivera celebrates the dignity of the Mexican peasants, as they collect coconuts from a palm. Their rounded forms echo one another to create a feeling of balance and harmony.

From 1930 to 1934, Rivera received a series of commissions in the United States. They included one from Edsel B. Ford and the Detroit Institute of Arts to create a series of frescoes for the museum's Garden Court on the subject of *Detroit Industry*, and another from the Rockefellers to create a lobby fresco entitled *Man at the Crossroads Looking with Hope and High Vision to a New and Better Future* for the RCA Building in Rockefeller Center in New York. When Rivera included a portrait of Communist leader Lenin in the lobby painting, Nelson A. Rockefeller insisted that he remove it. Rivera refused, and Rockefeller, after paying Rivera his commission, had the painting destroyed.

Rivera reproduced the fresco soon after in Mexico City and called it *Man, Controller of the Universe* (Fig. **37.15**). At the center, Man stands below a telescope with a microscope in his hand. Two ellipses of light emanate from him, one depicting the cosmos, the other the microscopic world. Beneath him is the earth, with plants growing in abundance, the products of scientific advancements in agriculture. To the right, between healthy microbes and a starry cosmos, is Lenin, holding the hands of workers of different cultures. On the left, between microscopic renderings of syphilis and other diseases and a warring cosmos, is New York society, including Nelson Rockefeller enjoying a cocktail. At the top left, armed figures wearing gas masks and marching in military formation evoke World War I, while at the upper right, workers wearing Communist red scarves raise their voices in solidarity. Man must steer his course between the evils of capitalism and the virtues of communism, Rivera appears to be saying.

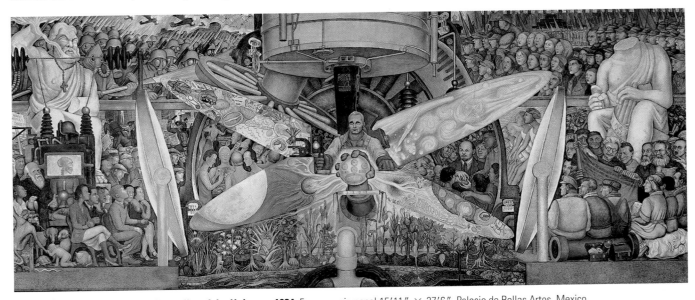

On April 26, 1937, a German air-force squadron led by Wolfram von Richthofen, cousin of the famous Red Baron of World War I, bombed the Basque town of Guernica, in Spain, during the Spanish Civil War. The attack was a blitzkrieg, the sudden, coordinated air assault that the Germans would later use to great effect against England in World War II. It lasted for three and a quarter hours. The stated target was a bridge used by retreating Republican forces at the northern edge of the town, but the entire central part of Guernica—about 15 square blocks—was leveled, and 721 dwellings (nearly three-quarters of the town's homes) were completely destroyed and a large number of people killed. In Paris, Picasso heard the news a day later. Complete stories did not appear in the press until Thursday, April 29, and photographs of the scene appeared on Friday and Saturday, April 30 and May 1. That Saturday, Picasso began a series of sketches for a mural that he had already been commissioned to contribute to the Spanish Pavilion at the 1937 Exposition Universelle in Paris. Only 24 days remained until the Fair was scheduled to open.

In the final painting, Picasso links the tragedy of Guernica to the ritualized bullfight, born in Spain, in which the preordained death of the bull symbolizes the ever-present nature of death. The work portrays a scene of violence, helpless suffering, and death. Picasso's choice of black-and-white instead of color evokes the urgency and excitement of a newspaper photograph. When the exposition closed, the painting was sent on tour and was used to raise funds for the Republican cause. *Guernica* would become the international symbol of the horrors of war and the fight against totalitarianism. Below is a history of the painting's life.

A *Guernica* Chronology

January 8, 1937 – Picasso accepts commission from Republican Spain for a painting for the Spanish Pavilion at the 1937 Exposition Universelle in Paris.

April 26 – Guernica bombed.

April 28 – Guernica occupied by Franco's troops; French Press coverage begins.

May 1 – Picasso draws six initial studies for *Guernica*.

May 11 – First photograph of the *Guernica* canvas.

May 28 – Picasso is paid 150,000 francs for *Guernica*, which he completes on June 4.

July 12 – Inauguration of the Spanish Pavilion at the Paris Exposition.

November 25 – Exposition closes, having received 33 million visitors.

Spring 1938 – *Guernica* exhibited in Stockholm and Copenhagen.

October 1938 to January 1939 – *Guernica* exhibited in London.

May 1, 1939 – *Guernica* arrives in New York, where it begins a fundraising tour to Los Angeles, San Francisco, and Chicago, concluding at the Museum of Modern Art, New York, November 15 to January 7, 1940, as part of the exhibition *Picasso: Forty Years of His Art*. After the outbreak of war in Europe, Picasso asks the Museum of Modern Art to accept *Guernica* for safekeeping.

1940–41 – The Picasso retrospective tours America with *Guernica*, traveling to Chicago, Saint Louis, Boston, San Francisco, Cincinnati, Cleveland, New Orleans, Minneapolis, and Pittsburgh.

1942 – *Guernica* exhibited at Fogg Art Museum, Cambridge, Massachusetts; thereafter, on continuing display at the Museum of Modern Art.

1950s – *Guernica* travels worldwide, until given to the Museum of Modern Art "on extended loan" in 1958. Picasso expresses the wish that the museum return the painting to Spain when and if civil liberties are restored in his native land.

November 20, 1975 – Franco dies in Madrid; two days later, Juan Carlos is crowned constitutional monarch.

June 15 – First general elections in Spain since the Civil War.

February 1981 – Picasso's lawyer approves returning *Guernica* to Spain.

October 24, 1981 – *Guernica* exhibited in Madrid and put on permanent display at Museo Nacional Centro de Arte Reina Sofia.

SEE MORE For a Closer Look at the history of Pablo Picasso's *Guernica*, go to **www.myartslab.com**

Picasso's *Guernica*

The bull is a symbol of the Spanish character and a reference to the legendary Minotaur of classical myth. For the Surrealists, the bull represented the irrational forces of the human psyche.

A spear penetrates the flank of the horse, whose scream echoes that of the mother at the left holding her dead child in her arms.

A woman screams to the sky, her house in flames.

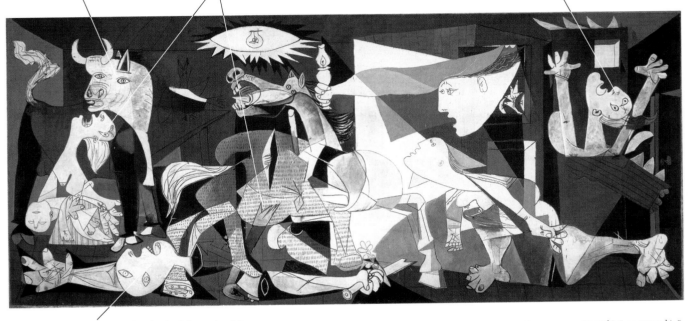

The figure lying face up is both a dead soldier and a slain picador (the chief antagonist of the bull and the one who torments him on horseback with a lance).

Pablo Picasso, *Guernica*, **1937.** Oil on canvas, 11′5 $^{1}/_{2}$″ × 25′5 $^{1}/_{4}$″. Museo Nacional Centro de Arte Reina Sofia, Madrid, Spain. John Bigelow Taylor/Art Resource, New York. © 2007 Estate of Pablo Picasso/Artists Rights Society (ARS), New York.

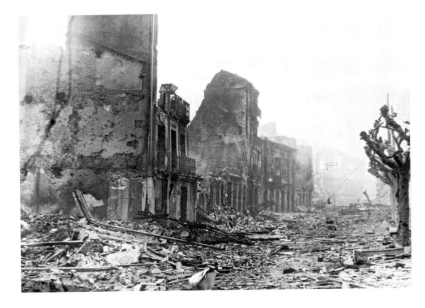

Ruins of Guernica, Spain. April 1937.

Something to Think About . . .

Why do you think *Guernica* became the seminal antiwar painting of the twentieth century?

The Private World of Frida Kahlo

Rivera's wife, Frida Kahlo [KAH-loh] (1907–1954), was also an artist. Although she was as political as her husband, her paintings document her personal tragedy. Already crippled by a bout of polio in childhood, she was injured severely in 1925 at the age of 18 when a tram hit the bus in which she was riding home from school. A metal handrail pierced her body through, her spine and pelvis were broken, and so were her right leg and foot. Her long recuperation was not completely successful, requiring some 30 operations and eventually the amputation of her right leg. In the hospital, she began painting, using a small lap easel, and somewhat miraculously regained the ability to walk.

A close friend introduced Kahlo to Diego Rivera, and in 1929, they were married. In addition to leftist political views, they shared a love for Mexican culture—Frida [FREE-dah] often dressed in traditional Mexican costume—and a passion for art. But they were also a study in contrasts, Kahlo small and slender, barely five feet tall, Rivera much taller, of considerable girth, and 20 years her senior. Frida's father remarked, "It was like the marriage between an elephant and a dove." Their stormy relationship survived infi-

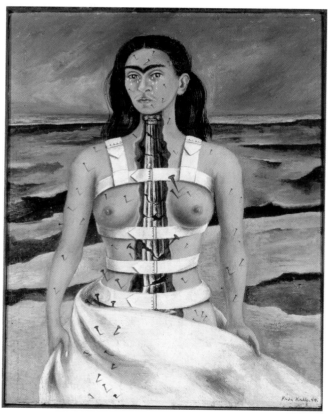

Fig. 37.16 Frida Kahlo, *The Broken Column*. 1944. Oil on canvas. 15 $^{11}/_{16}$" × 12". Collection Museo Dolores Olmedo Patiño, Mexico City. © 2008 Banco de Mexico Diego Rivera & Frida Kahlo Museums Trust. Av. Cinco de Mayo No. 2, Col. Centro, Del. Cuauhtemoc 06059, Mexico, D.F. Reproduction authorized by the Instituto Nacional de Bellas Artes y Literatura. The fractured and barren landscape behind Kahlo may symbolize her inability to bear children—another result of her injuries.

delities, the pressures of Rivera's career—she was clearly second fiddle to his murals—a divorce and remarriage, and Kahlo's poor health.

Kahlo's paintings—mostly self-portraits—bear witness to the trials of her health and marriage. "I have suffered two grave accidents in my life," she once said, "one in which a street car ran me over; the other accident is Diego." Many of the self-portraits are violent, showing, for instance, in *The Broken Column* (Fig. **37.16**), her body pierced with nails and ripped open from neck to navel to expose her spine as a broken stone column. Her work not only evokes her intense personal struggle, but also sets that struggle in an almost mythic or heroic universal struggle for survival.

Kahlo and Rivera traveled to the United States and France, where Kahlo met luminaries from the worlds of art and politics. Surrealist André Breton [bruh-TOHN] was especially attracted to her work. Although grateful for Breton's attention, she was quick to emphasize that she was by no means a Surrealist herself. "I never painted my dreams," she said. "I painted my own reality."

THE GREAT DEPRESSION IN AMERICA

After World War I, American money had flowed into Europe, mostly in the form of short-term loans, but by 1928, most of it was withdrawn and placed in the booming New York stock market, jeopardizing European economies. Investors borrowed freely from banks and overinvested in stocks. When the market crashed on October 29, 1929, investors lost huge amounts of money and could not repay their loans. Across the country, one bank after another closed its doors, savings were lost, businesses failed, and unemployment grew. Nearly 16 million men were out of work by the early 1930s, about one-third of the national workforce. Franklin Roosevelt's election as president in 1932 was understood as a mandate for the federal government to bring its resources to bear against what became known as the Great Depression.

The Road to Recovery: The New Deal

Roosevelt quickly implemented a host of measures that came to be known as the **New Deal**. To safeguard bank deposits, he created the Federal Deposit Insurance Corporation. The National Recovery Act regulated industrial competition and ensured the right of workers to organize and bargain. The 1935 Social Security Act provided for unemployment insurance and old-age pensions. New-home construction was encouraged by the Home Owners' Loan Corporation. The 1933 Civil Works Administration created 4 million make-work jobs on public projects for persons on relief in an effort to help them contribute to economic recovery by increasing their purchasing power. The program continued when it was replaced by the Work Projects Administration (WPA) two years later.

The WPA peaked at about 3.5 million people employed, but over its lifespan, it helped about 8.5 million people get back to work. The WPA's work force constructed 116,000

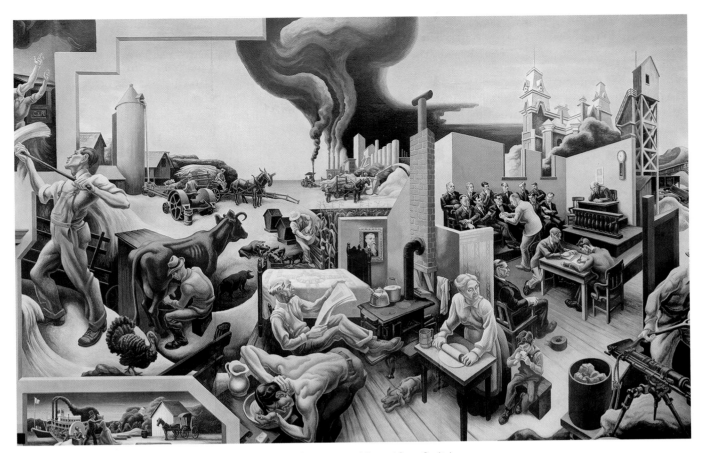

Fig. 37.17 Thomas Hart Benton, Missouri Mural (detail). 1936. Oil on canvas. Missouri State Capitol, Jefferson City, Missouri. © T. H. Benton and R. P. Benton Testamentary Trusts/UMB Bank Trustee. Art © Licensed by VAGA, NY. Reading from left to right, the traditional ways of Missouri agriculture are threatened by the specters of industry and litigation.

buildings, 78,000 bridges, and 651,000 miles of road, and improved 800 airports. But its most important contributions to American culture were the Federal Art Project, the Federal Writers' Project, the Federal Theatre Project, and the Federal Music Project. Through the WPA, artists produced nearly 10,000 drawings, paintings, and sculptures and decorated many public buildings (especially post offices) with murals. Theater performances under the project averaged 4,000 a month. Writers were employed to create a series of state and regional guidebooks, and musicians found work in newly created orchestras.

The Mural Movement The WPA mural project was led in large part by the example of Thomas Hart Benton (1889–1975), who between 1930 and 1936 created four enormous murals that required about 7,000 square feet of canvas and included more than 1,000 figures. They are *America Today* (for the New School of Social Research in New York, 1930), *The Arts of Life in America* (for the Whitney Studio Club in New York, 1932), *A Social History of Indiana* (for the Indiana pavilion at the 1933 Chicago World's Fair), and *A Social History of the State of Missouri*

(for the House Lounge in the Missouri State Capitol Building, Jefferson City, 1935/36). For the last of these, he was paid $16,000 over two years—a handsome sum at the time—and offered a position at the Kansas City Art Institute. The north wall of the Capitol lounge depicts Missouri's "Pioneer Days" and is highlighted by a depiction of Huckleberry Finn and Jim over the doorway. The east wall, the right half of which is illustrated here, is dedicated to "Politics, Farming, and Law in Missouri" (Fig. **37.17**). The south wall celebrates the state's two great cities, "St. Louis and Kansas City," including the lover's quarrel of the 1880s immortalized in the popular song "Frankie and Johnny." Benton worked in egg tempera, a medium seldom used in such a large scale since the Renaissance. He liked the medium's bright, clear colors and the fact that the paint dried quickly.

The WPA created special programs focused on three centuries of African-American cultural accomplishments. In 1935, it hired Aaron Douglas to paint a four-panel series, called *Aspects of Negro Life*, for the 135th Street branch of the New York Public Library in Harlem (today the Schomburg [SHOM-berg] Center for Research in Black Culture). It traces

African-American history from freedom in Africa to enslavement in the United States and from liberation after the Civil War to life in the modern city in a style very much like that of his painting *Aspiration* (see Fig. 36.1).

The Music Project: Aaron Copland's American Music The Depression had an enormous impact on the music industry. Thousands of musicians lost their jobs as orchestras and opera companies closed their doors, hotels and restaurants eliminated orchestras, and music education disappeared from school and university budgets. Even worse, the introduction of sound to motion pictures, discussed later in this chapter, meant that movie theater after movie theater dismissed the orchestras that had accompanied silent films. By 1933, two-thirds of the national membership of the American Federation of Musicians was unemployed. The WPA's Federal Music Project addressed this situation, organizing orchestras around the country.

When the project first began, there were only 11 recognized symphony orchestras in the United States. At the peak of the WPA, 34 more new orchestras had been created, and thousands of Americans were attending concerts. From October 1935 to May 1, 1937, almost 60 million people listened to 81,000 separate performances of WPA musical events. And through the Composers' Forum Laboratory, new music was created and performed.

One of the beneficiaries of this support was composer Aaron Copland [KOPE-lund] (1900–1990). Copland had begun his career deeply influenced by European modernism, particularly the work of Arnold Schoenberg (see Chapter 34), but he became increasingly interested in folk music. This interest began in the fall of 1926, when he met Mexican composer Carlos Chávez [SHAH-vays] (1899–1978), who was rooming with Mexican artist Rufino Tamayo [tah-MAH-yoh] (1899–1991) in a tenement on Fourteenth Street in New York and who introduced him as well to Diego Rivera. Writing about Chávez in 1928, Copland declared that the composer's "use of folk material in its relation to nationalism" constituted a major strain of modern music, one that he himself would soon begin to pursue.

In the early 1930s, Copland composed *El Salón México* [el sah-LOHN MAY-hee-koh], based on Mexican folk music he had heard when visiting Chávez in Mexico. Soon after this, he began to use purely American themes and material, including New England hymns, folk songs, and jazz, particularly in his work for the ballet: *Billy the Kid* (1938), *Rodeo* (1942), and *Appalachian Spring* (1944).

Copland composed *Appalachian Spring* for dancer and choreographer Martha Graham (1894–1991). Copland simply called it "Ballet for Martha," but Graham renamed it when she decided to set the ballet in the Pennsylvania hill country early in the nineteenth century. In Graham's dance, a young woman and her fiancé both express their excitement and joy at the prospect of their upcoming marriage and their sober apprehension of the responsibilities that their new life demands. While an older neighbor conveys a mood of confidence and satisfaction, a religious revivalist reminds the new bride and groom of their tenuous place in God's cosmos. At the end, the couple have evidently grown into their new life as they come to live in their new house. Copland's score for this concluding section is built around a single Shaker hymn, "Simple Gifts," which serves as the basis for a stirring set of variations that occur just before the final slow coda (track **37.3**). The orchestral version of *Appalachian Spring*, actually a suite, was extremely popular and demonstrated that Copland had found a truly American style.

HEAR MORE at www.myartslab.com

The Dust Bowl in Film and Literature Copland was not the only American composer moved by the Depression to pursue distinctly American themes. Virgil Thomson (1895–1989), who like Copland had studied in Paris, was hired in 1936 by the Resettlement Administration to score two documentary films directed by Pare Lorentz (1905–1992) in order to raise awareness about the New Deal. *The Plow That Broke the Plains* is about the devastation of the almost-ten-year drought that struck the American Midwest, particularly the southern Great Plains, and turned the region into a virtual dust bowl. *The River* celebrates the accomplishments of the Tennessee Valley Authority to harness water for electrical energy.

Thomson's score for *The Plow That Broke the Plains* consists of six movements that follow the transition from fertile plain to Dust Bowl: *Prelude*, *Pastorale* (*Grass*) (track **37.4**), *Cattle*, *Blues* (*Speculation*), *Drought*, and *Devastation*. Thomson spent considerable time researching the rural music of the Great Plains. He also incorporated military marches, gunfire, and the sound of rolling tanks into the score to accompany a film sequence of farmers plowing the land. In doing so he addressed musically a theme ignored in the narration: the contribution of agriculture to the war effort.

HEAR MORE at www.myartslab.com

Lorentz shot *The Plow That Broke the Plains* in Montana, Wyoming, Colorado, Kansas, and Texas, and was able to capture extraordinary dust-storm sequences and the pathos of those caught in their wake. The film's public premier was at the Mayflower Hotel in New York on May 10, 1936, at an evening sponsored by the Museum of Modern Art. The event also featured several foreign documentaries, including portions of Leni Riefenstahl's *Triumph of the Will*. Although *Plow* was critically acclaimed, none of the Hollywood studios would agree to distribute it commercially because, they claimed, it was strictly government propaganda. But the movie was shown at independent theaters with great success, and its popularity soon changed the distributors' minds. When *The River* was released in 1937, Paramount jumped to distribute it. The script was nominated for the Pulitzer Prize in Poetry in 1938.

The great novel of the Dust Bowl years was *The Grapes of Wrath* by John Steinbeck [STINE-bek] (1902–1968). Published in 1939, its interplay between panoramic interludes and close-up accounts of a family's cross-country journey was inspired by Lorentz's films. Steinbeck even worked

briefly with Lorentz on the documentary *The Fight for Life*, about a maternity ward in Chicago, the year after *The Grapes of Wrath* was published. The title of Steinbeck's novel comes from "The Battle Hymn of the Republic":

Mine eyes have seen the glory of the coming
　　of the Lord
He is trampling out the vintage where
　　the grapes of wrath are stored,
He has loosed the fateful lightning
　　of His terrible swift sword
His truth is marching on.

This mention of "grapes of wrath," as Steinbeck knew, was a reference back to the Bible: "And the angel thrust his sickle into the earth, and gathered the vine of the earth, and cast it into the great winepress of the wrath of God" (Rev. 14:19).

In a style so realistically detailed that it might be called cinematic, Steinbeck tells the story of the Oklahoma Joads, who lose their tenant farm and join thousands of others traveling to California on Route 66, the main migrant road. Their motivation is summarized in a handbill that they find on the road: "PEA PICKERS WANTED IN CALIFORNIA. GOOD WAGES ALL SEASON. 800 PICKERS WANTED." Things in California do not turn out as planned—thousands of workers turn up for the few available jobs, and food is scarce: "In the souls of the people," Steinbeck writes, "the grapes of wrath are filling and growing heavy, growing heavy for the vintage." Steinbeck's Joads are stoically heroic (especially Ma Joad) but also deeply perceptive about the social injustices that pervade the America they encounter in their journey. The novel is an outcry against the injustice encountered by all migrant workers in the Great Depression.

Photography and the American Scene

One of the important cultural contributions of the New Deal was the photographic documentation of the plight of poor farmers and migrant workers during the Dust Bowl and Great Depression under the auspices of the Farm Security Administration (FSA). The head of the FSA's photographic project, Roy Stryker, found in the work his team of 15 photographers created the same stoic heroism that

Steinbeck had portrayed in the Joad family: "You could look at the people and see fear and sadness and desperation," Stryker wrote. "But you saw something else, too. A determination that not even the Depression could kill. The photographers saw it—documented it."

This is certainly the quality that Dorothea Lange (1895–1965) captures in *Migrant Mother*, a portrait of Native American Florence Owens Thompson and three of her children in a pea-pickers' camp (Fig. **37.18**). Stryker said of this image: "When Dorothea took that picture, that was the ultimate. She never surpassed it. To me it was the picture of Farm Security. She has all the suffering of mankind in her, but all the perseverance too. A restraint and a strange courage." In the 1940s, Lange's documentary work included photo essays of the Japanese internment camps as well as a series focusing on World War II factory workers. She later was the first

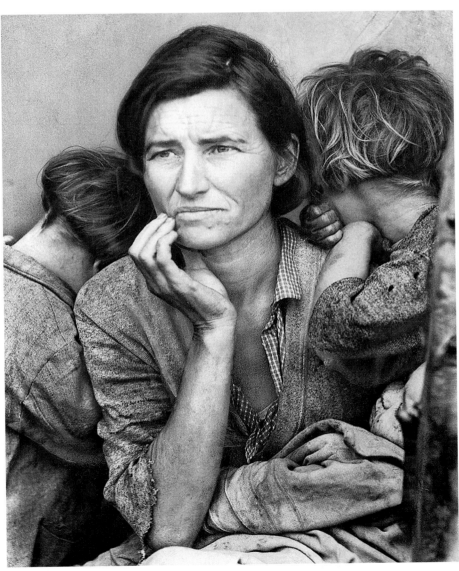

Fig. 37.18 Dorothea Lange, *Migrant Mother, Nipomo, California*. 1936. Gelatin silver print, 37 ⅛″ × 40 ⅝″. Library of Congress, Washington, D.C. The original caption for this photograph, taken for the Farm Security Administration, was: "Destitute pea pickers in California. Mother of seven children."

woman awarded a Guggenheim fellowship and spent nearly ten years making photo essays for *Life* and other magazines.

Of all the FSA photographs, the most well-known today are those of Walker Evans (1903–1975) first published in *Let Us Now Praise Famous Men*, a book produced in 1941 with writer James Agee [AY-jee] (1909–1955). The book's title is ironic, for Agee's subject is the least famous, the poorest of the poor: sharecroppers, the men, women, and children of Depression-ridden central Alabama in the summer of 1936 when he and Evans lived among them. But again, it is the simple life and inherent nobility of these poor people that form Evans and Agee's theme. This theme is captured in the rich textures and clean lines of Evans's photograph of a sharecropper's humble dwelling (Fig. 37.19). The photo is a revelation of the stark beauty in the middle of sheer poverty.

Fig. 37.19 Walker Evans, *Washroom and Dining Area of Floyd Burroughs's Home, Hale County, Alabama*. 1936. 35mm photograph, Library of Congress, Washington, D.C. During its eight-year existence, the Farm Security Administration created over 77,000 black-and-white documentary photographs.

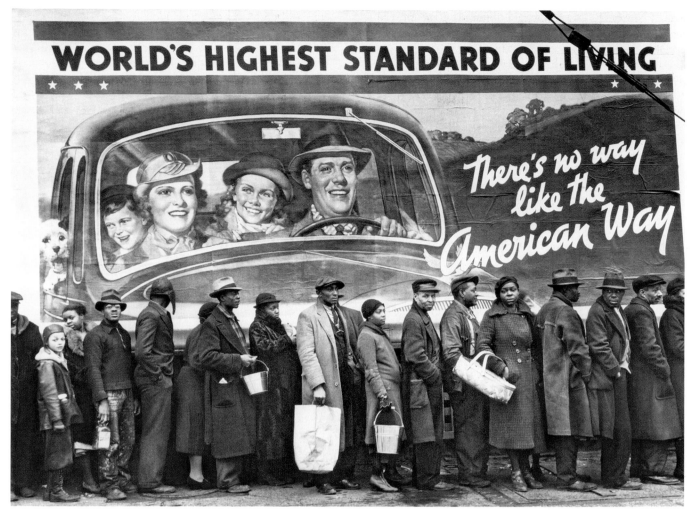

Fig. 37.20 Margaret Bourke-White, *At the Time of the Louisville Flood*. 1937. Gelatin silver print, 9 ³/₄″ × 13 ¹/₂″. The Hallmark Photographic Collection, Hallmark Cards, Inc., Kansas City, Missouri. Bourke-White later covered World War II and the Korean War for *Life*. She was the first woman photographer attached to the U.S. armed forces, and the only American photographer to cover the siege of Moscow in 1941.

Not all of the important photographers with social consciences worked for the FSA. Margaret Bourke-White (1904–1971) was one of the first four photographers hired by publisher Henry Luce for the new picture magazine *Life*, founded in 1936. That same year, she traveled the American South with writer Erskine Caldwell, documenting the living conditions of poor tenant farmers, a project that resulted in the 1937 book *You Have Seen Their Faces*. That same year, *Life* published one of her most famous photographs, *At the Time of the Louisville Flood* (Fig. **37.20**). Over 900 people had died when the Ohio River inundated Louisville, Kentucky, in January 1937. Bourke-White's photo stunningly indicts the American dream by juxtaposing desperately poor folk who have lost their homes (reality) with a government billboard touting well-being (propaganda).

CINEMA: THE TALKIES AND COLOR

Throughout the Great Depression, going to the movies was America's favorite leisure activity. The movies took people's minds off the harsh realities of the era, and although ticket prices were relatively expensive, ranging between 25 cents and 55 cents (between $4 and $9 in terms of today's buying power), people still found the means to flock to the movies. By the late 1930s, some 50 million viewers were drawn into American theaters each week.

Prior to the Depression, two forces were transforming motion pictures simultaneously—the introduction of sound and the advent of color film. Technicolor, the brainchild of Herbert Kalmus (1881–1963), was the first widely successful color-film process in which two film strips were dyed and

pasted together to create a single positive print containing all the colors that the audience would see. Douglas Fairbanks's 1926 film *The Black Pirate* was the first feature film in full color. By the mid-1930s, a three-color Technicolor process had been perfected, and motion-picture companies gradually began to work it into their productions.

What slowed the introduction of color in the industry was sound, the development of which consumed the attention of the industry. Before the advent of motion-picture sound, movies were by no means "silent." Every theater had a piano or organ to provide musical accompaniment to the films it projected. This made cinema a multimedia event, a live musician or orchestra reacting to and participating in the presentation of the film, mediating between audience and image. In this sense, films, before sound, were literally local events. But the introduction of sound radically changed the motion-picture industry. For one thing, theaters everywhere had to be wired, a process that took several years to accomplish. For another, incorporating sound into the film itself changed the culture of film viewing. In the 1920s, the cinema was the world's largest employer of musicians. Then, as noted earlier, just as the Great Depression hit, thousands of cinema musicians found themselves out of work.

Sound and Language

Sound also changed the nature of acting in the cinema. Before sound, communication with the audience depended on facial expression and physical gesture, often exaggerated. Now actors had to rely on speech to communicate, and many silent-era stars simply lacked a compelling voice. Foreign actors were especially affected—Greta Garbo, with her deeply sonorous and melancholy voice ("I vhant to be alone"), was one of the few foreign stars to make the transition successfully, except for English actors. Dialogue writing had never been important before, but now playwrights became an instrumental force in movie production. Most important, sound brought foreign languages into the theaters—English into European theaters, various European languages into each other's and American theaters. At first, some producers tried to produce their films in several languages, but this proved too expensive.

In Europe, English-language films were commonly produced using **dubbing** (shorthand for "vocal doubling"), with native speakers synchronizing new dialogue to the lip movements of the actor. In the United States, where a large part of the audience for foreign films were immigrants who spoke the foreign language, English-language text was more commonly scrolled across the bottom of the screen as subtitles. Interestingly, subtitles tend to announce the "foreignness" of the film, while dubbing suppresses it, so dubbing played a major role in the "Americanization" of world cultures.

***The Jazz Singer*: The First Feature-Length Talkie** Sound came to the feature-length motion picture on October 6, 1927, when Warner Bros. Studio premiered *The Jazz Singer*,

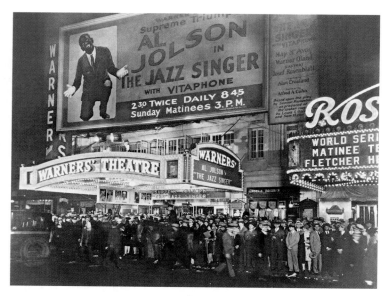

Fig. 37.21 Opening night crowd gathering to see Al Jolson in *The Jazz Singer*, Warner's Theatre, Times Square, New York, October 6, 1927. The film convinced producers and audiences that sound could be more than a novelty.

starring Al Jolson [JOL-sun] (1886–1950) (Fig. **37.21**). The first words of synchronous [SING-kruh-nus] speech were Jolson's prophetic statement, "Wait a minute. Wait a minute. You ain't heard nothing yet." *The Jazz Singer* is the story of a cantor's son, Jakie Rabinowitz [ruh-BIN-oh-vits], who longs to play jazz (calling himself Jack Robin) rather than follow his family's footsteps into the synagogue. Jakie/Jack falls in love with a woman outside his own faith, performs in minstrel-style blackface makeup, and otherwise challenges every notion of ethnic identity. The film contained only two dialogue scenes (in other respects it was a silent-era feature), but its success lay as much in this story line as in its introduction of sound. Audiences everywhere recognized it as an "American"—as opposed to an ethnic—tale.

The Blue Angel One of the most interesting early experiments with sound was the two-language production *Der blaue Engel* [der BLAU-uh EN-gul]/*The Blue Angel*, directed by Josef von Sternberg [SHTERN-berg] (1894–1969). Sternberg had emigrated from Germany to the United States at the turn of the century, and through the 1920s, he had gradually worked his way up the directorial ladder in Hollywood. In 1930, Paramount hired him to go to Germany to direct a co-production in both German and English with UFA (Universum Film Aktiengesellschaft), one of the largest studios in Europe. Marlene Dietrich (1901–1992) starred in the film as the nightclub performer Lola Lola opposite Emil Jannings as Professor Rath, a sexually repressed instructor at a boys' school whom Lola Lola seduces by exploiting his self-loathing (Fig. 37.22). Dietrich's portrayal of a temptress secured her fame. Sternberg would bring her back to Hollywood, where he would feature her in the role of the vamp who sexually humiliates her masochistic male counterpart in six more films over the next five years. The films demonstrate how thoroughly Freudian psychology had taken hold of the popular imagination.

Fig. 37.22 Marlene Dietrich in *Der blaue Engel/The Blue Angel*. 1930. UFA (Germany). Not unjustifiably, Sternberg was accused of putting Dietrich on display to exploit her sexuality.

Disney's Color Animation

Between 1928 and 1937, Disney studios, headed by Walt Disney (1901–1966), created over 100 animated cartoons, most starring Mickey Mouse but depending, for variety and development, on Mickey's entourage of sidekicks, particularly Pluto, Goofy, and Donald Duck. At least as important technically, however, were Disney's so-called Silly Symphonies, with scores that are masterpieces of parody, subjecting classical music—from opera to the piano concerto—to the good-natured fun of the cartoon medium. In essence, Disney's animation gave rise to the art of **postsynchronization**, in which sound is added as a separate step after the creation of the visual film. Actors became increasingly adept at speaking lines mouthed by cartoon characters, and musical scores could be adapted to fit the action.

Disney studios began work on its first feature-length Technicolor animation, *Snow White and the Seven Dwarfs*, in 1934. Over 300 animators, designers, and background artists worked on the film, with Disney hiring animators away from other studios and training many other artists who had never worked at animation before. The film took three years to finish and premiered in December 1937. It was an instant success, and Disney immediately set his team to work on three more features: *Bambi*, *Pinocchio*, and *Fantasia* [fan-TAY-zhuh]. The last of these animated classical music in order to introduce young people to the various classical forms. The didactic nature of *Fantasia* is unique in the annals of cartoon animation.

1939: The Great Year

As the nation recovered from its economic downturn, and audiences were able to afford to go the movies more often, Hollywood responded by making more and better films. In 1939, Hollywood created more film classics than at any time before or since. Among these are *Stagecoach*, *Mr. Smith Goes to Washington*, *Drums Along the Mohawk*, *Wuthering Heights*, *Of Mice and Men*, *Gone with the Wind*, and *The Wizard of Oz*, to name just a few.

The Wizard of Oz *The Wizard of Oz* was the most expensive film MGM made in 1939. It was in fact MGM's most expensive film of the decade—costing $2.77 million to produce (Fig. **37.23**). It starred Judy Garland (1922–1969), by then well known by movie audiences for her work with Mickey Rooney (1920–) in his string of box-office hits in the role of "Andy Hardy." The film begins in the black-and-white "reality" of Kansas. It switches to color when Dorothy and her dog Toto arrive in Oz after being transported there by a tornado. The sudden intrusion of color announced to the audience that Oz was the stuff of fantasy. Despite grossing over $3 million, *The Wizard of Oz* lost nearly $1 million, owing to higher-than-usual marketing costs.

Although the film launched Garland into stardom, virtually guaranteeing future income from her performances, it also taught the studio an important corporate lesson. Having paired Garland with Rooney once again in a series of remakes of Broadway musicals, beginning with *Babes in Arms*, the studio reaped similar or larger grosses with much less expenditure. The formula for studio success was clear: the economical production of star-driven vehicles with recyclable narrative traits. In this rested both Hollywood's financial success and its artistic limitations.

Gone with the Wind The most ambitious project of 1939 was *Gone with the Wind*, produced by David O. Selznick [SELZ-nik] (1902–1965) and based on the Civil War novel by Margaret Mitchell (1900–1949). Arguably the first true "blockbuster," its running time was 3 hours 42 minutes, plus an intermission, keeping audiences in theaters for over 4 hours. They came to see English actress Vivien Leigh in

Fig. 37.23 Judy Garland, as Dorothy, sees the Yellow Brick Road in *The Wizard of Oz*. 1939. © 1939 The Kobal Collection/ MGM. Warner Brothers Motion Picture Titles. Until this film, audiences associated color almost exclusively with cartoons.

the role of Southern belle Scarlett O'Hara, for Selznick had made sure everyone knew that America's biggest stars had all auditioned for the part, including Katharine Hepburn, Susan Hayward, Barbara Stanwyck, Joan Crawford, Lana Turner, Mae West, Tallulah Bankhead, and Lucille Ball. Errol Flynn, Ronald Colman, and Gary Cooper were also considered for Clark Gable's role as the Southern gunrunner Rhett Butler. Selznick spent an unheard-of $4 million to produce the film, but he was rewarded when it became the highest-grossing film ever—$400 million in lifetime box-office gross receipts. Finally, audiences were stunned by its sweeping Technicolor, a technology to which producer Selznick was more fully committed than any other Hollywood producer.

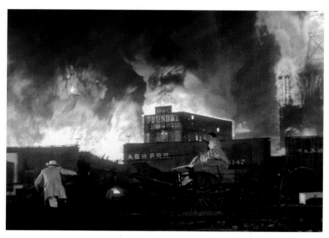

Fig. 37.24 The burning of Atlanta from *Gone with the Wind*. 1939.
Selznick and Menzies shot the burning-of-Atlanta sequence first so that the studio lot could be cleared for other sets.

The film was not easy to make. Selznick went through three directors during production, with Victor Fleming, who was responsible for about half the film and had just finished directing *The Wizard of Oz*, finally getting credit. As usual in Hollywood, a number of writers had a hand in the script. There were over 50 speaking roles and 2,400 extras. The subject matter was controversial—the fate of *Birth of a Nation* weighed on Selznick's mind—and the film was carefully scripted to avoid racial caricature. Indeed, Hattie McDaniel, who played the house servant Mammy in the film, would become the first African American to win an Academy Award (as Best Supporting Actress).

Much of the film's success can be attributed to art director William Cameron Menzies [MEN-zeez], whose reputation had been established years before when he designed the sets for *The Thief of Bagdad* (see Fig. 36.22). Menzies worked on visualizing the film for two years before production began, creating storyboards to indicate camera locations for the sets. This allowed the determination of camera angles, locations, lighting, and even the editing sequence well in advance of actual shooting. His panoramic overviews, for which the camera had to pull back above a huge railway platform full of wounded Confederate soldiers, required the building of a crane, and they became famous as a technical accomplishment. For the film's burning-of-Atlanta scene, Menzies's storyboard shows seven shots, beginning and ending with a panoramic overview, with cuts to close-ups of both Rhett Butler and Scarlett O'Hara fully indicated (Figs. **37.24** and **37.25**).

The Rules of the Game Not made in Hollywood but France, perhaps the greatest film of 1939 was *La Règle du jeu* (*The Rules of the Game*), directed by Jean Renoir (son of Impressionist painter Auguste Renoir). With *The Battleship Potemkin*, it is the only film always on the list of the top ten films ever made in the poll conducted every decade since 1952 by the European magazine *Sight and Sound*. At the most basic level, the film is a love farce with a double upstairs/downstairs plot that takes place one weekend at the country chateau of the Marquis de la Chesnaye. Upstairs are the rich: the Marquis, Robert; his wife, Christine; his mistress, Genevieve; and a famous aviation hero named André Jurieux, who is desperately in love with Christine. Downstairs among the hired help are Lisette, private maid to Christine; Schumacher, her

ɟ. 37.25 William Cameron Menzies, storyboard for the burning-of-Atlanta scene from *Gone with the Wind*.
39. Photofest. Such storyboards reflect the detailed level of planning necessary before filming could begin.

groundskeeper husband; and the newly hired valet, Marceau, whom the Marquis is intent on assisting in his efforts to seduce Christine. But Renoir's film is much more than a tale of his lovers' intrigues. It is a scathing indictment of French society at the brink of World War II, of a society intent on maintaining the status quo as each person pursues his or her own individual desires at the expense of social responsibility and engagement.

As a result, the movie was greeted by hisses and boos when first screened in 1939 and banned as demoralizing by the French government after the outbreak of war. Renoir himself called it a "war film" with "no reference to the war." War, in fact, seems imminent in the film as, in the forest surrounding the chateau, the random gunfire of "hunters" periodically startles the weekend party. Yet—and this is the point—it is a sound they choose to ignore.

Orson Welles and *Citizen Kane*

One of the most cinematographically inventive films of the postwar era was the 1940 *Citizen Kane*, directed by Orson Welles (1915–1985). The story is presented in a series of flashbacks as told to a journalist who is seeking to unravel the mystery of why media baron Charles Foster Kane (generally understood as a character based on actual newspaper mogul William Randolph Hearst) spoke the single word "Rosebud" on his deathbed. So the story is nonlinear, fragmented into different voices and different points of view, and its various perspectives carry over into the film's unorthodox construction.

Welles had made history—and a large reputation—in 1938 when his Halloween radio dramatization of H. G. Wells's novel *The War of the Worlds* convinced many listeners that Martians had actually invaded New Jersey. RKO gave him unprecedented freedom to make *Citizen Kane* in any manner he chose. Working as writer, director, producer, and actor simultaneously—and collaborating with cinematographer Gregg Toland on almost every shot—Welles produced a film unprecedented in its fresh look. In fact, he insisted that Toland experiment with almost every shot. Toland employed a special deep-focus lens that maintains focus from foreground to background in the deep space of the sets, in order to highlight multiple planes of action in the same shot (Fig. **37.26**). These shots were often lit with **chiaroscuro lighting**, a term borrowed from Renaissance painting to describe pools of light illuminating parts of an otherwise dark set. Toland also had the sets constructed in such a way that he could shoot from well above or well below the action.

Citizen Kane marked the end of the great era of the American motion picture. By 1945, with World War II in full swing, Hollywood production had fallen by more than 40 percent. Great films would continue to be made—the 1943 war film *Casablanca*, starring Humphrey Bogart [BOH-gart] and Swedish star Ingrid Bergman, was everyone's favorite wartime movie. After the war, the population began to shift to the suburbs, increasingly engaging in outdoor leisure activities, and television began to replace film as the primary delivery system of the moving image. As a result, motion-picture attendance began a slow decline.

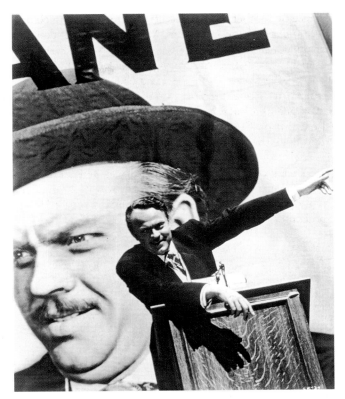

Fig. 37.26 Orson Welles as Kane campaigning for governor in *Citizen Kane. 1941. CITIZEN KANE © 1941 The Kobal Collection/RKO. Warner Brothers Motion Picture Titles. This shot is a subtle reference to film editing, simultaneously both a medium shot of Kane and a close-up in the poster behind him.

WORLD WAR II

As the motion picture industry was enjoying its greatest year, the war in Europe that Jean Renoir's *Rules of the Game* predicted broke out. The immediate causes of World War II can be traced to the meeting in Munich, on September 29 to 30, 1938, of Adolf Hitler and Benito Mussolini with the leaders of Britain and France. In an effort to appease the German dictator, the English and French granted him control of the Sudetenland [soo-DAY-tuhn-lahnd], an area of Czechoslovakia near the German border and home to 3.5 million Germans. In return, Hitler promised to spare the rest of Czechoslovakia and make no further territorial demands in Europe. Neville Chamberlain (1869–1940), the British prime minister, returned from Munich announcing he had secured "peace in our time." Statesman Winston Churchill (1874–1965) predicted a different outcome in Parliament: "All is over," he said. "Silent, mournful, abandoned, broken, Czechoslovakia recedes into the darkness." Six months later, his prediction proved true. On March 15, 1939, Hitler occupied Prague, and Czechoslovakia was no more. Poland would be next. On September 1, 1939, Hitler invaded that country, employing the blitzkrieg [BLITZ-kreeg] tactics he had practiced in Spain. Two days later, Britain and France declared war on Germany. As the United States attempted to maintain its neutrality, the following spring, Hitler invaded Norway and Denmark, then

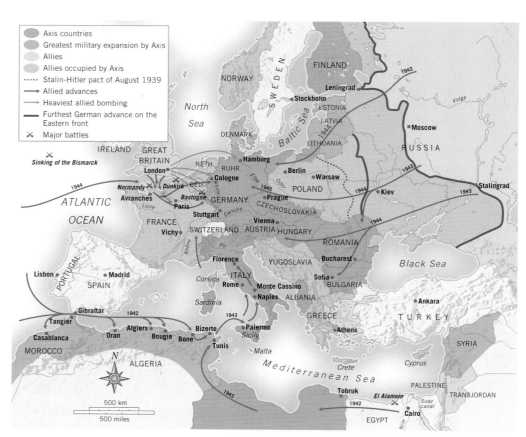

Belgium, the Netherlands, and Luxembourg. The fighting lasted only two days in the Netherlands, two weeks in Belgium. Hitler quickly marched on Paris. By mid-June 1940, France fell, and the Nazis installed the Vichy [VEE-shee] government of Marshall Pétain [pay-TEHN], with which they pursued a policy of collaboration.

From this point, the struggle continued on many fronts (Map **37.3**). The Luftwaffe [LOOFT-wah-fuh], the German air force, attacked Britain. At first it targeted Britain's air bases, but then it bombed London itself nearly every night throughout September and October. The raids only steeled British resolve to resist. To the east, Hitler turned his sights on Russia and the Ukraine, which he planned to invade in May 1941, a blitzkrieg assault that he hoped would be complete by the onset of winter. But meanwhile Mussolini attacked the British in Egypt and invaded Greece, meeting with little success. This caused Hitler to send General Erwin Rommel into North Africa and considerable forces into the Balkans. As a result, the Russian campaign was delayed six weeks, which together with several tactical errors on Hitler's part resulted in the loss of the entirety of his eastern forces at the Battle of Stalingrad in the summer of 1942.

The Holocaust

Meanwhile Hitler had instigated a plan to rid Europe of what he considered its undesirable populations, particularly Jews. To this end, he constructed a series of concentration and extermination camps, the largest of which was Auschwitz-Birkenau [AUSH-vits-BER-ken-ow], located near the provincial Polish town of Oswiecim [osh-FYEN-cheem], from which it took its Germanized name. The first camp on that site, known as Auschwitz I, was reserved for political prisoners, mainly Poles and Germans, but in October 1941, Birkenau (so named because birch trees surrounded the site) supplemented it. Here a subdivision of Adolf Hitler's protection units known as the SS developed a gigantic extermination complex. It included "Bathing Arrangements," lethal gas jets disguised as showerheads. Upon their arrival in cattle cars at the Hell's Gate (Fig. **37.27**), Jewish prisoners

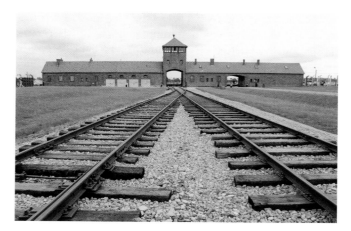

Fig. 37.27 Philippe Giraud, _Entrance, Auschwitz-Birkenau Death Camp_. Photographed 2003. Known as "Hell's Gate," this is the main entrance to Birkenau viewed from the unloading ramp where prisoners arrived by railroad. Nearly one-third of the 6 million Jews killed by the Nazis in World War II died here.

underwent a "Selection." Those deemed able-bodied were selected to work in the forced-labor camp, while the others—the old and the weak, as well as young children and their mothers—were exterminated in the "Bathing Arrangements." Every newcomer, except those selected for extermination, was given a number, which was tattooed on the arm. Altogether 444,000 numbers were officially issued, but the total number of Jews killed at Auschwitz-Birkenau can never be known with certainty because so many arrivals were exterminated and never registered. Estimates range from 1 to 2.5 million.

Auschwitz-Birkenau was one of six extermination camps. The others—Belzec [BEL-zek], Chelmno [KELM-no], Majdanek [my-DAH-nek], Sobibor [SO-bih-bore], and Treblinka [treb-LING-kah]—were also in Poland, off German soil and in a country that Hitler had invaded. All were equally dedicated to making Europe *Judenrein* [yoo-den-RINE], "free of Jews." There were many other concentration camps scattered across Germany and German-occupied territories (Map **37.4**). One of the largest on German soil was Buchenwald [BOO-ken-vahld], situated on the northern slope of Ettersberg [ETT-urz-berg], a mountain five miles north of Weimar. In February 1945, just before the American troops reached the camp, it housed over 85,000 prisoners. Of these, more than 25,500 people, severely weakened by their experience,

died as the Germans tried to evacuate the camp in order to hide their crimes before the Americans arrived.

The Buchenwald dead (Fig. **37.28**) were photographed by Lee Miller (1907–1977), an American photographer and

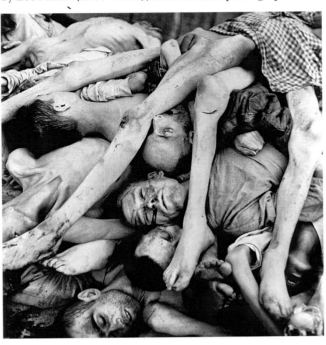

Fig. 37.28 Lee Miller, *Buchenwald, Germany.* **April 30, 1945.** © Lee Miller Archives, England 208. All rights reserved. www.leemiller.co.uk. Miller's pictures of Buchenwald and Dachau (liberated a few days earlier) appeared in British *Vogue* magazine in June under the headline "Believe It."

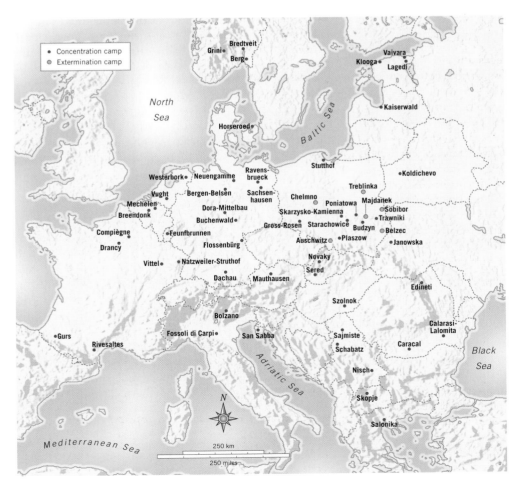

Map 37.4 German concentration camps in Europe. 1942–45.

former model who had worked with the Surrealists in Paris. The only woman combat photojournalist to cover the war in Europe, she had arrived on the Continent a mere 20 days after American forces assaulted the beaches of Normandy on D-Day. She witnessed the liberation of Paris and then followed American soldiers into Germany. The horror of her photograph is not just its depiction of the dead, but also its evidence of their starvation and suffering before dying.

The War in the Pacific

Meanwhile, in the Pacific, Japan was emboldened by the war in Europe to step up its imperial policy of controlling Asia. It had initiated this policy as early as 1931 with an invasion of Manchuria [man-CHOOR-ee-uh], followed by the conquest of Shanghai [SHANG-high] in 1932 and the invasion of the rest of China in 1937. By 1941, Japan had occupied Indochina, and when the United States in response froze Japanese assets in the United States and cut off oil supplies, Japan responded by attacking Pearl Harbor, Hawaii, the chief American naval base in the Pacific, on December 7, 1941. The surprise attack destroyed 188 aircraft, five battleships, one minelayer, and three destroyers, and left 2,333 dead and 1,139 wounded. The next day, the United States declared war on Japan, and Germany and Italy, with whom Japan had joined in an alliance known as the Axis, declared war on the United States. During the war, the American government interred thousands of Japanese and Japanese Americans (many of whom were U.S. citizens) living in California, Oregon, and Washington on the theory that they might be dangerous. (In 1988, President Ronald Reagan signed legislation that officially apologized for this act of racism.) Racism and consciousness of ethnic identity flourished in the American armed forces as well.

Six months later, the U.S. Navy began to recover from the Pearl Harbor air strike and moved on the Japanese, who had meanwhile captured Guam [gwahm], Wake Island, and the Philippines [fill-ih-PEENZ] (Map 37.5). A decisive naval battle in the Coral Sea, in which the Americans sank many Japanese ships, was followed by a victory at Midway Island and the landing of American Marines at Guadalcanal [gwah-dul-kuh-NAL] and the Solomon Islands. This turned the tide and enabled the United States to concentrate more fully on Europe.

The Allied Victory

Even as Russian forces were pushing westward, driving the Germans back through the Ukraine, Hungary, and Poland, Allied forces—largely troops from the United States and Great Britain—attacked the Germans on the Normandy coast on June 6, 1944, known as D-Day. Two months later, the Allies landed in southern France and advanced northward with little resistance. By the beginning of September, they had pushed back the Germans to their own border and had liberated France.

In December 1944, an increasingly desperate Hitler, his oil refineries decimated by Allied air strikes, launched a counterattack on Antwerp, the Allies' port of supply, through the Ardennes Forest of Belgium. Surprise and weather almost won him the day, as the Germans pushed forward into the Allied lines—hence the name, the Battle of the Bulge—but he was turned back. By March, the Allies had crossed the Rhine, and the Russians, the eastern arm of the Allied offensive, had approached the outskirts of Berlin. On May 1, 1945, Hitler and his intimates, recognizing that the war was lost, committed suicide in an underground bunker in Berlin. On May 8, the war in Europe came to an official end.

Meanwhile, in the Pacific, American troops had advanced as far north as Iwo Jima [ee-woh JEE-muh] and the southern Japanese island of Okinawa [oh-kih-NAH-wah], but the Japanese steadfastly refused to surrender. Faced with the possibility that an invasion of Japan itself might cost 1 million American lives, the Americans made the decision to drop the newly developed atomic bomb on the city of Hiroshima on August 6, 1945. Two days later, the Soviet Union declared war on Japan and invaded Manchuria. The next day, the United States dropped an atomic bomb on Nagasaki. The power of the atomic bomb, which devastated Hiroshima and Nagasaki, convinced Japan to surrender on August 14, 1945.

Decolonization and Liberation

The war was felt far beyond the Pacific and European theaters, in the many nations subject to colonial rule. The war had drawn the military forces of the colonial powers back to Europe, and in their absence, indigenous nationalist movements arose in Africa, Asia, and the Middle East. The American president Franklin D. Roosevelt felt especially strongly that it was hypocritical to fight tyranny in Europe and then tolerate colonial dominance in the rest of the world. His moral position was strengthened by the realization that American economic interests were far more likely to thrive in a decolonized world. Furthermore, the founding of the United Nations in 1945 guaranteed that the argument against colonization would find a public forum.

In Southeast Asia, the French had occupied Indochina (Laos [laus (rhymes with "mouse")], Cambodia, and Vietnam) since the late nineteenth century. But as early as 1930, Ho Chi Minh [ho chee min] (1892–1969) had transformed a nationalist movement resisting French rule into the Indochina Communist Party. During World War II, Ho Chi Minh led the military campaign against the invading Japanese and the pro-Vichy colonial French government allied with the Japanese. He established himself as the major anticolonial player in the region. When, in 1945, he declared Vietnam an independent state, civil war erupted. It ended with the artificial division of Vietnam at the seventeenth parallel of northern latitude, with Ho Chi Minh in control north of that line and centered in Hanoi, and the French in charge south of that line and centered in Saigon (Map 37.5).

Meanwhile, France had to deal with growing unrest in North Africa. It had maintained a strong base in Algeria

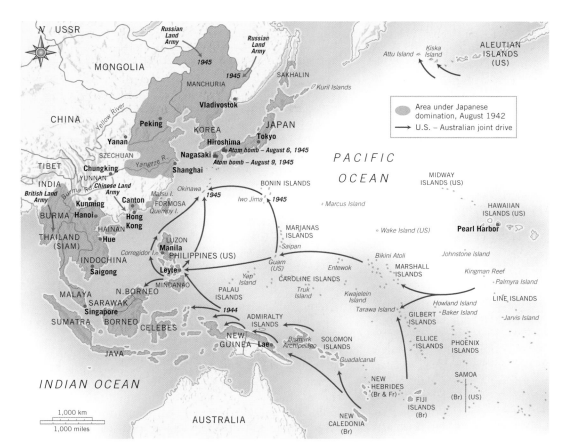

Map 37.5 Asian and Pacific theaters in World War II, 1941–45.

since the early nineteenth century, and during World War II, the antifascist government of Free France had headquartered there (see Map 37.3). But at the end of the war, violence broke out between French and European settlers, comprising about 1 million people, and a much larger population of Algerian Muslim nationalists who quickly demanded independence. The postwar French Republic, however, declared Algeria an integral part of France. Guerrilla resistance to the French began in 1954, led by the National Liberation Front (FLN), and lasted until 1962, during which time hundreds of thousands of Muslim and European Algerians were killed. Finally, in 1962, French president Charles de Gaulle [deh gohl] (1890–1970) called for a referendum in Algeria on independence. It passed overwhelmingly. Algeria became independent on July 3, 1962.

Mohandas Gandhi [moh-HAHN-dus GAHN-dee] (1869–1948) led the anticolonial movement in India (Fig. 37.29). While studying law in England, he had learned the concept of **passive resistance** from reading American writer Henry David Thoreau (see Chapter 27). Gandhi had worked for 20 years as an advocate for Indian immigrants in South Africa, and after returning to India in 1915, he began a long campaign against the British government. He was repeatedly arrested, and during his imprisonments, he engaged in long hunger strikes, bringing himself to the brink of death on more than one occasion. Gandhi's campaign of nonviolence finally convinced the British to leave India, which they did in 1947, partitioning the country into two parts, India and

Pakistan. This partition acknowledged the desire of the Muslim population within India to form their own distinctly Muslim state.

Almost simultaneously, Burma and Sri Lanka became independent, the Dutch were forced out of Indonesia, and the British packed up and left Palestine, which they had occupied since the end of the Ottoman Empire in 1918. The British left behind a murderous conflict

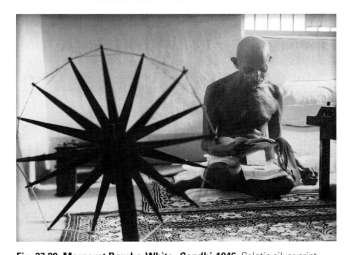

Fig. 37.29 Margaret Bourke-White, *Gandhi.* 1946. Gelatin silver print, 14″ × 11″. © Time, Inc. Bourke-White's photojournalistic work for *Life* magazine (see Fig. 37.20) led her to photograph Gandhi many times. He is shown here reading in a photograph that emphasizes his ascetic lifestyle. The spinning wheel in the foreground is the symbol of Indian independence, signifying, for Gandhi, tradition, patience, self-sufficiency, and peace.

between Arab nationalists and Jews whom they had helped to install in the new country of Israel. In the following decade, the British withdrew from Ghana, Nigeria, Cyprus, Kenya, and Aden (now part of Yemen), sometimes at their own choosing, sometimes under pressure from militant nationalists. The British never resisted decolonization militarily, but this was not the case with France.

Bearing Witness: Reactions to the War

The human cost of World War II was enormous. Somewhere in the vicinity of 17 million soldiers had died, and at least that many civilians had been caught up in the fighting. Hitler had exterminated 6 million Jews, and millions of other people had died of disease, hunger, and other causes. The final toll approached 40 million dead.

It was what Hitler had done to the Jews that most troubled Western consciousness and a large body of literature and film grew out of the events as survivors began to tell their stories to the world. Italian chemist Primo Levi's memoir, *If This Is a Man* (also known as *Survival at Auschwitz*), is the wrenching story of a man attempting to fathom why he survived the death camp. Levi would go on to write stories and novels for the rest of his life that he himself described as "accounts of atrocities." American cartoonist Art Spiegelman's graphic novel *Maus: A Survivor's Tale*, in which Jews are depicted as mice, Germans as cats, and Americans as dogs, recounts his parents' experiences as Jews in Poland before and at Auschwitz during the war. Paris-based documentary filmmaker Claude Lanzmann's 9½-hour *Shoah* (a Hebrew word meaning "catastrophe") is a series of deeply moving testimonies about the Holocaust drawn from survivors, those who stood by without doing anything, and the perpetrators themselves.

Wiesel's *Night* One of the most important memoirs to come out of the Holocaust is *Night* by Elie Wiesel [vee-ZELL] (1928–). "Auschwitz," wrote Wiesel, "represents the negation and failure of human progress: it negates the human design and casts doubts on its validity."

Wiesel was 16 years old in 1944 when he and his family were taken to Auschwitz, where he and his father were separated from his mother and younger sister. He never saw them again and learned later that they had died in the gas chambers. During the following year, Wiesel was moved to the concentration camps at Buna, Gleiwitz [GLY-vits], and finally Buchenwald, where his father died from dysentery, starvation, exposure, and exhaustion, like the many whom Lee Miller had photographed when the camp was liberated in April 1945 (see Fig. 37.28). The author of 36 works dealing with Judaism, the Holocaust, and the moral responsibility of all people to fight hatred, racism, and genocide, Wiesel's powerful prose and commitment won him the Nobel Peace Prize in 1986. He recounts his first day at Auschwitz (**Reading 37.5**):

> ### READING 37.5
>
> #### from Elie Wiesel, *Night* (1958)
>
> Never shall I forget that night, the first night in camp, which has turned my life into one long night, seven times cursed and seven times sealed. Never shall I forget that smoke. Never shall I forget the little faces of the children, whose bodies I saw turned into wreaths of smoke beneath a silent blue sky.
>
> Never shall I forget those flames which consumed my faith forever.
>
> Never shall I forget that nocturnal silence which deprived me, for all eternity, of the desire to live. Never shall I forget those moments which murdered my God and my soul and turned my dreams to dust. Never shall I forget these things, even if I am condemned to live as long as God Himself. Never.

Wiesel subsequently led the way to the creation of the United States Holocaust Memorial Museum in Washington, D.C.

Resnais's *Night and Fog* In 1955, the young French filmmaker Alain Resnais [ray-NAY] (1922–) startled the world with a 32-minute documentary about the Holocaust called *Night and Fog*. Combining contemporary footage of the eerily abandoned Auschwitz landscape with archival documentary footage recorded during the liberation, Resnais posed the question that desperately needed to be addressed: Who was responsible? The question stands for many more specific ones. Why did so many ordinary Germans passively stand by as Jews were hauled off to the camps? Why did the Soviets, as they moved into Poland, not halt it? Why had the Allies—and the United States in particular—not responded to the situation more quickly? And why had the Jews themselves not organized more active resistance in the camps? Resnais's narrator, Michel Bouquet [boo-KAY], himself a camp survivor, concludes with a dire warning. As the events of the Holocaust retreat into the past, it seems possible, he says, to hope again. It seems possible to believe that what happened in the camps was a one-time occurrence that will never be repeated. But, he insists, the Holocaust is symptomatic of humanity's very indifference to suffering and pain. Its truth always surrounds us.

The Japanese Response Japan was haunted for generations by the bombing of Hiroshima and Nagasaki. Both cities were civilian sites that contributed almost nothing to the Japanese military effort, and President Truman's motives for bombing them were unclear—to many Americans as well as the Japanese. Some argued that the bombings spared both the United States and the Japanese from a painful and devastating invasion and saved the lives of thousands of American soldiers if the war had continued. Others argued that the bombings were a means of forcing the question of the emperor's fate, a major sticking point in

Fig. 37.30 Shomei Tomatsu, *Man with Keloidal Scars*. 1962. From the series *11:02—Nagasaki*. 1966. Gelatin silver print, 16 1/8″ × 10 7/8″. Gift of the photographer. (700.1978). Digital Image © The Museum of Modern Art/Licensed by SCALA/Art Resource, New York. As horrified as they were by images such as this, the Japanese, who were near starvation by war's end, were equally attracted to the obvious wealth and plenty of the occupying American forces.

peace negotiations before the bombs were dropped. Still others felt that the bombings were a just retribution for devastation at Pearl Harbor. Truman's archives suggest that the president wanted to demonstrate U.S. military might to the Soviets, whom he recognized would be a threat to world stability after the war. There is probably some truth in all of these points, but none justified the bombings in the eyes of the Japanese.

One of the most powerful responses to the events is a series of photographs entitled *11:02—Nagasaki* by Shomei Tomatsu [toh-mah-tsoo] (1930–). The series is dedicated to the enduring human tragedy wrought by the atomic bomb, not merely to depicting keloidal burns and physical deformities that radiation from the explosion wreaked upon its survivors (Fig. **37.30**). The images are metaphors for the process of Americanization that Japan underwent at the war's conclusion. "If I were to characterize postwar Japan in one word," Tomatsu would write in an essay entitled "Japan Under Occupation," "I would answer without hesitation: 'Americanization.'" His photographs of survivors propose that to become "Americanized" is not necessarily a good thing. It is to become scarred, mutilated, deformed.

One of the more interesting ways in which the Japanese came to deal with the atomic bomb and its aftermath is the creation, in 1954, of the movie monster known in this country as *Godzilla*, but in Japan as *Gojira* [go-jee-rah], a hybrid name which joins the Western word *gorilla*—in honor of the 1933 film *King Kong*—with the

Japanese *kujira* [koo-jee-rah], meaning "whale." The radiation-breathing monster, born from the sea after an American test of an atomic bomb in the Pacific, was a creation of Toho Studios in Tokyo. This, the first of many Godzilla films, was directed by Ishiro Honda (1911–1993). It was inspired by the success of the 1953 U.S. film *The Beast from 20,000 Fathoms*, in which Rhedosaurus, a giant dinosaur, is awakened from eons of dormancy after an atomic bomb test in the northern polar ice cap. The dinosaur wreaks havoc on New York City, culminating in a showdown with military marksmen at Coney Island amusement park.

Godzilla became for the Japanese a vehicle through which they could confront the otherwise unspeakable significance of the atomic bomb. At the same time they could also shift blame for World War II from themselves to the Americans. Scenes of Tokyo devastated by the radiation-breathing monster leave little doubt as to the symbolic intent of the film (Fig. **37.31**). In its original form, it remains a powerful indictment of the bomb, but that was not the version available in the United States until 2004. *Gojira* was acquired by U.S. distributors in 1956. They renamed it *Godzilla: King of the Monsters* and completely reedited it. Leaving only its monster scenes, they excised most of the human story, replacing it with scenes featuring a U.S. reporter (played by Raymond Burr, television's Perry Mason) who has come to Tokyo to chronicle the devastation caused by "a force which until a few days ago was entirely beyond the scope of man's imagination." But, of course, the film represents not the unknown but a force completely within the scope of human imagination—the bomb—a fact that today American audiences can finally appreciate.

Fig. 37.31 Godzilla destroys Tokyo, in Ishiro Honda's *Gojira* (*Godzilla*). 1954. The Japanese have made at least 27 other Godzilla films.

The Bauhaus in America

After the Bauhaus closed in April 1933, many of its teachers left Germany for the United States. By the early 1950s, they dominated American architecture and arts education. Walter Gropius and Marcel Breuer moved to Cambridge, Massachusetts, to teach at the Harvard Graduate School of Design. Gropius would go on to design the Harvard Graduate Center (1949–1950) and Breuer the Whitney Museum of American Art (1966) in New York. Joseph Albers would become head of the design department at Yale University in New Haven, Connecticut. Ludwig Mies van der Rohe was appointed head of the architecture school at Chicago's Armour Institute of Technology (later the Illinois Institute of Technology), where he was commissioned to design the new buildings for the campus.

These Bauhaus artists came into their own in America after World War II, when the nation's economy was once again on the rebound. Their influence was nowhere more dramatically felt than in Mies van der Rohe's Seagram Building in New York, completed in 1958 on Park Avenue between 52nd and 53rd streets (Fig. 37.32). Just ten blocks from the Chrysler Building, it set a new standard for skyscraper architecture. Mies van der Rohe had begun to experiment with designs for glass towers in the early 1920s, and by the time he joined with Philip Johnson on the Seagram Building, he had cultivated an aesthetic of refined austerity summed up by the phrase "less is more."

The siting of the building, separated from the street by a 90-foot-wide plaza and bordered on either side by reflecting pools and ledges, used open space in a manner unprecedented in urban architecture, where every vertical foot above ground spells additional rent revenue. A curtain wall of dark, amber-tinted glass wraps the building and is interrupted by bronze-coated I-beams and by spandrels and mullions (the horizontal and vertical bands between the glass). Depending on the light, the reflective qualities of the glass make the skin appear bronze from one angle and almost-pitch-black from another. At night, the building is entirely lit, creating a golden grid framed in black.

The Seagram Building gives the impression of a giant monolith set on a granite plinth—a sort of sacred homage to the modernist spirit. As one critic rhapsodized, "The commercial office building in this instance has been endowed with a monumentality without equal in the civic and religious architecture of our time." ■

Fig. 37.32 Ludwig Mies van der Rohe and Philip Johnson, Seagram Building, New York City. 1954–58. The entry is set back beneath the columns on the first floor, just as it is at the Villa Savoye (see Fig. 37.9).

THINKING BACK

What was Berlin like in the 1920s?

In the 1920s, Berlin was a thriving center of the arts, rivaling New York and Paris in its innovation. It was notable especially for the libertine atmosphere of its cafés and cabarets, the deep political commitment of its artists. What characterizes the other side of Berlin life, as evidenced in the writing of Franz Kafka, the theater of Bertolt Brecht, and the Expressionist prints of Käthe Kollwitz?

What is fascism?

European conservatives were horrified at the Berlin lifestyle and yearned for a return to a lost past that they idealized as orderly and harmonious. In Germany, Adolf Hitler harnessed this interest. Who did he blame for the country's economic and social problems? How did Leni Riefenstahl's filmmaking support Hitler's cause? Hitler's Nazi party forced the Bauhaus, the leading exponent of modernist art and architecture in Germany inspired by the Dutch De Stijl movement, to close down. What characterizes De Stijl? How are its values reflected in the work of the Bauhaus?

In Russia, Stalin likewise attacked modernist art, which he proposed to replace with social realism, an art designed to be totally intelligible to the masses. And in Italy, Benito Mussolini's Fascist government came to power. What characterizes the Fascist architecture he promoted? Finally, in Spain, with Hitler's aid, Francisco Franco instigated a civil war. The blitzkrieg attack of the German air force on the Basque city of Guernica would be memorialized by Pablo Picasso in his painting *Guernica*.

What is the Mexican mural movement?

In 1910, guerrilla groups in Mexico had initiated a civil war to overthrow the government and restore to the peasants land that had been confiscated and turned over to foreign companies. The war inspired the nationalist feelings of many artists, including a number of painters, chief among them Diego Rivera. What characterizes Rivera's art? Rivera's wife, Frida Kahlo, long crippled by a debilitating childhood accident, developed an intensely personal and autobiographic painting style.

What was the WPA?

The collapse of the stock market in 1929 led to severe economic depression in the United States which President Franklin D. Roosevelt sought to remedy, in part, by the Work Projects Administration. The WPA funded painting projects (especially murals in public buildings, a project inspired by the example of muralist Thomas Hart Benton) and performances by musicians and theater companies, and employed writers to create a series of state and regional guidebooks. The effects of the Depression were heightened by drought in the Great Plains. In what ways can the creative works produced under the WPA and other New Deal agencies be viewed as propaganda? How does it differ from Hitler's propaganda?

How did sound and color change the motion-picture industry?

In the 1930s, the motion picture changed dramatically and became the most popular American art medium. Al Jolson's 1927 *The Jazz Singer* introduced sound into feature films. Producers were forced to perfect sound technology on the set and in theaters. Walt Disney introduced color film, but in 1939, perhaps the greatest year in the history of cinema, color became a real force. *The Wizard of Oz* led the way, soon followed by *Gone with the Wind*. To what ends did *The Wizard of Oz* use color? To what can we attribute the great success of *Gone with the Wind*? The most technically innovative film of the era was Orson Welles's *Citizen Kane* of 1940.

What was the Holocaust?

No event underscores the growing globalization of twentieth-century culture more than World War II. The fighting occurred across the Pacific region, in Southeast Asia, in North Africa and the Middle East, and in Europe, from France to Russia. As colonial powers withdrew their troops from occupied territories to fight in the war, nationalist movements arose in India, Palestine, Algeria, Indonesia, and across Africa, making the war's impact truly global. The human destruction was staggering—some 40 million dead—but even more devastating was the human capacity for genocide and murder revealed by the Holocaust in Germany and the American bombing of Hiroshima and Nagasaki in Japan. How did Elie Wiesel and Alain Resnais respond to the Holocaust? How did photographer Shomei Tomatsu respond to the atomic bomb? How do the *Godzilla* films of director Ishiro Honda reflect Japan's reaction to the bomb?

PRACTICE MORE Get flashcards for images and terms and review chapter material with quizzes at **www.myartslab.com**

GLOSSARY

chiaroscuro lighting In cinema, a term borrowed from Renaissance painting to describe pools of light illuminating parts of an otherwise dark set.

dubbing In cinema, shorthand for "vocal doubling," in which native speakers synchronize new dialogue to the lip movements of the actor.

epic theater A brand of theater created by Bertolt Brecht in which the audience is purposefully alienated so that it might approach the performance with a critical eye.

gulags Labor camps in Stalinist Russia.

Holocaust The systematic extermination of 6 million Jews and 5 million others—particularly Gypsies, Slavs, the handicapped, and homosexuals.

kulaks Prosperous peasant farmers in Russia blamed by Stalin for the country's economic ills.

New Deal President Franklin D. Roosevelt's economic recovery program.

passive resistance The method of protest used by Gandhi in his nonviolent campaign against the British in India, resulting in his repeated arrest.

postsynchronization The term that refers to the addition of sound as a separate step after the creation of a visual film.

READINGS

READING 37.2

from Franz Kafka, *The Metamorphosis* (1915)

Franz Kafka's novella The Metamorphosis *is one of the few works he published during his lifetime. Dreamlike in its central premise—it begins with its main character, Gregor Samsa, waking from "uneasy dreams" transformed into a "gigantic insect"—it is narrated in a direct, matter-of-fact style that seems at odds with its fantastic plot. While Kafka never questions the fact of Samsa's transformation, which leads inevitably to his death, we as readers understand that the story is something of a parable for the modern individual's alienation from his or her own humanity as well as from society.*

THE METAMORPHOSIS

I

As GREGOR SAMSA awoke one morning from uneasy dreams he found himself transformed in his bed into a gigantic insect. He was lying on his hard, as it were armor-plated, back and when he lifted his head a little he could see his domelike brown belly divided into stiff arched segments on top of which the bed quilt could hardly keep in position and was about to slide off completely. His numerous legs, which were pitifully thin compared to the rest of his bulk, waved helplessly before his eyes.

What has happened to me? he thought. It was no dream. His room, a regular human bedroom, only rather too small, lay ₁₀ quiet between the four familiar walls. Above the table on which a collection of cloth samples was unpacked and spread out— Samsa was a commercial traveler—hung the picture which he had recently cut out of an illustrated magazine and put into a pretty gilt frame. It showed a lady, with a fur cap on and a fur stole, sitting upright and holding out to the spectator a huge fur muff into which the whole of her forearm had vanished!

Gregor's eyes turned next to the window, and the overcast sky—one could hear raindrops beating on the window gutter— made him quite melancholy. What about sleeping a little longer ₂₀ and forgetting all this nonsense, he thought, but it could not be done, for he was accustomed to sleep on his right side and in his present condition he could not turn himself over. However

violently he forced himself toward his right side he always rolled onto his back again. He tried it at least a hundred times, shutting his eyes to keep from seeing his struggling legs, and only desisted when he began to feel on his side a faint dull ache he had never experienced before.

Oh God, he thought, what an exhausting job I've picked on! Traveling about day in, day out. It's much more irritating work than ₃₀ doing the actual business in the office, and on top of that there's the trouble of constant traveling, of worrying about train connections, the bed and irregular meals, casual acquaintances that are always new and never become intimate friends. The devil take it all! He felt a slight itching up on his belly; slowly pushed himself on his back nearer to the top of the bed so that he could lift his head more easily; identified the itching place which was surrounded by many small white spots the nature of which he could not understand and made to touch it with a leg, but drew the leg back immediately, for the contact made a cold shiver run through him. ₄₀

He slid down again into his former position. This getting up early, he thought, makes one quite stupid. A man needs his sleep. Other commercials live like harem women. For instance, when I come back to the hotel of a morning to write up the orders I've got, these others are only sitting down to breakfast. Let me just try that with my chief; I'd be sacked on the spot. Anyhow, that might be quite a good thing for me, who can tell? If I didn't have to hold my hand because of my parents I'd have given notice long ago, I'd have gone to the chief and told him

exactly what I think of him. That would knock him endways from his desk! It's a queer way of doing, too, this sitting on high at a desk and talking down to employees, especially when they have to come quite near because the chief is hard of hearing. Well, there's still hope; once I've saved enough money to pay back my parents' debts to him—that should take another five or six years—I'll do it without fail. I'll cut myself completely loose then. For the moment, though, I'd better get up, since my train goes at five.

He looked at the alarm clock ticking on the chest. Heavenly Father! he thought. It was half-past six o'clock and the hands were quietly moving on, it was even past the half-hour, it was getting on toward a quarter to seven. Had the alarm clock not gone off? From the bed one could see that it had been properly set for four o'clock; of course it must have gone off. Yes, but was it possible to sleep quietly through that ear-splitting noise? Well, he had not slept quietly, yet apparently all the more soundly for that. But what was he to do now? The next train went at seven o'clock; to catch that he would need to hurry like mad and his samples weren't even packed up, and he himself wasn't feeling particularly fresh and active. And even if he did catch the train he wouldn't avoid a row with the chief, since the firm's porter would have been waiting for the five o'clock train and would have long since reported his failure to turn up. The porter was a creature of the chief's, spineless and stupid. Well, supposing he were to say he was sick? But that would be most unpleasant and would look suspicious, since during his five years' employment he had not been ill once. The chief himself would be sure to come with the sick-insurance doctor, would reproach his parents with their son's laziness, and would cut all excuses short by referring to the insurance doctor, who of course regarded all mankind as perfectly healthy malingerers. And would he be so far wrong on this occasion? Gregor really felt quite well, apart from a drowsiness that was utterly superfluous after such a long sleep, and he was even unusually hungry.

As all this was running through his mind at top speed without his being able to decide to leave his bed—the alarm clock had just struck a quarter to seven—there came a cautious tap at the door behind the head of his bed. 'Gregor,' said a voice—it was his mother's—'it's a quarter to seven. Hadn't you a train to catch?' That gentle voice! Gregor had a shock as he heard his own voice answering hers, unmistakably his own voice, it was true, but with a persistent horrible twittering squeak behind it like an undertone, which left the words in their clear shape only for the first moment and then rose up reverberating around them to destroy their sense, so that one could not be sure one had heard them rightly. Gregor wanted to answer at length and explain everything, but in the circumstances he confined himself to saying: 'Yes, yes, thank you, Mother, I'm getting up now.' The wooden door between them must have kept the change in his voice from being noticeable outside, for his mother contented herself with this statement and shuffled away. Yet this brief exchange of words had made the other members of the family aware that Gregor was still in the house, as they had not expected, and at one of the side doors his father was already knocking, gently, yet with his fist, 'Gregor, Gregor,' he called, 'what's the matter with you?' And after a little while he called again in a deeper voice: 'Gregor! Gregor!' At the other side door his sister was saying in a low, plaintive tone: 'Gregor? Aren't you well? Are you needing anything?' He answered them both at once: 'I'm just ready,' and did his best to make his voice sound as normal as possible by enunciating the words very clearly and leaving long pauses between them. So his father went back to his breakfast, but his sister whispered: 'Gregor, open the door, do,' However, he was not thinking of opening the door, and felt thankful for the prudent habit he had acquired in traveling of locking all doors during the night, even at home.

READING CRITICALLY

Not long after Kafka's death, the term *Kafkaesque* began to be widely employed to describe the vision of modern life that his writing embodies. How would you define the Kafkaesque?

38 After the War

Existential Doubt, Artistic Triumph, and the Culture of Consumption

THINKING AHEAD

What is existentialism?

What is Abstract Expressionism?

Who are the Beats?

What is Pop Art?

What is Minimalism in art?

The Holocaust and the nuclear bombings of Hiroshima and Nagasaki compounded the pessimism that had gripped intellectual Europeans ever since the turn of the century. How could anyone pretend that the human race was governed by reason, that advances in technology and science were for the greater good, when human beings were not only capable of genocide, but also possessed the ability to annihilate themselves? For French philosopher Jean-Paul Sartre [SAR-tr] (1905–1980), the only certainty in the world was death. But he would go on to articulate a philosophy in which each person is capable of defining his or her existence for himself or herself—for good or evil.

In America, the 1950s were years of unprecedented prosperity, a fact reflected in the proliferation of new goods and products—literally hundreds of the kinds of things that Duane Hanson's *Supermarket Shopper* has loaded into her shopping cart in his hyperrealistic sculpture of 1970 (Fig. 38.1): CorningWare, Sugar Pops, and Kraft Minute Rice (1950); sugarless chewing gum and the first 33-rpm long-playing records, introduced by Deutsche Grammophon (1951); Kellogg's Sugar Frosted Flakes, the Sony pocket-sized transistor radio, fiberglass and nylon (1952); Sugar Smacks cereal and Schweppes bottled tonic water (1953); Crest toothpaste and roll-on deodorant (1955); Comet cleanser, Raid insecticide, Imperial margarine, and Midas mufflers (1956); the Wham-O toy company's Frisbee (1957) and Hula Hoop (1958); Sweet'n Low, Green Giant canned beans, and Teflon frying pans (1958). Tupperware, which had been introduced in 1945, could be found in every kitchen after its push-down seal was patented in 1949. In July 1955, Walt Disney opened Disneyland in Anaheim, California, the first large-scale theme park in America. That same year, two of the first fast-food chains opened their doors—Colonel Sanders's Kentucky Fried Chicken (KFC) and McDonald's. In 1953, the first issue of *Playboy* magazine appeared, featuring Marilyn Monroe as its first nude centerfold, and by 1956, its circulation had reached 600,000. Sales of household appliances exploded, and women, still largely relegated to the domestic scene, suddenly found themselves with leisure time. Diner's Club and American Express introduced the charge card in 1951 and 1958 respectively. Both cards required payment in full each month, but they paved the way for the BankAmericard, introduced in 1958 (eventually evolving into the Visa card), which allowed for individual borrowing—and purchasing—at an unprecedented level.

Television played a key role in marketing these products and services since advertisers underwrote entertainment and news programming by buying time slots for commercials. In television commercials, people could see

◄ **Fig. 38.1 Duane Hanson, *Supermarket Shopper*. 1970.** Fiberglass, height 65″. Neue Galerie – Sammlung Ludwig, Aachen, Germany. Hanson's sculptures are so lifelike that museum visitors often speak to them.

HEAR MORE Listen to an audio file of your chapter at **www.myartslab.com**

products firsthand. Although television programming had been broadcast before World War II, it was suspended during the war and did not resume until 1948. By 1950, four networks were broadcasting to 3.1 million television sets. By the end of the decade, that number had swelled to 67 million. Even the food industry responded to the medium. Swanson, which had introduced frozen potpies in 1951, began selling complete frozen "TV dinners" in 1953. The first, in its sealed aluminum tray, featured turkey, cornbread dressing and gravy, buttered peas, and sweet potatoes. It cost 98 cents, and Swanson sold 10 million units that year. Consumer culture was at full throttle.

Against this backdrop of prosperity and plenty, more troubling events were occurring. After the war, the territories controlled by the Nazis had been partitioned, and the Soviets had gained control of Eastern Europe, which they continued to occupy. Berlin, fully enclosed by Soviet-controlled East Germany, was a divided city, and it quickly became a focal point of tension when the Soviets blockaded land and river access to the city in 1948. President Truman responded by airlifting vital supplies to the 2 million citizens of West Berlin, but the crisis would continue, culminating in the construction of the Berlin Wall in 1961.

Events in Asia were equally troubling. In China, the communists, led by Mao Zedong [mauw (rhymes with "cow") dzu-doong] (1893–1976), drove the pro-Western nationalists, led by Chiang Kaishek [kigh-shek] (1887–1975), off the mainland to the island of Taiwan and established the pro-Soviet People's Republic of China on October 1, 1949. Korea was likewise partitioned into a U.S.-backed southern sector and a Soviet-backed northern sector, culminating in the 1950 invasion of the South by the North and the Korean War (1950–1953), which involved American and Chinese soldiers, the latter supported by Russian advisors and pilots, in another military conflict. As the tension between the Soviet Bloc and the West escalated throughout the 1950s, nuclear confrontation seemed inevitable.

This chapter traces the arc of these years in both Europe and America. On the one hand, in America, the realities of the Cold War and what many perceived as the country's crass materialism muted the sense of well-being that accompanied the rapid economic expansion. Artists and writers responded by creating a rebellious, individualistic art that, on the one hand, seemed to affirm American creativity and genius even as, on the other, it critiqued the inauthenticity and emptiness of American life. In Europe, the horrors of World War II provoked a profound philosophical uneasiness revolving around the idea of mankind's existential quest.

EUROPE AFTER THE WAR: THE EXISTENTIAL QUEST

If, after World War II, the urban landscape of Europe was in no small part destroyed—from Dresden to London, whole cities were flattened—the European psyche was even more devastated. In the face of countless deaths, pessimism reigned, and ideological conflict between the Western powers and the Eastern bloc exacerbated a growing sense of meaninglessness, alienation, and anxiety. And yet, even in the face of a future some felt was devoid of hope, existentialism, arguably the most important philosophical movement of the twentieth century, offered a path in which every individual might find at least some sense of meaning in life.

Christian Existentialism: Kierkegaard, Niebuhr, and Tillich

Christianity found itself in crisis as well. In the face of World War II's horrors, Christians had to question God's benevolence, if not his very existence. Their faith was put to a test that had been first articulated by the nineteenth-century Danish philosopher Søren Kierkegaard [keer-keh-GAHRD] (1813–1855). Kierkegaard had argued that Christians must live in a state of anguish caused by their own freedom of choice. They must first confront the fundamental Christian paradox, the assertion that the eternal, infinite, transcendent God became incarnated as a temporal, finite, human being (Jesus). To believe in this requires a "leap of faith" because its very absurdity means that all reason be suspended. So Christians must choose to live with objective uncertainty and doubt, a situation that leaves them in a state of "fear and trembling." But if the individual Christian can never really "know" God, he or she can and must choose to act responsibly and morally. What humans can define, in other words, are the conditions of their own existence. This is their existential obligation.

After World War II, Protestant theologians Reinhold Niebuhr [KNEE-bor] (1892–1971) and Paul Tillich [TILL-ick] (1886–1965) further articulated this position of **Christian existentialism** in America. When Tillich was forced to leave Germany in 1933 following Hitler's rise to power, Niebuhr arranged for Tillich to join him on the faculty of the Union Theological Seminary in New York City. There Tillich lectured on modern alienation and the role that religion could play as a "unifying center" for existence. Religion, he believed, provides the self with the courage *to be*. Niebuhr shared Tillich's dedication to reconciling religion and modern experience. "Without the ultrarational hopes and passions of religion," he wrote, "no society will ever have the courage to conquer despair."

The Philosophy of Sartre: Atheistic Existentialism

During and after World War II, the French philosopher Jean-Paul Sartre (1905–1980) rejected the religious existentialism of Kierkegaard, Niebuhr, and Tillich and argued for what he termed **atheistic existentialism**. "Existentialism isn't so atheistic," Sartre would write, "that it wears itself out showing that God doesn't exist. Rather, it declares that even if God did exist, that would change nothing. . . . His existence is not the issue." Living in a universe without God, and thus without

revealed morality, individuals unable to make Kierkegaard's "leap of faith" must nevertheless choose to act ethically. "Existence precedes essence" was Sartre's basic premise; that is, humans must define their own essence (who they are) through their existential being (what they do, their acts). "In a word," Sartre explained, "man must create his own essence; it is in throwing himself into the world, in suffering it, in struggling with it, that—little by little—he defines himself." Life is defined neither by subconscious drives, as Freud had held, nor by socioeconomic circumstances, as Marx had argued: "Man is nothing else but what he makes of himself. Such is the first principle of existentialism."

For Sartre there is no meaning to existence, no eternal truth for us to discover. The only certainty is death. Sartre's major philosophical work, the 1943 *Being and Nothingness*, outlines the nature of this condition, but his argument is more accessible in his play *Huis Clos* [hwee kloh] (*No Exit*). As the play opens, a Valet greets Monsieur Garcin [gahr-SEN] as he enters the room that will be his eternal hell (**Reading 38.1**):

READING 38.1

from Jean-Paul Sartre, *No Exit* (1944)

GARCIN (enters, accompanied by the VALET, and glances around him):

So here we are?

VALET Yes, Mr. Garcin.

GARCIN And this is what it looks like?

VALET Yes.

GARCIN Second Empire furniture, I observe . . . Well, well, I dare say one gets used to it in time.

VALET Some do, some don't.

GARCIN Are all the rooms like this one?

VALET How could they be? We cater for all sorts: Chinamen and Indians, for instance. What use would they have for a Second Empire chair?

GARCIN And what use do you suppose I have for one? Do you know who I was? . . . Oh, well, it's no great matter. And, to tell the truth, I had quite a habit of living among furniture that I didn't relish, and in false positions. I'd even come to like it. A false position in a Louis-Philippe dining room—you know the style?—well, that had its points, you know. Bogus in bogus, so to speak.

VALET And you'll find that living in a Second Empire drawing-room has its points.

GARCIN Really? . . . Yes, yes, I dare say . . . Still I certainly didn't expect—this! You know what they tell us down there?

VALET What about?

GARCIN About . . . this—er—residence.

VALET Really, sir, how could you believe such cock-and-bull stories? Told by people who'd never set foot here. For, of course, if they had—

GARCIN Quite so. But I say, where are the instruments of torture?

VALET The what?

GARCIN The racks and red-hot pincers and all the other paraphernalia?

VALET Ah, you must have your little joke, sir.

GARCIN My little joke? Oh, I see. No, I wasn't joking. No mirrors, I notice. No windows. Only to be expected. And nothing breakable. But damn it all, they might have left me my toothbrush!

VALET That's good! So you haven't yet got over your—what-do-you-call-it?—sense of human dignity? Excuse my smiling.

The play was first performed in May 1944, just before the liberation of Paris. If existence in existential terms is the power to create one's future, Garcin and the two women who will soon occupy the room with him are in hell precisely because they are powerless to do so. Garcin's "bad faith" consists in his insistence that his self is the creation of others. His sense of himself derives from how others perceive him. Thus, in the most famous line of the play, he says, "*l'enfer, c'est les autres*" [lehn-fair, say layz-ohtr]—"Hell is other people." In the drawing room, there need be no torturer because each character tortures the other two.

De Beauvoir and Existential Feminism

Sartre's existential call to self-creation resonated powerfully with Simone de Beauvoir [deh boh-VWAHR] (1908–1986), who argued that women had passively allowed men to define them rather than creating themselves. Sartre and de Beauvoir lived independent lives, but they maintained an intimate relationship that intentionally challenged bourgeois notions of decency. The open and free nature of their liaison, described and defended by de Beauvoir in four volumes of memoirs, became part of the mystique of French existentialism.

In her classic feminist text *The Second Sex*, which first appeared in 1949, de Beauvoir debunked what she called "the myth of femininity." She was well aware, as she said, that woman "is very often very well pleased with her role as *Other*"—that is, her secondary status beside men, what de Beauvoir describes as "the inessential which never becomes the essential." The reason for this, she writes, is women's unwillingness to give up the advantages men confer upon them (**Reading 38.2**):

READING 38.2

from Simone de Beauvoir, *The Second Sex* (1949)

Now, woman has always been man's dependent, if not his slave; the two sexes have never shared the world in equality. . . . To decline to be the Other, to refuse to be a party to the deal—this would be for women to renounce all the advantages conferred upon them by their alliance

with the superior caste. Man-the-sovereign will provide woman-the-liege with material protection and will undertake the moral justification of her existence; thus she can evade at once both economic risk and the metaphysical risk of a liberty in which ends and aims must be contrived without assistance. Indeed, along with the ethical urge of each individual to affirm his subjective existence, there is also the temptation to forgo liberty and become a thing. This is an inauspicious road. . . . But it is an easy road; on it one avoids the strain involved in undertaking an authentic existence.

The need to create an authentic existence motivates de Beauvoir's feminism. How much she personally succeeded in realizing her own existence, given her lifelong dedication to Sartre, remains a matter of some debate. What is indisputable, however, is the centrality of *The Second Sex* in defining the boundaries of the ever-growing feminist movement.

The Literature of Existentialism

Apart from Simone de Beauvoir, Sartre's closest companions were the novelists Albert Camus [kah-MOO] (1913–1960), Jean Genet [zhuh-NAY] (1910–1986), Boris Vian [vee-YAHN] (1920–1959), and fellow philosopher Maurice Merleau-Ponty [mare-loh-pon-TEE] (1908–1961), editor-in-chief of *Les Temps Modernes* [lay tahm moh-DAIRN], the journal founded by Sartre in 1945 to give "an account of the present, as complete and faithful as possible." Merleau-Ponty was a particular champion of Camus, whose novels he believed embodied the existential condition. The main protagonist of Camus's 1942 novel *The Stranger* is a young Algerian, Meursault [mer-SOH], who is more an antihero than a hero, since he lacks the personal characteristics that we normally associate with heroes. Meursault becomes tangled up with a local pimp whom he somewhat inexplicably kills. He is imprisoned and brought to trial. His prosecutors' case is absurdly beside the point—they demonstrate, for instance, that he both was unmoved by his mother's death and, worse, attended a comic movie on the eve of her funeral. Despite the irrelevance of the prosecutors' evidence, the jury convicts Meursault. Camus explained why in a preface written for a 1955 reissue of the novel (**Reading 38.3**):

READING 38.3

from Albert Camus, Preface to *The Stranger* (1955)

I summarized *The Stranger* a long time ago, with a remark I admit was highly paradoxical: "In our society any man who does not weep at his mother's funeral runs the risk of being sentenced to death." I only meant that the hero of my book is condemned

because he does not play the game. In this respect, he is foreign to the society in which he lives; he wanders, on the fringe, in the suburbs of private, solitary, sensual life. And this is why some readers have been tempted to look upon him as a piece of social wreckage. A much more accurate idea of the character, or, at least one much closer to the author's intentions, will emerge if one asks just how Meursault doesn't play the game. The reply is a simple one; he refuses to lie. To lie is not only to say what isn't true. It is also and above all, to say more than is true, and, as far as the human heart is concerned, to express more than one feels. This is what we all do, every day, to simplify life. He says what he is, he refuses to hide his feelings, and immediately society feels threatened. He is asked, for example, to say that he regrets his crime, in the approved manner. He replies that what he feels is annoyance rather than real regret. And this shade of meaning condemns him. For me, therefore, Meursault is not a piece of social wreckage, but a poor and naked man enamored of a sun that leaves no shadows. Far from being bereft of all feeling, he is animated by a passion that is deep because it is stubborn, a passion for the absolute and for truth.

The absurdity of Meursault's position found its fullest expression in what critic Martin Esslin in the 1960s termed the **Theater of the Absurd**, a theater in which the meaninglessness of existence is the central thematic concern. Sartre's own *No Exit* was the first example, but many other plays of a similar character followed, authored by Samuel Beckett (1906–1989), an Irishman who lived in Paris throughout the 1950s, the Romanian Eugène Ionesco [ee-oh-ness-KOH] (1909–1994), the Frenchman Jean Genet, the British Harold Pinter (1930–), the American Edward Albee (1928–), and the Czech-born Englishman Tom Stoppard (1937–). All of these playwrights share a common existential sense of the absurd plus, ironically, a sense that language is a barrier to communication, that speech is almost futile, and that we are condemned to isolation and alienation.

The most popular of the absurdist plays is Samuel Beckett's *Waiting for Godot* [goh-DOH], first performed in French in 1953 and subtitled *A Tragicomedy in Two Acts*. The play introduced audiences to a new set of stage conventions, from its essentially barren set (only a leafless tree decorates the stage), to its two clownlike characters, Vladimir and Estragon, whose language is incapable of affecting or even coming to grips with their situation. The play demands that its audience, like its central characters, try to make sense of an incomprehensible world in which nothing occurs. In fact, the play's first line announces, as Estragon tries without success to remove his boot, "Nothing to be done." In Act I, Vladimir and Estragon await the arrival of a person referred to as Godot (**Reading 38.4a**):

That is exactly what the audience must do as well—wait. Yet nothing happens. Godot does not arrive. In despair, Vladimir and Estragon contemplate hanging themselves but are unable to. Then they decide to leave but do not move. Act II takes place the next day (for the opening of the second act, see **Reading 38.4**, pages 1278–1279). But nothing changes—Vladimir and Estragon again wait for Godot, who does not arrive, and again contemplate suicide. There is no development, no change of circumstance, no crisis, no resolution. The play's conclusion, which repeats the futile decision to move on that ended Act I, demonstrates this (**Reading 38.4b**):

The promise of action and the realization of none—that is the Theater of the Absurd.

The Art of Existentialism

Faced with the lack of life's meaning that Sartre's existentialism proposed, painters and sculptors sought to explore the truth of this condition in their own terms. The Swiss-born Paris resident Alberto Giacometti took up sculpture while exiled from France in Switzerland during World War II, abandoning his earlier Surrealist mode (see Fig. 35.16). The existential position of his new figurative sculpture was clear to Jean-Paul Sartre, whose essay "The Search for the Absolute" appeared in the catalogue for the 1948 exhibition of Giacometti's sculpture at the Pierre Matisse Gallery in Paris. It was Giacometti's first exhibition in ten years, and Sartre tells the story of the artist beginning with life-size plaster sculptures and working at them obsessively until, in Sartre's words, "these moving outlines, always halfway between nothingness and being, always modified, bettered, destroyed and begun once more" were reduced to the size of matchsticks.

What impressed Sartre most was Giacometti's commitment to a search for the absolute, admittedly doomed to failure, but important for that very reason. The figures on the giant metal field in *City Square* are all uniformly striding men, each heading in a different direction to seek fulfillment (Fig. **38.2**). These figures, which do not interact, do not merely embody the alienation of the human condition. In their very frailty, they also embody the will to survive, which Giacometti guaranteed by finally casting his plaster sculptures in bronze.

Fig. 38.2 Alberto Giacometti, *City Square* (*La Place*)**. 1948.** Bronze, 8 1/2" × 25 3/8" × 17 1/4". Digital Image © The Museum of Modern Art/Licensed by SCALA/Art Resource, New York. © Artists Rights Society (ARS), New York. Purchase. In 1958, Giacometti proposed transforming this small piece into a monumental composition for the plaza in front of the Chase Manhattan Bank in New York, with these figures towering over pedestrians. The project was never realized.

One of the most important ideas contributing to post-war artists' understanding of what an existential art might be was the notion writer Georges Bataille [bah-TIGH] (1897–1962) first articulated in 1929, that beneath all matter lies a condition of formlessness that requires the artist to "un-form" all categories of making. This notion led the French artist Jean Dubuffet [doo-boo-FAY] (1901–1985) to collect examples of what he called *art brut*, "raw art," from psychotics, children, and folk artists—anyone unaffected by or untrained in cultural convention. His own work ranged from scribbling gesture and cut-up canvases reconstructed as collages to paintings employing sand and paste. In a series of nudes created during 1950 and 1951, he expanded the human body to fill the whole canvas (Fig. 38.3). He described the result in the following terms:

disorder of images, of beginnings of images, of fading images, where they cross and mingle, in a turmoil, tatters borrowed from memories of the outside world, and facts purely cerebral and internal—visceral perhaps.

The existential basis of Dubuffet's art resides both in its acceptance of the formlessness of experience and its quest for what he called an "authentic" expression, divorced from convention and tradition.

AMERICA AFTER THE WAR: TRIUMPH AND DOUBT

Only in Europe, where economic recovery lagged far behind the United States because its industries had been devastated by the war, did the magnitude of American

Fig. 38.3 Jean Dubuffet, *Corps de Dame.* **June–December, 1950.** Pen, reed pen, and ink, 10 $^5/_8$" × 8 $^3/_8$". The Museum of Modern Art/Licensed by SCALA/Art Resource, New York. The Joan and Lester Avnet Collection. Photograph © 2000 The Museum of Modern Art/Licensed by SCALA/Art Resource, New York. © 2005 Artists Rights Society (ARS), New York/ADAGP, Paris. Although one might interpret this work as having been done by someone who hates women, it is certainly an attack on tradition by targeting academic figure painting.

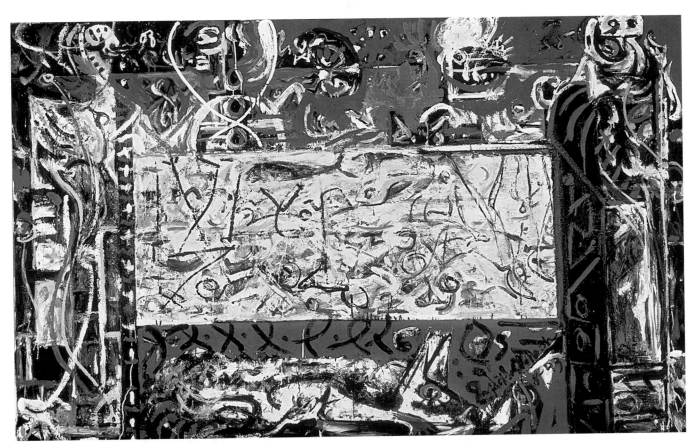

Fig. 38.4 Jackson Pollock, *Guardians of the Secret*. 1943. Oil on canvas, 4′ ³⁄₈″ × 6′ 3 ³⁄₈″. San Francisco Museum of Modern Art. Albert M. Bender Collection. Albert M. Bender Bequest Fund Purchase. © Pollock-Krasner Foundation/Artists Rights Society (ARS), New York. SFMOMA Internal Number: 45.1308. The rooster (top center) had deep psychological and autobiographical meaning to Pollock because, as a boy, a friend accidentally chopped off the top of Pollock's right middle finger with an ax, and a rooster ran up and stole it.

consumption seem obvious. It was in Europe, specifically London, that the first artistic critiques of consumer culture were produced by a group of artists known as the Independents (see *Closer Look*, pages 1256–1257). But, at the same time, the U.S. Department of State toured mammoth exhibitions of paintings and sculpture by contemporary American artists across Europe—and in Paris, especially— in order to demonstrate the spirit of freedom and innovation in American art (and, by extension, American culture as a whole). The individualistic spirit of these artists, whose work was branded **Abstract Expressionism**, was seen as the very antithesis of communism, and their work was meant to convey the message that America had not only triumphed in the war, but in art and culture as well. New York, not Paris, was now the center of the art world.

The Triumph of American Art: Abstract Expressionism

These artists included immigrants like Arshile Gorky [GOR-kee] (1904–1948), Hans Hoffmann (1880–1966), Milton Resnick (1917–2004), and Willem de Kooning [KOO-ning] (1904–1997), as well as slightly younger American-born artists like Franz Kline (1910–1962) and Jackson Pollock (1912–1956). All freely acknowledged

their debts to Cubism's assault on traditional representation, German Expressionism's turn inward from the world, Kandinsky's near-total abstraction, and Surrealism's emphasis on chance operations and psychic automatism. Together the Abstract Expressionists saw themselves as standing at the edge of the unknown, ready to define themselves through a Sartrian struggle with the blank canvas, through the physical act of applying paint and the energy that each painted gesture reveals.

Action Painting: Pollock and de Kooning In 1956, Willem de Kooning commented that "every so often, a painter has to destroy painting. Cézanne did it. Picasso did it with Cubism. Then Pollock did it. He busted our idea of a picture all to hell. Then there could be new paintings again." Around 1940, Pollock underwent psychoanalysis in order to explore Surrealist psychic automatism and to reveal, on canvas, the deepest areas of the unconscious. His 1943 *Guardians of the Secret* is an expression of that effort (Fig. 38.4). Locked in the central chest are indecipherable "secrets," watched over by a dog (perhaps the Id) and two figures at each side (perhaps the Ego and the Superego). Rising from the trunk are a mask, a rooster, and perhaps even a fetus.

CLOSER LOOK

I n the mid-1950s in London, a group of artists seeking to express contemporary culture in art formed the Independents. Headed by Richard Hamilton (1922–) and critic Lawrence Alloway (1926–1990), they were fascinated with the goods and products advertised in the American magazines that poured into an England still recovering from World War II. The third leader of the group, Edouardo Paolozzi [pow-LOH-tzee] (1924–2005), avidly collected these ads. The group soon began to describe their work as "Pop Art." It was meant to evoke the tension between popular culture and highbrow art.

In August and September 1956, the group staged an exhibition at the Whitechapel Gallery in London called "This Is Tomorrow." The show consisted of individual pavilions, each designed by a team of artists working in three different media. Hamilton and his two collaborators built a sort of funhouse just inside the gallery's front door. It included a working jukebox, a live microphone so that visitors might participate, films, and a 14-foot-high cutout of the poster for the 1956 film *The Forbidden Planet* showing Robby the Robot carrying off a pinup model. Beneath her knees, they stenciled in the famous photograph of Marilyn Monroe standing over an air vent in the 1955 film *The Seven Year Itch*, her skirt blowing up to reveal her legs.

Hamilton's collage *Just What Is It That Makes Today's Homes So Different, So Appealing?* was used as a catalog illustration to the exhibition and reproduced as a poster for the show. Its title came from a magazine, as did its imagery. In a later commentary, Hamilton listed the following as the subject of the work: "Journalism, Cinema, Advertising, Television, Styling, Sex symbolism, Randomization, Audience participation, Photographic image, Multiple image, Mechanical conversion of the imagery, Diagram, Coding, Technical drawing." In 1957, he created a second list, this one defining the Independents' art in general: "Popular (designed for a mass audience); Transient (short-term solution); Expendable (easily forgotten); Low Cost; Mass Produced; Young (aimed at Youth); Witty; Sexy; Gimmicky; Glamorous; and Big Business." Hamilton and his fellow British artists recognized the power of advertising to manipulate human desire for commercial ends, but at the same time, they celebrated that power.

Richard Hamilton, John McHale, and John Voelcker, pavilion for the "This Is Tomorrow" exhibition at the Whitechapel Gallery, London. 1956.

Something to Think About . . .

How does this English example of Pop Art compare to the later American versions, as seen in the work of Tom Wesselmann, Andy Warhol, and Roy Lichtenstein discussed later in the chapter?

Richard Hamilton, *Just What Is It That Makes Today's Homes So Different, So Appealing?* 1956. Collage on paper, 10 1/4" × 9 3/4". Kunsthalle Tübingen. Sammlung Zundel, Germany. © 2007 Artists Rights Society (ARS), New York/DACS, London.

SEE MORE For a Closer Look at Richard Hamilton's *Just What Is It That Makes Today's Homes So Different, So Appealing?*, go to **www.myartslab.com**

The *Romance* magazine cover on the back wall is at once an ironic comment on the relationship between the body builder and the stripper on the couch and a reference to such traditional depictions of relationships as Jan van Eyck's *Giovanni Arnolfini and His Wife Giovanna Cenami* (see Fig. 16.7).

A telescopic rendering of the surface of the moon serves as the room's ceiling, a reference to the theme of space and *The Forbidden Planet* in the "This Is Tomorrow" exhibition.

Outside the false window, the movie marquee advertises the first "talkie," Al Jolson's *The Jazz Singer* (see Fig. 37.21).

This advertisement for a Hoover vacuum cleaner reads "Ordinary cleaners reach only this far."

The Ford Motor Company logo decorates a lampshade that casts a strangely geometric white light on the wall behind it.

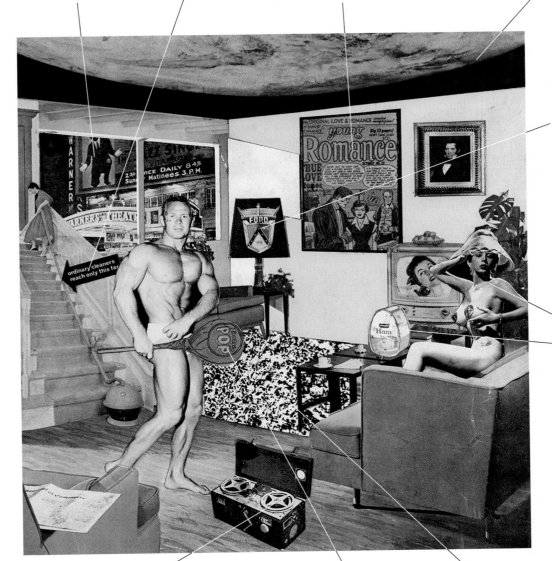

The canned ham on the table and the nearly nude stripper sitting on the sofa are "meat," consumable flesh, as is the body builder in the center of the room.

The reel-to-reel tape recorder, introduced in the early 1950s, symbolizes, like the television set and the newspaper on the chair in the foreground, the impact of the media on modern life.

The Tootsie Roll Pop, reproduced in giant scale, is a direct reference to *popular* culture.

The carpet is a blowup of the photograph of a beach by Weegee, the pseudonym of Arthur Felig (1899–1968), who became famous in 1945 with the publication of his first book of black-and-white photographs, *The Naked City*. That title resonates with Hamilton's composition.

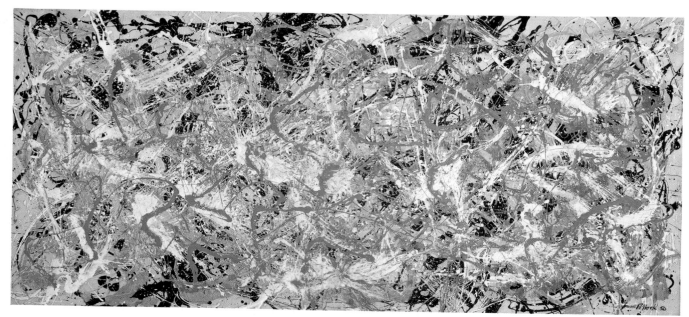

Fig. 38.5 Jackson Pollock, *Number 27*. 1950. Oil on canvas, 4'1" × 8'10". Collection, Whitney Museum of American Art, NY. Purchase. © 2008 ARS Artists Rights Society, NY. The year *Number 27* was painted, *Life* magazine ran a long, profusely illustrated story on Pollock asking, "Is he the greatest living painter in the United States?" It stimulated an astonishing 532 letters to the editor, most of them answering the question with a definitive "No!"

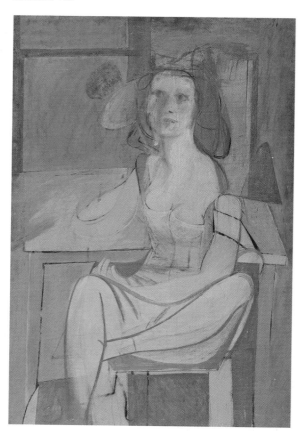

Fig. 38.6 Willem de Kooning, *Seated Woman*. ca. 1940. Oil on charcoal on masonite, 54 1/4" × 36". The Albert M. Greenfield and Elizabeth M. Greenfield Collection, 1974. Philadelphia Museum of Art, Philadelphia, Pennsylvania. U.S.A. Art Resource, New York. © Artists Rights Society (ARS), New York. The remarkable color contrasts reveal de Kooning's stunning sense of color.

Fig. 38.7 Willem de Kooning, *Pink Angels*. 1945. Oil on canvas, 52" × 40". Frederick Weisman Company, Los Angeles. The female anatomy here seems to have been disassembled, stretched, pushed, and pulled, and then rearranged in a sort of collage.

This depiction of a mental landscape would soon develop into large-scale **"action paintings,"** as described by the critic Harold Rosenberg in 1942 (Fig. **38.5**). The canvas had become, he said, "an arena in which to act." It was no longer "a picture but an event." Pollock would drip, pour, and splash oil paint, house and boat paint, and enamel over the surface of the canvas, determining the top and bottom of the piece only after the process was complete. The result was a galactic sense of space, what Rosenberg called "all-over" space, in which the viewer can almost trace Pollock's rhythmic gestural dance around the painting's perimeter.

De Kooning was 12 years Pollock's senior and had begun in the late 1930s and early 1940s in a more figurative vein.

CONTINUITY&CHANGE

Girl Before a Mirror, p. 1161

His 1940 *Seated Woman* shows the influence of Picasso's Cubist portraits of the 1930s (see *Girl Before a Mirror*, Fig. 35.13), even as it allows various anatomical parts to float free of the body or almost dissolve into fluid form (Fig. **38.6**). By the mid-1940s, in works like *Pink Angels*, the free-floating forms seem to refer to human anatomy even as they remain free from it (Fig. **38.7**). An eye here, a seated figure there, an extended arm, a breast, all set free of any logical skeletal relationships, begin to create the same allover space that distinguishes Pollock's work. The difference is that de Kooning's space is composed of shapes and forms rather than the woven linear skein of Pollock's compositions.

By 1950, the surface of de Kooning's paintings seemed densely packed with free-floating, vaguely anatomical parts set in a landscape of crumpled refuse, earthmoving equipment, concrete blocks, and I-beams. None of these elements is definitively visible, just merely suggested. *Excavation* is a complex organization of open and closed cream-colored forms that lead from one to the other, their black outlines overlapping, merging, disappearing across the surface (Fig. **38.8**). Small areas of brightly colored brushwork interrupt the surface.

When, in 1951, *Excavation* was featured in an exhibition of abstract painting and sculpture at the Museum of Modern Art in New York, de Kooning lectured on the subject "What Abstract Art Means to Me." His description of his relationship to his environment is a fair explanation of what we see in the painting: "Everything that passes me I can see only a little of, but I'm always looking. And I see an awful lot sometimes."

Fig. 38.8 Willem de Kooning (American 1904–1997 b. Netherlands), *Excavation*. **1950.** Oil on canvas, 205.7 × 254.6 cm (81″ × 100 ¹/₄″). Unframed. Mr. and Mrs. Frank G. Logan Purchase Prize Fund; restricted gifts of Edgar J. Kaufmann, Jr., and Mr. and Mrs. Noah Goldowsky, Jr., 1952.1 Reproduction, The Art Institute of Chicago. All rights reserved. © 2009 Artists Rights Society (ARS), New York. This is one of de Kooning's largest paintings. "My paintings are too complicated," he explained. "I don't use the large-size canvas because it's too difficult for me to get out of it."

De Kooning's abstraction differs from Pollock's largely in this. As opposed to plumbing the depths of the psyche, he represents the psyche's encounter with the world. Even in such early figurative works such as *Seated Woman*, where the curvilinear features of his sitter contrast with the geometric features of the room, de Kooning's primary concern is the relation of the individual to his or her environment. The tension between the two is the focus of his works.

Women Abstract Expressionists In many ways, women Abstract Expressionist artists held a position in the movement as a whole that is comparable to the women associated with the Surrealists in Europe. From the point of view of the men—and the critics who wrote about the men—they were spouses or lovers and, when noticed at all as artists, part of a "second generation" following on the heels of the great male innovators of the first generation. In 1948, for instance, the male Abstract Expressionists organized a group known as The Club, a social gathering that met regularly in a rented loft on East 8th Street in New York City. According to Pat Passlof, herself a painter and married to fellow Abstract Expressionist Milton Resnick, The Club's charter explicitly excluded communists, homosexuals, and women because, she was told, "those are the three groups that take over." In fact, women did attend meetings, though they were excluded from board meetings or policy discussions.

Although excluded from the inner circle, a number of the women associated with Abstract Expressionism were painters of exceptional ability. Elaine de Kooning (1918–1989), who married Willem in 1943, was known for her highly sexualized portraits of men. Lee Krasner [KRAZ-ner] (1908–1984), who married Jackson Pollock in 1945, developed her own distinctive allover style of thickly applied paint consisting of calligraphic lines. Though these lines sometimes enclose symbol-like forms, in *White Squares* their architecture possesses some of the energy of automatic writing—a kind of visual equivalent to "noise poetry" (Fig. **38.9**). Krasner later defined her relationship to the Abstract Expressionists and Pollock in particular:

> I was put together with the wives. They worked, they supported their husbands, they taught school and kept their mouths absolutely closed tight. I don't know if they were instructed never to speak publicly, I don't know if they had a thought. Jackson always treated me as an artist but his ego was so colossal, I didn't threaten him in any way. So he was aware of what I was doing, I was working, and that was that. That was our relationship.

One of the major tensions in Abstract Expressionism is the dynamic relationship between figuration and abstraction. As de Kooning once said, "Even abstract shapes must have a likeness." In *River Bathers* by Grace Hartigan [HAR-tih-gan] (1922–), the broad, gestural abstract washes of color have a powerful emotional and visual presence (Fig. **38.10**). She would later say, "My art was always about something," which in this case is five or six figures standing at a river's edge. For

Fig. 38.9 Lee Krasner (1908–1984), *White Squares*. ca. 1948. Oil on canvas, 24″ × 30″ (61 × 76.2 cm). Gift of Mr. and Mrs. B. H. Friedman. 75.1. Collection of the Whitney Museum of American Art, New York. The painting creates a tension between the geometric regularity of the grid and the gestural freedom of Krasner's line.

Fig. 38.10 Grace Hartigan, *River Bathers*. 1953. Oil on canvas, 5'9 3/8" × 7'4 3/4". Given anonymously. (11.1954). Digital Image. The Museum of Modern Art/Licensed by SCALA/Art Resource, New York. The most obvious bather is at the top right. Another seems to be splashing in the water in the middle section of the painting. Two others are behind her and another appears to be standing at the left.

Hartigan the painting is not realistic, but it captures real feelings experienced in a specific place and time.

Inspired by de Kooning, Joan Mitchell (1926–1992) began painting in New York in the early 1950s, but after 1955, she divided her time between Paris and New York, moving to Paris on a more permanent basis in 1959. Ten years later, she moved down the Seine to Vétheuil [vay-TOY], living in the house that Monet had occupied from 1878 to 1881. Although she denied the influence of Monet, her paintings possess something of the scale of Monet's water lily paintings, and her brushwork realizes in large what Monet rendered in detail. Like Monet, she was obsessed with water, specifically Lake Michigan, which as a child she had constantly viewed from her family's Chicago apartment. "I paint from remembered landscapes that I carry with me—and remembered feelings of them, which of course become transformed." As in most of her works, the unpainted white ground of *Piano mécanique* takes on the character of atmosphere or water, an almost touchable and semitransparent space that reflects the incidents of weather, time, and light (Fig. 38.11).

CONTINUITY & CHANGE

Water Lilies, **p. 1101**

Fig. 38.11 Joan Mitchell, *Piano mécanique*. 1958. Oil on canvas, 78" × 128". Gift of Addie and Sidney Yates. Image © 2009 Board of Trustees, National Gallery of Art, Washington, D.C. Alberto Giacometti and Samuel Beckett were among Mitchell's closest friends after she moved to Paris in 1959.

Fig. 38.12 Mark Rothko (American 1903–1970), *Green on Blue.* **1956.** Oil on canvas, 89 ³/₄″ × 63 ¹/₄″ (228.0 × 161.0 cm). Collection of the University of Arizona Museum of Art, Tucson, Gift of E. Gallagher, Jr. Acc. 64.1.1. The religious sensibility of Rothko's painting brought him, in 1964, a commission for a set of murals for a Catholic chapel in Houston, Texas.

The Color-Field Painting of Rothko and Frankenthaler A second variety of Abstract Expressionism offered viewers a more meditative and quiet painting based on large expanses of relatively undifferentiated color. Mark Rothko (1903–1970) began painting in the early 1940s by placing archetypal figures in front of large monochromatic bands of hazy, semitransparent color. By the early 1950s, he had eliminated the figures, leaving only the background color field.

The scale of these paintings is intentionally large. *Green on Blue*, for instance, is over 7 feet tall (Fig. **38.12**). "The reason I paint [large pictures]," he stated in 1951,

> is precisely because I want to be very intimate and human. To paint a small picture is to place yourself outside your experience, to look upon an experience as a stereopticon view or reducing glass. However you paint the larger picture, you are in it. It isn't something you command.

Viewers find themselves enveloped in Rothko's sometimes extremely somber color fields. These expanses of color become, in this sense, stage sets for the human drama that transpires before them. As Rothko further explains:

> I am interested only in expressing the basic human emotions—tragedy, ecstasy, doom, and so on—and the fact that lots of people break down and cry when confronted with my pictures shows that I communicate with those basic human emotions. The people who weep before my pictures are having the same religious experience I had when I painted them.

The emotional toll of such painting finally cost Rothko his life. His vision became darker and darker throughout the 1960s, and in 1970, he hanged himself in his studio.

In 1952, directly inspired by Pollock's drip paintings, 24-year-old Helen Frankenthaler (1928–) diluted paint almost to the consistency of watercolor and began pouring it onto unprimed cotton canvas to achieve giant stains of color that suggest landscape (Fig. **38.13**).

Fig. 38.13 Helen Frankenthaler, *The Bay*. 1963. Acrylic on canvas, 6′8 ¾″ × 6′9 ½″. The Detroit Institute of Arts, Founders Society Purchase, Dr. & Mrs. Hilbert H. DeLawter Fund/The Bridgeman Art Library. This is one of the first paintings in which Frankenthaler used acrylic rather than oil paint, resulting in a much stabler surface.

Fig. 38.14 Alexander Calder, *Black, White, and Ten Red.* 1957. Painted sheet metal and wire, 33″ × 144″. Image courtesy of Board of Trustees, National Gallery of Art, Washington, D.C. © 2011 Calder foundation, New York/Artists Rights Society (ARS), New York.

The risk she assumed in controlling her flooding hues, and the monumentality of her compositions, immediately inspired a large number of other artists.

The Dynamic Sculpture of Calder and Smith Sculpture, too, could partake of the same gestural freedom and psychological abstraction as Abstract Expressionist painting. It could become a field of action, like Pollock's and de Kooning's paintings, in which the sculptor confronts the most elemental forms of being.

When the American sculptor Alexander Calder (1898–1976) arrived in Paris in 1926, his studio was a favorite haunt of the Surrealists, who came to witness performances of Cirque Calder (1926-31), a miniature arena in which he manipulated diminutive figures built of wire and wood, including bareback riders, acrobats, sword swallowers, and the like. So time and chance—the happenstance of live performance—were built into his work. By the early 1930s he began to make what Marcel Duchamp labeled **mobiles**, which in French refer not only to things that move but "motives" as well, the causes or incentives for action (Fig. **38.14**). The movement of Calder's mobile comes from accidental and often unpredictable currents of air that hit the suspended sculpture—a breeze, a sudden

gust from the air-conditioning system, a wave of air from a passing bus. The mobile's appearance changes as continuously and as arbitrarily as a cumulus cloud on a summer's day, suggesting familiar shapes—fish, lily pads, birds—in the manner of a cloud. As the mobile turns in space, it defines a virtual volume like that defined by the linear tracery of a handheld light swung in an arc and photographed with a long exposure time. In other words, its path is like a dancer's over the space of a stage, a choreography of graceful forms. In a 1946 catalog for an exhibition of Calder mobiles, Jean-Paul Sartre summed up the mobile's appeal as stemming from "the beauty of its pure and changing forms, at once so free and so disciplined."

The sculpture of David Smith (1906–1965) offers the same sense of change but in a more stable form. Here it is not the sculpture that moves, but the viewer who must. For instance, when one views *Blackburn: Song of an Irish Blacksmith* from the front, the sculpture seems totally open and airy, consisting of negative spaces defined by linear elements, whereas from the side it becomes a complex network of densely packed forms (Fig. **38.15**). There is really no way for the viewer to intuit all of the sculpture's aspects without walking around it. From any single view it remains unpredictable. And the surprises that the sculpture presents

Fig. 38.15 David Smith, *Blackburn: Song of an Irish Blacksmith*, frontal and profile views. 1949–50. Steel and bronze, 46 ¼″ × 49 ¾″ × 24″. Wilhelm Lehmbruck Museum, Duisburg, Germany. Art © Estate of David Smith/Licensed by VAGA, NY. Smith was the descendant of a pioneer blacksmith in Indiana. The piece resonates with that autobiographical reference.

extend to its materials. It is constructed out of found objects from the industrial world—bent steel rods, cotter pins, and what appears to be the metal seat of a farm tractor—all transformed, in a consciously Surrealist manner, into something new, unique, and marvelous.

What most distinguishes Smith's work is the requirement of active participation from the viewer to experience it fully. So the responsibility for the creation of meaning in art begins to shift from artist to audience, as it does in Abstract Expressionism generally if less clearly. This shift will profoundly alter the direction of art in the last half of the twentieth century, when a work of art will increasingly have as many meanings as the viewers it attracts.

THE BEAT GENERATION

The participation of the audience and the multiple perspectives that the work of both Calder and Smith embodies became the central focus of the group of American poets, writers, and artists that we have come to call Beats or hipsters. *Beat* was originally a slang term meaning "down and out," or "poor and exhausted," but it came to designate the purposefully disenfranchised artists of the American 1950s who turned their backs on what they saw as the duplicity of their country's values. The **Beat generation** sought a heightened and, they believed, more authentic style of life, defined by alienation, nonconformity, sexual liberation, drugs, and alcohol.

Robert Frank and Jack Kerouac

The Beats' material lay all around them, in the world, as they sought to expose the tensions that lay under the presumed well-being of their society. One of their contemporary heroes was the Swiss photographer Robert Frank (1924–), who with the aid of a Guggenheim fellowship had traveled across America for two years, publishing 83 of the resulting 2,800 photographs as *The Americans* in 1958. The book

outraged a public used to photographic compilations like the 1955 exhibition *The Family of Man*, which drew 3,000 visitors daily to the Museum of Modern Art in celebration of its message of universal hope and unity. Frank's photographs offered something different. They capture everyday, mundane things that might otherwise go by unseen, with a sense of spontaneity and directness that was admired, especially, by writer Jack Kerouac (1922–1969), who had chronicled his own odysseys across America in the 1957 *On the Road*.

On the Road describes Kerouac's real-life adventures with his friend Neal Cassady (1926–1968), who appears in what Kerouac called his "true-story novel" as Dean Moriarty. Cassady advocated a brand of writing that amounted to, as he put it in a letter to Kerouac, "a continuous chain of undisciplined thought." In fact, Kerouac wrote the novel in about three weeks on a single, long scroll of paper, improvising, he felt, like a jazz musician, only with words and narrative. But like a jazz musician, Kerouac was a skilled craftsman, and if the novel seems a spontaneous outburst, it reflects the same sensibility as Robert Frank's *The Americans*. Frank, after all, had taken over 2,800 photographs, but he had published only 83 of them. One senses, in reading Kerouac's rambling adventure, something of the same editorial control.

Ginsberg and "Howl"

The work that best characterizes the Beat generation is "Howl," a poem by Allen Ginsberg (1926–1997). This lengthy poem in three parts and a footnote has a memorable opening (**Reading 38.5**):

READING 38.5

from Allen Ginsberg, "Howl" (1956)

I saw the best minds of my generation destroyed by
 madness, starving hysterical naked,
dragging themselves through the negro streets at dawn
 looking for an angry fix,
angelheaded hipsters burning for the ancient heavenly
 connection to the starry dynamo in the machinery of
 night,
who poverty and tatters and hollow-eyed and
 high sat up smoking in the supernatural darkness of
 cold-water flats floating across the tops of cities
 contemplating jazz
who bared their brains to Heaven under the El and saw
 Mohammedan angels staggering on tenement roofs
 illuminated,
who passed through universities with radiant cool eyes
 hallucinating Arkansas and Blake-light tragedy among
 the scholars of war,
who were expelled from the academies for crazy & pub-
 lishing obscene odes on the windows of the skull,
who cowered in unshaven rooms in underwear, burning
 their money in wastebaskets and listening to the Ter-
 ror through the wall . . .

Fig. 38.16 Robert Rauschenberg (1925–), *Bed*. 1955. Combine painting: oil and pencil on pillow, quilt, and sheet on wood supports, 6'3 $^1/_4$" × 31 $^1/_2$" × 8". Gift of Leo Castelli in honor of Alfred H. Barr, Jr. (79.1989). Digital Image © The Museum of Modern Art/Licensed by SCALA/Art Resource, New York. © Art Robert Rauschenberg Foundation/VAGA, Visual Artists & Galleries Association, NY. The mattress, pillow, quilt, and sheets are believed to be Rauschenberg's own and so may be thought of as embodying his famous dictum: "Painting relates to both art and life. . . . (I try to act in that gap between the two.)"

Ginsberg's spirit of inclusiveness admitted into art not only drugs and alcohol but also graphic sexual language, to say nothing of his frank homosexuality. Soon after "Howl" was published in 1956 by Lawrence Ferlinghetti's City Lights bookstore in San Francisco, federal authorities charged Ferlinghetti with obscenity. He was eventually acquitted. Whatever the public thought of it, the poem's power was hardly lost on the other Beats. The poet Michael McClure (1932–) was present the night Ginsberg first read it at San Francisco's Six Gallery in 1955:

> Allen began in a small and intensely lucid voice. At some point Jack Kerouac began shouting "GO" in cadence as Allen read it. In all of our memories no one had been so outspoken in poetry before—we had gone beyond a point of no return—and we were ready for it, for a point of no return. None of us wanted to go back to the gray, chill, militaristic silence, to the intellective void—to the land without poetry—to the spiritual drabness. We wanted to make it new and we wanted to invent it and the process of it as we went into it. We wanted voice and we wanted vision. . . .

> Ginsberg read on to the end of the poem, which left us standing in wonder, or cheering and wondering, but knowing at the deepest level that a barrier had been broken, that a human voice and body had been hurled against the harsh wall of America and its supporting armies and navies and academies and institutions and ownership systems and power-support bases.

Here, in fact, in the mid-1950s were the first expressions of the forces of rebellion that would sweep the United States and the world in the following decade.

Cage and the Aesthetics of Chance

Ginsberg showed that anything and everything could be admitted into the domain of art. This notion also informs the music of composer John Cage (1912–1992), who by the mid-1950s was proposing that it was time to "give up the desire to control sound . . . and set about discovering means to let sounds be themselves." Cage's notorious *4' 33"* (*4 minutes 33 seconds*) is a case in point. First performed in Woodstock, New York, by pianist David Tudor on August 29, 1952, it consists of three silent movements, each of a different length, but when added together totaling four minutes and thirty-three seconds. The composition was anything but silent, however, admitting into the space framed by its duration all manner of ambient sound—whispers, coughs, passing cars, the wind. Whatever sounds happened during its performance were purely a matter of chance, never predictable. Like Frank's, Cage's is an art of inclusiveness.

That summer, Cage organized a multimedia event at Black Mountain College in North Carolina, where he occasionally taught. One of the participants was 27-year-old artist Robert Rauschenberg [RAUW-shen-berg]

(1925–2008). By the mid-1950s, Rauschenberg had begun to make what he called **combine paintings**, works in which all manner of materials—postcards, advertisements, tin cans, pinups—are combined to create the work. If Rauschenberg's work does not literally depend upon matters of chance in its construction, it does incorporate such a diverse range of material that it creates the aura of representing Rauschenberg's chance encounters with the world around him. And it does, above all, reflect Cage's sense of all-inclusiveness. *Bed* literally consists of a sheet, pillow, and quilt raised to the vertical and then dripped not only with paint but also with toothpaste and fingernail polish in what amounts to a parody of Abstract Expressionist introspection (Fig. **38.16**). Even as it juxtaposes highbrow art-making with the vernacular quilt, abstraction with realism, *Bed* is a wryly perceptive transformation of what Max Ernst in the early days of Surrealism had called "The Master's Bedroom" (see Fig. 35.11).

The Art of Collaboration Rauschenberg had known Cage since the summer of 1952 when, not long before the premiere of *4' 33"* in New York state, Cage had organized an event, later known as *Theater Piece #1*, in the dining hall of Black Mountain College near Asheville, North Carolina. Although almost everyone who participated remembers the event somewhat differently, it seems certain that the poets M. C. Richards (1916–1999) and Charles Olson (1910–1970) read poetry from ladders, Robert Rauschenberg played Edith Piaf [pee-AHF] records on an old windup phonograph with his almost totally "White Paintings" hanging around the room, Merce Cunningham (1919–2009) danced through the audience, a dog at his heels, while Cage himself sat on a stepladder, sometimes reading a lecture on Zen Buddhism, sometimes just listening. "Music," Cage declared at some point in the event, "is not listening to Mozart but sounds such as a street car or a screaming baby."

The event inaugurated a collaboration between Cunningham (dance), Cage (music), and Rauschenberg (decor and costume) that would span many years. Their collaboration is unique in the arts because of its insistence on the *independence*, not interdependence, of each part of the dance's presentation. Cunningham explains:

> In most conventional dances there is a central idea to which everything adheres. The dance has been made to the piece of music, the music supports the dance, and the decor frames it. The central idea is emphasized by each of the several arts. What we have done in our work is to bring together three separate elements in time and space, the music, the dance and the decor, allowing each one to remain independent.

So Cunningham created his choreography independently of Cage's scores, and Rauschenberg based his decors on only minimal information offered him by Cunningham and

Fig. 38.17 Merce Cunningham, *Summerspace*. 1958. Set and costumes by Robert Rauschenberg. Photo by Jack Mitchell. Courtesy of Cunningham Dance Foundation, Inc. © Estate of Robert Rauschenberg/VAGA, NY. *Summerspace*, Cunningham said, was "about space. I was trying to think about ways to work in space. . . . When I spoke to Bob Rauschenberg—for the decor—I said, 'One thing I can tell you about this dance is it has no center. . . .' So he made a pointillist backdrop and costumes."

Cage (Fig. **38.17**). The resulting dance was, by definition, a matter of music, choreography, and decor coming together (or not) as a chance operation.

The music Cage composed for Cunningham was also often dependent on chance operations. For instance, in 1959, Cage recorded an 89-minute piece entitled *Indeterminacy* (track **38.1**). It consisted of Cage narrating short, humorous stories while, in another room, out of earshot, pianist David Tudor performed selections from Cage's 1958 *Concert for Piano and Orchestra* as well as pre-recorded tape from another 1958 composition, *Fontina Mix*. For a 1965 collaboration with Cunningham, *Variations V*, Cage's score consisted of sounds randomly triggered by sensors reacting to the movements of Cunningham's dancers. This results in what Gordon Mumma, a member of Cunningham's troupe, called "a superbly poly: -chromatic, -genic, -phonic, -morphic, -pagic, -technic, -valent, multi-ringed circus."

HEAR MORE at www.myartslab.com

Johns and the Obvious Image Whereas the main point for Cunningham, Cage, and Rauschenberg was the idea of composition without a central focus, Rauschenberg's close friend and fellow painter Jasper Johns (1930–) took the opposite tack. Throughout the 1950s, he focused on the most common, seemingly obvious subject matter—numbers, targets, maps, and flags—in a manner that in no way suggests the multiplicity of meaning in his colleagues' work. Johns's painting *Three Flags* is nevertheless

capable of evoking in its viewers emotions ranging from patriotic respect to equally patriotic outrage, from anger to laughter (Fig. **38.18**). But Johns means the imagery to be so obvious that viewers turn their attention to the wax-based paint itself, to its almost sinuous application to the canvas surface. In this sense, the work—despite being totally recognizable—is as abstract as any Abstract Expressionist painting, but without Abstract Expressionism's assertion of the primacy of subjective experience.

Fig. 38.18 Jasper Johns (b. 1930), *Three Flags*. 1958. Encaustic on canvas, 30 $7/8$ × 45 $1/2$ × 5 in. (78.4 × 115.6 × 12.7 cm). 50th Anniversary Gift of the Gilman Foundation, Inc., The Lauder Foundation, A. Alfred Taubman, an anonymous donor, and purchase. 80.32. Collection of Whitney Museum of American Art, New York. Photo by Geoffrey Clements. Art © Jasper Johns/Licensed by VAGA, NY. Each of the three flags diminishes in scale by about 25 percent from the one behind. Because the flags project outward, getting smaller each time, they reject pictorial perspective's illusion of depth and draw attention to the surface of the painting itself.

Allan Kaprow and the Happening Cage's aesthetic of diversity and inclusiveness also informs the inventive multimedia pieces of Alan Kaprow (1927–2006). In an essay called "The Legacy of Jackson Pollock," written just two years after Pollock's death in an automobile accident in 1956, Kaprow described Pollock's art, with its willingness to bury nails, sand, wire, screen mesh, even coins in its whirls of paint, as pointing toward new possibilities for the subsequent generation of artists (**Reading 38.6**):

READING 38.6

from Allan Kaprow, "The Legacy of Jackson Pollock" (1958)

Pollock, as I see him, left us at the point where we must become preoccupied with and even dazzled by the space and objects of our everyday life, either our bodies, clothes, rooms, or, if need be, the vastness of Forty-second Street. Not satisfied with the suggestion through paint of our other senses, we shall utilize the specific substances of sight, sound, movements, people, odors, touch. Objects of every sort are materials for the new art: paint, chairs, food, electric and neon lights, smoke, water, old socks, a dog, movies, a thousand other things that will be discovered by the present generation of artists. Not only will these bold new creators show us, as if for the first time, the world we have always had about us but ignored, but they will disclose entirely unheard-of happenings and events, found in garbage cans, police files, hotel lobbies; seen in store windows and on the streets; and sensed in dreams and horrible accidents. An odor of crushed strawberries, a letter from a friend, or a billboard selling Drano; three taps on the front door, a scratch, a sigh, or a voice lecturing endlessly, a blinding staccato flash, a bowler hat—all will become materials for this new concrete art.

> Young artists of today need no longer say, "I am a painter" or "a poet" or "a dancer." They are simply "artists." All of life will be open to them.

It is hardly surprising that it was Kaprow who founded the **Happening**, a new multimedia event in which artists and audience participated as equal partners. Kaprow's *18 Happenings in 6 Parts* took place over the course of six evenings in October 1959 at the Reuben Gallery in New York. It was inspired by *Theater Piece #1*. In order to add sound to his environment, Kaprow enrolled in Cage's music composition course at the New School for Social Research in New York. Included in the environment were record players, tape recorders, bells, a toy ukulele, a flute, a kazoo, and a violin. Kaprow scored the directions for playing them in precisely timed outbursts that approximated the cacophony of the urban environment. He divided the gallery into three rooms, created by plastic sheets and movable walls, between which audience members were invited to move in unison. Performers played instruments and records, painted, squeezed orange juice, spoke in sentence fragments—all determined by chance operations. The audience, although directed to move according to Kaprow's instructions, was also invited to participate in the work, and Kaprow would increasingly include the audience as a participant in his later Happenings.

Architecture in the 1950s

If the Beat generation was antiestablishment in its sensibilities, the architecture of the 1950s embodied the very opposite. The International Style aesthetic that Mies van der Rohe brought to his 1954 to 1956 Seagram Building (1954–1956; see Fig. 37.32) could also be applied to the private residence, as he made clear with the 1950 Farnsworth House (Fig. **38.19**). A more direct homage to Le Corbusier's

Fig. 38.19 Ludwig Mies van der Rohe, Farnsworth House, Fox River, Plano, Illinois. 1950. © 2008 Artists Rights Society (ARS), New York/VG Bild-Kunst, Bonn. The house was commissioned as a weekend retreat. Its bathroom and storage areas are behind non-load-bearing partitions that divide the interior space.

Fig. 38.20 Frank Lloyd Wright, The Solomon R. Guggenheim Museum, New York, 1957–59. Photo: David Heald/Courtesy of the Solomon R. Guggenheim Museum. FL W#7. © 2008 Artists Rights Society (ARS), New York. The tower behind Wright's original building was designed much later by Gwathmey Siegel and Associates. It contains 51,000 square feet of new and renovated gallery space, 15,000 square feet of new office space, a restored theater, new restaurant, and retrofitted support and storage spaces. Wright had originally proposed such an annex to house artists' studios and offices, but the plan was dropped for financial reasons.

Villa Savoye (see Fig. 37.9), though more severe in its insistence on the vertical and the horizontal, it is virtually transparent, opening out to the surrounding countryside, with views of the Fox River, and also inviting the countryside in.

Frank Lloyd Wright's design for the Solomon R. Guggenheim [GOO-ghen-hime] Museum in New York is a conscious counterstatement to Mies van der Rohe's severe rationalist geometry, which, in fact, Wright despised (Fig. **38.20**). Situated on Fifth Avenue directly across from Central Park, the museum's organic forms echo the natural world. The plan is an inverted spiral ziggurat, or stepped tower, that dispenses with the right-angle geometries of standard urban architecture and the conventional approach to museum design, which led visitors through a series of interconnected rooms. Instead, Wright whisked museumgoers to the top of the building via elevator, allowing them to proceed downward on a continuous spiral ramp from which, across the open rotunda in the middle, they can review what they have already seen and anticipate what is to come. The ramp is cantilevered to such an extent that several contractors were frightened off by Wright's plans. The plans were complete in 1943, but construction did not begin until 1956

because of a prohibition of new building during World War II and permit delays stemming from the radical nature of the design. It was still not complete at the time of Wright's death in 1959. In many ways, Wright's Guggenheim Museum represents the spirit of architectural innovation that still pervades the practice of architecture to this day.

POP ART

In the early 1960s, especially in New York, a number of artists created a "realist" art that represented reality in terms of the media—advertising, television, comic strips—the imagery of mass culture. The famous paintings of Campbell's Soup cans created by Andy Warhol (1928–1987) were among the first of these to find their way into the gallery scene (Fig. **38.21**). In the fall of 1962, he exhibited 32 uniform 20″ × 16″ canvases, at the Ferus Gallery in Los Angeles. Each depicted one of the 32 different Campbell's Soup "flavors." Even as the paintings debunked the idea of originality—are they Campbell's or Warhol's?—their literalness redefined the American landscape as the visual equivalent of the supermarket aisle. The works were

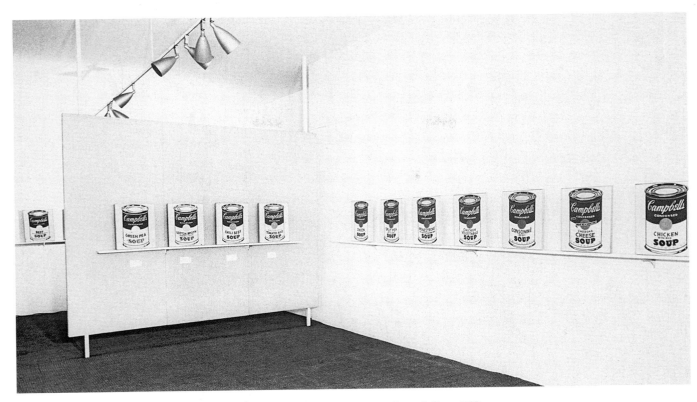

Fig. 38.21 Andy Warhol, Installation view of *Campbell's Soup Cans*, installation at Ferus Gallery. 1962.
Founding Collection, The Andy Warhol Museum, Pittsburgh. In order to evoke the way we encounter Campbell's Soup on the grocery shelf, Warhol placed the cans on narrow shelves on the gallery walls.

deliberately opposed to the self-conscious subjectivity of the Abstract Expressionists. It was, in fact, as if the painter had no personality at all. As Warhol himself put it, "If you want to know all about Andy Warhol, just look at the surface of my paintings and films and me, and there I am. There's nothing behind it."

The term Pop Art quickly became attached to work such as Warhol's. Coined in England in the 1950s (see *Closer Look*, pages 1256–1257), it soon came to refer to any art whose theme was essentially the commodification of culture—that is, the marketplace as the dominant force in the creation of "culture." Thus, *Still Life #20* (Fig. **38.22**) by Tom Wesselmann (1931–2004) is contemporaneous with Warhol's *Soup Cans*, though neither was aware of the other until late in 1962, and both are equally "pop." Inside the cabinet with the star stenciled on it—which can be either opened or closed—are actual household items, including a package of SOS scouring pads and a can of Ajax cleanser. Above the blue table on the right, covered with two-dimensional representations (cut out of magazines) of various popular varieties of food and drink, is a reproduction of a highly formalist painting by the Dutch artist Piet Mondrian (see Fig. 37.5). The implication, of course, is that art—once so far removed from everyday life, not even, in this case, referring to the world—has itself become a commodity, not so very different from Coke or a loaf of Lite Diet bread. In fact, the structure and color of Wesselmann's collage subtly reflect the structure and color of

Mondrian's painting, as if the two are simply two different instances of "the same."

By late 1962, Warhol had stopped making his paintings by hand, using a photo-silkscreen process to create the

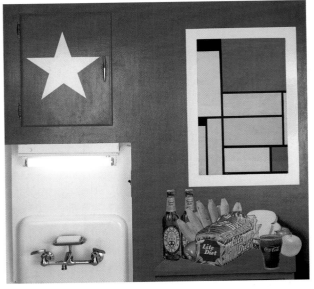

Fig. 38.22 Tom Wesselmann, *Still Life #20*. 1962. Mixed media, 48″ × 48″ × 5 ¹/₂″ (104.14 × 121.92 × 13.97 cm). Albright-Knox Art Gallery, Buffalo, New York. Gift of Seymour H. Knox, Jr. Art © 2008 Estate of Tom Wesselmann/VAGA, NY. An actual sink faucet and soap dish are incorporated into the composition. Its fluorescent light can be turned on or off.

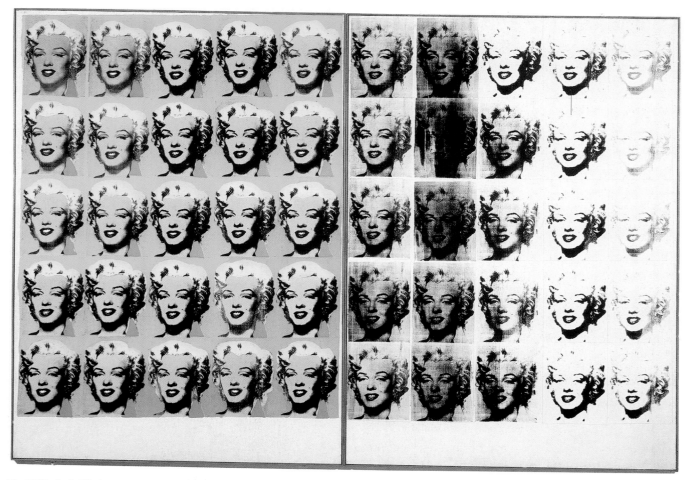

Fig. 38.23 Andy Warhol, _Marilyn Diptych._ 1962. Oil, acrylic, and silkscreen on enamel on canvas, 6′ 8 $^7/_8$″ × 4′9″. Tate Gallery, London. Art Resource, New York. © 2003 The Andy Warhol Foundation for the Visual Arts/Artists Rights Society (ARS), New York. ™ 2002 Marilyn Monroe LLC under license authorized by CMG Worldwide Inc., Indianapolis, IN 46256 www.MarilynMonroe.com. Warhol was obsessed with Hollywood, especially with the false fabric of fame that it created.

SEE MORE For a Closer Look at Andy Warhol's _Marilyn Diptych_, go to **www.myartslab.com**

images mechanically and employing others to do the work for him in his studio, The Factory. One of the first of these is the _Marilyn Diptych_ (Fig. **38.23**). Marilyn Monroe had died, by suicide, in August of that year, and the painting is at once a memorial to her and a commentary on the circumstances that had brought her to despair. She is not so much a person, as Warhol depicts her, but a personality, the creation of a Hollywood studio system whose publicity shot Warhol repeats over and over again here to the point of erasure.

The enlarged comic strip paintings of Roy Lichtenstein [LIK-ten-stine] (1923–1997) are replete with heavy outlines and Ben Day dots, the process created by Benjamin Day at the turn of the century to produce shading effects in mechanical printing. Widely used in comic strips, the dots are, for Lichtenstein, a conscious parody of Seurat's pointillism (see Chapter 33). But they also reveal the extent to which "feeling" in popular culture is as "canned" as Campbell's Soup. In _Oh, Jeff_ . . . (Fig. **38.24**), "love" is emptied of real meaning as the real weight of the message is carried by the final "But. . ." Even the feelings inherent in Abstract Expressionist brushwork came under Lichtenstein's attack (Fig. **38.25**). In fact, Lichtenstein had taught painting to college students, and he discovered that the "authentic" gesture of Abstract Expressionism could easily be taught and replicated without any emotion whatsoever—as a completely academic enterprise.

One of the most inventive of the Pop artists was Claes Oldenburg (1929–), born in Sweden but raised from age seven in Chicago. Inspired by Allan Kaprow's essay "The Legacy of Jackson Pollock," in 1961, he rented a storefront on New York's Lower East Side, and in time for Christmas, opened _The Store_, filled with life-size and

EXPLORE MORE View a studio technique video about silkscreen at **www.myartslab.com**

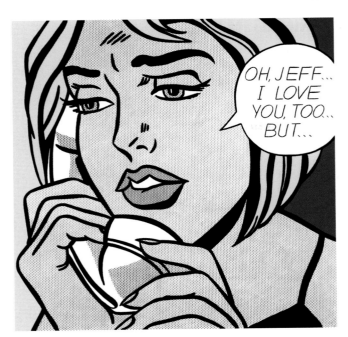

Fig. 38.24 Roy Lichtenstein, *Oh, Jeff . . . I Love You, Too . . . But. . . .* 1964. Oil on magma on canvas, 4′ × 4′. © Estate of Roy Lichtenstein. The large size of these paintings mirrors the scale of the Hollywood screen and the texture of the common billboard.

Fig. 38.25 Roy Lichtenstein (1923–1997), *Little Big Painting*. 1965. Oil on synthetic polymer on canvas, 70″ × 82″ × 2 ¼″ (177.8 × 208.3 × 5.7 cm). Purchase, with funds from the Friends of the Whitney Museum of America Art. 66.2. Collection of the Whitney Museum of American Art, New York. This "detail" of an imaginary larger painting is nonetheless a giant in its own right.

over-life-size enameled plaster sculptures of everything from pie à la mode, to hamburgers, hats, caps, 7-Up bottles, shirt-and-tie combinations, and slices of cake. "I am for an art," he wrote in a statement accompanying the exhibition,

> that is political-erotica-mystical, that does something other than sit on its ass in a museum.
>
> I am for an art that grows up not knowing it is art at all, an art given the chance of having a starting point of zero.
>
> I am for an art that embroils itself with the everyday crap & still comes out on top. I am for an art that imitates the human, that is comic, if necessary, or violent, or whatever is necessary.
>
> I am for an art that takes its form from the lines of life itself, that twists and extends and accumulates and spits and drips, and is heavy and coarse and blunt and sweet and stupid as life itself.

Admiring the way that cars filled the space of auto showrooms, Oldenburg soon enlarged his objects to the size of cars and started making them out of vinyl stuffed (or not) with foam rubber. These objects toy not only with our sense of scale—a giant lightplug, for instance—but with the tension inherent in making soft something meant to be hard (Fig. 38.26). They play, further, in almost Surrealist fashion, with notions of sexuality as well—the analogy between inserting a lightplug into its socket and sexual intercourse was hardly lost on Oldenburg, who delighted even more at the image of cultural impotence that his "soft" lightplug implied.

Fig. 38.26 Claes Oldenburg, Swedish, (b. 1929), *Soft Toilet*. 1966. Vinyl, Kapok, Liquitex, Wood, 52 × 32 × 30. Collection of Whitney Museum of American Art, NY. Oldenburg's art is epitomized by his slightly but intentionally vulgar sense of humor.

MINIMALISM IN ART

At first it seems that nothing could be further in character from Pop Art than *Pagosa Springs* (Fig. **38.27**), a 1960 painting by Frank Stella (1936–). Stella's work is contemporaneous with Pop, but it seems, in its almost total formality and abstraction—its overtly unsymbolic and minimal means—to turn its back almost entirely on popular culture. It is composed, simply, of copper metallic parallel lines painted carefully between visible pencil marks on an I-shaped canvas. But in its austere geometry and lack of expressive technique, it represents a revolt against the same commodity culture targeted by the Pop artists. In fact, nothing could be further from the onslaught of mass-media images in the culture of consumption than Minimal Art's almost pure and classical geometries. Cool and severe where Pop is brash and sardonic, Minimal Art is nevertheless equally concerned with challenging the presumption that art's meaning originates in the "genius" of the individual artist. If Warhol could say, "just look at the surface of my paintings and . . . and there I am. There's nothing behind it," so Stella would say of paintings such as *Pagosa Springs*: "What you see is what you see. Painting to me is a brush in a bucket and you put it on a surface. There is no other reality for me than that."

Like Warhol producing series of silkscreen works at the Factory, Minimalist artists were also intrigued with utilizing

Fig. 38.27 Frank Stella (American, b. Malden, MA 1936), *Pagosa Springs.* **1960.** Copper metallic (enamel?) and pencil on canvas, 99 $^3/_8$″ × 99 $^1/_4$″ (252.3 × 252.1 cm). Hirshhorn Museum and Sculpture Garden, Smithsonian Institution, Gift of Joseph H. Hirshhorn, 1972. © 2009 Artists Rights Society (ARS), New York. The shaped canvas draws attention to one of the fundamental properties of painting—the support.

LEARN MORE Gain insight from a primary source document from Frank Stella at **www.myartslab.com**

Fig. 38.28 Carl Andre, 10 × 10 *Altstadt Copper Square.* **1967.** Copper, 100 units, $^3/_{16}$″ × 19 $^{11}/_{16}$″ × 19 $^{11}/_{16}$″ each; $^3/_{16}$″ × 197″ × 197″ overall. Solomon R. Guggenheim Museum, Panza Collection. 91.3673. Space is defined by both the work and the spectator who is free to walk across it.

Fig. 38.29 Sol LeWitt, *Wall Drawing #146A: All two-part combinations of arcs from corners and sides, and straight, not straight, and broken lines within a 36-inch (90 cm) grid.* June 2000. White crayon on blue wall. LeWitt Collection, Chester, Connecticut. Mass MoCA, North Adams, MA. LeWitt conceived of the exhibition at Mass MoCA, of which this drawing is a small part, in 2004, but did not live to see it installed.

the processes of mass production, the use of ready-made materials, the employment of modular units. A sculptural piece by Carl Andre (1935–), *10 × 10 Altstadt Copper Square* (Fig. **38.28**), is composed of 100 identical copper tiles. In form, it closely parallels Warhol's 32 *Soup Cans* or the 50 Marilyns that make up the *Marilyn Diptych*, except that it has no imagery.

The ultimate question Minimalist Art asks is "What, minimally, makes a work of art?" This was not a new question. Marcel Duchamp had posed it with his "ready-mades" (see Fig. 35.5), and so had Kasimir Malevich with his Suprematist paintings (see Fig. 35.9). In many ways, Pop itself was asking the same question: What, after all, made a picture of a soup can or a comic strip "art"? But Minimalist artists stressed the aesthetic quality of their works; they were confident that they were producing works of (timeless) beauty and eloquence. Perhaps most of all, Minimalism invites the viewer to contemplate its sometimes seductively simple beauty. It invites, in other words, the active engagement of the viewer in experiencing it.

This is precisely the point of a room installation at the Massachusetts Museum of Contemporary Art (Mass MoCA) by Sol LeWitt (1928–2007), one of 105 wall drawings installed at the museum in 2008 as part of a survey exhibition of LeWitt's work that will be on display until 2033 (Fig. **38.29**). The piece literally surrounds the viewer, covering every wall of a 26-by-46-foot room. Like the other wall drawings in the exhibition, which cover over one acre of interior walls in a 27,000-square-foot, three-story historic old mill building situated at the heart of Mass MoCA's campus, the drawing began as a set of instructions to be followed by workers who execute the work independently of the artist. "The idea," LeWitt says, in one of his most famous statements, "becomes the machine that makes the art." The instructions are comparable to a composer's musical score—notations designed to guide those executing the piece as if it were a performance. For *Wall Drawing #146A*, LeWitt proposed a "vocabulary" of 20 different kinds of lines to be combined in pairs of two in order to realize 192 different pairs. His inspiration was the work of photographer Eadweard Muybridge, who in the late nineteenth century created photographic sequences of animals and humans in motion (see Fig. 34.17). "I've long had a strong affinity toward Muybridge," LeWitt has said. "A lot of his ideas appear in my work." In this case, LeWitt captures the sense of a logical, serial movement through space.

Nevertheless, the "art" in works such as Andre's and LeWitt's is extremely matter-of-fact—unmediated, that is, by concerns outside itself. One hardly needs to know of LeWitt's interest in Muybridge to find oneself totally immersed in and engaged by the work. The wall drawing is about the simple beauty of its form, insisting specifically that we pay attention to its order and arrangement. But the order reflected in Andre's and LeWitt's work does not represent belief in a transcendent, universal order, as the work of Mondrian did (see Fig. 37.5). Andre's copper squares and LeWitt's white chalk lines are simply conscious arrangements of parts, without reference to anything outside themselves. To paraphrase Frank Stella: What they are is what they are.

The Civil Rights Movement

Soon after Reconstruction, the period immediately following the Civil War, Southern states passed a group of laws that effectively established a racial caste system that relegated black Americans to second-class status and institutionalized segregation. In the South, the system was known as Jim Crow, but discrimination against blacks was entrenched in the North as well. At the outset of World War II, A. Philip Randolph (1889–1979) had organized a march on Washington "for jobs in national defense and equal integration in the fighting forces." Ten thousand blacks were scheduled to march on July 1, 1941, when President Roosevelt issued Executive Order 8802 on June 25, banning discriminatory hiring practices in the defense industry and the federal government.

But it was not until 1954 that the U.S. Supreme Court ruled that racially segregated schools violated the Constitution. In *Brown v. Board of Education*, the Court found that it was not good enough for states to provide "separate but equal" schools. "Separate educational facilities are inherently unequal," the Court declared, and were in violation of the Fourteenth Amendment to the Constitution's guarantee of equal protection. The Justices called on states with segregated schools to desegregate "with all deliberate speed."

Within a week, the state of Arkansas announced that it would seek to comply with the court's ruling. The state had already desegregated its state university and its law school. Now it was time to desegregate elementary and secondary schools. The plan was for Little Rock Central High School to open its doors to African-American students in the fall of 1957. But on September 2, the night before school was to start, Governor Orval Faubus ordered the state's National Guard to surround the high school and prevent any black students from entering. Faubus claimed he was trying to prevent violence. The nine black students who were planning to attend classes that day decided to arrive together on September 4. Unaware of the plan, Elizabeth Eckford arrived alone (Fig. **38.30**). The others followed, but were all turned away by the Guard. Nearly three weeks later, after a federal injunction ordered Faubus to remove the Guard, the nine finally entered Central High School. Little Rock citizens then launched a campaign of verbal abuse and intimidation to prevent the black students from remaining in school. Finally, President Eisenhower ordered 1,000 paratroopers and 10,000 National Guardsmen to Little Rock, and on September 25, Central High School was officially desegregated. Nevertheless, chaperoned throughout the year by the National Guard, the nine black students were spit at and reviled every day, and none of them returned to school the following year.

The momentum of the civil rights movement really began soon after, on December 1, 1955, when Rosa Parks (1913–2005) was arrested in Montgomery, Alabama, for refusing to move to the Negro section of a bus. Dr. Martin Luther King, then pastor of the Dexter Avenue Baptist Church in Montgomery, called for a boycott of the municipal bus system in protest. The boycott lasted over a year. In November 1956, the U.S. Supreme Court declared that the segregation of buses violated the Fourteenth Amendment. A federal injunction forced Montgomery officials to desegregate their buses, and Dr. King and a white minister rode side by side in the front seat of a city bus, setting the stage for a decade of liberation and change that reached across American society. ■

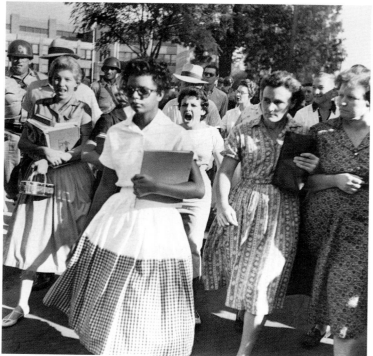

Fig. 38.30 One of the "Little Rock Nine," Elizabeth Eckford, braves a jeering crowd, September 4, 1957. Alone, as school opened in 1957, Elizabeth Eckford faced the taunts of the crowd defying the Supreme Court order to integrate Central High School in Little Rock, Arkansas. The image captures perfectly the hatred—and the determination—that the civil rights movement inspired.

THINKING BACK

What is existentialism?

After the war, Europe was gripped by a profound pessimism. The existential philosophy of Jean-Paul Sartre was a direct response. What did Sartre mean by the phrase "Existence precedes essence"? He agreed that the human condition is defined by alienation, anxiety, lack of authenticity, and a sense of nothingness, but he said that this did not abrogate the responsibility to act and create meaning. How did Sartre's lifelong companion, Simone de Beauvoir, extend Sartre's argument in *The Second Sex*? Others in Sartre's circle contributed to the existential movement. What existential virtue does Albert Camus's anti-hero Meursault, in *The Stranger*, possess? Sartre's own play *No Exit* and Samuel Beckett's *Waiting for Godot* are examples of the Theater of the Absurd. What are the characteristics of this brand of theater? In art, Alberto Giacometti's emaciated figures seemed to capture the human condition as trapped halfway between being and nothingness. Jean Dubuffet's *art brut*, "raw art," projected a condition of formlessness that reflected the disorder and chaos of the age.

What is Abstract Expressionism?

The unprecedented prosperity of the United States after the war included the introduction of new products and services and the mass adoption of television as the primary form of entertainment. A counternote of sincerity was struck by the Abstract Expressionists. How did they apply Sartre's theories to the act of painting? Jackson Pollock and Willem de Kooning inspired a generation of artists, including their own wives, to abandon representation in favor of directly expressing their emotions on the canvas in totally abstract terms. Color-field painters Mark Rothko and Helen Frankenthaler created more meditative spaces based on large expanses of undifferentiated color. The sculptors Alexander Calder and David Smith created dynamic works that, in the first instance, literally moved, and in the second, required the viewer to move around them.

Who are the Beats?

At the same time, the Beat generation, a younger, more rebellious generation of writers and artists, began to critique American culture. Swiss photographer Robert Frank's *The Americans* revealed a side of American life that outraged a public used to seeing the country through the lens of a happy optimism. Allen Ginsberg lashed out in his poem "Howl" with a forthright and uncensored frankness that seemed to many an affront to decency. What was the nature of the collaboration between composer John Cage, dancer Merce Cunningham, and artist Robert Rauschenberg? What characterizes Rauschenberg's combine paintings? What defines Cage's *4′33″* as music? What are the characteristics of Allan Kaprow's Happenings? In what ways do the American Beats reflect the existentialism of Jean-Paul Sartre?

In architecture, Mies van der Rohe, transplanted from the Bauhaus to Chicago, brought the International Style to America. Frank Lloyd Wright's Solomon R. Guggenheim Museum, however, is a conscious counterstatement to Mies van der Rohe's rationalist geometry, its organic forms echoing the natural world. To the Beats, the architecture of both represented all that was wrong with America. How would you explain their thinking?

What is Pop Art?

Pop Art reflected the commodification of culture and the marketplace as a dominant cultural force. In what terms did Andy Warhol compare Marilyn Monroe to Campbell's soup? How did Tom Wesselmann suggest that painting itself was a commodity? How did Roy Lichtenstein parody Abstract Expressionist painting? Claes Oldenburg created witty reproductions of American goods. How did he change them?

What is Minimalism in art?

Minimalism reduces art to almost total formality and abstraction in terms that at first seem diametrically opposed to Pop Art. But, in fact, Pop Art and Minimalist art have much in common. What values do they share? What differentiates them?

PRACTICE MORE Get flashcards for images and terms and review chapter material with quizzes at **www.myartslab.com**

GLOSSARY

Abstract Expressionism A style of painting practiced by American artists working during and after World War II.

action painting A term coined by critic Harold Rosenberg to reflect his understanding that the Abstract Expressionist canvas was "no longer a picture, but an event."

art brut Literally "raw art," any work unaffected by cultural convention.

atheistic existentialism A philosophy that argues that individuals must define the conditions of their own existence and choose to act ethically even in a world without God.

Beat generation The American poets, writers, and artists of the 1950s who sought a heightened and, they believed, more authentic style of life, defined by alienation, nonconformity, sexual liberation, drugs, and alcohol.

Christian existentialism A philosophy that argues that individuals must define the conditions of their own existence and that religion can provide a "unifying center" for that existence.

combine painting Work created by Robert Rauschenberg beginning in the mid-1950s that combines all manner of materials.

Happening A type of multimedia event in which artists and audience participate as equal partners.

mobile Alexander Calder's suspended sculpture, the movement of which is subject to the unpredictable currents of air.

Theater of the Absurd A theater in which the meaninglessness of existence is the central thematic concern.

READING

READING 38.4

from Samuel Beckett, *Waiting for Godot* (1953)

Beckett wrote Waiting for Godot *between early October 1948 and late January 1949. It was first produced in French in 1953 and in English in 1955. In many respects, the play radically changed theater because, as the following selection suggests, its stage directions are for all practical purposes as important as the actual dialogue. Thus, as Vladimir and Estragon wait for Godot in this scene from the beginning of Act II, contradictions of their interchange with one another are matched by the wide range of feelings Beckett demands of them in his stage directions.*

Enter Vladimir agitatedly. He halts and looks long at the tree, then suddenly begins to move feverishly about the stage. He halts before the boots, picks one up, examines it, sniffs it, manifests disgust, puts it back carefully. Comes and goes. Halts extreme right and gazes into distance off, shading his eyes with his hand. Comes and goes. Halts extreme left, as before. Comes and goes. Halts suddenly and begins to sing loudly.

VLADIMIR: A dog came in–
 Having begun too high he stops, clears his throat, resumes:
 A dog came in the kitchen 10
 And stole a crust of bread.
 Then cook up with a ladle
 And beat him till he was dead.

 Then all the dogs came running
 And dug the dog a tomb–
 He stops, broods, resumes:
 Then all the dogs came running
 And dug the dog a tomb
 And wrote upon the tombstone 20
 For the eyes of dogs to come:

 A dog came in the kitchen
 And stole a crust of bread.
 Then cook up with a ladle
 And beat him till he was dead.

 Then all the dogs came running
 And dug the dog a tomb–
 He stops, broods, resumes:
 Then all the dogs came running
 And dug the dog a tomb– 30
 He stops, broods. Softly.
 And dug the dog a tomb . . .

He remains a moment silent and motionless, then begins to move feverishly about the stage. He halts before the tree, comes and goes, before the boots, comes and goes, halts extreme right, gazes into distance, extreme left, gazes into distance. Enter Estragon right, barefoot, head bowed. He slowly crosses the stage. Vladimir turns and sees him.

VLADIMIR: You again! (*Estragon halts but does not raise his head. Vladimir goes towards him.*) Come here till I embrace you.

ESTRAGON: Don't touch me! 40

Vladimir holds back, pained.

VLADIMIR: Do you want me to go away? (*Pause.*) Gogo! (*Pause. Vladimir observes him attentively.*) Did they beat you? (*Pause.*) Gogo! (*Estragon remains silent, head bowed.*) Where did you spend the night?

ESTRAGON: Don't touch me! Don't question me! Don't speak to me! Stay with me!

VLADIMIR: Did I ever leave you?

ESTRAGON: You let me go.

VLADIMIR: Look at me. (*Estragon does not raise his head. Vio-* 50 *lently.*) Will you look at me!

Estragon raises his head. They look long at each other, then suddenly embrace, clapping each other on the back. End of the embrace. Estragon, no longer supported, almost falls.

ESTRAGON: What a day!

VLADIMIR: Who beat you? Tell me.

ESTRAGON: Another day done with.

VLADIMIR: Not yet.

ESTRAGON: For me it's over and done with, no matter what happens. (*Silence.*) I heard you singing. 60

VLADIMIR: That's right, I remember.

ESTRAGON: That finished me. I said to myself, He's all alone, he thinks I'm gone for ever, and he sings.

VLADIMIR: One is not master of one's moods. All day I've felt in great form. (*Pause.*) I didn't get up in the night, not once!

ESTRAGON: (*sadly*). You see, you piss better when I'm not there.

VLADIMIR: I missed you . . . and at the same time I was happy. Isn't that a strange thing?

ESTRAGON: (*shocked*). Happy?

VLADIMIR: Perhaps it's not quite the right word. 70

ESTRAGON: And now?

VLADIMIR: Now? . . . (*Joyous.*) There you are again . . . (*Indifferent.*) There we are again. . . (*Gloomy.*) There I am again.

ESTRAGON: You see, you feel worse when I'm with you. I feel better alone too.

VLADIMIR: (*Vexed*). Then why do you always come crawling back?

ESTRAGON: I don't know.

VLADIMIR: No, but I do. It's because you don't know how to defend yourself. I wouldn't have let them beat you. 80

ESTRAGON: You couldn't have stopped them.

VLADIMIR: Why not?

ESTRAGON: There was ten of them.

VLADIMIR: No, I mean before they beat you. I would have stopped you from doing whatever it was you were doing.

ESTRAGON: I wasn't doing anything.

VLADIMIR: Then why did they beat you?

ESTRAGON: I don't know.

VLADIMIR: Ah no, Gogo, the truth is there are things that escape you that don't escape me, you must feel it yourself. 90

ESTRAGON: I tell you I wasn't doing anything.

VLADIMIR: Perhaps you weren't. But it's the way of doing it that counts, the way of doing it, if you want to go on living.

ESTRAGON: I wasn't doing anything.

VLADIMIR: You must be happy too, deep down, if you only knew it.

ESTRAGON: Happy about what?

VLADIMIR: To be back with me again.

ESTRAGON: Would you say so?

VLADIMIR: Say you are, even if it's not true. 100

ESTRAGON: What am I to say?

VLADIMIR: Say, I am happy.

ESTRAGON: I am happy.

VLADIMIR: So am I.

ESTRAGON: So am I.

VLADIMIR: We are happy.

ESTRAGON: We are happy. (*Silence.*) What do we do now, now that we are happy?

VLADIMIR: Wait for Godot. (*Estragon groans. Silence.*) Things have changed here since yesterday. 110

ESTRAGON: And if he doesn't come?

VLADIMIR: (*after a moment of bewilderment*). We'll see when the time comes.

READING CRITICALLY

How does Beckett convey a sense of the absurd through his treatment of happiness in this passage?

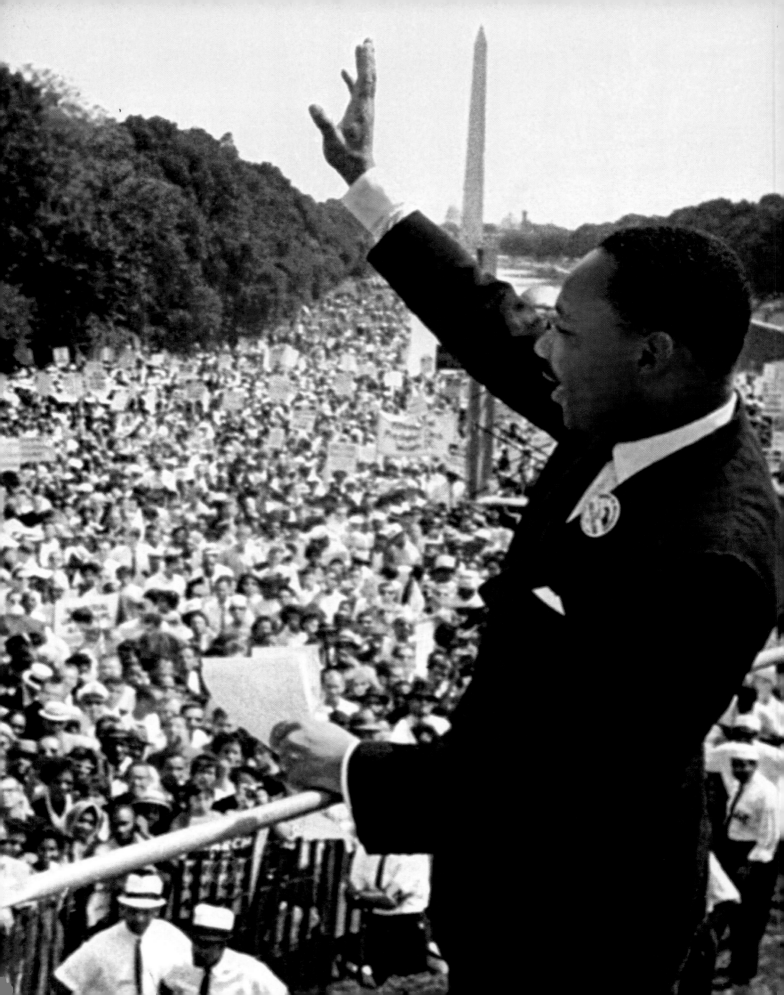

Multiplicity and Diversity

Cultures of Liberation and Identity in the 1960s and 1970s

THINKING AHEAD

What factors contributed to changes in African-American self-definition in the 1960s?

How did artists respond to the Vietnam War?

How did "high" culture and "popular" culture coexist in the musical world?

How did the feminist movement find expression in the arts?

How did male self-definition come into question?

By April 1963, the focus of the civil rights movement that had begun with Rosa Parks and the Little Rock Nine had shifted to Birmingham, Alabama (Map **39.1**). In protest over desegregation orders, the city had closed its parks and public golf courses. In retaliation, the black community called for a boycott of Birmingham stores. The city responded by halting the distribution of food normally given to the city's needy families. In this progressively more heated atmosphere, the Southern Christian Leadership Conference (SCLC), led by the Reverend Martin Luther King, Jr. (1929–1968), decided Birmingham would be their battlefield. Just a few months later, King would deliver his famous "I Have a Dream" speech to a crowd of more than 200,000 people from the steps of the Lincoln Memorial in Washington, D.C. (Fig. **39.1**). But in the spring of 1963, King led groups of protesters, gathering first at local churches, who descended on the city's downtown both to picket businesses that continued to maintain "separate but equal" practices, such as different fitting rooms for blacks and whites in clothing stores, and to take seats at

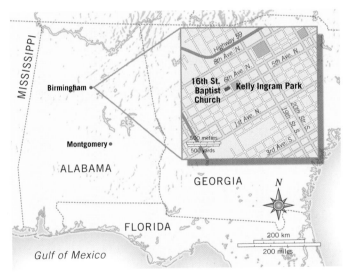

Map 39.1 The city of Birmingham, Alabama.

◀ **Fig. 39.1 August 28, 1963: American minister and civil rights leader Dr. Martin Luther King, Jr., waves to the crowd of more than 200,000 people gathered on the Mall during the March on Washington after delivering his "I Have a Dream" speech, Washington, D.C.** Photo by Hulton Archive/Getty Images.

HEAR MORE Listen to an audio file of your chapter at **www.myartslab.com**

"whites-only" lunch counters. The city's police chief, Bull Connor, responded by threatening to arrest anyone marching on the downtown area. On April 6, 50 marchers were arrested. The next day, 600 marchers gathered, and police confronted them with clubs, attack dogs, and the fire department's new water hoses, which, they bragged, could rip the bark off a tree. But day after day, the marchers kept coming, their ranks swelling. A local judge issued an injunction banning the marches, but on April 12, King led a march of 50 people in defiance of the injunction. Crowds gathered in anticipation of King's arrest, and, in fact, he was quickly taken into custody and placed in solitary confinement in the Birmingham jail.

From jail, King dispatched a letter to a group of local white clergy who had publicly criticized him for willfully breaking the law and promoting demonstrations. Published in June 1963 in *The Christian Century*, what came to be known as the "Letter from Birmingham Jail" became the key text in the civil rights movement, providing the philosophical framework for the massive civil disobedience that King believed was required (**Reading 39.1**):

READING 39.1

from Martin Luther King, "Letter from Birmingham Jail" (1963)

You express a great deal of anxiety over our willingness to break laws . . . [but] there are two types of laws. There are just laws and there are unjust laws. One has not only a legal but a moral responsibility to obey just laws. Conversely, one has a moral responsibility to disobey unjust laws. . . . We can never forget that everything Hitler did in Germany was "legal" and everything the Hungarian freedom fighters did in Hungary was "illegal." It was "illegal" to aid and comfort a Jew in Hitler's Germany.

In the days between King's incarceration and the letter's publication, the situation in Birmingham had worsened. A local disc jockey urged the city's African-American youth to attend a "big party" at Kelly Ingram Park, across from the 16th Street Baptist Church (see Map 39.1). It was no secret that the "party" was to be a mass demonstration. At least 1,000 youth gathered, most of them teenagers but some as young as seven or eight years old. As the chant of "Freedom, freedom *now!*" rose from the crowd, the Birmingham police closed in with their dogs, ordering them to attack those who did not flee.

Police wagons and squad cars were quickly filled with arrested juveniles, and as the arrests continued, the police used school buses to transport over 600 children and teenagers to jail. By the next day, the entire nation—in fact, the entire world—had come to know Birmingham Police Chief Bull Connor, as televised images documented his dogs attacking children and his fire hoses literally washing them down the streets.

The youth returned, with reinforcements, over the next few days. By May 6, over 2,000 demonstrators were in jail, and police patrol cars were pummeled with rocks and bottles whenever they entered black neighborhoods. As the crisis mounted, secret negotiations between the city and the protestors resulted in change: Within 90 days, all lunch counters, restrooms, department-store fitting rooms, and drinking fountains would be open to all, black and white alike. The 2,000 people under arrest would be released.

It was a victory, but Birmingham remained uneasy. On Sunday, September 15, a dynamite bomb exploded in the basement of the 16th Street Baptist Church, a center for many civil rights rallies and meetings, killing four girls—one 11-year-old and three 14-year-olds. As news of the tragedy spread, riots and fires broke out throughout the city and two more teenagers were killed.

The tragedy drew many moderate whites into the civil rights movement. Popular culture had put them at the ready. In June 1963, the folk-rock trio Peter, Paul, and Mary released "Blowin' in the Wind," their version of the song that Bob Dylan (1941–) had written in April 1962. The Peter, Paul, and Mary record sold 300,000 copies in two weeks. The song famously ends:

How many years can some people exist,
Before they're allowed to be free?
How many times can a man turn his head,
Pretending he just doesn't see?
The answer, my friend, is blowin' in the wind,
The answer is blowin' in the wind.

At the March on Washington later that summer—an event organized by the same A. Philip Randolph who had conceived of a similar event over 20 years earlier, this time to promote passage of the Civil Rights Act—Peter, Paul, and Mary performed the song live before 250,000 people, the largest gathering of its kind to that point in the history of the United States. Not many minutes later, Martin Luther King delivered his famous "I Have a Dream" speech to the same crowd. The trio's album, *In the Wind*, released in October, quickly rose to number one on the charts. The winds of change were blowing across the country.

The civil rights movement that was ignited in Birmingham was just one manifestation of a growing dissatisfaction in America—and abroad—with the status quo, especially among a younger generation that had not experienced the hardships of the Great Depression and the horrors of the Second World War. African-American artist Faith Ringgold (1934–) captures something of the dynamics of this dissatisfaction in her 1964 painting *God Bless America* (Fig. **39.2**). The blue-eyed white woman portrayed in the painting, hand over her heart as she hears the same Irving Berlin song that a generation earlier Woody Guthrie had found jingoistic and elitist (see Chapter 37), embodies the status quo of blind patriotism. But this same woman, the image implies, is also a racist, as on

Fig. 39.2 Faith Ringgold, *God Bless America*. 1964. Oil on canvas, 31″ × 19″. © Faith Ringgold, 1964. This is one of a series of 20 paintings done between 1963 and 1967 called *The American People*, focusing on racial conflict and discrimination.

the right side of the painting, the stripes of the flag are transformed into the black bars of a jail cell and the star of the flag, by implication, into a sheriff's badge. This is an image painted by a 30-year-old woman challenging the worldview of an older generation—and not without a sense of righteous indignation.

That challenge is the subject of this chapter. It manifested itself not only in the civil rights movement, but in the anti–Vietnam War movement and in the burgeoning feminist movement, and in student unrest both in the United States and abroad, and it finds particularly powerful expression in popular music, epitomized by Bob Dylan's 1964 anthem "The Times They Are A-Changin'." It manifested itself in ways that, in retrospect, seem slightly ridiculous—in the way, for instance, that long hair, on young males especially, signified to their elders a rejection of traditional values. But it manifested itself in other ways that have had a profound impact on American culture ever since—in, for instance, the 1973 Supreme Court decision

Roe v. Wade that legalized abortion. This challenge to traditional values found a sympathetic audience in the arts, which, after all, had been challenging the authority of tradition since at least Picasso. But as never before, except perhaps in Berlin as Hitler rose to power (see Chapter 37), did the arts so overtly engage in social critique.

The 1960s—a decade whose spirit extends well into the 1970s, until the end of the Vietnam War in 1975—was an era with many centers. New York was the center of the art world; Birmingham of the civil rights movement; Berkeley, California, of the student movement. Women began to question their central role as homemakers. And while Washington, D.C. was the center of government, it was being torn apart, as marchers filled its streets in protest and an embattled president was forced to resign before he could be impeached. Without a well-defined center—geographic or otherwise—the nation seemed to many unmoored and adrift, "blowing in the wind."

BLACK IDENTITY

It is probably fair to say that an important factor contributing to the civil rights movement was the growing sense of ethnic identity among the African-American population. Its origins can be traced back to the Harlem Renaissance (see Chapter 36), but throughout the 1940s and 1950s, a growing sense of cultural self-awareness and self-definition was taking hold, even though African Americans did not share in the growing wealth and sense of well-being that marked postwar American culture.

Sartre's "Black Orpheus" One of the most important contributions to this development was existentialism, with its emphasis on the inevitability of human suffering and the necessity for the individual to act responsibly in the face of that predicament. Jean-Paul Sartre's 1948 essay "Orphée Noir" [or-FAY nwahr], or "Black Orpheus," was especially influential. The essay defined "blackness" as a mark of authenticity:

> A Jew, a white among whites, can deny that he is a Jew, declaring himself a man among men. The black cannot deny that he is black nor claim for himself an abstract, colorless humanity: he is black. Thus he is driven to authenticity: insulted, enslaved, he raises himself up. He picks up the word "black" ["Négre"] that they had thrown at him like a stone, he asserts his blackness, facing the white man, with pride.

If, like the Jews, blacks had undergone a shattering diaspora [die-AS-por-uh], or dispersion, across the globe, traces of the original African roots were evident in everything from American blues and jazz to the African-derived religious and ritual practices of the Caribbean that survived as Vodun, Santeria, and Condomblé. For Sartre, these were "Orphic" voices, which like master musician and poet Orpheus of Greek legend, who descended into Hades [HAY-deez] to

Fig. 39.3 Wifredo Lam (Cuban, b. Sagua la Grande, 1902–1982), *The Siren of the Niger.* **1950.** Oil and charcoal on canvas, 51″ × 38 ¹/₈″ (129.5 × 96.8 cm). Signed LR in Oil: Wifredo Lam/1950. Hirshhorn Museum and Sculpture Garden, Smithsonian Institution, Gift of Joseph H. Hirshhorn, 1972. © 2009 Artists Rights Society (ARS), New York/DACS. Lam arrived in Paris in 1938 with a letter of introduction to Picasso, who both befriended him and influenced his work.

rescue his beloved Eurydice [yoo-RID-ih-see], had descended into the "black substratum" of their African heritage to discover an authentic—and revolutionary—voice. In works like *The Siren of the Niger* (Fig. **39.3**), Wifredo Lam, a Cuban-born artist of African, Chinese, and European descent, evokes the Orphic voice of Africa, the fertile wellspring of inspiration and creativity. Similarly, the black American writer James Baldwin (1924–1987) would describe the power of the blues in his 1957 short story, "Sonny's Blues." Playing the jazz standard "Am I Blue," the band "began to tell us what the blues were all about," Baldwin writes:

> They were not about anything very new. He and his boys up there were keeping it new, at the risk of ruin, destruction, madness and death, in order to find new ways to make us listen. For, while the tale of how we suffer, and how we are delighted, and how we may triumph is never new, it must always be heard. There isn't any other tale to tell, it's the only light we've got in all this darkness.

Ralph Ellison's *Invisible Man* Baldwin was, in fact, one of the most influential writers of his generation. *Go Tell It on the Mountain* (1953) and *Notes of a Native Son* (1955), the first a semi-autobiographical account of growing up in

Harlem and the second a collection of deeply personal essays on race, won him great praise. But probably more instrumental in introducing existentialist attitudes to an American audience was the novel *Invisible Man*, published in 1952 by Ralph Waldo Ellison (1913–1984) and written over a period of about seven years in the late 1940s and early 1950s. In part, the novel is an ironic reversal of the famous trope of Ellison's namesake, Ralph Waldo Emerson, in his essay "Nature" (see Chapter 27): "I become a transparent eye-ball. I am nothing. I see all. . . ." "I am an invisible man," Ellison's prologue to the novel begins (**Reading 39.2a**):

READING 39.2a

from Ralph Ellison, *Invisible Man* **(1952)**

No, I am not a spook like those who haunted Edgar Allan Poe; nor am I one of your Hollywood-movie ectoplasms. I am a man of substance, of flesh and bone, fiber and liquid—and I might even be said to possess a mind. I am invisible—understand, simply because people refuse to see me. . . . That invisibility to which I refer occurs because of a peculiar disposition of the eyes of those with whom I come in contact. A matter of the construction of their inner eyes, those eyes with which they look through their physical eyes upon reality.

Ellison's story is told by a narrator who lives in a subterranean "hole" in a cellar at the edge of Harlem into which he has accidentally fallen in the riot that ends the novel (Fig. **39.4**). As "underground man," his self-appointed task is to realize, in the narrative he is writing (the novel itself), the realities of black American life and experience. At the crucial turning point of the novel, after seeing three boys in the subway, dressed in "well-pressed, too-hot-for-summer suits. . . . walking slowly, their shoulders swaying, their legs swinging from their hips in trousers that ballooned from cuffs fitting snug about their ankles; their coats long and hip-tight with shoulders far too broad to be those of natural western men," he muses (**Reading 39.2b**):

READING 39.2b

from Ralph Ellison, *Invisible Man* **(1952)**

Moving through the crowds along 125th Street, I was painfully aware of other men dressed like the boys, and of girls in dark exotic-colored stockings, their costumes surreal variations of downtown styles. They'd been there all along, but somehow I'd missed them. . . . They were outside the groove of history, and it was my job to get them in, all of them. I looked into the design of their faces, hardly a one that was unlike someone I'd known down South. Forgotten names sang through my head like forgotten scenes in dreams. I moved through the crowd, the sweat pouring off me, listening to the grinding roar of traffic, the growing sound of a record shop

Fig. 39.4 Jeff Wall, *After* Invisible Man *by Ralph Ellison, "The Preface," Edition of 2.* 1999–2000.
Cibachrome transparency, aluminum light box, fluorescent bulbs, 75 ¼″ × 106 ¼″ × 10 ¼″. Marian Goodman Gallery, New York. In his photographic re-creation of the setting of Ellison's novel, Wall emphasizes, as does the novel, the 1,269 light bulbs in the room, all illegally connected to the electricity grid. "I love light," Ellison writes, "perhaps you'll think it strange that an invisible man should need light, desire light, love light. But it is precisely because I am invisible. Light confirms my reality, gives birth to my form." Wall recognizes in these words a definition of photography as well.

loudspeaker blaring a languid blues. I stopped. Was this all that would be recorded? Was this the only true history of the times, a mood blared by trumpets, trombones, saxophones and drums, a song with turgid, inadequate words?

The blues is not enough. His new self-appointed task is to take the responsibility to find words adequate to the history of the times. Up to this point, his own people have been as invisible to him as he to them. He has opened his own eyes as he must now open others'. At the novel's end, he is determined to come out of his "hole." "I'm shaking off the old skin," he says, "and I'll leave it here in the hole. I'm coming out, no less invisible without it, but coming out nevertheless. And I suppose it's damn well time. . . . Perhaps that's my greatest social crime, I've overstayed my hibernation, since there's a possibility that even an invisible man has a socially responsible role to play."

Asserting Blackness in Art and Literature One of Ellison's narrator's most vital realizations is that he must, above all else, assert his blackness instead of hiding from it. He must not allow himself to be absorbed into white society. "Must I strive toward colorlessness?" he asks.

But seriously, and without snobbery, think of what the world would lose if that should happen. America is woven of many strands; I would recognize them and let it so remain. . . . Our fate is to become one, and yet many—This is not prophecy, but description.

There could be no better description of the collages of Romare Bearden (1911–1988), who had worked for two decades in an almost entirely abstract vein, but who in the early 1960s began to tear images out of *Ebony*, *Look*, and *Life* magazines and assemble them into depictions of

Fig. 39.5 Romare Bearden (1914–1988), *The Dove*. 1964. Cut-and-pasted photoreproductions and papers, gouache, pencil and colored pencil on cardboard, 13 3/8″ × 18 3/4″. Blanchette Rockefeller Fund. (377.1971). The Museum of Modern Art/Licensed by SCALA/Art Resource, New York. Art © Estate of Romare Bearden/Licensed by VAGA, NY. The white dog at the lower left appears to be stalking the black cat at the foot of the steps in the middle, in counterpoint to the dove above the door.

LEARN MORE Gain insight from a primary source document from Romare Bearden at **www.myartslab.com**

black experience. *The Dove* (Fig. **39.5**)—named for the white dove that is perched over the central door, a symbol of peace and harmony—combines forms of shifting scale and different orders of fragmentation. For example, a giant cigarette extends from the hand of the dandy, sporting a cap, at the right, and the giant fingers of a woman's hand reach over the windowsill at the top left. The resulting effect is almost kaleidoscopic, an urban panorama of a conservatively dressed older generation and hipper, younger people gathered into a scene nearly bursting with energy—the "one, and yet many." As Ellison wrote of Bearden's art in 1968:

> Bearden's meaning is identical with his method. His combination of technique is in itself eloquent of the sharp breaks, leaps of consciousness, distortions, paradoxes, reversals, telescoping of time and surreal blending of styles, values, hopes, and dreams which characterize much of [African] American history.

The sense of a single black American identity, one containing the diversity of black culture within it that Bearden's work embodies, is also found in the work of poet and playwright Amiri Baraka [buh-RAH-kuh] (1934–). Baraka changed his name from Leroi Jones in 1968 after the assassination of the radical black Muslim minister Malcolm X in 1965. Malcolm X believed that blacks should separate themselves from whites in every conceivable way, that they should give up integration as a goal and create their own black nation. As opposed to Martin Luther King, who advocated nonviolent protest, Malcolm advocated violent action if necessary: "How are you going to be nonviolent in Mississippi," he asked a Detroit audience in 1963, "as violent as you were in Korea? How can you justify being nonviolent in Mississippi and Alabama, when your churches are being bombed, and your little girls are being murdered? . . . If violence is wrong in America, violence is wrong abroad."

Baraka's chosen Muslim name, Imamu Amiri Baraka, refers to the divine blessing associated with Muslim holy men that can be transferred from a material object to a person, so that a pilgrim returning from Mecca is a carrier of *baraka*. Baraka's 1969 poem, "Ka'Ba" [KAH-buh], seeks to

imbue *baraka* upon the people of Newark, New Jersey, where Baraka lived (**Reading 39.3**):

READING 39.3

Amiri Baraka, "Ka'Ba" (1969)

A closed window looks down
on a dirty courtyard, and Black people
call across or scream across or walk across
defying physics in the stream of their will.

Our world is full of sound
Our world is more lovely than anyone's
tho we suffer, and kill each other
and sometimes fail to walk the air.

We are beautiful people
With African imaginations
full of masks and dances and swelling chants
with African eyes, and noses, and arms
tho we sprawl in gray chains in a place
full of winters, when what we want is sun.

We have been captured,
and we labor to make our getaway, into
the ancient image; into a new

Correspondence with ourselves
and our Black family. We need magic
now we need the spells, to raise up
return, destroy, and create. What will be

the sacred word?

The sacred word, the poem's title suggests, is indeed "Ka'Ba." But, despite the spiritual tone of this poem, Baraka became increasingly militant during the 1960s. In 1967, he produced two of his own plays protesting police brutality. A year later, in his play *Home on the Range*, his protagonist Criminal breaks into a white family's home only to find them so immersed in television that he cannot communicate with them. The play was performed as a benefit for the leaders of the Black Panther party, a black revolutionary political party founded in 1966 by Huey P. Newton (1942–1989) and Bobby Seale (1936–) and dedicated to organizing support for a socialist revolution.

Other events, too, reflected the growing militancy of the African-American community. In August 1965, violent riots in the Watts district of South Central Los Angeles lasted for six days, leaving 34 dead, over 1,000 people injured, nearly 4,000 arrested, and hundreds of buildings destroyed. In July 1967, rioting broke out in both Newark and Detroit. In Newark, six days of rioting left 23 dead, over 700 injured, and close to 1,500 people arrested. In Detroit, five days of rioting resulted in 43 people dead, 1,189 injured, over 7,000 people arrested, and 2,509 stores looted or burned. Finally, it seemed to many that Martin Luther King's pacifism had

come back to haunt him when he was assassinated on April 4, 1968.

It was directly out of this climate that the popular poetry/music/performance/dance phenomenon known as rap, or hip-hop, came into being. Shortly after the death of Martin Luther King, on Malcolm X's birthday, May 19, 1968, David Nelson, Gylan Kain, and Abiodun Oyewole founded the group the Last Poets, named after a poem by South African poet Willie Kgositsile (1938–) in which he had claimed that it would soon be necessary to put poetry aside and take up guns in the looming revolution. "Therefore we are the last poets of the world," Kgositsile concluded. In performance, the Last Poets were deeply influenced by the musical phrasings of Amiri Baraka's poetry. They improvised individually, trading words and phrases back and forth like jazz musicians improvising on each other's melodies, until their voices would come together in a rhythmic chant and the number would end. Most of all, they were political, attacking white racism, black bourgeois complacency, the government and the police, whoever seemed to stand in the way of significant progress for African Americans. As Abiodun Oyewole put it, "We were angry, and we had something to say."

Equally influential was performer Gil Scott-Heron, whose recorded poem "The Revolution Will Not Be Televised" appeared on his 1970 album *Small Talk at 125th and Lenox* (**Reading 39.4**):

READING 39.4

from Gil Scott-Heron, "The Revolution Will Not Be Televised" (1970)

You will not be able to stay home, brother.
You will not be able to plug in, turn on and cop out.[1]
You will not be able to lose yourself on skag[2] and
skip out for beer during commercials because
The revolution will not be televised.

The revolution will not be televised.
The revolution will not be brought to you by Xerox
 in 4 parts without commercial interruptions. . . .
There will be no highlights on the Eleven O'clock News
and no pictures of hairy armed women liberationists
and Jackie Onassis blowing her nose.
The theme song will not be written by Jim Webb or
 Francis Scott Key,
nor sung by Glen Campbell, Tom Jones, Johnny Cash,
Englebert Humperdink, or Rare Earth.
The revolution will not be televised.

[1]**turn on and cop out:** A play on the motto of Timothy Leary (1920–1996), advocate and popularizer of the psychedelic drug LSD, who in the 1960s urged people to "turn on, tune in, drop out."
[2]**skag:** Slang for heroin.

> The revolution will not be right back after a message
> about a white tornado, white lightning or white people.
> You will not have to worry about a dove in your
> bedroom,
> a tiger in your tank, or the giant in your toilet bowl.
> The revolution will not go better with coke.
> The revolution will not fight the germs that may cause
> bad breath.
> The revolution *will* put you in the driver's seat.
> The revolution will not be televised,
> will not be televised,
> not be televised,
> be televised.
> The revolution will be no re-run, brothers;
> The revolution will be LIVE.

As the next section of this chapter underscores, as angry as Scott-Heron's poem is, the poet's attitude toward American popular culture, which he strongly condemns, is closely aligned with that of Pop artists of the 1960s as well (see Chapter 38).

THE VIETNAM WAR: REBELLION AND THE ARTS

Even as the civil rights movement took hold, the Cold War tensions with the Soviet Union were increasingly exacerbated by the United States' involvement in the war in Vietnam. By the mid-1960s, fighting between the North Vietnamese Communists led by Ho Chi Minh and the pro-Western and former French colony of South Vietnam (see Chapter 37) had led to a massive troop buildup of American forces in the region, fueled by a military draft that alienated many American youth, the population of 15- to 24-year-olds that over the course of the 1960s increased from 24.5 million to 36 million.

Across the country, the spirit of rebellion that fueled the civil rights movement took hold on college campuses and in the burgeoning antiwar community. Events at the University of California at Berkeley served to link, in the minds of many, the antiwar movement and the fight for civil rights. In 1964, the university administration tried to stop students from recruiting and raising funds on campus for two groups dedicated to ending racial discrimination. Protesting the administration's restrictions, a group of students organized the Free Speech Movement, which initiated a series of rallies, sit-ins, and student strikes at Berkeley. The administration backed down, and the Berkeley students' tactics were quickly adapted by groups in the antiwar movement, which focused on removing the Reserve Officers' Training Corps from college campuses and helped to organize antiwar marches, teach-ins, and rallies across the country. By 1969, feelings reached a fever pitch, as over a half million protesters, adopting the tactics of the civil rights movement in 1963, marched on Washington.

Kurt Vonnegut's *Slaughterhouse-Five*

Antiwar sentiment was reflected in the arts in works primarily about earlier wars, World War II and Korea, as if it were impossible to deal directly with events in Southeast Asia, which could be seen each night on the evening news. Joseph Heller's novel *Catch-22* was widely read, and the Robert Altman (1925–2006) film *M*A*S*H*, a smash-hit satiric comedy about the 4077th Mobile Army Surgical Hospital in Korea, opened in 1970 and spawned an 11-year-long television series that premiered in 1972. But perhaps the most acclaimed antiwar work was the 1969 novel *Slaughterhouse-Five* by Kurt Vonnegut [VON-uh-gut] (1922–2007). It is the oddly narrated story of ex–World War II GI Billy Pilgrim, a survivor, like Vonnegut himself, of the Allied fire-bombing of Dresden [DREZ-den] (where 135,000 German civilians were killed, more than at Hiroshima and Nagasaki combined). Pilgrim claims to have been abducted by extraterrestrial aliens from the planet of Trafalmadore. At the beginning of the book, the narrator (more or less, Vonnegut himself) is talking with a friend about the war novel he is about to write (*Slaughterhouse-Five*), when the friend's wife interrupts (**Reading 39.5**):

READING 39.5

from Kurt Vonnegut, *Slaughterhouse-Five* (1969)

"You'll pretend that you were men instead of babies, and you'll be played in the movies by . . . John Wayne. . . . And war will look just wonderful, so we'll have a lot more of them. And they'll be fought by babies. . . ." She didn't want her babies or anyone else's babies killed in wars. And she thought wars were partly encouraged by books and movies.

In response, Vonnegut creates, in Pilgrim, the most innocent of heroes, and subtitles his novel: *The Children's Crusade: A Duty-Dance with Death*. Pilgrim's reaction to the death he sees everywhere—"So it goes"—became a mantra for the generation that came of age in the late 1960s. The novel's fatalism mirrored the sense of pointlessness and arbitrariness that so many felt in the face of the Vietnam War.

Artists Against the War

In the minds of many, the Vietnam War was symptomatic of a more general cultural malaise for which the culture of consumption, the growing dominance of mass media, and the military-industrial complex were all responsible. Among many others, Pop artist James Rosenquist explicitly

tied the American military to American consumer culture (see *Closer Look*, pages 1290–1291).

The establishment itself, especially as embodied by university administrations and their boards of trustees, was often the target of protests. Just such a work was Pop artist Claes Oldenburg's *Lipstick (Ascending) on Caterpillar Tracks* (Fig. **39.6**). The work was pulled into a central square at Yale University, Oldenburg's alma mater, in the fall of 1969 to stand in front of a World War I monument inscribed with the words "In Memory of the Men of Yale who True to her Traditions Gave their Lives that Freedom Might not Perish from the Earth." In Oldenburg's typically audacious way, the piece consists of a three-story-high inflatable lipstick tube mounted on tank-like caterpillar treads. At once a missile-shaped phallic symbol and a wry commentary on the fact that Yale had admitted women to the university for the first time that fall, it was commissioned by the university's architecture graduate students as an antiwar demonstration. Yale authorities were not amused, and had the

piece removed before convocation (though it was subsequently reinstalled on campus in 1974).

By the fall of 1969, many other artists had organized in opposition to the war. In a speech at an opening hearing that led to the creation of the antiwar Art Workers' Coalition, art critic and editor Gregory Battcock outlined how the art world was complicit in the war effort:

> The trustees of the museums direct NBC and CBS, The New York Times, and the Associated Press, and that greatest cultural travesty of modern times—the Lincoln Center. They own AT&T, Ford, General Motors, the great multi-billion dollar foundations, Columbia University, Alcoa, Minnesota Mining, United Fruit, and AMK, besides sitting on the boards of each other's museums. The implications of these facts are enormous. Do you realize that it is those art-loving, culturally committed trustees of the Metropolitan and the Modern museums who are waging the war in Vietnam?

For Pop artist James Rosenquist (1933–) the society of the spectacle is above all a society of billboards, which, in fact, he once painted for a living. "Painting," he says, "is probably much more exciting than advertising, so why shouldn't it be done with that power and gusto, with that impact?" The mammoth *F-111* possesses precisely the impact Rosenquist was seeking.

The painting was specifically designed as a wraparound work, like Monet's *Water Lilies* murals (see Chapter 33), for Rosenquist's first solo exhibition at the Leo Castelli Gallery in New York, where it filled all four walls of the space. It depicts an F-111 fighter bomber at actual scale, "flying," in

Rosenquist's words, "through the flack of an economy." In 1964, when Rosenquist was at work on the piece, the F-111, although still in its planning stages, was understood to be obsolete. Nevertheless, production continued on it, by and large to keep those working on it employed and General Dynamics, the company responsible for it, afloat. In his farewell address to the nation in January 1961, President Dwight David Eisenhower (1890–1969) had warned: "This conjunction of an immense military establishment and a large arms industry is new in the American experience. The total influence—economic, political, even spiritual—is felt in every city, every statehouse, every office

SEE MORE For a Closer Look at James Rosenquist's *F-111*, go to **www.myartslab.com**

James Rosenquist (b. 1933), *F-111*. 1964–65. Oil on canvas with aluminum, 10′ × 86′ overall. Purchase Gift of Mr. and Mrs. Alex L. Hillman and Lillie P. Bliss Bequest (both by exchange). (00473.96.a-w). Digital Image © The Museum of Modern Art/Licensed by SCALA/Art Resource, NY. © Art James Rosenquist/VAGA Visual Artists Galleries & Association, NY.

The aluminum panels on this end of the painting would have met up with the strip of aluminum panels at the other end of the painting when installed around the four walls of a gallery. They not only evoke industry, but their reflective quality incorporates viewers into the painting's space, implicating them in the artist's critique of American culture. The scale of the painting makes it impossible to take it all in at once; viewers are always aware that there is more work in their peripheral vision. "I'm interested in contemporary vision," Rosenquist has explained, "the flick of chrome, reflections, rapid associations, quick flashes of light. Bing-bang! Bing-bang!"

The Italian flowered wallpaper, according to Rosenquist, "had to do with atomic fallout."

A runner's hurdle is meant to evoke the arms race.

The Firestone tire, according to Rosenquist, resembles a "crown," becoming a symbol of the supremacy and power of corporate America, the military-industrial complex that Eisenhower warned against. By emphasizing the tire's tread, Rosenquist focuses our attention on the sense of safety that corporate America claimed to provide consumers.

The angel food cake is decorated, stadiumlike, with little pennants listing food additives such as riboflavin and Vitamin D. One even boasts "Food Energy." The chemical manipulation of food is Rosenquist's target here, together with the lack of any real food value in sugar-laden "angel" food.

The three light bulbs can probably best be explained by a comment Rosenquist made in an interview in the *Partisan Review* in 1965: "All the ideas in the whole picture are very divergent, but I think they all seem to go toward some basic meaning . . . [toward] some blinding light, like a bug hitting a light bulb." They also evoke consumer culture and corporations like General Electric or Westinghouse that were also major defense contractors.

Rosenquist's *F-111*

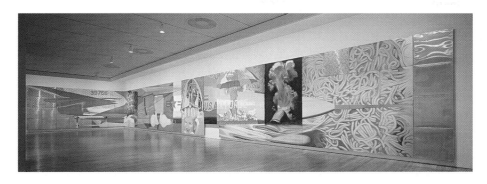

of the federal government. . . . In the councils of government, we must guard against the acquisition of unwarranted influence, whether sought or unsought, by the military-industrial complex. The potential for the disastrous rise of misplaced power exists and will persist." It is precisely this military-industrial complex and its pervasiveness throughout American consumer culture that Rosenquist's painting addresses. As the Vietnam War escalated, and the painting traveled to eight museums in Europe, the painting became more generally associated with the antiwar movement. It returned to the United States in 1968, and remains on display at New York's Museum of Modern Art.

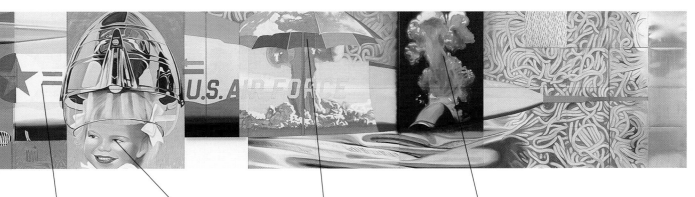

The bars of the Air Force logo, on each side of the hairdryer, function like equal signs in the picture.

"The little girl," Rosenquist says, "was the pilot under a hairdryer." She is also a figure, he says, for "a generation removed, the post-Beat young people. They're not afraid of atomic war and think that sort of attitude is passé, that it won't occur." Thus she smiles happily, her face turned away from the mushroom cloud behind her. She also represents consumer economy, the idea of female beauty, and female passivity in general—the opposite of the phallic jet fighter.

The umbrella, like the Italian flowered wallpaper, is meant to suggest both the defense umbrella of national security and atomic fallout, from which it offers no real protection.

"The swimmer gulping air," Rosenquist explains, "was like searching for air during an atomic holocaust." Visually it echoes the atomic mushroom cloud to its left.

A plate of Franco-American canned spaghetti lies behind the nose of the plane like a pile of entrails. "Franco-American" also suggests French and American involvement in the Vietnam War.

Something to Think About . . .

Rosenquist's enormous painting also makes reference, in its technique as well as its size, to the highway billboard. What makes this appropriate?

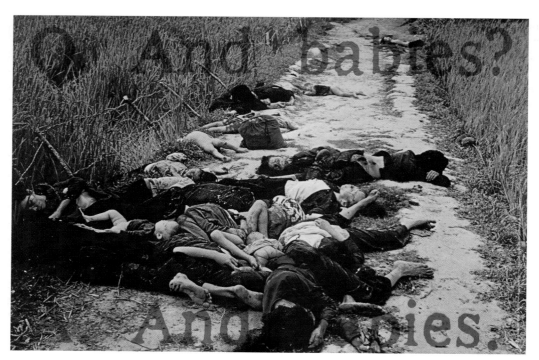

Fig. 39.7 Ron Haeberle, Peter Brandt, and the Art Workers' Coalition, *Q. And Babies? A. And Babies.* 1970. Offset lithograph, 24″ × 38 ″. The Museum of Modern Art, New York. Gift of the Benefit for the Attica Defense Fund. Brandt was the poster's designer.

In other words, the museums embodied, in the minds of many, the establishment politics that had led to the war in the first place. On October 15, 1969, the first Vietnam Moratorium Day, artists managed to close the Museum of Modern Art, the Whitney Museum, and the Jewish Museum, but the Metropolitan and the Guggenheim refused to close.

The Art Workers' Coalition also quickly reacted to reports that American soldiers, the men of Charlie Company, had slaughtered men, women, and children in the Vietnam village of My Lai on March 16, 1968. Over a year later, in November 1969, as the army was investigating Charlie's Company's platoon leader, First Lieutenant William L. Calley, Jr., photographs taken at My Lai by army photographer Ron Haeberle appeared in the *Cleveland Plain Dealer*. Four days later, in an interview by Mike Wallace on CBS-TV, Paul Meadlo, who had been at My Lai, reported that Lt. Calley had rounded up 40 or 45 villagers and ordered them shot. "Men, women, and children?" Wallace asked. "Men, women, and children," Meadlo answered. "And babies?" "And babies." The transcript of the interview was published the next day in the *New York Times*, accompanied by the photograph. Quickly, the Art Workers' Coalition added Wallace's question and Meadlo's response to the image (Fig. 39.7), printed a poster, and distributed it around the world.

Conceptual Art

Rather than attacking the museums directly, another strategy designed to undermine the art establishment emerged—making art that was objectless, art that was conceived as either uncollectible or unbuyable, either intangible, temporary, or existing beyond the reach of the museum and gallery system that artists in the antiwar movement believed was, at least in a de facto way, supporting the war. The strategies for creating this objectless art had already

been developed by a number of artists who, reacting to the culture of consumption, had chosen to stop making works of art that could easily enter the marketplace. In the catalogue for an exhibition entitled "January 5–31, 1969," a show consisting, in fact, of its catalog but no objects, artist Douglas Huebler (1924–1997) wrote: "The world is full of objects, more or less interesting: I do not wish to add any more." In this way, he sidestepped both the museum and the individual collector. His *Duration Piece #13*, for instance, consists of one hundred $1 bills listed by serial number and put into circulation throughout the world, the serial numbers to be reprinted 25 years later in an art magazine. Each person holding one of the bills would receive a $1,000 reward.

In light of such works, critics began to speak of "the dematerialization of art" and "the death of painting," even as California artist John Baldessari (1931–) destroyed 13 years worth of his paintings, cremating them at a mortuary. The following year, he created a lithograph with the single phrase "I will not make any more boring art" written over and over again across its surface.

Land Art

Closely related to both the conceptualists and the minimalists (see Chapter 38) are those artists who, in the 1960s, began to make site-specific art. (Such art defines itself in relation to the particular place for which it was conceived.) Many of these were earthworks, conceived as enormous mounds and excavations made in the remote regions of the American West. One of the primary motivations for making them was to escape the gallery system. In an essay published in 1972, Robert Smithson (1938–1973) put it this way: "A work of art when placed in a gallery loses its charge, and becomes a portable object or surface disengaged from

the outside world. . . . Works of art seen in such spaces . . . are looked upon as so many inanimate invalids, waiting for critics to declare them curable or incurable. The function of the warden-curator is to separate art from society. Next comes integration. Once the work of art is totally neutralized, ineffective, abstracted, safe, and politically lobotomized it is ready to be consumed by society."

Robert Smithson's *Spiral Jetty* One of the most famous of works designed specifically to escape the gallery system is Smithson's *Spiral Jetty* (Fig. **39.8**), created in 1970. Using dump trucks to haul rocks and dirt, Smithson created a simple spiral form in the Great Salt Lake. The work is intentionally outside the gallery system, in the landscape—and a relatively inaccessible and inhospitable portion of the Utah landscape at that. Smithson chose the site, on the shores of the Great Salt Lake about 100 miles north of Salt Lake City and 15 miles south of the Golden Spike National Historic Monument, where the Eastern and Western railroads met in 1869, connecting both sides of the American continent by rail, because, in his mind, it was the very image of *entropy*, the condition of decreasing organization or deteriorating order. For Smithson, the condition of entropy is not only the hallmark of the modern, but the eventual fate of all things—"an ironic joke of nature," as one historian has described the lake, "water that is itself more desert than a desert."

Smithson's work on the jetty in fact coincided with the rise of ecology as a wider public issue. On April 22, 1970, the first Earth Day inaugurated the environmental movement, which could trace its roots back to the publication, in 1953, of Eugene P. Odum's textbook *The Fundamentals of Ecology* but, more importantly, in terms of its wide popularity, to the 1962 publication of a book by Rachel Carson (1907–1964), *Silent Spring*, first serialized in three issues of *The New Yorker* magazine. Carson was a marine biologist who had previously published a series of meditative books on the sea that serve as models of nature writing to this day. But *Silent Spring* was far more polemical, arguing that the introduction of synthetic pesticides, particularly DDT, into the environment threatened human life itself.

Smithson's jetty was, as a result, widely understood as a work of environmental art. Humans had already degraded the site: Jetties had once stretched out into the lake to serve now-abandoned oil derricks. As Smithson wrote not long after completing the *Spiral Jetty*, "Across the country there are many mining areas, disused quarries, and polluted lakes and rivers. One practical solution for the utilization of such devastated places would be land and water re-cycling in terms of 'Earth Art.'"

As he was constructing the jetty, Smithson made a film of the event. The typical camera angle is aerial, looking straight down at the surface of the lake from above, so that the spiral seems to lie flat, like a two-dimensional design. The image reinforces the spiral's status as one of the most widespread of all ornamental and symbolic designs on Earth, suggesting, too, the motion of the cosmos. The spiral is also found in three main natural forms: expanding like a nebula, contracting like a whirlpool, or ossified as in a snail's shell. Smithson's work suggests the ways in which these contradictory forces are simultaneously at work in the universe.

At the end of the film, a helicopter follows Smithson as he runs out the length of the spiral in a dizzying swirl of cinematography that leaves the viewer unsure which direction is which. When Smithson arrives at the center of the

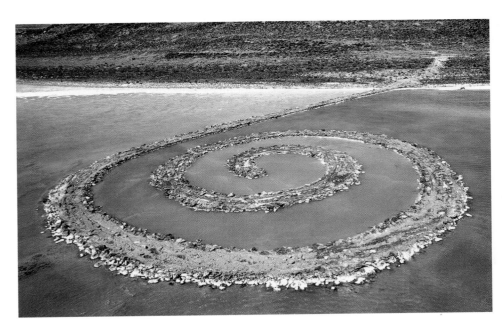

Fig. 39.8 Robert Smithson, *Spiral Jetty*, Great Salt Lake, Utah. April 1970. Black rock , salt crystals, earth, red water (algae). 3 1/2′ × 15′ × 1500′. Art © Estate of Robert Smithson/Licensed by VAGA, New York. Courtesy James Cohan Gallery, New York. Collection: DIA Center for the Arts, New York. Photo: Gianfranco Goroni. Smithson's film of the *Jetty*'s construction mirrors the earthwork not only by imaging it, but, as a spiral loop of 16mm film, by formally mirroring its structure.

spiral, he pauses, breathless, then turns to walk back, a purposefully deflated image of purposelessness, the very image of the tensions between motion and stasis, entropy and creation, expansion and contraction, even life and death, that inform Smithson's work.

Michael Heizer's New Sublime

One of Smithson's good friends, Michael Heizer (1944–), preferred working in the desert landscapes of Nevada. In the summer of 1968, accompanied by Smithson, he made a 520-mile-long series of loops, troughs, and other intrusions into the desert landscape, connecting nine separate dry lake beds on government-owned land along the California–Nevada border. In 1969, however, he conceived of a much more ambitious project. On property purchased by Virginia Dwan, whose gallery was the first to support earthworks created precisely to avoid the gallery space, Heizer carved two notches out of the side of the Virgin River Mesa about 80 miles northeast of Las Vegas, Nevada. The two notches face each other across a broad escarpment. They were excavated with dynamite and bulldozers, which pushed the soil and rock from the troughs into the chasm below. Originally 42 feet deep and 30 feet wide, Heizer expanded them the following year, making them 50 feet deep and thus extending the length of the work from the top of one trough, down and across the escarpment and up the other side to 1,500 feet. He called the work *Double Negative*—literally, two minus signs on each side of the escarpment, but also, grammatically, two negatives that cancel each other out to produce an affirmative (Fig. **39.9**).

To this day, in fact, many see this work as a desecration of the landscape. But if originally the work's perpendicular walls and rigid geometry underscored the impact of human intervention on the environment in a negative sense, today, some 40 years after the fact, as the walls have given way to the vicissitudes of weather and time and crumbled to floors of the troughs, it is quite clear that at least one of Heizer's goals was to draw attention to the difference between the relative brevity of human time and the vastness of geological time. For the impact of *Double Negative* on the environment is actually minimal beside the deep cut that the Virgin River has, over the millennia, gorged out of the Nevada desert. In fact, it is quite clear that *Double Negative* will one day disappear, absorbed by the erosion of the mesa's escarpment. To come to such an understanding is to confront the sublime. As John Beardsley, one of the major historians of land art, has put it: "*Double Negative*, in fact, provides the experience of awe inspiring vastness, solitude, and silence that has long been associated with the sublime. . . . [It] is thus somewhat paradoxical: executed in a contemporary geometric idiom, meant to refute the artistic conventions and escape the economic fate of traditional sculpture, it nevertheless evoked some very familiar metaphors of American landscape."

Temporary Intrusions: Christo and Jeanne-Claude

If Heizer's works evoke the vastness of time, the works of Christo (1935–) and Jeanne-Claude (1935–2009) seem to evoke, instead, time's very passing and the fragility of human experience. Christo and Jeanne-Claude's works are literally here today and gone tomorrow, leaving no lasting footprint on the landscape and impacting the environment minimally if at all—considering the enormous scale at which they work, an extraordinary feat. *Running Fence*, which took nearly five years to realize, from 1972 to 1976, is a case in point (Fig. **39.10**). Eighteen feet high and running

Fig. 39.9 Michael Heizer, *Double Negative*. 1969–70. 240,000-ton displacement of rhyolite and sandstone, 1500′ × 50′ × 30′. The Museum of Contemporary Art, Los Angeles. Gift of Virginia Dwan. 85.105. Location: Mormon Mesa, Overton, Nevada. The work was owned by Dwan and Heizer until 1985, when it was donated to the Museum of Contemporary Art in Los Angeles.

Fig. 39.10 Christo and Jeanne-Claude, _Running Fence_, Sonoma and Marin Counties, California. 1972–76. Photo: Jeanne-Claude. © 1976 Christo. Perhaps the most compelling aspect of _Running Fence_ is the way its line defines the contour of the landscape, making it visible as if for the first time.

for 24.5 miles through Sonoma and Marin Counties in Northern California, it extended from US Route 101 across 14 other roadways and the rolling hills of 59 private ranches until descending into the Pacific Ocean at Bodega Bay. It required more than 2.2 million square feet of white nylon fabric, hung from a steel cable stretched between 2,050 steel poles. It stood in place for 14 days, from September 10 to September 24, 1976. All expenses for the temporary work of art were paid by Christo and Jeanne-Claude through the sale of studies, preparatory drawings and collages, scale models, and original lithographs. On the occasion of the 2010 exhibition at the Smithsonian American Art Museum, "Christo and Jeanne-Claude: Remembering the _Running Fence_," Christo explained the thinking behind both the site-specificity of the work and its temporary qualities: "This project is entirely designed for that specific landscape and nothing can be transported. Nobody can buy the work, nobody can own the work, and nobody can charge tickets for the work. We do not own the projects, they are beyond the ownership of the artists because freedom is the enemy of possession, that's why these projects do not stay. They are absolutely related to artistic and aesthetic freedom."

One of the primary features of _Running Fence_—and all of Christo and Jeanne-Claude's work—is the public debate and buy-in that was required to execute it, including the ranchers' participation, 18 public hearings, three sessions at the Superior Courts of California, and the drafting of a 450-page Environmental Impact Report. The debate about the work's merits as art, the spirit of collaboration that resulted, and, perhaps above all, the stories and memories that the piece subsequently evoked (including Albert and David Maysles's extraordinary documentary film of the project, released in 1978), are all equally part and parcel of the work itself. But the tranquility and beauty of the _Running Fence_—to say nothing of the sense of community and cooperation it embodied—could, finally, be taken as a counterstatement to the political climate in which it was realized. In fact, the poles used to construct the fence were Vietnam surplus, used in the construction of military airports in Vietnam, and Christo and Jeanne-Claude were able to purchase them from the Army for $42 each. Then, after the _Fence_ was dismantled, the local ranchers used them for their own fences and to build cattle guards. _Running Fence_ thus literally transformed war materials into artistic and peaceable use.

The Music of Youth and Rebellion

Given the involvement of American youth in the antiwar movement, it was natural that their music—rock and roll—helped to fuel the fires of their increasingly passionate expressions of dismay at American foreign policy. Rock-and-roll music had, after all, originated in an atmosphere of youthful rebellion. Beginning at the end of the 1940s, it gained increasing popularity in the 1950s when the gyrating hips and low-slung guitar of one of its earliest stars, Elvis Presley (1935–1977), made the music's innuendo of youthful sexual rebellion explicit. In the 1960s, led by the Beatles, British rock bands (including Led Zeppelin and the Rolling Stones) transformed rock into the musical idiom of a youthful counterculture that embraced sex, drugs, and rock 'n' roll.

Fig. 39.11 Bonnie MacLean, *Six Days of Sound*. December 26–31, 1967. Poster. © Bill Graham Archives, LLC. All rights reserved. The lineup of artists includes the Doors, Freedom Highway, Chuck Berry, Salvation, Big Brother & the Holding Company, Quicksilver Messenger Service, and Jefferson Airplane.

Audiences at most concerts openly smoked marijuana, and hallucinogenic mushrooms and LSD, a semisynthetic psychedelic drug which was not made illegal in the United States until 1967, were regularly used by rock groups such as the Beatles, the Doors, Pink Floyd, the Grateful Dead, and Jefferson Airplane. The Airplane's "White Rabbit," which appeared on their 1967 album *Surrealistic Pillow*, draws clear analogies between the experiences of Alice in Lewis Carroll's *Alice's Adventures in Wonderland* and the hallucinatory effects of taking LSD. And in their self-titled debut album of 1967, the Velvet Underground describes in dark, almost sardonic terms, which would deeply influence the later punk movement, the heroin addiction of its leader, Lou Reed (1942–).

One of the great promoters of rock in the 1960s was Bill Graham (1931–1991), a refugee from Nazi Germany who was raised by foster parents in New York City. Graham operated two rock venues in San Francisco, the Fillmore West and Winterland, and another in New York, the Fillmore East. Almost every major rock group of the era performed in these halls, and the posters Graham commissioned for these concerts became the emblems of the era.

Bonnie MacLean, a recent graduate of Penn State, was one of the founders of the Fillmore poster "look." Her poster for *Six Days of Sound* (Fig. **39.11**), a Christmas-to-New-Year's celebration in 1967, captures the mood of the era. Deeply indebted to Art Nouveau posters by artists such as Jan Toorop (see Fig. 33.5), many of the posters convey the same sexual energy as Art Nouveau, but combined with a spirit of political protest. In her right hand, the long-haired lady of MacLean's poster carries mistletoe; in her left, the peace sign, large and colored red and green, a Christmas ornament that she is about to hang from the branches of a Christmas tree.

The presence of the peace sign in the Fillmore poster is not only appropriate to the season—"Peace on earth, goodwill to men"—but signals the intimate association between rock music and the antiwar movement. As in the civil rights March on Washington in 1963, which was highlighted by Peter, Paul, and Mary's rendition of Bob Dylan's "Blowin' in the Wind" in front of the Lincoln Memorial, most peace marches concluded in large public spaces where speakers and bands alternately shared the stage. The peace march in San Francisco on the nationwide Vietnam Moratorium Day, November 15, 1969, concluded at Golden Gate Park, where, among others, Crosby, Stills, Nash, & Young performed. A quarter of a million people attended. That same day, a half million people marched in Washington, D.C. (and in Columbus, Ohio, Dave Thomas opened the first Wendy's restaurant).

Fig. 39.12 John Paul Filo, *Kent State—Girl Screaming over Dead Body*. May 4, 1970. Collection of John Paul Filo. Filo's photograph appeared on the cover of *Newsweek* on May 18, 1970, beside the headline "Nixon's Home Front." Filo was awarded the Pulitzer Prize in photography for his work at Kent State.

The quartet of David Crosby (1941–), Stephen Stills (1945–), Graham Nash (1942–), and Neil Young (1945–) had come together just months before. Their first performance together was at the Fillmore East in July, their second at Woodstock in August.

The Woodstock Festival, held on a 600-acre dairy farm outside Woodstock, New York, from August 15 to August 18, 1969, known soon after, by the subtitle of the film documenting it, as "3 Days of Peace and Music," has, for an entire generation, become legendary. Approximately 500,000 people attended—and thousands more claim to have been there. On both Saturday, August 16, and Sunday, August 17, bands played all night. Crosby, Stills, Nash, & Young began their 16-song set at 3 AM on Sunday, a marathon evening that concluded on Monday morning with guitarist Jimi Hendrix playing his notorious version of "The Star-Spangled Banner" on a wailing, weeping, whining electric guitar that to conservative ears seemed a direct assault on American tradition.

Perhaps as important as the event itself was the release, in March 1970, of the documentary film of the event, with Crosby, Stills, Nash, & Young performing "Woodstock," written by Joni Mitchell (1943–), over the closing credits. The last verse makes the politics of the event concrete (**Reading 39.6**):

READING 39.6
from Joni Mitchell, "Woodstock" (1970)

By the time we got to Woodstock
We were half a million strong
And everywhere there was song and celebration

And I dreamed I saw the bombers
Riding shotgun in the sky
And they were turning into butterflies
Above our nation
We are stardust
Billion year old carbon
We are golden
Caught in the devil's bargain
And we've got to get ourselves
Back to the garden

The utopian dream of "Woodstock," the desire to return to "the garden," was quickly shattered. Just days before the national Moratorium Day March, reporter Seymour Hersh (1937–) broke the story of the My Lai massacre in the *New York Times* (see Fig. 39.7). A few months later, on April 30, 1970, President Nixon announced that American troops had invaded Cambodia five days earlier. Protests erupted on college campuses across the United States. At Kent State University near Akron, Ohio, the governor of Ohio called out the Ohio National Guard, who arrived on campus as students burned down an old ROTC building (already boarded up and scheduled for demolition). On Monday, May 4, some 2,000 students gathered on the school commons. The National Guard ordered them to disperse. They refused. A group of 77 guardsmen advanced on the students, and for reasons that have never been fully explained, opened fire. Four students were killed, nine wounded. Photojournalism student John Paul Filo's photograph of 14-year-old runaway Mary Ann Vecchio kneeling over the dead body of 20-year-old Jeffery Miller became an instant icon of the antiwar movement (Fig. **39.12**).

Neil Young quickly penned what would become Crosby, Stills, Nash, & Young's most famous protest song, "Ohio," commemorating the four who died. The song quickly rose to number two on the charts.

American involvement in Vietnam would not end until January 1973, when a ceasefire was agreed upon in Paris and American troops were finally withdrawn. Two years later, on April 30, 1975, the Viet Cong and North Vietnamese army took control of Saigon, renaming it Ho Chi Minh City, and Vietnam was reunited as a country for the first time since the French defeat in 1954.

HIGH AND LOW: THE EXAMPLE OF MUSIC

Rock and roll's ascendancy as the favorite music of American popular culture in the 1950s and 1960s underscores a shift in cultural values in which the line between "high" and "low" art became more and more difficult to define. Composers from the time of Dufay and Josquin had based their work on secular melodies, but the phenomenon really began to take shape in the nineteenth century, as nationalist composers like Giuseppe Verdi in Italy and Peter Ilyich Tchaikovsky in Russia began to draw on traditional folk songs for their otherwise classical compositions. Over the course of the nineteenth century, classical music was increasingly considered the provenance of elite and intellectual audiences while lighter fare was understood to appeal to wider, more populist tastes. By the jazz era, everyone from the American George Gershwin to the Russian Igor Stravinsky incorporated jazz idioms into their work, and Aaron Copland, as we have seen, looked to the regional traditions of the Appalachian hills and the American West for inspiration. The Boston Pops Orchestra was founded as early as 1885 to present "concerts of a lighter kind of music." Its conductor of over 50 years, Arthur Fiedler (1894–1979), was followed by academy-award winner John Williams (1932–), composer of the soundtracks to the films *Star Wars* and *Indiana Jones and the Raiders of the Lost Ark*. Of all of them, twentieth-century composer Leonard Bernstein (1918–1990) was probably most at home in both classical and popular idioms. High and low were distinctions that, in his own work, he tried to ignore. He could write Broadway hit musicals such as *Candide* (1956) and *West Side Story* (1957), as well as profoundly moving symphonies such as his 1963 Third Symphony, *Kaddish*, a musical interpretation of the Jewish prayer for the dead, written for an orchestra, a chorus, a soloist, a children's choir, and a narrator.

György Ligeti and Minimalist Music

Minimalist music was inspired by advances in new media—particularly electronic recording and production innovations—but their sound was so different that both popular and classical audiences were often put off. Like Minimalist artists, minimalist composers emphasized the use of consciously limited means, but rather than creating Minimalist Art's simple geometric compositions, minimalist musicians transformed the simple elements with which they began into dense, rich compositions.

Interest in electronic music was stimulated, in New York, by the Radio Corporation of America's development of the electronic synthesizer in 1955. But Europeans were equally committed to its development, among them Hungarian composer György Ligeti [lih-get-tee] (1923–2006). After World War II, the USSR controlled all of Eastern Europe, and when Hungary tried to break away in 1956, the Soviets sent their tanks into Budapest. Ligeti, then 32 years of age, ignored the gunfire and shellbursts that had sent most of his fellow citizens into basement shelters so that he could continue to listen to a West German radio broadcast of a piece by German composer Karlheinz Stockhausen [SHTOK-howzun] (1928–2007). Stockhausen had composed the first piece of music using synthesized tones in 1953, *Studie I*. Its instrumentation consisted of three tape recorders, a sine wave generator, and a "natural echo chamber." Stockhausen felt he was returning to the very basis of sound, which, in his words, rises from "pure vibration, which can be produced electrically and which is called a sine wave. Every existing sound, every noise, is a mixture of such sine waves—a spectrum." For the first time, the musical composition existed entirely on tape and required no performer to produce it.

When Ligeti escaped Hungary late in 1956, he joined Stockhausen at the Studio for Electronic Music in West Germany. Stockhausen was editing tapes of electronically generated sounds—as well as music generated by traditional instruments and voices—in the same way that a filmmaker edits film. And he was experimenting with the ways in which sound was heard by an audience as well. In what is probably the hallmark electronic composition of the era, Stockhausen's *Gesang der Jünglinge* [geh-SAHNG der YOONG-ling-uh] (*Song of the Children*), composed in 1956, was one of the first works to include spatialization as a compositional element, inaugurating the "stereo" and "surround sound" era. Combining taped voices in combination with taped electronic sounds, the original version utilized five loudspeakers, positioned to surround the audience. Stockhausen's plan was to play the work at the Cologne Cathedral, but the archbishop didn't think loudspeakers belonged in church. As Stockhausen describes it: "The direction and movement of the sounds in space is shaped by the musician, opening up a new dimension in musical experience"—and, he thought, spiritual experience as well.

Meanwhile, throughout the 1960s, Ligeti was moving in a very different direction. Rather than exploring the vast diversity of sound, as Stockhausen did, he developed a rich, but much more minimal, brand of polyphony—which he called "micropolyphony"—dense, constantly changing clusters of sound that blur the boundaries between melody, harmony, and rhythm. This effect can be heard in Ligeti's 1966 HEAR MORE at *Lux Aeterna* [luks ee-TER-nuh] (track **39.1**), the www.myartslab.com parts of which seem to blend together in a sort of shimmering

atmosphere of overall sound. The piece is actually a canon, an arrangement of theme and variations, except that the entrances are neither contrapuntal nor harmonic, but rather densely compacted and atonal. In 1968, the composition reached a mass audience when American director Stanley Kubrick (1928–1999) used it in the soundtrack of his film *2001: A Space Odyssey*.

Ligeti gradually became aware of the young American "minimalist" composers Terry Riley (1935–), Steve Reich (1936–), and Philip Glass (1937–). Like the Minimalist artists, their work relied on repetition of units that differ only slightly or that vary only gradually over extended periods of time. In his ground-breaking *In C* of 1964, Riley created 53 brief thematic fragments, to be played in any combination by any group of instruments. Though each musician plays these fragments in the same sequence, they are free to repeat any fragment as many times as they like. The one constant, providing a foundation for the texture of interweaving fragments in the piece, is a C octave played in a high range of the piano throughout the piece, repeating as many as ten or fifteen thousand times in any given performance (the length of performance will vary depending upon how many times each musician repeats each fragment). Steve Reich's 1965 *It's Gonna Rain* consists of the repetition of a single phrase of text (the title), taken from a tape recording of a street preacher by the name of Brother Walker sermonizing on the subject of Noah and the Flood. Reich spliced together two copies of the same tape played at slightly different speeds, so that they gradually shift, in his words, "out of phase," and the monotony of the repetition is transformed as the original sound of the phrase gradually comes to sound entirely different.

John Adams (1947–) echoed Reich's practice in *It's Gonna Rain* to create a composition for the Shaker religion, *Shaker Loops*. But in this piece, Adams added a profoundly emotional, almost Romantic dynamic to its minimalist repetition. In 1987, Adams wrote an opera, *Nixon in China*, based on the February 1972 meeting between American president Richard Nixon (1913–1994) and Chinese communist leader Mao Zedong. Adams created what he describes as "the first opera ever to use a staged 'media event' as the basis for its dramatic structure." Nixon and Mao were both adept manipulators of public opinion, and in his opera, Adams sought to reveal "how dictatorships on the right and on the left throughout the century had carefully managed public opinion through a form of public theater and the cultivation of 'persona' in the political arena." Nixon made much of his visit, the first by an American president to Communist-controlled China, and the driving propulsion of Adams's repetitive score captures perfectly Nixon's excitement, his passionate desire to leave an indelible mark on history.

The Theatrical and the New *Gesamtkunstwerk*

The ambition and scope of Adams's opera reflects a renewed interest in reinventing what, in the nineteenth century, the German composer Richard Wagner had called the

Gesamtkunstwerk, or "total work of art," merging visual art, music, opera, dance, and so on, into a single integrated whole (see Chapter 30). Decades later, Bertolt Brecht, the German playwright, warned in response:

> So long as the expression "Gesamtkunstwerk" means that the integration is a muddle, so long as the arts are supposed to be "fused" together, the various elements will all be equally degraded, and each will act as a mere "feed" to the rest. The process of fusion extends to the spectator who gets thrown into the melting pot too and becomes a passive (suffering) part of the total work of art. . . . Words, music, and setting must become more independent of one another.

It was this aesthetic philosophy that guided Merce Cunningham, John Cage, and Robert Rauschenberg in their collaborations that combined independent compositions (see Chapter 38). In its intentional heterogeneity, the Cunningham, Cage, and Rauschenberg "events" created a clear precedent for postmodern theatrical practice, which sought not to "fuse" the arts but underscored their *difference* within the same stage space.

Robert Wilson and Postmodern Opera Describing his 1976 postmodern opera *Einstein on the Beach*, innovative director and producer Robert Wilson (1941–) explained:

> In making *Einstein*, I thought about gestures or movements as something separate. And I thought about light . . . the decor, the environments, the painted drops, the furniture, and they're all separate. And then you have all of these screens of visual images that are layered against one another and sometimes they don't align, and then sometimes they do. If you take a baroque candelabra and you put it on a baroque table, that's one thing. But if you take a baroque candelabra and you place it on a rock, that's something else. . . .

The music for Wilson's opera is also its own "separate" entity. Created by minimalist composer Philip Glass, *Einstein on the Beach* has a score that brims with slowly developing variations that accompany recurring patterns. As Glass himself says, "The difficulty is not that it keeps repeating, but that it almost never repeats." It is thus a fabric composed not of sameness but *difference*. The five-hour opera unfolds, subtly, as in John Ashbery's expression, like "A whispered phrase passed around HEAR MORE at ●)) the room" (track 39.2). www.myartslab.com

Glass was chiefly inspired by the music of Indian sitarist and composer Ravi Shankar [SHAN-kar] (1920–), whose raga improvisations he had transcribed into Western notation for a soundtrack to the 1966 counterculture film *Chappaqua*. He was fascinated by the structure of Indian ragas, which he perceived to be made up of small units of notes built up into chains of larger rhythmic patterns. The compositions Glass subsequently created based on this understanding

had little in common with Indian music, but they did incorporate the hypnotic, almost mystical, cyclic repetitive patterns that he equated with meditative aural space.

In *Einstein on the Beach*, Wilson sets Glass's music to dance sequences choreographed by Lucinda Childs (1940–) to create contrasting elements (Fig. **39.13**). "I thought of the dances as landscapes, as fields," Wilson said, "And so the space is the biggest. They break apart the space." In much of the opera, the visual backdrops create a shallow visual field, but the dances occur in a space that is lighted as if receding into the infinite. Each dance sequence occurs twice, the second time to music so distinctly different from the first instance that it is virtually unrecognizable the second time around. This doubling—at once the same and not the same—is another facet of postmodern experience.

Laurie Anderson and Rock Postmodern While Robert Wilson's *Einstein* remained a relatively "high art" phenomenon, the possibility of creating a work of "total art" that spoke more directly to a popular culture, rock-'n'-roll aesthetic, remained an attractive alternative, one addressed first by the rock band The Who when they created the "rock opera" *Tommy* in 1969. However, it was Laurie Anderson, who most fully realized the *Gesamtkunstwerk* ideal, with her four-part, four-night, eight-hour multimedia *United States*, which premiered at the Brooklyn Academy of

Music's "New Wave Festival" in 1983 a year before Wilson's *Einstein on the Beach* was revived there.

Anderson's work was categorized as a "rock" phenomenon, and drew the kind of criticism that rock music has often attracted, especially after a song from *United States, Part II*, "O Superman," became a pop hit in 1981, selling over 1 million records. "O Superman's" eight-minute video version even helped inaugurate MTV, being broadcast during that channel's first year of existence. The song was an indictment of the American dream—"So hold me, Mom, in your long arms, in your petrochemical arms, your military arms, in your arms"—as a mother's arms and the country's armaments combine to form a distinctly chilly postmodern embrace. But despite the song's antiestablishment attitude, Anderson's success was, to many in the avant-garde art scene, a sure sign that she had "sold out," just as many other artists in New York seemed to have submitted to the attractions of postmodern consumer culture. After she reached a lucrative agreement with Warner Brothers records and then made a feature-length performance film, *Home of the Brave*, in 1985, their suspicions seemed confirmed.

But Anderson remains one of the most distinctive innovators in the postmodern scene. Early on, in her role as a musician, she began creating new electronic instruments, including a series of electronic violins, called "tape-bow violins," on which a tape playback head has been mounted on

Fig. 39.13 Robert Wilson, *Einstein on the Beach*, Dance, Field. 1976. Performers, Lucinda Childs Company. The dance is almost devoid of the visual resources that dominate the rest of the production, a fact that draws attention to the "openness" of the space in which it occurs, itself a metaphor for the openness of interpretation itself.

Fig. 39.14 Laurie Anderson performing "O Superman," from *United States, II.* **1983.** Anderson's imagery is almost always ambiguous. Here the projection of a hand evokes both the authoritative pointing finger of the mother and a gun—the primary themes of "O Superman."

the body of the instrument and a strip of recorded audiotape on the bow. She transforms her voice, in the narratives that compose what she calls her "talking operas," by means of a harmonizer that drops it a full octave and gives it a deep male resonance, which she describes as "the Voice of Authority," an attempt to create a corporate voice. She has attached microphones to her body, transforming it into a percussion instrument. And the projected imagery and lighting that provide the backdrop for her performances (Fig. **39.14**) are a combination of pop imagery and cultural critique, which unite the local and the global in an image that underscores the not always positive results of the "American dream."

THE BIRTH OF THE FEMINIST ERA

At the same time that the antiwar and civil rights movements galvanized political consciousness among both men and women, "the Pill" was introduced in the early 1960s.

As women gained control over their own reproductive functions, they began to express the sexual freedom that men had always taken for granted. The struggle for gender equality in the United States found greater and greater expression throughout the 1960s until, by the early 1970s, a full-blown feminist era emerged.

The Theoretical Framework: Betty Friedan and NOW

In 1963, a freelance journalist and mother of three, Betty Friedan (1921–2006), published *The Feminine Mystique.* In many ways, hers was an argument with Freud, or at least with the way Freud had been understood, or misunderstood. While she admits that "Freudian psychology, with its emphasis on freedom from a repressive morality to achieve sexual fulfillment, was part of the ideology of women's emancipation," she is aware that some of Freud's writings

had been misused as a tool for the suppression of women (**Reading 39.7**):

READING 39.7

from Betty Friedan, *The Feminine Mystique* (1963)

The concept "penis envy," which Freud coined to describe a phenomenon he observed in women—that is, in the middle-class women who were his patients in Vienna in the Victorian era—was seized in this country in the 1940s as the literal explanation of all that was wrong with American women. Many who preached the doctrine of endangered femininity . . . seized on it—not the few psychoanalysts, but the many popularisers, sociologists, educators, ad-agency manipulators, magazine writers, child experts, marriage counsellors, ministers, cocktail-party authorities—could not have known what Freud himself meant by penis envy. . . . What was he really reporting? If one interprets "penis envy" as other Freudian concepts have been reinterpreted, in the light of our new knowledge that what Freud believed to be biological was often a cultural reaction, one sees simply that Victorian culture gave women many reasons to envy men: the same conditions, in fact, that the feminists fought against. If a woman who was denied the freedom, the status, and the pleasures that men enjoyed wished secretly that she could have these things, in the shorthand of the dream, she might wish herself a man and see herself with that one thing which made men unequivocally different—the penis. She would, of course, have to learn to keep her envy, her anger, hidden: to play the child, the doll, the toy, for her destiny depended on charming man. But underneath, it might still fester, sickening her for love. If she secretly despised herself, and envied man for all she was not, she might go through the motions of love, or even feel a slavish adoration, but would she be capable of free and joyous love? You cannot explain away woman's envy of man, or her contempt for herself, as mere refusal to accept her sexual deformity, unless you think that a woman, by nature, is a being inferior to man. Then, of course, her wish to be equal is neurotic.

Latent in Friedan's analysis, but central to the feminist movement, is her understanding that in Freud, as in Western discourse as a whole, the term *woman* is tied, in terms of its construction as a word, to man (its medieval root is "*wifman*," or "wife [of] man"). It is thus a contested term that does not refer to the biological female but to the sum total of all the patriarchal society expects of the female, including behavior, dress, attitude, and demeanor. *Woman*, said the feminists, is a cultural construct, not a biological one. In *The Feminine Mystique*, Friedan rejects modern American society's cultural construction of women. But she could not, in the end, reject the word *woman* itself. Friedan would go on to become one of the founders of the National Organization for Women (NOW), the primary purpose of which was to advance women's rights and gender equity in the workplace. In this, she dedicated herself to changing, in American culture, her society's understanding of what "woman" means.

Feminist Poetry

The difficulties that women faced in determining an identity outside the patriarchal construction of "woman" became, in the 1960s, one of the chief subjects of poetry by women, particularly in the work of the poets Anne Sexton (1928–1974) and Sylvia Plath (1932–1963). Both investigate what it means *to be*, in an existential sense, "woman."

Plath had famously examined the psychology of being in her poem "Lady Lazarus" (see **Reading 39.8**, page 1311, for the full text). The title alludes to T. S. Eliot's "Love Song of J. Alfred Prufrock," specifically to Eliot's lines: "I am Lazarus, come from the dead, / Come back to tell you all, I shall tell you all." Like Lazarus, Lady Lazarus is reborn in the poem in order to attack the male ego, specifically that of her husband, the poet Ted Hughes (1930–1998). The poem concludes:

> Out of the ash
> I rise with my red hair
> And I eat men like air.

Sexton's marriage was probably more problematic than Plath's. An affluent housewife and mother, she lived in a house with a sunken living room and a backyard swimming pool in the Boston suburb of Weston, Massachusetts. But she was personally at odds with her life, and as her husband saw his formerly dependent wife become a celebrity, their marriage dissolved into a fabric of ill will, discord, and physical abuse. The poem with which she opened most readings, the ecstatically witty "Her Kind," published in 1960 in her first book of poems, *To Bedlam and Part Way Back*, captures the sense of independence that defined her from the beginning (**Reading 39.9**):

READING 39.9

Anne Sexton, "Her Kind" (1960)

I have gone out, a possessed witch
haunting the black air, braver at night;
dreaming evil, I have done my hitch
over the plain houses, light by light:
lonely thing, twelve-fingered, out of mind.
A woman like that is not a woman, quite.
I have been her kind.

I have found the warm caves in the woods,
filled them with skillets, carvings, shelves,
closets, silks, innumerable goods;
fixed the suppers for the worms and the elves:
whining, rearranging the disaligned.

A woman like that is misunderstood.
I have been her kind.

I have ridden in your cart, driver,
waved my nude arms at villages going by,
learning the last bright routes, survivor
where your flames still bite my thigh
and my ribs crack where your wheels wind.
A woman like that is not ashamed to die.
I have been her kind.

Another important poet of the era is Adrienne Rich (1929–), whose poem "Diving into the Wreck" was published in 1973. The poem delves into a metaphoric wreck created by a patriarchal culture that inherently devalues anything female or feminine, a wreck that would include the lives of both Plath and Sexton. Rich's project is to dissolve myth, discover truth, and recover the treasures left by her feminist forebearers (**Reading 39.10**):

READING 39.10

from Adrienne Rich, "Diving into the Wreck" (1973)

I came to explore the wreck.
The words are purposes.
The words are maps.
I came to see the damage that was done
and the treasures that prevail.
I stroke the beam of my lamp
slowly along the flank
of something more permanent
than fish or weed

the thing I came for:
the wreck and not the story of the wreck
the thing itself and not the myth
the drowned face always staring
toward the sun
the evidence of damage
worn by salt and sway into this threadbare beauty
the ribs of the disaster
curving their assertion
among the tentative haunters.

This is the place.
And I am here, the mermaid whose dark hair
streams black, the merman in his armored body
We circle silently
about the wreck
we dive into the hold.
I am she: I am he

The first-person "I" of her poem is androgynous, a figure who has given up the sexual stereotyping that constitutes the battered hulk of the wreck. And what Rich discovers in her explorations there is the will to survive.

Feminist Art

In the 1960s and 1970s—in fact well into the 1990s—the art world was dominated by male artists. Although in 1976 approximately 50 percent of the professional artists in the United States were women, only 15 in 100 one-person shows in New York's prestigious galleries were devoted to work by women. Eight years later, in 1984, the Museum of Modern Art reopened its enlarged facilities with a show entitled *An International Survey of Painting and Sculpture*. Of the 168 artists represented, only 13 were women.

As a result, many women artists were insistent that their work be approached in formal, not feminine terms—that is, in the same terms that the work of men was addressed. Eva Hesse [HESS-uh] (1936–1970), for instance, when asked if works such as *Ringaround Arosie* (Fig. 39.15) contained

Fig. 39.15 Eva Hesse, *Ringaround Arosie*. March 1965. Varnish, graphite, ink, enamel, cloth-covered wire, papier-mâché, unknown modeling compound, Masonite, wood, 26 $5/8$ × 16 $3/4$ × 4 $1/2$ (67.5 × 42.5 × 11.4 cm). Museum of Modern Art, New York, fractional and promised gift of Kathy and Richard S. Fuld, Jr., 2005. © The Estate of Eva Hesse, Hauser & Wirth Zurich, London. Photo: Abby Robinson/Barbora Gerny, New York. "A woman is sidetracked by all her feminine roles," Hesse wrote in 1965. "She also lacks the conviction that she has the 'right' to achievement."

female sexual connotations, quickly shot back: "No! I don't see that at all." Of the work's circular forms, she later said, "I think the circle is very abstract. . . . I think it was a form, a vehicle. I don't think I had a sexual, anthropomorphic, or geometric meaning. It wasn't a breast and it wasn't a circle representing life and eternity."

Even when an artist like Judy Chicago (1939–) would try to invest her work with feminist content, the public refused to recognize it. Her series of 15 *Pasadena Lifesavers* (Fig. **39.16**) exhibited in 1970 at Cal State Fullerton, expressed, she felt, "the range of my own sexuality and identity, as symbolized through form and color." Their feminist content was affirmed by a statement on the gallery wall directly across from the entrance, which read:

> Judy Gerowitz hereby divests herself of all names imposed upon her through male social dominance and freely chooses her own name Judy Chicago.

But male reviewers ignored the statement. As Chicago says in her 1975 autobiography, *Through the Flower: My Struggle as a Woman Artist*: "[They] refused to accept that my work was intimately connected to my femaleness." But, in part, their misapprehension was her own doing. As she explains in *Through the Flower*, "I had come out of a formalist

Fig. 39.16 Judy Chicago, *Pasadena Lifesavers, Yellow No. 4.* 1969–70. Sprayed acrylic on Plexiglas (series of 15) 59" × 59". Whereabouts unknown. © 2008 Artists Rights Society (ARS), New York. Photo © Donald Woodman. To many viewers, the geometry of Chicago's forms completely masked their sexual meaning.

Fig. 39.17 Judy Chicago, *The Dinner Party*. 1979. Mixed media, 48′ × 48′ × 48′ installed. Collection of the Brooklyn Museum of Art, Gift of the Elizabeth A. Sackler Foundation. Photograph © Donald Woodman. © 2005 Judy Chicago/Artists Rights Society (ARS), New York. The names of 999 additional women are inscribed in ceramic tiles along the table's base.

background and had learned to neutralize my subject matter. In order to be considered a 'serious' artist, I had had to suppress my femaleness. . . . I was still working in a frame of reference that people had learned to perceive in a particular, non-content-oriented way."

Chicago's great collaborative work of the 1970s, *The Dinner Party* (Fig. 39.17), changed all that. In its bold assertion of woman's place in social history, the piece announced the growing power of the women's movement itself. More than 300 women worked together over a period of five years to create the work, which consists of a triangle-shaped table, set with 39 places, 13 on a side, each celebrating a woman who has made an important contribution to world history. The first plate is dedicated to the Great Goddess, and the third to the Cretan Snake Goddess (see Fig. 4.4). Around the table the likes of Eleanor of Aquitaine (see Chapter 10), Artemisia Gentileschi (see Fig. 21.17), novelist Virginia Woolf (see Chapter 35), and Georgia O'Keeffe (see Fig. 36.20) are celebrated. Where the *Pasadena Lifesavers* had sheltered their sexual content under the cover of

their symbolic abstraction, in *The Dinner Party*, the natural forms of the female anatomy were fully expressed in the ceramic work, needlepoint, and drawing. But, as Chicago is quick to point out, "the real point of the vaginal imagery in *The Dinner Party* was to say that these women are not known because they have vaginas. That is all they had in common, actually. They were from different periods, classes, ethnicities, geographies, experiences, but what kept them within the same historical space was the fact that they had vaginas."

One of the woman artists who has most consistently explored the construction of female identity in contemporary American society is Eleanor Antin (1935–). Beginning in the early 1970s, Antin began assuming a series of personae designed to allow her to explore dimensions of her own self that might otherwise have remained hidden if she had not adopted these other identities. One of the earliest of these personae was the King—a medieval knight errant, decked out in a false beard, a velvet cape, lacy blouse, and leather boots, who would wander the streets of "his" kingdom, the small town of Solana Beach, just north of San Diego,

Fig. 39.18 Eleanor Antin, *My Kingdom Is the Right Size*, from *The King of Solana Beach.* 1974. Photograph mounted on board, 6″ × 9″. Courtesy Ronald Feldman Fine Arts, New York. This is one of 11 photographs and two text panels that compose the work as a whole. One of the text panels reads: "Solana Beach is a small kingdom but a natural kingdom for no kingdom should extend any farther than its king can comfortably walk on any given day. My kingdom is the right size for my short legs."

California, conversing with his "subjects" (Fig. **39.18**). "The usual aids to self-definition," Antin wrote the same year as this performance piece, "sex, age, talent, time, and space—are merely tyrannical limitations upon my freedom of choice." Here she explores the possibilities of being not merely male, but a powerful male—something wholly at odds with her diminutive physical presence. "I took on the King," Antin further explained, "who was my male self. As a young feminist I was interested in what would be my male self . . . he became my political self." Beginning in 1979, Antin adopted another persona, this time a black ballerina by the name of Eleanora Antinova who had once danced with Diaghilev's Ballets Russes (see Chapter 34). In this guise, which she performed in black face (actually more of an artificial tan), she explored the dimensions of racism in America by imagining the fate of a black ballerina in the "white machine" that is classical ballet.

Antin's King was designed to reveal that gender is constructed—her sex remained constant even as her gender changed—and, by extension, that our social "being" is equally constructed. This too would become the project of Cindy Sherman (1954–) who in 1977 began casting herself in a variety of roles, all vaguely recognizable as stereotypical female characters in Hollywood and foreign movies, television shows, and advertising. These *Untitled Film Stills*, as the original series of black-and-white photographs are known, do more, however, than simply assert that "woman" is a construction of consumer society. They address, in particular, the question of the *gaze*. In *Untitled Film Still #35* (Fig. **39.19**), Sherman turns to

Fig. 39.19 Cindy Sherman, *Untitled Film Still #35.* 1979. Photograph mounted on board, 10″ × 8″. Courtesy of the artist and Metro Pictures, New York. The entire series of *Film Stills* consists of 69 photographs shot between 1977 and 1980.

LEARN MORE Gain insight from a primary source document from Cindy Sherman at **www.myartslab.com**

Fig. 39.20 Richard Prince, *Untitled (Cowboy)*. 1989. Ektacolor photograph, edition of two, 50″ × 70″. © Richard Prince. One of the underlying themes of this image is that the Marlboro cowboy, apparently riding free on the range, is actually galloping headlong toward his death.

face someone—perhaps another figure in the room, perhaps the camera, perhaps the audience—but she is clearly the object of someone's gaze. The image purposefully evokes the 1975 essay by film critic Laura Mulvey (1941–), "Visual Pleasure and Narrative Cinema." For Mulvey, women in cinema reflect a "traditional exhibitionist role" in which they are "simultaneously looked at and displayed, with their appearance coded for strong visual and erotic impact." This, she says, is "the magic of the Hollywood style," which "arose, not exclusively, but in one important aspect, from its skilled and satisfying manipulation of visual pleasure. Unchallenged, mainstream film coded the erotic into the language of the dominant patriarchal order." Mulvey's project, in writing her essay, was to subvert this pleasure and the patriarchal order it sustained by exposing it. Sherman's project is the same. She is, after all, both subject and object of her own gaze, literally exposing in her photographs the vocabulary of the patriarchal order. In essence, she returns our gaze with the same sense of condescension and superiority as Manet's Olympia (see *Closer Look*, Chapter 30).

QUESTIONS OF MALE IDENTITY

It stands to reason that if female identity is not essential but socially constructed, the same should hold true for men. One of the first artists to address this theme was Richard Prince, who during the late 1970s had lived with Sherman in New York. By 1980—the year that horse-riding Hollywood hero Ronald Reagan was elected president—Prince had taken to photographing advertisements of cowboys, specifically the Marlboro Man, a practice that has continued down to the present day (Fig. **39.20**). Prince recognized that Philip Morris Co. was not so much selling cigarettes as it was an image—the smoker as the independent, rough-and-tumble hero. Thus in rephotographing the original ads, Prince underscored the inauthenticity of the ad campaign itself. As he well understood, in identifying with the image, the American male was mistaking dependence for independence.

If Prince's cowboys represent the macho side of American male identity, the gay rights movement would play a dramatic role in challenging such American attitudes about the nature of masculinity. In the early hours of Saturday morning, on

Fig. 39.21 Andy Warhol, *Lance Loud,* from *America.* 1985.
Black-and white photograph. In the late 1970s and early 1980s, Warhol was rarely seen without his Polaroid camera. In 2007, the Andy Warhol Foundation gave away about 28,000 photographs by Warhol to 185 museums nationwide.

June 28, 1969, police officers entered a gay nightclub in New York's Greenwich Village called the Stonewall Inn, more or less expecting to close the establishment down for lack of a liquor license. But the Inn's patrons reacted violently, throwing garbage cans, bricks, beer cans, and bottles at the windows and what a reporter for the *Village Voice* called "a rain of coins" at the police. Very soon after, the Inn was on fire. Rioting continued until about 4 AM, and nightly for several days thereafter. A year later, the first ever gay pride parade was staged to celebrate the events of June 1969.

The gay struggle for equal rights continues, of course, to this day. Even 16 years after Stonewall, in 1985, Andy Warhol conceived of his book *America*, a collection of his Polaroid photographs, at least in part as a means to "out" America, to show it its own gay side. At the very heart of the book is a "Physique Pictorial," showing male bodybuilders. Early on he includes a portrait of himself in drag, just one of many he shot in the early 1980s . There's an image of a gay pride parade. And then there are the portraits of gay celebrities, such as Liberace (with punk star John Sex), Keith Haring, and Robert Rauschenberg.

Warhol also includes a portrait of Lance Loud (Fig. **39.21**). Loud was the first reality TV star. Born in 1951, he grew up in

Eugene, Oregon, before moving to Santa Barbara for his teenage years He discovered Warhol in his early teens, became his pen pal, and then, as a young man, moved to New York. When he was 22, in 1973, PBS featured the William C. Loud family—Mom and Dad, Bill and Pat (who incidentally separated and divorced on the show) and their five children, Delilah, Kevin, Grant, Michele, and Lance—in a 12-hour documentary series entitled *An American Family*. It chronicled the day-to-day lives of the family for seven months, and it attracted 10 million viewers. As a *Newsweek* cover story proclaimed in March 1973, the show torpedoed the fantasy of the American family embodied in shows like *The Brady Bunch*. Lance's openly gay lifestyle spurred a national controversy, especially after he appeared on the Dick Cavett Show and other talk shows, and as it became apparent that he was inspiring countless other gay and lesbian Americans to acknowledge their own sexuality. By 1978, Lance had started the band The Mumps, a rock band that played weekly at CBGBs and Max's in New York; Warhol's photograph is of Lance Loud, the rock star. American attitudes about masculinity and male identity were in a state of transition. If nothing else, sexual stereotypes were being challenged as never before.

The Global Village

On the morning of October 9, 1991—a morning that began 16 hours earlier in Japan than in California—along a stretch of interstate highway in the Tehachapi [ti-HACH-uh-pee] Mountains north of Los Angeles, 1,760 yellow umbrellas, each 19 feet 8 inches tall, and 28 feet 5 inches wide, weighing 448 pounds, appeared. Each one was slowly opened across the parched gold hills and valleys (Fig. 39.22). Meanwhile, in the prefecture of Ibaraki [ee-buh-RAHK-eh], Japan, north of Tokyo, in the fertile, green Sato River valley, with its small villages, farms, gardens, and fields, 1,340 blue umbrellas had opened as well (Fig. 39.23). Built at a cost of $26 million, which the artists Christo and Jeanne-Claude (see Fig. 39.10) had raised entirely through the sale of their proprietary work, *The Umbrellas*, blue on one side of the Pacific, yellow on the other, symbolized both the differences underlying global culture and its interdependency. California and Japan were, after all, the two places from which the electronic revolution of the 1970s and 1980s had sprung, California's Silicon Valley providing the innovation and invention and Japan providing the practical application in its massive industrial complex south of Tokyo. Together they changed the world, but their differences were as striking as their interdependence, and Christo and Jeanne-Claude's work underscored this. The landscapes in which the *Umbrellas* rose differed dramatically. In Japan, where less space is available (steep volcanic mountains make most of the land unusable), 124 million people live on only 8 percent of the land. Christo and Jeanne-Claude responded by densely positioning the *Umbrellas*, sometimes following the geometry of the rice fields. In California, in the vast grazing lands of the Tehachapis, the *Umbrellas* seemed to stretch in every direction, along the ridges, down hills, with great spaces between them. Still, in both cultures, the umbrella is an image of shelter and protection, from both rain and sun, and therefore a symbol of community life. If visitors could never experience the work as a whole, they were always aware that the work continued, in a way, on the other side of the world, that in some sense the umbrellas sheltered a global village.

The term "global village" was coined in 1962 by Marshall McLuhan (1911–1980) to describe the way that electronic mass media fundamentally altered human communication, enabling people to exchange information instantaneously, across the globe. In the nearly half century since then, of course, the introduction of personal computers,

Fig. 39.22 Christo and Jeanne-Claude, *The Umbrellas, Japan – USA.* **1984–91.** © 1991 Christo. Each umbrella could be cranked open in about 45 seconds. Over 4,000 workers opened them in about four hours. They remained on view for 18 days.

Fig. 39.23 Christo and Jeanne-Claude. *The Umbrellas, Japan – USA.* **1984–91.** © Christo. As opposed to California, where Christo and Jeanne-Claude had to negotiate with 26 landowners, in Japan, they worked with 452 different landowners.

cell phones, and pagers has empowered individuals to expand this communication further on an almost unimaginable scale. McLuhan idealistically viewed media as the means of creating a united, global community bridging the gap between the world's haves and have-nots. But because much of the electronic mass media has been controlled by the West, many critics saw it as a new means of asserting commercial and political control over the rest of the world—a new kind of imperialism. But in fact, the globalization of

mass media has resulted in a crisis of identity for most world cultures as local values and customs have come into conflict or been assimilated by those of the West.

Global media—whether it be motion pictures, cable television channels such as CNN, or Internet sites like Google and Wikipedia—have also transmitted many elements of popular foreign culture to the West. Asian and Mideastern cuisines, Japanese comic books and video games, and a vast array of foreign films, fashions, and fads have become popular in the West, aided by the "unlimited bandwidth" of modern telecommunications that offers individuals massive quantities of whatever information or entertainment they desire. International art exhibits, music and film festivals, and book fairs attract visitors and collectors from around the world in search of the latest trends and directions in contemporary art.

In the late twentieth and early twenty-first centuries, artists increasingly find themselves in a double bind—how, they ask, can they remain true to their native or ethnic identities and still participate in the larger world market? What happens to their work when it enters a context where it is received with little or no understanding of its origins? How, indeed, does the global threaten the local? Is the very idea of the "self" threatened by technology and technological innovation?

THINKING BACK

What factors contributed to changes in African-American self-definition in the 1960s?

By 1963, the Southern Christian Leadership Conference (SCLC), led by the Reverend Martin Luther King, Jr., had decided that Birmingham, Alabama, would be the focal point of the burgeoning civil rights movement. What message to the movement did King provide in his 1963 "Letter from Birmingham Jail"? In the summer of 1963, 250,000 people marching in Washington, D.C. heard Martin Luther King deliver his famous "I Have a Dream" speech, shortly after the folk-rock trio Peter, Paul, and Mary sang Bob Dylan's "Blowin' in the Wind."

One of the most important factors contributing to the success of the civil rights movement was the growing sense of ethnic identity among the African-American population. How did French existentialist philosopher Jean-Paul Sartre contribute to this newfound sense of self? How did it find expression in Ralph Ellison's novel *Invisible Man*? How did Romare Bearden celebrate the diversity of black experience? What contributed to the growing militancy of the civil rights movement, as reflected, for instance, in the poetry and drama of Amiri Baraka?

How did artists respond to the Vietnam War?

As American involvement in the war in Vietnam escalated throughout the 1960s, artists and writers responded in a number of ways. What tack did Kurt Vonnegut take in his 1969 novel *Slaughterhouse-Five*? Artworks like Claes Oldenburg's *Lipstick (Ascending) on Caterpillar Tracks* were conceived as antiwar protests, but more direct protests were taken up by the Art Workers' Coalition. What steps did they take? How did the artists' relationship with museums and galleries motivate both Conceptual Art and Land Art? But it was rock music that most reflected the spirit of rebellion and protest that characterized the antiwar movement. Musicians called for peace at festivals such as Woodstock and wrote songs reflecting the events of the day.

How did "high" culture and "popular" culture coexist in the musical world?

The ascendancy of rock and roll in popular culture underscores the ongoing intrusion of "low" or popular forms into the world of "high" culture that had begun with nationalist music movements in the nineteenth century. But minimalist musicians such as Karlheinz Stockhausen and György Ligeti put off both classical and popular audiences. What characterizes Ligeti's music? On what techniques did American minimalist composers like Terry Riley, Steve Reich, and Philip Glass rely? How does Glass's *Gesamtkunstwerk*, *Einstein on the Beach*, differ from Wagner's conception of the form? How does Laurie Anderson's *United States* transform the *Gesamtkunstwerk* in a popular idiom?

How did the feminist movement find expression in the arts?

In 1963, in her book *The Feminine Mystique*, Betty Friedan attacked the patriarchal construction of the idea of "woman." What was the primary object of her attack? Women artists and writers were equally engaged in asserting their place in an art world from which their work was, if not completely excluded, then demeaned as second rate. Poets Sylvia Plath, Anne Sexton, and Adrienne Rich wrote overtly feminist tracts directed against the social institutions that relegated women to second-place status in American society. Painters Eva Hesse and Judy Chicago fought to find a place in an art world that almost totally excluded women from exhibition and even gallery representation. However, the primary focus of artists like Eleanor Antin and Cindy Sherman was the social construction of female identity. How did each approach the issue?

How did male self-definition come into question?

Following the lead of feminists, artists like Richard Prince explored the ways in which male identity is socially constructed. What in particular did Prince focus on? How did the growing gay rights movement challenge male stereotypes?

PRACTICE MORE Get flashcards for images and terms and review chapter material with quizzes at **www.myartslab.com**

READINGS

Sylvia Plath, "Lady Lazarus" (1962)

Most of Sylvia Plath's best poetry was published posthumously. The major tension of the poem lies in its flippant tone compared with the seriousness of its subject—repeated suicide attempts. Plath wrote the poem and several other of her greatest works in the last month of her life, after her separation from her husband, the poet Ted Hughes, and just before her suicide in London. It establishes her poetic voice as a kind of performance, making light of her desire to die and her failure to succeed in accomplishing the deed. She is, thus, a deeply ironic Lazarus, returned from the dead, resurrected, but not in joy.

I have done it again.
One year in every ten
I manage it—

A sort of walking miracle, my skin
Bright as a Nazi lampshade,
My right foot

A paperweight,
My face featureless, fine
Jew linen.

Peel off the napkin 10
O my enemy.
Do I terrify?—

The nose, the eye pits, the full set of teeth?
The sour breath
Will vanish in a day.

Soon, soon the flesh
The grave cave ate will be
At home on me

And I a smiling woman.
I am only thirty. 20
And like the cat I have nine times to die.

This is Number Three.
What a trash
To annihilate each decade.

What a million filaments.
The peanut-crunching crowd
Shoves in to see

Them unwrap me hand and foot—
The big strip tease.
Gentlemen, ladies 30

These are my hands
My knees.
I may be skin and bone,

Nevertheless, I am the same, identical woman.
The first time it happened I was ten.
It was an accident.

The second time I meant
To last it out and not come back at all.
I rocked shut

As a seashell. 40
They had to call and call
And pick the worms off me like sticky pearls.

Dying
Is an art, like everything else.
I do it exceptionally well.

I do it so it feels like hell.
I do it so it feels real.
I guess you could say I've a call.

It's easy enough to do it in a cell.
It's easy enough to do it and stay put. 50
It's the theatrical

Comeback in broad day
To the same place, the same face, the same brute
Amused shout:

'A miracle!'
That knocks me out.
There is a charge

For the eyeing of my scars, there is a charge
For the hearing of my heart—
It really goes. 60

And there is a charge, a very large charge
For a word or a touch
Or a bit of blood

Or a piece of my hair or my clothes.
So, so, Herr Doktor.
So, Herr Enemy.

I am your opus,
I am your valuable,
The pure gold baby

That melts to a shriek. 70
I turn and burn.
Do not think I underestimate your great concern.

Ash, ash—
You poke and stir.
Flesh, bone, there is nothing there—

A cake of soap,
A wedding ring,
A gold filling.

Herr god, Herr Lucifer
Beware 80
Beware.

Out of the ash
I rise with my red hair
And I eat men like air.

READING CRITICALLY

Why does Plath evoke the Holocaust in this poem? What does she see as analogous to her own situation?

40 Without Boundaries

Multiple Meanings in a Postmodern World

THINKING AHEAD

What characterizes postmodern architecture?

How does postmodern theory reflect pluralist thought?

How are pluralism and diversity reflected in art and literature?

t is difficult to pinpoint exactly when "modernism" ended and "postmodernism" began, but the turning point came in the 1970s and 1980s. Architects began to reject the pure, almost hygienic uniformity of the Bauhaus and International styles, represented by the work of Mies van der Rohe (see Figs. 37.32 and 38.19), favoring more eclectic architectural styles that were anything but pure. A single building might incorporate a classical colonnade and a roof line inspired by a piece of Chippendale furniture. Or it might look like the Rasin Building in Prague (Fig. **40.1**). Built on the site of a Renaissance structure destroyed in World War II, the building's teetering sense of collapse evokes the postwar cityscape of twisted I-beams, blown-out facades with rooms standing open to the sky, and sunken foundations, all standing next to a building totally unaffected by the bombing. But that said, the building is also a playful, almost whimsical celebration, among other things, of the marvels of modern engineering—a building made to look as if it is at the brink of catastrophe, even as it is completely structurally sound. So lighthearted is the building that it was called the "Dancing House," or, more specifically, "Ginger and Fred," after the American film stars Ginger Rogers and Fred Astaire. The more solid tower on the corner seems to be leading the transparent tower—Ginger—by the waist, as the two spin around the corner.

The building was the idea of Czech architect Vlado Milunic [MILL-un-itch] (1941–), and he enlisted American architect Frank Gehry [GHEH-ree] (1929–) to collaborate on the project. To many eyes in Prague, a city renowned for its classical architecture, it seemed an absolutely alien American element dropped into the city. But Milunic conceived of the building as addressing modern Prague even as it engaged the city's past. He wanted the building to consists of two parts: "Like a society that forgot its totalitarian past—a static part—and a society that forgot its totalitarian past but was moving into a world full of changes. That was the main idea. Two different parts in dialogue, in tension, like plus and minus, like Yang and Yin, like man and woman." It was Gehry who nicknamed it "Ginger and Fred."

The use of many different, even contradictory elements of design is the hallmark of **postmodern** architecture. The English critic Peter Fuller explained the task of the postmodern architect this way:

> The west front of Wells Cathedral, the Parthenon pediment, the plastic and neon signs on Caesar's Palace in Las Vegas, even the hidden intricacies of a Mies curtain wall, are all equally "interesting." Thus the Post-Modern designer must offer a shifting pattern of changing strategies

◀ **Fig. 40.1 Frank Gehry and Vlado Milunic, the Rasin Building, also known as the Dancing House or "Ginger and Fred," Prague, Czech Republic. 1992–96.** The building was championed by Václav Havel (1936–), the Czech playwright who served as president of first Czechoslovakia and then the Czech Republic from the fall of the Soviet Union in 1989 until 2003. Havel had lived next door since childhood.

HEAR MORE Listen to an audio file of your chapter at **www.myartslab.com**

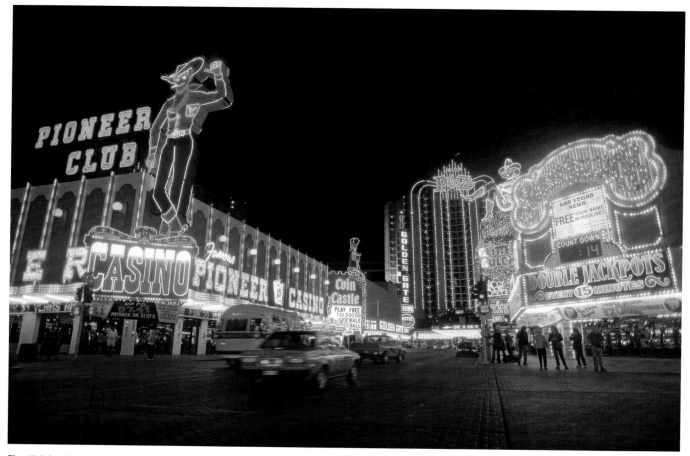

Fig. 40.2 Las Vegas, Nevada, Superstock, Inc. Especially at night, Las Vegas attacks the senses with a profusion of signs and lights. Known as the "Strip," it represents the overload of sensory input that has created the postmodern condition. The neon cowboy on the left is known as "Vegas Vic." In 1981, Vegas Vickie rose across the street above Glitter Gulch, which took its name from what locals were already calling the four-block length of Fremont Street. This photograph dates from about 1985.

and substitute a shuffling of codes and devices, varying ceaselessly according to audience, and/or building type, and/or environmental circumstance.

But perhaps the clearest and most seminal statement of the postmodern aesthetic is that of architect Robert Venturi (1925–), whose 1966 "Gentle Manifesto" described criteria for a new eclectic approach to architecture that abandoned the clean and simple geometries of the International Style (see Chapters 36 and 37). For Mies van der Rohe, "less is more" had become a mantra which he used to describe the refined austerity of his designs. Venturi argued for the opposite:

> An architecture of complexity and contradiction has a special obligation toward the whole: its truth must be in its totality or its implications of totality. It must embody the difficult unity of inclusion rather than the easy unity of exclusion. More is not less.

The model for this new architecture became, for Venturi, Las Vegas (Fig. 40.2). In *Learning from Las Vegas*, written in 1972 with his wife Denise Scott Brown (1931–) and fellow architect Steven Izenour (1940–2001), Venturi describes Las Vegas as a "new urban form":

> Although its buildings suggest a number of historical styles, its urban spaces owe nothing to historical space. Las Vegas space is neither contained and enclosed like medieval space nor classically balanced and proportioned like Renaissance space nor swept up in a rhythmically ordered movement like Baroque space, nor does it flow like Modern space around freestanding urban space makers.
>
> It is something else again. But what? Not chaos, but a new spatial order. . . . Las Vegas space is so different from the docile spaces for which our analytical and conceptual tools were evolved that we need new concepts and theories to handle it.

In what the authors describes as "the seemingly chaotic juxtaposition of honky-tonk elements," they also discovered an "intriguing kind of vitality and validity." Thus, for

Venturi and his colleagues, faced with the multiplicitous visual stimuli of Las Vegas, the postmodern architect has no choice but to design with various, even contradictory elements in order to communicate not a homogenous sense of unity, but rather "a difficult whole."

Living in this "difficult whole" constitutes the postmodern condition. The postmodern art and architecture examined in this chapter cannot be understood as a product of a single style, purpose, or aesthetic. It is defined by multiple meanings and its openness to interpretation. "Meaning" itself becomes contingent and open-ended. Indeed, postmodern media art introduces situations in which sight, sound, and text each challenge the "undivided" attention of the audience, sometimes creating a sensory overload in which meaning is buried beneath layers of contradictory and ambiguous information. Confronting the postmodern object, the postmodern mind must ask itself, "How do I sort this out?" And this is a question that, as people living in the postmodern age, we are increasingly adept at answering.

POSTMODERN ARCHITECTURE: COMPLEXITY, CONTRADICTION, AND GLOBALIZATION

Architects and builders exemplify the affluent nomads of the new postmodern society. They, like the people for whom they design and build, inhabit the "world metropolis," a vast, interconnected fabric of places resembling Las Vegas in large measure, where people do business, and between which they travel, work, and seek meaning. Travel, in fact, accounts for nearly 10 percent of world trade and global employment. As nearly 700 million people travel internationally each year, a half million hotel rooms are built annually across the globe to house them.

Today's architect works in the culture first introduced by the Sony Walkman and carried forward by the iPod and iPhone. These are technologies "designed for movement," as cultural historian Paul du Gay describes their function, "for mobility, for people who are always out and about, for traveling light . . . part of the required equipment of the modern 'nomad.'" And architects also are also responsible for helping to provide the most elusive of qualities in the postmodern world—a sense of meaning and a sense of place.

Architecture in this culture is largely a question of creating distinctive buildings, markers of difference like Frank Gehry's Ginger and Fred building in Prague that stand out in the vast sameness of the "world metropolis," so that travelers feel they have arrived at someplace unique, someplace identifiable. In this climate, contemporary architecture is highly competitive. Most major commissions are competitions, and most cities compete for the best, most distinctive architects.

Gehry first distinguished himself with the design of his own home in Los Angeles (Fig. 40.3). On the surface, it is a collision or eruption of parts. In the mid-1970s, still a young and relatively unknown architect, Gehry and his wife moved into a Santa Monica house that fulfilled their

Fig. 40.3 Frank Gehry, residence, Santa Monica, California, and axonometric drawing. 1977–78. Photograph by Tim Street-Porter. Gehry's neighbors were not at all pleased with his new house, but Gehry claims that he was trying to use "materials that were consistent with the neighborhood." He explains: "When I built that house, that neighborhood was full of trailer trucks in the back yards, and often on the lawn. A lot of old, aging Cadillacs and big cars on blocks on the front lawn, people fixing their cars. A lot of chain link fences, corrugated metal; I know they didn't use it like I did, and that's the difference."

Fig. 40.4 Frank Gehry, Guggenheim Museum, Bilbao. 1997. Photo: David Heald. © The Solomon R. Guggenheim Foundation, New York. The official description of the building begins: "The building itself is an extraordinary combination of interconnecting shapes. Orthogonal blocks in limestone contrast with curved and bent forms covered in titanium. Glass curtain walls provide the building with the light and transparency it needs." Even in its materials, it embodies complexity and contradiction.

main criterion—it was affordable. "I looked at the old house that my wife found for us," Gehry recalls, "and I thought it was kind of a dinky little cutesy-pie house. We had to do something to it. I couldn't live in it. . . . Armed with very little money, I decided to build a new house around the old house and try to maintain a tension between the two." The new house surrounding the old one is deliberately unfinished, almost industrial. A corrugated metal wall, chain-link fencing, plywood walls, and concrete block surround the original pink frame house with its asbestos shingles. The surrounding wall, with randomly slanted lines and angled protrusions, thus separates not only the "outside" house from the house within, but the entire structure from its environment. The tension established by Gehry between industrial and traditional materials, between the old house and the almost fortresslike shell of his home's new skin, intentionally creates a sense of unease in viewers (one certainly shared by Gehry's neighbors). The sense that they are confronting the "difficult whole" Venturi speaks about defines, for Gehry, the very project of architecture. If Gehry's architecture is disturbingly unharmonious with its surroundings, it cannot be ignored or taken for granted. It draws attention to itself *as* architecture.

Gehry's use of sculptural frames to surround his house—note the steel and wire fencing that extends over the roof behind the front door, which would be "decorative" or "ornamental" were it not so mundane—has continued throughout his career, culminating in his design for the Guggenheim Museum in Bilbao [bill-BOW ("bow" as in

"now")], Spain (Fig. **40.4**). Working on the models with the Catia computer program originally developed for the French aerospace industry, Gehry notes, "You forget about it as architecture, because you're focused on this sculpting process." The museum itself is enormous—260,000 square feet, including 19 gallery spaces connected by ramps and metal bridges—and covered in titanium, its undulating forms evoking sails as it sits majestically along the river's edge in the Basque port city. But it is the sense of the museum's discontinuity with the old town and the surrounding countryside (Fig. **40.5**) that most defines its postmodern spirit. It makes Bilbao, as a city, a more "difficult whole," but a more interesting one, too.

Gehry's design for the Guggenheim in Bilbao was stunningly successful, drawing critical raves, massive numbers of visitors, and even reservations that the architecture was so noteworthy that it overshadowed the art within the structure. One of the key elements of this success was Gehry's ability to ensure that the "organization of the artist" prevailed, as he put it, "so that the end product is as close as possible to the object of desire that both the client and architect have come to agree on." So postmodern architectural design and theory were not necessarily incompatible with the efficient completion of large, complex, and innovative structures like the Guggenheim in Bilbao (or the Experience Music Project museum in Seattle, another large-scale Gehry structure). And it turns out that the digital design models produced by the Catia program were not only useful for envisioning the shapes of "sculpted" buildings.

The data produced by such computerized designs was critical in estimating construction costs and budgets.

Besides Gehry, one of the most successful architects in these international competitions where contemporary architects make their reputations has been Spaniard Santiago Calatrava [kah-lah-TRAH-vah] (1951–), who has degrees in both engineering and architecture. Known especially for the dynamic curves of his buildings and bridges, his designs include the Athens Olympics Sports Complex (2001–2004), the Tenerife Opera House in the Canary Islands (2003), and the Turning Torso residential tower in Malmø, Sweden (2005). Based on the model of a twisting body, the 54-story Malmo tower consists of nine cubes, twisting 90 degrees from bottom to top, and rising to a rooftop observation deck with vistas across the Øresund [UR-uh-sun] strait to Copenhagen. Calatrava also won the

Fig. 40.5 Frank Gehry, Guggenheim Museum, Bilbao. 1997. Photo: David Heald. © The Solomon R. Guggenheim Foundation, New York. This view of the building looks through the streets of the old town to the hills beyond.

design competition for the Port Authority Trans Hudson (PATH) train station at the site of the former World Trade Center in New York (Fig. **40.6**). Scheduled for completion in 2014, it is based on a sketch Calatrava drew of a child's hands releasing a bird into the air. Calatrava said that the goal of his design was to "use light as a construction material." At ground level, the station's steel, concrete, and glass canopy functions as a skylight that allows daylight to penetrate 60 feet to the tracks below. On nice days, the canopy's roof retracts to create a dome of sky above the station.

One of the newest approaches to contemporary architecture takes into consideration the compatibility of the building with its environment. Increasingly, a building's viability—even beauty—is measured by its environmental self-sufficiency. Rather than relying on unsustainable energy sources, architects strive to design using sustainable building materials—eliminating steel, for instance, since it is a nonrenewable resource. The other important factor in modern architecture is adapting new buildings to the climate and culture in which they are built. These are the principles of what has come to be known as "green architecture."

One of the more intriguing new buildings to arise in the South Pacific region is the Jean-Marie Tjibaou [jee-bah-OO] Cultural Center in Nouméa, New Caledonia, an island northeast of Australia. It illustrates green architecture at work (Fig. **40.7**). The architect is Renzo Piano (1937–), an Italian, but the principles guiding his design are indigenous to New Caledonia. Named after a leader of the island's indigenous people, the Kanak, the center is dedicated to preserving and transmitting indigenous culture as well as incorporating sustainable environmental principles. The buildings are constructed of wood and bamboo, easily renewable resources, and each of the center's ten pavilions represents a typical Kanak dwelling. Piano left the dwelling forms unfinished, as if under construction, but they serve a function as wind scoops, catching breezes from the nearby ocean and directing them to cool the inner rooms. As in a Kanak village house, the pavilions are linked with a covered walkway. Piano describes the project as "an expression of the harmonious relationship with the environment that is typical of the local culture. They are curved structures resembling huts, built out of wood joists and ribs; they are containers of

Fig. 40.6 Santiago Calatrava, Design for Port Authority Trans Hudson (PATH) station, World Trade Center Site. 2004. Courtesy Santiago Calatrava/Port Authority of New York. The memorial to those who lost their lives at the World Trade Center lies directly behind the station.

Fig. 40.7 Renzo Piano, Jean-Marie Tjibaou Cultural Center in Nouméa, New Caledonia. 1991–98. The center's namesake, Jean-Marie Tjibaou, was assassinated in 1989 while trying to forge an agreement to free his country of French colonial rule. New Caledonia remains under French control today.

an archaic appearance, whose interiors are equipped with all the possibilities offered by modern technology."

The principles of environmentally sensitive architecture are, of course, harder to implement in densely populated urban environments. But when the city of Fukuoka, Japan, realized that the only space available for a much-needed government office building was a large two-block park that also happened to be the last remaining green space in the city center, Argentine-American architect Emilio Ambasz presented a plan that successfully maintained, even improved upon, the green space (Fig. **40.8**). A heavily planted and pedestrian-friendly stepped terrace descends down the entire park side of the building. Reflecting pools on each level are connected by upwardly spraying jets of water, to create a ladderlike climbing waterfall, which also serves to mask the noise of the city streets beyond. Under the building's 14 terraces lie more than 1 million square feet of space, including a 2,000-seat theater, all cooled by the gardens on the outside. The building is not entirely green—it is constructed of steel-framed reinforced concrete—and its interior spaces are defined by an unremarkable and bland white that might be

Fig. 40.8 Emilio Ambasz, ACROS Building (Fukuoka Prefecturial International Hall), Fukuoka, Japan. 1989–95. © Emilio Ambasz & Associates. On the street side of the building facing away from this view, the building looks like any other modern office building.

found in any modern high-rise office building. Still, the building suggests many new possibilities for reconceptualizing the urban environment in more environmentally friendly terms.

In planning for the 2008 Olympic Games in Beijing, the Chinese government invested in expensive energy-efficient heating and transportation systems and water-saving technologies that were designed to improve greatly the environmental quality of the city—one of the world's most populated. For the Olympic Stadium (Fig. **40.9**), the Chinese hired the Swiss design firm of Herzog and de Meuron, who conceived of a double structure, dubbed the "Bird's Nest": a red concrete seating bowl and, 50 feet outside the bowl, the outer steel frame, which structurally resembles the twigs of a bird's nest. The stadium floor provides enough space for the underground pipes of a geothermal heat pump (GHP) system, which in winter absorbs the heat from the soil and helps heat the stadium, while in summer the soil cools the stadium. A rainwater-collection system, on the stadium roof and the surrounding areas, purifies water and recycles it for use in the venue. The translucent roof provides essential sunlight for the grass below, and a natural, passive ventilation system.

PLURALISM AND POSTMODERN THEORY

During the Beijing Olympic Games in 2008, a painting by Chinese artist Zhang Hongtu [jang hong-too] (1943–), *Bird's Nest, in the Style of Cubism* (Fig. **40.10**), was seized by Chinese officials when it arrived at customs for exhibition at the German embassy. They were holding it, they said, pending "clarification of its meaning." As it turned out, officially, the painting's muted palette was deemed inappropriate for the celebratory nature of the Olympic games, and the government demanded that the painting be removed from China. But more than the painting's Cubist idiom, the government was provoked by the inclusion of the word "Tibet" just above "Human Right," both of which directly refer to China's 50-year occupation of that country (or province, from China's point of view). Also prominently displayed in the picture are the Chinese characters for the French supermarket chain Carrefour, which has stores all over China and whose purported support of the Dalai Lama (the Buddhist head of the Tibetan government in exile) resulted in protests across the country in the spring of 2008. The number "8" is repeated 23 times: the Chinese had decided to open the Olympics at 8 PM on August 8,

Fig. 40.9 Herzog & de Meuron, the Bird's Nest—Beijing National Stadium. 2004–08.
Corbis. The stadium was designed to be supplied with Beijing's first wind power plant.

Fig. 40.10 Zhang Hongtu, *Bird's Nest, in the Style of Cubism*. 2008. Oil on canvas, 36″ × 48″. © 2009 Zhang Hongtu Studio. "I'm a Chinese Muslim," Zhang Hongtu told the *New York Times* in 2008. "I don't care about anything pure—pure Chinese culture, or pure European culture. I don't think there's anything pure. I just want to mix, and from the mixture to make something new."

2008, and Zhang Hongtu was mocking what he called China's "stupid" numerological superstitions. At the bottom right is the letter *J* beside four horizontal lines, a reference to June 4, the date of the Tiananmen Square massacre in Beijing in 1989. Finally, the motto for the 2008 Olympics appears in Chinese characters: "One World, One Dream." If nothing else, these words clearly mean different things to Zhang Hongtu and Chinese government officials.

Zhang Hongtu's *Bird's Nest, in the Style of Cubism* is a clear-cut demonstration of one of the primary theoretical principles of postmodern thought: the growing conviction that meaning resides not in the work itself but in its audience, together with the understanding that the audience is itself diverse and various. Such thinking in turn gives rise to the belief that meaning is itself always plural in nature. There is no meaning, only a plurality of *meanings*.

Structuralism

The roots of this idea lie in French structuralism, which argues that meaning occurs not through identification but through difference. For instance, the words *woman* and *lady*

both refer to the human female, and yet their meanings are determined by cultural markers or codes of enormous difference. Structuralism also forms the basis for semiotics, the study of signs. A sign consists of the relation between the signifier and the signified—that is, the relation between the word *tree*, for instance, and all the possible trees to which that word might refer. Semiotic theory thus posits the following formula as fundamental to the study of signs:

$$\text{Sign} = \frac{\text{S [signifier]}}{...s1...s2...s3...s4...}$$
$$\text{[possible signifieds]}$$

The string of signifieds is potentially infinite. That is, the word *tree* technically refers to every possible tree, and we understand its reference only in context. For instance, we add other words to "tree" to differentiate it from other trees—"pine tree" or "willow tree"—to delimit the plurality of its potential meanings, or still more words, "the tallest pine tree in the park." This construction of difference is fundamental to understanding, but it is important to understand that the word *tree* in and of itself is infinitely plural in its potential meanings.

Some signs carry with them larger cultural meanings. The French philosopher Roland Barthes [BART] (1915–1980) described these as "mythologies." Anything can take on the characteristics of myth. For example, two-story pillars supporting the portico of a house are a mythic signifier of wealth and elegance, and Barthes's great self-appointed task as a philosopher was to expose the mythologies—instances of what he calls the "falsely obvious"—that inform contemporary understanding. Zhang Hongtu's *Bird's Nest, in the Style of Cubism* could usefully be approached as an example of just such a reading of the Beijing Olympic Games. The act of reading cultural "texts"—and "texts" need not be thought of here as actual sentences strung together, but as any system of signs, including painting, performance, advertising, film, and so forth—becomes an act of decoding and revealing the mythologies at work in the text. We have come to call this process *deconstruction*.

Deconstruction and Poststructuralism

The chief practitioner of deconstruction was the French philosopher Jacques Derrida (1930–2004). Deconstruction is not synonymous with "destruction," as is commonly thought, but rather it suggests that the "text" be analyzed and taken apart in order to show what has been left out or overlooked. Why does this matter? Because it indicates that there is always more to be said, that meaning is never complete. Deconstruction poses meaning as an arena of endless and open possibility.

Derrida is considered a poststructuralist (as is Barthes in his later writing) because one of the "texts" that poststructuralists most thoroughly submit to deconstruction is structuralism itself. Because it is founded on the principle of difference, structuralism tends to focus on the binary opposition as fundamental to the structure of thought. In his most famous work, *Of Grammatology* (published in France in 1967 and in English translation in 1976), Derrida points out that binary oppositions are algebraic (a = not-b), and thus the two terms in binary pairs (good/evil; conscious/unconscious; masculine/feminine; light/dark; presence/absence) can't exist without reference to the other. That is, light (as presence) is defined as the absence of darkness, goodness as the absence of evil, and so on. *Of Grammatology* looks particularly at the opposition speech/writing. In Western philosophy, speech has always been privileged over writing because in the act of speech the self is fully present in its being; on the other hand, writing, in its dissemination across time and space to an audience necessarily removed from the originary moment of meaning, is always experienced as an absence, as second-hand speech. Metaphoric speech is a particularly potent example of this. A metaphor is a form of substitution, at one remove from its meaning. It is but a *trace* (Derrida's word) of what is already absent. In the end, what Derrida reveals in his deconstruction of the speech/writing binary in Western culture is that the emphasis on that fullness of being realized in the act of speech is

actually a cultural nostalgia for a wholeness that has long since—perhaps always—been lost.

Chaos Theory

Derrida is by no means easy to understand, but it should be clear that his thinking is not unrelated to Robert Venturi's idea of the "difficult whole." It is also akin to developments taking place in the natural sciences first introduced to a wider public in James Gleik's 1987 *Chaos: Making a New Science*. To many, in fact, the new chaos theory offered a way to go beyond deconstruction, which seemed doomed to subvert endlessly the binary structures that structuralists construct. Chaos theorists posited that biological and mathematical patterns that appear random, unstable, and disorderly are actually parts of larger, more "difficult wholes." The fractal geometry of Benoit Mandelbrot (1924–2010) is a prime example. Mandlebrot disdained traditional Euclidean geometry because it was incapable of describing such forms as clouds, mountains, and coastlines, all of which, like most things in nature, exhibit a different order of complexity than the traditional building blocks of geometry—the sphere, the cylinder, and the cone, for instance. Mandlebrot was convinced that such irregular shapes as coastlines and mountains display previously unrecognized orders. When certain basic forms, he argues, are repeated again and again at different scales of length, structures emerge that are quite different from the basic forms of which they are composed. One of Mandlebrot's favorite examples is the so-called Koch snowflake in which the structure of an equilateral triangle is repeated again and again to create remarkably intricate curvilinear and twisted shapes. Equipped with mathematical models he developed to describe these shapes, Mandlebrot was able to generate dynamic, unpredictable, and seemingly living organisms on the computer screen from basic rectilinear or triangular forms.

The computer has, in fact, made it possible to visualize this complexity. If each pixel on a computer screen is assigned a numerical value and then submitted to what is known in mathematics as iterative equations, a series of increasingly and infinitely complex patterns emerge that have come to be known as the Mandelbrot set (Fig. **40.11**). If the result of these iterative equations is stable, the pixel is colored black. If the equation moves off toward infinity, the pixel is assigned a color, depending on its rate of acceleration—blue, for instance, for slow rates, red for faster ones. Acceleration occurs at the boundaries of the set, and it is possible, in these areas, to bring out finer and finer detail by zooming in to smaller and smaller areas of the edge. The haunting beauty of these designs has attracted artists and scientists alike.

Of at least equal importance to chaos theory is the work of meteorologist Edward Lorenz (1917–2008). In 1961, he was working on the problem of weather prediction. His computer was equipped with a set of 12 equations to model what the weather might be. One day, he wanted to see a

Fig. 40.11 The Mandelbrot set. From Hans-Otto Peitgen and Peter H. Richter, *The Beauty of Fractals* (Berlin: Springer-Verlag, 1986). Since an infinite number of points exist between any two given points, by zooming in to a small area of the set, the infinite complexity of the set reveals itself. The detail of the Mandelbrot set is infinite. By focusing in on the area between the left-hand circle and the largest black form, an area known as the "seahorse valley," with its spiraling tails, reveals itself.

particular sequence again, and to save time, he started in the middle of the sequence, instead of at the beginning. When he came back an hour later, he discovered that instead of the same pattern as before, a wildly different one had emerged. He eventually discovered what caused the difference. In the original sequence, the beginning number had been 0.506127, but to save paper, in the second instance, he had only typed the first three digits, 0.506. This result came to be known as the *butterfly effect*. The amount of difference in the starting points of the two curves is so small that it is comparable to a butterfly flapping its wings, thus producing a minute change in the state of the atmosphere, but one of profound consequence—producing, in a monthtime, perhaps a hurricane in the Atlantic, or, as the case may be, averting one that was otherwise bound to happen.

The Human Genome

Today, chaos theory is being usefully applied to everything from project management to population dynamics, to the descriptions of the spread of disease, and to DNA and genome research. In fact, in 2003, the federally sponsored Human Genome Project, initiated in 1990, succeeded in identifying all of the approximately 20,000 to 25,000 genes in human DNA and determining the structural sequences of the approximately 3 billion chemical base pairs that make up human DNA that regulate the human cellular system in its operations and functions. There are four similar chemicals that make up DNA, paired in the human genome and repeated 3 billion times; their order determines

how we look, how we eat and fight disease, and even, sometimes, how we behave. Through their understanding of this order, scientists are increasingly able to diagnose and predict hereditary disease and, perhaps the most exciting application of DNA research, use gene therapy to repair and regenerate tissue. Among the more recent outcomes of this revolutionary new medical practice are a treatment for a type of inherited blindness, the use of reengineered immune cells to attack cancer cells in patients with advanced metastatic melanoma (the most deadly form of skin cancer), the cure of deafness in guinea pigs, and the eradication of sickle cell anemia in mice—these last two, treatments that scientists hope to apply to human subjects one day.

PLURALISM AND DIVERSITY IN THE ARTS

Our understanding of the complexities of experience as realized in the practice of deconstruction, chaos theory, and the opportunities opened to science by the mapping of the human genome, has found expression in the arts as well. Despite the apparent plurality of its many "-isms," modern art, from the moment that Braque and Picasso affirmed the primacy of the conceptual over the optical, systematically replaced the representation of the world with the representation of an "idea." This was a process that led to ever greater abstraction, culminating in many ways in the art of Minimalism. Pop Art offered a different model—works that aimed at inclusion, not exclusion, and the promise that anything might be permissible. A photograph by Louise Lawler

Fig. 40.12 Louise Lawler, *Pollock and Tureen*. 1984. Cibachrome, 28″ × 39″. Courtesy Metro Pictures, New York. The formal parallel of linear rhythm and color harmonies in both the painting and the tureen contradicts their obvious differences.

(1947–), *Pollock and Tureen* (Fig. **40.12**), summarizes this sense of diversity and multiplicity. Lawler's work attempts to demonstrate how context, from museums to exhibition catalogues to private homes, determines the ways in which images are received and understood. Thus, the Pollock painting in this photograph is transformed into a decorative or ornamental object, much like the tureen centered on the side table in front of it. Lawler both underscores the fact that the painting is, like the tureen, a marketable object and suggests that the expressive qualities of the original work— its reflection of Pollock's Abstract Expressionist feelings— have been emptied, or at least nearly so, when looked at in this context.

A Plurality of Styles in Painting

By the end of the 1960s, artists felt free to engage in a wide spectrum of experimental approaches to painting, ranging from the stylized imagery introduced by Pop artists to the street style of graffiti writers (see the *Closer Look* on Jean-Michel Basquiat, pages 1326–1327), and from full-blown abstraction to startlingly naturalistic realism. Indeed, the exchange of ideas between proponents of realism and those of abstraction during the post–World War II era had far-reaching effects. Rather than an either/or proposition, there is abundant cross-fertilization between the approaches. We can see this in the work of the contemporary German artist Gerhard Richter [RIKH-ter] (1930–), who moves freely between the two—sometimes repainting

photographs, black-and-white and color—and sometimes creating large-scale abstract works. Richter uses photographs, including amateur snapshots and media images, because, he says, they are "free of all the conventional criteria I had always associated with art . . . no style, no composition, no judgment." To him, they are "pure" pictures, unadulterated by the intervention of conscious aesthetic criteria. *Meadowland* (Fig. **40.13**), an oil painting on canvas, might as well have been taken from the window of a passing car. The questions it raises are quite simple: Why did he select this photograph to translate into a painting? How and when does the eye sense the difference between a painting and the photographic surface?

In comparing *Meadowland* to the artist's abstractions, which he concentrated on throughout the 1980s and 1990s, we can begin to answer these questions. Works such as *Ice (2)* (Fig. **40.14**) are obviously paintings. One senses that Richter begins with a realistic image, and before the ground completely dries, he drags another layer of paint through it with a squeegee or palette knife. The result is like viewing an object close up while passing it at high speed. But the resulting work is above all a painterly surface, not a photographic one. Nevertheless, in Richter's words:

abstract paintings . . . visualize a reality which we can neither see nor describe but which we may nevertheless conclude exists. We attach negative names to this reality; the unknown, the ungraspable, the infinite, and for

Fig. 40.13 Gerhard Richter, _Meadowland_. 1992. Oil on canvas, 35 ⁵/₈″ × 37 ¹/₂″. Blanchette Rockefeller, Betsy Babcock, and Mrs. Elizabeth Bliss Parkinson Funds. (350.1985). Digital Image © The Museum of Modern Art/Licensed by SCALA/Art Resource, New York. © Gerhard Richter, Germany. In 1964, Richter began collecting the source photos for all his paintings and arranging them on panels. When the resulting work, _Atlas_, was exhibited in 1995 at the Dia Center for the Arts in New York, it contained 683 panels and close to 5,000 photographs.

thousands of years we have depicted it in terms of substitute images like heaven and hell, gods and devils. With abstract painting we create a better means of approaching what can be neither seen nor understood because abstract painting illustrates with the greatest clarity, that is to say with all the means at the disposal of art, "nothing." . . . [Looking at abstract paintings] we allow ourselves to see the un-seeable, that which has never before been seen and indeed is not visible.

Given this artistic strategy, Richter's photograph-based works are paintings of the graspable and visible. Why did he select the photograph upon which _Meadowland_ is based? Precisely because it is so mundane, a prospect we have so often seen before. How and when do we recognize _Meadowland_ as a painting and not a photograph? When we accept photographic clarity—or photographic blurring, for that matter—as one of the infinite methods of painting. Richter's photographic paintings are thus the very antithesis of his abstractions, except that both styles are equal statements of the artist's vision. Together, in them, Richter explores not only the conditions of seeing but the possibilities of painting. Richter might be the ultimate postmodernist: "I pursue no objects, no system, no tendency," he writes. "I have no program, no style, no direction. . . . I steer clear of definitions. I don't know what I want. I am inconsistent, non-committal, passive; I like the indefinite, the boundless; I like continued uncertainty."

Fig. 40.14 Gerhard Richter (German, b. 1932), _Ice (2)_. 1989. Oil on canvas, 6′8″ × 63⁷/₈″ (203.2 × 162.6 cm). Through prior gift of Joseph Winterbotham; gift of Lannan Foundation, 1997.188. Reproduction, the Art Institute of Chicago. All Rights Reserved. In the abstractions, the blurred effect of the photograph-based works has been heightened. We seem to be looking at the world through a sheet of ice.

Charles the First by Jean-Michel Basquiat [bah-skee-AH] (1960–1988) is an homage to the great jazz saxophonist Charlie Parker, one of a number of black cultural heroes celebrated by the graffiti-inspired Basquiat. Son of a middle-class Brooklyn family (his father was a Haitian-born accountant, his mother a black Puerto Rican), Basquiat left school in 1977 at age 17 and lived on the streets of New York for several years, during which time he developed the "tag"—or graffiti pen-name—SAMO, a combination of "Sambo" and "same ol' shit." SAMO was most closely associated with a three-pointed crown (as self-anointed "king" of the graffiti artists) and the word "TAR," evoking racism (as in "tar baby"), violence ("tar and feathers," which he would entitle a painting in 1982), and, through the anagram, the "art" world as well. A number of his paintings exhibited in the 1981 New York/New Wave exhibit at an alternative art gallery across the 59th Street Bridge from Manhattan attracted the attention of several art dealers, and his career exploded.

Central to his personal iconography is the crown, which is a symbol of not only his personal success but also the other African-American heroes that are the subject of many of his works—jazz artists, as is the case here, and "famous Negro athletes," as he calls them, such as boxer Sugar Ray Leonard and baseball's Hank Aaron.

The price of a halo at 59¢ suggests that martyrdom is "for sale" in Basquiat's world.

Beneath the crown that Basquiat had introduced in his SAMO years is a reference to Thor, the Norse god; below it, the Superman logo; and above it, a reference to the Marvel comic *X-Men* heroes. Thor is, in fact, another X-Man hero. Marvel describes the X-Men as follows: "Born with strange powers, the mutants known as the X-Men use their awesome abilities to protect a world that hates and fears them." Basquiat clearly means to draw an analogy between the X-Men and his African-American heroes.

The *X* in Basquiat's work is never entirely negative. In Henry Dreyfuss's *Symbol Sourcebook: An Authoritative Guide to International Graphic Symbols*, Basquiat discovered a section on "Hobo Signs," marks left, graffiti-like, by hobos to inform their brethren about the lay of the local land. In this graphic language, an *X* means "O.K.; All right."

This phrase is a reference to the other "Charles the First"—King Charles I of England, beheaded by Protestants in the English Civil War in 1649 (see Chapter 23). But it also suggests, especially considering the crossed-out word *young*, Basquiat's sense of his own martyrdom. In fact, four months before his twenty-eighth birthday, in 1978, he would become the victim, according to the medical examiner's report, of "acute mixed drug intoxication (opiates–cocaine)."

The *S*, especially crossed out, also suggests dollars, $.

Something to Think About . . .

Many viewers are at least initially put off by the apparent sloppiness of Basquiat's distinctive style. But Basquiat has adopted this style for a purpose. What do you imagine his purpose might be?

SEE MORE For a Closer Look at Jean-Michel Basquiat's *Charles the First,* go to **www.myartslab.com**

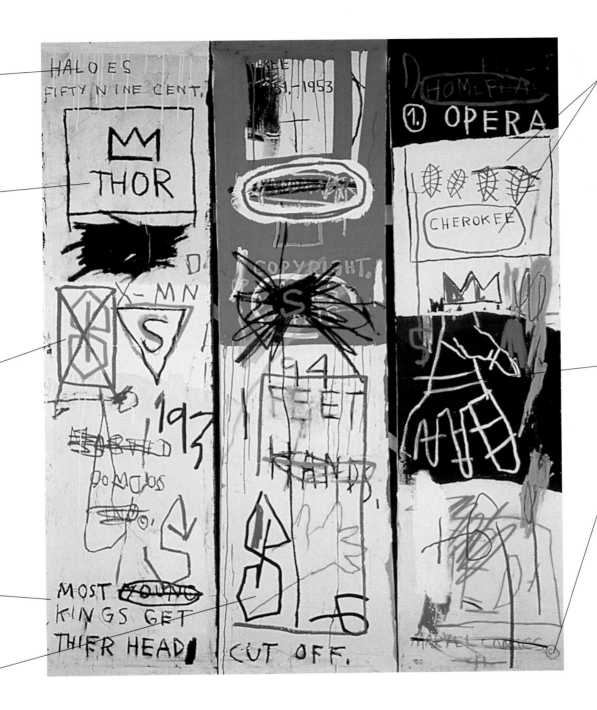

Beneath the word *Opera*, and apparently on a par with the most aristocratic of musical genres, is the title of one of Parker's greatest tunes, "Cherokee," topped by four feathers in honor of Parker's nickname, *Bird*. The feathers and song also evoke the Cherokee Indians' forced removal from Georgia to Oklahoma in 1838 (see Chapter 32).

The hand probably represents the powerful hand of the musician, and equally the painter.

The copyright sign, ©, which also appears spelled out at the top of the middle panel, is repeated again and again in Basquiat's work and suggests not just ownership but the exercise of property rights and control in American society, which Basquiat sees as the root cause of the institution of slavery (to say nothing of the removal of the Cherokee nation to Oklahoma).

Jean-Michel Basquiat, *Charles the First.* **1982.** Acrylic and oil paintstick on canvas, three panels, 78″ × 62¹/₄″ overall. © The Estate of Jean-Michel Basquiat/© 2009 Artists Rights Society (ARS), New York.

Another approach to the question of the relation between abstraction and representation is seen in the works of Pat Steir [steer] (1940–). In 1989, she adapted Pollock's drip technique to her own ends, allowing paint to flow by force of gravity down the length of her enormous canvases to form recognizable waterfalls. *Yellow and Blue One-Stroke Waterfall* (Fig. **40.15**) is 14 feet high, its format reminiscent of Chinese scroll paintings of waterfalls. Steir explained the rationale behind her series of waterfall paintings in a 1992 interview:

> I don't think of these paintings as abstract. . . . These are not only drips of paint. They're paintings of drips which

form waterfall images: pictures. . . . [Nor are] they realistic . . . I haven't sat outdoors with a little brush, trying to create the illusion of a waterfall. The paint itself makes the picture. . . . Gravity make the image. . . .

> These paintings are, in a sense a comment on the New York School [i.e., the first generation of Abstract Expressionists, including Pollock and de Kooning], a dialogue and a wink. They [her waterfall paintings] say, "You didn't go far enough. You stopped when you saw abstraction." . . . I've taken the drip and tried to do something with it that the Modernists denied.

Multiplicity in Postmodern Literature

The pursuit of meaning lies at the heart of postmodern literature, but because meaning is always plural and fleeting, attempting to find any permanent or stable meaning in the postmodern world can only lead to frustration. The postmodern hero seeks meaning, but accepts the fact that the search is never-ending. At the beginning of his study of the Western experience of order, entitled *The Order of Things* (in English translation), French historian Michel Foucault [foo-KOH] (1926–1984) describes the origins of his study (**Reading 40.1**):

Fig. 40.15 Pat Steir, *Yellow and Blue One-Stroke Waterfall.* 1992. Oil on canvas, 14′6 $\frac{1}{4}$″ × 7′6 $\frac{3}{4}$″. The Solomon R. Guggenheim Museum, New York. Gift, John Eric Cheim, 1999. 99.5288. Steir's work is deeply informed by her interest in Tibetan and Chinese religious lore, and she is interested in creating something of their meditative space.

READING 40.1

from Michel Foucault, *The Order of Things* (1966)

This book first arose out of a passage in Borges, out of the laughter that shattered, as I read the passage, all the familiar landmarks of my thought—our thought, the thought that bears the stamp of our age and our geography—breaking up all the ordered surfaces and all the planes with which we are accustomed to tame the wild profusion of existing things. . . . This passage quotes a "certain Chinese encyclopedia" in which it is written that "animals are divided into: (a) belonging to the Emperor, (b) embalmed, (c) tame, (d) suckling pigs, (e) sirens, (f) fabulous, (g) stray dogs, (h) included in the present classification, (i) frenzied, (j) innumerable, (k) drawn with a very fine camelhair brush, (l) et cetera, (m) having just broken the water pitcher, (n) that from a long way off look like flies." In the wonderment of this taxonomy, the thing we apprehend in one great leap, the thing that . . . is demonstrated as the exotic charm of another system of thought, is the limitation of our own, the stark impossibility of thinking that.

The impossibility of Borges's encyclopedia is based on how impossible it is for contemporary thought to recognize difference with no relation to opposition or relation to a common ground—each element in Borges's taxonomy requires a complete shift in point of view, requiring readers to reposition their viewpoint. There is, as Foucault points out, "no *common locus*" beneath this taxonomy, no *center* around which to organize its elements. But it is precisely this possibility of

"thinking *that*" that is the goal of postmodern literature. To this point in this survey of the Western humanities, we have referred to a historical series of shifting geographic centers, each one providing a common cultural locus for thought. Postmodern thought alters the situation. The postmodern world consists of multiple centers of thought, each existing simultaneously and independently of one another.

Jorge Luis Borges's [BOR-hays] (1899–1986) short essay entitled "Borges and I" (see **Reading 40.2**, page 1345) may be the first postmodern exploration of this state of affairs. Borges describes himself as a bodily self divided from his persona as a writer. In the postmodern world, meaning shifts according to place and time and, Borges teaches us, point of view—not only the writer's but our own. Meaning might well be determined by a myriad of semantic accidents or misunderstandings, or by a reader whose mood, gender, or particular cultural context defines, for the moment, how and what he or she understands. Postmodern writing produces texts that willingly place themselves in such an open field of interpretation, subject to uncertainty.

Postmodern Fiction A working definition of postmodern fiction thus might include any form of writing that defeats the readers' expectations of coherence, that dwells on the uncertainty and ambiguity of experience, and that requires readers who can adjust to that situation. Among its most notable practitioners are Paul Auster (1947–), William Gass (1924–), Don DeLillo (1936–), Donald Barthelme (1931–1989), John Barth (1930–), John Hawkes (1925–1998), Italo Calvino (1923–1985), Umberto Eco (1932–), and Thomas Pynchon (1937–).

Pynchon's 1963 novel *V.* is a good example. Set in the mid-1950s, it takes its title from the ongoing quest of one of its two protagonists, Herbert Stencil, for a woman mentioned in his late father's journals. The journal entry is cryptic: "Florence, April, 1899 . . . There is more behind and inside V. than any of us had suspected. Not who, but what: what is she." She is connected, Stencil understands, "with one of those grand conspiracies or foretastes of Armageddon which seemed to have captivated all diplomatic sensibilities in the years preceding the Great War. V. and a conspiracy." Stencil is convinced that "she" still exists, that she is something of an explanation for World War II, for the bomb, for apartheid in South Africa, for all evil. And, as it turns out, "she" is everywhere. She is Venus, the Virgin, the Vatican, Victoria Wren (who had seduced Stencil's father in Florence in the late nineteenth century), Veronica Manganese (Victoria Wren's reinvention of herself in World War I Malta), and Vera Meroving (her next incarnation in Southwest Africa). Ultimately she is transformed from the animate human being to an inanimate "force" behind Germany's V-1 missiles, which devastated London in World War II. Perhaps most of all, V. is the *vanishing point*, the place on the horizon where two parallel lines appear to converge, but is never reachable. Pynchon's novel ends as a conventional murder mystery, in which the criminal does not turn out to be a person so much as a metaphysical force.

In another metaphysical detective story, *City of Glass* (1985), Paul Auster finds himself a character in his own story, suddenly confronting another of his characters, a mystery writer named Daniel Quinn who writes under the pseudonym William Wilson. Quinn has come to Auster's door (**Reading 40.3a**):

READING 40.3a

from Paul Auster, *City of Glass* (1985)

It was a man who opened the apartment door. He was a tall dark fellow in his mid-thirties, with rumpled clothes and a two-day beard. In his right hand, fixed between his thumb and first two fingers, he held an uncapped fountain pen, still poised in a writing position. The man seemed surprised to find a stranger standing before him.

"Yes?" he asked tentatively.

Quinn spoke in the politest tone he could muster. "Were you expecting someone else?"

"My wife, as a matter of fact. That's why I rang the buzzer without asking who it was."

"I'm sorry to disturb you," Quinn apologized. "but I'm looking for Paul Auster."

"I'm Paul Auster," said the man.

The elimination of any distance between the author and his work draws attention to the act of writing, a typical strategy of postmodern fiction. In blurring the boundaries between life and art, reality and fiction, Auster's fictional work becomes *real* in some sense. We can thus gain a clue to Auster's motivation by his character Quinn's explanation early in the novel, about why he writes detective stories (**Reading 40.3b**):

READING 40.3b

from Paul Auster, *City of Glass* (1985)

What he liked about these books was their sense of plenitude and economy. In the good mystery there is nothing wasted, no sentence, no word that is not significant. And even if it is not significant, it has the potential to be so—which amounts to the same thing. The world of the book comes to life, seething with possibilities, with secrets and contradictions. Since everything seen or said, even the slightest, most trivial thing, can bear connection to the outcome of the story, nothing must be overlooked. Everything becomes essence; the center of the book shifts with each event that propels it forward. The center, then, is everywhere, and no circumference can be drawn until the book has come to its end.

The detective is one who looks, who listens, who moves through this morass of objects and events in search of the thought, the idea that will pull all these things together and make sense of them. In effect, the writer and the detective are interchangeable. The reader

sees the world through the detective's eyes, experiencing the proliferation of its detail as if for the first time. He has become awake to the things around him, as if, because of the attentiveness he now brings to them, they might begin to carry a meaning other than the simple fact of their existence.

By abolishing distinction between detective, writer, and reader, Auster not only highlights the act of writing, but the act of reading as well, with the reader becoming implicated in the novel's intrigues. Literally caught up in his own fiction, Auster's fictional self spins into a life "seething with possibilities, with secrets and contradictions."

Postmodern Poetry

Because the postmodern self is plural, postmodern literature—including poetry—encompasses a plurality of meanings. Indeed, one of the principal strategies of postmodern poetry is to take advantage of the indeterminacy of certain words—particularly "it," and so-called "pointers," such as "this" and "that"—which, without clear antecedent, might designate anything and everything. This short poem, by David Antin (1932–), is a clear example (**Reading 40.4a**):

READING 40.4a
David Antin, "If We Get It" (1987–1988)

IF WE GET IT TOGETHER
CAN THEY TAKE IT APART
OR ONLY IF WE LET THEM

To make the point even more indeterminate (and evanescent), Antin's poem was traced out by skywriters in the skies above Santa Monica beach, one line at a time, each line disappearing as the planes circled back to start the next, on Memorial Day, May 23, 1987. Over a year later, on Labor Day weekend, 1988, skywriters wrote the second stanza of Antin's poem over a beach in La Jolla, north of San Diego (**Reading 40.4b**):

READING 40.4b
David Antin, "If We Make It" (1987–1988)

IF WE MAKE IT TOGETHER OR
FIND IT WILL THEY BREAK IN
OR OUT OF IT OR LEAVE IT
AS THEY FIND IT STRICTLY ALONE

The "it" here is completely imprecise and open to interpretation, but the opacity of its reference was exacerbated by the fact that each line of the poem disappeared from sight before the next was written even as the second stanza followed the first by 15 months. Always in the process of its own dissolution and revision, the poem is never "wholly" present to its audience, its meaning always disappearing.

The abolition of meaning is the express subject of many of the poems of one of America's most prominent—and eclectic—poets, John Ashbery (1927–). As Ashbery relates in "On the Towpath," every time we arrive at meaning, we realize, "No, / We aren't meaning that any more." The poem opens as narrative, but the promise of a story almost immediately recedes (**Reading 40.5**):

READING 40.5
from John Ashbery, "On the Towpath" (1977)

At the sign "Fred Muffin's Antiques" they turned off the road into a narrow lane lined with shabby houses.

If the thirst would subside just for awhile
It would be a little bit, enough.
This has happened.
The insipid chiming of the seconds
Has given way to an arc of silence
So old it had never ceased to exist
On the roofs of buildings, in the sky.

The ground is tentative.
The pygmies and jacaranda that were here yesterday
Are back today, only less so.
It is a barrier of fact
Shielding the sky from the earth.

When Ashbery writes, "This has happened," the reader asks, *what* has happened? Ashbery's "This" is entirely ambiguous. What is "tentative" ground? Muddy? Slippery? Along the "towpath" it might well be, but it is also possible for "the ground" to mean "meaning" itself. Isn't "meaning" frequently tentative and slippery? Similarly, when Ashbery writes "It is a barrier of fact," to what does his "it" refer? Later in the poem, he writes,

The sun fades like the spreading
Of a peacock's tail, as though twilight
Might be read as a warning to those desperate
For easy solutions.

Ashbery's sense of play and experimentalism, along with his subversive humor, deliberately frustrates those who desire closure, or meaning. "No," he writes at the end of the poem:

We aren't meaning that any more.
The question has been asked
As though an immense natural bridge had been
Strung across the landscape to any point you wanted.
The ellipse is as aimless as that,
Stretching invisibly into the future so as to reappear
In our present. Its flexing is its account,
Return to the point of no return.

The pun here involves the elliptical arch of Ashbery's imaginary bridge: "The ellipse is" is also "the ellipsis," literally omitting from a sentence a word or phrase that would complete or clarify its meaning. The poem, finally, returns to the point where we recognize we must go on, "into the future," with however little "meaning" there is. For Ashbery, there are only questions, uncertainties, and tentative ground—a concise statement of the postmodern condition.

A Diversity of Cultures: The Cross-Fertilization of the Present

"Language is a virus," declared American author William S. Burroughs (1914–1997), referring, at least in part, to the fact that American English has become the international language of business, politics, the media, and culture—a plague upon indigenous languages that threatened their extinction. In this context, the collision of global cultures could hardly be ignored. In Asia and Africa, in the Latino, Hispanic, and American Indian worlds, and in Islam, artists have responded by acknowledging that life in a global world increasingly demands that they accept multiple identities. They increasingly find themselves in a double bind—how, they ask, can they remain true to their native or ethnic identities and still participate in the larger world market? What happens to their work when it enters a context where it is received with little or no understanding of its origins? How, indeed, does the global threaten the local? Is the very idea of the "self" threatened by technology and technological innovation?

The Asian Worldview Although the Japanese have traditionally considered their culture as literally "insular," and largely isolated from outside influence, by the late 1980s, artists like Yasumasa Morimura [mor-ih-moo-rah] (1951–) directly engaged the West. In *Portrait (Twins)* (Fig. 40.16), the artist poses as both Manet's *Olympia* (see the *Closer Look*, Chapter 30) and her maid, manipulating the photograph with a computer in the studio, while subverting the idea of

CONTINUITY & CHANGE

Olympia, **p. 1001**

Japanese isolationism even more pointedly. On the one hand, he copies the icons of Western culture, but at the same time he undermines them, drawing attention to the fact that the courtesan and her maid share the same identity—they are "twins"—slaves to the dominant (male) forces of Western society. He places Japanese culture as a whole—and in particular the Japanese male—in the same position, as prostitute and slave to the West.

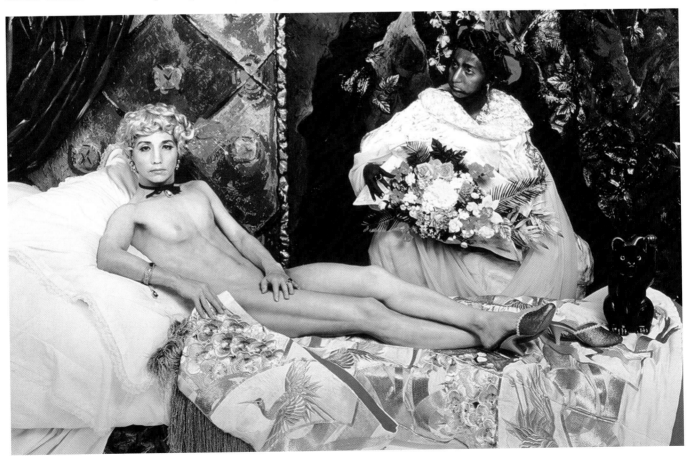

Fig. 40.16 Yasumasa Morimura, *Portrait (Futago)*. 1988. Color photograph, clear medium; 82 $^3/_4$″ × 118″ inches.
Courtesy of the artist and Luhring Augustine, New York. By cross-dressing—and in this image, un-cross-dressing, Morimura challenges Japanese male gender identity as well.

Fig. 40.17 Zhang Huan, *To Raise the Water Level in a Fish Pond.* **August 15, 1997.** Performance documentation (middle distance detail), Nanmofang Fishpond, Beijing, China. C-Print on Fuji archival, 60″ × 90″. Courtesy Max Protetch Gallery. Though the performance was a political act, Zhang Huan acknowledged that raising the water in the pond one meter higher was "an action of no avail."

In Morimura's photograph, transcultural exchange is also a transgendered performance. All boundaries, between East and West, male and female, seem to disintegrate, as does the distinction between humans and machines. Morimura's work is a parable of the real possibility of the loss of the self—imagined as the loss of the body—in the technological space of the global future. In China, where, after the rise to power of Mao Zedong in 1949, the government tightened its control over individual expression, the loss of the self has been taken for granted, and the arts have focused on exposing the mechanisms of repression and overthrowing them. For many, like Zhang Hongtu, this has meant leaving China, and his painting, *Bird's Nest, in the Style of Cubism* (see Fig. 40.10), is firmly entrenched in the protest tradition. Despite the fate of that painting, however, in post-Mao China, Chinese artists have been somewhat freer to state their opposition to the government's oppression. In 1997, for instance, performance artist Zhang Huan [hwahn] (1965–) invited 40 peasants who had recently emigrated to Beijing looking for work to stand with him in a pond (Fig. **40.17**). In this way, the city's class of new poor raised the level of the water one meter, an act that Zhang Huan considered a metaphor for raising the government's consciousness. The performance was, Zhang Huan says, "an action of no avail," and yet as an image of people working together in all their vulnerability, the performance is an image of hope.

The African Experience in Art The controversial painting *The Holy Virgin Mary* by Chris Ofili (1968–) (Fig. **40.18**), British-born Nigerian painter, is a case in point. Ofili portrays the Virgin as a black woman, and surrounding her are *putti* (winged cherubs) with bare bottoms and genitalia cut out of pornographic magazines. Two balls of elephant dung, acquired from the London Zoo, support the painting, inscribed with the words "Virgin" and "Mary," a third clump

defining one of her breasts. The son of black African Catholic parents, both of whom were born in Lagos [LAY-goss], Nigeria, and whose first language was Yoruba, Ofili has used this West African culture as a source of inspiration for his art.

Fig. 40.18 Chris Ofili, *The Holy Virgin Mary.* 1996. Paper collage, oil paint, glitter, polyester resin, map pins, and elephant dung on linen, 8′ × 6′. The Saatchi Gallery, London. Photo: Diane Bondareff/AP World Wide Photos. While on display in Brooklyn, the painting was smeared with white paint by an angry 72-year-old spectator.

Fig. 40.19 Yinka Shonibare, _Victorian Couple_. 1999. Wax-printed cotton textile L: 153 × 92 × 92 cm (60″ × 36″ × 36″). R: 153 × 61 × 61 cm (60″ × 24″ × 24″). Courtesy of the artist, Stephen Friedman Gallery, London, and James Coehn Gallery, New York. Part of the power of these pieces is that they possess no identity—no heads, no hands.

Giuliani threatened to cut off the museum's funding as well as evict it from the city-owned building it leased. (He was forced to back down by the courts.) For Ofili, the conflict his painting generated was itself emblematic of the collision of cultures that define his own identity. At the same time, it can be said that the controversy helped make Ofili even more prominent and did nothing to diminish the "marketability" of his art. In 2003, he was chosen to represent Great Britain at the Venice Biennale, perhaps the most prominent contemporary global art exhibition.

Like Chris Ofili, Yinka Shonibare (1962–) was born in England to Nigerian parents, but unlike Ofili, he was raised in Nigeria before returning to art school in London. In the mid-1990s, he began creating artworks from the colorful printed fabrics that are worn throughout West Africa, all of which are created by English and Dutch designers, manufactured in Europe, then exported to Africa. At that point, they are remarketed in the West as authentic African design (Fig. **40.19**). "By making hybrid clothes," Shonibare explains, "I collapse the idea of a European dichotomy against an African one. There is no way you can work out where the opposites are. There is no way you can work out the precise nationality of my dresses, because they do not have one. And there is no way you can work out the precise economic status of the people who would've worn those dresses because the economic status and the class status are confused in these objects." Sometimes, even the time period of these costumes is drawn into question. They are identified as "Victorian," and indeed the bustle on the woman is a Victorian fashion, but the man's dress seems startlingly hip.

The Latino and Hispanic Presence in the United States A cross-fertilization of traditions has traditionally infused the art of Latino and Hispanic culture in North America. From the beginning of the sixteenth century, the Hispanization of Indian culture and the Indianization of Hispanic culture in Latin and South America created a unique cultural pluralism (see Chapter 23). By the last half of the twentieth century, Latino culture became increasingly Americanized, and an influx of Hispanic immigrants helped Latinize American culture. The situation has been summed up by Puerto Rico–born poet Aurora Levins Morales [moh-RAH-lays] (1954–), in "Child of the Americas" (**Reading 40.6**):

> **READING 40.6**
>
> **Aurora Levins Morales, "Child of the Americas" (1986)**
>
> I am a child of the Americas,
> a light-skinned mestiza of the Caribbean,
> a child of many diaspora, born into this continent at
> a crossroads.
> I am a U.S. Puerto Rican Jew,
> a product of the ghettos of New York I have never
> known.

The display of sexual organs, especially in representations of female divinities, is common in Yoruba culture, and Ofili's putti are meant to represent modern examples of this indigenous tradition, symbolizing the fertility of the Virgin Mary. As for elephant dung, in 1992, during a trip to Zimbabwe [zim-bah-bway], Ofili was struck by its beauty after it was dried and varnished. He also came to understand it was worshiped as a symbol of fertility in Zimbabwe, and he began to mount his paintings on clumps of dung as a way, he said, "of raising the paintings up from the ground and giving them a feeling that they've come from the earth rather than simply being hung on a wall."

The Holy Virgin Mary artwork thus reflects Ofili's African heritage. But he understood that the African association of genitalia and dung with fertility and female divinities would be lost on his Western audience. Indeed it was. When the painting was exhibited at the Brooklyn Museum in late 1999, it provoked a stormy reaction. The Catholic Cardinal in New York called it a blasphemous attack on religion, and the Catholic League called for demonstrations at the Museum. New York's Mayor Rudolph W.

An immigrant and the daughter and granddaughter
of immigrants.
I speak English with passion: it's the tongue of my
consciousness,
a flashing knife blade of crystal, my tool, my craft.
I am Caribeña, island grown. Spanish is my flesh,
Ripples from my tongue, lodges in my hips:
the language of garlic and mangoes,
the singing of poetry, the flying gestures of my hands.
I am of Latinoamerica, rooted in the history of my
continent:
I speak from that body.

I am not African. Africa is in me, but I cannot return.
I am not taína. Taíno[1] is in me, but there is no way back.
I am not European. Europe lives in me, but I have no
home there.

I am new. History made me. My first language was
spanglish.
I was born at the crossroads
and I am whole.

[1] **Taíno:** The first Native American population encountered by Christopher Columbus.

Just such a "difficult whole" is also captured by Chicana muralist Judith F. Baca (1946–) in a 1990 project created for the town of Guadalupe [GWAHD-ul-oop], California (Fig. **40.20**), in an area whose economy is almost entirely dependent on enormous farms that employ 80 percent of the population of Mexican heritage. The project offers a thought-provoking glimpse of the new "Mexican towns" that have become more commonplace in rural California.

Reflecting the community's pride in its heritage, the mural refers directly to César Chávez's [SHAH-vez] (1927–1993) successful efforts to unionize farm workers through the creation of the National Farm Workers Association in 1962 (today known as the United Farm Workers). One of the union's most effective actions was the boycott of table grapes from 1966 to 1970. Beginning with local strikes, marches, and demonstrations, the movement spread across the state and then nationwide. Chávez and a coalition of Hispanic and Filipino farm workers effectively challenged the substandard wages and working conditions imposed by large vineyards. Political and labor activism had cultural consequences, as a vital theatrical tradition developed alongside Chávez's new union.

Luis Valdez (1940–) was a playwright before joining Chávez to help organize farm workers in Delano, California. There he founded El Teatro Campesino [el tay-AH-troh kahm-pay-SEE-noh] (The Farmworkers Theater) to raise funds for "La Causa" (the cause), the simple but effective term that helped transform a local strike into a broad, instantly identifiable global movement. Combining Italian commedia dell'arte [koh-MEH-dee-ah dell-AR-teh] (improvisational comedy) and Mexican vaudeville, by 1968, the Farmworkers Theater had redefined itself as a "teatro chicano" and moved out of the fields and into Los Angeles in an effort to portray a wider range of Chicano experience.

Valdez's national success came in 1978, when he produced *Zoot Suit*, a play that exposed the police brutality and injustices faced by the Chicano community during the "Zoot Suit Riots" and the "Sleep Lagoon" trial of the 1940s. The main character in the play, Henry Reyna, is the leader of the 38th Street Gang. Heading to a party that had been terrorized by rival gang members just moments before, Henry and his friends were mistaken for members of the rival gang and attacked. After a man from the party was killed, the entire gang was indicted on charges

Fig. 40.20 Judith F. Baca, *Farmworkers at Guadalupe*. 1990. One of four murals, 8' × 7'. Guadalupe, California. © 1997 Judith F. Baca. Courtesy of the artist. To make the murals, Baca hired five local teenagers to construct a town chronology, collected family photos and stories, and called town meetings to discuss her imagery.

of murder. Their identity, both cultural and criminal, was tied to "zoot suits," two-piece suits consisting of a long jacket and pegged pants, accompanied by a long keychain that looped almost to the ankle. The importance of the apparel is expressed by the character El Pachuco [pah-CHOO-koh]—part Aztec god, part quintessential 1940s Zoot Suiter, and part Greek chorus—when he sings the following *corrido* [kor-REE-doh], or traditional Mexican narrative ballad (**Reading 40.7**):

READING 40.7

from Luis Valdez, *Zoot Suit* (1978)

Trucha, ese loco, vamos al rorlo
Wear that carlango, tramos y tando
Dance with your huisa
Dance to the boogie tonight!
'Cause the zoot suit is the style in California
También en Colorado y Arizona
They're wearing that tacuche en El Paso
Y en todos los salones de Chicago
You better get hep tonight
And put on that zoot suit!

Valdez's use of "Spanglish" is like that of Aurora Levins Morales in "Child of the Americas," and both exemplify the confluence of cultures that the Latino experience in the United States represents—a plural language for a plural self.

Recovering Tradition: Contemporary Native American Art
Native North Americans have been among the most isolated and marginalized of all the world's indigenous peoples. Diverse but sequestered on arid reservations, enmeshed in poverty and unemployment, their traditions and languages on the brink of extinction, Native Americans seemed the consummate "Other." However, in 1968, in Minneapolis, Minnesota, a gathering of local Native Americans, led by Dennis Banks, George Mitchell, and Clyde Bellecourt, decided to address these problems through collective action, and founded the American Indian Movement (AIM). Almost a quarter-century later, Banks recalled what motivated them:

> Because of the slum housing conditions; the highest unemployment rate in the whole of this country; police brutality against our elders, women, and children, Native Warriors came together from the streets, prisons, jails and the urban ghettos of Minneapolis to form the American Indian Movement. They were tired of begging for welfare, tired of being scapegoats in America and decided to start building on the strengths of our own people; decided to build our own schools; our own job training programs; and our own destiny. That was our motivation to begin. That beginning is now being called "the Era of Indian Power."

AIM was, from the outset, a militant organization. On Thanksgiving Day 1970, AIM members boarded the *Mayflower II* at its dock in Plymouth harbor as a countercelebration of the three hundred and fiftieth anniversary of the Pilgrims' landing at Plymouth Rock. A year later, they occupied Mount Rushmore National Monument. In AIM's point of view, the site, which was sacred to their culture, had been desecrated by the carving of the American presidents Washington, Jefferson, Roosevelt, and Lincoln into the mountain. The occupation was designed to draw attention to the 1868 Treaty of Fort Laramie, which had deeded the Black Hills, including Mount Rushmore, to the Lakota Sioux. The U.S. military had ignored the treaty, forcing the Lakota onto the Pine Ridge reservation on the plains south of the Black Hills. There, on December 29, 1890, with the Battle of Wounded Knee, conflict erupted (see Chapter 32). In 1973, AIM militants took control of Wounded Knee and were quickly surrounded by federal marshals. For over two months, they exchanged gunfire, until the AIM militants surrendered. Of course, not everyone agreed with AIM's tactics, but the group did help to revitalize Native American cultures throughout the hemisphere and furthered an interest in traditional art forms.

A member of AIM's Central Council, who served as representative to the United Nations, Cherokee-born Jimmie Durham (1940–) makes what he calls "fake Indian artifacts," in which non-Indian materials, such as the bright red, chrome automobile bumper, is transformed into something that looks completely Indian (Fig. **40.21**). As he explains: "We took glass beads, horses, wool blankets, wheat flour for frybread, etc., very early, and immediately made them identifiably 'Indian' things. We are able to do that because of our cultural integrity and because our societies are dynamic and able to take in new ideas." But the cultural forces at work here are highly complex. As much as Indian culture has the ability to absorb Western materials and make them its own, anything an Indian makes, Durham knows, is always seen by the dominant Anglo-American culture as an "artifact,"

Fig. 40.21 Jimmie Durham, *Headlights*. 1983. Car parts, antler, shell, etc. Private collection. Courtesy of the artist. The presence of the antler on the bumper suggests that the Native American reaction to European contact was comparable to that of "a deer caught in the headlights."

Fig. 40.22 David P. Bradley (White Earth Ojibwe and Mdewakaton Dakota), *Indian Country Today.* **1996–97.** Acrylic on canvas, 70″ × 60″. Museum Purchase through the Mr. and Mrs. James Krebs Fund. Photograph courtesy Peabody Essex Museum. In the foreground is the Rio Grande River, teeming with fish, the lifeblood of region.

In the center of the pueblo, Bradley depicts a traditional kachina [kah-CHEE-nuh] dance taking place in the pueblo. Performed by male dancers who impersonate kachinas, the spirits who inhabit the clouds, the rain, crops, animals, and even ideas such as growth and fertility (see Chapter 1), the dances are sacred and, although tourists are allowed to view them, photography is strictly prohibited. The actual masks worn in ceremonies are not considered art objects by the Pueblo. Rather, they are thought of as active agents in the transfer of power and knowledge between the gods and the men who wear them in dance. Kachina figurines are made for sale to tourists, but they are considered empty of any ritual power or significance. This commercialization of native tradition is the real subject of Bradley's painting. The native peoples' ability to withstand this onslaught is suggested by the giant mesa, endowed with kachina-like eyes and mouth, that overlooks the entire scene, suggesting that the spirits still oversee and protect their people.

a surviving fragment of a "lost" people that does not quite qualify as "art" proper. His "fake" artifacts expose this assumption.

Contemporary life in the Southwestern pueblos is the subject of *Indian Country Today* (Fig. **40.22**) painted by David P. Bradley (1954–), a Native American of Ojibwe [oh-JIB-way] descent who has lived for the last 30 years in Santa Fe, New Mexico. Behind the pueblo, to the left, the parking lot of an Indian-run casino is filled with tourist buses. Behind it, in the distance, is the city of Santa Fe. The train passing behind the pueblo is the Santa Fe Railroad's "Chief"—the very image of Anglo-American culture's appropriation of Native traditions. To the right of the central mesa is the Four Corners Power Plant in northwestern New Mexico, one of the largest coal-fired generating stations in the United States and one of the greatest polluters. (Note the smoke reemerging on the far side of the mesa.) Behind the plant is an open-pit strip mine. Fighter jets rise over the landscape, reminders of the nearby Los Alamos National Laboratory, where classified work on the design of nuclear weapons is performed.

Imaging Islam The tension between political reality, cultural identity, and personal identity is especially evident in the work of Middle Eastern women artists who have moved between their homelands and the West. Shirin Neshat (1957–) grew up in Iran in an upper-middle-class family, but after graduating from high school, she moved to the United States to study art. When the Islamic Revolution overtook her homeland in 1979, 22-year-old Neshat found herself living in exile. When she returned home 11 years later, Iran had completely changed. She recalls:

> During the Shah's regime, we had a very open, free environment. There was a kind of dilution between West and East—the way we looked and the way we lived. When I went back everything seemed changed. There seemed to be very little color. Everyone was black or white. All the women wearing the black chadors. It was immediately shocking. Street names had changed from old Persian names to Arabic and Muslim names. . . .

This whole shift of the Persian identity toward a more Islamic one created a kind of crisis. I think to this day there's a great sense of grief that goes with that.

In Neshat's series of photographs, *Women of Allah*, of which *Rebellious Silence* (Fig. **40.23**) is characteristic, many of the women hold guns, subverting the stereotype of women as submissive. At the same time, they bury their individuality beneath the black *chador*, and their bodies are inscribed in Farsi calligraphy with poetry by Tahereh Saffarzadeh, whose verses express the deep belief of many Iranian women in Islam. Only within the context of Islam, they believe, are women truly equal to men, and they claim that the *chador* [CHAH-dor], by concealing a woman's sexuality, prevents her from becoming a sexual object. The *chador* also expresses the women's solidarity with men in the rejection of Western culture. Yet, even as she portrays the militant point of view, Neshat does not blindly accept the Islamic fundamentalist understanding of the *chador*. It is clear that the *Women of Allah* photographs underscore the Islamic world's inability to separate beliefs that focus on religion and spirituality from those that concern politics and violence.

The Pakistani painter Shahzia Sikander (1969–) addresses her heterogeneous background in works such as *Pleasure Pillars* (Fig. **40.24**) by reinventing the traditional genre of miniature painting in a hybrid of styles. Combining her training as a miniature artist in her native Pakistan with her focus on contemporary art during her studies at the Rhode Island School of Design, Sikander explores the tensions inherent in Islam's encounter with the Western world, Christianity as well as the neighboring South Asian tradition of Hinduism. In the center of *Pleasure Pillars*, Sikander portrays herself with the spiraling horns of a powerful male ram. Below her head are two bodies, one a Western Venus (see Fig. 5.20), the other Devi, the Hindu goddess of fertility, rain, health, and nature, who is said to hold the entire universe in her womb (see Chapter 7). Between them, two hearts pump blood, a reference to her dual sources of inspiration, East and West. Eastern and Western images of

CONTINUITY & CHANGE

Aphrodite of Knidos, p. 159

Fig. 40.23 Shirin Neshat, *Rebellious Silence*, from the series *Women of Allah*. 1994. Gelatin silver print and ink. Photo: Cynthia Preston. © Shirin Neshat, courtesy Gladstone Gallery, New York. "The main question I ask," Neshat has said, "is, what is the experience of being a woman in Islam? I then put my trust in those women's words who have lived and experienced the life of a woman behind the *chador*."

power also inform the image as a lion kills a deer at the bottom left, a direct artistic quote from an Iranian miniature of the Safavid [sah-FAH-weed] dynasty (1499–1736), and at the top, a modern fighter jet roars past.

Fig. 40.24 Shahzia Sikander, *Pleasure Pillars*. 2001. Watercolor, dry pigment, vegetable color, tea, and ink on wasli paper, 12″ × 10″. Courtesy Sikkema Jenkins & Co., New York. As part of her ongoing investigation of identity, Sikander has taken to wearing the veil in public, something she never did before moving to America, in what she labels "performances" of her Pakistani heritage.

Fig. 40.25 Eleanor Antin, *Minetta Lane—A Ghost Story*. 1994–95. Filmic installation. View [one, two, three] of three. Installation view (left), two stills from video projections (below and right). Below: Through the Lover's Window. Right: Through the Artist's Window. Copyright Eleanor Antin Courtesy Ronald Feldman Fine Arts, New York. Each of the installation's three films is about ten minutes long.

A Multiplicity of Media: New Technologies

Just as the electronic media have revolutionized modern culture, dating from Thomas Edison's first audio recording to the motion picture, radio, television, and digital technologies, from the Internet to the iPod, so too have the arts been revolutionized by these media. This transformation was most fundamentally realized in the visual arts through the medium of video

Eleanor Antin, for instance, came to video art through performance. She understood that her race- and gender-blurring performances—as the invented personae the King of Solana Beach (see Fig. 39.18) and Eleanora Antinova, the black ballerina of Diaghilev's Ballets Russes—could be documented by video camera. But she also realized that she could project multiple versions of herself and others simultaneously in installation settings.

An example is *Minetta Lane—A Ghost Story* (Fig. **40.25**), first exhibited in New York City in 1995. It consists of a re-creation of three buildings on a Greenwich Village (New York) street that runs for two blocks. In the 1940s and 1950s, it was the site of a low-rent artists' community, and

Antin's installation recreates the bohemian character of that lost world. The installation itself consists of three narrative films, transferred to video disc, and back-projected onto the tenement windows of the reconstructed lane. The viewer, passing through the scene, thus voyeuristically peers into each window and views what transpires inside. In one window, two lovers play in a kitchen tub. In a second, an Abstract Expressionist painter is at work. And in a third, an old man tucks in his family of caged birds for the night. Ghosts of a past time, these characters are trapped on celluloid, but their world is inhabited by another, unseen ghost. A little girl, who is apparently invisible to those in the scene but clearly visible to us, paints a giant "X" across the artist's canvas and destroys the relationship of the lovers in the tub. She represents a destructive force that, in Antin's view, is present in all of us—and, in fact, present in the very nature of her electronic medium. For the artist, the lovers and the old man represent the parts of us that we have lost—our youth. They represent ideas about art, sexuality, and life that, despite our nostalgia for them, are no longer relevant.

Contemporary video art is, in fact, haunted by ghosts. In a catalogue essay that she wrote for another installation of *Minetta Lane*, Antin mused, "What I'm after is some image in my mind that I want to make visible, knowable, perceivable. Make the immaterial material, so that someone else can turn it back into some other immaterial image that I hope is not too alien from my own." Antin's films produce images that are imprinted on our minds, where they become immaterial again, summoned by an act of memory. The filmic image is the trace—or what remains—of a lost past. It is, of its nature, inherently "ghostly."

As the "ghost" metaphor suggests, temporal media like video art are often concerned with the passing of time itself, the life cycle from birth to death. Video artist Bill Viola [vye-OH-la] (1951–) has been fascinated, throughout his career, by the passage of time. His principal metaphor for this passage is water, which not only flows, like time, but because it can be seen, seems to make both time and space tangible and palpable. His video installation piece *Five Angels for the Millennium* (Fig. **40.26**) is composed of five individual video sequences that show a clothed man plunging into a pool of water. The duration of each video is different, with long sequences of peaceful aqueous landscape suddenly interrupted by the explosive sound of the body's dive into the water. He describes the process of making the piece:

> *Five Angels* came out of a three-day shoot in Long Beach that I had undertaken for several other projects. All I knew was that I wanted to film a man plunging into water, sinking down, below, out of frame—drowning. A year or so later, going through this old footage, I came across five shots of this figure and started working with them—intuitively and without a conscious plan. I became completely absorbed by this man sinking in water, and by the sonic and physical environment I had in mind for the piece.

Fig. 40.26 Bill Viola, *Five Angels for the Millennium*. 2001. Video/sound installation, five channels of color video projection on walls in a large, dark room (room dimensions variable); stereo sound for each projection; project image size 7'10 $^1/_2$" × 10' × 6" each. Edition of three. Photo: Mike Bruce, courtesy Anthony d'Offay, London.

When I showed the finished work to Kira [Perov], my partner, she pointed out something I had not realized until that moment: this was not a film of a drowning man. Somehow, I had unconsciously run time backwards in the five films, so all but one of the figures rush upwards and out of the water. I had inadvertently created images of ascension, from death to birth.

Because the videos are continuously looped and projected onto the gallery walls, their different durations make it impossible to predict which wall will suddenly become animated by the dive—the one behind you, the one in front of you, the one at your side. The experience is something like being immersed in both water and time simultaneously, in the flow of the moment. For Viola, video differs from film in exactly this sense. The most fundamental aspect of video's origin as a medium is the *live* camera. Video is in the moment. And Viola's installation literally spatializes time, even as time becomes as palpable as the watery surfaces that Viola depicts.

Today, of course, video art *per se* no longer exists—the medium has become entirely digital, and, in fact, although it is far more expensive, artists working with time-based media have preferred, given the higher quality of the image, to work with film. One of the seminal time-based works of the late twentieth century, *The Way Things Go*, was shot on film by Swiss artists Peter Fischli (1952–) and David Weiss (1946–) (Fig. **40.27**). It was first screened in 1987 at Documenta, the international art fair that takes place every five years in Kassel, Germany. There it caused an immediate sensation, and since then it has been screened in museums around the world. It consists of a kinetic sculptural installation inside a 100-foot warehouse that begins when a black plastic bag (full of who knows quite what), suspended from the ceiling,

Fig. 40.27 Peter Fischli and David Weiss, two stills from *Der Lauf der Dinge (The Way Things Go)*. 1987. 16mm color film, 30 min. © Peter Fischli, David Weiss, Courtesy of Matthew Marks Gallery, New York. Fischli and Weiss's film is widely available on DVD (released by First Run/Icarus Films).

spins downward until it hits a tire on top of a slightly inclined orange-colored board and nudges it over a small strip of wood down the shallow slope. This initiates a series of physical and chemical, cause-and-effect chain reactions in which ordinary household objects slide, crash, spew liquids onto, and ignite one another in a linear 30-minute sequence of self-destructing interactions. In part a metaphor for the history of Western culture, in part an hilarious slapstick comedy of errors, for many viewers *The Way Things Go* captures the spirit of modern life.

The 21-minute film *Flooded McDonald's*, by the Danish collaborative group Superflex, consisting of Jakob Fenger (1968–), Rasmus Nielsen (1969–), and Bjørnstjerne Reuter Christiansen (1969–), reenacts a similar scenario (Fig. **40.28**). The film was shot in a hangar outside Bangkok, Thailand, where they built an exact replica of a McDonald's restaurant on a scale of 1:1 at the bottom of a swimming pool, which they then proceeded to flood. The restaurant is empty as water begins to seep in under the doors and then slowly fills the entire establishment, eventually rising to a

level where French fries, burgers, and soft drink containers float off the tables and counters, and then submerging even their cameras which shoot the floating detritus like some parody of a Jacques Cousteau underwater adventure. "McDonald's," the group has explained, "is a global living-room," and to flood it is to raise the apocalyptic specter of

Fig. 40.28 Superflex, two stills from *Flooded McDonald's*. 2008. Film (color, sound), 21 min. Produced by Propeller Group (Ho Chi Minh City) in association with Matching Studio (Bangkok) and co-commissioned by the South London Gallery, the Louisiana Museum of Modern Art (Denmark) and Oriel Mostyn Gallery (Wales) with generous support from the Danish Film Institute. Production: Director: Tuan Andrew Nguyen and Superflex. Cinematography: Ha Thuc Phu Nam. Sound Design: Alan Hayslip. Editing: The Propeller Group. Louisiana Museum of Modern Art. Acquired with the support of a private donor. As the credits make clear, the work is itself an example of international artistic collaboration.

Fig. 40.29 Pipilotti Rist, three stills from *I'm Not a Girl Who Misses Much*. 1986. Single-track video (color, sound), 5 min. As much as Rist's video is a parody of music videos in general, it also evokes the horror of John Lennon's assassination in 1980 and the terrible irony that would come to inform the lyrics of *Happiness is a Warm Gun*.

global warming at the same time that it seems to take comedic revenge on global merchandising, putting the filmmakers in the absurdist role of God bringing down the deluge upon the world.

One of the more innovative artists exploring the technological possibilities of time-based media is the Swiss-born Pipilotti Rist (1962–), who began working with video in 1986 with a single-track video, *I'm Not the Girl Who Misses Much* (Fig. **40.29**), a sort of parody of the videos that had begun to air on television with the advent of MTV in 1983. The video transforms the lyrics to John Lennon's song *Happiness Is a Warm Gun* (1968) from "She's not a girl," to "I'm not the girl." Rist, who would play percussion, bass, and flute in the all-girl rock band Les Reines Prochaines (The Next Queens) from 1988 to 1994, bounces up and down as she dances, manipulating her voice by speeding it up to a frenetic pace and slowing it down to the pace of a funereal march, her image sliding in and out of focus. Her

blatant dismissal of high production values is equally a dismissal of the social values of MTV itself, where women had quickly been diminished to mere sexual objects.

In an installation first screened at the Venice Biennale in 1997, *Ever Is Over All* (Fig. **40.30**), a woman is seen walking down a street, dressed in a conservative blue dress and bright red shoes à la Dorothy in *The Wizard of Oz*. She is carrying a large red flower—in fact, a flower known as a red-hot poker, images of which are simultaneously projected around the corner of the room. A soft, even soothing "la, la, la" of a song accompanies her. With a broad smile on her face, she lifts the long-stemmed flower in her hand and smashes it into the passenger window of a parked car. Glass shatters. She moves on, smashing more car windows. Up from behind her comes a uniformed woman police officer, who passes her by with a smiling salute. Her stroll down the boulevard plays in a continuous loop in the gallery. This is the new Oz, the Emerald City that we discover "somewhere

Fig. 40.30 Pipilotti Rist, *Ever Is Over All*. 1997. Video installation, National Museum of Foreign Art, Sofia, Bulgaria, 1999; sound with Anders Guggisbert; two overlapping video projections, audio system. Collection, The Museum of Modern Art, New York. The person playing the part of the hit woman is Swiss journalist and documentary filmmaker Silvana Ceschi.

Fig. 40.31 Janine Antoni, *Touch*. 2002. Color video, sound (projection), 9:36 min. loop. The Art Institute of Chicago. Gift of Donna and Howard Stone, 2007.43. A short segment of *Touch*, narrated by Antoni, is available for viewing at www.pbs.org/art21/artists/antoni/index.html#.

over the rainbow," where the tensions between nature and civilization, violence and pleasure, the legal and the criminal, impotence and power—all seem to have dissolved.

Artist Janine Antoni (1964–) works in a variety of media, including performance and video, often making art out of everyday activities such as eating, bathing, and sleeping. The tension between the mundane qualities of her activities and the technical sophistication of their recording results in a sense of almost magical transformation comparable to that of the Surrealists (see Chapter 35). In the video, *Touch* (Fig. **40.31**), Antoni appears to walk along the horizon, an illusion created by her walking on tightrope stretched between two backhoes on the beach directly in front of her childhood home on Grand Bahama Island. She had learned to tightrope walk, practicing about an hour a day, as an exercise in bodily control and meditation. As she practiced, she realized, she says, that "it wasn't

that I was getting more balanced, but that I was getting more comfortable with being out of balance." This she took as a basic lesson in life. In *Touch*, this sense of teetering balance is heightened by the fact that she appears to be walking on an horizon line that we know can never be reached as it continually moves away from us as we approach it. We know, in other words, that we are in an impossible place, and yet it is a place that we have long contemplated and desired as a culture—the same horizon that Romantic painters such as Caspar David Friedrich looked out upon in paintings like *Monk by the Sea* (see Fig. 27.9). When, in the course of the full-length video, both Antoni and the rope disappear, we are left, as viewers, contemplating this illusory line and what it means. And we come to understand that the horizon represents what is always in front of us. "It's a very hopeful image," Antoni says, "it's about the future, about the imagination."

The Environment and the Humanist Tradition

What is the role of art today? What does the museum offer us? What about literature, the book, the poem? Is the museum merely a repository of cultural artifacts? Is the poem a tired and self-indulgent form of intellectual narcissism? Can opera move us even more meaningfully than popular music? How can the arts help us to understand not only our past, but our present and our future? These are questions that artists, writers, and musicians are continually asking themselves, and questions that a student of the humanities, coming to the end of a book such as this one, might well ask themselves as well.

Consider an installation by Danish artist Olafur Eliason (1967–), *The Weather Project* (Fig. **40.32**). When he installed it in the mammoth Turbine Hall of the Tate Modern, London, in the winter of 2003, it was roundly criticized as "mere" entertainment, in no small part because it attracted over 2 million visitors. At the end of the 500-foot hall hung a giant yellow orb, 90 feet above the floor. The ceiling itself was covered with mirrors, thus doubling the size of the space. The "sun" was actually a semicircle of some 200 yellow sodium streetlights, which, when reflected in the ceiling mirrors, formed a circle. Artificial mist machines filled the hall with a dull, wintry fog. What was the attraction?

In no small part, it seemed to reside in the very artificiality of the environment. Visitors to the top floor of the gallery could easily see the trussing supporting the mirrored ceiling as well as the construction of the sun shape. The extraordinary visual effects of Eliason's installation were, in the end, created by rather ordinary means. But this ordinariness, in turn, suggested profound and somewhat disturbing truths about our world and our environment. If Eliason could create this almost postapocalyptic environment—with its dead, heatless sun, perpetual fog, and cold stone ground—with such minimal means, what might we, as a world, create with the advanced technologies so readily at our disposal? In other words, as viewers laid on the floor of the museum, and

Fig. 40.32 Olafur Eliason, *The Weather Project*, installation view at the Tate Modern, London. 2003. Monofrequency lights, projection foil, haze machine, mirror oil, aluminum, and scaffolding. Courtesy of the artist, Tanya Bonakdar Gallery, New York, and neugerriemschneider, Berlin.

saw themselves reflected on the ceiling above, were they viewing themselves in the present, or seeing themselves in the future? What hath humanity wrought?

The Weather Project was, then, something of a chilling experience, both literally and figuratively. "I regard . . . museums," Eliason has said, "as spaces where one steps even deeper into society, from where one can scrutinize society." It is perhaps relevant for you to consider this book as such a space. To conclude, what is it about your world that you have come to understand and appreciate more deeply and fully? ∎

What characterizes postmodern architecture?

The 1972 book *Learning from Las Vegas* argued that the visual complexity of Las Vegas, with its competing sign systems, created a condition of contradiction that was inclusive, not exclusive. How does the new spatial order epitomized by Las Vegas reflect the postmodern condition? How would you describe Robert Venturi's "difficult whole"? Among the most itinerant artists of our increasingly nomadic postmodern era are its architects. Responding to competitions that will lend individual sites in the "world metropolis" a sense of being unique, they design monuments to national and corporate identity. How have architects responded to environmental concerns in their work? One useful way to define the "postmodern" is to create a list of words—like "uncertainty"—that define it. What other words help you to define the postmodern?

How does postmodern theory reflect pluralist thought?

The roots of postmodern theory rest in the linguistic model of meaning established in French structuralism. How would you describe that linguistic model? How does the poststructuralist thought of Jacques Derrida build on and differ from Saussure's example? How would you describe deconstruction as a philosophical methodology? Chaos theorists posit that biological and mathematical patterns that appear random, unstable, and disorderly, are actually parts of larger, more "difficult wholes." How does the fractal geometry of Benoit Mandelbrot counter traditional Euclidean geometry? What is the butterfly effect? How has chaos theory helped us to understand the human body and begin to cure disease?

How are pluralism and diversity reflected in art and literature?

The postmodern sense of inclusiveness authorized a wide variety of experimentation in painting, often mediating between the competing and contradictory demands of realism and abstraction. How do artists like Gerhard Richter and Pat Steir approach this problem?

Postmodern literature pursues meaning where meaning is always plural, multiplicitous, and fleeting—frustrating any kind of significant final answer. Multiple, contradictory centers of thought exist simultaneously and independently of one another. In fiction, a novel like Thomas Pynchon's *V.* creates a world of uncertainty and ambiguity, similar to Paul Auster's *City of Glass*, in which the line between fiction and reality totally collapses. How do poets like David Antin and John Ashbery approach the problem of meaning in their work?

The mobility of modern artists has led many to feel they have multiple identities. How do artists like Chris Ofili and Yinka Shonibare mediate between their British training and their Nigerian roots? How does the work of Yasumasa Morimura collapse the boundaries between East and West, male and female? In the United States, the encounters of Hispanic with North American society, especially in California, led to political murals and theater. How does "Spanglish" reflect this encounter? In the late 1960s, the American Indian Movement (AIM) sought to restore power to Native American peoples, the plurality of whose cultures was itself enormous. How do artists like Jimmie Durham and David P. Bradley address the confrontation between native and Anglo cultures? Finally, how do Islamic artists like Shirin Neshat and Shahzia Sikander negotiate the boundaries between Islam and the West?

Artists have also used new electronic media in creating new artistic spaces. Artists like Eleanor Antin make installations designed to be viewed for a specific length of time and then be dismantled. Bill Viola creates video installations that take advantage of the medium's ability to evoke the world of dreams, memories, and reflections, and Viola's especially immerses the viewer in the flow of time, the cycle of life and death. How do films like Peter Fischli and David Weiss's *The Way Things Go* and Superflex's *Flooded McDonald's* address the contemporary historical moment? How do Pipilotti Rist's videos address popular culture?

PRACTICE MORE Get flashcards for images and terms and review chapter material with quizzes at **www.myartslab.com**

READINGS

from Jorge Luis Borges, "Borges and I" (1967)

Although Jorge Luis Borges published widely in almost every imaginable form, his reputation as one of the leaders of modern Latin-American literature rests almost entirely on a series of some 40 short stories, tales, and sketches—"fictions," as he called them—the bulk of them published between 1937 and 1955. Many of these sometimes very brief fictions take on a quality of dreamlike mystery. The short fiction, reprinted here in its entirety, "Borges and I," is a late example of the form.

BORGES AND I

The other one, the one called Borges, is the one things happen to. I walk through the streets of Buenos Aires and stop for a moment, perhaps mechanically now, to look at the arch of an entrance hall and the grillwork on the gate; I know of Borges from the mail and see his name on a list of professors or in a biographical dictionary. I like hourglasses, maps, eighteenth-century typography, the taste of coffee and the prose of Stevenson; he shares these preferences, but in a vain way that turns them into the attributes of an actor. It would be an exaggeration to say that ours is a hostile relationship; I live, let ⏐10 myself go on living, so that Borges may contrive his literature, and this literature justifies me. It is no effort for me to confess that he has achieved some valid pages, but those pages cannot save me, perhaps because what is good belongs to no one, not even to him, but rather to the language and to tradition. Besides, I am destined to perish, definitively, and only some instant of myself can survive in him. Little by little, I am giving over everything to him, though I am quite aware of his perverse custom of falsifying and magnifying things. Spinoza knew that ⏐20 all things long to persist in their being; the stone eternally wants to be a stone and the tiger a tiger. I shall remain in Borges, not in myself (if it is true that I am someone), but I recognize myself less in his books than in many others or in the laborious strumming of a guitar. Years ago I tried to free myself from him and went from the mythologies of the suburbs to the games with time and infinity, but those games belong to Borges now and I shall have to imagine other things. Thus my life a flight and I lose everything and everything belongs to oblivion, or to him.

I do not know which of us has written this page.

Translated by J. E. I.

READING CRITICALLY

In this short parable, the "I" accuses "Borges" of "falsification and exaggerating." Whom are we to trust, or are we to trust anyone, and how would you say that defines the postmodern condition?

INDEX

Boldface names refer to artists.
Pages in italics refer to illustrations.

"0,10: The Last Futurist Exhibition of Painting" (Malevich), 1153, *1153*
10 x 10 Altstadt Copper Square (Andre), *1274*, 1275
12-tone system, 1133
16th Street Baptist Church, 1282
18 Happenings in 6 Parts (Kaprow), 1269
2001: A Space Odyssey (Kubrick), 1299
4' 33" (4 minutes 33 seconds) (Cage), 1267

A

Abortion, 1283
Abstract expressionism
　action painting, 1255, 1258–1260
　color-field painting, 1262, 1263–1264
　introduction to, 1255
　sculpture and, 1264–1265
　women and, 1260–1262
Abstraction, Porch Shadows (Strand), 1183, *1183*
Academy Awards, 1236
ACORS Building (Fukuoka Prefecturial International Hall) (Ambasz), *1319*, 1319–1320
"Action against the Un-German Spirit," 1205
Action painting, 1255, 1258–1260
Adams, John
　Nixon in China, 1299
　Shaker Loops, 1299
Africa
　Congo, atrocities in, 1121–1122, *1122*
　decolonization and, 1241
　experience in art, 1332–1333
African Americans
　See also Black identity; Harlem Renaissance
　Civil Rights Movement, 1276, 1281–1282
　Diaspora, black, 1283
　Great Migration, 1167, 1173–1174
　Jim Crow laws, 1276
Afro-Americans Poetics (Baker), 1176
After Invisible Man by Ralph Ellison (Wall), *1285*
Agee, James, *Let Us Now Praise Famous Men*, 1232
Agikas, 1154
Agriculture, collectivization of, 1221
Airplanes, 1117
Albee, Edward, 1252
Albers, Josef, 1217, 1244
Alen, William van, Chrysler Building, *1181–1182*, 1181–1182
Alfonso XIII, king, 1224
Algeria, 1240–1241
Alice's Adventures in Wonderland (Carroll), 1296
All Quiet on the Western Front (Remarque), *1146*, 1146–1147
Alloway, Lawrence, 1256
Altman, Robert, *M*A*S*H*, 1288
"Am I Blue," 1284
Ambasz, Emilio, ACORS Building (Fukuoka Prefectural International Hall), *1319*, 1319–1320
America (Warhol), 1308, *1308*
America Today (Benton), 1229
American Art News, 1150
American colonies
　See also United States
An American Family, 1308
American Indian Movement (AIM), 1335
An American Place gallery, 1187, 1194
Americanization of cinema, 1200–1201
The Americans (Frank), 1265–1266
An Andalusian Dog, 1204, *1204*
Anderson, Laurie
　"O Superman," 1300–1301, *1301*
　United States, 1300
　United States II, 1300–1301, *1301*
Andre, Carl, *10 x 10 Altstadt Copper Square*, *1274*, 1275
Animation, 1235
Annie G., Cantering Saddled (Muybridge), *1136*, 1136
"Anti-art," 1150
Antin, David, *1330*, 1330
Antin, Eleanor
　Minetta Lane—A Ghost Story, *1338*, 1338
　My Kingdom Is the Right Size, 1305–1306, *1306*
Antinova, Eleanora, 1306
Anti-Semitism, 1217
Anti-war movement, 1288–1289, 1292, 1296
Antoni, Janine, *Touch*, *1342*, 1342
Anxiety, age of (1930s and 1940s), 1211–1247
　cinema during, 1233–1237
　fascism, rise of, 1215–1224
　Germany and, 1211–1215
　Great Depression, 1228–1233
　introduction to, 1211–1212
　Mexican Revolution, 1224–1228
　World War II, 1237–1243
Apollinaire, Guillaume, 1144
　"Il Pleut" ("It's Raining"), 1134, *1134*, 1135
　"Lundi, rue Christine," *1134*, 1134
　on surrealism, 1158–1159
Appalachian Spring (Copland), 1230

Aragon, Louis, 1159
Arámbula, Doroteo Arango, 1224
Arbeiter-Illustrierte Zeitung, 1217
Archetypes, 1158
Architecture
　in the 1950s, 1269–1270
　Bauhaus, 1217–1220
　green architecture, 1318
　International style, 1184–1186, 1217–1220
　machine aesthetic in, 1182–1184
　mass production, 1219
　postmodern, 1313–1314, 1315–1320
　skyscraper architecture in New York, 1181–1186
Armstrong, Louis, *Hotter Than That*, 1178–1179
Arnett, William, *Gee's Bend: The Architecture of the Quilt*, 1177
Arp, Jean, *Fleur Manteau (Flower Hammer)*, *1149*, 1149
Arrival of a Train at La Ciotat (Lumière brothers), 1137
Art brut, 1254
The Art Critic (Hausmann), 1151, *1151*
Art Deco, 1182
Art Moderne, 1182
Art Nouveau, 1296
Art Workers' Coalition, 1289
　Q. And Babies? A. And Babies., 1292, *1292*
The Arts of Life in America (Benton), 1229
As I Lay Dying (Faulkner), 1189
Ashbery, John, 1299
　"On the Towpath," *1330*, 1330–1331
Asian worldview, 1331–1332
Aspects of Negro Life (Douglas, A.), 1229–1230
Aspiration (Douglas, A.), *1172–1173*, 1173, 1230
Astra Construction, 1117
At the Time of the Louisville Flood (Bourke-White), 1233, *1233*
Atheistic existentialism, 1250–1251
Athens Olympic Sports Complex (Calatrava), 1317
Atomic bomb, 1240, 1242–1243
Atonal music, 1133
Atonality, 1133
Aucassin and Nicolette (Demuth), 1195
Auschwitz-Birkenau, *1238*, 1238–1239
Auster, Paul, *City of Glass*, 1329–1330, *1329–1330*
Austria, modernism in, 1131–1134
The Autobiography of Alice B. Toklas (Stein), *1119*, 1119
The Autobiography of William Carlos Williams (Williams), 1192, 1194, *1195*
Automobiles, 1118

B

Babes in Arms, 1235
Baca, Judith F., *Farmworkers at Guadalupe*, *1334*, 1334
Baker, Houston, Jr., *Afro-Americans Poetics*, 1176
Baldessari, John, 1292
Baldwin, James
　Go Tell It on the Mountain, 1284
　Notes of a Native Son, 1284
　"Sonny's Blues," 1284
Ball, Hugo, 1148–1149
　"Gadji beri bimba," *1149*
Balla, Giacomo, 1128
Ballets Russes, 1129
Bambi, 1235
Baraka, Amiri
　Home on the Range, 1287
　"Ka'Ba," 1286–1287, *1287*
Barnes, Albert C., "Negro Art and America," 1176
Barr, Alfred H., Jr., 1182, 1185, 1190, 1219
Bars and String-Pieced Columns (Pettway), 1177, *1177*
Barth, John, 1329
Barthelme, Donald, 1329
Barthes, Roland, 1322
Basie, Count, 1179
Basquiat, Jean-Michel, *Charles the First*, 1326–1327, *1327*
Bataille, Georges, 1254
"Bathing Arrangements," 1238–1239
Battcock, Gregory, 1289
"The Battle Hymn of the Republic," 1231
Battle of Wounded Knee, 1335
The Battleship Potemkin (Eisenstein), 1118, 1155, 1156–1157, *1156–1157*
Baudelaire, Charles, "L'invitation au voyage," 1122
Bauhaus, 1217–1220, 1244
Bauhaus Building (Gropius), *1219*, 1219–1220
Bayer, Herbert, 1217
Beach, Sylvia, 1164, *1164*
Bearden, Romare, 1285–1286
　The Dove, *1286*, 1286
　Ellison on, 1286
Beardsley, John, 1294
The Beast from 20,000 Fathoms, 1243
Beat generation, 1265–1270
　architecture in the 1950s, 1269–1270
　Cage and, 1267–1269

Frank and, 1265–1266
　Ginsberg and, 1266–1267
　Kerouac and, 1265–1266
Beat the Whites with the Red Wedge (Lissitzky), 1154, *1154*
Beckett, Samuel, *Waiting for Godot*, 1252–1253, *1253*, 1278–1279
Bed (Rauschenberg), 1266, 1267
Beijing National Stadium, 1320, *1320*
Being and Nothingness (Sartre), 1251
Bellecourt, Clyde, 1335
Benton, Thomas Hart
　America Today, 1229
　The Arts of Life in America, 1229
　A Social History of Indiana, 1229
　A Social History of the State of Missouri, 1229, *1229*
Berg, Alban, 1133
Bergman, Ingrid, 1237
Bergson, Henri, 1164, 1166
Berlin, Germany, 1210–1211, *1211*–1215, 1221
Berlin, Irving, 1282
Bernini, Gian Lorenzo, *Kaddish*, 1298
Bernstein, Leonard
　Candide, 1298
　West Side Story, 1298
Bessie Smith portrait (Van Vechten), *1178*
Beyond the Horizon (O'Neill), 1199
Beyond the Pleasure Principle (Freud), 1155
"Big Two-Hearted River" (Hemingway), 1188–1189, 1188–1189
Billy the Kid (Copland), 1230
Bird's Nest (Beijing National Stadium), 1320, *1320*
Bird's Nest, in the Style of Cubism (Zhang), 1320–1321, *1321*, 1322, 1332
Birmingham, Alabama, *1281*, 1281–1282
The Birth of a Nation (Griffith), 1137–1138, *1138*
The Birth of the World (Miró), 1160, 1160
Black, White, and Ten Red (Calder), *1264*
Black identity, 1283–1288
　in art and literature, 1285–1288
　Ellison and, 1284–1285
　Sartre and, 1283–1284
"Black Orpheus" (Sartre), 1283–1284
Black Panther Party, 1287
The Black Pirate, 1234
Black Square (Malevich), 1153
Blackburn: Song of an Irish Blacksmith (Smith, D.), 1264–1265, *1265*
Der blaue Engel (The Blue Angel), 1234, *1235*
Der Blaue Reiter, 1131–1133, 1215
Blaue Reiter Almanac, 1131
Bleyl, Fritz, 1130
The Blind Man (Duchamp), 1151
Bloomsbury Group, 1165
"Blowin' in the Wind" (Peter, Paul, and Mary), 1282
The Blue Angel, 1234
The Blue Gable (Münter), *1131*, 1131–1132
Blue note, 1177
Blues music, 1177–1178
Boas, Franz, 1176
Boccioni, Umberto, 1128, 1144
　Unique Forms of Continuity in Space, 1128, *1129*
Bogart, Humphrey, 1237
La Bohème (Puccini), 1133
Bohr, Niels, 1118
Bolshevik Revolution, 1152
Bombing of 16th Street Baptist Church, 1282
Bonaparte, Napoleon. *See* Napoleon
Book burning, 1205
The Book Burning (Brecht), 1205
Borges, Jorge Luis
　"Borges and I," *1329*, *1345*
　Foucault and, 1328
　"Borges and I" (Borges), 1329, *1345*
Boston Pops Orchestra, 1298
Bottle of Suze (Picasso), *1139*, 1139
"Le Bouillon de Tête" (Radiguez), *1122*
Bouquet, Michel, 1242
Bourke-White, Margaret
　Chrysler Building: Gargoyle outside Margaret Bourke-White's Studio, 1182
　Gandhi, 1242
　At the Time of the Louisville Flood, 1233, *1233*
　You Have Seen Their Faces, 1233
Bradley, David P., *Indian Country Today*, 1336, 1336
Brandt, Peter, *Q. And Babies? A. And Babies.*, 1292, *1292*
Braque, Georges, 1124–1125
　collages, 1125–1126
　Fruit Dish and Glass, 1126
　Houses at l'Estaque, 1124, 1124
　Picasso and, 1124–1125
　Violin and Palette, 1125, *1125*
　in World War I, 1144
Brecht, Bertolt, 1213–1214
　Die Bücherverbrennung (The Book Burning), 1205
　Drums in the Night, 1213
　on *Gesamtkunstwerk*, 1299
　"Mack the Knife," 1214
　Mahagonny-Songspiel, 1214
　"Theater for Pleasure or Theater for Imagination," *1214*

The Threepenny Opera, 1214
Breton, André
　on Kahlo, 1228
　on Picasso, 1160
　Surrealist Manifesto, 1158, 1158–1159
Breuer, Josef, *Studies in Hysteria*, 1155
Breuer, Marcel, 1217
　Whitney Museum of American Art, 1244
The Bridge (Crane), *1191*, 1191, 1194
The Bridge (Stella). *See The Voice of the City of New York Interpreted* (Stella)
Bridges, 1191
Brod, Max, 1213
The Broken Column (Kahlo), 1228, *1228*
Brooklyn Academy of Music, 1300
Brooklyn Bridge, 1191
"The Brooklyn Bridge (A Page of My Life)" (Stella, J.), 1194
Brown, Denise Scott, *Learning from Las Vegas*, 1314–1315
Brown v. Board of Education, 1276
Buchenwald, *1239*, 1239
Buchenwald, Germany (Miller, L.), *1239*, 1239–1240
Buñuel, Luis
　Un Chien andalou (An Andalusian Dog), 1204, *1204*
　L'Age d'or (The Golden Age), 1204
Burma, 1241
Burroughs, William S., 1331
The Butter Plate, *1122*, 1122
Butterfly effect, 1323

C

Cabinet of Dr. Caligari, 1203
Cage, John, 1267–1269, 1299
　4' 33" (4 minutes 33 seconds), 1267
　Concert for Piano and Orchestra, 1268
　Fontina Mix, 1268
　Indeterminancy, 1268
　Variations V, 1268
Calatrava, Santiago
　Athens Olympic Sports Complex, 1317
　Port Authority Trans Hudson (PATH) train station, 1318, *1318*
　Tenerife Opera House, 1317
　Turning Torso, 1317
Calder, Alexander, 1264–1265
　Black, White, and Ten Red, *1264*
Caldwell, Erskine, *You Have Seen Their Faces*, 1233
Call-and-response, 1179
Calley, William L., Jr., 1292
Calligrammes, 1134
Calligraphy, 1337, *1337*
Calvino, Italo, 1329
Camera Work (Stieglitz), 1183
Campbell's Soup Cans (Warhol), 1270–1271, *1271*, 1275
Camus, Albert, *The Stranger*, 1252, *1252*
Candide (Bernstein), 1298
Cane (Toomer), 1175
Cantos (Pound), 1136
The Cardiff Team (Delaunay), 1116–1117, *1117*
Carrà, Carlo, *Interventionist Demonstration*, 1128, 1128
Carroll, Lewis, *Alice's Adventures in Wonderland*, 1296
Carson, Rachel, *Silent Spring*, 1293
Cartoons, 1235
Casablanca, 1237
Cassady, Neal, 1266
Castle, Irene, 1176
Castle, Vernon, 1176
Catch-22 (Heller), 1288
Catholic Church
　See also Counter-Reformation
Catholic League, 1333
Catia computer program, 1316–1317
Celluloid film movie projector, 1136–1137
Cézanne, Paul
　influence of, 1196
　Picasso and, 1121
Chador, 1337
Chamberlain, Neville, 1237
Chaney, Lon, 1202
Chaos: Making a New Science (Gleik), 1322
Chaos theory, 1322–1323
Chaplin, Charlie, 1201, *1201*
Chappaqua, 1299
Charcot, Jean-Martin, 1155
"Charge of the Light Brigade" (Tennyson), 1145, *1145*
Charles the First (Basquiat), 1326–1327, *1327*
Chávez, Carlos, 1230
Chávez, César, 1334
Chevreul, Michel-Eugène, *The Principle of Harmony and Contrast of Colors*, 1118
Chiang Kaishek, 1250
Chiaroscuro lighting, 1237
Chicago, Judy
　The Dinner Party, 1305, 1305
　Pasadena Lifesavers, 1304, *1304*
　Through the Flower, 1304
　Un Chien andalou (An Andalusian Dog), 1204, *1204*

"Child of the Americas" (Morales), *1333–1334*, *1333–1334*
Childs, Lucinda, 1300
The Child's Brain (Chirico), 1159
China
 2008 Olympic Games, *1320, 1320*
 civil war in, 1250
 Shang Dynasty, 1190
 World War II, 1240
Chirico, Ciorgio de, *The Child's Brain,* 1159
The Christian Century, 1282
Christian existentialism, 1250
Christiansen, Bjørnstjerne Reuter, *Flooded McDonald's, 1340,* 1340–1341
Christo
 Running Fence, 1294–1295, *1295*
 The Umbrellas, Japan – USA, 1309, 1309
 "Christo and Jeanne-Claude: Remembering the *Running Fence,*" 1295
Chrono-photographs, *1136,* 1136
Chrysler, Walter, 1181–1182
Chrysler Building, 1181–1182, 1181–1182
Chrysler Building: Gargoyle outside Margaret Bourke-White's Studio (Bourke-White), *1182*
Churchill, Winston, 1174, 1237
Cinema
 in 1939, 1235–1237
 Americanization of, 1200–1201
 Disney's color animation, 1235
 in Europe, 1202–1204
 German Expressionism in, 1202–1203
 during Great Depression, 1233–1237
 Griffith and, 1137–1138, 1201
 Hollywood genres, 1202
 Nickelodeon, 1118, 1137
 origins of, 1136–1138
 Orson Welles and *Citizen Kane,* 1237, *1237*
 as propaganda tool, 1220
 Russian, 1154–1155
 silent films, 1199–1204
 sound and language, 1234
 studios and star system, 1200–1201
 surrealist films, 1204
Cinematic space, 1137–1138
Cinématographe, 1136
Cinématographe, poster for, *1137*
Citizen Kane, 1237, 1237
City Lights bookstore, 1267
City of Glass (Auster), 1329–1330, *1329–1330*
City Square (Giacometti), 1253, *1253*
Civil Rights Movement, 1276, 1281–1282
Civil Works Administration, 1228
Civilization and Its Discontents (Freud), 1155, 1158, 1170
Clair, René, *Entr'acte,* 1204
Classic Landscape (Sheeler), *1196,* 1196
Cleveland Plain Dealer, 1292
Close-up, 1138
The Club, 1260
Club Dada, 1151
Collaboration, art of, 1267–1268
Collage (Bearden), 1285–1286
Collage (Braque), 1125–1126
Collage (Picasso), 1126–1127
Collective unconscious, 1158
Collectivization of agriculture, 1221
Color animation, 1235
Color-field painting, *1262,* 1263–1264
Combine paintings, 1267
Commedia dell'arte, 1334
Communism, 1217
Composition VII (Kandinsky), *1132,* 1132–1133
Composition with Blue, Yellow, Red and Black (Mondrian), *1218,* 1218
Concentration camps, 1238, *1238,* 1239
 See also Holocaust
Conceptual art, 1292
Concerning the Spiritual in Art (Kandinsky), 1131
Concert for Piano and Orchestra (Cage), 1268
Congo, atrocities in, 1121–1122, *1122*
Connor, Bull, 1282
Copland, Aaron, 1298
 Appalachian Spring, 1230
 Billy the Kid, 1230
 Rodeo, 1230
 El Salón México, 1230
Corps de Dame (Dubuffet), *1254,* 1254
Cotton Club, 1179, *1179*
Cowley, Malcolm, *Exile's Return,* 1188
Crane, Hart
 The Bridge, 1191, 1191, 1194
 "To Brooklyn Bridge," *1191*
 Pound and, 1190
Creole Jazz Band, 1178
The Crisis, 1174
Crosby, David, 1296–1297
Crosby, Stills, Nash, & Young, 1296–1298
Cross-cutting, 1138
Cross-fertilization of cultures, 1331–1337
Cubism, 1124–1125
Cubist poets, 1134
Cubo-Futurism, 1152
Cullen, Countee, 1167
 "Heritage," *1175*–1176, *1207–1208*
 portrait of, *1175*
Cullen, Frederick and Carolyn, 1175
Cummings, E. E., 1190–1191
 Pound and, 1190
 "she being Brand," 1190–1191, *1191*
Cunningham, Merce, 1299
 Summerspace, 1267–1268, *1268*

D

Dada, 1148–1152, 1159
"Dada Manifesto 1918" (Tzara), 1148
Dalí, Salvador
 Un Chien andalou (An Andalusian Dog), 1204, *1204*
 The Lugubrious Game, 1161–1162, *1162*
 Persistence of Memory, 1162, *1163*
Dance
 modernist, 1129–1130
 postmodern, 1299–1300, *1300*
Dance II (Matisse), *1122, 1123*
Dancing House (Gehry/Milunic), *1312–1313,* 1313–1314
Daniel Gallery, 1194
Day of the God (Gauguin), 1122
De Beauvoir, Simone de, *The Second Sex,* 1251–1252, *1251–1252*
De Kooning, Elaine, 1260
De Kooning, Willem, 1255
 Excavation, 1259, 1259
 Pink Angels, 1258, 1259
 Seated Woman, 1258, 1259, 1260
 "What Abstract Art Means to Me," 1259
De Stijl movement, 1217
"Dead Man's Dump" (Rosenberg, I.), 1145–1146
Debussy, Claude, *Golliwog's Cakewalk,* 1179
Decolonization, 1240–1241
Deconstruction, 1322
Degenerate Art exhibition, 1220
Le Déjeuner sur l'herbe (Luncheon on the Grass) (Manet), 1164
Delaunay, Robert
 The Cardiff Team, 1116–1117, 1117
 Simultanism, 1118
DeLillo, Don, 1329
DeMille, Cecil B., 1200
Les Demoiselles d'Avignon (Picasso), *1120,* 1120–1122
Demuth, Charles, 1195–1196
 Aucassin and Nicolette, 1195
 The Figure 5 in Gold, 1192–1193, *1193*
 Incense of a New Church, 1195, *1195*
 My Egypt, 1195
Depression, economic
 See also Great Depression
Derrida, Jacques, *Of Grammatology,* 1322
Desegregation, 1276
Desire Under the Elms (O'Neill), 1199
Detroit Industry (Rivera), 1225
Detroit riots, 1287
The Development of Transportation, The Five-Year Plan (Klucis), *1222,* 1222
Diaghilev, Sergei, 1129
Diaspora, black, 1283
Díaz, Porfirio, 1224
Dick Cavett Show, 1308
Dickson, W. K. Laurie, 1136
Die Brücke, 1130–1131, 1215
Die Bücherverbrennung (The Book Burning) (Brecht), 1205
Dietrich, Marlene, *Der blaue Engel (The Blue Angel),* 1234, *1235*
The Dinner Party (Chicago), 1305, *1305*
"Disabled" (Owen, W.), 1146
Disney, Walt, 1235
Diversity in the arts, 1323–1342
 African experience in art, 1332–1333
 Asian worldview, 1331–1332
 contemporary Native American art, 1335–1336
 cross-fertilization of cultures, 1331–1337
 Islam, 1336–1337
 Latino and Hispanic presence in U.S., 1333–1335
 literature, 1328–1330
 new technologies, 1338–1342
 painting, 1324–1325, 1328
 postmodern poetry, 1330–1331
"Diving into the Wreck" (Rich), 1303, *1303*
Dixieland jazz, 1178–1179
DNA, 1323
Doesburg, Theo van, 1217
Domino House (Le Corbusier), *1219*
Dorsey, Tommy, 1179
Double Negative (Heizer), 1294, *1294*
Double-consciousness, 1174, 1176
Douglas, Aaron, 1179–1180
 Aspects of Negro Life, 1229–1230
 Aspiration, 1172–1173, 1173, 1230
 illustrations for *God's Trombones,* 1179, *1180*
The Dove (Bearden), *1286,* 1286
Drama. *See* Theater
Dreams, Freud and, 1155
Drugs and alcohol, 1296
Drums in the Night (Brecht), 1213
Du Bois, W. E. B.
 The Philadelphia Negro, 1174
 The Souls of Black Folk, 1174, 1174
Dubbing, 1234
Dubuffet, Jean, *Corps de Dame, 1254,* 1254
Duchamp, Marcel, 1204
 The Blind Man, 1151
 Fountain, 1150, 1150
 mobiles, 1264
 Mona Lisa (L.H.O.O.Q.), 1151, *1151*
 Nude Descending a Staircase, 1150, *1150*
 "ready-mades," 1275
"Dulce et Decorum Est" (Owen, W.), 1146, *1146*
Duration Piece #13 (Huebler), 1292
Dürer, Albrecht, 1215
Durham, Jimmie, *Headlights,* 1335–1336

Dust Bowl in film and literature, 1230–1231
Dylan, Bob, "The Times They Are A-Changin'," 1282–1283

E

Earth Day, 1293
Eastman, George, 1136
Ebert, Friedrich, 1214
Ebert, Roger, 1236
Ebony magazine, 1285
Eckford, Elizabeth, *1276,* 1276
Eco, Umberto, 1329
Edison, Thomas, 1136, 1200
Ego, 1155
The Ego and the Id (Freud), 1155, 1158
Einstein, Albert, *General Principles of Relativity,* 1118–1119
Einstein on the Beach (Wilson), 1299–1300, *1300*
Eisenhower, Dwight, 1276, 1290
Eisenstein, Sergei, 1188, 1154–1155
 The Battleship Potemkin, 1155, 1156–1157, 1156–1157
 "Odessa Steps Sequence," 1156–1157
Electronic synthesizer, 1298
Eliason, Olafur, *The Weather Project, 1343,* 1343
Eliot, T. S., 1147–1148
 "Love Song of J. Alfred Prufrock," 1302
 The Waste Land, 1147–1148, *1148,* 1169
Ellington, Duke, *It Don't Mean a Thing (If It Ain't Got That Swing),* 1179
Ellison, Ralph
 on Bearden, 1286
 Invisible Man, 1284–1285, *1284–1285*
The Emperor Jones (O'Neill), 1199
Empire State Building, 1181, 1182
Entr'acte, 1204
Entrance, Auschwitz-Berkinau Death Camp (Giraud, P.), *1238*
Entropy, 1293
Environmental movement, 1293, 1343
Epic theater, 1214
Ernst, Max, *The Master's Bedroom, 1159,* 1159
Esslin, Martin, 1252
Europe
 atheistic existentialism, 1250–1251
 Christian existentialism, 1250
 cinema in, 1202–1204
 De Beauvoir and existential feminism, 1251–1252
 division of after World War II, 1250
 existentialism, art of, 1253–1254
 literature of existentialism, 1252–1253
 map of, 1939–45, *1238*
 post-World War II period, 1250–1254
Europe, James Reese, 1176
Evans, Walker, 1194
 Let Us Now Praise Famous Men, 1232
 Washroom and Dining Area of Floyd Burroughs's Home, Hale County, Alabama, 1232
Ever Is Over All (Rist), *1341,* 1341–1342
Excavation (de Kooning, W.), *1259,* 1259
Exile's Return (Cowley), 1188
Existential feminism, 1251–1252
Existentialism, 1250–1254
Exposition Universelle, 1117, 1226
Expressionism movement, 1130–1134
Expressionist prints, 1214–1215
Extreme close-up, 1138

F

F-111 (Rosenquist), 1290–1291, *1290–1291*
Fairbanks, Douglas
 The Black Pirate, 1234
 The Thief of Bagdad, 1201, *1201*
Falange, 1224
Fallingwater, Bear Run, Pennsylvania (Wright), 1186, 1186–1187
The Family of Man exhibition, 1266
Fantasia, 1235
A Farewell to Arms (Hemingway), 1188
Farm Security Administration (FSA), 1231
Farmworkers at Guadalupe (Baca), *1334,* 1334
The Farmworkers Theater, 1334–1335
Farnsworth House (Mies van der Rohe), 1269, *1269*
Farsi calligraphy, 1337, *1337*
Fascism, 1205, 1215–1224
 Franco in Spain, 1224
 Hitler in Germany, 1216–1221
 Mussolini in Italy, 1223
 rise of, 1215–1216
 Stalin in Russia, 1221–1223
Faubus, Orval, 1276
Faulkner, William
 As I Lay Dying, 1189
 The Sound and the Fury, 1189, 1189
 Southern novel, 1189
Fauves, 1122–1123
Fauvism, 1122
FDIC (Federal Deposit Insurance Corporation), 1228
Federal Deposit Insurance Corporation (FDIC), 1228
Federal Music Project, 1230
The Feminine Mystique (Friedan), 1301–1302, 1302
Feminism, 1301–1307
 art, 1303–1307
 existential, 1251–1252
 Friedan and, 1301–1302
 poetry, 1302–1303
 theoretical framework, 1301–1302

Fenger, Jakob, *Flooded McDonald's, 1340,* 1340–1341
Ferdinand, Francis, 1143
Ferlinghetti, Lawrence, 1267
Ferris wheels, 1117
Ferus Gallery, 1270, *1271*
Fiction, postmodern, 1329–1330
Fiedler, Arthur, 1298
Le Figaro, 1128
The Fight for Life, 1231
The Figure 5 in Gold (Demuth), 1192–1193, *1193*
Fillmore poster "look," 1296
Film School in Moscow, 1154
Films. *See* Cinema
Filo, John Paul, *Kent State—Girl Screaming over Dead Body, 1297,* 1297
Fin de Siècle
 modernism, 1130–1134
 Paris Exposition of 1889. *See* Exposition Universelle
First All-Union Congress of Soviet Writers, 1222
Fischli, Peter, *The Way Things Go, 1339,* 1339–1340
Fitzgerald, Ella, 1179
Fitzgerald, F. Scott
 The Great Gatsby, 1187–1188, *1187–1188*
 Tales of the Jazz Age, 1179
Five Angels for the Millennium (Viola), 1338–1339, *1339*
"Five Points of a New Architecture" (Le Corbusier), 1219
Flashback, 1138
Fleming, Victor, 1236
Flesh and the Devil, 1202
Fleur Manteau (Flower Hammer) (Arp), 1149
Flint, S. F., 1135, 1190
Flooded McDonald's (Superflex), *1340,* 1340–1341
Florida-Bound Blues (Smith, B.), 1178
Folk music, 1230, 1282
Folklore, 1176–1177, 1179
Fontina Mix (Cage), 1268
The Forbidden Planet, 1256
Ford, Edsel B., 1225
Ford, Henry, 1118
Ford Motor Company, 1196
Foucault, Michel, *The Order of Things, 1328,* 1328–1329
Founding and Manifesto of Futurism (Marinetti), 1128, *1141*
Fountain (Duchamp), *1150,* 1150
Fox, William, 1200
Franco, Francisco, 1224
Frank, Robert, *The Americans,* 1265–1266
Frankenthaler, Helen, 1263–1264
 The Bay, 1263
"Fred and Ginger" (Gehry/Milunic), *1312–1313,* 1313–1314
Free association, 1155
Free Speech Movement, 1288
Freud, Sigmund, 1155
 Beyond the Pleasure Principle, 1155
 Civilization and Its Discontents, 1155, 1158, 1170
 The Ego and the Id, 1155, 1158
 The Interpretation of Dreams, 1155
 "The Sexual Life of Human Beings," 1155
 Studies in Hysteria, 1155
Friedan, Betty, *The Feminine Mystique,* 1301–1302, *1302*
Friedrich, Caspar David, *Monk by the Sea,* 1342
From Caligari to Hitler (Krakauer), 1203
Fruit Dish and Glass (Braque), 1126
FSA (Farm Security Administration), 1231
Fukuoka Prefectural International Hall (Ambasz), *1319,* 1319–1320
Full shot, 1138
Fuller, Peter, 1313–1314
The Fundamentals of Ecology (Odum), 1293
Futurism, 1128, *1129*

G

Gable, Clark, 1236
"Gadji beri bimba" (Ball), 1149
Galerie Dada, 1149
Gallery 291, 1183, 1194
Gandhi (Bourke-White), *1242*
Gandhi, Mohandas, 1241, *1242*
Garbo, Greta, 1202, 1234
 Flesh and the Devil, 1202
 Love, 1202
 A Woman of Affairs, 1202
Garland, Judy, *The Wizard of Oz,* 1235, *1235*
Gass, William, 1329
Gassed (Sargent), 1144, *1145*
Gaud and Toqué, 1121–1122
Gauguin, Paul
 Mahana no atua (Day of the God), 1122
 Picasso and, 1121
Gay, Paul du, 1315
Gay, Peter, 1215
Gay rights movement, 1307–1308
Gee's Bend, Alabama, 1177
Gee's Bend: The Architecture of the Quilt (Arnett), 1177
Gehry, Frank
 Guggenheim Museum, Bilbao, 1316, *1316, 1317*
 Rasin Building (Dancing House), *1312–1313,* 1313–1314
 residence of, *1315,* 1315–1316
Gender, 1197–1198

General Dynamics, 1290
General Principles of Relativity (Einstein), 1118–1119
Genet, Jean, 1252
Genres, of films, 1202
"Gentle Manifesto" (Venturi), 1314
Georgia O'Keeffe Museum, 1198
German Expressionism, 1202–1203, 1205
Germany
 anti-Semitism, 1217
 Bauhaus, 1217–1220, 1244
 Berlin and, 1210–1211, 1211–1215, 1221
 Brecht and, 1213–1214
 Degenerate Art exhibition, 1220
 fascism in, 1205, 1216–1221
 Kafka and, 1212–1213
 Kollwitz and, 1214–1215
 map of, *1212*
 modernism in, 1130–1134
 propaganda, art of, 1220–1221
 Weimar Republic, 1212, 1215, 1217
Gershwin, George, 1298
 Porgy and Bess, 1179
 Rhapsody in Blue, 1179
Gertrude Stein (Picasso), *1119*
Gesamtkunstwerk, 1299–1301
Giacometti, Alberto
 City Square, 1253, *1253*
 Suspended Ball, 1162, *1163*
Gilbert, Cass, *1184*, 1185
Ginsberg, Allen, "Howl," *1266*, 1266–1267
Giraud, Albert, *Pierrot lunaire*, 1133
Giraud, Philippe, *Entrance, Auschwitz-Berkinau Death Camp*, *1238*
Girl before a Mirror (Picasso), 1161, *1161*
The Girl of the Golden West (Puccini), 1133
Glass, Philip, *Einstein on the Beach*, 1299–1300
Gleik, James, *Chaos: Making a New Science*, 1322
Global village, 1309–1310
Go Tell It on the Mountain (Baldwin), 1284
God Bless America (Ringgold), 1282–1283, *1283*
God's Trombones (Johnson, J.), 1179, *1180*
Godzilla (*Gojira*), *1243*, 1243
Goebbels, Joseph, 1205, 1220
The Gold Rush, 1201, *1201*
The Golden Age, 1204
Gold art, *See* Goldwyn, Sam
Goldwyn, Sam, 1200
Golliwog's Cakewalk (Debussy), 1179
Gone with the Wind, 1235–1236, *1236*
Goodman, Benny, 1179
Gorky, Arshile, 1255
Graffiti, 1326–1327, *1327*
Graham, Bill, 1296
Graham, Martha, 1230
La Grande Odalisque (Ingres), 1121
The Grapes of Wrath (Steinbeck), 1230–1231
Great Depression, 1228–1233
 cinema during, 1233–1237
 Dust Bowl in film and literature, 1230–1231
 Federal Music Project, 1230
 mural movement, 1229–1230
 New Deal, 1228–1233
 photography and, 1231–1233
Great Digest (Ta Hsio), 1190
"The Great Figure" (Williams, W.), 1192–1193
The Great Gatsby (Fitzgerald), 1187–1188, *1187–1188*
Great German Art exhibitions, 1220
Great Migration, 1167, 1173–1174
Great Migration series of paintings, *1180*, 1180
Great Salt Lake, 1293
The Great Train Robbery, 1202, *1202*
Greater Berlin Act, 1212
"Green architecture," 1318
Green on Blue (Rothko), 1262, *1263*
Griffith, D. W., 1201
 The Birth of a Nation, 1137–1138, *1138*
Gropius, Walter, 1217
 Bauhaus Building, *1219*, 1219–1220
 Harvard Graduate Center, 1244
Gros, Antoine Jean, *Napoleon at Eylau*, 1144
Grosz, George, 1151
 The Pillars of Society, 1212, *1213*
Grynszpan, Herschel, 1217
Guardians of the Secret (Pollock), 1255, *1255*
Guernica (Picasso), 1226–1227, *1227*
Guernica, Spain, 1226–1227, *1227*
Guggenheim Museum, Bilbao (Gehry), 1316, *1316*, *1317*
Guggenheim Museum, New York, *1270*, 1270, 1292
Guiliani, Rufolph W., 1333
Guitar, Sheet Music, and Wine Glass (Picasso), *1127*, 1127
Gulags, 1221

H

Haeberle, Ron, *Q. And Babies? A. And Babies.*, *1292*, 1292
Haiku Chinese poetry tradition, 1135
The Hairy Ape (O'Neill), 1199
Hamilton, Richard, *Just What Is It That Makes Today's Homes So Different, So Appealing?* 1256–1257, *1257*
Hanson, Duane, *Supermarket Shopper*, 1248–1249, *1249*
Happening, 1269
Happiness Is a Warm Gun (Lennon), 1341
Harbou, Thea von, *Metropolis*, *1203*, 1203
Hardin, Lil, 1178–1179
Harlem, 1167, 1173

"Harlem" (Hughes), *1209*
Harlem Art Workshop, 1167
Harlem: Mecca of the New Negro, 1175
Harlem Renaissance, 1167, 1174–1180
 and black identity, 1283
 Hughes and, 1176
 Hurston and, 1176–1177
 introduction to, 1173–1174
 jazz music, 1177–1179
 "The New Negro," 1175–1176
 quilts of Gee's Bend, 1177
 visual arts, 1179–1180
Harlem Shadows (McKay), 1174–1175
Hart, William S., 1202
Hartigan, Grace, *River Bathers*, 1260–1261, *1261*
Hartpence, Alanson, 1194
Hartley, Marsden, 1192
 New Mexico Landscape, 1196, *1197*
 on O'Keeffe, 1197
Hausmann, Raoul, *The Art Critic*, 1151, *1151*
Hawkes, John, 1329
Headlights (Durham), 1335–1336
Heartfield, John, *The Meaning of the Hitler Salute*, *1216*, 1217
Heckel, Erich, 1130
Heizer, Michael
 Double Negative, *1294*, 1294
 New Sublime, 1294
Heller, Joseph, *Catch-22*, 1288
Hemingway, Ernest
 "Big Two-Hearted River," 1188–1189, *1188–1189*
 A Farewell to Arms, 1188
 Michigan and, 1188–1189
 In Our Time, 1188
 The Sun Also Rises, 1188
 during World War I, 1145
Hendrix, Jimi, "The Star-Spangled Banner," 1297
Hennings, Emmy, 1149
"Her Kind" (Sexton), 1302, *1302–1303*
"Heritage" (Cullen), 1175–1176, *1207–1208*
Hersh, Seymour, 1297
Herzog and de Meuron, Olympic Stadium, Beijing, 1320, *1320*
Hesse, Eva, *Ringaround Arosie*, 1303, *1303–1304*
High art, and low art, 1298–1301
Hispanic and Latino presence in U.S., 1333–1335
History of Surrealism (Nadeau), 1162
Hitler, Adolph, 1205, 1211, 1216–1221
 1938 Munich meeting, 1237
 Mein Kampf, 1216, *1216*
 propaganda, art of, 1220
Ho Chi Minh, 1240, 1288
Hoffmann, Hans, 1255
Hollywood, California, *1199*, 1199–1200
Hollywood genres, 1202
"Hollywoodland" sign, *1199*
Holocaust, 1212, *1238*, 1238–1240
Holocaust Memorial Museum, 1242
Home of the Brave, 1300
Home on the Range (Baraka), 1287
Home Owners' Loan Corporation, 1228
Honda, Ishiro, 1243
Hotter Than That (Armstrong), 1178–1179
Houses at l'Estaque (Braque), 1124, *1124*
Houses on the Hill, Horta de Ebro (Picasso), *1125*
Housing, Gehry residence, *1315*, 1315–1316
"Howl" (Ginsberg), *1266*, 1266–1267
Huebler, Douglas
 Duration Piece #13, 1292
 "January 5–31, 1969," 1292
Huelsenbeck, Richard, 1148–1149, 1151
Hughes, Langston, 1176
 "Harlem," *1209*
 "Jazz Band in a Parisian Cabaret," 1176, *1176*
 One Way Ticket, 1167
 in Paris, 1176
 "Theme for English B," *1209*
 Weary Blues, 1176
 "Weary Blues," 1177–1178, *1208*
Hughes, Ted, 1302
Human Genome Project, 1323
Humanism, environment and, 1343
The Hunchback of Notre Dame, 1202
Hurston, Zora Neale
 "Spunk," 1176–1177
 Their Eyes Were Watching God, 1177

I

"I Have a Dream" speech (King), 1280–1281, 1281–1282
Ibaraki, Japan, *1309*, 1309
Ice (Richter), 1324, *1325*
The Iceman Cometh (O'Neill), 1199
Id, 1155, 1158
If This Is a Man (Levi), 1242
"If We Get It" (Antin, D.), *1330*, 1330
"If We Make It" (Antin, D.), 1330, *1330*
"If We Must Die" (McKay), 1174
"Il Pleut" ("It's Raining") (Apollinaire), *1134*, 1134, *1135*
I'm Not a Girl Who Misses Much (Rist), *1340*, 1341
Imagism, 1134–1136
Impressionism
 See also French Impressionism
Improvisational comedy, 1334
"In a Station of the Metro" (Pound), 1135, *1135*
In C (Riley), 1299

In Our Time (Hemingway), 1188
In the North the Negro had better educational facilities (Lawrence), 1180
In the Wind (Peter, Paul, and Mary), 1282
Incense of a New Church (Demuth), 1195, *1195*
Independents, 1255, 1256–1257
Indeterminancy (Cage), 1268
India, 1241
Indian Country Today (Bradley), *1336*, 1336
Industrial scene, 1195–1196
Ingres, Jean-Auguste-Dominique, *La Grande Odalisque*, 1121
Installations
 Antin's *Minetta Lane—A Ghost Story*, *1338*, 1338
 Eliasson's *The Weather Project*, *1343*, 1343
 Fischli's *The Way Things Go*, *1339*, 1339
 Rist's *Ever Is Over All*, *1341*, 1341
 Viola's *Five Angels for the Millennium*, 1339, *1339*
International Exhibition of Modern Architecture, 1185
International style, 1184–1186, 1217–1220
The International Style: Architecture since 1922, 1185
An International Survey of Painting and Sculpture, 1303
Internment of Japanese Americans, 1240
The Interpretation of Dreams (Freud), 1155
Intertitles, 1137, 1138
Interventionist Demonstration (Carrà), 1128
Invention, era of, 1117–1141
 cinema, origins of, 1136–1138
 early-20th century literature, 1134–1136
 Expressionist movement, 1130–1134
 introduction to, 1117–1119
 in Paris, 1119–1134
Invisible Man (Ellison), 1284–1285, *1284–1285*
Ionesco, Eugène, 1252
Iran, 1336–1337
Iris shot, 1138
Islam, 1336–1337
Islamic Revolution, 1336–1337
It Don't Mean a Thing (If It Ain't Got That Swing) (Ellington), 1179
Italy, fascism in, 1223
It's Gonna Rain (Reich), 1299
"It's Raining" (Apollinaire), *1134*, 1134, *1135*
Izenour, Steven, *Learning from Las Vegas*, 1314–1315

J

James, Harry, 1179
James, Henry, 1139
James, William, *Psychology*, 1164
Jannings, Emil, 1234
"January 5–31, 1969" (Huebler), 1292
Japan
 engaging the West, 1331–1332
 World War II, 1240
Jazz, 1177–1179
Jazz Age, 1173–1209
 Harlem Renaissance, 1174–1180
 introduction to, 1173–1174
 place of, 1187–1199
 silent films, 1199–1204
 skyscraper architecture in New York, 1181–1186
"Jazz Band in a Parisian Cabaret" (Hughes), 1176, *1176*
Jazz music, 1177–1179
The Jazz Singer, 1234, *1234*
Jean-Marie Tjibaou Cultural Center (Piano), 1318, *1319*
Jeanne-Claude
 Running Fence, 1294–1295, *1295*
 The Umbrellas, Japan – USA, 1309, *1309*
Jeanneret, Charles-Édouard. *See* Le Corbusier
Jefferson Airplane
 Surrealistic Pillow, 1296
 "White Rabbit," 1296
Jewish Museum, 1292
Jewish people, 1217
 See also Anti-Semitism; Holocaust
Jim Crow laws, 1276
Johns, Jasper, *Three Flags*, 1268, *1268*
Johnson, Charles S., 1175
Johnson, James Weldon
 God's Trombones, 1179, *1180*
 "The Prodigal Son," 1179–1180
Johnson, Philip, 1182, 1185, 1190, 1219, 1244, *1244*
Johnson, Robert, 1178
Jolson, Al, 1234, *1234*
Jones, Leroi, 1286
The Joy of Life (Matisse), 1122, *1123*
Joyce, James
 photograph of, *1164*
 Ulysses, 1164–1165
Jung, Carl, 1158
Just What Is It That Makes Today's Homes So Different, So Appealing? (Hamilton), 1256–1257, *1257*

K

"Ka'Ba" (Baraka), 1286–1287, *1287*
Kaddish (Bernstein), 1298
Kafka, Franz, 1212–1213
 The Metamorphosis, 1213, 1246–1247
 The Trial, 1213, *1213*
Kahlo, Frida, *The Broken Column*, 1228, *1228*

Kain, Gylan, 1287
Kalmus, Herbert, 1233
Kanak people, 1318–1319
Kandinsky, Wassily, 1202, 1217
 Composition VII, *1132*, 1132–1133
 Concerning the Spiritual in Art, 1131
Kaprow, Allan
 18 Happenings in 6 Parts, 1269
 "The Legacy of Jackson Pollock," 1269, *1269*, 1272
Kaufmann, Edgar, 1186
Kaufmann House (Wright), 1186, *1186*
Kent State University, 1297
Kent State—Girl Screaming over Dead Body (Filo), *1297*, 1297
Kerouac, Jack, 1265–1266
 On the Road, 1266
Kgositsile, Willie, 1287
Kierkegaard, Søren, 1250, 1251
Kinetoscope, 1136
King, Martin Luther, Jr., 1276
 "I Have a Dream" speech, 1280–1281, 1281–1282
 "Letter from Birmingham Jail," 1282, *1282*
 nonviolent protest and, 1286–1287
Kirchner, Ernst Ludwig, 1202
 Self-Portrait as a Soldier, 1142–1143, 1144
 Self-Portrait with Model, 1130, 1130–1131
Klee, Paul, 1217
Kline, Franz, 1255
Klucis, Gustav, *The Development of Transportation, The Five-Year Plan*, 1222, *1222*
Koklova, Olga, 1160–1161
Kollwitz, Käthe, 1214–1215
 Never Again War, 1215, *1215*
Korean War, 1250
Krakauer, Siegfried, *From Caligari to Hitler*, 1203
Krasner, Lee, *White Squares*, 1260, *1260*
Kristallnacht, 1217
Kubrick, Stanley, *2001: A Space Odyssey*, 1299
Kulaks, 1221
Kuleshov, Lev, 1154–1155
Kuleshov effect, 1154
Kurowsky, Agnes von, 1188

L

La Règle du jeu (*The Rules of the Game*), 1236–1237
"Lady Lazarus" (Plath), 1302, *1311*
Lady Macbeth of the Mtsensk District (Shostakovich), 1222
L'Age d'or (*The Golden Age*), 1204
"The Lake Isle of Innisfree" (Yeats), 1147, *1147*
Lakota Sioux, 1335
Lam, Wifredo, *The Siren of the Niger*, 1284, *1284*
Lance Loud (Warhol), *1308*, 1308
Land art, 1292–1295
 Christo and Jeanne-Claude, 1294–1295, *1295*
 Heizer's New Sublime, 1294
 Smithson's *Spiral Jetty*, 1293, *1293*–1294
Lang, Fritz, *Metropolis*, 1203, 1203
Lange, Dorothea, *Migrant Mother*, 1231, *1231*
Lanzmann, Claude, *Shoah*, 1242
"L'Après-midi d'un faune" (Mallarmé), 1122
The Large Blue Horses (Marc), 1131, *1131*
L'Arroseur arrosé (*Waterer and Watered*) (Lumière brothers), 1137, *1137*
Las Vegas, Nevada, 1314, 1314–1315
Lasky, Jesse, 1200
L'Assiette au beurre (*The Butter Plate*), 1122, *1122*
Last Poets, 1287
Latino and Hispanic presence in U.S., 1333–1335
Lawler, Louise, *Pollock and Tureen*, 1323–1324, *1324*
Lawrence, Jacob, 1180
 Great Migration series of paintings, 1180
 The Migration of the Negro, 1180
 In the North the Negro had better educational facilities, 1180
Le Corbusier
 Domino House, 1219
 "Five Points of a New Architecture," 1219
 Towards a New Architecture, 1219
 Villa Savoye, 1219, *1219*
 "Leap of faith," 1250–1251
Learning from Las Vegas (Venturi/Brown/Izenour), 1314–1315
Leaves of Grass (Whitman), 1136
"The Legacy of Jackson Pollock" (Kaprow), 1269, *1269*, 1272
Leigh, Vivian, 1235
Leighten, Patricia, 1121
Lenin, Vladimir, *The State and Revolution*, 1152
Lennon, John, *Happiness Is a Warm Gun*, 1341
Leo Castelli Gallery, 1290
L'Espirit Nouveau, 1219
"Let No One Sleep" (Puccini), 1133–1134
Let Us Now Praise Famous Men (Agee/Evans), 1232
"Letter from Birmingham Jail" (King), 1282, *1282*
Levi, Primo, *If This Is a Man*, 1242
LeWitt, Sol, *Wall Drawing #146A*, 1275, *1275*
Liberation and identity (1960s and 1970s), 1281–1311
 black identity, 1283–1288
 feminist era, 1301–1307
 high and low art, 1298–1301
 introduction to, 1281–1283

male identity, 1307–1308
Vietnam War, and the arts, 1288–1298
Lichtenstein, Roy
 Little Big Painting, 1272, *1273*
 Oh, Jeff. I Love You, Too. But., 1272, *1273*
Life magazine, 1232, 1233, 1285
Ligeti, György, *Lux Aeterna*, 1298–1299
"L'invitation au voyage" (Baudelaire), 1122
Lipstick (Ascending) on Caterpillar Tracks
 (Oldenburg), 1289, *1289*
Lissitzsky, Lazar (El), *Beat the Whites with the*
 Red Wedge, 1154, *1154*
Literature
 asserting blackness in, 1285–1288
 cubist poets, 1134
 diversity in the arts, 1328–1330
 early-20th century, 1134–1136
 of existentialism, 1252–1253
 Imagists, 1134–1136
 multiplicity in postmodern literature,
 1328–1330
 place, art of, 1187–1189
 postmodern fiction, 1329–1330
 postmodern poetry, 1330–1331
 Southern novel, 1189
 stream-of-consciousness novel, 1164–1166,
 1189
 trench warfare and, 1145–1148
Literature, readings
 All Quiet on the Western Front (Remarque),
 1146
 The Autobiography of Alice B. Toklas (Stein),
 1119
 The Autobiography of William Carlos Williams
 (Williams), 1195
 "Big Two-Hearted River" (Hemingway),
 1188–1189
 "Borges and I" (Borges), 1345
 "To Brooklyn Bridge" (Crane), 1191
 "Charge of the Light Brigade" (Tennyson),
 1145
 City of Glass (Auster), 1329–1330
 Civilization and Its Discontents (Freud), 1170
 "Dada Manifesto 1918" (Tzara), 1148
 "Diving into the Wreck" (Rich), 1303
 "Dulce et Decorum Est" (Owen), 1146
 The Feminine Mystique (Friedan), 1302
 Founding and Manifesto of Futurism
 (Marinetti), 1141
 "Gadji beri bimba" (Ball), 1149
 The Great Gatsby (Fitzgerald), 1187–1188
 "Harlem" (Hughes), 1209
 "Her Kind" (Sexton), 1302–1303
 "Heritage" (Cullen), 1207–1208
 "Howl" (Ginsberg), 1266
 "If We Must Die" (McKay), 1174
 "Il Pleut" (Apollinaire), 1134
 Invisible Man (Ellison), 1284–1285
 "Jazz Band in a Parisian Cabaret" (Hughes),
 1176
 "Lady Lazarus" (Plath), 1311
 "The Lake Isle of Innisfree" (Yeats), 1147
 "The Legacy of Jackson Pollock" (Kaprow),
 1269
 "Letter from Birmingham Jail" (King), 1282
 "Lundi, rue Christine" (Apollinaire), 1134
 Mein Kampf (Hitler), 1216
 The Metamorphosis (Kafka), 1246–1247
 Monsieur Antipyrine's Manifesto (Tzara),
 1148–1149
 Mrs. Dalloway (Woolf), 1165
 The New Negro (Locke), 1175
 Night (Wiesel), 1242
 No Exit (Sartre), 1251
 The Non-Objective World (Malevich), 1153
 The Order of Things (Foucault), 1328
 "A Pact" (Pound), 1135
 poetry and the machine aesthetic, 1190–1191
 "The Prodigal Son" (Johnson), 1179–1180
 "The Revolution Will Not Be Televised"
 (Scott-Heron), 1287–1288
 "A Room of One's Own" (Woolf), 1171
 "The Second Coming" (Yeats), 1147
 The Second Sex (De Beauvoir), 1251–1252
 Slaughterhouse-Five (Vonnegut), 1288
 The Souls of Black Folk (Du Bois), 1174
 "In a Station of the Metro" (Pound), 1135
 The Stranger (Camus), 1252
 Surrealist Manifesto (Breton), 1158
 Swann's Way (Proust), 1164
 "Theater for Pleasure or Theater for Imagina-
 tion" (Brecht), 1214
 "Theme for English B" (Hughes), 1209
 "On the Towpath" (Ashbery), 1330
 The Trial (Kafka), 1213
 Waiting for Godot (Beckett), 1253, 1278–1279
 The Waste Land (Eliot), 1148, 1169
 "The Weary Blues" (Hughes), 1208
 "Woodstock" (Mitchell), 1297
 Zoot Suit (Valdez), 1335
Littérature magazine, 1159
Little Big Painting (Lichtenstein), 1272, *1273*
Little Review, 1164, 1165
Little Rock Central High School, 1276
"Little Rock Nine," *1276*, 1276
Locke, Alain Leroy, 1175
 The New Negro, 1175
Loeb, Kuhn, 1201
Long Day's Journey into Night (O'Neill), 1199
Long shot, 1138
Look magazine, 1285
Looking Northwest from the Shelton, New York
 (Stieglitz), 1184, *1184*
Lorentz, Pare, 1230–1231

The Fight for Life, 1231
The Plow That Broke the Plains, 1230
The River, 1230
Lorenz, Edward, 1322–1323
Loud, Lance (photograph by Warhol), 1308,
 1308
Loud, William C., 1308
Love, 1202
"Love Song of J. Alfred Prufrock" (Eliot), 1302
Low art, and high art, 1298–1301
The Lugubrious Game (Dalí), 1161–1162, *1162*
Lumière Brothers, 1118, 1136–1137
 Arrival of a Train at La Ciotat, 1137
 L'Arroseur arrosé (*Waterer and Watered*), 1137,
 1137
"Lundi, rue Christine" (Apollinaire), *1134*, 1134
Lux Aeterna (Ligeti), 1298–1299
Luxe, calme, et volupté (*Luxury, Calm, and*
 Pleasure) (Matisse), 1122
Lyricism, 1133–1134

M

*M*A*S*H* (Altman), 1288
Machine aesthetic, 1182–1184, 1190–1191
Machine Art exhibition, 1182, 1185, 1190
"Mack the Knife" (Brecht), 1214
Macke, Auguste, 1131, 1144
MacLean, Bonnie, *Six Days of Sound*, 1296, *1296*
Madama Butterfly (Puccini), 1133
Madero, Francisco I., 1224
Mahagonny-Songspiel (Brecht/Weill), 1214
Mahana no atua (*Day of the God*) (Gauguin),
 1122
Make It New (Pound), 1190
Malcolm X, 1286
Male identity, 1307–1308
Malevich, Kasimir, 1152
 "0,10: The Last Futurist Exhibition of Paint-
 ing," 1153, *1153*
 Black Square, 1153
 The Non-Objective World, 1153, *1153*
 Painterly Realism: Boy with Knapsack - Color
 Masses in the Fourth Dimension, 1152, *1153*
 Suprematist Painting, 1154, 1275
Mallarmé, Stéphane, "L'Après-midi d'un faune,"
 1122
Man, Controller of the Universe (Rivera), 1225,
 1225
Man at the Crossroads Looking with Hope and High
 Vision to a New and Better Future (Rivera),
 1225
Man with Keloidal Scars (Tomatsu), *1243*
Mandelbrot, Benoit, 1322
Mandelbrot set, 1322, *1323*
Manet, Édouard
 Le Déjeuner sur l'herbe (*Luncheon on the*
 Grass), 1164
 Olympia, 1121
Manon Lescaut (Puccini), 1133
Mao Zedong, 1250, 1299
Maps
 Birmingham, Alabama, *1281*
 concentration camps, Europe, *1238*
 Montmartre, *1118*
 New York City skyscrapers, *1181*
 Spanish Civil War, *1224*
 Weimar Germany, *1212*
 Western Front, 1914-1918, *1143*
 World War II, *1238*, *1241*
Marc, Franz, 1144, 1202
 The Large Blue Horses, 1131, *1131*
March on Washington, 1280–1281, 1282
Marey, Étienne-Jules, *Movement*, 1136
Marilyn Diptych (Warhol), 1272, *1272*, 1275
Marinetti, Filippo, *Founding and Manifesto of*
 Futurism, 1218, 1141
Marketing, 1249–1250
Marlboro Man, 1307, *1307*
Marx, Karl, 1217
Mass production, 1219, 1275
Massachusetts Museum of Contemporary Art,
 1275
The Master's Bedroom (Ernst), *1159*, 1159
Matisse, Henri
 Dance II, 1122, *1123*
 The Joy of Life, 1122, *1123*
 Luxe, calme, et volupté (*Luxury, Calm, and*
 Pleasure), 1122
 Picasso and, 1122–1123
Maus: A Survivor's Tale (Spiegelman), 1242
Mayflower II, 1335
Maysles, Albert, 1295
Maysles, David, 1295
McClure, Michael, 1267
McDaniel, Hattie, 1236
McHale, John, 1256
McKay, Claude
 Harlem Shadows, 1174–1175
 "If We Must Die," 1174
McLuhan, Marshall, 1309
Meadlo, Paul, 1292
Meadowland (Richter), 1324–1325, *1325*
The Meaning of the Hitler Salute (Heartfield),
 1216, 1217
Media, global, 1310
Medium shot, 1138
Mein Kampf (Hitler), 1216, *1216*
Menzies, William Cameron
 Gone with the Wind, 1236, *1236*
 sets for *The Thief of Bagdad*, 1200
Merleau-Ponty, Maurice, 1252
The Metamorphosis (Kafka), 1213, 1246–1247
Metropolis, *1203*, 1203

Metropolitan Life Tower, 1181
Metropolitan Museum of Art, 1292
Mexico, 1224–1228
Meyer, Hannes, 1220
Michigan, 1188–1189
Mies van der Rohe, Ludwig, 1217, 1220, 1314
 Farnsworth House, *1269*, 1269
 Seagram Building, *1244*, 1244, 1269
Migrant Mother (Lange), 1231, *1231*
The Migration of the Negro (Lawrence), *1167*,
 1167
Miller, Glenn, 1179
Miller, Jeffrey, 1297
Miller, Lee, *Buchenwald, Germany*, *1239*,
 1239–1240
Milunic, Vlado, Rasin Building (Dancing
 House), *1312–1313*, 1313–1314
Minetta Lane—A Ghost Story (Antin, E.), *1338*,
 1338
Minimalism, 1274–1275, 1298–1299
Miró, Joan
 The Birth of the World, 1160, *1160*
 surrealism and, 1160–1161
Mitchell, George, 1335
Mitchell, Joan, *Piano mécanique*, 1261, *1261*
Mitchell, Joni, "Woodstock," 1297, *1297*
Mitchell, Margaret, 1235
Mix, Tom, *The Great Train Robbery*, 1202, *1202*
Mobiles, 1264
Modernism, 1130–1134
Modernist dance, 1129–1130
Mona Lisa (L.H.O.O.Q.), 1151, *1151*
Mondrian, Piet, 1217–1218, 1271
 Composition with Blue, Yellow, Red and Black,
 1218, 1218
Monk by the Sea (Friedrich), 1342
Monroe, Marilyn, 1256, 1272
Monsieur Antipyrine's Manifesto (Tzara),
 1148–1149, *1148–1149*
Montage, 1137
Montmartre, map of, *1118*
Morales, Aurora Levins, "Child of the
 Americas," 1333–1334, *1333–1334*
Morimura, Yasumasa, *Portrait (Twins)*, 1331,
 1331
Motion Picture Patents Company, 1200
Motion pictures. *See* Cinema
Mount Rushmore National Monument, 1335
Movement (Marey), 1136
Moving pictures. *See* Cinema
Mrs. Dalloway (Woolf), *1165*, 1165–1166
Mulvey, Laura, "Visual Pleasure and Narrative
 Cinema," 1307
Mumma, Gordon, 1268
Münter, Gabriele, *The Blue Gable*, 1131,
 1131–1132
Mural movement, Mexico, 1224–1225
Mural movement, United States, 1229–1230
Museum of Fine Arts, Houston, 1177
Museum of Modern Art, 1198, 1291, 1292,
 1303
Music
 atonal music vs. lyricism, 1133–1134
 blues music, 1177–1178
 Dixieland jazz, 1178–1179
 folk music, 1230, 1282
 gesamtkunstwerk, 1299–1301
 high and low art, 1298–1301
 jazz, 1177–1179
 minimalist music, 1298–1299
 modernist, 1129–1130
 postmodern opera, 1299–1300
 rock and rock, 1296–1298
 rock postmodern, 1300–1301
 social realism, 1222–1223
 during Vietnam era, 1295–1298
Mussolini, Benito, 1223, 1237
Muybridge, Eadweard, *Annie G., Cantering*
 Saddled, 1136, *1136*
My Egypt (Demuth), 1195
My Kingdom Is the Right Size (Antin), 1305–1306,
 1306
My Lai massacre, 1292, 1297

N

NAACP (National Association for the
 Advancement of Colored People), 1174
Nadeau, Maurice, *History of Surrealism*, 1162
Nagasaki (Tomatsu), *1243*, 1243
Napoleon at Eylau (Gros), 1144
Nash, Graham, 1296–1297
National Association for the Advancement of
 Colored People (NAACP), 1174
National Farm Workers Association, 1334
National Organization for Women (NOW),
 1301–1302
National Recovery Act, 1228
National Socialist Party, 1211
Native Americans
 Battle of Wounded Knee, 1335
 contemporary art, 1335–1336
 Lakota Sioux, 1335
La Nature, 1136
Nazi Party, 1211
Nazi rally photograph, *1210–1211*
"Negro Art and America" (Barnes), 1176
Nelson, David, 1287
Neshat, Shirin, 1336–1337
 Rebellious Silence, 1337, *1337*
 Women of Allah, 1337
Nessun dorma ("Let No One Sleep") (Puccini),
 1133–1134
Never Again War (Kollwitz), *1215*, 1215

New Deal, 1228–1233
New Mexico Landscape (Hartley), 1196, *1197*
"The New Negro," 1175–1176
The New Negro (Locke, A.), *1175*
New Negro Movement, 1175
New Orleans, Louisiana, 1178–1179
New Sublime (Heizer), 1294
New technologies, 1338–1342
"New Wave Festival," 1300
New York City
 See also Harlem Renaissance
 map of skyscrapers, *1181*
 skyscraper architecture in, 1181–1186
New York Society of Independent Artists,
 1150–1151
New York Times, 1292, 1297
The New Yorker magazine, 1293
Newark riots, 1287
Newsweek magazine, *1297*, 1308
Newton, Huey P., 1287
Nicholas II, tsar, 1152
Nickelodeon, 1118, 1137
Niebuhr, Reinhold, 1250
Nielsen, Rasmus, *Flooded McDonald's*, *1340*,
 1340–1341
Nietzsche, Friedrich, *Thus Spoke Zarathustra*,
 1130
Nigger Heaven (Van Vechten), 1175
Night (Wiesel), 1242, *1242*
Night and Fog (Resnais), 1242
Nijinsky, Vaslav, 1129–1130
Nixon, Richard, 1297, 1299
Nixon in China (Adams), 1299
No Exit (Sartre), 1251, 1251, *1252*
Nobel Peace Prize, 1242
Nolde, Emile, 1130, 1220
The Non-Objective World (Malevich), *1153*,
 1153
Nonviolent protest, 1286–1287
Notes of a Native Son (Baldwin), 1284
NOW (National Organization for Women),
 1301–1302
Nude Descending a Staircase (Duchamp), 1150,
 1150
Number 27 (Pollock), 1258
Nuremberg Laws, 1217

O

"O Superman" (Anderson), 1300–1301, *1301*
Object (Le Déjeuner en fourrure) (Oppenheim),
 1163, 1163
Obregón, Alvaro, 1224
"Odessa Steps Sequence" (Eisenstein),
 1156–1157
Odum, Eugene P., *The Fundamentals of Ecology*,
 1293
Of Grammatology (Derrida), 1322
Ofili, Chris, *The Holy Virgin Mary*, 1332,
 1332–1333
Oh, Jeff. I Love You, Too. But. (Lichtenstein),
 1272, *1273*
"Ohio" (Young), 1298
O'Keeffe, Georgia, 1183, 1197–1198
 Hartley on, 1197
 Red Hills and Bones, 1198, *1198*
 Stieglitz and, 1197–1198
Oldenburg, Claes, 1272–1273
 Lipstick (Ascending) on Caterpillar Tracks, 1289,
 1289
 Soft Toilet, *1273*, 1273
Oliver, Joe, 1178
Olson, Charles, 1267
Olympia (Riefenstahl), 1221, *1221*
Olympia (Manet), 1121
Olympic Games, 1117, 1221, 1320, *1320*
Olympic Stadium, Beijing, *1320*, 1320
On the Road (Kerouac), 1266
"On the Towpath" (Ashbery), 1330, 1330–1331
One Fine Day (Puccini), 1133
One Way Ticket (Hughes), 1167
O'Neill, Eugene, 1199
 Beyond the Horizon, 1199
 Desire Under the Elms, 1199
 The Emperor Jones, 1199
 The Hairy Ape, 1199
 The Iceman Cometh, 1199
 Long Day's Journey into Night, 1199
 Strange Interlude, 1199
Opera, postmodernism, 1299–1300
Oppenheim, Meret
 Object (Le Déjeuner en fourrure), 1163, *1163*
 Picasso and, 1164
Opportunity, 1177
The Order of Things (Foucault), 1328, 1328–1329
Orozco, José Clemente, 1224
"Orphée Noir" (Sartre), 1283–1284
Ostinato, 1130
Owen, Wilfred
 "Disabled," 1146
 "Dulce et Decorum Est," *1146*, 1146
Owens, Jesse, 1221
Oyewole, Abiodun, 1287

P

Pacific, World War II in, 1240
"A Pact" (Pound), 1135, *1135*
Pagosa Springs (Stella, F.), *1274*, 1274
Painterly Realism: Boy with Knapsack - Color
 Masses in the Fourth Dimension (Malevich),
 1152, *1153*
Paintings
 abstract expressionism, 1255, 1258–1262
 action painting, 1255, 1258–1260

color-field painting, *1262, 1263–1264*
diversity in, *1324–1325, 1328*
Expressionist movement, *1130–1134*
German Expressionism, *1205*
industrial scene, *1195–1196*
place, art of, *1194–1198*
pluralism in styles, *1324–1325, 1328*
surrealism and, *1158–1164*
Pakistan, 1241
Palazzo degli Uffici (Piacentini), *1222, 1223*
Palestine, 1241
Pan, in motion pictures, 1138
Pancho Villa, 1224
Paolozzi, Edouardo, 1256
Papiers-collés, 1126
Paris, France
cubism, *1124–1125*
futurism, *1128, 1129*
Hughes in, 1176
Matisse and Fauves, *1122–1123*
modernist music and dance, *1129–1130*
Picasso and, *1119–1122*
Paris Exposition of 1889. *See Exposition Universelle*
Parker, Charlie, *1326–1327, 1327*
Parks, Rosa, 1276
Pasadena Lifesavers (Chicago), *1304, 1304*
Passive resistance, 1241
Passlof, Pat, 1260
Pechstein, Max, 1130
Persistence of Memory (Dalí), *1162, 1163*
Pétain, Marshall, 1238
Peter, Paul, and Mary
"Blowin' in the Wind," 1282
In the Wind, 1282
Peter and the Wolf (Prokofiev), 1222
Pettway, Jessie T., *Bars and String-Pieced Columns,* *1177, 1177*
The Phantom of the Opera (film), 1202
The Philadelphia Negro (Du Bois), 1174
Philip Morris Co., 1307
Philosophy
atheistic existentialism, *1250–1251*
Christian existentialism, 1250
existential feminism, *1251–1252*
Photography, during Great Depression, *1231–1233*
Photomontage, 1151
Photo-silkscreen process, *1271–1272*
Piacentini, Marcello, Palazzo degli Uffici, *1222, 1223*
Piaf, Edith, 1267
Piano, Renzo, Jean-Marie Tjibaou Cultural Center, *1318–1319, 1319*
Piano mécanique (Mitchell), *1261, 1261*
Picabia, Francis, 1150, 1204
Picasso, Pablo, *1119–1122*
Bottle of Suze, *1139, 1139*
Braque and, *1124–1125*
Breton on, 1160
Cézanne and, 1121
collages, *1126–1127*
Les Demoiselles d'Avignon, *1120, 1120–1122*
Exposition Universelle, 1226
Gauguin and, 1121
Gertrude Stein, 1119
Girl before a Mirror, *1161, 1161*
Guernica, *1226–1227, 1227*
Guitar, Sheet Music, and Wine Glass, *1127, 1127*
Houses on the Hill, Horta de Ebro, *1125*
Matisse and, *1122–1123*
Oppenheim and, 1164
surrealism and, *1160–1161*
Violin, *1126, 1126*
Pickford, Mary
The Poor Little Rich Girl, 1201
Rebecca of Sunnybrook Farm, 1201
Pierrot lunaire (Schoenberg), 1133
The Pillars of Society (Grosz), *1212, 1213*
Pink Angels (de Kooning, W.), *1258, 1259*
Pinocchio, 1235
Pinter, Harold, 1252
Place, art of, *1187–1199*
literature, *1187–1189*
painting, *1194–1198*
poetry, *1190–1191*
theater, 1199
Planck, Max, 1118
Plath, Sylvia, "Lady Lazarus," *1302, 1311*
Pleasure Pillars (Sikander), *1337, 1337*
The Plow That Broke the Plains, 1230
Pluralism, *1320–1323*
African experience in art, *1332–1333*
Asian worldview, *1331–1332*
contemporary Native American art, *1335–1336*
cross-fertilization of cultures, *1335–1337*
diversity in the arts, *1323–1342*
Islam, *1336–1337*
Latino and Hispanic presence in U.S., *1333–1335*
multiplicity in postmodern literature, *1328–1330*
new technologies, *1338–1342*
in painting styles, *1324–1325, 1328*
postmodern poetry, *1330–1331*
Poetry
cubist poets, 1134
feminist poetry, *1302–1303*
Jazz Age, 1176
machine aesthetic, *1190–1191*
place, art of, *1190–1191*

postmodern, *1330–1331*
Poetry (journal), 1135, 1190
Poincaré, Raymond, 1139
Poison gas, *1143–1144*
Pollock, Jackson, 1255, *1258–1260*
Guardians of the Secret, *1255, 1255*
Krasner on, 1260
Number 27, 1258
Pollock and Tureen (Lawler), *1323–1324, 1324*
Polyrhythms, *1129–1130*
Polytonal, 1130
The Poor Little Rich Girl, 1201
Pop art, *1270–1273*
Porgy and Bess (Gershwin), 1179
Port Authority Trans Hudson (PATH) train station (Calatrava), *1318, 1318*
Porter, Edwin S., *The Great Train Robbery,* 1202
Portrait (Twins) (Morimura), *1331, 1331*
Portrait of Countee Cullen in Central Park (Van Vechten), *1175*
Postmodern theory, *1320–1323*
Postmodernism, *1313–1345*
architecture, *1313–1314, 1315–1320*
chaos theory, *1322–1323*
dance, *1299–1300, 1300*
deconstruction, 1322
fiction, *1329–1330*
human genome, 1323
introduction to, *1313–1315*
literature, *1328–1330*
pluralism and diversity in the arts, *1323–1342*
pluralism and postmodern theory, *1320–1323*
poetry, *1330–1331*
poststructuralism, *1321–1322*
structuralism, 1321
Poststructuralism, 1322
Postsynchronization, 1235
Post–World War II period, *1249–1279*
Beat generation, *1265–1270*
Civil Rights Movement, *1276, 1281–1282*
in Europe, *1250–1254*
introduction to, *1249–1250*
minimalism, *1274–1275, 1298–1299*
pop art, *1270–1273*
in United States, *1254–1265*
Pound, Ezra, *1134–1136*
Cantos, 1136
Make It New, 1190
"A Pact," *1135, 1135*
"In a Station of the Metro," *1135, 1135*
translation of *Ta Hsio (Great Digest),* 1190
on Whitman, *1135–1136*
Prairie Houses, 1186
Pravda, 1222
"A Prayer for My Daughter" (Yeats), 1147
Presley, Elvis, 1296
Prince, Richard, *Untitled (Cowboy),* *1307, 1307*
The Principle of Harmony and Contrast of Colors (Chevreul), 1118
Prints, expressionist, *1214–1215*
"The Prodigal Son" illustrations, *1180*
"The Prodigal Son" (Johnson, J.), *1179–1180*
Prokofiev, Sergei, *Peter and the Wolf,* 1222
Propaganda
art as, *1220–1221*
cinema as, 1220
Proust, Marcel, 1166
À la recherche, Time Regained, 1166
À la recherche du temps perdu (Remembrance of Things Past), 1166
Swann's Way, *1166, 1166*
Psychoanalytic techniques, 1155
Psychology, *1155–1164*
See also **Freud, Sigmund**
Psychology (James, W.), 1164
Puccini, Giacomo, *1133–1134*
La Bohème, 1133
The Girl of the Golden West, 1133
Madama Butterfly, 1133
Manon Lescaut, 1133
Nessun dorma ("Let No One Sleep"), *1133–1134*
Tosca, 1133
Turandot, *1133–1134*
Un bel dì ("One Fine Day"), 1133
Pynchon, Thomas, *V,* 1329

Q

Q. And Babies? A. And Babies. (Haeberle, Brandt, Art Workers' Coaltion), *1292, 1292*
Quantum mechanics, 1118
Quilts of Gee's Bend, 1177

R

Race riots, 1174
Radiguez, Maurice, *Le Bouillon de Tête* ("The Torturers of Blacks"), *1122*
Radio, role of in propaganda, 1220
Ragtime for Eleven Instruments (Stravinsky), 1179
Rainey, Ma, 1176
Randolph, A. Philip, 1276, 1282
Rasin Building (Gehry/Milunic), *1312–1313, 1313–1314*
Rauschenberg, Robert, 1299
Bed, *1266, 1267*
RCA Building, 1181
Rebecca of Sunnybrook Farm, 1201
Rebellious Silence (Neshat), *1337, 1337*
À la recherche, Time Regained (Proust), 1166
À la recherche du temps perdu (Remembrance of Things Past) (Proust), 1166
Red Hills and Bones (O'Keeffe), *1198, 1198*
Red Terror, 1152

"The Red Wheelbarrow" (Williams, W.), *1190, 1190*
Reed, Lou, 1296
Reich, Steve, *It's Gonna Rain,* 1299
Relâche, 1204
Remarque, Erich
All Quiet on the Western Front, *1146, 1146–1147*
during World War I, 1145
Remembrance of Things Past (Proust), 1166
Renoir, Jean, 1236
Reserve Officers' Training Corp (ROTC), 1288
Resettlement Administration, 1230
Resnais, Alain, *Night and Fog,* 1242
Resnick, Milton, 1255
"The Revolution Will Not Be Televised" (Scott-Heron), *1287–1288, 1287–1288*
Rhapsody in Blue (Gershwin), 1179
Rich, Adreinne, "Diving into the Wreck," *1303, 1303*
Richards, M. C., 1267
Richter, Gerhard
Ice, *1324, 1325*
Meadowland, *1324–1325, 1325*
Richthofen, Wolfram von, 1226
Riefenstahl, Leni
Olympia, *1221, 1221*
Triumph of the Will, 1220
Rietveld, Gerrit, Schroeder House, *1218, 1218*
Riley, Terry, *In C,* 1299
Ringaround Arosie (Hesse), *1303, 1303–1304*
Ringgold, Faith, *God Bless America,* *1282–1283, 1283*
Riots, 1287
Rist, Pipilotti
Ever Is Over All, *1341, 1341–1342*
I'm Not a Girl Who Misses Much, *1340, 1341*
The River (Lorentz), 1230
River Bathers (Hartigan), *1260–1261, 1261*
River Rouge Plant, Detroit, 1196
Rivera, Diego
Detroit Industry, 1225
Kahlo and, 1228
Man, Controller of the Universe, *1225, 1225*
Man at the Crossroads Looking with Hope and High Vision to a New and Better Future, 1225
Sugar Cane, *1224–1225, 1225*
Robie House, Chicago (Wright), *1185, 1185–1186*
Rock opera, 1300
Rock postmodern, *1300–1301*
Rockefeller, Nelson A., 1225
Rodeo (Copland), 1230
Roe v. Wade, 1283
Rommel, Erwin, 1238
"A Room of One's Own" (Woolf), *1165, 1171*
Rooney, Mickey, 1235
Roosevelt, Franklin, 1228, 1240
Roosevelt, Theodore, 1150
Rosenberg, Harold, 1259
Rosenberg, Isaac, "Dead Man's Dump," *1145–1146*
Rosenquist, James, *1288–1289*
F-111, *1290–1291, 1290–1291*
Rothko, Mark, *1263–1264*
Green on Blue, *1262, 1263*
The Rules of the Game, *1236–1237*
Running Fence (Christo/Jeanne-Claude), *1294–1295, 1295*
Russia
See also Soviet Union
cinema in, *1154–1155*
collectivization of agriculture, 1221
fascism in, *1221–1223*
Lenin and, 1152
social realism, *1222–1223*
World War I and, *1152–1155*
Russia Revolution, arts of, *1152–1155*
Russolo, Luigi, 1128
Rutherford, Ernest, 1118

S

La Sacre de printemps (The Rite of Spring), 1129
Saffarzadeh, Tahereh, 1337
Salon des Indépendants, 1122
El Salón México (Copland), 1230
SAMO, *1326–1327*
Sargent, John Singer, *Gassed,* *1144, 1145*
Sartre, Jean-Paul, 1249
Being and Nothingness, 1251
"Black Orpheus," *1283–1284*
No Exit, *1251, 1251, 1252*
"The Search for the Absolute," 1253
Sassoon, Siegfried, "Suicide in Trenches," 1145
Satie, Eric, 1204
Scat, 1179
Schmidt-Rottluff, Karl, 1130
Schoenberg, Arnold, *1133–1134*
Pierrot lunaire, 1133
School desegregation, 1276
Schroeder House (Rietveld), *1218, 1218*
Scientific discoveries, 1118
"Scientific management," 1118
SCLC (Southern Christian Leadership Conference), 1281
Scott-Heron, Gil, "The Revolution Will Not Be Televised," *1287–1288, 1287–1288*
Sculpture
abstract expressionism, *1264–1265*
existentialism, 1253
futurism, *1128, 1129*
mobiles, 1264
post–World War II period, *1248–1249*

surrealism and, *1162–1164*
Seagram Building (Mies van der Rohe/Johnson), *1244, 1244, 1269*
Seale, Bobby, 1287
"The Search for the Absolute" (Sartre), 1253
Seated Woman (de Kooning, W.), *1258, 1259, 1260*
"The Second Coming" (Yeats), *1147, 1147*
The Second Sex (De Beauvoir), *1251–1252, 1251–1252*
Self-Portrait as a Soldier (Kirchner), *1142–1143*
Self-Portrait with Model (Kirchner), *1130, 1130–1131*
Selznick, David O., *1235–1236*
Semiotics, 1321
Serial composition, 1133
The Seven Year Itch, 1296
Severance, H Craig, 1181
Sexton, Anne
To Bedlam and Part Way Back, 1302
"Her Kind," *1302, 1302–1303*
"The Sexual Life of Human Beings" (Freud), 1155
Shaker Loops (Adams), 1299
Shang Dynasty, 1190
Shankar, Ravi, 1299
Shaw, Artie, 1179
"she being Brand" (Cummings), *1190–1191, 1191*
Sheeler, Charles, *Classic Landscape,* *1196, 1196*
Shelton Towers, *1181, 1184, 1184*
Sherman, Cindy, *Untitled Film Stills,* *1306, 1306–1307*
Shoah, 1242
Shonibare, Yinka, *Victorian Couple,* *1333, 1333*
Shostakovich, Dimitri
Lady Macbeth of the Mtsensk District, 1222
Symphony No. 5, *1222–1223*
Shot, in motion pictures, 1138
Sight and Sound, 1236
Signs, *1321–1322*
Sikander, Shahzia, *Pleasure Pillars,* *1337, 1337*
Silent films, *1199–1204*
Silent Spring (Carson), 1293
Silly Symphonies, 1235
Simultanism, 1118
Singer Building, 1181
Siqueiros, David, 1224
The Siren of the Niger (Lam), *1284, 1284*
Six Days of Sound (MacLean), *1296, 1296*
Six Gallery, 1267
Sixteenth Street Baptist Church, 1282
Skyscraper architecture, *1181, 1181–1186*
Slaughterhouse-Five (Vonnegut), *1288, 1288*
Smith, Bessie, *1177–1178*
Florida-Bound Blues, 1178
portrait of, *1178*
Smith, David, *Blackburn: song of an Irish Blacksmith,* *1264–1265, 1265*
Smithson, Robert, *1292–1294*
Spiral Jetty, *1293, 1293–1294*
Smithsonian American Art Museum, 1295
Snow White and the Seven Dwarfs, 1235
A Social History of Indiana (Benton), 1229
A Social History of the State of Missouri (Benton), *1229, 1229*
Social realism, *1222–1223*
Social Security Act, 1228
Soft Toilet (Oldenburg), *1273, 1273*
Solomon R. Guggenheim Museum, *1270, 1270, 1292*
Song of the Children (Stockhausen), 1298
"Sonny's Blues" (Baldwin), 1284
The Souls of Black Folk (Du Bois), *1174, 1174*
The Sound and the Fury (Faulkner), *1189, 1189*
Southern Christian Leadership Conference (SCLC), 1281
Southern novel, 1189
Southwest, U.S., 1196
Soviet Union, 1205, 1250
See also Russia
Spain
Civil War, 1224
Civil War, map of, *1224*
fascism in, 1224
Spanish Popular Front, 1224
Spiegelman, Art, *Maus: A Survivor's Tale,* 1242
Spiral Jetty (Smithson), *1293, 1293–1294*
Sprechstimme, 1133
"Spunk" (Hurston), *1176–1177*
The Squaw Man, 1200
Sri Lanka, 1241
Stalin, Joseph, *1221–1223*
Stanford, Leland, 1196
Star system, 1201
"The Star-Spangled Banner" (Hendrix), 1297
The State and Revolution (Lenin), 1152
The Steerage (Stieglitz), *1182, 1183*
Stein, Gertrude
The Autobiography of Alice B. Toklas, *1119, 1119*
portrait of, *1119*
on World War I, 1144
Steinbeck, John, *The Grapes of Wrath,* *1230–1231*
Steir, Pat, *Yellow and Blue One-Stroke Waterfall,* *1328, 1328*
Stella, Frank, *Pagosa Springs,* *1274, 1274*
Stella, Joseph
"The Brooklyn Bridge (A Page of My Life)," 1194
The Voice of the City of New York Interpreted, *1191, 1194, 1194, 1196*

Sternberg, Josef von, *Der blaue Engel (The Blue Angel)*, 1234, *1235*
Stieglitz, Alfred
 An American Place gallery, 1187, 1194
 Camera Work, 1183
 Gallery 291, 1183, 1194
 Looking Northwest from the Shelton, New York, 1184, *1184*
 O'Keeffe and, 1197–1198
 The Steerage, 1182, 1183
Still Life #20 (Wesselmann), *1271*, 1271
Stills, Stephen, 1296–1297
Stimmung, 1203
Stockhausen, Karlheinz
 Song of the Children, 1298
 Studie 1, 1298
Stonewall riots, 1307–1308
Stoppard, Tom, 1252
The Store, 1272–1273
Storyboards for *Gone with the Wind*, 1236
Strand, Paul, *Abstraction, Porch Shadows*, *1183*, 1183
Strange Interlude (O'Neill), 1199
The Stranger (Camus), *1252*, 1252
Stravinsky, Igor, 1129–1130, 1298
 Ragtime for Eleven Instruments, 1179
Stream-of-consciousness novel, 1164–1166, 1189
Structuralism, 1321–1322
Stryker, Roy, 1231
Studie I (Stockhausen), 1298
Studies in Hysteria (Freud/Breuer), 1155
Studio for Electronic Music, 1298
Studio system, 1200–1201
Sublimation, 1158
Sugar Cane (Rivera), 1224–1225, *1225*
"Suicide in Trenches" (Sassoon), 1145
Sullivan, Louis, 1181
Summerspace (Cunningham), 1267–1268, *1268*
The Sun Also Rises (Hemingway), 1188
Superego, 1158
Superflex, *Flooded McDonald's*, *1340*, 1340–1341
Supermarket Shopper (Hanson), 1248–1249, 1249
Suprematism, 1153–1154
Suprematist Painting (Malevich), 1154, 1275
Surrealism, 1158–1164
 Apollinaire on, 1158–1159
 Breton and, 1158–1159
 Dali and, 1161–1162
 film and, 1204
 Miró and, 1160–1161
 Picasso and, 1160–1161
 sculpture, 1162–1164
Surrealist Manifesto (Breton), 1158, 1158–1159
Surrealist Pillow (Jefferson Airplane), 1296
Survey Graphic, 1175, 1176
Survival at Auschwitz (Levi), 1242
Suspended Ball (Giacometti), 1162, *1163*
Swann's Way (Proust), 1166, 1166
Swanson TV dinners, 1250
Symphony No. 5 (Shostakovich), 1222–1223

T

Ta Hsio (Great Digest), 1190
Tales of the Jazz Age (Fitzgerald), 1177
Tamayo, Rufino, 1230
Tang, emperor, 1190
Tate Modern, 1343
Taylor, Frederick, 1118
Tchaikovsky, Pyotr Ilyich, 1298
El Teatro Campesino (The Farmworkers Theater), 1334
Technicolor, 1233
Tehachapi Mountains, 1309, *1309*
Television, 1249–1250
Les Temps Modernes, 1252
Tenerife Opera House (Calatrava), 1317
Tennyson, Alfred Lord, "Charge of the Light Brigade," *1145*, 1145
The Holy Virgin Mary (Ofili), *1332*, 1332–1333
Theater
 Brecht, 1214
 The Farmworkers Theater, 1334–1335
 place, art of, 1199
 Theater of the Absurd, 1252–1253
"Theater for Pleasure or Theater for Imagination" (Brecht), *1214*
Theater of the Absurd, 1252
Theater Piece #1, 1267, 1269
Their Eyes Were Watching God (Hurston), 1177
"Theme for English B" (Hughes), *1209*
Theory of relativity, 1118–1119
The Thief of Bagdad, *1201*, 1201

"This Is Tomorrow" exhibition, *1256*, 1256
Thompson, Florence Owens, *1231*, 1231
Thompson, J. J., 1118
Thomson, Virgil, 1230
Thoreau, Henry David, 1241
Three Flags (Johns), 1268, *1268*
The Threepenny Opera (Brecht), 1214
Through the Flower (Chicago), 1304
Thus Spoke Zarathustra (Nietzsche), 1130
Tillich, Paul, 1250
"The Times They Are A-Changin'" (Dylan), 1283
To Bedlam and Part Way Back (Sexton), 1302
"To Brooklyn Bridge" (Crane), *1191*
To Raise the Water Level in a Fish Pond (Zhang Huan), *1332*, 1332
To the Lighthouse (Woolf), 1166
Toho Studios, 1243
Toklas, Alice B., 1119
Toland, Gregg, 1237
Tomatsu, Shomei
 Man with Keloidal Scars, 1243
 Nagasaki, 1243, *1243*
Tommy (The Who), 1300
Tonality, 1133
Tone row, 1133
Toomer, Jean, *Cane*, 1175
Toorop, Jan, 1296
Toqué and Gaud, 1121–1122
"The Torturers of Blacks" (Radiguez), 1121–1122, *1122*
Tosca (Puccini), 1133
Touch (Antoni), *1342*, 1342
Towards a New Architecture (Le Corbusier), 1219
Transition, 1148
Traveling shot, 1138
Treaty of Fort Laramie, 1335
Trench warfare, and the literary imagination, 1145–1148
The Trial (Kafka), *1213*, 1213
Triumph of the Will, 1220
Trotsky, Leon, 1221
Trotting horse photography, *1136*, 1136
Truman, Harry, 1242, 1250
Tudor, David, 1267, 1268
Turandot (Puccini), 1133–1134
Turning Torso (Calatrava), 1317
TV dinners, 1250
Tzara, Tristan
 "Dada Manifesto 1918," 1148
 Monsieur Antipyrine's Manifesto, 1148–1149, *1148–1149*

U

Ulysses (Joyce), 1164–1165
The Umbrellas, Japan – USA (Christo/Jeanne-Claude), *1309*, 1309
Un bel dì ("One Fine Day") (Puccini), 1133
Union Theological Seminary, 1250
Unique Forms of Continuity in Space (Boccioni), 1128, *1129*
United States
 See also American colonies
 abstract expressionism, 1255, 1258–1265
 Bauhaus in, 1244
 Christian existentialism, 1250
 cinema and, 1200–1201
 Dust Bowl in film and literature, 1230–1231
 Federal Music Project, 1230
 Great Depression in, 1228–1233
 Latino and Hispanic presence in U.S., 1333–1335
 mural movement, 1229–1230
 New Deal, 1228–1233
 photography during Great Depression, 1231–1233
 post–World War II period, 1254–1265
United States (Anderson), 1300
United States II (Anderson), 1300–1301, *1301*
University of California at Berkeley, 1288
Untitled (Cowboy) (Prince), *1307*
Untitled Film Stills (Sherman), *1306*, 1306–1307

V

V (Pynchon), 1329
Valdez, Luis, *Zoot Suit*, 1334–1335, *1335*
Valentino, Rudolph, 1202
Van Vechten, Carl
 Bessie Smith portrait, *1178*
 Nigger Heaven, 1175
 Portrait of Countee Cullen in Central Park, 1175

Variations V (Cage), 1268
Vauxcelles, Louis, 1124
Vecchio, Mary Ann, 1297
Velvet Underground, 1296
Venturi, Robert
 "Gentle Manifesto," 1314
 Learning from Las Vegas, 1314–1315
Verdi, Giuseppe, 1298
Vian, Boris, 1252
Victorian Couple (Shonibare), *1333*, 1333
Video art, 1338–1342
Vietnam, 1240
Vietnam Moratorium Day, 1292, 1296
Vietnam War, and the arts, 1288–1298
 anti-war movement, 1288–1289, 1292, 1296
 artists against the war, 1288–1289, 1292
 conceptual art, 1292
 land art, 1292–1295
 music and, 1295–1298
 Vonnegut and, 1288
Villa Savoye (Le Corbusier), *1219*, 1219
Village Voice, 1308
Viola, Bill, *Five Angels for the Millennium*, 1338–1339, *1339*
Violin (Picasso), *1126*, 1126
Violin and Palette (Braque), *1125*, 1125
Visual arts, 1179–1180
"Visual Pleasure and Narrative Cinema" (Mulvey), 1307
Vitagraph, 1202
Voelcker, John, 1256
The Voice of the City of New York Interpreted (Stella), 1191, *1194*, 1194, 1196
Vonnegut, Kurt, *Slaughterhouse-Five*, 1288, *1288*

W

Wagner, Richard, *Gesamtkunstwerk*, 1299
Waiting for Godot (Beckett), 1252–1253, *1253*, 1278–1279
Waka Chinese poetry tradition, 1135
Wall, Jeff, *After Invisible Man by Ralph Ellison*, 1285
Wall Drawing #146A (LeWitt), 1275, *1275*
Wallace, Mike, 1292
Walter, Marie-Thérèse, 1160–1161
Wandervogel movement, 1215
The War of the Worlds (radio dramatization), 1237
The War of the Worlds (Wells), 1237
Warhol, Andy
 America, 1308, 1308
 Campbell's Soup Cans, 1270–1271, *1271*, 1275
 Lance Loud, 1308, 1308
 Marilyn Diptych, *1272*, 1272, 1275
Washroom and Dining Area of Floyd Burroughs's Home, Hale County, Alabama (Walker), 1232
The Waste Land (Eliot), 1147–1148, *1148*, 1169
Waterer and Watered (Lumière brothers), *1137*, 1137
Watts riots, 1287
The Way Things Go (Fischli/Weiss), *1339*, 1339–1340
The Weather Project (Eliason), *1343*, 1343
Webern, Anton, 1133
The Wedge (Williams), 1190
Weill, Kurt, *Mahagonny-Songspiel*, 1214
Weimar Republic, 1212, 1215, 1217
Weiss, David, *The Way Things Go*, *1339*, 1339–1340
Welles, Orson, *Citizen Kane*, 1237, *1237*
Wells, H. G., 1237
Wesselmann, Tom, *Still Life #20*, *1271*, 1271
West Side Story (Bernstein), 1298
"What Abstract Art Means to Me" (De Kooning, W.), 1259
"White Rabbit" (Jefferson Airplane), 1296
White Squares (Krasner), *1260*, 1260
Whitman, Walt
 Leaves of Grass, 1136
 Pound on, 1135–1136
Whitney Museum of American Art, 1198, 1244, 1292
The Who, *Tommy*, 1300
Wiene, Robert, 1203
Wiesel, Elie, *Night*, *1242*, 1242
Williams, John, 1298
Williams, William Carlos

The Autobiography of William Carlos Williams, 1192, 1194, *1195*
 "The Great Figure," 1192–1193
 Pound and, 1190
 "The Red Wheelbarrow," *1190*, 1190
 The Wedge, 1190
Wilson, Robert, *Einstein on the Beach*, 1299–1300, *1300*
The Wizard of Oz, 1235, *1235*
Woman, meaning of, 1302
A Woman of Affairs, 1202
Women
 abstract expressionism, 1260–1262
 existential feminism, 1251–1252
 gender and O'Keeffe, 1197–1198
 in Islam, 1336–1337
 Münter, Gabriele, 1131–1132
Women of Allah (Neshat), 1337
"Woodstock" (Mitchell), 1297, *1297*
Woodstock Festival, 1297
Woolf, Virginia
 To the Lighthouse, 1166
 Mrs. Dalloway, 1165, 1165–1166
 "A Room of One's Own," 1165, *1171*
Woolworth Building, 1181, *1184*, 1184–1185
Woolworth Building, New York City, sketch elevation (Gilbert), *1184*
Work Projects Administration (WPA), 1228–1229
Workers Leaving the Lumière Factory, 1136
World Exhibition, Rome, 1223
World War I, 1143–1171
 Dada, 1148–1152
 Freud and Jung, 1155–1164
 introduction to, 1143–1145
 map of Western Front, *1143*
 prospect of, 1139
 Russia and, 1152–1155
 stream-of-consciousness novel, 1164–1166
 trench warfare and the literary imagination, 1145–1148
World War II, 1237–1243
 Allied victory, 1240
 decolonization and liberation, 1240–1241
 the Holocaust, 1238–1240
 Japanese response, 1242–1243
 map of, *1238*, *1241*
 in the Pacific, 1240
 reactions to, 1241–1243
WPA (Work Projects Administration), 1228–1229
Wright, Frank Lloyd
 Fallingwater, Bear Run, Pennsylvania, 1186, *1186*
 Robie House, Chicago, *1185*, 1185–1186
 Solomon R. Guggenheim Museum, *1270*, 1270

Y

Yale University, 1289
Yeats, William Butler
 "The Lake Isle of Innisfree," 1147, *1147*
 "A Prayer for My Daughter," 1147
 "The Second Coming," 1147
Yellow and Blue One-Stroke Waterfall (Steir), 1328, *1328*
Yoruba culture, 1332–1333
You Have Seen Their Faces (Caldwell/Bourke-White), 1233
Young, Neil, 1296–1298
 "Ohio," 1298

Z

Zapata, Emiliano, 1224
Zhang Hongtu, *Bird's Nest, in the Style of Cubism*, 1320–1321, *1321*, 1322, 1332
Zhang Huan
 Bird's Nest, in the Style of Cubism, 1332
 To Raise the Water Level in a Fish Pond, 1332, *1332*
Zoot Suit (Valdez), 1334–1335, *1335*
Zuckmeyer, Carl, 1212
Zukor, Adolph, 1201
Zweig, Stefan, 1211, 1212

PHOTO CREDITS

(ARS), New York; **38-28** Carl Andre, "10 × 10 Altstadt Copper Square". 1967. Düsseldorf Copper. 100-units, each: 3/16" × 19 11/16" × 19 11/16" (.5 × 50 × 50 cm). Solomon R. Guggenheim Museum, New York. Panza Collection, 1991. 91.3673; **38-30** © Bettmann/CORBIS All Rights Reserved; page 1256, © 2009 Artists Rights Society (ARS), New York/DACS, London; page 1257, Richard Hamilton (English, b. 1922), "Just what is it that makes today's homes so different, so appealing?", 1956. Collage. Kunsthalle, Tubingen, Germany. The Bridgeman Art Library International © 2010 Artists Rights Society (ARS), New York / DACS, London; page 1259, Pablo Picasso (1881-1973) "Girl Before a Mirror". Boisgeloup, March 1932. Oil on canvas, 64 × 51 1/4". Gift of Mrs. Simon Guggenheim. (2.1938). Digital Image © The Museum of Modern Art/Licensed by SCALA / Art Resource, NY. © ARS Artists Rights Society, NY.

Chapter 39

39-1 AP Images; **39-2** Faith Ringgold, "God Bless America", 1964. Oil on canvas, 31 × 19 in. © Faith Ringgold 1964; **39-3** Wifredo Lam (Cuban, b. Sagua la Grande, 1902-1982), "Siren of the Niger". 1950. Oil and charcoal on canvas, 51" × 38 1/8" (129.5 × 96.8 cm). Signed LR in Oil: Wifredo Lam/1950. Hirshhorn Museum and Sculpture Garden, Smithsonian Institution, Gift of Joseph H. Hirshhorn, 1972. © 2009 Artists Rights Society (ARS), New York/DACS; **39-4** Ralph Ellison, "Invisible Man". 1999-2000. Edition of 2. Marian Goodman Gallery; **39-5** Romare Bearden (1914-1988), "The Dove". 1964. Cut-and-pasted photoreproductions and papers, gouache, pencil and colored pencil on cardboard. 13 3/8 × 18 3/4". Blanchette Rockefeller Fund. (377.1971). The Museum of Modern Art/Licensed by Scala-Art Resource, NY. Art © Romare Bearden Foundation/Licensed by VAGA, NY; **39-6** Claes Oldenburg, "Lipstick (Ascending) on Caterpillar Tracks". 1969. Cor-Ten stee, aluminum; coated with resin and painted with polyurethane enamel. 23'6" × 24' 10'11" (7.16 × 7.58 × 3.33 m). Collection Yale University Art Gallery, Gift of Colossal Keepsake Corporation Photo by Attilio Maranzano. © 2008 Oldenburg Van Bruggen Foundation, NY; **39-7** Haeberle, R.L. (20th CE) and Peter Brandt (20th CE). "Q. And Babies? A. And Babies". 1970. Offset lithograph, printed in color, 25 × 38". Gift of the Benefit for Attica Defense Fund. (498.1978). The Museum of Modern Art, New York, NY, U.S.A. Photo Credit : Digital Image © The Museum of Modern Art/Licensed by SCALA / Art Resource, NY; **39-8** Robert Smithson, "Spiral Jetty". April 1970. Great Salt Lake, Utah. Black rock , salt crystals, earth, red water (algae). 3 1/2' × 15' × 1500'. Art © Estate of Robert Smithson/Licensed by VAGA, New York. Courtesy James Cohan Gallery, New York. Collection: DIA Center for the Arts, New York. Photo: Gianfranco Goroni; **39-9** Michael Heizer, "Double Negative". 1969-70. 240,000-ton displacemtn at Mormon Mesa, Overton, Nevada. 1500' × 50' × 30' (457.2 × 15.2 × 9.1 m). Gift of Virginia Dwan, Photograph courtesy the artist. Museum of Contemporary Art; **39-10** Christo and Jeanne-Claude, "Running Fence", Sonoma and Marin Counties, California, 1972-76. Height: 5.48 meters (18 ft.), Length: 39.4 kilometers (24 1/2 miles). Copyright Christo 1976. Photograph: Wolfgang Volz; **39-11** Bonnie Maclean, "Six Days of Sound". December 26-31, 1967. Poster. Bill Graham Archives/Wolfgang's Vault; **39-12** John Paul Filo/Getty Images; **39-13** Photograph © 1984 Jack Vartoogian/FrontRowPhotos. All Rights Reserved; **39-14** © Perry Hoberman; **39-15** Eva Hesse, "Ringaround Arosie", March 1965. Varnish, graphite, ink, enamel, cloth-covered wire, papier-mâché, unknown modeling compound, Masonite, wood, 67.5 × 42.5 × 11.4 cm / 26 5/8 × 16 3/4 × 4 1/2 inch. Museum of Modern Art, New York, fractional and promised gift of Kathy and Richard S. Fuld, Jr., 2005. © The Estate of Eva Hesse, Hauser & Wirth Zurich, London. Photo: Abby Robinson/Barbora Gerny, New York; **39-16** Judy Chicago, "Pasadena Lifesavers Red Series #3". c. 1969-1970. Sprayed acrylic lacquer on sheet acrylic. 5' × 5'. © 2008 ARS Artists Rights Society. Photo © Donald Woodman; **39-17** Judy Chicago (American, b. 1939), The Dinner Party". 1979. Mixed Media, 48 ft. × 42 ft. × 3 ft. installed. Collection of The Brooklyn Museum of Art, Gift of the Elizabeth A. Sackler Foundation. Photograph © Donald Woodman. © 2005 Judy Chicago/Artists Rights Society (ARS), NY; **39-18** Courtesy Ronald Feldman Fine Arts, New York / www.feldmangallery.com; **39-19** Untitled Film Still, 1979. Cindy Sherman. Courtesy of the Artist and Metro Pictures; **39-20** Richard Prince, Untitled (Cowboy), 1989. © Richard Prince. Courtesy Gagosian Gallery; **39-22** Christo and Jeanne-Claude, "The Umbrellas, Japan-USA". 1984-91. Photo: Wolfgang Volz; **39-23** Christo and Jeanne-Claude, "The Umbrellas, Japan-USA". 1984-91. Photo: Wolfgang Volz; pages 1290-1290, James Rosenquist (b. 1933) "F-111". 1964-65. Oil on canvas with aluminum, 10' × 86' overall. Purchase Gift of

Mr. and Mrs. Alex L. Hillman and Lillie P. Bliss Bequest (both by exchange). (00473.96.a-w). Digital Image © The Museum of Modern Art/Licensed by SCALA / Art Resource, NY. © Art James Rosenquist/VAGA Visual Artists Galleries & Association, NY; page 1291 (top), James Rosenquist (b. 1933) "F-111". 1964-65. Oil on canvas with aluminum, twenty-three sections, 10 × 86' (304.8 × 2621.3 cm). Gift of Mr. and Mrs. Alex L. Hillman and Lillie P. Bliss Bequest (both by exchange). (473.1996.a-w) The Museum of Modern Art, New York, NY, U.S.A. Digital Image The Museum of Modern Art/Licensed by SCALA / Art Resource, NY. Art © Estate of James Rosenquist/VAGA, NY.

Chapter 40

40-1 © Curva de Luz / Alamy; **40-2** Ron Dahiquist/SuperStock; **40-3** (left) Tim Street-Porter/Esto; **40-3** (right) Frank Gehry, Gehry house, 1977-1978, axonometric drawing. Tim Street-Porter; **40-4** The Guggenheim Museum Bilbao, 1997. Photo: David Heald © The Solomon R. Guggenheim Foundation, New York; **40-5** The Guggenheim Museum Bilbao, 1997. Photo: David Heald © The Solomon R. Guggenheim Foundation, New York, USA; **40-6** AP Photo/Port Authority of New York and New Jersey; **40-7** Nr. RP2-8 Centre Tjibou, New Caledonia. © Hans Schlupp/archenova. Architect/Designer: Renzo Piano Building Workshop; **40-8** Archetect - Emilio Ambasz Hon. FAIA, The photographer is Hiromi Watanabe; **40-9** © Xiaoyang Liu / CORBIS All Rights Reserved; **40-12** Courtesy of the Artist and Metro Pictures; **40-13** Gerhard Richter (1932-) "Meadowland (Wiesenthal)". 1985. Oil on canvas, 35 5/8 × 37 1/2". Blanchette Rockefeller, Betsy Babcock, and Mrs. Elizabeth Bliss Parkinson Funds. (350.1985). Digital Image © The Museum of Modern Art/Licensed by SCALA / Art Resource, NY. © Gerhard Richter, Germany; **40-14** Gerhard Richter (German, b. 1932). "Ice (2)". 1989. Oil on Canvas, 203.2 × 162.6 cm. Through prior gift of Joseph Winterbotham; gift of Lannan Foundation, 1997.188. Reproduction, The Art Institute of Chicago. All Rights Reserved; **40-15** Pat Steir, "Yellow and Blue One-Stroke Waterfall". 1992. Oil on Canvas. 172 5/8" × 91" (438.5 × 231.2 cm). The Solomon R. Guggenheim Museum, New York. Gift, John Eric Cheim, 1999. 99.5288; **40-16** Yasumasa Morimura, "Portrait (Futago), 1988. Color Photograph, 82 3/4 × 118 inches. Courtesy of the artist and Luhring Augustine, New York; **40-17** © Zhang Huan; **40-18** Chris Ofili, "The Holy Virgin Mary". 1996. Paper collage, oil paint, glitter, polyester, resin, map pins, and elephant dung on linen. 8' × 6'. The Saatchi Gallery, London. Photo: Diane Bondareff/AP World Wide Photos; **40-19** Yinka Shonibare, "Victorian Couple". 1999. Was printed cotton textile. L: 153 × 92 × 92 cm (60...× 36"× 36"). R: 153 × 61 × 61 cm (60" × 24" × 24"). Courtesy of the Artist, Stephen Friedman Gallery, London, and James Cohan Gallery, New York; **40-20** Judith F Baca, "The Farmworkers of Guadalupe". 1990. Acrylic on plywood, 9' × 9'. From "Guadalupe Mural Project". Photo © SPARC, Venice, CA; **40-21** Jimmie Durham, "Headlights", 1983. Car parts, antler, shell, etc. Private Collection. Courtesy of the artist; **40-22** David P. Bradley (white Earth Ojibwe and Mdewakaton Dakota), "Indian Country Today". 1996-97. Acrylic on Canvas. Museum Purchase through the Mr. and Mrs. James Krebs Fund. Photograph courtesy Peabody Essex Museum; **40-23** Shirin Neshat, courtesy Gladstone Gallery, New York; **40-24** Shahzia Sikander, "Pleasure Pillars". 2001. Watercolor, dry pigment, vegetable color, tea, and ink on wasli paper. 12" × 10". Courtesy Sikkema Jenkins & Co., New York; **40-25** Eleanor Antin, "A Ghost Story. 1994-1995. Filmic installation. View [one, two, three] of three. Installation view (left), two stills from video projections (below and right). Below: Through the Lover's Window. Right: Through the Artist's Window. Copyright Eleanor Antin Courtesy Ronald Feldman Fine Arts, New York; **40-26** Mike Bruce/Courtesy Anthony d'Offay, London; **40-27** (top) Peter Fischli & David Weiss, "Still from Der Lauf der Dinge (The Way Things Go)". 1987. © Peter Fischli David Weiss, Courtesy of Matthew Marks Gallery, New York; **40-27** (bottom) Peter Fischli & David Weiss, "Still from Der Lauf der Dinge (The Way Things Go)". 1987. © Peter Fischli David Weiss, Courtesy of Matthew Marks Gallery, New York; page 1327, Jean-Michel Basquiat, "Charles the First". 1982. Acrylic and Oilstick on Canvas. Triptych. 6'6" × 5'2 1/4" (1.98 × 1.58 m). © The Estate of Jean-Michel Basquiat/ © 2009 Artists Rights Society (ARS), NY; page 1331, Edouard Manet(1832-1883), "Olympia". 1863. Oil on canvas, 130.5 × 190.0 cm. Inv. RF 2772. Hervé Lewandowski/Musee d'Orsay, Paris, France. RMN Reunion des Musees Nationaux/Art Resource, NY. © 2008 Edouard Manet/Artists Rights Society (ARS), New York; page 1337, P. Zigrossi/Vatican Museums, Rome, Italy.

▶ TEXT CREDITS

Chapter 34

Reading 34.3, page 1134: Guillaume Apollinaire, "Lundi, rue Christine" by Guillaume Apollinaire from APOLLINAIRE: SELECTED POEMS trans. by Oliver Bernard. New edition published by Anvil Press Poetry in 2004. Reprinted by permission of the publisher. **Reading 34.4**, page 114: Guillaume Apollinaire, "Il Pleut" by Guillaume Apollinaire from APOLLINAIRE: SELECTED POEMS trans. by Oliver Bernard. New edition published by Anvil Press Poetry in 2004. Reprinted by permission of the publisher. **Reading 34.5**, page 1135: Ezra Pound, "In a Station of the Metro" from PERSONAE, copyright 1926 by Ezra Pound. Reprinted by permission of New Directions Publishing Corp. and Faber & Faber Ltd. Electronic rights by permission of New Directions Publishing Corp. **Reading 34.6**, page 1135: Ezra Pound, "A Pact" from PERSONAE, copyright 1926 by Ezra Pound. Reprinted by permission of New Directions Publishing Corp. and Faber & Faber Ltd. Electronic rights by permission of New Directions Publishing Corp. **Reading 34.2**, page 1141: Filippo Marinetti, from MARINETTI: SELECTED WRITINGS by FT. Marinetti, edited by R.W. Flint, translated by R.W. Flint and Arthur A. Coppotelli. Translation copyright © 1972 by Farrar, Straus & Giroux, Inc. Reprinted by permission of Farrar, Straus and Giroux, LLsC

Chapter 35

Reading 35.6a, page 1148: T. S. Eliot, from "The Waste Land" from COLLECTED POEMS 1909-1962 by T.S. Eliot. Reprinted by permission of the publisher, Faber & Faber Ltd. Copyright © the Estate of T.S. Eliot. **Reading 35.15**, page 1165: Virginia Woolf, excerpt from MRS. DALLOWAY by Virginia Woolf, copyright 1925 by Harcourt, Inc. and renewed 1953 by Leonard Woolf, reprinted by permission of the publisher and The Society of Authors as the Literary Representative of the Estate of Virginia Woolf. **Page 1167:** Langston Hughes, lines from "One Way Ticket" by Langston Hughes from THE COLLECTED POEMS OF LANGSTON HUGHES, ed. by Arnold Rampersad with David Roessel, Associate Editor, copyright © 1994 by the Estate of Langston Hughes. Used by permission of Alfred A. Knopf, a division of Random House, Inc. and Harold Ober Associates. Inc. Electronic rights administered by Harold Ober Associates, Inc. **Reading 35.6**, page 1169: T.E. Eliot, from "The Waste Land" from COLLECTED POEMS 1909-1962 by T.S. Eliot. Reprinted by permission of the publisher, Faber & Faber Ltd. Copyright © the Estate of T.S. Eliot. **Reading 35.11**, page 1170: Sigmund Freud, from CIVILIZATION AND ITS DISCONTENTS by Sigmund Freud, trans. by James Strachey. Copyright © 1961 by James Strachey, renewed 1989 by Alix Strachey. Used by permission of W.W. Norton & Company, Inc. and The Random House Group Ltd. Published in Great Britain in THE STANDARD EDITION OF THE PSYCHOLOGICAL WORKS OF SIGMUND FREUD, trans. and ed. by James Strachey (Hogarth Press). Electronic rights by permission of Paterson Marsh Ltd. on behalf of Sigmund Freud copyrights. **Reading 35.14**, page 1171: Virginia Woolf, from A ROOM OF ONE'S OWN by Virginia Woolf, copyright © 1929 by Harcourt, Inc. and renewed 1957 by Leonard Woolf, reprinted by permission of Houghton Mifflin Harcourt Publishing Company and The Society of Authors as the Literary Representative of the Estate of Virginia Woolf.

Chapter 36

Reading 36.2, page 1174: Claude McKay, "If We Must Die" courtesy of the Literary Representative for the Works of Claude McKay, Schomburg Center for Research in Black Culture, The New York Public Library, Astor, Lenox and Tilden Foundations. **Reading 36.3**, page 1175: Alain Locke, reprinted with the permission of Scribner, a division of Simon & Schuster, Inc. from THE NEW NEGRO: VOICES OF THE HARLEM RENAISSANCE by Alain Locke. Copyright © 1925 by Albert & Charles Boni, Inc. All rights reserved. **Reading 36.5a**, page 1176: Langston Hughes, lines from "Jazz Band in a Parisian Cabaret" from THE COLLECTED POEMS OF LANGSTON HUGHES, ed. by Arnold Rampersad with David Roessel, Associate Editor, copyright © 1994 by the Estate of Langston Hughes. Used by permission of Alfred A. Knopf, a division of Random House, Inc. and Harold Ober Associates, Inc. Electronic rights administered by Harold Ober Associates, Inc. **Reading 36.6**, pages 1179-1180: James Weldon Johnson from "The Prodigal Son" from GOD'S TROMBONES by James Weldon Johnson, copyright © 1927 The Viking Press, Inc., renewed © 1955 by Grace Nail Johnson. Used by permission of Viking Penguin, a division of Penguin Group (USA) Inc. **Reading 36.7a**, page 1187: F. Scott Fitzgerald, Reprinted with the permission of Scribner, a Division of Simon & Schuster, Inc. and Harold Ober Associates from THE GREAT GATSBY by F. Scott Fitzgerald. Copyright © 1925 by [...] Scribner's Sons. Copyright renewed 1953 by Frances Scott Fitzgerald Lanahan. All rights reserved. **Reading** [...] 1188: F. Scott Fitzgerald, Reprinted with the permission of Scribner, a Division of Simon & Schuster, Inc. [...] Associates from THE GREAT GATSBY by F. Scott Fitzgerald. Copyright © 1925 by Charles [...] 1953 by Frances Scott Fitzgerald Lanahan. All rights reserved. **Reading 36.10**, [...] Wheelbarrow" by William Carlos Williams from THE COLLECTED [...] New Directions Publishing Corp. Reprinted by permission of [...] 36.11, page 1191: E. E. Cummings, "she being [...] [C]ummings Trust. Copyright © 1985 by George [...] [read]ings, ed. by George J. Firmage. Used by per- [...] 191: Hart Crane, "To Brooklyn Bridge," from [...] Simon. Copyright © 1933, 1958, 1966 by Liv- [...] [U]sed by permission of Liveright Publishing Cor- [...] [fi]gure" by William Carlos Williams from THE [...] [b]y New Directions Publishing Corp. Reprinted [...] [Pr]ess Ltd. **Reading 36.4**, page 1207-1208: Countee [...] [H]arper & Brothers; renewed 1952 by Ida M. Cullen. [...] [a]dministered by Thompson and Thompson, Brook- [...] [W]eary Blues," "Harlem (2)," and "Theme for English

B" from THE COLLECTED POEMS OF LANGSTON HUGHES, ed. by Arnold Rampersad with David Roessel, Associate Editor, copyright © 1994 by the Estate of Langston Hughes. Used by permission of Alfred A. Knopf, a division of Random House, Inc. and Harold Ober Associates, Inc. Electronic rights administered by Harold Ober Associates, Inc.

Chapter 37

Reading 37.3, page 1214: Bertolt Brecht, From "Theater for Pleasure or Theater for Imagination" from BRECHT ON THEATER THE DEVELOPMENT OF AN AESTHETIC, ed. and trans. by John Willett. Reprinted by permission of Farrar Straus and Giroux, LLC and Methuen Drama, an imprint of A.C. Black Publishers Ltd. **Reading 37.2**, page 1146-1147: Franz Kafka, from "The Metamorphosis" from THE METAMORPHOSIS, THE PENAL COLONY & OTHER STORIES by Franz Kafka, trans. by Willa & Edwin Muir, Copyright 1948 by Schocken Books. Copyright © renewed 1975 by Schocken Books. Used by permission of Schocken Books, a division of Random House, Inc. and Secker & Warburg, an imprint of The Random House Group Ltd. Electronic rights administered by Random House, Inc.

Chapter 38

Reading 38.1, page 1251: Jean-Paul Sartre, from NO EXIT AND THE FLIES by Jean-Paul Sartre, trans. by Stuart Gilbert, copyright 1946 by Stuart Gilbert. Copyright renewed 1974, 1975 by Maris Agnes Mathilde Gilbert. French language edition © 1947 Editions Gallimard. Used by permission of Alfred A. Knopf, a division of Random House, Inc. and Penguin Books Ltd. Electronic rights administered by Editions Gallimard, www.gallimard.fr. **Reading 38.4a**, page 1253: Samuel Beckett, from WAITING FOR GODOT, copyright © 1954 by Grove Press, Inc., copyright © renewed 1982 by Samuel Beckett. Used by permission of Grove/Atlantic, Inc. and Faber & Faber Ltd. **Reading 38.4b**, page 1253: Samuel Beckett, from WAITING FOR GODOT, copyright © 1954 by Grove Press, Inc., copyright © renewed 1982 by Samuel Beckett. Used by permission of Grove/Atlantic, Inc. and Faber & Faber Ltd. **Reading 38.5**, page 1266: Allen Ginsberg, first 17 lines from "Howl" from COLLECTED POEMS 1947-1980 by Allen Ginsberg. Copyright © 1955 by Allen Ginsberg. Reprinted by permission of HarperCollins Publishers and The Wylie Agency (UK) Ltd. **Reading 38.4**, page 1278-1279: Samuel Beckett, from WAITING FOR GODOT, copyright © 1954 by Grove Press, Inc., copyright © renewed 1982 by Samuel Beckett. Used by permission of Grove/Atlantic, Inc. and Faber & Faber Ltd.

Chapter 39

Page 1282: Bob Dylan, from "Blowin' in the Wind" by Bob Dylan. Copyright © 1962 by Warner Bros. Inc.; renewed 1990 by Special Rider Music. All rights reserved. International copyright secured. Reprinted by permission. **Reading 39.3**, page 1287: Amiri Baraka, "Ka'Ba" from LEROI JONES/AMIRI BARAKA READER, 2/e, by William J. Harris. Copyright © 1999 Genevieve Davis Ginsburg. Reprinted by permission of Basic Books, a member of the Perseus Books Group. **Reading 39.4**, page 1287-1288: Gil Scott-Heron, "The Revolution Will Not Be Televised" from SO FAR, SO GOOD copyright © 1990, by Gil Scott-Heron, copyright of Third World Press, Inc., Chicago, Illinois. **Reading 39.6**, page 1297: Joni Mitchell, from the lyrics to "Woodstock" words and music by Joni Mitchell. Copyright © 1969 (Renewed) Crazy Crow Music. All Rights Reserved. Used by Permission. © Sony/ATV Music Publishing. All Rights Reserved. Used by permission. **Reading 39.7**, page 1302: Betty Friedan, from THE FEMININE MYSTIQUE by Betty Friedan. Copyright © 1983, 1974, 1973, 1963 by Betty Friedan. Used by permission of W.W. Norton & Company, Inc. and victor Gollancz, an imprint of The Orion Publishing Group, London. Electronic rights by permission of Curtis Brown Ltd. Copyright © 1963, 1974, 1991, 1997 by Betty Friedan. **Reading 39.9**, page 1302-1303: Anne Sexton, "Her Kind" from TO BEDLAM AND PART WAY BACK by Anne Sexton. Copyright © 1960 by Anne Sexton, renewed 1998 by Linda G. Sexton. Reprinted by permission of Houghton Mifflin Harcourt Publishing Company and SLL/Sterling Lord Literistic. All rights reserved. **Reading 39.10**, page 1303: Adrienne Rich, from "Diving into the Wreck." Copyright © 2002 by Adrienne Rich. Copyright © 1963 by W.W. Norton & Company, Inc. from THE FACE OF A DOORFRAME: SELECTED POEMS 1950-2001 by Adrienne Rich. Used by permission of the author and W.W. Norton & Company, Inc. **Reading 39.8**, page 1311: Sylvia Plath, All lines from "Lady Lazarus" from ARIEL by Sylvia Plath. Copyright © 1963 by Ted Hughes. Reprinted by permission of HarperCollins Publishers and Faber & Faber Ltd.

Chapter 40

Reading 40.1, page 1238: Michel Foucaul, from the Preface to the ORDER OF THINGS by Michel Foucaul. Copyright © 1970 by Random House, Inc., New York. British edition Copyright © 1970 Tavistock/Routledge. Originally published in French as LES MOTS ET LES CHOSES. Copyright © 1966 by Editions Gallimard. Reprinted by permission of Georges Borchardt, Inc. for Editions Gallimard and Taylor & Francis Books UK. Electronic rights administered by Georges Borchardt, Inc. and Editions Gallimard, http://www.gallimard.fr. **Reading 40.4a**, page 1330: David Antin, "If We Get It" by David Antin is reprinted by permission of the author. **Reading 40.4b**, page 1330: David Antin, "If We Make It" by David Antin is reprinted by permission of the author. **Reading 40.5**, page 1330: John Ashbery, from "On the Towpath" from HOUSEBOAT DAYS by John Ashbery. Copyright © 1975, 1976, 1977, 1999 by John Ashbery. Reprinted by permission of Georges Borchardt, Inc. on behalf of the author and Carcanet Press Ltd. **Reading 40.6**, page 1333-1334: Aurora Levins Morales, "Child of the Americas" by Aurora Levins Morales from GETTING HOME ALIVE by Aurora Levins Morales and Rosario Morales (Firebrand Books 1986) is reprinted by permission of Aurora Levins Morales. **Reading 40.2**, page 1345: Jorge Luis Borges, "Borges and I" by Jorge Luis Borges, trans. by James E. Irby, from LABYRINTHS, copyright © 1962, 1964 by New Directions Publishing Corp. Reprinted by permission of New Directions Publishing Corp. and Pollinger Ltd. Currently collected in SELECTED POEMS, Copyright © 1962, 1999 by Maria Kodama. Electronic rights administered by The Wylie Agency LLC.